GARDEN

GARDEN

Exploring the
Horticultural
World

Phaidon Press Limited
2 Cooperage Yard
London E15 2QR

Phaidon Press Inc.
65 Bleecker Street
New York, NY 10012

phaidon.com

First published 2023
© 2023 Phaidon Press Limited

ISBN 978 1 83866 597 5

A CIP catalogue record for this book is available from
the British Library and the Library of Congress.

Commissioning Editor: Victoria Clarke
Project Editor: Lynne Ciccaglione
Production Controller: Andie Trainer
Design: Hans Stofregen
Layout: Cantina

Printed in China

Arrangement
The illustrations in this book have been arranged in pairs
to highlight interesting comparisons and contrasts based
loosely on their subject, age, purpose, origin or appearance.
This organizational system is not definitive and many other
arrangements would have been possible. A chronological
survey can be found in the timeline at the back.

Dimensions
The dimensions of works are listed by height then width.
Digital images have variable dimensions. Where differences
in dimensions exist between sources, measurements listed
refer to the illustrated version.

Introduction 6

Garden: The Works 10

Timeline 334

Select Biographies 341
Glossary 343
Further Reading 345
Index 346

Connecting with Nature: A World of Gardeners

From Nature to Garden

The United Nations recognizes 195 countries – but there is a strong argument that there is a 196th: the United Nation of Gardeners. This is a nation that welcomes all, regardless of age, race, colour, class or creed. At any time, somewhere in the world, many hundreds of thousands of people – perhaps even millions – are digging, hoeing, planting, tending, harvesting or creating a garden.

The gardening impulse has evolved in humans over many millennia. Like other animals, we live on a planet dominated by plants; they represent around 80 per cent of all living material on Earth by mass. Our distant ancestors hunted in flower-filled meadows, crept through deciduous woodlands, harvested fruit, nuts, berries and roots, and learned by a process of trial and error which were edible, medicinal or poisonous. The natural world was their larder, medicine cabinet and shelter.

The first attempts at horticulture – the deliberate growing and management of gardens – were inspired by necessity, not aesthetics. Hunter-gatherers began to try to ensure a reliable supply of food by plant selection and cultivation, and the eventual domestication of such crops as emmer wheat and barley. They began to fence off enclosures to protect valuable plants from predators. Once they could guarantee a supply of food, they could begin to settle in communities.

The first gardens, then, were food gardens. Yet a deeper appreciation of plants, on a more aesthetic and spiritual level, seems to be a deep-rooted part of the human psyche, so it may be that even the earliest gardeners enjoyed the beauty of crops – their texture, form and colour of flower, fruit and foliage – as well as the reassurance of survival they provided.

Recent research by Semir Zeki, professor of neuroaesthetics at University College London, discovered that the same parts of the brain originally used for the appraisal of objects of biological importance, such as food or suitable mates – the anterior insula and orbitofrontal cortex – were also the locations that developed the appreciation of beauty. The idea of beauty elevated gardens beyond the practical to the aesthetic and opened the way to ornamental gardening, or gardening for the sake of appearance rather than solely to meet practical needs. The tradition of the *potager*, or ornamental kitchen garden, for example, combines practicality and aesthetics. Seeing beauty in vegetables requires only a change of mindset in the viewer.

The combination of usefulness and beauty, of being both within and outside the natural environment, of order and serenity in a busy world, gave gardens a special status. From ancient times, the garden became linked with the idea of paradise: an idyllic place of perpetual spring, with an abundance of food, sensory pleasures, and peace and harmony between nature and humanity. This vision of perfection manifested itself in the Sumerian-Babylonian concept of the Garden of the Gods, and again later in both the biblical Garden of Eden and the paradise described in the Koran. In China and Japan, meanwhile, gardens were linked with quiet contemplation and refuge, and were spiritual places where monks and acolytes could meditate.

The garden remains a place with a special status. As people's daily lives have grown more distant from the natural world, so ornamental gardening has become increasingly important as both an expression of human creativity and a way to reconnect with nature. With the growth of towns and cities, and with modern lifestyles that are far removed from the seasonal cycles of nature, gardening brings us back to our origins – a return that is evidenced in the contemporary world by the proliferation of houseplant-filled rooms, offices and hotels full of cut flowers, gardens, parks, allotments and tree-lined streets.

Ancient Gardens: Paradise on Earth

The earliest gardens survive only in art or stories. The oldest images of Egyptian gardens date from around 3000–2000 BC. Reliefs, frescoes and miniature models in tombs depict gardens arranged around rectangular pools, planted with lotus, papyrus and rows of palms, and enclosed to protect them against wind and encroaching sand (see pp.52, 146).

In a relief dated to around 645 BC, the Assyrian king Ashurbanipal reclines on a couch shaded by vines (see p.132); his predecessor, Sennacherib, had planted a garden at the ancient and religious capital of Ashur. Around the same time in Mesopotamia, the ruler Nebuchadnezzar II is said to have created the Hanging Gardens of Babylon – one of the seven wonders of the ancient world – for his wife, who missed the vegetation of her mountainous homeland (see p.54).

Later the gardens of the ancient Greeks, as described in Homer's *Odyssey*, were primarily for growing vegetables, grapevines and fruit trees, while public spaces were planted with trees and shrubs to create shady retreats, often with sources of water. Following the Greeks, the Romans created gardens throughout their empire, planting courtyards within their villas, and orchards and vineyards on the surrounding land. Remains still exist at Pompeii (see p.255) and there is a surprisingly complex garden at Fishbourne Roman Villa in West Sussex, given the relatively cool English climate. Even this early, gardens had come to be seen as a symbol of cultural refinement, success and the pursuit of a virtuous life.

After Islam spread across the Middle East, North Africa and Asia from the AD 600s, Islamic gardens were modelled on the Garden of Eternal Paradise

detailed in the Koran, which was irrigated by four rivers flowing with milk, honey, wine and water, respectively. Known as *chahar bagh*, from the Persian for 'four gardens', Islamic gardens were typically rectangular, walled and divided into quadrants around a central pool or fountain, with an emphasis on water and shade (see pp.56–7). Cooling water ran alongside paths, with tanks and reflecting pools surrounded by fragrant plants and fruit trees, such as orange, pomegranate and lemon.

There are many variations on this theme. Early Mughal gardens established by the Islamic rulers of India relied less on moving water and had greater symmetry than their predecessors; the Turkish and Mongolian heritage of the emperors was reflected in the ornate carpets and tents set up in the garden. The oldest Mughal garden in India, the sixteenth-century Ram Bagh in Agra, a short distance from the Taj Mahal (see p.38), has a four-square design, with the remains of three terraces, fountains and wells that watered the garden.

Changing Ideas: From Medieval to Picturesque

Walled gardens were also a feature of medieval European gardens. Enclosed and cloistered, the *hortus conclusus* (enclosed garden) built alongside many monasteries was steeped in symbolism for Christians (see pp.133, 235). The roses that grew there were emblematic of the Virgin Mary, while the straight paths that divided the gardens reminded the monastery's inhabitants of their commitment to the straight and narrow – and the wall protected them from the worldly pleasures they had forsaken.

During the Renaissance of the fifteenth and sixteenth centuries, a stark contrast to the enclosed medieval sanctuaries emerged. The elite of Italy's city-states began to create extravagant and expansive gardens that were based more on the idea of pleasure and indulgence than on spiritual contemplation. For the first time, designers began to conceive of the garden as a whole, linking such areas as terraces, water features, vegetable gardens and wooded copses in a geometrical form around their patrons' palaces and villas.

The geometric formality that began with the Italian Renaissance was brought to its height on a vast scale in seventeenth-century France, most famously by the architect André Le Nôtre at Vaux-le-Vicomte and later at Versailles for King Louis XIV, the Sun King, where the surrounding countryside lent itself to expansive panoramas (see p.16). With its parterres, fountains, marble statuary and grottoes, Versailles was on a scale that was widely imitated by other monarchs and aristocrats, including at Het Loo in the Netherlands (see p.256), Drottningholm Palace in Denmark, Hampton Court in England (see p.82) and Peter the Great's Peterhof in Russia – a direct response to Versailles. Gardens of such scale and extravagance were the ultimate in gardening for the ego, demonstrating wealth and absolute power through the 'taming' of nature. These gardens became locations for earthly pleasures ranging from simple walking and talking to providing recreational spaces for dance, parties and theatrical performances. One particularly lavish evening of entertainment held by the French courtier Nicolas Fouquet at Vaux-le-Vicomte was said to have made Louis XIV so envious that he had the overly ambitious Fouquet imprisoned for the rest of his life.

As early as 1490, the Netherlandish artist Hieronymus Bosch painted *The Garden of Earthly Delights* (see p.76), a satirical commentary on the sinful indulgence associated with such gardens – and yet their popularity has persisted. Gardens are still popular settings for cinema, sport, *son et lumières*, concerts and fireworks.

Italian gardens remained influential throughout Europe until around the middle of the eighteenth century, when their primacy was challenged by the English Landscape movement. Designers such as William Kent and Lancelot 'Capability' Brown (see pp.102–3, 162) saw themselves as improving upon nature. They created grand designs with serpentine lines to reduce formality, and modified the landscape so that the garden merged seamlessly into the countryside beyond.

The subsequent Picturesque movement of the late eighteenth and early nineteenth century was a reaction against the smooth lines of the improvers, embracing and enhancing rugged, dramatic scenery to manipulate the viewer's feelings, seeking to create a frisson of fear or breathtaking beauty with views on a panoramic scale. In a further reaction, such landscape gardeners as Humphry Repton (see p.83) brought gardens back to a more domestic scale, providing greater convenience and order for the family, furnishing gardens with the new plants that by the early nineteenth century were flooding into Europe from the Americas, South Africa and Australia – a status symbol in themselves.

The Plant Collectors

The transfer of plants around the world through colonial expansion, exchange and goodwill transformed the horticultural world, particularly in Europe and North America. As early as classical times, Roman invaders had taken lavender with them during their conquests. In the seventeenth century Henry Compton, the Bishop of London, who ran the Church of England overseas, sent clergymen with a botanical interest to India, North America, the Caribbean and Africa with instructions to collect local species. Reverend John Banister, the first major American botanist in Virginia, responded with magnolias and liquidambar.

For fifty years in the eighteenth century, Philip Miller, curator of Chelsea Physic Garden, London, grew melons, pineapples and papaya while also maintaining diligent correspondence with other gardeners and collectors around the world, who sent him great quantities of seeds (see pp.106, 327). At the same time American botanist and horticulturist John Bartram sent boxes of treasures from North America to Peter Collinson, a fellow Quaker in London, who distributed them to British collectors (see p.32). 'Bartram's boxes' were awaited with eager anticipation.

China was a treasure trove of plants for cool temperate climates from the late nineteenth to the mid-twentieth century. A succession of intrepid explorers and collectors – including early French missionary botanists, such as Père Armand David; English collectors, notably George Forrest, Frank Kingdon-Ward and Ernest 'Chinese' Wilson; and more recently plant-hunters such as Dan Hinkley of Heronswood Nursery, and Bleddyn and Sue Wynn-Jones – introduced more botanical bounty for gardeners while also conserving plants through cultivation. In the tropics in the mid-twentieth century, landscape architect Roberto Burle Marx (see p.177) was an early spokesman against the destruction of the Amazon rainforest. He also introduced endangered plants into gardens to secure their conservation, while nurseries continued to add to a burgeoning, almost overwhelming choice.

Many newly encountered species found homes in botanic gardens allied to universities or other centres of scientific study. From the seventeenth century onwards, scientists and plant-collectors sent out by British, Dutch and French colonial powers returned with exotics to create botanic gardens at home, while also establishing them in locations abroad, including Singapore Botanic Gardens, Bogor Botanic Gardens in Java, and the Sir Seewoosagur Ramgoolam Botanic Garden (formerly Pamplemousse Gardens) in Mauritius. In the United States, collections were established at the New York Botanical Garden and the Missouri Botanical Garden in St. Louis, and specialist gardens were created for native species, such as the Desert Botanical Garden in Phoenix, Arizona. Such symbols of colonial exploitation are now at the forefront of conservation, research and public education, alerting the public to the importance of plants to human survival.

Chinese and Japanese Gardens: Connecting with Nature

Travelling to Asia brought Europeans into contact with the world's oldest continuous tradition of garden design, in China. Chinese gardens reflect ancient ideas of humans' relationship with nature alongside an appreciation of wild scenery. Like Japanese gardens, they are based on philosophies such as Confucianism, Daoism and Buddhism, which highlight a quest for enlightenment.

These gardens are spaces of spiritual significance, contemplation and symbolism, comprising a series of perfectly composed and framed glimpses of a pond, lake or rock garden, or a borrowed view of a distant mountain peak or pagoda. Pavilions, temples, bridges and other structures fill much of the space but remain in harmony with the landscape. Features such as moon gates – circular holes in walls – connect gardens with the universe beyond Earth. Chinese scholar gardens, such as the Garden of the Inept Administrator created in the mid-sixteenth century, served as escapes from the world where nature could be contemplated in peace (see pp.118, 227). Court gardens, on the other hand, made use of pavilions not only for quiet reflection but also to hold banquets and gatherings of literati, musicians, and other entertainment (see pp.119, 253).

Chinese gardens influenced Japanese garden design, which developed its own style through the influence of Shinto. Shinto gardens highlighted the natural landscape with carefully pruned evergreens, artfully positioned rocks, manicured moss and water – either literal or symbolic – and structures for specific uses, such as pavilions and tea houses, with a focus on meticulous attention to detail. All horticultural activities are meditative and deeply spiritual. *Karesansui*, gardens inspired by Zen Buddhism, go one step further and dispense with plants entirely: they are pared down to a few symbolic rocks and meditatively raked gravel.

Japanese Zen gardens have been maintained for centuries at temples across the country, from Ginkaku-ji, or the Silver Pavilion, dating from the mid-fifteenth century, and the garden at Daisen-in within the grounds of Daitoku-ji Temple that was laid out in the early sixteenth century, to the more recent Tofuku-ji Hojo, completed in 1939 by leading designer Mirei Shigemori (see pp.187, 190, 308–9).

From Naturalism to Modernism

By the mid-nineteenth century, the dominant garden style in Europe was High Victorian: formal layouts filled with colourful 'bedding' plants. Their formality clashed with the new creative spirit of the age as expressed by English art critic John Ruskin and designer William Morris, whose promotion of traditional artisan skills helped to create the Arts and Crafts movement, which spilled into architecture and gardening (see p.84). In the garden, the most influential voice was that of Irish horticultural writer William Robinson, who published *The Wild Garden* in 1870 to promote planting in a freer, more naturalistic style influenced by cottage gardens, where plants grew in their natural habit and expressed their natural form (see p.62). Robinson's experiments at his home at Gravetye Manor, West Sussex, were perfected by the doyenne of garden designers Gertrude Jekyll in the early twentieth century (see p.61).

Jekyll was just one in a line of prominent female gardeners. Mary Somerset, Duchess of Beaufort, was a passionate botanical collector and cultivator of exotic plants in the decades on either side of 1700. Beatrix Havergal founded Waterperry Horticultural School in 1932 as a 'centre of excellence' for female gardeners (see p.197); its alumni included Valerie Finnis (see p.81), as well as Sibylle Kreutzberger and Pamela Schwerdt, who joined together to continue the work of author and gardener Vita Sackville-West at Sissinghurst in Kent (see pp.80, 302). In the 1920s and 1930s, American garden designer Beatrix Farrand designed outstanding gardens at Dumbarton Oaks (see p.64) and cultivated her own at Reef Point and Garland Farm in Bar Harbor, Maine. Further

south in Lynchburg, Virginia, the garden and studio of poet Anne Spencer became a creative sanctuary for luminaries of the Harlem Renaissance (see p.59). Sometimes these women combined their genius with partners or associates, such as Jekyll's long association with architect Edwin Lutyens (see p.261), or exchanged regular correspondence with gardening friends, as in the case of pioneering plantswoman Beth Chatto with Christopher Lloyd at Great Dixter (see pp.304–5).

The Arts and Crafts movement and William Robinson's more naturalistic style both emerged in the late nineteenth century, at a time when gardening was changing. On the one hand, it was becoming more popular among amateurs, with nurseries and magazines helping people to create their own gardens at home. On the other, municipal authorities began to create parks for residents of the world's great cities, with arboreta, lawns, bandstands and teahouses, laid out by some of the greatest designers at the time, such as Frederick Law Olmsted and Calvert Vaux's Central Park in New York (see p.95). These public gardens were an early acknowledgement of the physical and mental health benefits of public access to gardens.

Despite the development of a naturalistic garden style, formality never entirely disappeared. After great debate, many garden designers settled on the glorious compromise of a formal framework of informal planting within borders. There were exceptions, however, as when highly effective marketing created a vogue for formal rose gardens after World War II. The most recent incarnation is the New Perennial movement led by Dutch landscape designer Piet Oudolf, who also introduced the new concept that 'dead' herbaceous foliage in winter had its own beauty (see p.221).

For nearly two hundred years, arbiters of garden taste such as Oudolf have gathered followers who want to be 'on trend' and buy plants or style their own garden in a similar manner to their horticultural heroes. There are iconic figures linked with specific gardens – such as Vita Sackville-West and Sissinghurst, Christopher Lloyd and Great Dixter, or California Modernist Thomas Church and El Novillero (see p.50) – but there are also individuals who worked on numerous projects, such as Beatrix Farrand, Edith Wharton, and Wolfgang Oehme and James van Sweden, among others. Those who win coveted gold medals at the Chelsea Flower Show in London are set on a fast track to gain commissions; after all, who doesn't love to drop a 'name'?

At the other extreme are the efforts of the amateur: small flower-filled suburban spaces and window boxes reflect an intensely personal interpretation of beauty and self-expression, achieved through one's own industry and for no other return than the hands-on pleasure of gardening, often on a restricted budget. It is this numberless army of gardeners who arguably achieve the greatest satisfaction from their work.

The Garden as Art

Throughout the broad developments in the history of gardening, gardens remain ultimately the creations of individuals. They are arguably the quintessential form of creative expression, a three-dimensional work of art stimulating the senses, changing both daily and through the seasons, and unfolding from a multitude of angles.

Gardens have always attracted artists, and artists' gardens are a distinct genre that combines horticulture with a broader creative vision aligned to the creator's two-dimensional oeuvre. Many great artists have been eager gardeners. The Impressionist Claude Monet experimented with colour and texture in his garden at Giverny before applying oil to canvas, most notably in his many paintings of waterlilies (see pp.40, 212). Leading painters such as Camille Pissarro, Henri Matisse, Max Liebermann and Wassily Kandinsky also tilled and planted (see pp.93, 143, 213, 314). In Marrakech, Morocco, the French artist Jacques Majorelle developed the now iconic 'Majorelle blue' paint for his garden walls, fountains and other structures (see p.142). Gertrude Jekyll trained as an artist, transferring her vision to planting design only

in her forties, when her eyesight began to fail. More recently, ecological gardener Nigel Dunnett's seed mixes for the Tower of London 'Superbloom', celebrating the Platinum Jubilee of Queen Elizabeth II in 2022, were inspired by the concepts of colour and techniques of pointillism, or the technique of painting with dots, used most notably by French artist Georges Seurat.

As the more than 300 images in *Garden: Exploring the Horticultural World* reveal, gardening is indeed an art form – but not just for artists. It is open to anyone with plants, space and a growing medium. Gardening is an opportunity to create a paradise customized precisely to your own time, space and finances: from managed countryside and vast parklands to window boxes, pots of herbs on balconies, home-grown food or even a single houseplant. Whatever scale you garden on and whatever your taste, gardening is your access to the pleasure dome.

Like art, a garden may not appeal to your taste, but it is never wrong. Gardens are their makers' self-expression. Some styles may show greater refinement than others; some may use texture, form and colour in a highly 'painterly' way. Others may be less varied, or more random. To their creators, they all express a personal notion of what a garden should be.

In 1757 English philosopher Edmund Burke wrote: 'Beauty is, for the greater part, some quality in bodies, acting mechanically upon the human mind by the intervention of the senses.' Patterns of beauty are rooted in the mathematics of nature. The curves and proportions of the Golden Ratio and fractals – repeating, self-similar geometric shapes – occur widely in nature, which is one reason trees, twigs, flower clusters and leaf veins have universal appeal to humans. This unanimous appeal is modified according to culture, heritage or fashion, yet it remains universal. Given that our appreciation of beauty comes from the innate harmony found among plants, it is little wonder that our interiors are often decorated with floral fabrics, wallpaper and furnishings, and that we devote so much attention to our gardens.

our brain, away from our self-created, stressed-out world. After all, little is more gratifying than the joy and satisfaction of growing your own plants.

In the pages that follow there is a unique opportunity to explore gardens through time and across geographic regions, artistic styles and the work of great artists and gardeners. What makes this book so fascinating is the sheer variety of the artistic responses to gardens. The works it presents cover myriad media and mindsets from the traditional to the innovative: gardens and plants appear on textiles, ceramics, book illustrations, advertising posters, garden plans, jewellery, oils and watercolours (from landscape to Surrealist), folded paper, three-dimensional art installations, mind maps, prints, manuscripts, sculptures and reliefs, all capturing the many facets of the horticultural world.

Some images have been juxtaposed for comparative study, while others act as visual exclamation marks in the form of bursts of colour to refocus vision and mind. You will discover thrilling stories, including the parallels between cultivating plants on Mars and in a common greenhouse, or how the origins of community gardening influenced the design of a cutting-edge sneaker.

I urge you not simply to scan the images, but to observe the detail, marvel at the artistic vision, then read the back story for enlightenment and enjoyment. Doing so will enable you to appreciate the rich, varied interpretation of the garden and horticulture through history, and will increase your appreciation of both artist and gardener.

To gain the greatest benefit from *Garden: Exploring the Horticultural World*, however, you should be inspired to put it down and pick up a trowel or paintbrush (or both). I hope this book will fully reawaken the sheer pleasure of being surrounded by plants and reconnecting with the natural world. As Spanish artist César Manrique wrote, 'Man was not created for this artificiality. There is an imperative need to go back to the soil. Feel it, smell it.'

Matthew Biggs
Gardener, author and broadcaster

A New Age of Gardening

Over time, the increased popularity of gardening as a hobby – sometimes prompted by necessity, notably during the World War II Dig for Victory campaign (see pp.30, 200) – and the desire for not only beauty but also knowledge brought gardening to the mainstream media to feed a public voracious for gardening know-how. Today it is the subject of television and radio shows (see p.210, 262), blogs and TikToks, but innovation has long been part of the depiction of gardens. From English botanist Anna Atkins's early cyanotypes to the advent of black-and-white, colour and now digital imagery, gardens have often been the favoured subjects of photography, whether professional or taken on camera phones by a younger generation of gardeners.

Gardeners now focus on 'Earth friendly' gardening to benefit wildlife and mitigate climate change through sound horticultural practice. The use of peat, for example, is rapidly diminishing, while the planting of native species is gaining support. Gardens have also come to be seen as essential nature reserves, but still require management to optimize the range of habitats. There is a renewed urgency to cultivate and educate. Visionaries, such as guerilla gardener Ron Finley in Los Angeles, are transforming derelict inner-city spaces into productive plots, filled with flowers and vegetables to encourage healthy diets and bring communities together through gardening (see p.166). 'Cutting gardens' are increasingly popular, reducing the carbon footprint of cut flowers for enjoyment in bouquets and floral arrangements, or simply to bring nature indoors to enjoy in a vase. There is also a resurgence of interest in houseplants that filter out chemicals and oxygenate our homes. But all types of garden, whether grand outdoor spaces or indoor pots, are acknowledged as beneficial to our physical and mental health and social well-being. They offer a chance to go back to a more primeval way of existence, working mindfully at the pace of nature to rest and recharge

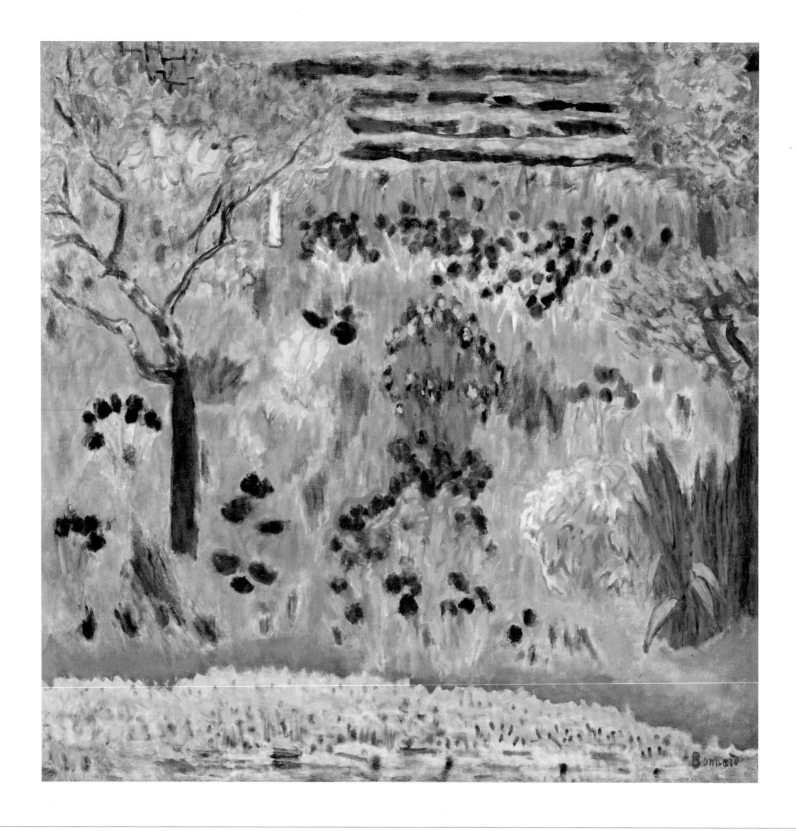

Pierre Bonnard

Garden, c.1935

Oil on canvas, 90.2 × 90.5 cm / 35½ × 35⅝ in
Metropolitan Museum of Art, New York

The green lawn at the centre of this painting by French post-Impressionist artist Pierre Bonnard (1867–1947), ablaze with bunches of brightly coloured flowers, stands like the decorated backdrop of a theatre set, with lemon trees as its curtains and banded footlights of white flowers. Bonnard, like his friend Henri Matisse (see p.143), was a keen artist-gardener, and a follower of Irish horticulturist William Robinson (see p.62). First at Vernonnet near Giverny and later in Le Cannet in southern France, Bonnard applied Robinson's theories to create a 'jardin sauvage', or wild garden. Here, in *Garden*, the flowers push against the garden's borders, flaunting the vibrant over-ripe colours and verdant, disorderly nature that drew Bonnard to move to the area in 1925 and fuelled the near-abstract intensity of his later works. Bonnard is synonymous with the intimate domestic interior, particularly in those works that capture fleeting glimpses of his wife, Marthe, engaged in everyday tasks. But the garden beyond often encroaches, with lush greenery or the yellows of Bonnard's favourite mimosa trees clamouring to enter at the windows and doors. Even with his sunlit garden subject so close at hand, Bonnard still worked in his studio from memory, refusing to paint *en plein air*. His chief concern was with the painting's surface as a site of aesthetic energy – what he called an 'enclosed world' of the emotions. And despite his own interests in a 'wild' nature over more formal planting, even the outdoor scene of *Garden* is bounded, circumscribed as a semi-domestic space by a pathway leading towards the hint of a wall at the top left of the picture.

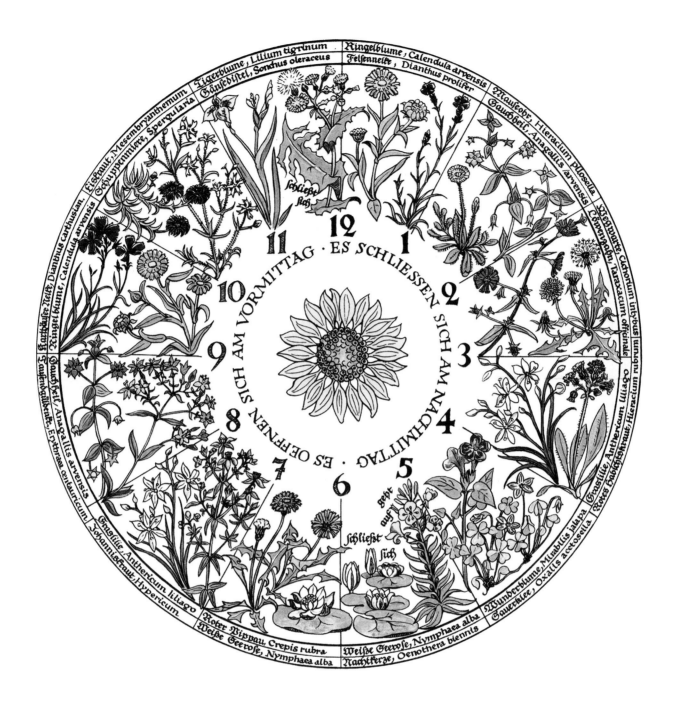

Ursula Schleicher-Benz

Flower Clock, from *Lindauer Bilderbogen*, 1948

Colour lithograph, sheet approx. 31 × 21 cm / 12¼ × 8¼ in
Private collection

In 1751 in his *Philosophia Botanica*, influential Swedish botanist Carl Linnaeus proposed the idea of a *horologium florae*, or flower clock, using plants whose flowers open or close at particular times of the day to tell the time. Linnaeus divided plants into three categories: *meteorici*, whose flowers open and close according to the weather; *tropici*, which follow the changing hours of daylight; and *aequinoctales*, whose blooms open and close at the same hour each day. There is no evidence that he ever planted such a border, but the theory was put into practice

in the early nineteenth century, with mixed results. Here, German illustrator Ursula Schleicher-Benz adapted Linnaeus's concept of a flower clock for the popular series of picture booklets published by Friedrich Böer in the mid-twentieth century. Linnaeus was born in southern Sweden, where his father decorated his cradle with cut blooms and would later put him down in a garden or meadow to play among the flowers. Even as a child, Linnaeus was eager to learn plant names, playing truant from school to search for plants in nearby fields. Having

studied medicine, where plants were used for healing, and experiencing the limitations of existing systems of classification, he devised his own binomial system, based on the number and arrangement of the sexual organs. Where coffee had been described as '*Jasminum, arabicum, lori folio, cujus semen apud nos coffee cicitur*', Linnaeus simply named it *Coffea arabica*. In 1753 he published *Species Plantarum*; its 1,200 pages covered 5,900 species in 1,098 genera. His binomial system remains and he is regarded as the 'father' of modern taxonomy.

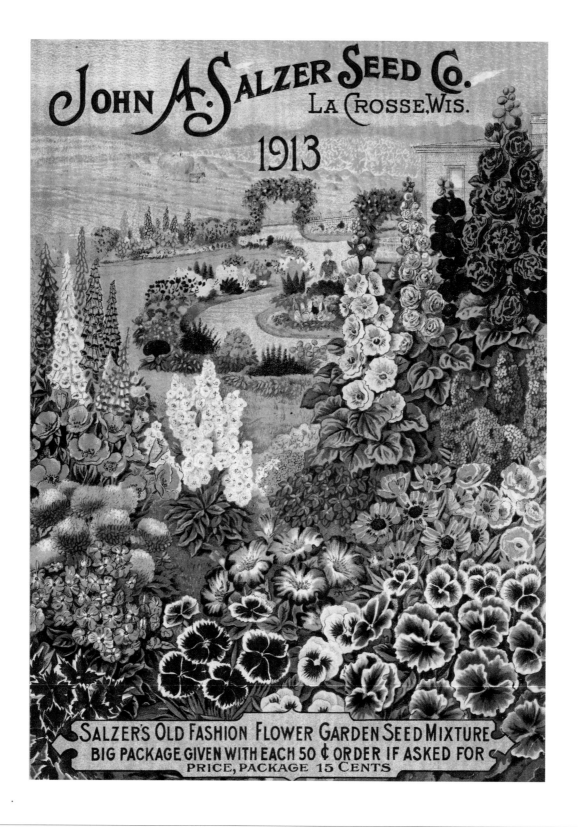

John A. Salzer Seed Company

Catalogue back cover design, 1913

Lithograph, 26.7 × 19.6 cm / 10½ × 7¾ in
Wisconsin Historical Society Archives, Madison

Offering a glimpse into the plant varieties in fashion at the time – among them pansies, carnations, California poppies, foxgloves and hollyhocks – this beautifully composed image illustrates both sides of the John A. Salzer Seed Company's business: gardening and farming. Started in 1866 as a garden market in La Crosse, Wisconsin, by 1868 Salzer Seeds had expanded and become the largest business of the kind in the northwestern United States outside Chicago. By the early twentieth century, paper production and printing technology had dramatically improved, making colour images more affordable for commercial purposes such as catalogues, which in turn brought in more customers. This vibrant cover for Salzer's 1913 catalogue would have been financially unviable only a couple of decades earlier. An established international trader, in 1919 the company added the slogan 'Salzer's Seeds Are Sown the World Over' to its logo. The cover represents all the plants of 'Salzer's Old Fashion Flower Garden Seed Mixture' in full bloom, echoing the otherworldly beauty and harmony of the Garden of Eden. John Salzer was a Methodist pastor and, to him, cultivating the land was a religious act of devotion as much as a pastime or means of sustenance. The illustration also subtly reinforces gender stereotypes that dominated society at the time, in which women were associated with the domestic sphere – tending beautiful flowers, symbols of grace and elegance – while men worked hard in the fields providing food for the family.

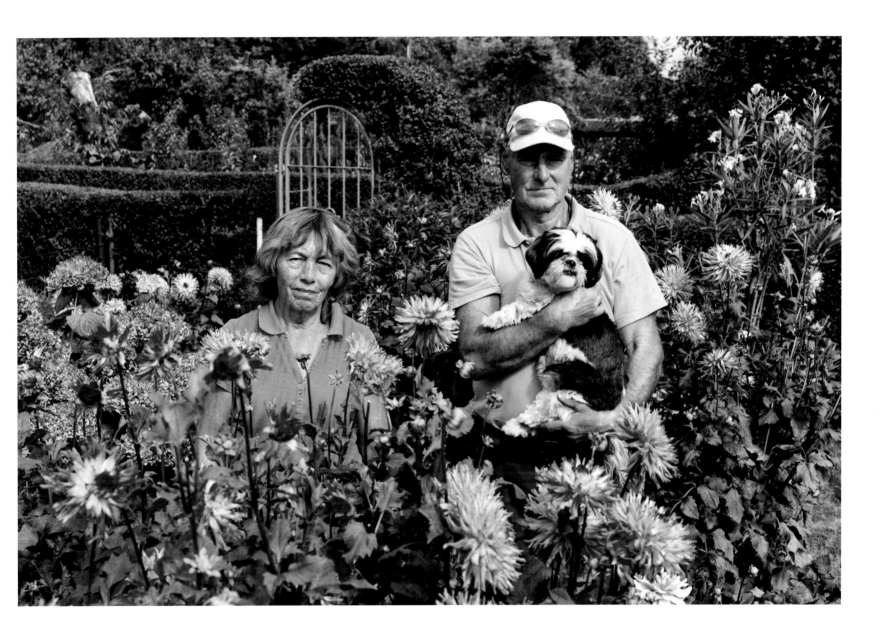

Martin Parr

Ursula and Wolfgang Opitz with Dog Lina, 2018 Photograph, dimensions variable

Martin Parr (b. 1952) is one of the most original and well-respected art photographers in the world. His bold and colourful images are often funny, at times sarcastic, and always grounded in a subtle humour. A close observer of and keen commentator on our times, Parr has documented the inherent absurdity of everyday life, its paradoxes, contradictions and incongruities, to ultimately question human nature. In 2018 Parr turned his lens on hobby gardeners for his *Allotment Holders* series, which he shot entirely in Düsseldorf, Germany.

More than half of Germans have an allotment where they grow flowers and vegetables – it is a national cliché. Parr's series is, characteristically, more of a tongue-in-cheek anthropological study than simple documentation. Comprising eighty photographs in which gardeners proudly stand in their allotments, it captures more than simple portraits of their physical appearances. In this image, Ursula and Wolfgang pose surrounded by their beloved dahlias. Lina, their dog, completes the perfect picture. And yet, their expressions remain ambiguous. Are they

proud, downtrodden or just tired? As one looks at the images in this series, Parr's aim becomes clearer. Allotments are pre-defined places in which humans attempt to reconnect with nature in ways that are ultimately outlined by cultural customs and consumerism. In the lives of modern city dwellers, the allotment is a dream, perhaps an illusion – a temporary return to an idyllic Garden of Eden where flowers and vegetables provide a temporary escape and a sense of connection with a natural world from which modern societies are often alienated.

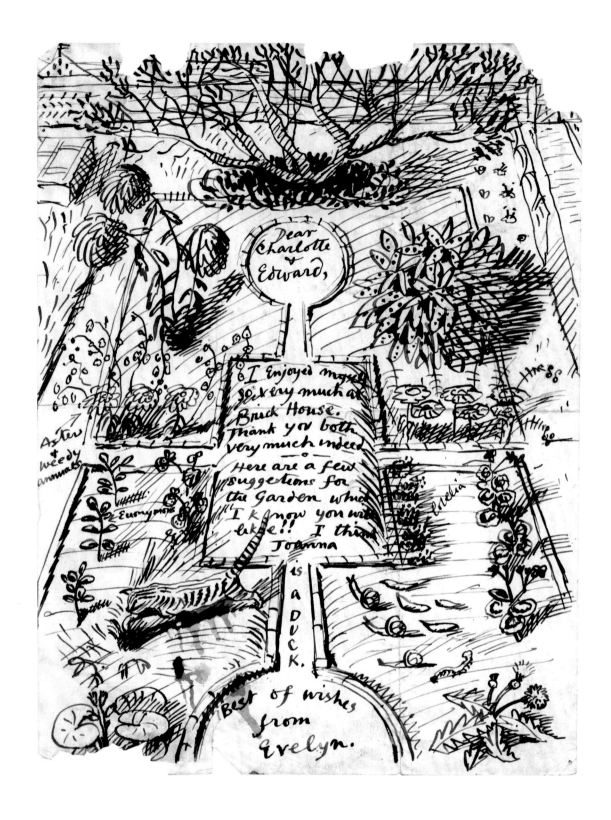

The drawing itself contains handwritten text:

Dear
Charlotte
&
Edward,

I Enjoyed myself very much at Brick House. Thank you both very much indeed — Here are a few suggestions for the Garden which I know you will like!! I think

Joanna

is a DUCK.

Best of wishes from Evelyn.

Aster & weedy annuals

Euonymus

lobelia

Evelyn Dunbar

Letter to Edward and Charlotte Bawden, 1936

Ink on paper
Private collection

Along the bottom of a formally laid out garden filled with a variety of planting suggestions, a cat slinks across a neatly edged bed just below a personalized inscription by British artist Evelyn Dunbar (1906–1960). Dunbar sketched this garden plan for fellow artists Edward and Charlotte Bawden after visiting their home in Essex, Brick House, with Charles Mahoney (see p.265), Dunbar's former Royal College of Art tutor and lover, as well as a fellow gardener. Dunbar was as serious about horticulture as she was about her art, and she and Mahoney

collaborated on the book *Gardeners' Choice*, published in 1937. Containing cultivation advice for forty garden plants and illustrated with Dunbar's pen-and-ink drawings, the book reveals the couple's intimate knowledge of plants, although several choices uncommon in English gardens might have been classed as weeds by more traditional gardeners. Dunbar's love of the unconventional is reflected in this sketch, where she encourages the Bawdens to consider 'weedy annuals' alongside aster. In addition to the cat, she mischievously includes slugs

and snails, along with dandelions. Other recommended plants include the hardy shrub euonymus and the bright blue bedding plant lobelia, which Dunbar has placed next to a line of geraniums. The Bawdens' Georgian residence in the village of Great Bardfield became home – both spiritual and actual – to a number of English artists, including Eric Ravilious (see p.125), John Aldridge and Geoffrey Hamilton Rhoades, all of whom painted its garden. None of their paintings, however, suggest that Dunbar's ideas were ever implemented.

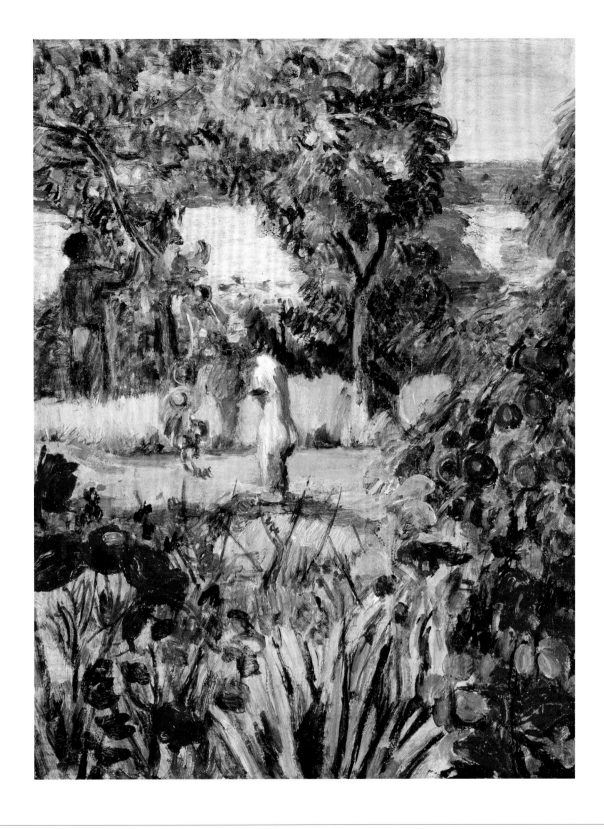

Vanessa Bell

Garden at Charleston, c.1940s

Oil on canvas, 45.8 × 36 cm / 18 × 14¼ in
Private collection

Painted in a vibrant post-Impressionistic style with warm colours and confident brushstrokes, this scene shows a country garden overflowing with life; flowers are in full bloom and trees are laden with ripening fruit. It is one of many views that English artist Vanessa Bell (1879–1961) painted of her garden at Charleston House, the country home at the foot of the Sussex Downs she shared with fellow artist Duncan Grant. A place to explore new ideas and escape societal expectations, Charleston was frequented by artists, writers and other members of the bohemian Bloomsbury Group. Bell and Grant decorated its interiors with murals, painted furniture, ceramics, paintings and textiles, while their walled garden became an outdoor studio, gallery and theatre. The pair were enthusiastic gardeners and worked hard to transform the property's former vegetable plots and muddy chicken runs into a quintessential English cottage garden. Following the designs of their close friend the critic Roger Fry, they installed intersecting paths, box hedges, a rectangular lawn, a pool and flower beds. They chose the flora with a painter's eye, introducing an array of brightly coloured flowers, including red-hot pokers, hollyhocks, foxgloves, globe artichokes, roses, oriental poppies and alliums. In contrast with Bell's earliest paintings of the garden, which show the rolling Sussex hills beyond, this tightly cropped scene creates a sense of intimacy and shelter. Here, the garden becomes a refuge from the turmoil of the outside world, which was coming to terms with the realities of World War II.

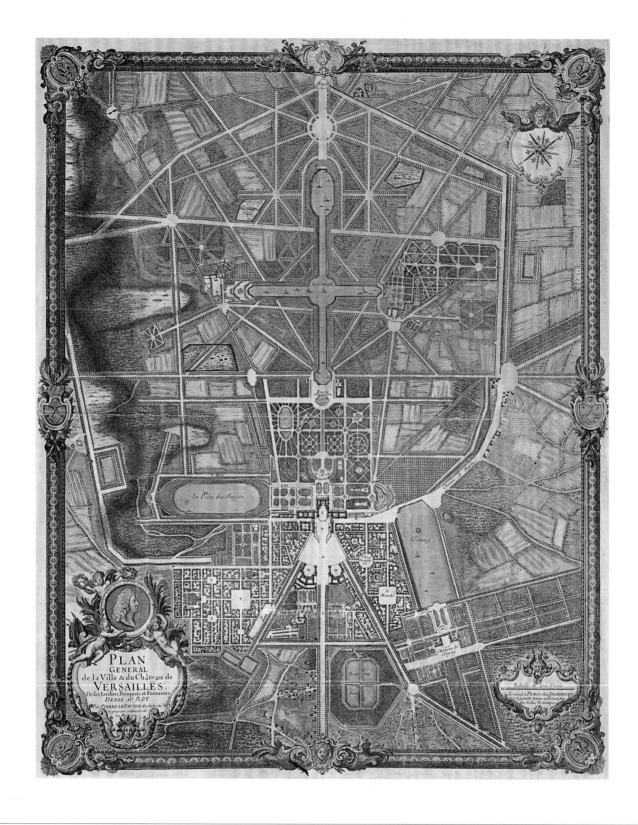

Pierre Lepautre

Plan général de la ville et du château de Versailles, de ses jardins, bosquets et fontaines, 1717

Hand-coloured engraving (detail), 80 × 120 cm / 31 × 48 in
Bibliothèque nationale de France, Paris

The sheer scale and organization of the gardens at the Palace of Versailles, outside Paris, are instantly apparent from this map by architect and engraver Pierre Lepautre (1652–1716) published in 1717. The main axis of the garden – centred on the bedroom of King Louis XIV – stretches across a terrace and along a grassy walk (the *tapis vert*, or green carpet) and a canal. Nearer the house are complex *parterres de broderie* – flower beds inspired by embroidery – and an area for growing fruit trees for the vast orangerie.

The garden was created for Louis by celebrated architect André Le Nôtre in the 1660s, when the king decided to turn his father's hunting lodge, where he had spent time as a child, into one of the most celebrated expressions of the power of absolute monarchy. Le Nôtre imposed a sense of formal symmetry on the gently sloping site by creating long allées that divide the garden into compartments, planted with patches of trees, or *bosquets*, and ornamented by statues and buildings. Le Nôtre's design – augmented later

by Louis Le Vau and Charles Le Brun – included a series of remarkable fountains, including the Latona Fountain, which reflects the facade from the terrace in front of the house (Latona was the mother of the Sun God, one of the garden's many allusions to Louis's soubriquet). A total of 1,400 fountains used six times as much water each day as the whole of Paris. Further from the house are the vegetable garden and Le Hameau, the hamlet built for Marie Antoinette in 1783.

16

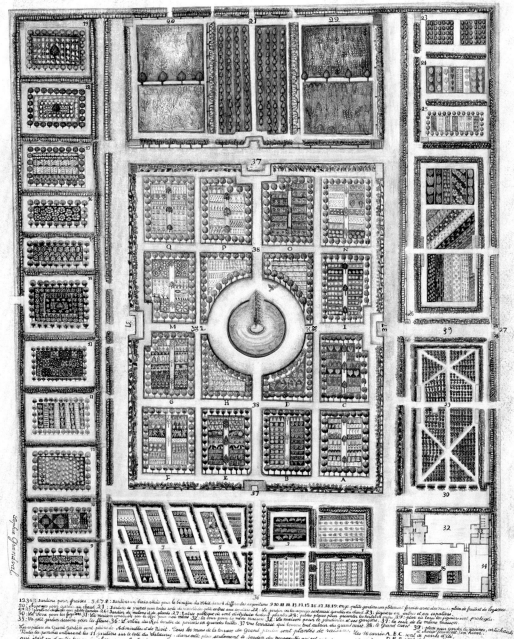

Le Jardin Potager du Roi à Versailles

Sophie Grandval

The King's Vegetable Garden at Versailles, c.1984

Ink and watercolour on paper
Private collection

The modern horticultural world is full of those who have had previous careers, but this is not a new trend. In the seventeenth century Jean-Baptiste de La Quintinie, a Parisian lawyer, developed a taste for botany while visiting the gardens of Italy and France, and started his own gardening practice. He soon gained a reputation for his scientific and experimental approach, working at Chantilly then Vaux-le-Vicomte with French landscape architect André Le Nôtre. In 1670 La Quintinie was appointed director of the royal fruit and vegetable gardens of King Louis XIV. From 1677 to 1683, La Quintinie, assisted by architect Jules Hardouin-Mansart, created a *potager*, or kitchen garden, on 9.3 hectares (23 acres) of unpromising, marshy land a short distance from the royal kitchen. Given the state of the grounds, La Quintinie's scientific approach was invaluable. The King's Swiss Guard dug out and drained the marsh, his horses provided vast quantities of manure to improve the soil, an underground aqueduct for watering was installed and subsoil heating extended the growing season. As indicated on this plan, re-created in colour by artist Sophie Grandval (b. 1936), La Quintinie created vegetable beds and built a series of large garden 'rooms' divided by high stone walls, creating microclimates in which plants from warmer regions could be cultivated and fruit ripened to perfection. Under his guidance lettuces were grown in January, strawberries harvested in March and asparagus in December. It was said the garden could supply up to 4,000 figs and 150 melons each day – truly a *potager* fit for a king.

17

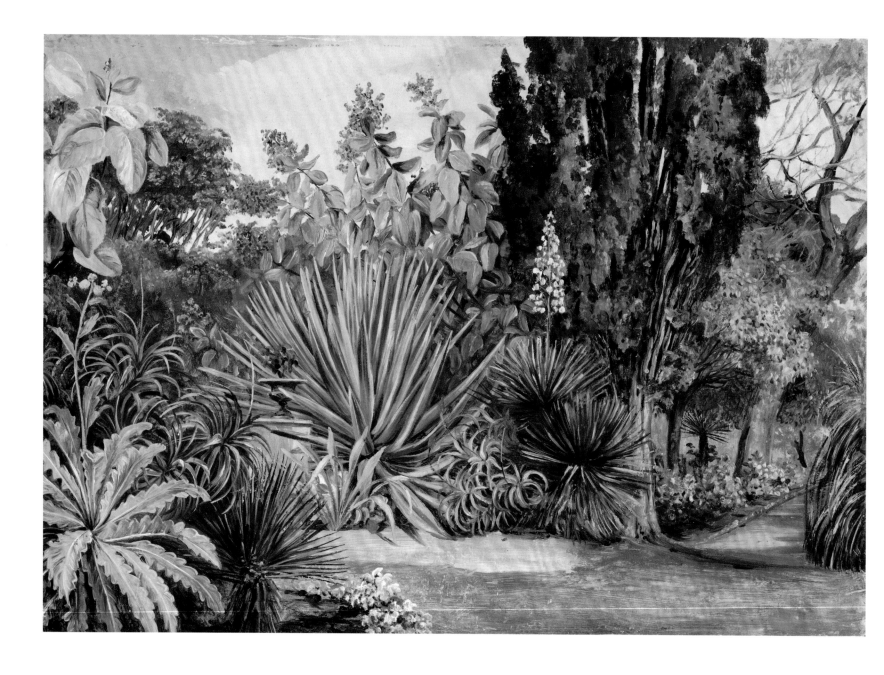

Marianne North

*View in the Garden of Acclimatisation,
Teneriffe*, 1875

Oil on board, 25 × 35.5 cm / 9¾ × 14 in
Marianne North Gallery, Royal Botanic Gardens, Kew, London

Marianne North (1830–1890), the renowned Victorian botanical painter, was far from home when she painted this vividly coloured garden on Tenerife in the Canary Islands – and so were some of the plants. The acclimatization garden, founded by the Spanish monarchy in 1788, was a place where tropical and subtropical plants could become adapted to the cooler conditions of the Atlantic in case they proved suitable for the European market. North travelled to Tenerife in early 1875 armed with letters of introduction, including one from the

director of Kew Gardens to Hermann Wildpret, Swiss-born director of the acclimatization garden in Puerto de la Cruz. Arriving by donkey, North set up her easel and captured the scene – including sowthistle, aloe, wigandia, cypress and yucca – in vivid colours, exuberant brushstrokes and a seemingly spontaneous vantage point far different from the normally controlled depictions found at the intersection of botany and horticulture at the time. As a female artist-traveller, North was a rarity of the era, using her independent means to travel for

much of her adult life, painting *en plein air* as she escaped the strictures and harsh climate of her native England, following a globe-trotting itinerary in search of suitable subjects. Not quite landscape and yet not individual botanical portraiture, this view is characteristic of North's lively approach to painting and emphasizes her focus on plants or groupings possessing outstanding horticultural potential. Today, North's reputation is recognized in the purpose-built gallery that displays hundreds of her works within the Royal Botanic Gardens, Kew.

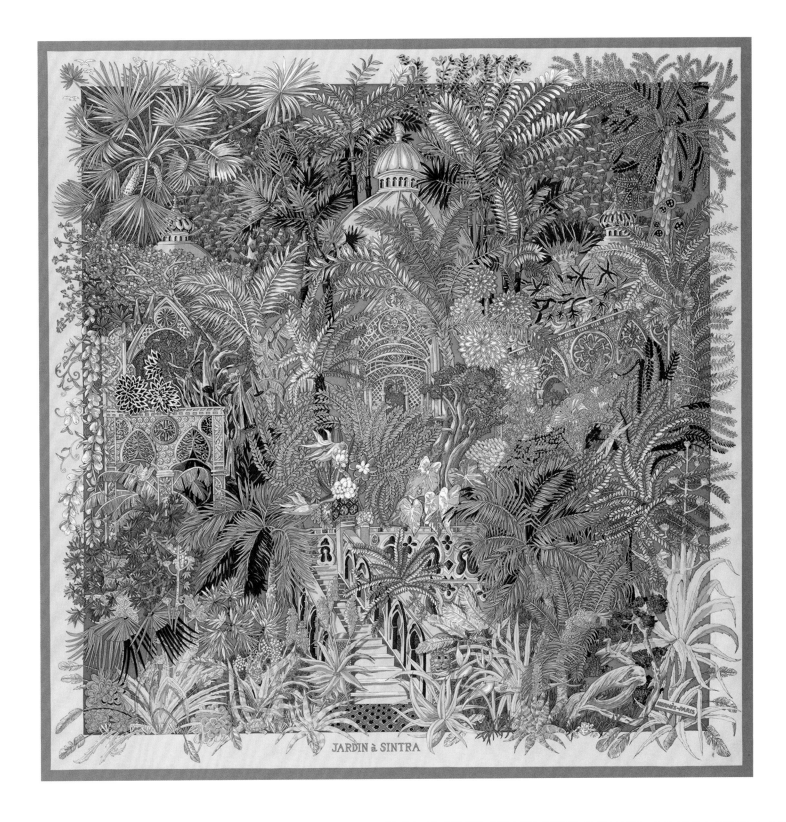

JARDIN à SINTRA

Annie Faivre for Hermès

Jardin à Sintra, Autumn/Winter 2017

Silk, 90 × 90 cm / 35½ × 35½ in
Hermès collection, Paris

This detailed and intricate scarf design by French illustrator Annie Faivre (b. 1944) for the artisanal house Hermès captures the lush exuberance of the verdant park at Sintra in Portugal, which surrounds beautiful palace buildings inspired by Gothic, Indian and Moorish art. Designated a UNESCO World Heritage Site for its cultural landscape, the park of Monserrate was created by English writer William Beckford in the early nineteenth century and further developed by merchant and art collector Francis Cook, botanist William Nevill and gardener James Burt. Home to more than 2,500 species, the park brings together native trees and shrubs, such as holm oak and arbutus, with a huge range of species from all over the world, flourishing in the temperate climate. Like many visitors to this extraordinary place, Faivre was amazed by the beauty of the site and her design is inspired by both its architectural grandeur and its botanical diversity. The detail is remarkable, and a careful search reveals a butterfly, dragonfly and other insects, as well as lurking tree frogs, a tortoise trundling along the bottom, flocks of gulls and ducks soaring above, a squirrel sitting on a branch and a pair of golden birds gathering nesting material. Faivre has long been associated with Hermès, for which she has designed more than fifty beautiful silk scarves since her first, released in 1983. Since its appearance in 1937, the Hermès silk scarf, known as a *carré* (French for 'square'), has attained high-fashion cult status as a symbol of refinement.

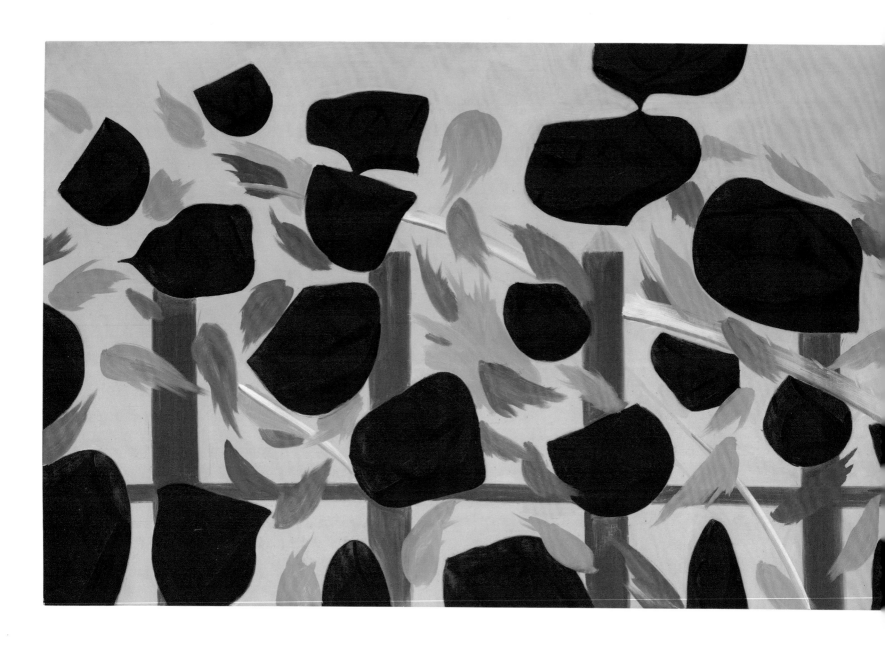

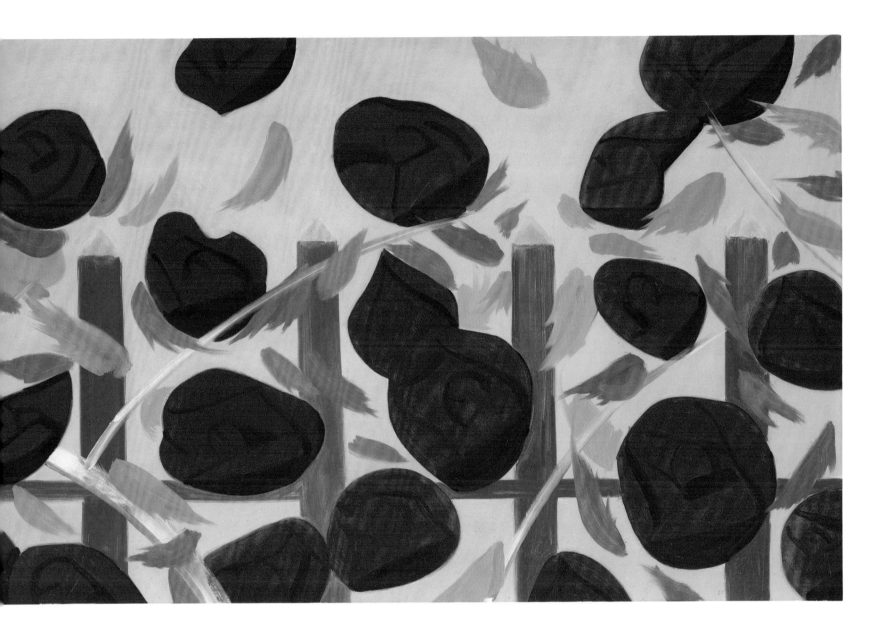

Alex Katz

Roses on Blue, 2002

Oil on canvas, 1.2 × 3.8 m / 4 ft × 12 ft 6 in
Private collection

Dominated by bold colours and geometrical shapes, this close-cropped detail of a fence is immediately suggestive of a garden as a whole. Scarlet roses riot over the posts with the stems shown sparingly and, in some cases, completely absent, leaving flowers and leaves hanging untethered against the flat blue ground indicative of the sky. Here are abundance and profusion, painted in colours so vibrant that they have an almost psychedelic intensity. American artist Alex Katz (b. 1927) has described flowers as being some

of the most difficult forms to paint, so to give his flower pictures a sense of immediacy and animation he adopted a 'wet on wet' technique in which each stroke of paint is applied before the previous one has been allowed to dry. The leaves are dashed in, so that they appear to flutter, and the roses themselves have a dynamic vivacity in the bright light that saturates the scene. This is one of many flower paintings that Katz has made over many summers spent in Maine, and it is typical of his elegantly reductive approach. The roses

are pared back to their essentials, painted as flat, stylized motifs; their shapes are sharp-edged and sketched with the minimum of modelling, characteristic of the way in which Katz blends abstraction and realism. The panoramic composition, with no sense of depth or recession, is so tightly cropped that the viewer is immersed in an intimate close-up with these dazzling blooms and can only imagine the lush garden of which they are a part.

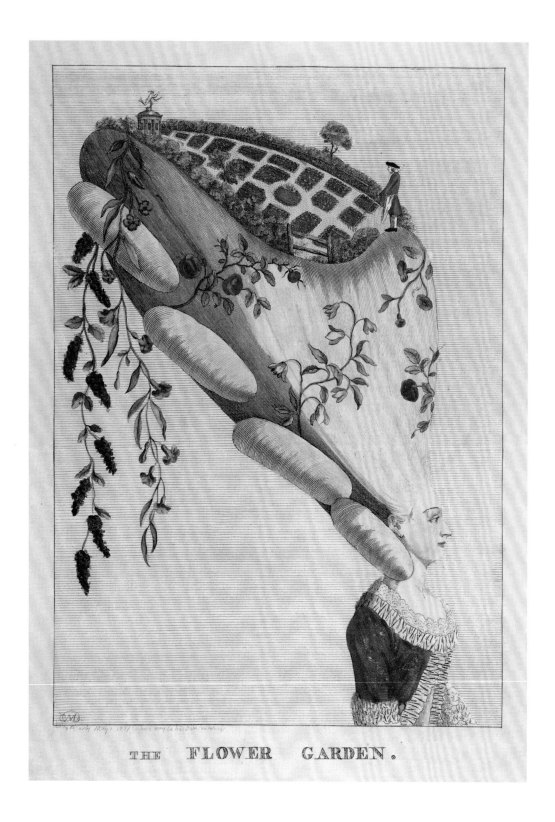

THE FLOWER GARDEN.

Matthew Darly

The Flower Garden, 1777

Etching and engraving with watercolour,
35 × 24.6 cm / 13¾ × 9¾ in
Metropolitan Museum of Art, New York

Rising like a chalk cliff face above the head of its remarkably unperturbed wearer and entwined with brightly flowering tendrils, a powdered wig of preposterously large dimensions is topped by the even more incongruous sight of a stately garden in this engraving by the English satirical illustrator Matthew Darly (c.1720–1780). A red-coated servant looks up the gravel paths that he tends with his rake towards the garden's apex, where more flowering vines tumble from around a neoclassical rotunda topped by a statue of the Greek deity

Hermes. From their shop on the Strand in London, Darly and his wife, Mary – also an artist and the author of the first book on caricature – pioneered the satirical cartoon in such cheaply produced hand-coloured prints. The exaggerated features and oversized accoutrements of Darly's figures were instantly recognizable and became wildly popular among an upper-class audience keen to display a fashionably bourgeois self-awareness. Key to their popularity was a series of prints, satirizing the effeminate fashions and

impractical, oversized powdered wigs of the 'Macaroni' – Georgian precursors of the dandy – as well as the towering and flamboyant hairstyles popular among contemporary women. By the late eighteenth century, the ornately symmetrical parterre planting of gravel paths, beds and neatly trimmed hedges of the *jardin à la française* had been entirely overtaken in popularity throughout England by the more open 'Landscape' style of William Kent and Lancelot 'Capability' Brown (see p.102, 162).

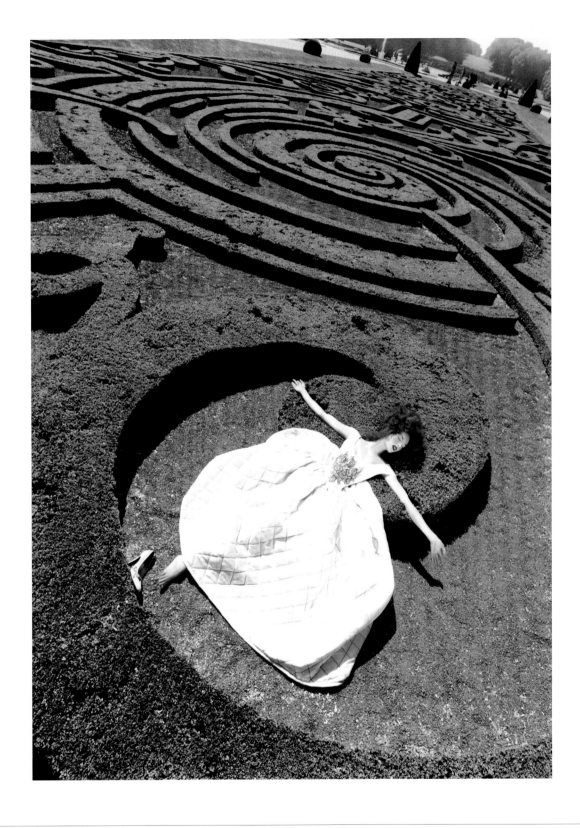

David LaChapelle

Collapse in a Garden, 1995

Chromogenic print, 101.6 × 73.7 cm / 40 × 29 in
Private collection

A woman lies in reverie on top of a box hedge, her arms outstretched, one shoe slipped loose, and wearing a voluminous quilted gown, the bodice embroidered with roses that complement her auburn hair and the red ground of the garden. In the background the perfectly trimmed hedges stretch in a maze-like arrangement as far as the eye can see. This fairy tale-like image is the work of American photographer, artist and filmmaker David LaChapelle (b. 1963), who rose to prominence in the 1990s with his provocative and highly stylized surreal photographs, often featuring celebrities and other public figures in fantastical settings. This image is drawn from the series *Collapse in a Garden*, which features various tableaus of fashion models in nineteenth-century settings, all staged in the grounds of an unspecified chateau that is at once a fairy tale and an echo of the Fall of Man in the Garden of Eden, full of reminders of human indulgence, frailty and punishment. In LaChapelle's hands, the formal gardens suggest a baroque world that brings together a range of inspiration from the Bible and the decline of the Roman Empire to the grandeur of the court of the Sun King (Louis XIV) in France. This particular image suggests specific connections to the garden scenes in *Alice in Wonderland* (see p.294), as well as the story of Cinderella's lost glass slipper and perhaps the story of Sleeping Beauty, all of which help to build LaChapelle's hyper-real world of glamour and decadence.

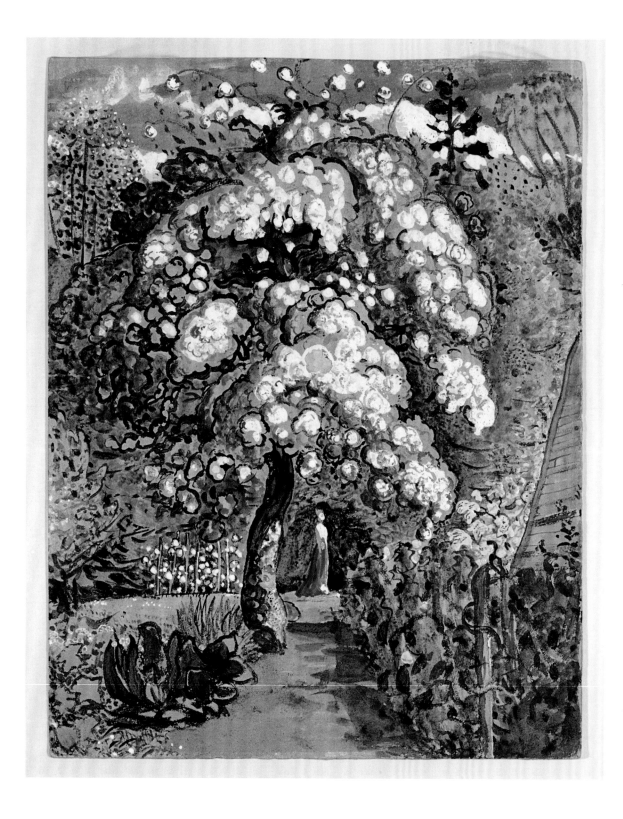

Samuel Palmer

In a Shoreham Garden, c.1829

Watercolour and gouache on paper,
28.2 × 22.3 cm / 11 × 8¾ in
Victoria and Albert Museum, London

Foaming with pink and white blossoms, the very embodiment of spring, an apple tree stands at the heart of this walled garden by British painter Samuel Palmer (1805–1881). Everything around the tree is lush and vivid, alight with bright colour, including a woman on the path, dressed in a gown of white and crimson, her face lifted to the sun. Some have interpreted this scene as a Garden of Eden, with the woman's red robe symbolic of Eve in her role as temptress, and the dark, sinuous line of moss or lichen twining around

the tree trunk perhaps resembling a serpent. Certainly, Palmer's paintings were heavily influenced by his reading of the Bible and the poems of John Milton – particularly *Paradise Lost* – and also the work of the visionary artist William Blake, although the symbolism of this picture is more allusive than explicit. It was painted when Palmer was living in Shoreham (from around 1826 to 1833), a quiet Kentish village nestled in the Darent Valley in England. The scene is probably based on the garden at the Water

House, a property that was rented for a time by Palmer's father and where Samuel lived during his last two years in the village. He chose Shoreham for its seclusion, when he was 'forced into the country by illness', and by his longing to escape London and the industrialization that he saw encroaching on the natural world. The garden was both a real place of sanctuary and a representation of Palmer's deeply spiritual vision of human life in harmony with nature's exuberant fecundity.

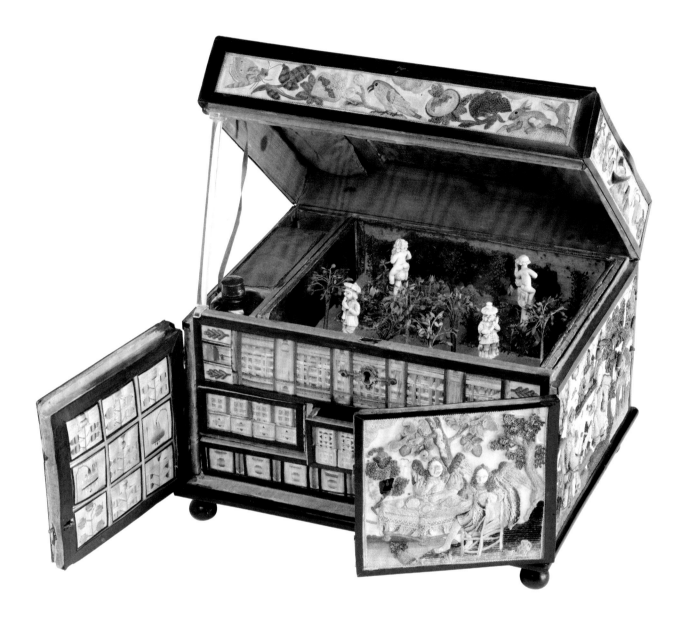

Anonymous

Embroidered casket, c.1660–85

32.3 × 21 × 26 cm / 12 × 8 × 10 in
Victoria and Albert Museum, London

Attention to detail was crucial in the creation of this exquisite embroidered casket, which depicts scenes from the Old Testament. Likely borrowed from contemporary prints, the scenes show Isaac meeting Rebekah, a story told in Genesis, and Eliezer giving Rebekah betrothal gifts. On the back, the casket shows Sarah and Isaac in a tent while an angel appears in the wilderness. Sewing was a skill universally taught to young women across the highly stratified society in the seventeenth century. But while the basics were necessary for making and mending underclothes and household linens, women from the upper classes would learn and practice embroidery, for which a casket like this would be a coveted necessity. This work would not have been attempted by an amateur – samplers were the usual way for training embroiderers, after which they would tackle a project like this. While depictions of fruit, flowers and animals can be found throughout the panels, including varieties that would have been considered rare or exotic at the time, such as pomegranates and parrots, it is inside the top compartment that a miniature garden stands in three dimensions. Here, to tiny scale, ivory figures stand in separate flower beds, with fruit trees. Rather than risk a mistake on a completed panel, it is likely that each part would have been sewn and then applied to the white satin backing, on top of padding for the raised elements. The panels would then have been sent to a cabinetmaker to construct into a useful item for further embroidery projects.

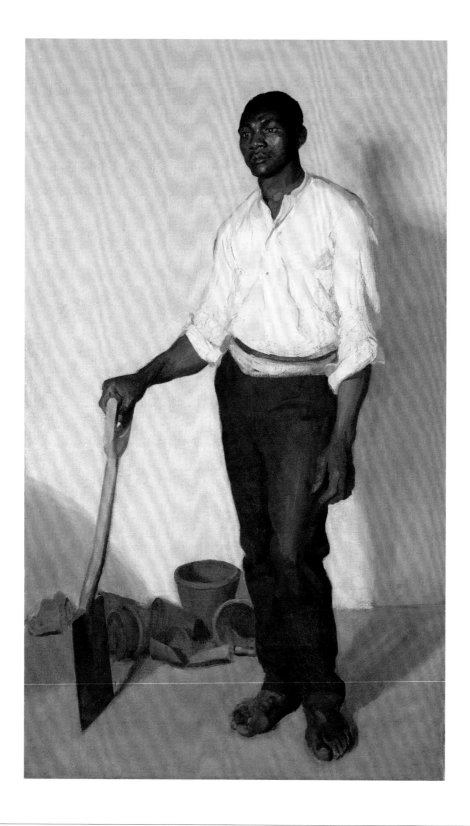

Harold Gilman

Portrait of a Black Gardener, c.1905

Oil on canvas, 131.5 × 77.5 cm / 51¾ × 30½ in
Garden Museum, London

A male gardener stands in a pose of classical contrapposto, right hand resting on the top of his shovel, a look of contemplative exhaustion in his eyes – perhaps the result of a long day's labour. This painting by British artist Harold Gilman (1876–1919), one of the Camden Town Group of artists, is the first full-length portrait of a solo Black sitter in twentieth-century British art. Gilman was a confirmed socialist whose deep empathy for excluded members of society pervades his work. This work, with its nods to the triumphal portraiture of Velázquez (whose works Gilman had studied closely), may have been intended to highlight the nobility of garden labour. Some experts have suggested that the portrait was painted in Chicago, which Gilman visited in 1905, on the simplistic grounds that Black gardeners were more common at the time in the United States than in Great Britain. Others point out, however, that there are records of a number of Black gardeners in Britain from the mid-1700s. They included John Ystumllyn, who was abducted from his family in Africa as a child and ended up working in a garden in Gwynedd, north Wales; and Thomas Freeman, who was head gardener at Orwell Park in Suffolk before becoming a missionary and collecting plants for Kew Gardens on the Gold Coast in Africa. Gilman was himself a keen gardener, and later owned one of the first plots at the newly created suburban Letchworth Garden City in 1908.

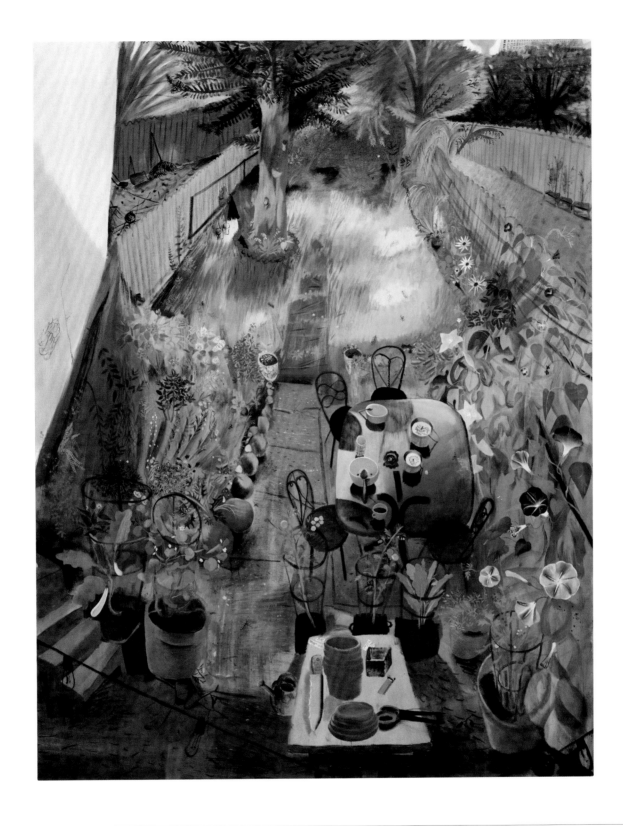

Louis Fratino

Morning, 2020

Oil on canvas, 2.3 × 1.8 m / 7 ft 8 in × 6 ft
Private collection

An exuberant sense of joy and tenderness radiates from this painting by American artist Louis Fratino (b. 1993) of a long, narrow backyard in Brooklyn filled with morning light. The New York-based artist includes in the foreground a glimpse of the preparation of garden pots in progress and intimate details of a recently abandoned breakfast for two, where spoons rest on bowls and a cup of coffee sits untouched on the table. Against the green lawn, which appears an almost surreal shade of lime in the sunlight, morning-glory

flowers reach their peak before they fade. The image brims with life: tender tomato, lettuce and white eggplant grow in the pots closest to the house, suggesting a settled life of daily routine that celebrates the beauty and extraordinary ordinariness of everyday life. Fratino is a self-confessed classicist inspired by, among others, Rembrandt, Pablo Picasso and Henri Matisse (see p.143), and he seeks to bring a 'vitality or life force' of its own to each piece. Drawing not just on the canon of Western art but also on art history and

memory, Fratino's painting invites the viewer into a private, domestic space, which is both unique and individual and yet completely universal, as he explores the emotionally evocative qualities not just of the morning light but also of the routines that time of day brings: the simple pleasure of sitting outside in a sunlit back garden, enjoying breakfast.

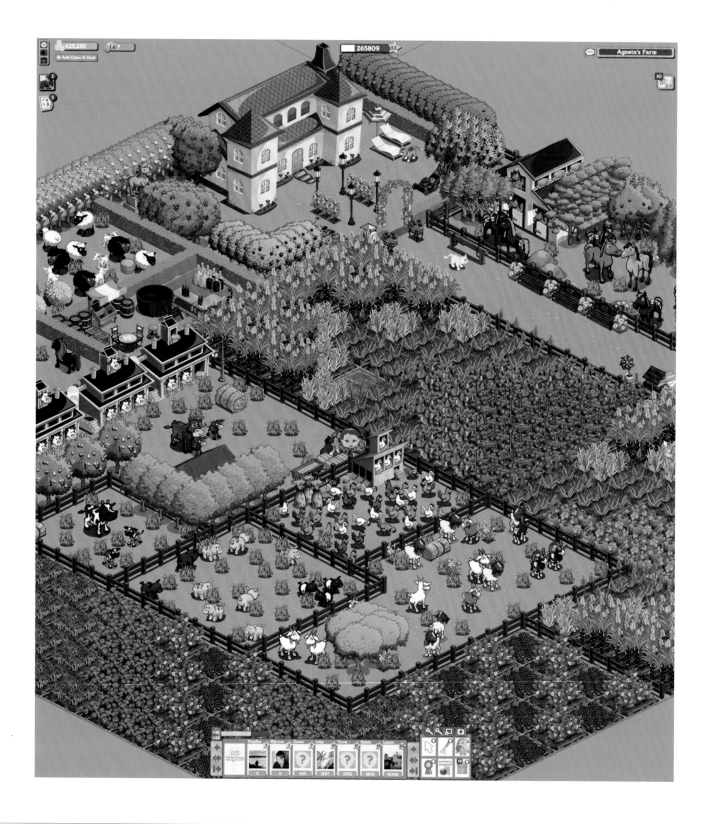

Zynga

FarmVille, 2009–20

Digital game still, dimensions variable

When Zynga's *FarmVille* appeared in 2009, few expected an online game that did not involve war and violence to become the phenomenon it did. Indeed, the free-to-play game based on farming and horticulture became Facebook's most popular game after launching on the social-network platform, a position it held for more than two years with over 83 million monthly active users at its peak in March 2010. The aim of the game was simple: to successfully build and run a farm, with all the different aspects of farm management that entailed. As well as ploughing the fields, crops had to be planted, grown, gathered and sold at market, livestock had to be cared for and the farmland maintained. The skill in the game was therefore not simply to keep the crops alive but to get them to grow so they could be successfully harvested, which as real-world gardeners know can be harder than it seems. An algorithm could cause crops to wither in less than half the time it took them to grow, meaning that players had to check in daily to water them and keep them alive. Unlike in the real world, however, players could use Farm Cash, one of two in-game currencies, to instantly revive crops or accelerate their growth for immediate harvesting. Utilizing the social network to the fullest, users could also invite their Facebook friends to become virtual neighbours, join together to create co-ops or send gifts. Although the original game on Facebook was shut down in 2020, fans can still enjoy *FarmVille 2* and *FarmVille 3* on mobile devices.

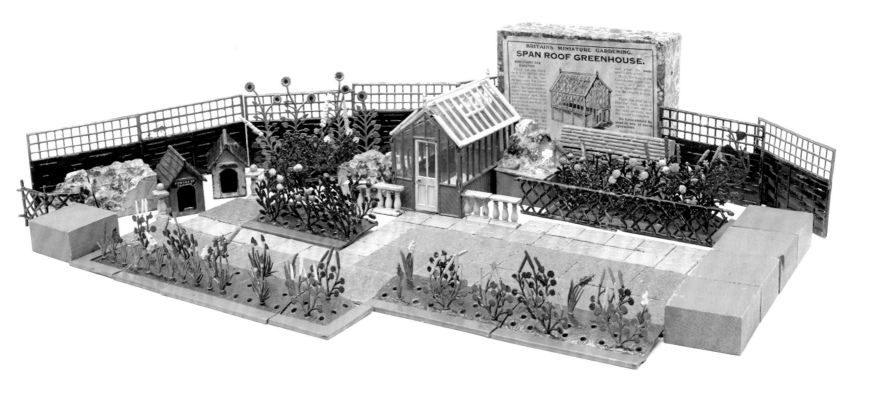

Britains

Miniature garden set, 1937

Painted lead, dimensions variable
Private collection

Imagine a garden where the flowers never faded or died, where there were no insects to worry about and no dirt got under fingernails. That was the promise delivered by the model-making company Britains in 1930, when it created a miniature garden system that featured not only colourful flower beds but also luscious green-leaved trees, fencing and even a span-roof greenhouse, complete with glass panels. Made from a special lead alloy, each flower was pliable, allowing it to be twisted into a natural position and making

it as realistic as possible. The model gardens were marketed for children to use for creative play, but also for amateur and professional gardeners as a means to plan their gardens, moving beds and paths around and experimenting with colour combinations for plants before starting work on the ground. The garden system launched in 1930 on the heels of earlier Britains sets featuring a farm and a zoo. They were a long way from the miniature toy soldiers that had given the company's founder, William Britain, his initial success

in the late 1800s, but the devastation of World War I convinced his successors that both children and adults would prefer more benign playthings. Britains added new pieces to the system throughout the 1930s, appealing to children's weekly pocket-money budgets, before it disappeared in 1940. By then, World War II had destroyed the idea of filling a garden with flowers as the British instead began their campaign to 'Dig for Victory' (see pp.30, 200).

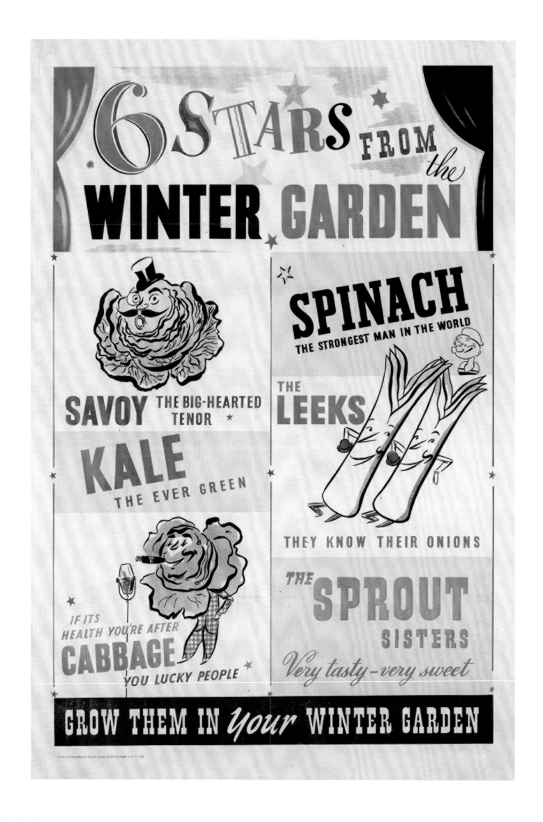

Anonymous

6 Stars from the Winter Garden –
Grow Them in Your Winter Garden, 1940s

Lithograph, 74.9 × 51 cm / 29½ × 20 in
Imperial War Museum, UK

Vegetable growing received huge government support during the 1940s, when the 'Dig for Victory' campaign during World War II resulted in many ornamental gardens and parks being dug up for food production. Food shortages and rationing in the years after the war kept interest in vegetable growing high for some years. The authorities decided that Britons, whose traditional cuisine accorded vegetables a low status, needed reminding that vegetables were healthy, cheap and a vital source of vitamins and minerals. Children may have continually been told by their parents to 'eat your greens', but clearly the government thought adults needed reminding too. Adopting the style and language of a theatre playbill, this poster encourages Britons to appreciate their veg – to grow them and eat them. It would have been displayed on stations and bus stops, and possibly in shops selling seeds and garden sundries. The humorous text plays on a number of stereotypes about the featured vegetables. Spinach is dubbed 'The strongest man in the world', evoking its high iron content and the erroneous connection with physical strength – a belief supported by the cartoon character Popeye the Sailor Man, who first appeared in 1929 and was known by all children to owe his remarkable strength to the consumption of large quantities of the vegetable. Other winter-friendly produce featured include savoy cabbage, sporting a jaunty top hat and monocle; kale, rather ironically smoking a cigar while promoting health; and a pair of dancing leeks.

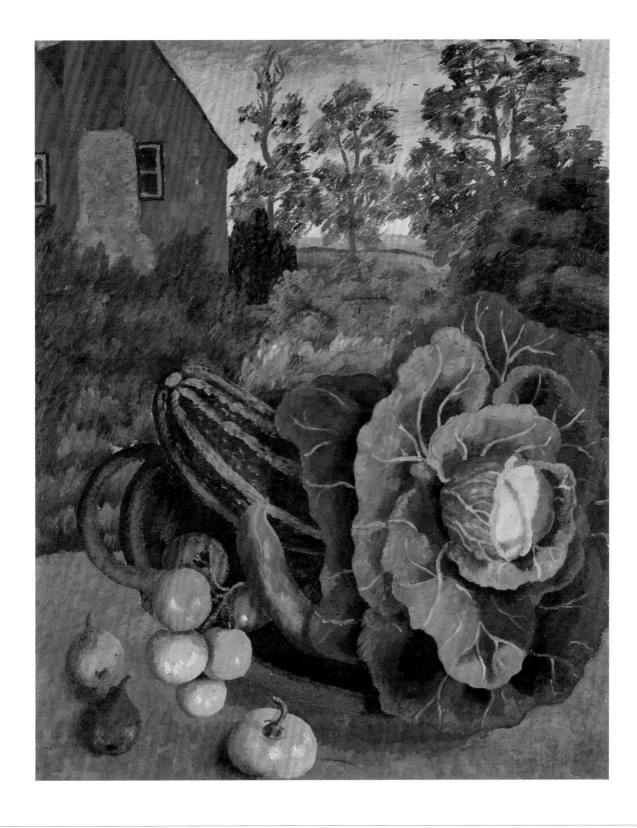

Cedric Morris

Still Life in Summer Garden, 1963

Oil on canvas, 81.5 × 66 cm / 32 × 26 cm
Private collection

This painting by British artist and plantsman Cedric Morris (1889–1982) puts such a detailed focus on the fruit and vegetables that it could almost be described as a portrait as much as a still life. A trug, tilted towards the viewer, over-flows with garden produce: a leafy cabbage, a fat marrow and a crisp-looking cucumber, alongside glossy red, yellow and green tomatoes and two small ripe pears. It was painted at Benton End in Suffolk, the home Morris shared with his partner, the artist and teacher Arthur Lett-Haines. When

Morris arrived in 1940, the 1.2-hectare (3-acre) walled garden of the sixteenth-century farmhouse was an overgrown wilder-ness. Morris transformed it, including plants he collected on expeditions to the Mediterranean and North Africa to create an idiosyncratic mixture of colours, textures and shapes that was highly influential for a generation of British gardeners, such as Beth Chatto (see p.304). Morris was renowned for the various irises he collected and cultivated – 1,000 varieties, with up to 90 cultivars of his own – and whose beauty he recorded in

many paintings. Although he studied painting with the artistic avant-garde in Paris, Morris eschewed modernist styles to concentrate on still lifes and pictures of flowers, describing himself as a 'painter of reality'. Benton End was the centre of a lively artistic community – Morris and Lett-Haines taught a succession of students, including Lucian Freud (see p.96) – and while Morris busied himself with the gardening, Lett-Haines was passionate about food and cooking, serving students and guests lavish meals, often using produce from the garden.

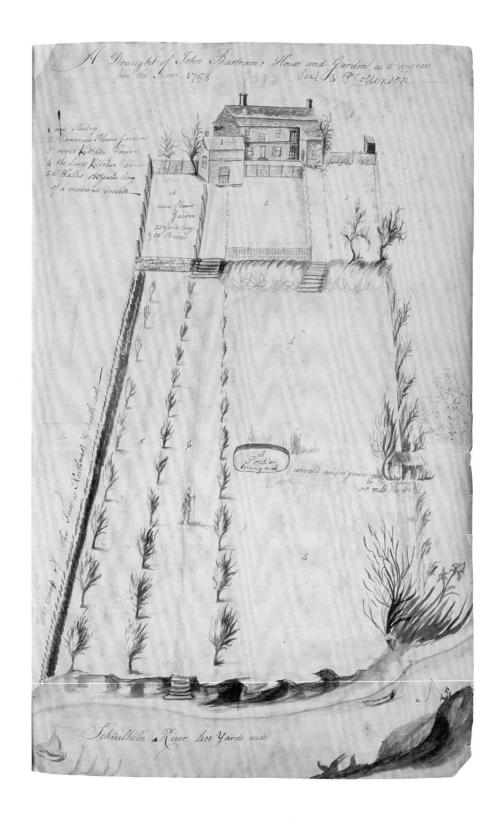

William Bartram

*A Draught of John Bartram's House
and Garden as It Appears from the River*, 1758

Watercolour on paper, 42 × 26.4 cm / 16½ × 10⅜ in
Private collection

American botanist and natural historian William Bartram (1739–1823) was only nineteen years old when he drew this simple depiction of his family's home and garden in 1758. He and his father, John Bartram, are considered America's first botanists, and their estate, on the west bank of the Schuylkill River in Philadelphia, is recognized as the first botanic garden in the United States. Bartram's disproportionate, map-like drawing exaggerates the garden's size, alienated from the surrounding land, and introduces the

European concept of an 'enclosed' garden. Contained within a clear demarcation of property ownership, it is a tamed, cultivated landscape, in contrast to the Lenapehoking, the largely unaltered traditional land of the Lenape people. Kitchen and flower gardens are labelled, although specific plants are not discernible and the plan does not reflect the garden's encyclopedic range of species: it was home to specimens collected on the Bartrams' many expeditions in North America, as well as those sent to them from plantsmen around the world.

Nearly camouflaged among allées of trees stands the figure of John Bartram, the son of a Quaker farmer, who developed the homestead. Initially built to grow fruit and vegetables for food, the garden later became the epicentre for the scientific study of plants. It was the most important nursery for ornamental trees and shrubs in the eighteenth century. As the first people to ship native American plant species to Europe, the Bartrams helped transform gardens around the world by providing seeds, plants and other materials to collectors fascinated by New World flora.

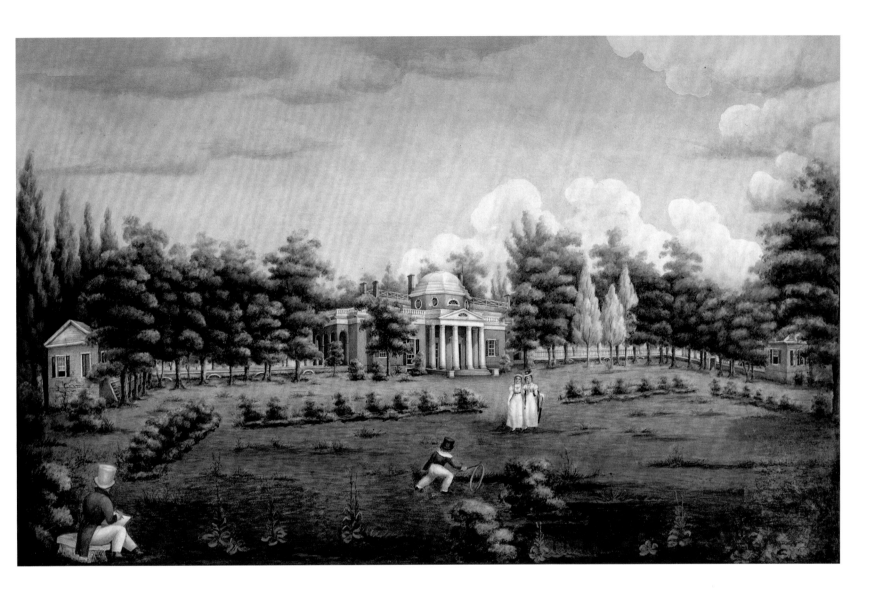

Jane Braddick Peticolas

View of the West Front of Monticello and Garden, 1825

Watercolour on paper, 34.6 × 46 cm / 13⅝ × 18⅛ in
Thomas Jefferson Foundation, Charlottesville, Virginia

Between 1769 and 1826, the resplendent gardens of Monticello, the plantation home Thomas Jefferson designed for himself in Virginia, became a botanical showcase. This watercolour view of the West Lawn by Jane Braddick Peticolas (1791–1852), one of the few depictions of Monticello made during the third US President's lifetime, conveys the sense of unity Jefferson strove to achieve between the landscape and his neoclassical home. Peticolas's portrayal of the garden as an idyllic place of leisure – enjoyed here by three of Jefferson's grandchildren – belies the plantation's reliance on slave labour. The principal gardener was Wormley Hughes, an enslaved man who each year planted the twenty oval flower beds and borders along the winding walkways with hyacinths, tulips, narcissus, lilies and anemones, among other flowering bulbs. While many of the flowers were common to early American gardens, one bed contained the rare woodland perennial twinleaf (*Jeffersonia diphylla*), which was named after Jefferson by the American botanist Benjamin Smith Barton. The garden's informal layout drew on the English gardens that Jefferson had seen on a visit to Europe in 1786, a time when garden designers inspired by Picturesque landscape painting were moving away from earlier formality. A diversity of fruit and vegetables were grown at Monticello, and slaves, such as George Granger Sr, oversaw labourers in Jefferson's orchard, while professional Italian gardeners were hired to tend his vineyard. Although Monticello's flower gardens were mostly lost after Jefferson's death in 1826, they were restored between 1939 and 1941 and are now open to the public.

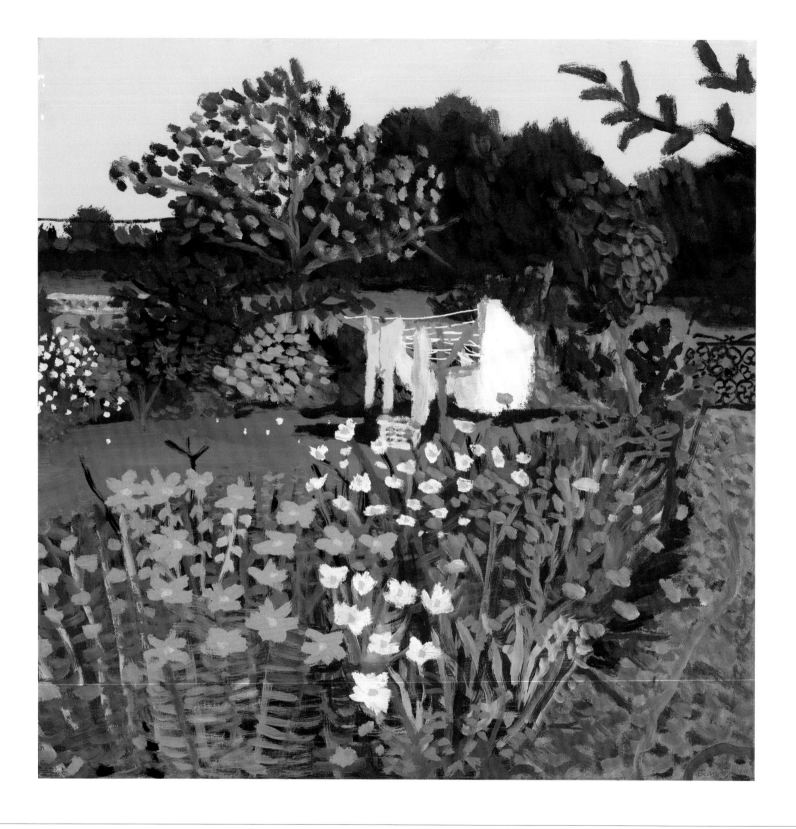

Jean Jullien

Kent, 2019

Acrylic gouache on canvas, 59.5 × 60 cm / 23⅜ × 23⅜ in
Private collection

A garden on a summer's day is joyfully depicted in this painting by prolific French graphic artist Jean Jullien (b. 1983). Originally from Nantes, Jullien studied and worked in London for many years before moving to Paris. Known principally for his eclectic early work, which spans different art forms – from illustration, video and photography to dolls, installation and clothing design – he has created more than two thousand works since graduating from the Royal College of Art in 2010. Despite the wide range of media, Jullien sees a unifying approach to his work by 'communicating the positive in things, making people smile, making them think'. In the series of paintings celebrating daily life of which this image is part, he explores the *quotidien*: laundry is drying on a rotary washing line, basket left on the grass to await the dry clothes. A garden path snakes towards a wrought-iron gate, leading to a grassy green expanse beyond. Within the garden itself is a riot of orange, pink, purple and white flowers, none of which is precisely delineated; they are simply beautiful flowers in full bloom. In Jullien's words, 'Paintings are very inexact. They're a mix of photo reference and loose depictions of things, not necessarily perfectly accurate. I love how we remember things differently, how we "occult" certain details and emphasize others.' The blue sky contrasts with the green grass in an image bursting with vitality. Portraying nature so vibrantly is deliberate: Jullien actively seeks to raise awareness of climate change and protect the beauty of the natural world.

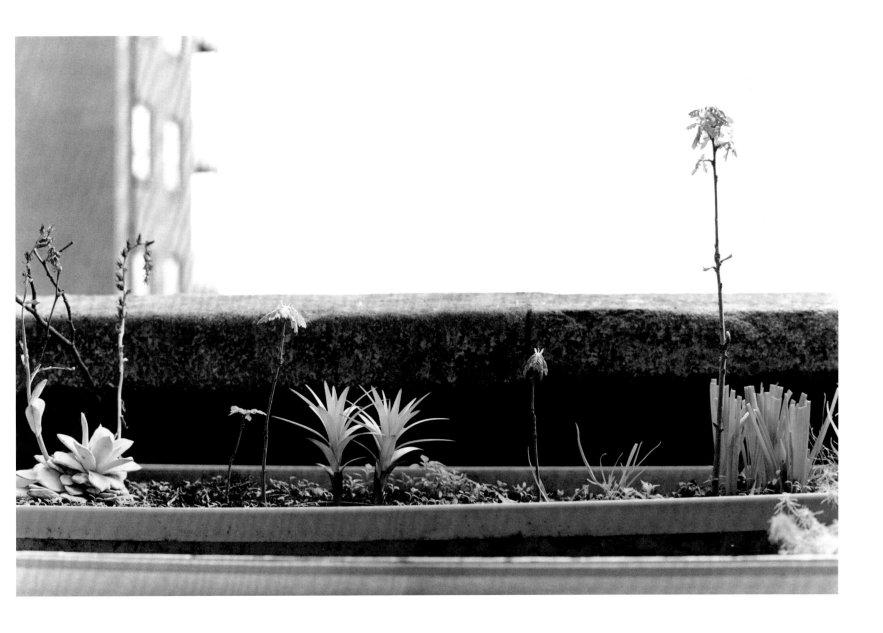

Wolfgang Tillmans

windowbox (37-36), 2000

C-type print, dimensions variable

A sparse display of succulents softens the edge of a concrete balcony in front of a tower block and empty sky, high above the ground. Window boxes are frequently associated with generous spills of geraniums, begonias, impatiens or petunias: they are miniature hanging gardens in situations where a narrow balcony or a windowsill is the only available outdoor space. But floral profusion requires attention – regular watering and fertilizing – and this plastic window box seems to have received little. Instead, its random population

of plants are survivors, living here by accident, growing despite rather than because of a gardener's intervention. These resilient plants make the most of the little at their disposal, and can get by even when forgotten for extended periods. This urban image was taken by one of the most original and influential photographers of his generation, German-born Wolfgang Tillmans (b. 1968), whose pictures of people, animals, plants and landscapes foreground the specialness of what might otherwise be considered

mundane. Tillmans' approach to photography is strongly informed by LGBTQIA+ culture and the conviction that classical conceptions of beauty ultimately limit our appreciation of the world around us. Images such as *windowbox (37-36)* capture the antithesis of what the word might usually suggest. Tillmans' focus on these succulents, however, can teach us to find inspiration in the natural resilience of plants that allows them to persevere and resist adverse conditions and unfavourable situations.

Liber

Sextus Fo.xciiij.

Aiozana calida et sicca est in secundo gradu.alio noie dicit eseron . eius flos z folia competūt medicine. Colligiť in estate cum flozibus. z in vmbzoso loco siccat.et per annū seruatur. virtutem habet confortandi ex aromaticitate.dissoluēdi z cōsumendi ex qualitatibz z etiam mūdificandi. puluis maiozane in cibo datur vľ vinū decoctiōis eius stomachū infrigidatū calefacit.z digestiones confortat.naribz apposita cerebzū confortat Flozes z folia i testa calefacta z in sacello posita z loco dolenti superposita doloze et ventositate prouenientem soluit. Item capiti suppoposita valet contra reuma capitis . Item nota op mures insidiantur radicibz eius.in de medicinam querentes.

les aliquos vt alij roborent quos in locis vz cuis transferre poteris. serunt circa finem in lij z toto tempoze mensis augusti si pluuie desunt irrigatione iuuent.possunt etiā cōmode seri inter miliū z panicam maxime serotanū in secūda sarculatiōe ipsius sarculatiōis iunatur napus z rapa.ex napis nobilioris sapoz sunt illi.qui sunt longi z sere rugosi nō grossi.multas radices habētes.sed vnam tantuz acutā z rectam. Ex napis sunt optima composita cum rafano z modico sale acceto melle z sinapi z speciebz odoziferis.z sine speciebus possunt fieri satis bona.calidi sunt in secundo gradu z multū nutriūt.sed dure digerunt.mollem z inflatā minus tamen qp rape faciunt carnē.qui si in aqua coquat zilla eiecta in alia recoquat duricia sue substantie tēperat.z mediocriter inter bonū z malū generant nutrimentū.qui bene cocti non sunt difficile digerunt.vētositate faciunt. z in venis z pozis opilatione Idcirco vtiles sunt si bis coquant.z vtraqz aqua proiecta in alia recoquant cum pinguissima carne.

De Napo.

Apus omnē fere aerem patiť terram desiderat pinguē.z in solo sicco z tenui z propezinū z deuero z sabuloso melius nasci tur loco. Proprietas napi in rapam z econnerso trāsmutat.sed vt optime proficiat subactū solū stercozatuz z versatū querit.et in illis locis optime prouenit in quibz segetes eo anno fuerunt.Si spissi sunt nimis interuel

De Nasturcio.

Q ij

Liber

Sextus Fol.xcv.

Igella calida z sicca est in tertio gradu semē est cuiusdā herbe. que in locis paludosis z inter frumentū reperit. Semē p.x. annos seruat. Est autē rotundū z planū sub ruffum z subamarū . vnde habet virtutē diureticam ex amaritudine dissoluendi z consumendi ex suis qualitatibz.emplastrū factū ex farina nigelle z succo absinthij circa vmblicū z pzecipue pueris lūbzicos necat.maiozibus cōficiat cum melle z detur farina nigelle facta cum acceto tepido.z auribz inflata vermes necat.vnguentū tamen nigelle in multa quātitate fiat decoctio in forti acceto vsqz ad cōsumptionē.z aliquantulā spissitudinem.z tunc addito oleo fiat quasi vnguentū.qđ optimum est ad scabiem. z impetigines defacile tollit.

mesticū quod in oztis reperit.z minoza habz folia z suauius operat z est domesticuz quod in oztis reperit qđ in medicinis ponit. Colligitur autē in tepoze productiōis flozū. debet in medicinis poni abiectis stipitibz.per annū seruat z in vmbza suspendit.z siccant folia.virtutē habet dissoluendi cōsumendi z attrahendi. Contra frigidū reuma capitis folia cū flozibz in testa sine liquoze bene calefacta in sacello ponant z sacellū capiti superpo naf z patiens cooperiat pannis.vt caput sudet.vinū decoctionis eius gargarisatū ginguiarū z fauciū cōsumit humiditatē. Cōtra frigidū asma detur vinū decoctiōis eius z ficuum siccarū.vel puluis eius digestionē cōfortat confectus cum melle detur cū aqua calida.vinū decoctionis eius digestionē cōfortat.dolozem stomachi z intestinoz excludit. Itez fasciculi facti ex herba ipsius decocti in vino z renibus superpositi stranguiriam et dissenteriam soluunt.

De Origano.

Riganū calidū z siccū est in tercio gradu. Alio nomie dicit gondla. Cui9 duplex est maneries . scz origanū agreste.qđ latioza habet folia.sed z foztius operat.z est do

De Poris.

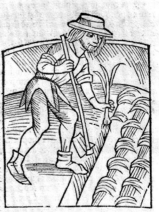

Ozi sustinent fere omnē aerem.z terrā desiderant mediocriter solutā. vt optime proficiant.z pinguē z stercozatā.Serunt aūt in locis calidis z teperato pzimis de mē

Q iij

Pietro de Crescenzi

Ruralia commoda, c.1490–5

Woodblock print, open 29 × 42.5 cm / 11½ × 16¾ in
Biblioteca de Real Jardín Botánico, Madrid

Four woodcuts and their accompanying text from a widely read medieval manual on agriculture show, from left to right, pondlily, corncockle and oregano, and a farmer using a hoe to plant leeks in rows of furrows. *Ruralia commoda* was written around 1306 by Bolognese jurist Pietro de Crescenzi (c.1230–c.1321); its longer Latin title, *Commodum ruralium cum figuris libri duodecim*, roughly translates to 'the convenience of country living in twelve books'. The first of its kind since the Roman Empire, it was the standard work on agriculture through the sixteenth century, providing instructions for landowners and farmers in all aspects of land work, from planting to animal husbandry. Numerous manuscript and printed editions were produced, and it has been translated into many languages, although never English. King Henry VIII owned a copy of this same edition and closely adhered to its instructions, using it as a guide for his now lost garden at Whitehall Palace. This Latin edition, printed by Peter Drach in Germany around 1490–95, is an excellent example of fifteenth-century incunabula, or early printed books. Heavily illustrated – the most of all the fifteenth century *Ruralia* copies – it features Gothic type and nearly 290 woodcuts. Some of the plant illustrations were copied from *Hortus sanitatis*, an encyclopedic herbal from the same period. It is divided into twelve sections, of which the sixth, *Liber Sextus*, covers gardening and describes the medicinal and nourishing uses of herbs and vegetables. A detailed treatise on the care and cultivation of useful plants, the book offers best growing practices and information that is still useful to gardeners today.

Pieter Brueghel the Younger

Spring, 1632

Oil on panel, 43 × 59 cm / 16⅞ × 23¼ in
National Museum of Art of Romania, Bucharest

This detailed representation of everyday life in the Netherlands by Flemish painter Pieter Brueghel the Younger (1564–1638) is one of four panels in a polyptych, each representing one of the four seasons. The idea was originally devised by the artist's father, Pieter Bruegel the Elder, who sketched the composition of each work. The painting was directly influenced by such medieval masterpieces as the thirteenth-century books of hours, religious manuals in which labour was represented as ennobling and divine. *Spring* is a perfect example of this

tradition. It depicts a formal flower garden that is most likely part of a noble estate. The geometric flower beds arranged around a central motif are borrowed from the Italian Renaissance garden style. Another debt to Italian art and culture is visible in the gardener in the right corner of the painting, whose pose echoes that of Noah in one of the panels of the Sistine Chapel ceiling by Michelangelo. In *Spring*, the gardeners are seen preparing the soil for sowing and planting. While some blooming plants – most

recognizably the ever-popular tulip – appear to be already in the ground, others are still in pots. This detail indicates the widespread practice among gardeners at the time of jump-starting their seedlings indoors, often in heated greenhouses, in order to extend the growing season and guarantee a harvest if there was an early autumn. This garden, however, as the topiary trees visible in the middle of the painting suggest, might have been more prominently dedicated to ornamental and exotic varieties.

Anonymous

Bird's-eye view of the Taj Mahal at Agra, 1790–1810

Pen and opaque watercolour on paper, 52.8 × 34.4 cm / 20¾ × 13½ in, Smithsonian Institution, National Museum of Asian Art, Washington DC

Built by the fifth Mughal emperor, Shah Jahān, as the final resting place of his favourite wife, Mumtaz Mahal, the ethereally beautiful Taj Mahal was completed in 1653. This bird's-eye perspective offers an artistic representation rather than an accurate portrayal of the world's most famous mausoleum and garden complex. It does, however, capture how the translucent ivory-white marble structure appears to float in the sky, when viewed for the first time on entering the Great Gate (seen at the bottom

of the painting). In the foreground, the artist depicts the garden laid out in the typical Islamic four-part *chahar bagh* form: a central water tank feeding four perpendicular rills that demarcate the four tree-ornamented beds. A somewhat later to-scale plan drawn by Colonel John Hodgson, Surveyor-General of India, in 1828 clearly shows sixteen beds, which have been further quartered, giving a total of sixty-four beds, all of which would have been richly planted with bright and sweetly scented flowers. Today

the quarters are laid to grass and trees. At the top of the painting, the Mehtab Bagh ('Moonlight Garden') is shown on the far side of the River Yamuna. It was eventually lost under river silt, before being restored in 1994. In reality, the Mehtab Bagh is square and is not surrounded by a branch of the river. The artist's depiction is also missing the octagonal reflecting pool that gave rise to the myth of the Black Taj, where the moonlit reflection of the white structure appears in the dark waters.

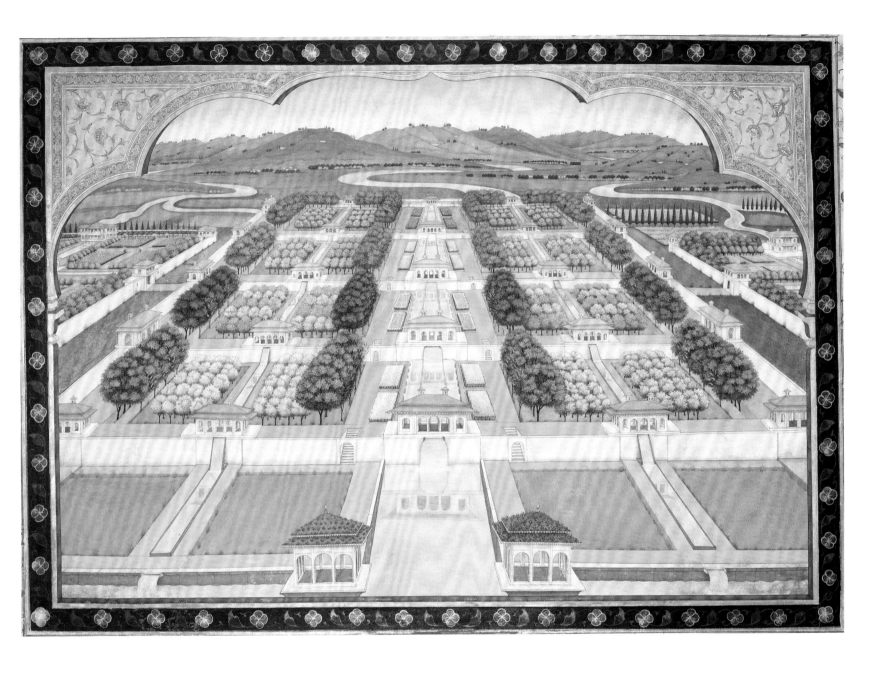

Hafiz Nurallah

A View of Shalimar Bagh, Srinagar,
from the *Polier Album*, c.1780

Opaque watercolour heightened with gold on paper,
24.5 × 37.2 cm / 9½ × 14½ in
Private collection

One of the most famous of all the Mughal gardens of South Asia, Shalimar Bagh was created from about 1619 as part of the summer residence of Emperor Jahangir. An enclosed garden, it lies in a romantic setting close to the bank of Dal Lake near Srinagar in Kashmir, with formal flower beds, lawns and trees and narrow canals that channel spring water from the hills behind. Oddly, the lake does not feature in the painting, nor do the mountains that dominate the background of the real site, so it is possible that the artist

was inspired by the garden but created the work elsewhere. The work of Mughal calligrapher Hafiz Nurallah, who served at the court of Asaf-ud-Daulah (Nawab of Awadh, 1775–97) in Lucknow, India, this beautifully framed illustration of Shalimar Bagh is from one of ten albums that belonged to Swiss engineer-architect Antoine Louis Henri Polier, a former officer of the British East India Company. The Shalimar garden was later famously popularized in a love poem, *Kashmiri Song* by British poet Adela Florence

Nicolson – beginning with the words 'Pale hands I loved beside the Shalimar' – which was published in 1901 under her pseudonym Laurence Hope and set to music by Amy Woodforde-Finden in 1902. Shalimar and the other Mughal gardens would have been peaceful, healthy places for relaxation and contemplation for the emperor and his court, a welcome retreat from the hot, dusty plains where they could admire the beauty of the surrounding natural landscape, as visitors still do to this day.

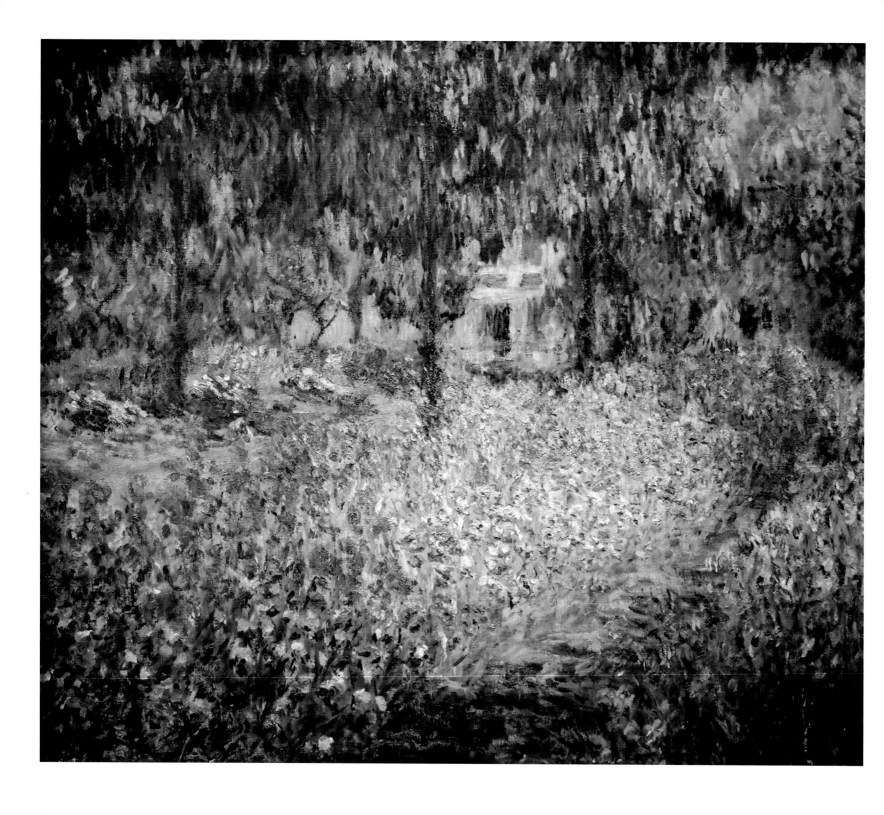

Claude Monet

Le Jardin de l'artiste à Giverny, 1900

Oil on canvas, 81.6 × 92.6 cm / 32 × 36½ in
Musée d'Orsay, Paris

One of the most famous gardens in the world, the home of French Impressionist painter Claude Monet (1840–1926) is immortalized in many of his best-known paintings. After settling in the small village of Giverny in the Seine Valley, Monet created a horticultural masterpiece where he would spend the final three decades of his life (see p.212). His carefully planned garden was a constant source of inspiration, as seen here in *Le Jardin de l'artiste à Giverny* (*The Artist's Garden at Giverny*). As devoted to gardening as he was to painting, Monet built two distinct gardens at Giverny: the flower garden, a riot of colourful annuals and perennials, and the water garden, with its famed waterlilies. This vibrant natural environment also served as his studio, where he frequently painted *en plein air*. An avid plant and seed collector, Monet experimented with plants with the same boldness as he did with thick brushstrokes of paint. Flowers were arranged carefully to create impressionistic forms and textures, changing with light and seasons. Successive plantings ensured that the gardens were in full bloom throughout the year. Flower beds located near the house include wide rows of thousands of blue and lavender bearded irises, captured in this painting from 1900, one of several monochromatic but vivid floral compositions. The recognizable building, with pink stucco and green shutters, is seen in the background. The fragrant spring-blooming irises are drenched in sunlight. A planter of flowers as well as a painter of them, Monet intentionally designed scenes for capturing such ephemeral moments of changing light.

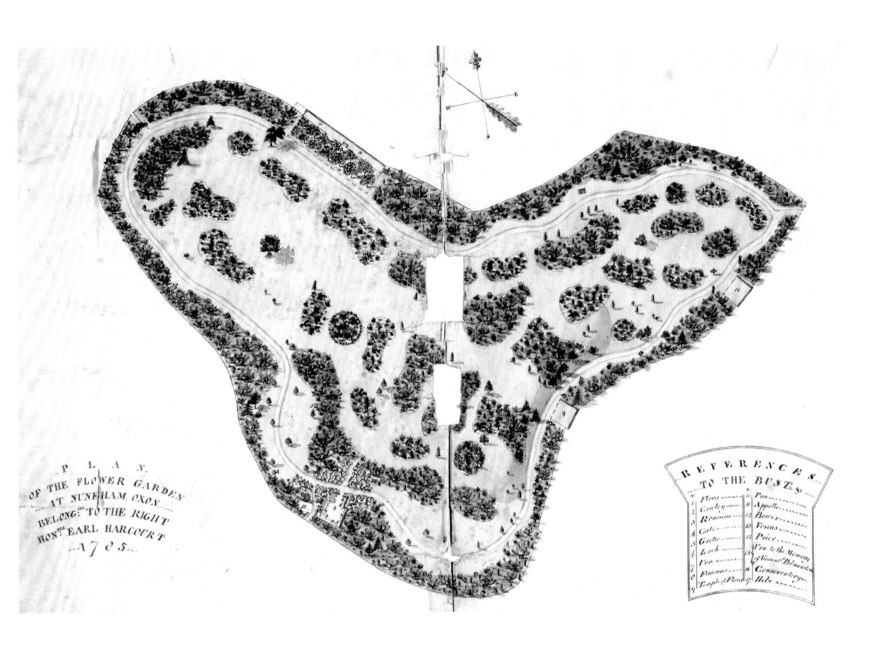

PLAN
OF THE FLOWER GARDEN
AT NUNEHAM, OXON.
BELONG: TO THE RIGHT
HON^BLE EARL HARCOURT
1785

REFERENCES
TO THE BUSTS &c.

1 Flora
2 Cowley
3 Rousseau
4 Cato
5 Grotto
6 Lock
7 Urn
8 Parnassus
9 Temple of Flora

10 Pan
11 Appello
12 Bower
13 Venus
14 Prior
15 Urn to the Memory of Viscount Palmerston
16 Conservatory
17 Hebe

William Mason

Plan of the Flower Garden at Nuneham, Oxon, Belonging to the Right Honourable Earl Harcourt, 1785

Ink on paper, 38 × 46.5 cm / 15 × 18⅜ in
National Archives, London

English gardening was revolutionized in the eighteenth century when British poet, draughtsman and gardener William Mason (1724–1797) created a new informal flower garden for Nuneham Courtenay in Oxfordshire, a country estate owned by the 1st Earl of Harcourt, one of George III's leading courtiers. Inspired by classical culture and the Roman villas he had seen on his Grand Tour of Europe, Harcourt sought to create his own Arcadian retreat in the English countryside. His son, George Simon, had very different ideas

and, while the earl was abroad in 1771, he employed Mason to help him install a garden of irregularly shaped flower beds that contrasted sharply with the rigid formality of his father's classical sensibilities. Although Mason's original plans are lost, this hand-painted plan from 1785 shows the development of the flower garden after Simon inherited the estate in 1777. Simon and Mason were great supporters of William Gilpin's principles of picturesque beauty, taking ideas from contemporary landscape painting and applying them to garden

design. The plan shows an assortment of circular, oval and kidney-shaped beds filled with red and yellow flowers and shrubbery, surrounded by trees of various species. A winding walkway around the garden leads visitors past busts of poets, inscriptions and urns to a Temple of Flora and a grotto. The innovative garden was highly influential and Mason's ideas, encapsulated in his expansive four-part poem *The English Garden* (1777–81), inspired many other gardeners of the era, including Humphry Repton (see p.83).

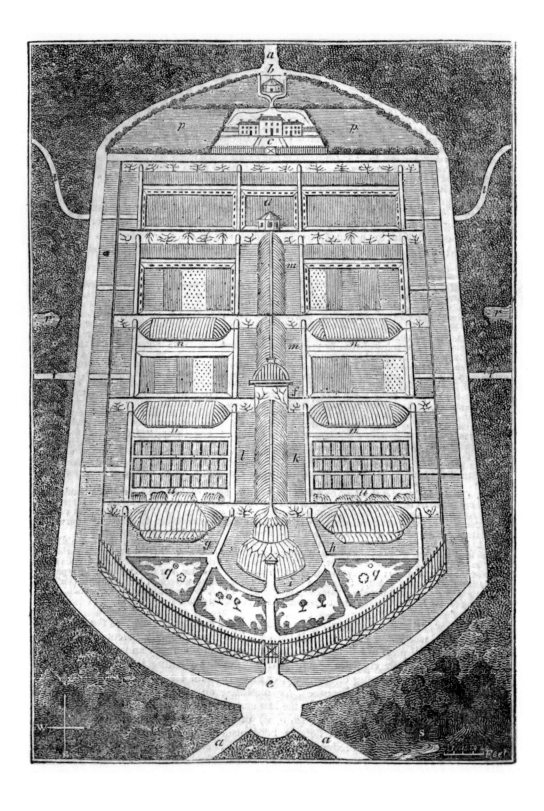

John Claudius Loudon

Design for an Extensive Kitchen-garden with a Flower-garden and Orchard,
from *An Encyclopaedia of Gardening*, 1825

Engraving, sheet 20.6 × 14 cm / 8⅛ × 5½ in
University of California Libraries, Los Angeles

Scottish botanist, garden designer and writer John Claudius Loudon (1783–1843) revolutionized garden and architectural writing in the early 1800s and went on to become one of the most influential garden writers of the nineteenth century. His information-gathering tours of Europe and Britain culminated in the publication of *An Encyclopaedia of Gardening* in 1822, which was expanded in numerous subsequent editions. With more than 1,200 pages, Loudon's *Encyclopaedia* was a comprehensive look at gardening and featured hundreds

of illustrations, including this plan for an extensive kitchen garden combined with a flower garden and orchard – showing hothouses, heated pits to grow exotic fruit such as pineapple, offices and a gardener's lodge – that epitomized gardening aspirations in Britain in the 1820s. In *The Suburban Gardener and Villa Companion* (1838) and *The Gardener's Magazine* (1826–43), Loudon aimed to provide more focused guidance for the growing middle classes of Britain, with plans for laying out and planting gardens of various sizes. He included

illustrations of new composite-stone garden ornaments and fountains, which were more affordable than hand-carved stone ornaments. A prolific writer – from 1830 aided by his wife, Jane – Loudon increasingly argued that gardens should be recognized as works of art. In 1832 he first used the term 'gardenesque', which emphasized the use of non-native trees to accentuate gardens as art, and specified that trees be planted and managed as separate specimens so that the hand of the gardener could be appreciated.

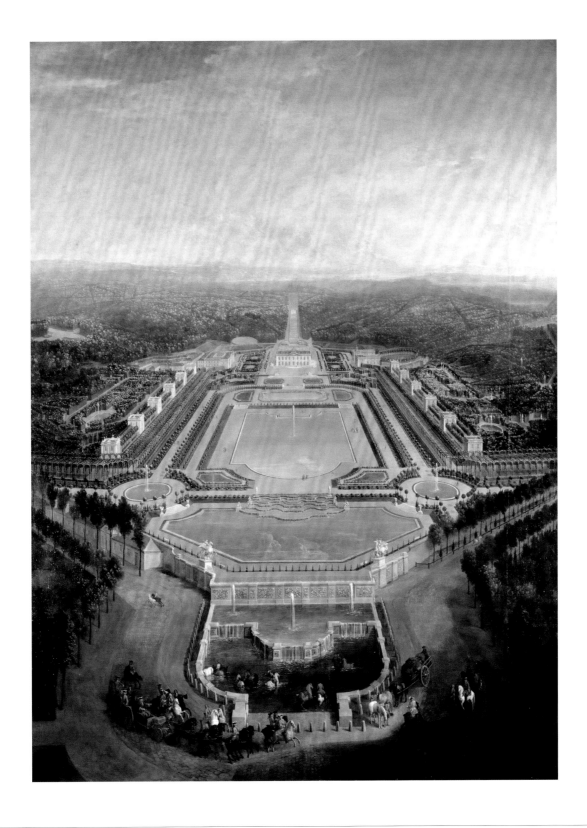

Pierre-Denis Martin

General View of Château de Marly, c.1724

Oil on canvas, 3 × 2.3 m / 9 ft 10 in × 7 ft 6 in
Château de Versailles, France

Pierre-Denis Martin (c.1663–1742) was a French painter of battles, hunts, historical subjects and architectural views, particularly of royal residences. Château de Marly, west of Paris, shown here in bird's-eye perspective from the watering pool outside the walled-in garden, was King Louis XIV's private and quiet retreat, where he escaped the formal court at Versailles. The painting is orientated on the garden's main axis, which is in front of Louis's square château – flanked by pairs of *salles vertes* or green rooms – and takes the form

of a formal central canal and two smaller geometric pools with fountains and cascades. Behind the château the axis extends to a stepped water cascade, the *allée de la rivière*. In a display of mirrored symmetry, three narrow terraces with allées rise from the level of the pools, the uppermost covered by an arched wooden tunnel. Behind this stand the two sets of six pavilions that accommodated those select courtiers invited by the king. Beyond the pavilions are the *bosquets*: compartments of formal woodland pierced by straight paths

and ornamented with fountains, statues and other elements, such as an amphitheatre, cascades, theatres and buildings. Work on the Château de Marly began in May 1679 and the buildings were a collaboration between court painter Charles Le Brun and architect Jules Hardouin-Mansart, the latter of whom also laid out the gardens. Marly was destroyed during the French Revolution and today the Marly-le-Roi National Estate and Park occupies much of the grounds, including the restored waterways and lawns.

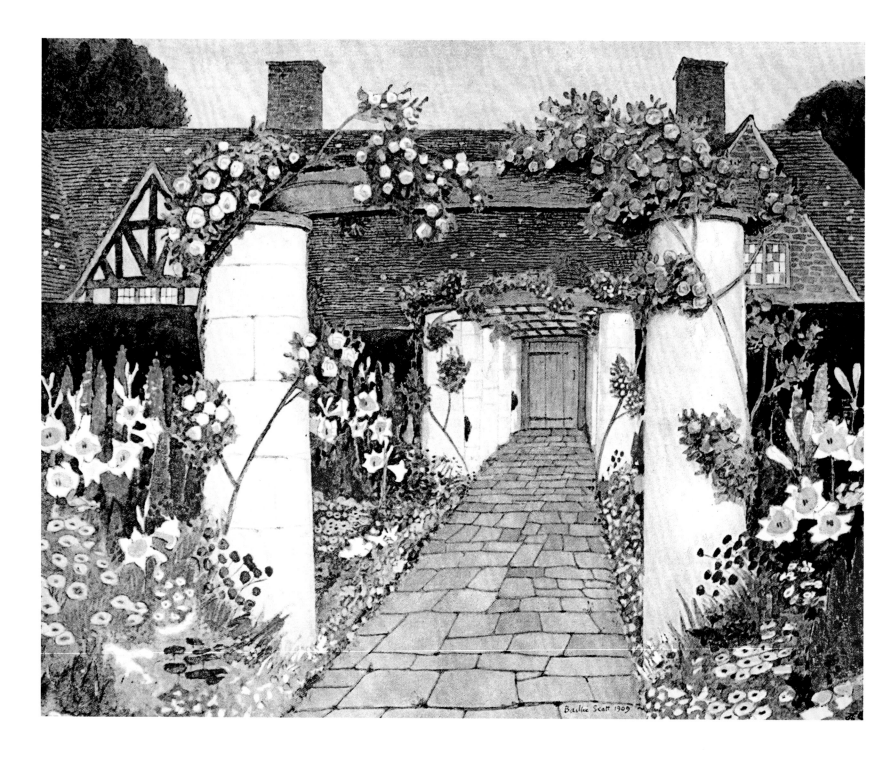

M. H. Baillie Scott

Proposed Residence at Guildford,
from *The Studio: An Illustrated Magazine
of Fine and Applied Art*, vol. 46, 1909

Halftone illustration, sheet 28.6 × 21 cm / 11¼ × 8¼ in
Private collection

A path leads to a wooden door through a series of paired white columns that provide a free-standing support for climbing roses, while the flanking beds contain a profusion of flowers. The bright kaleidoscope of colours, however, disguises the orderly geometrical layout that characterizes this garden designed by M. H. Baillie Scott (1865–1945), a leading proponent of an Arts and Crafts style that combined precise craftwork with simple forms of architecture. The path in Scott's design for the garden at Undershaw, in Guildford,

Surrey, led to a gallery overlooking a hall, the windows of which faced the flower garden shown to the left. This illustration by Scott was published in 1909 in *The Studio*, then the premier international journal for fine and applied art, to illustrate his article on the proposed house, the residence and garden being completed soon afterwards. The focus of this luminous rendering is the garden and north front of the house, a *rus in urbe* – a glimpse of the countryside in the city – in England's Arts and Crafts heartland, embodying

the quintessential fusion of art and craft eagerly sought by affluent Edwardians. In the decades on either side of 1900, Surrey became a preferred location for country residences for the upper middle classes, within easy reach of London yet close to the Surrey Hills and South Downs. Hand in hand with this flourishing estate creation was patronage of Britain's most fashionable creative minds, notably garden designer Gertrude Jekyll and architects Charles F. A. Voysey, Edwin Lutyens and Scott himself (see pp.61, 73, 261).

Ebony G. Patterson

...below the crows, a blue purse sits between the blades, shoes among the petals, a cockerel comes to witness..., 2019

Mixed media, 279.4 × 248.9 × 15.2 cm / 110 × 98 × 6 in
Private collection

At first glance, this colossal collage by Jamaican artist Ebony G. Patterson (b. 1981) is an intriguing arrangement of flowers, butterflies and birds, all beauty and bright colours, lush with plants and embellished with jewels. Upon closer inspection, the collage is revealed as a multi-layered assemblage of discovery, mystery and perhaps something slightly sinister. Like the horticultural technique of layering, Patterson's paper garden is densely 'interplanted' with different species – a mixed-media tapestry of feathers and blooms. Perforated with holes, the

work draws the gaze inwards and the viewer becomes voyeur and investigator. The cut-out portals, like garden paths, might lead to other areas of the tableau ... or might go nowhere. It is a world of contradictions, as gardens can sometimes be. Nearly obscured by flora and fauna, the titular objects come into focus: a blue handbag, a pair of pink sneakers, a rooster. Other objects become visible, too: a muscle car, a jacked-up jeep, fingers, a face. The shifting scene unfolds through a screen of leaves and grass – the 'blades' referred to in the title, but also suggestive

of sharp objects. With such a disorientating effect, active observation is required and results in the viewer questioning what they are witnessing. Is it something violent? Meanwhile, among the unexpected and unsettling landscape, carefully placed flowers create a rococo-esque pattern of an ornamental flower garden with lilies, irises, orchids, primroses, morning glories and fritillaries. A recurring theme in Patterson's work, the garden often serves as a metaphor for such issues as colonialism, class, culture, gender, race, loss and death.

Studio Ghibli

Spirited Away, 2001

Animated film, dimensions variable

In the 2001 animated feature film *Spirited Away*, Miyazaki Hayao – co-founder of Japan's iconic Studio Ghibli – blends the spiritual and fantastical with the touchingly real and human. In this wildly imaginative take on the familiar coming-of-age story, ten-year-old Chihiro is moving with her mother and father to a house in the suburbs. Along the way they stray into an abandoned amusement park where a witch steals Chihiro's name and cursed food transforms her parents into pigs. In order to restore them she must learn

to navigate the world of *kami*, or spirits, gaining valuable self-knowledge along the way. As in many Ghibli films, the relationship between the characters and the natural world plays a major role. Vibrant, impossibly lush flowers blur the boundaries between fantasy and reality as the dreaming Chihiro pushes her way through a rhododendron garden – rendered hyper-real by the Ghibli artists' masterly blending of hand-drawing and computer animation – towards the pig pen where her transfigured parents now live. In another

scene, her friend and guide Haku comforts Chihiro with *onigiri* – traditional Japanese rice balls – as they lean against a bank of perennial sweet peas. Winter, spring and summer coexist as camellias, azalea and oleander bloom together in a way impossible in nature. In this fantastical world, gardens and flowers represent innocence and experience, dislocation and homecoming, both a celebration and a poignant reminder of what we stand to lose if we fail to properly value and protect the natural world.

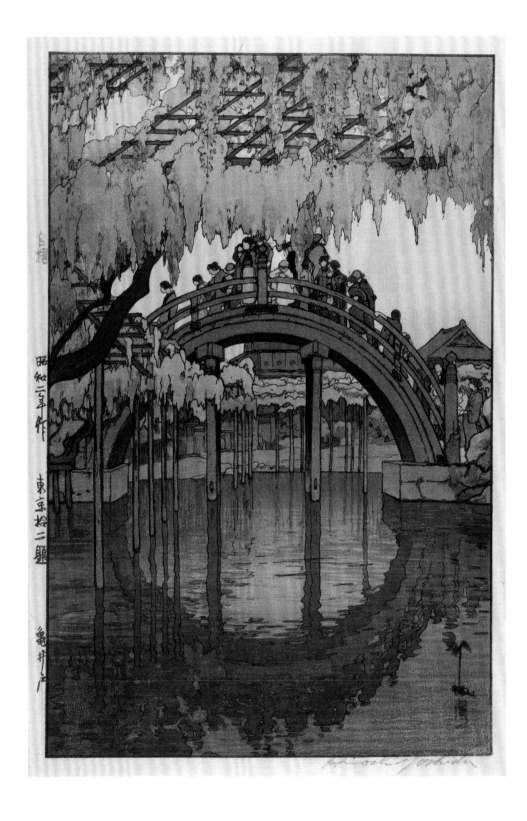

Hiroshi Yoshida

Kameido Bridge, Tokyo, 1927

Woodblock print, 40.7 × 27.2 cm / 16 × 10¾ in
Art Institute of Chicago

In this carefully composed Japanese woodblock print, a group of people walks over a steeply arched bridge, seen beyond a trellis dripping with clusters of purple wisteria flowers. Beyond the bridge the trellis continues, supported by poles rising from the water, and the purple inflorescences form cloud-like strata. Japanese wisteria blooms spectacularly in spring, when its racemes burst into clouds of fragrant flowers of white, pink, violet or blue. The view of the Tenmangu shrine in Kameido – from the series *Twelve Scenes of Tokyo*

by artist Hiroshi Yoshida (1876–1950) – belongs to the Shin-Hanga (New Prints) movement that revived traditional Japanese woodblock printing in the early twentieth century, reflecting a romanticized view of Japan to appeal to a Western audience. Wisteria was a common subject of such views, having become very popular in gardens around the world after being introduced from Japan to North America in the 1830s; it was appreciated for its hardiness, its spectacular flowers and its longevity (a plant can live up to fifty years).

Hiroshi, one of the leading artists of Shin-Hanga, toured Europe and the United States after the Kanto earthquake of 1923, painting and selling his work. In 1925 he returned to Japan and mainly painted landscapes inspired by his travels, both in Japan and abroad. He continued to produce paintings in watercolour and oil until shortly before his death, incorporating a traditional Japanese approach and Western ideas of aesthetics, as here, to appeal to an international audience.

649. HORIKIRI IRIS FLOWER GARDEN, AT TOKIO.

Kusakabe Kimbei

Horikiri Iris Flower Garden at Tokyo,
1880s–1910s

Albumen silver print, watercolour,
20.1 × 26.3 cm / 8 × 10¼ in
National Gallery of Victoria, Melbourne

A small wooden bridge crosses a field of irises amid the pavilions of Horikiri, a popular iris garden in Tokyo, in this hand-coloured photograph from the turn of the twentieth century. Irises have long been featured in Japanese stories and art, reflecting their enduring popularity in the country – Japanese growers have cultivated around 2,000 varieties – where the flowers are seen as an expression of beauty and sophistication, as well as warding off bad luck. In the tenth-century classic *Tales of Ise*, the iris is associated with the story of a nobleman who, forced to leave his lover in Kyoto, writes a poem of heartbreak beside a zigzag bridge crossing a pond lined with irises. Irises bloomed at the start of the rainy season, so farmers were said to grow them near their rice fields to give a sign that planting season was about to begin. Japan is home to three native irises – kakitsubata (*I. san-guinea*), ayame (*Iris laevigata*) and hanashobu (*I. ensata*) – the last of which is often referred to in the West as the Japanese iris. Selective breeding of irises began in the 1800s, with flowers being chosen for wide falls (the hanging petals) and narrow standards (the upright petals). They were frequently grown in special gardens like Horikiri, with ponds and artificial water channels to provide moist conditions, together with reproductions of the zigzag bridge from the famous story. This image was created by photographer Kusakabe Kimbei (1841–1934), whose studio supplied images to Western customers at a time when Japanese art was very fashionable in Europe.

Casey Boyden

Japanese Tea Garden, 2007

LEGO, 26 × 45 × 30 cm / 10¼ × 17¾ × 11¾ in
Private collection

Founded in 1932 by Danish carpenter Ole Kirk Kristiansen, LEGO – an abbreviation of the Danish *leg godt*, meaning 'play well' – began as a wooden toy company. Its now iconic plastic bricks were introduced in 1958 and became an instant classic, their versatility and broad appeal quickly conquering the hearts of children and adults alike. Beginning in the 1960s and '70s, LEGO targeted mature consumers with a series of model sets that came with building instructions. This more sophisticated line of products became a classic

that still fascinates today. *Japanese Tea Garden* is a prototype designed by MOC (My Own Creation) LEGO enthusiast Casey Boyden (b. 1998), encouraged by LEGO's standing invitation to creators from around the world to reinvent and combine existing model sets to produce entirely new designs. This detailed model is loosely inspired by the Japanese tea garden in San Francisco at Golden Gate Park, California. Built in 1894, as part of the California Midwinter International Exposition, the garden is the oldest of its

kind in the United States. Central to the garden is the tea house, a roofed open structure in which tea ceremonies are performed. In plastic bricks, this LEGO model reproduces the features of a Japanese garden, such as the *niwaki* trees perched on the edge of the pond, a typical *sori-bashi* half-moon bridge, and some lotuses in bloom. On one side, it offers a section view that makes visible and emphasizes the presence of tree roots, while an underwater view of the pond features a quintessential golden koi carp.

Thomas Dolliver Church

Pool Area Design, Donnell (Dewey) Residence, c.1948

Coloured pencil and ink on paper, 25.4 × 20.3 cm / 10 × 8 in
University of California, Berkeley

Melding seamlessly into a hillside near Sonoma, California, with views of San Pablo Bay, sits the Donnell Pool Garden at El Novillero. With a relaxed and informal plan by American landscape architect Thomas Dolliver Church (1902–1978), the garden features a central pool containing a sculpture by Adaline Kent, lanai and square-patterned concrete surfacing, decking around the trunks of shade-giving native live oaks and sculptural rocks artfully positioned. The design was influenced at least in part by Church's meeting with Finnish

architect Alvar Aalto in 1937, and encapsulates Church's belief that 'A garden should have no beginning and no end, and should be pleasing when seen from any angle, not only from the house.' Church invented and perfected the Californian Modern garden, designing more than 2,000 private gardens in the state. He was also a pioneer in the broader evolution of the Modernist American garden, along-side Garrett Eckbo, Lawrence Halprin, Dan Kiley and James Rose. Although their design expressions were different, they

all believed in the constructivist creation of a new kind of landscape space that responded to the demands of twentieth-century life while rebelling against the sentimentalizing of nature. With unconfined, flowing spaces and meeting the functional needs of his modern clients, this design captures other key Churchian design essentials: those of freedom, the importance of the natural setting and the siting of the design within it, and the belief that gardens were places to live in rather than just homes for plants.

Alvar Aalto

Villa Mairea, c.1941

Photograph, dimensions variable

It may seem a little strange to include a swimming pool as part of a garden made at a latitude of 61.59° north and 'enjoying' an average daily high temperature of 19°C (66°F) in the summer, but then much of the design of this woodland retreat built by Finnish architect Alvar Aalto (1898–1976) for Harry and Maire Gullichsen was explorative. The couple gave Aalto carte blanche to experiment with ideas, styles and materials, and the result marked his stylistic transition from traditional Finnish Romantic to Functional Modern.

The garden and villa in Noormarkku, southwestern Finland, perfectly capture Aalto's notion that human emotion and natural forms may be used to inspire organic architecture and design that remains rational and structurally modern. Contrasting the asymmetric angularity of the villa with the free-form swimming pool encapsulates Aalto's remark made in 1926 that the 'curving, living, unpredictable line which runs in dimensions unknown to mathematics is for me the incarnation of everything that forms a contrast to

the modern world between brutal mechanicalness and religious beauty in life'. The garden sits in the angle of the L-shaped house, and a canopy walk connects the house to the grass-roofed sauna beside the pool, while large doors on to a terrace with an outdoor fireplace helps bring house and garden together. The shape of the pool resembles that built by Thomas Church at El Novillero (see p.50), after he met Aalto in 1937 and the Finn inspired the American towards a style of more relaxed, informal and natural garden design.

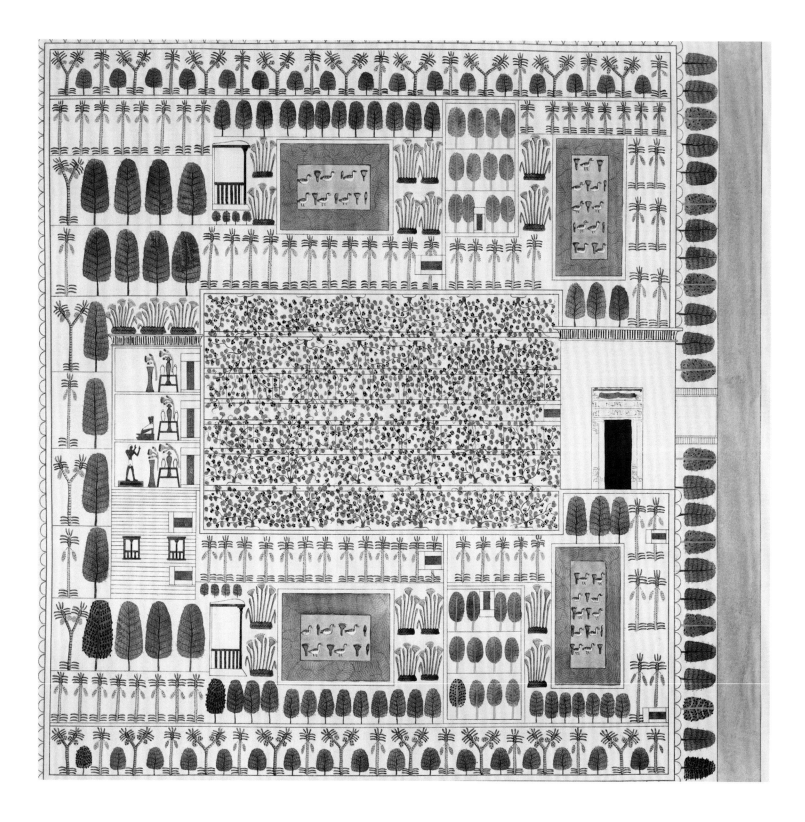

Giuseppe Angelelli
and Ippolito Rosellini

Plate LXIX, from *Monuments of Egypt
and Nubia*, 1832–44

Colour lithograph, sheet approx. 72 × 52 cm / 28⅜ × 20½ in
Private collection

Repeated geometrical shapes, subtle colours and regular divisions make this garden design seem so contemporary it could almost be brought to life today – but it was created some 3,500 years ago in ancient Egypt. The main garden – laid out symmetrically, with avenues between trees and shrubs – was surrounded by a mudbrick wall and entered by a gateway through a tree-lined facade facing a canal, at right. Beyond the central courtyard, shaded by trellised grapevines, was a house that was probably single-storeyed. On either side of the courtyard,

across avenues of palms, are pools with ducks and lotus flowers, surrounded by marshy areas containing papyrus; the two pools nearest the house are overlooked by roofed pavilions. This garden was probably managed (and possibly designed) by Sennefer, mayor of Thebes under the eighteenth-dynasty pharaoh Amenhotep II, and 'overseer of the cattle, granaries and orchards of Amun', the chief deity at Thebes' Karnak temple. The painting came from the hallway leading to the tomb Sennefer shared with his wife, Meryt, which depicted scenes

showing Amun's gardens and grain fields, while the ceiling of the innermost chamber depicted a grape bower. The Tomb of the Vines, as it is now called, dates from *c.*1439–1413 BC, and the condition of the garden scene is today very poor. This copy, preserving its state when found, was made by Italian artist Giuseppe Angelelli (1803–1848) while accompanying Ippolito Rosellini (1800–1843), founder of Italian Egyptology, on the excavation of Sennefer's tomb in 1834; it was later published in Rosellini's twelve-volume *Monuments of Egypt and Nubia*.

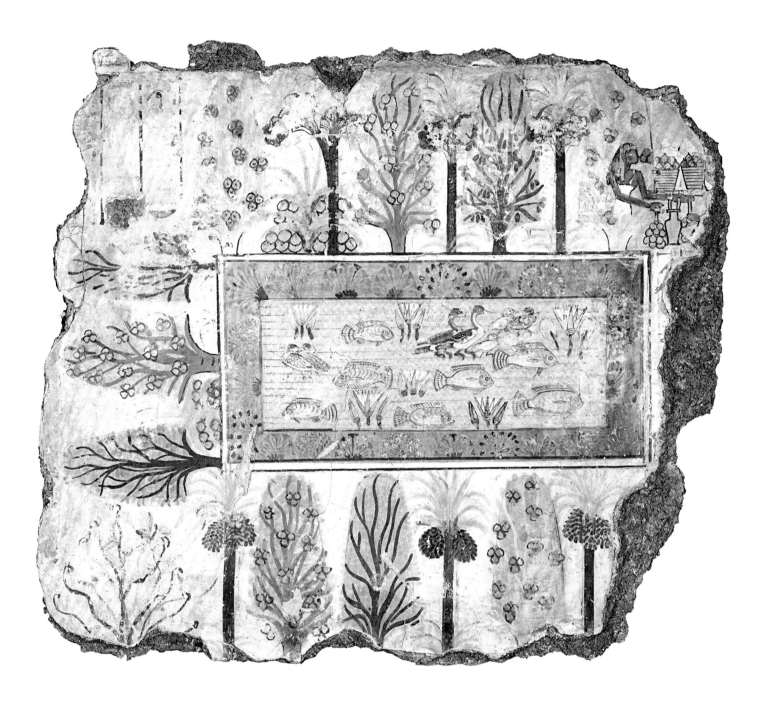

Anonymous

Estate garden from the Tomb
of Nebamun, *c*.1350 BC

Fresco, 73 × 64 cm / 28¾ × 25 in
British Museum, London

This idealized scene of a pool in a flourishing garden, including palms (shown with fruit at different stages of ripeness), doum palms, sycamore fig, mandrake and other shrubs, symbolizes rebirth and renewal. The subject was particularly appropriate for the wall painting's location inside the tomb chapel of Nebamun, a middle-ranking 'scribe and grain-accountant' at the ancient Egyptian temple of Amun in Thebes (now Luxor). The fragment of painting, one of several created by an artist who has been called the Michelangelo of the Nile,

shows the pool from above, full of tilapia fish, lotus flowers and geese, with papyrus around the edges. Much of the blue pigment of the pond and the green of the trees has been lost. In the upper right, Hathor, a protector goddess, leans out of a tree and offers gifts to someone on her right, probably Nebamun and his wife. At upper left, a sycamore fig greets Nebamun as the owner of the garden. The paintings were removed from the walls of Nebamun's tomb chapel by Greek adventurer Giovanni d'Athanasi, who was working for Henry

Salt, the British Consul-General; Salt then sold them to the British Museum in 1821. The newfound popularity of Egypt following Napoleon's military explorations from 1798 to 1801 caused great rivalry among treasure-hunters, and d'Athanasi refused to reveal the whereabouts of the tomb. Its location is still unknown, although analysis of the fragments has indicated an area on the west bank of the Nile between the Valley of the Kings and that of the Queens. The paintings were extensively conserved from 2001 to 2007.

Lievin Cruyl and Athanasius Kircher

Hanging Gardens of Babylon, from *Turris Babel*, 1679

Engraving, 37 × 46 cm / 14½ × 18 in
Cornell University Library, Ithaca, New York

The Hanging Gardens of Babylon have fascinated scholars for centuries – but no remains have ever been found, and the very existence of the gardens is still disputed. According to ancient accounts, the gardens were built in Babylon, in present-day Iraq, most likely in the sixth century BC by King Nebuchadnezzar II. In one story, the king built the gardens for his wife, Amytis, who missed the mountain greenery of her homeland in Media. Scholars today suggest that the gardens were 'hanging' in the sense that they were raised, possibly

on a series of terraces supported by vaulted chambers or as part of a stepped pyramid, or ziggurat. The gardens were said to be irrigated using an ingenious system that pumped water to the top to flow down from level to level. This fanciful representation of the gardens is from a work by German Jesuit scholar Athanasius Kircher (1601–1680), a polymath who studied Egyptian hieroglyphics, optics, volcanoes and microscopic organisms. This plate, drawn by Lievin Cruyl (c.1634–c.1720) to accompany Kircher's description of the

ancient Seven Wonders of the World, imagines the Hanging Gardens as a prototype of the Renaissance Italian garden, with formal terraces, a water feature with fountain, and plants in beds. Kircher doubted that a structure could actually have been built, particularly in view of the pumping technology required to bring sufficient water to the height of the terraces. His view is supported by recent scholarly investigation, which suggests that the Hanging Gardens were Assyrian rather than Babylonian: built at Nineveh by King Sennacherib.

VIEW OF THE BEAUTIFUL ISLAND.

Publd at RACKERMANN's REPOSITORY of ARTS. 101. Strand, 1820.

Mathias Gabriel Lory

View of the Beautiful Island, 1811–19

Hand-coloured aquatint, 29 × 44.6 cm / 11½ × 17½ in
Private collection

On an island on Lake Maggiore, on the south side of the Alps, lies one of Italy's most famous gardens. During the seventeenth century, the wealthy Borromeo family built a sumptuous palace on Isola Bella, 'the beautiful island', and surrounded it with an elaborate example of Baroque landscaping. The undisputed highlight of the garden is a spectacular set of ten scenic terraces crowned by the Teatro Massimo (great theatre), adorned with statues, obelisks and fountains. The design follows the tradition of the classical Italian garden, according to which the presence of the divine is manifested through the perfection of geometric form, carefully calibrated proportion and modular repetition. The planting is arranged so as to produce spectacular blooming events throughout the growing season. Of note are the camphor trees and the gigantic gunneras, with leaves more than 2 metres (7 ft) wide, as well as the white-blooming *Halesia diptera*, originally from the southern coasts of the United States – a plant that does not grow anywhere else in Italy. The gardens of Isola Bella boast a substantial collection of azaleas that in May attract tourists from all over the world. Thanks to the mild climate, the most diverse species of palm manage to coexist with Californian sequoias and Mexican pines, while collections of wisteria and rare *pittosporums* contrast with shady forests of rhododendrons, camellias and magnolias. The gardens are also renowned for the charming flock of white peacocks that freely roams the grounds.

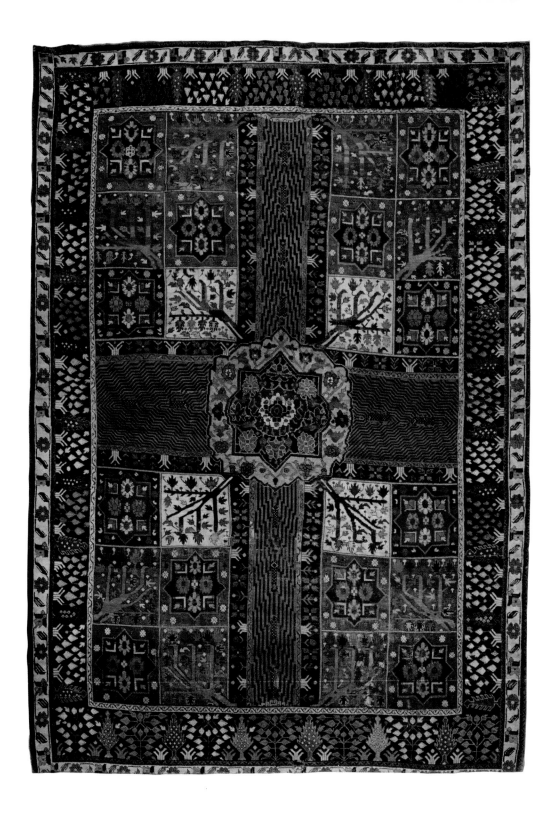

Anonymous

Garden carpet, 1700–1800

Hand-knotted woollen pile, on cotton warp and woollen weft,
approx. 3.8 × 2.6 m / 12 ft 5 in × 8 ft 7 in
Victoria and Albert Museum, London

Taking the form of a classical Persian garden, or *chahar bagh*, this elaborate carpet depicts the characteristic four quadrants separated by two channels of water intersecting at right angles. Richly planted with flowers behind a frequently humble exterior, the *chahar bagh* was a haven of beauty in a harsh land. The inner border of the carpet forms the 'wall' around the garden, on which fruit trees would have been trained, and the narrow outer border may represent meadows outside the enclosure. Stylized cypresses and pines, oaks and maples cast welcome shade. From the central decorative medallion extend four schematic trees on a pale background, with colourful leaves at the ends of the branches; in other panels, blue rills indicate canals of water elsewhere in the garden, perhaps for irrigation. The remaining squares are filled with formal flower beds, and stylized fish swim in the main channels. Gardens were deeply appreciated in the dry, barren landscapes of West Asia. They were celebrated by poets and painted by artists, and they were not confined to the wealthy elite; common people planted gardens along rivers and streams, while aristocrats incorporated irrigation systems to create walled 'paradise gardens'. This carpet, later restored, was originally made at the end of Safavid rule in Iran (1501–1736), which was known for its patronage of the arts and architecture, including gardens. The earliest and best examples of garden carpets date to the late sixteenth and early seventeenth centuries, becoming more stylized and abstract towards the end of the seventeenth century and into the eighteenth.

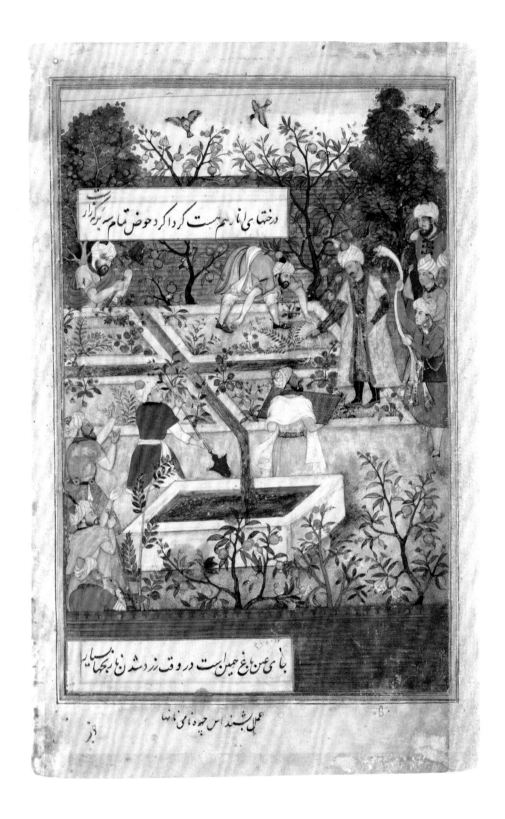

Nanha and Bishndas

Babur's Garden, from the *Baburnama*, c.1590

Opaque watercolour on paper, 21.7 × 14.3 cm / 8½ × 5½ in
Victoria and Albert Museum, London

Dressed in brilliant yellow robes, the Mughal emperor Babur stands amid his Garden of Fidelity (Bagh-e Vafa), directing the laying out of the lush space. The garden was created in Kabul, Afghanistan, from 1508 to 1509 to honour the loyalty of Babur's inner circle of nobles following an earlier rebellion. In the *Baburnama*, Babur's entertaining and startlingly frank memoir, the emperor describes oranges, citrons and pomegranates growing in abundance, and says that the plantains brought and planted there 'did very well'. Babur also notes that 'the garden lies high, has running water close at hand, and has a mild winter climate. In the middle, a mill stream flows past a hill on which are four garden plots. In the southwest part is a reservoir ... the whole encircled by a trefoil meadow. This is the best part of the garden, a beautiful sight when the oranges take colour.' In this illustration, the servant next to Babur holds a white sash, a symbol of royalty, while an assistant looks over the squared red planning grid. The Bagh-e Vafa was the first of many gardens created in India and Afghanistan by Babur, who was a passionate plantsman. The form is that of a Persian *chahar bagh*, meaning 'four gardens': an enclosed, square or rectangular space divided into four beds by perpendicular rills intersecting at right angles and fed by a central water source. The garden was enclosed within a high brick wall and laid out along strict geometric lines, as is indicated by string markers being used by the gardeners at the top to make sure the beds are straight.

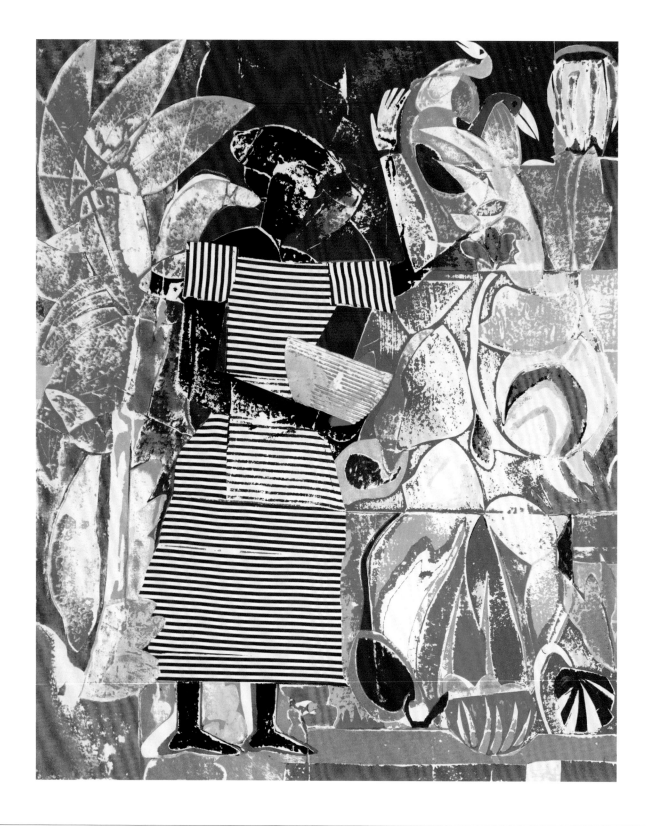

Romare Bearden

In the Garden, from *Prevalence of Ritual*, 1974 Screenprint, 91.4 × 73.7 cm / 36 × 29 in

Combining a multi-hued patchwork of textures, patterns, shapes and coloured fragments, this semi-abstract screenprint depicts a Black woman tending a garden filled with exotic plants. Two birds at the top of the composition observe the gardener, who wears a red-and-white-striped dress and raises her hand as if gesturing to an unseen figure. American artist Romare Bearden (1911–1988) created this print for his 1974 portfolio *Prevalence of Ritual*, a series of five prints inspired by episodes from Greek mythology

and the Bible interpreted through the lens of his distinctive Southern sensibility. Bearden was a prolific artist who experimented with many different media and styles but is best known for his evocative collages of Black life in the United States. Integrating magazine clippings, painted papers and ephemera, his works draw on personal memories, observations and allusions to art history, mythology and religion. In this print, the garden alludes to the Garden of Eden, but Eve appears in the guise of a 'conjure' woman,

a folkloric figure remembered from Bearden's childhood visits to his family in North Carolina and familiar to many Black Americans, especially those raised in rural Southern states in the early twentieth century. The conjure woman, both feared and admired for her magical, spiritual and healing abilities, appeared frequently in Bearden's works in the 1960s and '70s. She stands here powerful amid the garden plants and herbs that are the raw materials for her work.

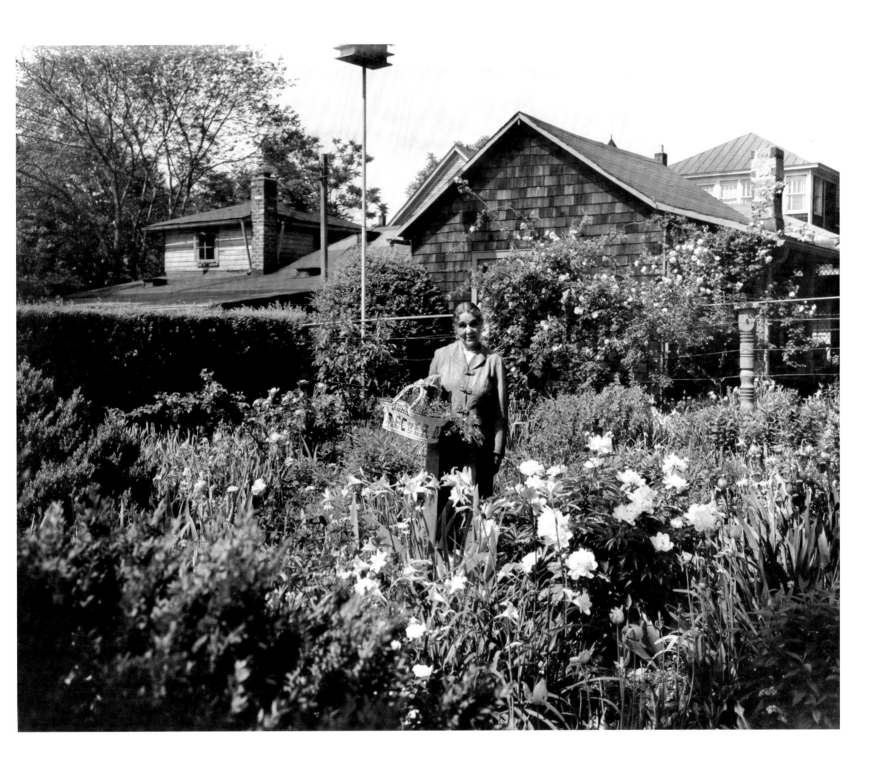

Richard 'Jimmie' Ray

Anne Spencer in Her Garden, 1947

Photograph, dimensions variable
Anne Spencer House and Garden Museum,
Lynchburg, Virginia

One of the most important literary figures in American history, Anne Spencer was a Harlem Renaissance poet, civil rights activist, librarian, feminist and gardener. The first Black woman poet published in *The Norton Anthology of Modern Poetry* (1973), Spencer centred her life and work around her prized garden – it was her writing studio and her muse. In 1903 she and her husband, Edward, built their Queen Anne-style house in Lynchburg, Virginia, and it is now a museum and public garden listed in the National Register of Historic

Places. Anne designed and meticulously maintained the garden. It was her creative sanctuary as well as a legendary salon for the many Harlem Renaissance luminaries who visited. In this black-and-white photo by local photographer Richard 'Jimmie' Ray (1910–1983), Spencer stands in the middle of her garden, holding a basket of freshly picked flowers. She is surrounded by the numerous heritage roses that she planted. Behind her, a purple martin birdhouse towers atop a pole. Densely planted, with lush, colourful flower beds,

Spencer's garden was primarily a place of beauty and respite, though she did keep a small vegetable garden too. Bold combinations of wild-collected plants, heirloom cultivars, carefully clipped hedges, and native trees and shrubs, such as dogwood and juniper, are separated by grassy pathways. Spencer incorporated a wisteria-covered pergola and a grape arbour made using salvaged architectural elements. As her expression in this photograph makes clear, the garden that was so integral to her life and work was where she wanted to be.

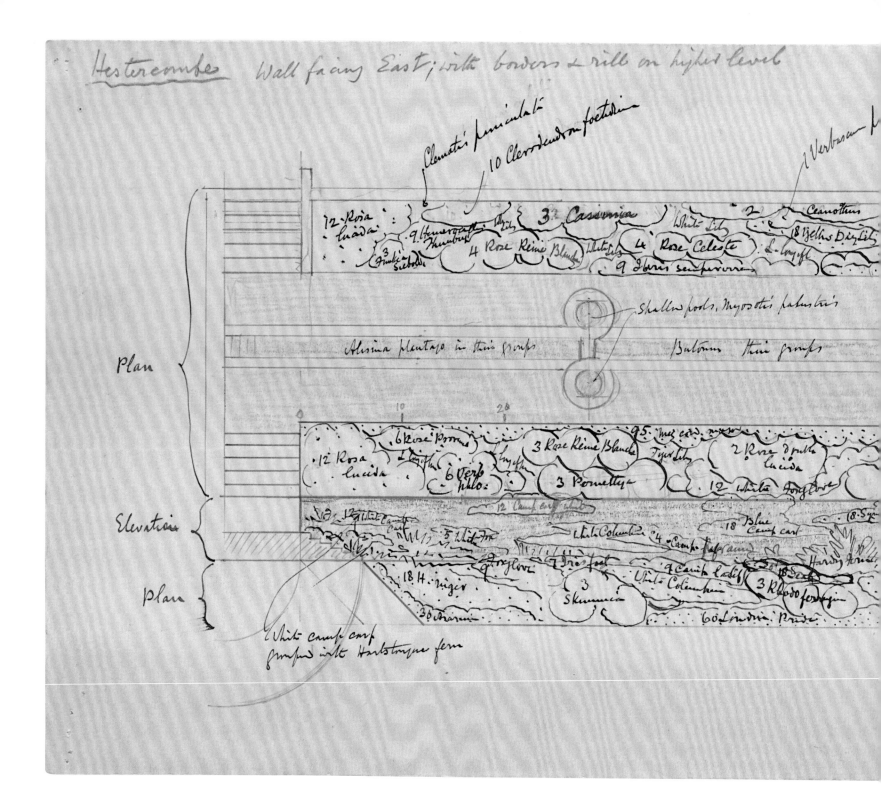

Hestercombes Wall facing East; with borders & rill on higher level

Plan

Elevation

Plan

60

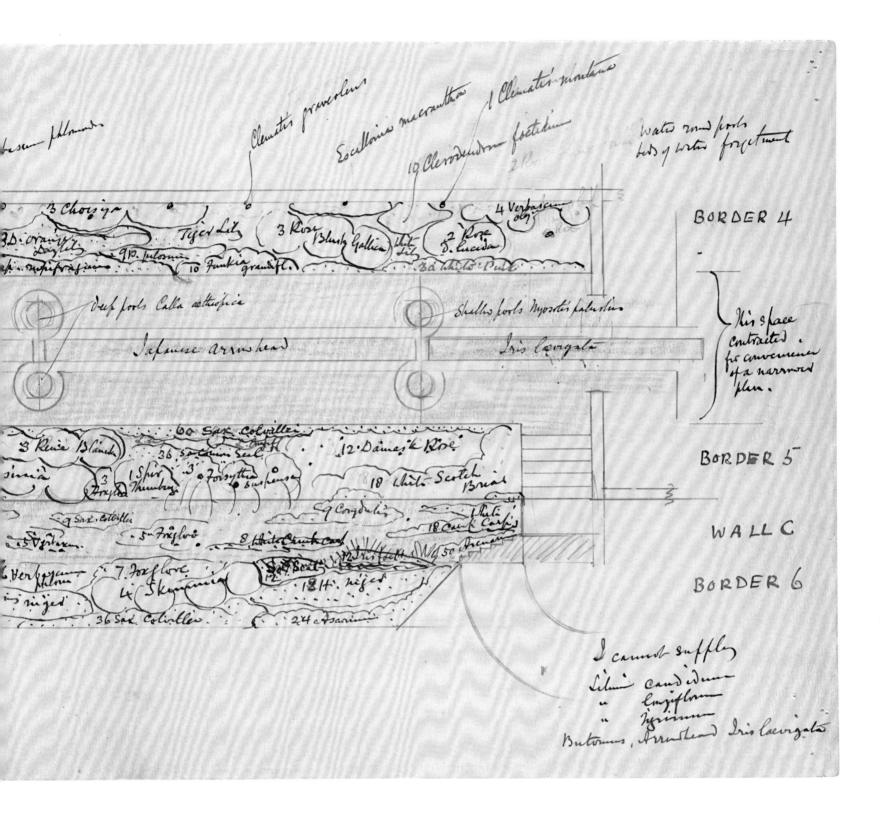

The plan contains numerous handwritten plant labels including:
Verbascum phlomoides, Clematis grandiflora, Escallonia macrantha, Clematis montana, Clerodendron foetidum, Water round pools beds of water forget-me-not, 3 Choisya, Tiger Lily, 3 Rose Blush Gallica, 4 Verbascum olympicum, Orange Daylily, 9 P. Tulensis, 10 Funkia grandifl., 2 Rose R. lucida, 3a White Pink, deep pools Calla aethiopica, Japanese Arrowhead, Shallow pools Myosotis palustris, Iris laevigata, 3 Rosa Blanda, 60 Sax. Colvillei, 12 Damask Rose, 36 Solomon's Seal, 1 Spiraea Thunbergi, 3 Forsythia suspensa, 18 White Scotch Briar, 9 Sax. Colvillei, 5 Foxglove, 8 White Chunk Card, 9 Corydalis, 18 Cauk Card, 7 Foxglove, 4 Skimmia, Iris filifolia, 50 Anemone, 18 H. niger, 36 Sax. Colvillei, 24 Asarum

BORDER 4

This space contracted for convenience of a narrower plan.

BORDER 5

WALL C

BORDER 6

I cannot supply Lilium candidum, " longiflorum, " tigrinum, Butomus, Arrowhead, Iris laevigata

Gertrude Jekyll

Planting Scheme for West Rill, Hestercombe, 1904

Ink and pencil on paper, 22.2 × 53.3 cm / 8¾ × 21 in
University of California, Berkeley

The enchanting gardens at Hestercombe House are a superb example of the dynamic collaboration between two brilliant artists: groundbreaking garden designer Gertrude Jekyll (1843–1932) and architect Sir Edwin Lutyens. Hestercombe Gardens embraces the sensibilities of the Arts and Crafts movement, with its emphasis on fine craftsmanship and quality workmanship. Like their other projects, Jekyll's detailed planting scheme complements and softens Lutyens' manmade hardscapes. Plant selections are strategically positioned among herbaceous borders along two long, narrow rills, documented precisely in this plan. Trained as a painter, the multi-talented Jekyll turned to gardening in midlife when her eyesight began to fail. Trading paints for plants, she created impressionistic tableaus with 'drifts' of flowers. Using colour theory, she contrasts and harmonizes to horticultural perfection. Jekyll created hundreds of imaginative, artistic gardens that were the antithesis of the Victorian aesthetic. Eschewing formal garden beds with their geometric shapes and blocks of uniform colour, she instead created gardens with pleasing palettes and used plants of varying texture and height, accentuating both foliage and flowers for year-round interest. Here, the rill itself, contains such aquatic plants as iris and arrowhead. Running alongside it are old-fashioned roses, phlox, foxglove, gaura, hellebore and more. White flowers and silver-leaved plants, such as stachys and lavender, balance painterly brushstrokes, demonstrating why Jekyll's design style has had an everlasting influence on generations of gardeners.

"I wish it to be framed, as much as may be, to a naturall wildnesse."
LORD BACON.

THE WILD GARDEN

OR,

OUR GROVES & SHRUBBERIES

MADE BEAUTIFUL

BY THE NATURALIZATION OF HARDY EXOTIC PLANTS:

WITH A CHAPTER

ON THE GARDEN OF BRITISH WILD FLOWERS.

BY W. ROBINSON,

AUTHOR OF

"ALPINE FLOWERS FOR ENGLISH GARDENS," "THE PARKS, PROMENADES,
AND GARDENS OF PARIS," ETC.

LONDON:
JOHN MURRAY, ALBEMARLE STREET.
1870.

Alfred Parsons and William Robinson

The Wild Garden, 1870

Printed book, each page 23 × 15 cm / 9 × 6 in
Private collection

Revolutionizing gardening at the start of the twentieth century, Irish-born garden designer and journalist William Robinson (1838–1935) wrote *The Wild Garden* – with illustrations by fellow garden designer Alfred Parsons (1847–1920) – in 1870 as a reaction to the High Victorian fashion for brightly coloured bedding plants in regimented displays. Robinson's philosophy was to enhance the natural landscape informally with hardy, native plants in what he termed 'wild' gardens. Initially trained in private gardens and at Glasnevin Botanic Gardens in Dublin, Robinson then moved to England and in the late 1860s visited Paris, where he was particularly taken with the fashion for subtropical planting and subsequently wrote two books about French gardens and another on subtropical gardening. Robinson launched a weekly journal, *The Garden*, in 1871, and his best-known and highly influential book *The English Flower Garden* was published in 1883. Financial success as a writer enabled him to purchase Gravetye Manor in West Sussex, where he applied his wild garden philosophy and used drifts of shrubbery, bulbs, hardy small plants and ground covers to soften the transition from the garden around the house to the wider landscape. Robinson was outspoken and was said to be hot-tempered, but the influence of his writing earned him recognition as the 'Father of the English Flower Garden'. While that may be his most popular contribution, in the context of garden history, *The Wild Garden* was his most radical.

Helen Allingham

South Border at Munstead Wood, 1900–3

Watercolour, 40.5 × 29 cm / 16 × 11½ in
Garden Museum, London

The tranquil beauty of an English country garden in high summer is captured in this detailed portrait of a corner of the garden at Munstead Wood, a property in Godalming, Surrey, which was at the time home to the famous garden designer Gertrude Jekyll (see p.61). Designed by Edwin Lutyens and completed in 1897, Munstead Wood is one of the finest examples of Early Modern English country houses, and both house and garden are listed Grade I. Jekyll lived at the house until her death in 1932 and is buried nearby at Busbridge church.

This is one of a series of seven works British artist Helen Allingham (1848–1926) painted at Munstead Wood, depicting different combinations of flowering plants. Allingham was an accomplished artist, well known for her considerable output of paintings that included children, country cottages, rural scenes and gardens. The South Border shown here displays a range of flowers set against an old wall overhung by creepers, with tall trees beyond. Yuccas, with their spikes of pale flowers, and tall hollyhocks with red and pink blossoms tower

above an array of other species including lavender, lilies, marigolds, nasturtiums and pelargoniums. The overall effect is a multicoloured bed planted in a highly artistic manner, a characteristic of Jekyll's approach to garden design, with pale, cool-coloured flowers at each end building to hot reds and yellows at the centre. Other areas of the garden at Munstead Wood included a shady North Court with a water tank, a sunken Rock Garden, and Spring and Summer Gardens with displays of tulips, irises and peonies.

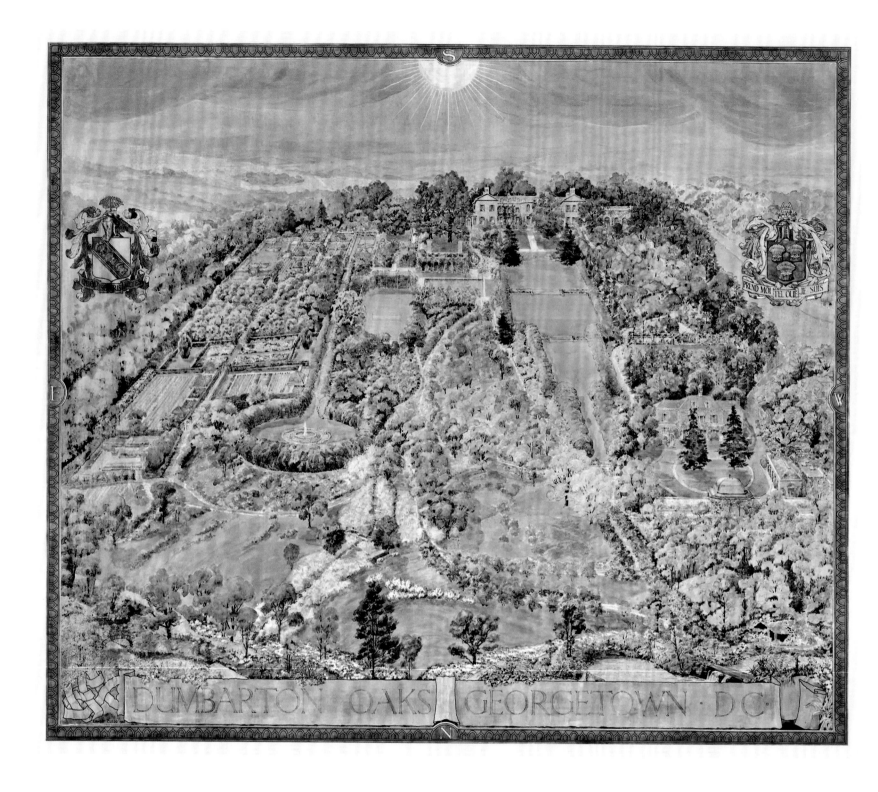

Ernest Clegg

Dumbarton Oaks, Topographical Map, 1935

Coloured ink on paper on board, 1.2 × 1.4 m / 3 ft 10 in × 4 ft 7 in
Dumbarton Oaks House Collection, Washington DC

Dumbarton Oaks, on the slopes of Georgetown in Washington DC, has a number of historical associations: in 1944 the house was the location for the international conference that led to the creation of the United Nations as a body to resolve disputes without conflict; it also gave its name to a chamber concerto by Igor Stravinsky, commissioned by American diplomat Robert Woods Bliss and his wife, Mildred, who lived in the house. Dumbarton Oaks is also arguably the finest garden design by American landscape architect Beatrix

Farrand. Commissioned by the Blisses following their acquisition of the 22-hectare (54-acre) estate in 1920, the garden was the result of nearly thirty years' close collaboration between Mildred and Farrand. It consists of a series of contrasting garden rooms joined by steps. The upper terraces reflect the formality of the house, but the planting becomes less formal lower down, with plantings of cherry, crab apple and forsythia. Visible to the left of centre is the serene Ellipse Garden with its fountain, which is now surrounded

by a hedge of pleached American hornbeam. This drawing, prepared in 1935 by British cartographer Ernest Costain Clegg (1876–1954) to hang above a fireplace in the house, provided a bird's-eye view of the rapidly maturing garden, aided by specially commissioned aerial photographs. Clegg had trained at the Birmingham School of Art and worked as a jewellery designer before making his name in the United States for his combination of mapping and whimsical illustration, as seen here.

Gerard Gauci

Public Gardens Stamp Series, 1991

Offset lithograph, each 4 × 3 cm / 1½ × 1 in
Private collection

An array of colourful blooms, finely manicured flower beds and neatly trimmed lawns adorned Canadians' mail in 1991, when this series of 40-cent postage stamps was released to honour the country's most celebrated public gardens. Illustrated by Gerard Gauci (b. 1959), each stamp depicts a different garden and associated flowers. Himalayan blue poppies represent the Butchart Gardens on Vancouver Island, where the attractive flower has grown since the 1920s. Founded in 1904 in a former limestone quarry, the garden boasts more than 900 plant varieties spread over more than 22 hectares (55 acres) of landscaped lawns and beds. The Royal Botanical Gardens in Hamilton, Ontario, was established in the 1940s as Canada's answer to London's Kew Gardens, and now contains one of the world's most diverse lilac collections. Pictured with its Art Deco administration building, Montreal Botanical Gardens contains more than 22,000 species across 30 themed areas, including a magnificent Rose Garden with more than 10,000 varieties. The International Peace Garden opened in 1932 on the border between Canada and the United States as a symbol of goodwill between the two nations. On its stamp, beyond yellow chrysanthemums, a channel of water dividing colourful beds marks the border between Manitoba and North Dakota. The final stamp, not depicted here, portrays the Victorian-era splendour of Canada's oldest surviving public garden, Halifax Public Gardens in Nova Scotia, with pink rhododendrons and a bandstand, which is used for free public concerts during the summer.

Plate XXIX.

Flat Garden—Intermediary Style.

Josiah Conder

Flat Garden – Intermediary Style,
from *Landscape Gardening in Japan*,
second edition, 1912

Lithograph, 26.5 × 36.5 cm / 10½ × 14¼ in
Private collection

Until the late 1800s relatively few people outside Japan knew of the country's rich tradition of dry Zen gardens, stroll gardens and landscape gardens. This print comes from the book that effectively introduced Japanese gardens to the West, *Landscape Gardening in Japan* (1893) by British architect Josiah Conder (1852–1920). In this diagram, Conder explains the different types of stone displayed in a flat garden, from the Guardian Stone standing upright at the heart of the garden to the Label Stone in the foreground. Conder trained under Gothic Revival architect William Burges, becoming fascinated by the Japanese ornaments then arriving in British museums, which he saw as the contemporary equivalent of medieval craftsmanship. In 1877 Conder moved to Japan, where he taught architecture at the Imperial College of Engineering, Tokyo, and eventually became the first president of the Society of Japanese Architects. In addition to designing buildings, he became enthusiastic about Japanese gardens. *Landscape Gardening in Japan* was published in two volumes, the first – featured here – discussing such subjects as Japanese stone lanterns, fences and water features, illustrated by Conder himself, and the second volume containing photographs of famous Japanese gardens by photographer Kazumasu Ogawa. The book brought accurate information about Japanese garden style to the West for the first time, stimulating the fashion for Japanese gardens that flourished in the early twentieth century. Conder also wrote *The Flowers of Japan* (1891), introducing the rest of the world to *ikebana*, or Japanese flower arranging.

Jonas Wood

Japanese Garden 2, 2018

Oil and acrylic on canvas, 1.8 × 1.8 m / 6 × 6 ft
Private collection

With his highly recognizable bold, graphic style, internationally acclaimed American artist Jonas Wood (b. 1977) often uses plants and gardens as the subjects of his paintings. Flat and saturated colours are accentuated by textural patterns that bring vibrancy and freshness. In this painting, the artist explores the traditional theme of the Japanese garden. Recognizable in the foreground are three *niwaki* conifers – also known as 'cloud trees' because of their typical, sculptural pruning – which take many years to become ready for inclusion in a garden. Niwaki is an ancient Japanese tradition devoted to a conception of the garden as a site of harmonious balance designed for reflection and meditation. In line with this principle, the taller trees in the foreground are counterpointed by shorter, cloud-pruned bushes, probably Japanese holly (*Ilex crenata*), which are among the most popular in Japanese gardens. Wood's painting captures what is probably a *sansui*, or landscape, garden, which typically features hills or mounds in order to generate a sense of tranquillity and awe-inspiring balance. In Japanese, *san* (山) means mountain and *sui* (水) means water. A quintessential feature of the Japanese garden, a pond or small lake symbolizes renewal, calm and continuity. Sansui gardens were inspired by Chinese *Sansui-ga* paintings depicting idealized landscapes with mountains and lakes that became particularly popular with the new samurai class of the fourteenth century.

FIG. 170.—SUMMERHOUSE AT MONTACUTE.

Thomas Hayton Mawson

Summerhouse at Montacute, from *The Art & Craft of Garden Making*, fourth edition, 1912

Lithograph, 25.4 × 35.5 cm / 10 × 14 in
University of California Libraries

Perfectly clipped topiary and close-cropped lawns sit alongside wisteria spilling over a gateway and a border filled with flowering plants arranged in clumps of bright colour. These features at Montacute House in Somerset, southern England, were typical of the garden designs of Thomas Hayton Mawson (1861–1933), a builder turned nurseryman who, with his brothers, established Lakeland Nurseries in Windermere in 1884. Thomas was responsible for the landscape design business and his first commission was a local property, Graythwaite Hall. By 1900 he had left Lakeland Nurseries to pursue a solo career, and that year he published *The Art & Craft of Garden Making*, from which this plate comes. The book went through five editions over the next twenty-six years and doubled as an advertisement for further commissions during the last great period of country-house garden-making in Britain in the years immediately before World War I, when his contemporaries included Gertrude Jekyll (see p.61), Edwin Lutyens, Harold Peto and Henry Avray Tipping. Highly prolific, Mawson was influenced by Tudor and Renaissance gardens and used architectural detail, axial symmetry and formal terraces adjacent to the main house. Typical features included ornamental tennis or croquet lawns, pool gardens, lily and rose gardens, Japanese gardens, herbaceous borders, timber pergolas with stone pillars, sweeping steps and stylish seats. While his gardens were formal in structure, true to his nurseryman origins, Mawson filled them with elaborate topiary and colourful plants.

John Glover

A View of the Artist's House and Garden,
in Mills Plains, Van Diemen's Land, 1835

Oil on canvas, 76.4 × 114.4 cm / 30 × 45 in
Art Gallery of South Australia, Adelaide

Under the hot Australian sun, an English-inspired garden flourishes with shrubs, flowers and herbs amid an Antipodean landscape. The garden belonged to English painter John Glover (1767–1849) and was situated on his farm at Mill Plains on the northern slope of Ben Lomond in northeast Van Diemen's Land, now Tasmania. Glover painted this luminous view of his garden, which also features his wooden studio and shingle-roofed farmhouse – named Patterdale, after the English village in Cumbria where he once lived – just four

years after migrating to Australia with his family in 1831, at the age of sixty-three. He carried many of the garden's plants, and even some English songbirds, with him on the ship from England, where he had been a prolific painter of picturesque landscapes in oil and watercolour. The many works he produced in Tasmania, depicting the local scenery in a naturalistic style, were influential on younger generations of artists, leading Glover to be dubbed 'the father of Australian landscape painting'. Glover's carefully maintained garden

with its orderly paths contrasts with the natural bushland outside its perimeter, lush with manna gum trees. The artist's colonial attitude to the new land in his possession is reflected in his desire both to echo his homeland and to impose order and rationality on what he perceived as untamed wilderness. More than 1,600 hectares (4,000 acres) of his former property are now heritage listed, but attempts to restore the garden have proved challenging, since some plants he introduced are now considered invasive and are banned in Australia.

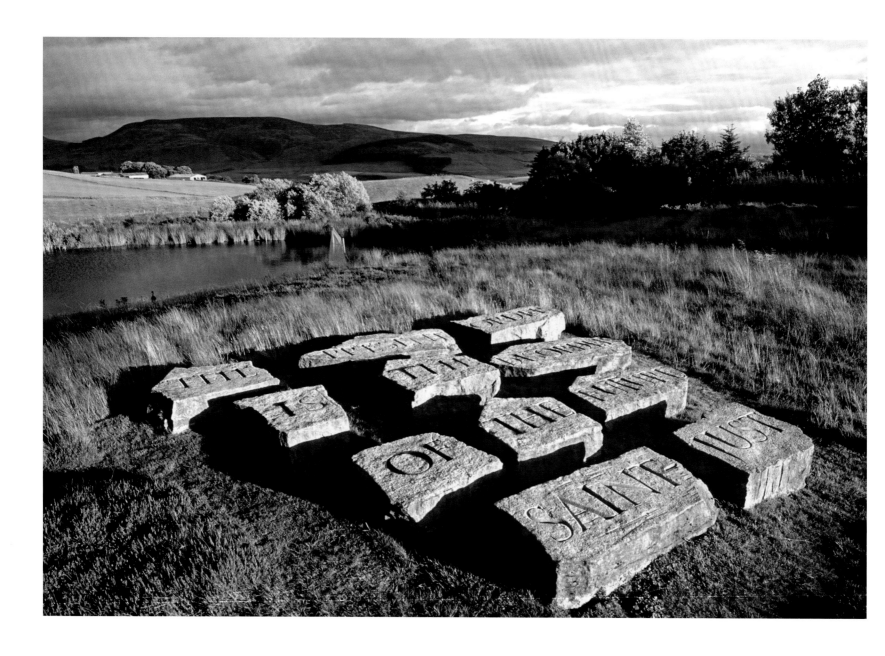

Ian Hamilton Finlay

The Present Order Is the Disorder of the Future – Saint-Just, 1983

Carved granite installation
Little Sparta, Dunsyre, Scotland

On the bank of Lochan Eck, Scotland, granite slabs proudly proclaim, 'The Present Order Is the Disorder of the Future', a quotation attributed to the French revolutionary Antoine de Saint-Just. Words populate the gardens designed by Scottish artist and poet Ian Hamilton Finlay (1925–2006), and, as shown here, the archetypal Finlay device of using large blocks of quarried stone incised with words or symbols is integral to Little Sparta, the iconic garden he built on the top of a gentle rise in the Pentland Hills near Edinburgh – and his life's

artwork. Garden art, garden poetics and evocations of Arcady were hallmarks of Finlay's garden design. His priorities were ideas, imagination and humour, and the intellectual concepts embodied in the garden offered many interpretations. Little Sparta is one of the most original gardens of the late twentieth century, and to visit is akin to making a pilgrimage. Finlay, a masterful handler of space and scale, once asserted that 'Superior gardens are composed of Glooms and Solitudes and not of plants and trees.' The impression of being embraced

by green 'glooms' in his gardens is visceral and contrasts with the airy light of more open expanses. His manipulation of vegetation frames discreet moments for contemplation, while narrow pathways concentrate the eye on the poetics of the place and individual sculptural elements. At Little Sparta, paths lead the visitor past monuments, through thick green refuges and over bridges to burst upon the glorious view over the Saint-Just stones, invoking an Arcadian landscape in an entirely new way.

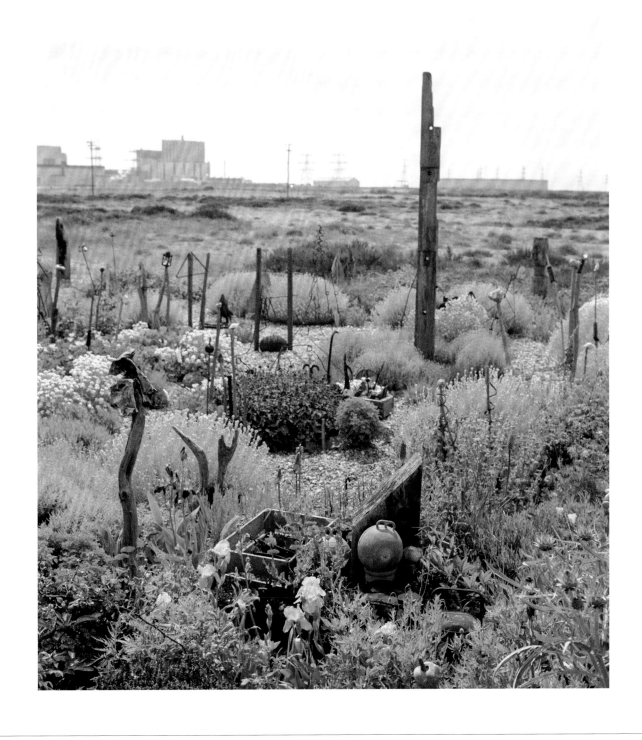

Howard Sooley

Derek Jarman's Prospect Cottage, 1993

Photograph, dimensions variable

Pieces of driftwood and debris from fishing boats provide a framework for one of Britain's most celebrated – and most distinctive – gardens, created by filmmaker Derek Jarman at Prospect Cottage. Jarman's tiny wooden hut sits on the bleak shingle headland at Dungeness in Kent, the site of the nuclear power station rising in the background of this image by British photographer Howard Sooley (b. 1963). Jarman bought the property in 1987, and over a period of eight years gathered found objects and planted species that could withstand the salty winds, low rainfall and beating sun. Some plants were native to the headland, including purple sea kale, green broom and sea pea, but others were introduced by Jarman for colour, including marigolds, irises and Californian poppies. Pictured here is the garden behind the cottage; the front has more formal elements, including two stone circles and an oblong made from concentric flints and bricks, inspired by Jarman's interest in ley lines. The garden, which has no borders and simply fades into the surrounding landscape, became a form of therapy for Jarman after he was diagnosed as HIV positive in 1986. Sooley, whose own plant addiction had begun with a pot of *Lilium regale*, was commissioned by *The Face* magazine to photograph Jarman in 1990, and for five years until Jarman's death became his photographer and gardener, chronicling the development of the unique space. Jarman described its creation as an act of love and grief for the friends he lost to AIDS. In *Modern Nature* he calls the garden 'a memorial, each circular bed and dial a true lover's knot'.

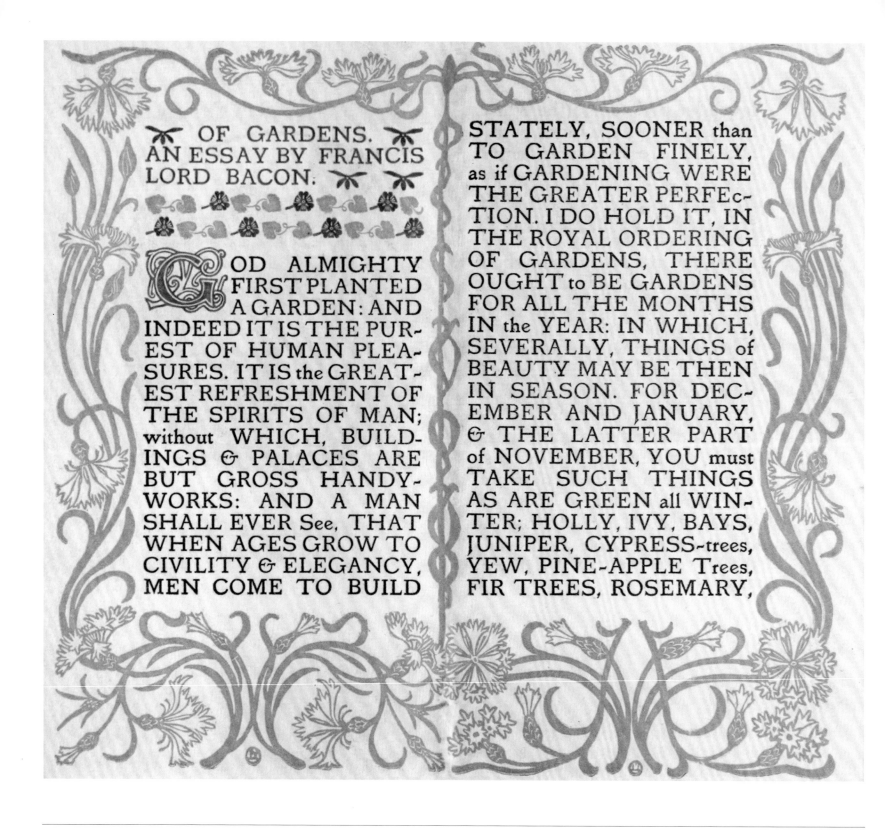

OF GARDENS.
AN ESSAY BY FRANCIS
LORD BACON.

GOD ALMIGHTY FIRST PLANTED A GARDEN: AND INDEED IT IS THE PUREST OF HUMAN PLEASURES. IT IS the GREATEST REFRESHMENT OF THE SPIRITS OF MAN; without WHICH, BUILDINGS & PALACES ARE BUT GROSS HANDYWORKS: AND A MAN SHALL EVER See, THAT WHEN AGES GROW TO CIVILITY & ELEGANCY, MEN COME TO BUILD

STATELY, SOONER than TO GARDEN FINELY, as if GARDENING WERE THE GREATER PERFECTION. I DO HOLD IT, IN THE ROYAL ORDERING OF GARDENS, THERE OUGHT to BE GARDENS FOR ALL THE MONTHS IN the YEAR: IN WHICH, SEVERALLY, THINGS of BEAUTY MAY BE THEN IN SEASON. FOR DECEMBER AND JANUARY, & THE LATTER PART of NOVEMBER, YOU must TAKE SUCH THINGS AS ARE GREEN all WINTER; HOLLY, IVY, BAYS, JUNIPER, CYPRESS-trees, YEW, PINE-APPLE Trees, FIR TREES, ROSEMARY,

Lucien Pissarro and Francis Bacon

Pages from *Of Gardens: An Essay*, 1902

Engraving, each page 18 × 10 cm / 7 × 4 in
University of Toronto Libraries, Canada

Protagonists of all shades have invoked the essay *Of Gardens* by Francis Bacon (1561–1626) since it was published in 1625, and it has enjoyed a transcendent appeal across the ages. Formal garden promoters of the late nineteenth century seized on Bacon's elements of regularity and order, while advocates of natural gardens, such as William Robinson (see p.62), praised his 'Naturall wildnesse'. In truth, the ideal garden Bacon described comprised a three-part design radiating in decreasing formality from a 'Greene' through a 'Maine Garden' to a

'Heath'. A British statesman, empirical thinker and influential author, Bacon was also an avid gardener and had some experience in garden design, particularly at his home in Twickenham. *Of Gardens*, and its pendant *Of Building*, stood apart from many of his philosophical and professional works, not least because the essays were in English rather than Latin. Bacon also elevated gardening and its attendant principles of horticulture to the status of literary text rather than a mere technical manual. It was republished many times, but few editions are as elegant

as this Eragny Press edition, with its plant-filled margins and hand lettering designed by Lucien Pissarro (1863–1944), son of painter Camille Pissarro (see p.93), and engraved by his British-born wife, Esther Bensusan. Founded in 1894, the Eragny Press was greatly influenced by the Kelmscott Press of British designer William Morris (see p.84). Although unmistakably influenced by Art Nouveau, the soul of this edition lies in the Arts and Crafts movement of the late nineteenth century, with its emphasis on handcraft and beauty.

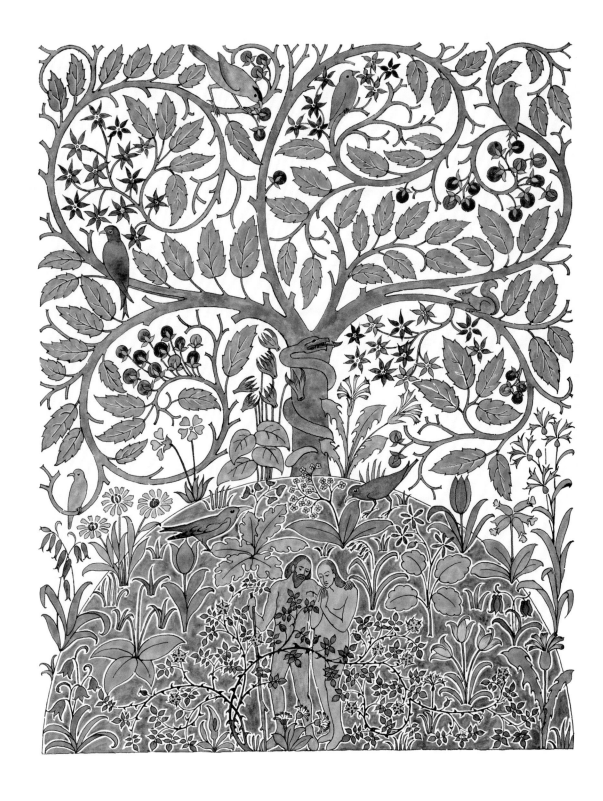

C.F.A. Voysey

The Garden of Eden, 1923

Pen and ink and watercolour on paper,
51.8 × 40.3 cm / 20⅜ in × 15¾ in
Victoria and Albert Museum, London

Best known as an Arts and Crafts architect, Charles Francis Annesley Voysey (1857–1941) used his talent for design to create Gesamtkunstwerke, or 'total works of art', by also designing the interiors, including furniture, fixtures and fittings, down to the smallest detail. In the early years of his career, Voysey's income depended almost entirely on wallpaper and textile designs. In 1883 he began designing wallpapers for Jeffrey & Co. – which produced William Morris's designs (see p.84) before he took production in-house – and became so prolific

that by 1896 *The Studio* magazine claimed that Voysey had 'become to wallpaper what Wellington was to the boot'. Voysey himself was a relative of the Duke of Wellington and hymn writer Charles Wesley; when his own father, also Charles, a maverick clergyman, was expelled from the Church of England for heresy, he simply founded a church of his own. Given such a heritage, it is inevitable that his son, richly blessed with independent thought and influenced by his Christian faith, would aim to create his own nature-inspired paradise on Earth.

Unlike Jan Brueghel the Elder's fauna-filled idyll, Voysey's Eden in this design for a wall hanging depicts a garden filled with delicate wildflowers, both British natives and introduced. He eschews the traditional apple of temptation for the red fruit of woody nightshade, with dainty tulips, bluebells, cornflowers, cowslips and cyclamen decorating the ground below. The only sinister elements in this paradise are the serpent lying in wait and the sinuous, thorny barrier of *Rosa foetida*, its thorns and odour a menacing portent of the decline after the fall.

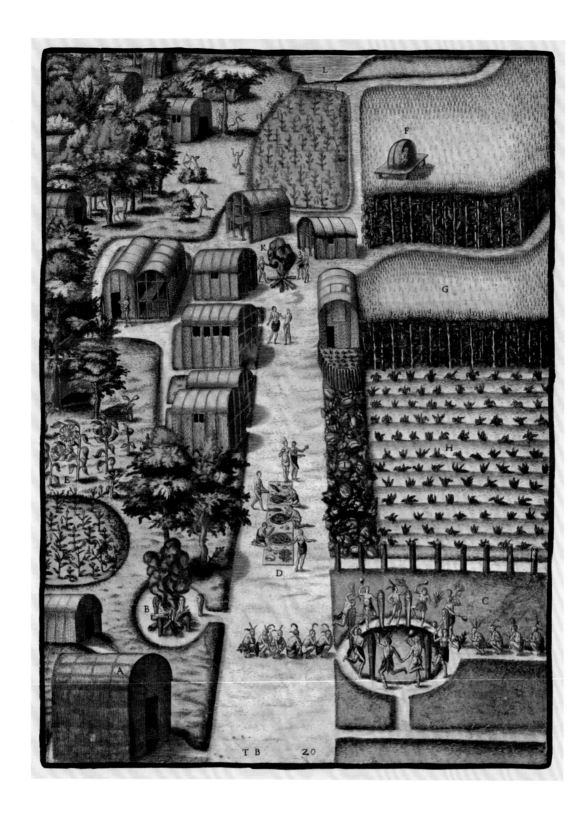

Theodor de Bry

Secotan, an American Indian Community in North Carolina, 1590

Hand-coloured engraving, 32 × 22 cm / 12½ × 8½ in
University of North Carolina at Chapel Hill Library

This scene of a well-ordered village was one of the first Western representations of farming and cultivation among the Native Americans encountered by early English colonizers who landed in North Carolina in 1585. The English met the Secotans, who lived in several communities near the shore – the location in 1590 of the failed colony at Roanoke, an offshore island. This coloured engraving by Theodor de Bry (1528–1598), a prolific engraver, goldsmith and publisher, was based on a first-hand drawing by artist-explorer

John White and notes by Thomas Hariot, who had learned the Algonquian language of the North Carolina groups. It was included in Hariot's *A Brief and True Report of the Newfound Land of Virginia* (1588), and de Bry used Hariot's descriptions to add White's original observations of a field of tobacco in the top centre and pumpkins to the left of the cornfield. Secotans take part in a dance ceremony in the lower part of the illustration, while at the top others are busy hunting. Although not a faithful depiction of the

Secotans or their life and customs, the illustration foregrounds the importance agricultural practices played in Indigenous culture. Corn was traditionally not just a staple of the diet, but also a sacred plant – a symbol of fertility. Similarly, tobacco was considered a divine gift, and was used for ceremonial and medicinal purposes. It is also believed that the pumpkin patch seen here might be the very first depicted in the history of the United States.

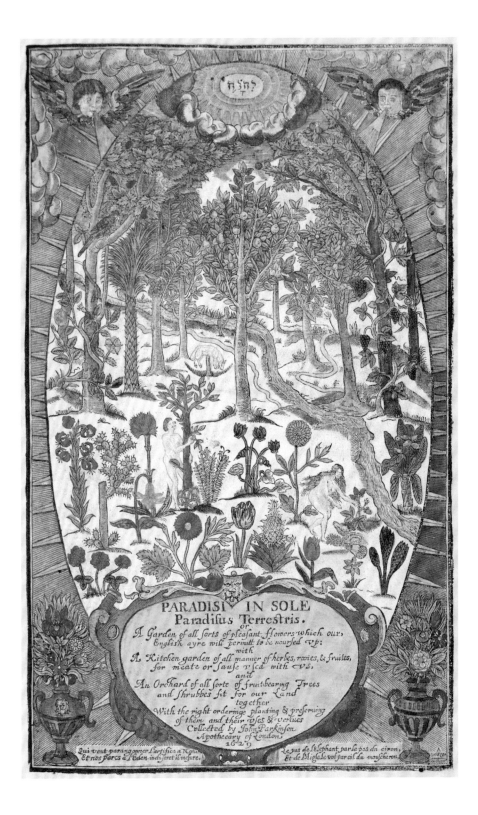

John Parkinson and Christopher Switzer

Title page of *Paradisi in sole paradisus terrestris*, 1629

Hand-coloured woodcut, 35.8 × 22.6 cm / 14⅛ × 8⅞ in
Oak Spring Garden Foundation, Upperville, Virginia

Published in 1629, *Paradisi in sole paradisus terrestris* by English florist, apothecary and gardener John Parkinson (1567–1650) is among the earliest English books devoted to horticulture, a venerated folio embracing plants for 'a garden of delight and pleasure'. The Edenic imagery of the woodcut title page, attributed to Christopher Switzer (active 1593–1611), encapsulates the character of this work and, with Latin as a universal language of botany, the punning cosmographical eponymy of the title's literal translation – 'park in

sun's earthly garden' – was presumably understood by many of the book's readers. In his introductory epistle, Parkinson explains that he has 'selected and set forth a Garden of all the chiefest for choyce, and fairest for shew, from among all the seuerall Tribes and Kindreds of Natures beauty'. This included almost a thousand plants available in England, a mix of local and introduced species, most to be found in the author's own garden in London's Long Acre. Spanning the flower garden, kitchen garden and orchard, the work

derives much of its charm from the author's knowledgeable observations and evident love of gardens, coupled with full-page woodcuts of the plants being described. Parkinson was also a skilled botanist, whose *Paradisi* was followed in 1640 by *Theatrum botanicum*, one of the last of the great English herbals. His books, especially *Paradisi*, constitute an intimate portrait of early seventeenth-century English gardens, allowing today's readers to rejoice in the beauty of their plants and the horticultural skill of their maintenance.

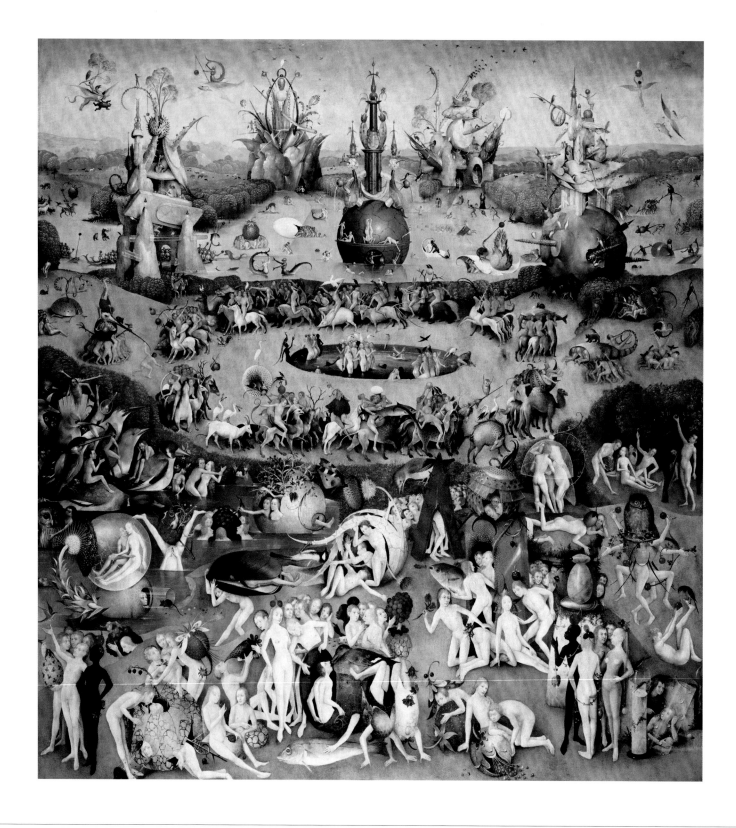

Hieronymus Bosch

Central panel of *The Garden of Earthly Delights*, 1490–1500

Oil on oak panel, triptych, central panel 1.9 × 1.7 m / 6 ft 3 in × 5 ft 6 in; wings each 1.9 × 0.8 m / 6 ft 3 in × 2 ft 6 in
Museo del Prado, Madrid

At the centre of this fantastical triptych, a lush garden filled with birds, animals and fish has become a playground for hordes of amorous men and women, who cavort naked in their verdant surroundings. Brimming with religious symbolism, the complex painting by Netherlandish master Hieronymus Bosch (c.1450–1516) takes as its theme the sin of lust and its dire consequences. The mythical narrative begins on the left, where Adam and Eve are depicted in the Garden of Eden, before eating of the forbidden fruit

that allowed sin into the world. In the middle panel, carnal passion has corrupted the paradisiacal garden, subverting God's mandate to 'be fruitful and multiply' in an orgy of sensuality. The inclusion of flowers, birds and a fountain alludes to the sensual imagery of the medieval French poem *The Romance of the Rose*, while other elements correspond to archaic Dutch figures of speech – 'to pluck fruit' was a euphemism for sex, while the word for bird, 'vogel', was the root of a double entendre for 'intercourse'. On the final

panel, the garden has disintegrated into a nightmarish vision of Hell, where burning buildings, tormented souls and malevolent demons illustrate the medieval conception of eternal punishment. On the triptych's outer faces, visible when the wings are closed, is an unassuming scene depicting the third day of creation, when God created land and plants. Painted in dull grey tones, it belies the explosion of colour within that no doubt impressed the guests of Henry III of Nassau, for whom the work was commissioned.

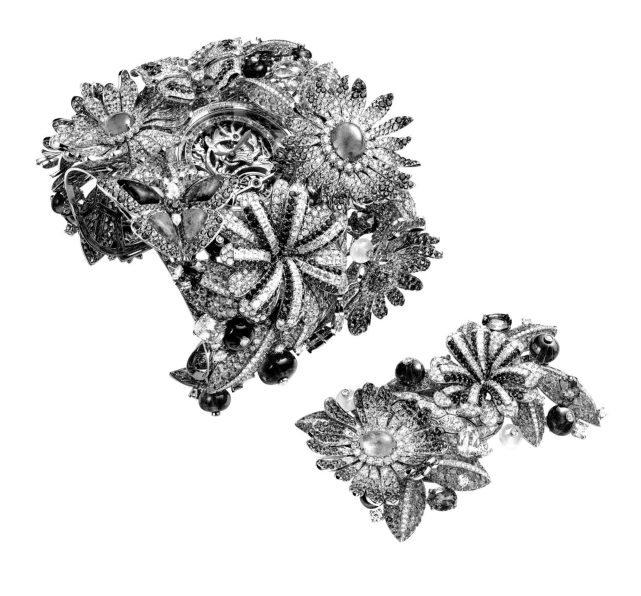

Bulgari

Giardino dell'Eden Tourbillon Cuff Watch, from *Bulgari Eden, The Garden of Wonders Collection*, 2022

Paraiba tourmalines, emeralds, garnets, pink tourmalines, opals, rubies, sapphires and diamonds, dimensions variable

In the hands of Italian jewellery house Bulgari, the Garden of Eden is reimagined and made solid by the exuberant use of glittering gems to create what at first sight looks like an arm piece but is in fact primarily a watch, albeit a highly ornate one. When he imagined the piece for Bulgari's 2022 watch collection, creative director Fabrizio Buonamassa Stigliani set about re-creating a fantastical garden complete with fluttering butterflies and, to underline the fact that this garden is the biblical Eden, a slippery snake. The Giardino

dell'Eden Tourbillon uses 6,500 gemstones to create a lush garden of vibrantly coloured flowers. This was achieved by using a wide variety of stones, from pavé-set diamonds to emeralds, opals, rubies and sapphires in hues of blue, pink, purple and yellow. Rare Paraiba tourmalines, notable for their intense blue shades, sit aside the slightly less rare pink tourmaline and far more familiar rock-crystal beads, together creating a profusion of blooms that might suggest a tropical garden as well as the biblical paradise. Jewelled

butterflies appear to move, being set on springs, while the snake is hidden beneath the flowers represented by the skeletonized watch dial. If such a timepiece might over-whelm the wearer's wrist, its upper part can be detached to be worn as a brooch. Since its founding in Rome in 1884, Bulgari has garnered a reputation for its exquisite craftsmanship and its use of extraordinary stones – as in the luminosity and extravagance of this highly personal fantasy of the Garden of Eden.

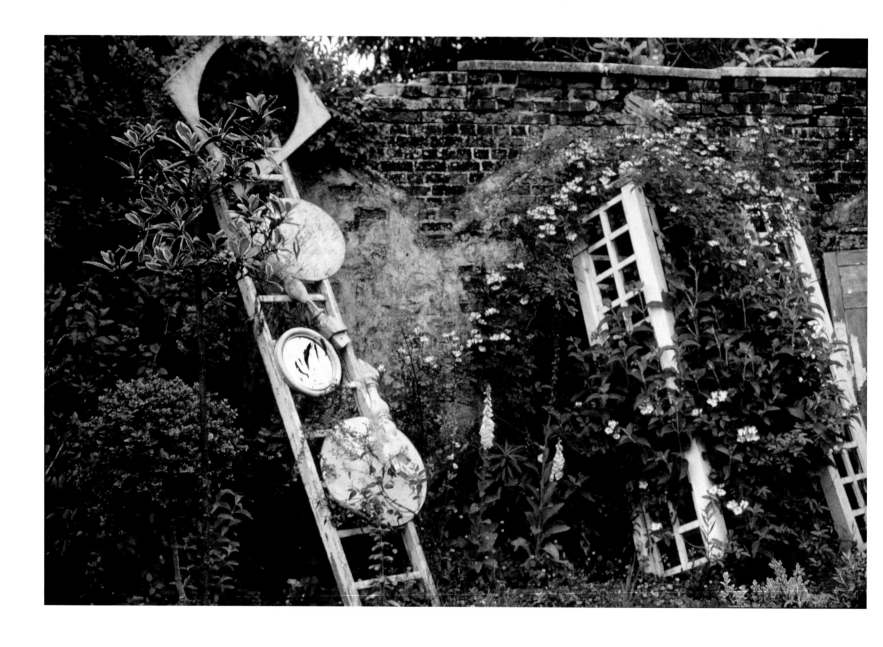

Ivan Hicks

The Garden in Mind, 1990

Photograph, dimensions variable

Taking its cue from the realm of dreams, obsessions and fantasies, every inch of this eccentric garden is permeated by the influence of surrealism. Bizarre objects interrupt the plantings: clockfaces hang from trees, typewriters become flower beds, rusty garden tools grow like reeds and dismembered mannequins litter the lawns. Created by British garden designer and landscape artist Ivan Hicks (b. 1944), the Garden in Mind was originally commissioned for the BBC television series *Dream Gardens*. Established within an abandoned walled garden on the Stansted Park estate in Hampshire, England, its design reflected Hicks's love of surrealism, which had been fostered early in his career while working in West Sussex as head gardener to Edward James, the British patron and collector of surrealist art, with whom he collaborated to create surrealist-inspired gardens in England, Italy and Mexico. At Stansted Park, some of the embellishments reference specific works of art, such as an upturned tuba, alluding to René Magritte's painting *The Discovery of Fire* (1935), which depicts the instrument on fire. Elsewhere, a stone fireplace is reminiscent of the open-air drawing room that Salvador Dalí (see p.79) designed for Carlos de Beistegui's Paris penthouse, while at the centre of the garden a towering 'cosmic tree' constructed from cable drums sits atop a large, spiralling mound, recalling similar structures in the works of Giorgio de Chirico. The Garden in Mind was open to the public, with the entry fees being donated to charity, but has since been replaced with a yew maze.

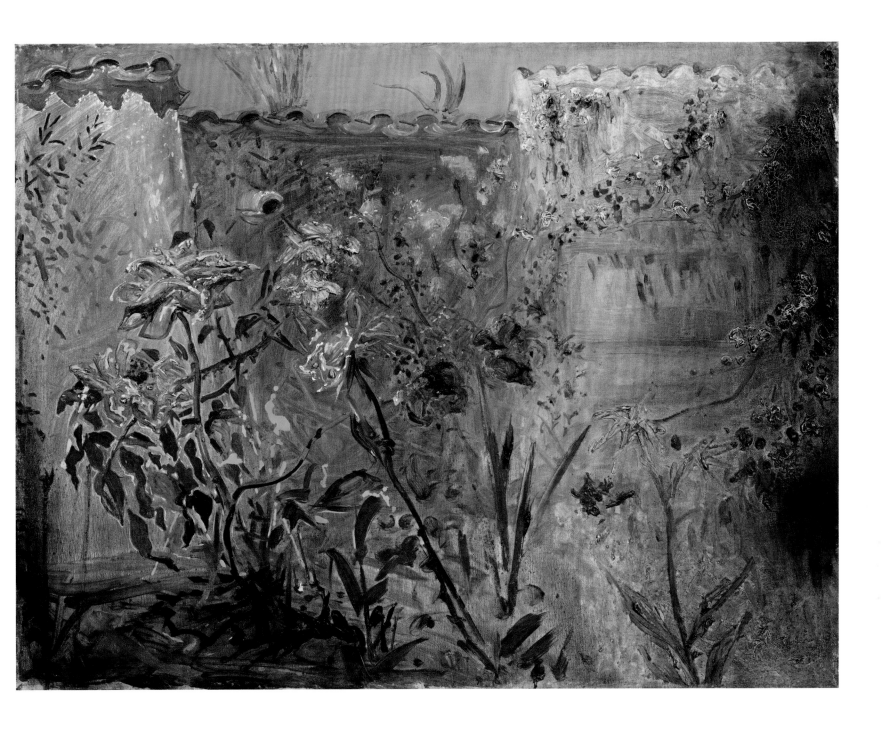

Salvador Dalí

Jardín de Port Lligat (Portlligat Garden), c.1968

Oil on canvas, 60 × 77.5 cm / 23½ × 30½ in
Fundació Gala-Salvador Dalí, Figueres, Girona, Spain

Abstract, almost otherworldly flowers with blooms of red, pink and yellow stand in stark contrast to the muted garden wall in the background, lush with fringes of flowering vines. The surrealist artist Salvador Dalí (1904–1989) is most often associated with the world of dreams and the darkest recesses of the human unconscious. However, much of his artistic inspiration was grounded in close observation of the natural world – including the plants and animals in his garden at Port Lligat, a small village located in a bay on Cap

de Creus peninsula on Spain's Costa Brava, where Dalí and his wife, Gala, moved in 1930, following a heated argument with the artist's father. In Port Lligat, the couple purchased a modest fisherman's hut and over the years transformed the simple building into a labyrinthine home oozing eccentricity and artistic flair. The surrounding garden became a safe oasis. Not only was it carefully landscaped to respect the original morphology and character of the area, but Dalí also turned it into a sculpture garden featuring many of his

best-known and most iconic works. Mediterranean staples, such as olive trees, agave and figs, framed a picturesque view of the bay. In this understated and unusually realistic painting, Dalí emphasizes the simplicity and privacy that the garden provided. The typical local architecture with its vernacular of white-painted walls topped by terracotta tiles provides a rustic and earthly backdrop to an intimate gathering of flowering shrubs.

**Paul Holmes and
Vita Sackville-West**

In Your Garden, 1951

Printed book, 20.5 × 13.5 cm / 8 × 5¼ in
Museum of English Rural Life, University of Reading, UK

Sissinghurst, the garden created on the site of a castle ruin by English writer Vita Sackville-West (1892–1962) and her diplomat husband Harold Nicolson, is a global phenomenon. Vita favoured the poetic and romantic, while Harold preferred the rational and classical, and together they created a memorable garden within what the estate agent described as 'a farmhouse with some picturesque ruins in the grounds'. Harold divided the garden into interconnecting 'rooms' and Vita painted them with flowers, sometimes with bold, lavishly coloured brushstrokes and sometimes with subtle, delicate dabs. The couple's friend, English architect and designer Edwin Lutyens, helped them plan a small parterre. The whole garden realized a desire for 'the strictest formality of design, with the maximum informality in planting'. Little wonder that the garden remains a beacon to taste and style. *In Your Garden*, published in 1951 featuring this cover design by artist Paul Holmes, contained a selection of the articles Vita wrote for *The Observer* newspaper between 1948 and 1951, covering twelve months of her gardening year at Sissinghurst, as well as a reprint of her earlier book *Some Flowers*, a review of a seventeenth-century treatise on the flower garden and an article on Hidcote Manor Gardens in Gloucestershire, England. Sackville-West received letters – often in the thousands – from exasperated readers of her gardening column requesting the sources for her recommendations, so she satisfied their curiosity with an appendix that included suppliers of roses, herbs and 'oddments of Useful Addresses'.

Valerie Finnis

Lady Rhoda Birley, c.1970s

Unmounted medium format colour slide,
6 × 6 cm / 2⅜ × 2⅜ in
Royal Horticultural Society, Lindley Library, London

British photographer and gardener Valerie Finnis (1924–2006) was trained at the famed Waterperry Horticultural School (see p.197), where she eventually established a nursery for alpine plants, propagating some 50,000 plants a year. In 1968 Sir David Scott, a retired diplomat and collector of Victorian art, visited Waterperry and commented on a specimen of *Gillenia trifoliata*; Finnis remarked that he was the first person she had met who had known that plant. They were married in 1970, and Finnis moved part of her plant collection to the couple's new home at the Dower House, Boughton House, where they collaborated on the garden. After Sir David's death she founded the Merlin Trust, a charity that provided funds to enable young gardeners to travel. Finnis had developed a second career as a photographer, using a Rolleiflex camera given to her by Wilhelm Schacht, director of the Munich Botanic Garden; but while photographs of plants were lucrative work for her, she also took portrait photographs of botanists and gardeners, many of which were published after her death in Ursula Buchan's book *Garden People* (2007). This photograph shows Rhoda Birley, wife of the society portrait painter Oswald Birley, tending a border at Charleston Manor, Sussex, where she developed the garden with the help of the garden designer Walter Godfrey and her friends Virginia Woolf and Vita Sackville-West (see p.80). Whether this was Birley's normal gardening attire is uncertain – known to be fond of extravagant hats, Finnis may have arranged Birley's costume for her portrait.

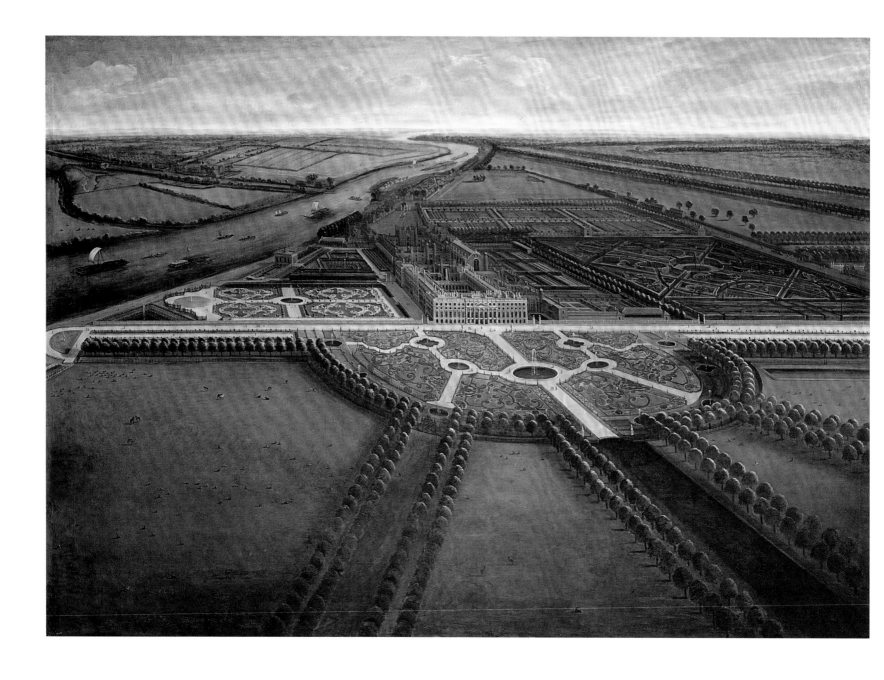

Leonard Knyff

A View of Hampton Court, c.1702–14

Oil on canvas, 1.5 × 2.2 m / 5 × 7 ft
Royal Collection Trust, UK

Hampton Court, acquired by King Henry VIII from his adviser Cardinal Wolsley in 1529, was actively used by successive monarchs and Lord Protector Oliver Cromwell before William II and Mary II commissioned Sir Christopher Wren in 1689 to redesign part of the palace complex in a Baroque style. This bird's-eye view looking west shows the associated gardens designed by George London and Daniel Marot. In the foreground the Long Water (canal) and two allées together form a *patte d'oie* arrangement centred on the east facade, where

the semicircular Fountain Garden is laid out with *parterres de broderie* and circular pools. To the left and aligned on the south front, the similarly structured Privy Garden overlays Henry VIII's earlier incarnation; behind it is William III's Banqueting House and to its right the three Pond Gardens, the sole remnants of the Tudor garden. To the right (north) of the palace are the enclosed rectangular gardens of the Wilderness originally laid out in the 1680s. Inspired by the *bosquets* at the Palace of Versailles, gravel walks lead through plots of formal woodland

interspersed with large topiary yews; four of the compartments contained mazes, the largest of which survives. The Dutch artist Leonard Knyff (1650–1722) had settled in England by 1681, specializing in painting country houses and their gardens. This painting is probably the outcome of preparatory drawings Knyff referred to in a 1703 letter, when he wrote, 'I have done a great many [drawings] of Hampton Courte and Windsor for his Majesty [then Queen Anne's husband, Prince George of Denmark] which are not yet engraved.'

Humphry Repton

The Red Book of Ferney Hall, 1789

Pen, brown ink and watercolour on paper,
each page 21.6 × 29.2 cm / 8½ × 11½ in
Morgan Library & Museum, New York

These two visions of the grounds of Ferney Hall, a Victorian mansion in Shropshire, England, use flaps that open to show the 'before' and 'after' of a garden design by English landscape architect Humphry Repton (1752–1818). Instead of the present view from the house (top), of a broad path flanked by lawns with circular flower beds, all constrained by red-brick walls, Repton proposes an open view (bottom) across parkland with paths and grazing cows, past artfully placed trees to a distant church tower and the hills beyond,

with a white neoclassical temple amid a copse of trees. This watercolour from 1789 forms the opening spread of the Red Book Repton prepared for Ferney Hall after visiting and surveying the grounds. It was his standard practice to prepare an album for each client, invariably bound in the red Morocco leather that gave them their name, analyzing each site and using paper flaps, or reveals, to show how Repton proposed to transform the view; he called the books 'a means of making my ideas equally visible, or intelligible

to others'. Repton's career spanned the eighteenth and nineteenth centuries, while his style evolved from the ambitious landscapes of his predecessor Lancelot 'Capability' Brown (see p.162), whose designs Repton was often asked to finesse, to more intricate and varied gardens. Unusually, Repton acted more as a consultant than as a builder, simply selling the client the plans in the Red Book and leaving them to arrange for the work to be done.

MORRIS & C°

William Morris

Trellis, 1864

Woodblock print in distemper colours, sheet 68.6 × 54.6 cm / 27 × 21½ in
Metropolitan Museum of Art, New York

Trellis, the first of many wallpapers with floral patterns designed by William Morris (1834–1896), was inspired by the gardens at the Red House, Morris's home in England in the early years of his marriage to Jane Burden. Morris had married Burden in April 1859 and commissioned a house from the architect Philip Webb to be built on a plot at Bexleyheath in Kent, which was then quite rural and surrounded by orchards. The house, reflecting Morris's romantic utopianism and Webb's practical common sense,

was, in Morris's words, 'very mediaeval in spirit'. The decorations and furniture were created by Morris and his friends for his newly established firm Morris & Co., an enterprise prompted by his difficulties in finding furnishings he liked well enough to use in his own home. He designed the garden to complement the house, basing his vision on images in illuminated manuscripts. In his *Story of an Unknown Church* (1856) Morris had envisaged a garden with trellises on which 'grew nothing but deep crimson roses' – a feature

echoed in the Red House garden, 'with its long grass walks, its mid-summer lilies and autumn sunflowers, its wattled rose-trellis enclosing richly flowered square garden plots'. Yet more roses were trained to grow against the walls of the house. The *Trellis* wallpaper, which has old-fashioned red roses climbing through a wooden trellis, interspersed with gauchely rendered butterflies and birds (the latter drawn by Webb), captures the spirit of Morris's gardens, both real and imagined.

Mattel

Barbie Doll and Gardening Playset, 2019

Mixed media, dimensions variable
Private collection

Barbie is a global phenomenon. More than sixty years after American toy company Mattel released Barbie in 1959, two Barbies are sold in the world every second. Since 2019 they have included Gardener Barbie, complete with a flower bed and trellis, and produce – lettuce, grapes, strawberries, tomatoes, carrots – for the user to 'pick'. Gardener Barbie is the latest in a series of female role models, of which there were relatively few in gardens, gardening and horticulture prior to the early nineteenth century, except those enabled by wealth or rank.

The early 1800s brought an explosion in town and suburban gardening and a commensurate rise in books written for or by women gardeners, such as Jane Loudon in Britain and 'Madame Celnart' in France. Much of this early literature had a focus on flower gardening, indoor plants and balcony gardening, but it carried an unmissable message that horticulture was not confined to 'lady gardeners' but was suited to all women. Some women-only horticulture courses were established around the turn of the twentieth century, while female students were

slowly admitted to established institutions. In 1900 Charles Bogue Luffman, principal of Melbourne's Burnley School of Horticulture, encouraged participation of female students by remarking, 'I do not think horticulture is an affair of sex.' With enhanced access to professional training and the loss of many male gardeners during World War I, women rose in prominence in gardening, especially in the nursery trade and among professional garden designers and landscape architects. Gardener Barbie is an empowering affirmation for a new generation.

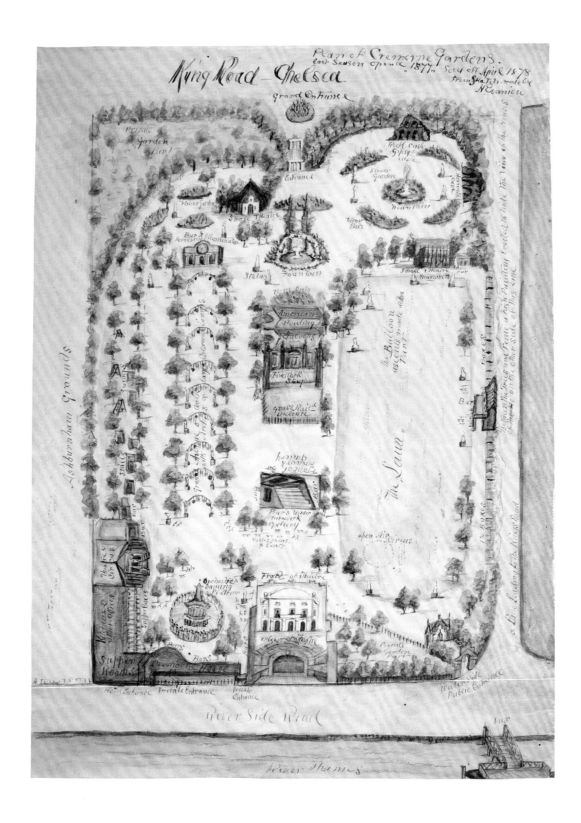

Henry Evans Evanion

Cremorne Gardens, Chelsea, 1878

Ink and colour on paper, 38.5 × 28.5 cm / 15 × 11¼ in
British Library, London

The park of Cremorne Gardens, in Chelsea, London, flourished from the 1840s until it saw its last season in 1877 and the land was sold the following year. This plan, accompanying the recollections of conjuror and humorist Henry Evans Evanion (1832–1905), paints a charming picture of mid-nineteenth-century leisure. His father, a confectioner, had trade links to Vauxhall Gardens (see p.87) until its closure at the end of the 1859 season, giving the young illusionist an early familiarity with the pleasure-garden scene. Commercial pleasure gardens were a common feature of London life in the eighteenth and nineteenth centuries. Some, such as Sadler's Wells, were developed around mineral springs, while others took the form of tea gardens, but the majority followed the precedents of Vauxhall and Ranelagh as stand-alone gardens complete with facilities for concerts, dancing, eating and drinking – as is reflected in Evanion's plan of Cremorne. After making their way through the grand entrance, visitors could stroll in at the flower gardens to one of the small theatres or past the fountain to the American bowling salons or the lawn with an open-air circus, or they could walk along the grand avenue of arches hung with coloured lamps. A typical season extended for a few months over the summer, and pleasure gardens were at their peak in the evening, when illuminations and fireworks were seen to best effect. Continental Europe had long known the joys of pleasure gardens, and derivative Cremornes, Ranelaghs and Vauxhalls proliferated elsewhere in the mid-nineteenth century, from Melbourne to Madrid.

The Triumphal Arches, Mr Handel's Statue &c. in the South Walk of VAUXHALL GARDENS. Les Ares de Triomphe avec la Statue du celebre musicien Handel dans les Jardin de Vauxhall.

Printed for John Bowles at the Black Horse in Cornhil, & Carington Bowles in St Pauls Church Yard, London.

J. S. Muller

The Triumphal Arches,
Vauxhall Gardens, *c.*1751

Coloured engraving, 28.5 × 42 cm / 11¼ × 16½ in
Garden Museum, London

In the late seventeenth and early eighteenth century, as a new, monied, urban middle class emerged in such cities as London, a series of pleasure gardens sprang up to cater for their leisure needs. The first – and most spectacular – of these outdoor entertainment spaces was that depicted here: Vauxhall Pleasure Gardens in Lambeth, on the south side of the River Thames. The earliest mention of the gardens is in the diary of John Evelyn (see p.204) in 1661, and they were intended to be a place where – after paying the high entrance fee that was intended to discourage pickpockets and prostitutes – people could meet, talk, listen to concerts, eat and drink, dance and view art. Indeed, English painter William Hogarth's first exhibition was at Vauxhall, making the gardens Britain's first public art gallery. This engraving, the work of German-born Vauxhall resident Johann Sebastian Muller (also known as John Miller, 1715–*c.*1792) shows part of Vauxhall Gardens around 1751. The statue to the right is dedicated to the composer George Frideric Handel, the premiere of whose *Music for the Royal Fireworks* attracted an audience of twelve thousand to the gardens. The formal gardens, which were laid out with miniature waterways, shrubs, galleries and eateries, were often the setting for firework displays, operas and masquerades. Despite attracting the wealthy, the gardens soon gained a louche reputation as the shady allées and wooded areas were frequently the scene of illicit encounters. Described as being simultaneously a park, concert hall, art gallery, restaurant and brothel, the gardens closed in 1859, marking the end of an era.

Anonymous

Courtiers in a Rose Garden:
A Lady and Two Gentlemen, c.1440–50

Wool warp; wool, silk, metallic weft yarns,
2.9 × 3.3 m / 9 ft 6 in × 10 ft 8 in
Metropolitan Museum of Art, New York

Against a flat background of white, red and blue stripes, two male courtiers wearing richly embroidered pleated tunics surround a female figure in an elaborately jewelled and veiled headdress, her skirts billowing with the heft of a mountain range, filling the lower half of this tapestry by an unknown artist. She turns her body in pleasing *contrapposto*, theatrically posing the dilemma of her choice between the suitors. On the right, the gripping of one of the many thorny rose branches that surround the figures seems

to hint symbolically at the risks of sexual attraction in the medieval imagination. But it is the figure on the left, who reveals a rose concealed within his hat, who seems closest to capturing the lady's affection. Flemish and Netherlandish tapestries from this period were prized throughout Europe, and this expensively made example, rich with metallic threads that glisten to accentuate the jewels and winding roses as equivalent charms, was possibly made for Charles VII, King of France. The tapestry's subject matter may also have been

inspired by the Old French poem *Le Roman de la Rose* (*The Romance of the Rose*), one of the most widely reproduced secular poems of the Middle Ages. The chivalric romance of a pilgrim courting a lady within a *hortus conclusus*, or walled garden, and the plucking of a rose – traditional symbol of love and the Virgin Mary – is closely echoed here.

Slim Aarons

Garden Party, 1970

Photograph, dimensions variable

American photographer Slim Aarons (1916–2006) once described his job as capturing 'attractive people doing attractive things in attractive places', and this 1970 colour image of an idyllic garden party in Miami, Florida, does exactly that. From above the scene, the camera lingers on a disparate group of glamorous, fashionable guests enjoying themselves in a well-tended formal garden. Sunshine floods the image and the lengthening shadows suggest it is late afternoon or early evening on a summer's day. Amid the beautifully

manicured lawns and precisely clipped low hedges, the guests set up their picnics and hampers, and sip wine and champagne as musicians play. The celebratory mood is enhanced by a series of pastel-coloured balloons swaying in the breeze. With its statues, gravel paths, tree-lined walkway and large pools, this garden clearly belongs to a suitably impressive house – yet it is ultimately somewhat generic and undistinguished. Aarons, whose lengthy career meant that his work frequently appeared in *Life*, *Vogue*, *Town & Country*

and *Holiday* magazines, photographed *everyone*, including such cultural icons as Humphrey Bogart, Grace Kelly, Marilyn Monroe and the Kennedys. He claimed to have been born into a world of privilege, so that he was uniquely qualified to capture the jet set at play. It was only in 2017, more than a decade after his death, that it was revealed that Aarons had not been what he claimed – a New Hampshire orphan with automatic entry into the high society world – but the son of a poor, Yiddish-speaking immigrant family in Manhattan.

PARA ELEVAR AGUA

Bomba Bloch

NO NECESITA ENGRASE

Bomba Bloch

Advertising poster, *c.*1935

Lithograph, 109 × 76 cm / 43 × 30 in
Private collection

Two ladies dressed in summer whites protect themselves from the sun with a parasol next to a fountain in a garden of bright flowers and lush greenery, while a gardener uses a hosepipe in the background. Set into the drawing is the unlikely piece of technology that makes the whole scene possible: a water pump designed by the Valencia-based company Bomba Bloch, with the slogan 'To raise water, Bomba Bloch does not need oiling.' Founded in Barcelona in 1915, the company rose to prominence with its display

at the 1929 Exposición Internacional de Barcelona, and still operates today, specializing in hydraulic pumps and accessories. The walls of the villa in the background have been cut away to reveal water being used for washing in the kitchen and bathing upstairs. This home is a quinta, a villa with its own agricultural estate – a farm building can be seen on the hill in the background – that is a distinctive feature of the landscape in Spain and Portugal. Quintas were often built as retreats for feudal lords from the busy,

hot cities, and combined productive agriculture with more ornamental domestic gardens, as here. In the plains in the heart of the Iberian Peninsula, they often relied on underground water sources, and Spanish gardens generally have traditionally made great use of water. This advertising poster produced by the Ortega printing company in Valencia drew on contemporary graphic design, with use of bold hues, simplified blocks of colour and a dramatic viewpoint to create an idyllic view of Spain.

Emil Nolde

Blumengarten (O), 1922

Oil on burlap, 74 × 89.9 cm / 29⅛ × 35⅜ in
Nolde Stiftung Seebüll, Nordfriesland, Germany

Juxtaposing the deep blue of tall, regal Siberian irises with the warm reds and pinks of the other blooms positioned in the background, *Blumengarten* (*Flower Garden*) by German-Danish painter and printmaker Emil Nolde (1867–1956) perfectly exemplifies the vigorous brushwork and bold choice of colours, inspired by flowers and plants, for which the Expressionist pioneer was known. Although Nolde frequently painted plants in gardens, his compositions and cropping normally excluded overt references to cultivated environments, thus conveying a sense of openness and naturalness. He was also a garden designer and a fond gardener himself, who loved brightly coloured flowers, such as dahlias and sunflowers. It was normal for Nolde to transfigure the flowers and foliage he painted through an expressivist language that aimed at summoning emotional vibrancy rather than accurately depicting each species. For Nolde, the garden was a timeless space of heightened emotional intensity. However, the artist's experimental, modern style was disliked by Nazi Party officials, who classified it, alongside that of other modern masters such as Pablo Picasso and Wassily Kandinsky (see p.314), as 'degenerate'. In 1941 Nolde, who initially sympathized with Nazi politics, was prohibited from painting under the regime. He returned to capturing the intense beauty of his garden immediately after the end of World War II, when he was well into his seventies.

André Kertész

Chairs, Luxembourg Gardens, Medici Fountain, 1925

Gelatin silver print, 9 × 12 cm / 3½ × 4¾ in
Réunion des musées nationaux, Grand Palais, Paris

The slatted garden chairs casting shadows on a dusty foot-path in the Luxembourg Gardens in Paris are not just any chairs, but a folding version of the iconic green metal SENAT chairs that had been introduced by the Parisian senate (hence the name) in 1923, two years before this image was taken by renowned Hungarian documentary photographer André Kertész (1894–1985). The Luxembourg Gardens date back to the beginning of the seventeenth century, when Queen Marie de' Medici purchased 8 hectares (20 acres) of land in

the sixth arrondissement, between Saint-Germain-des-Prés and the Latin Quarter. With the queen's Italian heritage, it is unsurprising that the urban oasis is in some ways an homage to the Boboli Gardens behind Pitti Palace in Florence, a long-term residence of the Medici family. Much of the Luxembourg Gardens was designed by Jacques Boyceau, superintendent of the royal gardens of Tuileries (see p.93) and early plans for the grounds at the Palace of Versailles (see p.16). Queen Marie's ambition to build an impressive garden eventually led to

a substantial expansion, bringing the garden to 25 hectares (62 acres) in total. While today's Luxembourg Gardens have been substantially altered, often to make space for the burgeoning urbanization of modern Paris, they retain much of the original formal character Boyceau created. Surviving early features include the octagonal pond and fountain (Grand Bassin), the orchard, the apiary and greenhouses containing many varieties of orchid – together with the long tree-lined promenades dotted with SENAT chairs for visitors.

Camille Pissarro

The Garden of the Tuileries on a Winter Afternoon, 1899

Oil on canvas, 73.7 × 92.1 cm / 29 × 36¼ in
Metropolitan Museum of Art, New York

The distant Parisian cityscape of grey roofs rises to meet a watery blue and white sky, interrupted by the twin steeples of the basilica church of Sainte-Clotilde. The foreground is occupied by the stately Tuileries gardens, where knots of people stroll or play on wide paths separated by large areas of grass, and a formal pond with a fountain disappears on the left edge. This was the view from the window of the artist, renowned Impressionist Camille Pissarro (1830–1903), who in 1898 secured an apartment on rue de Rivoli.

The Tuileries had been founded in the 1560s, when Queen Catherine de' Medici, widow of King Henri II, ordered the construction of a palace and gardens on a site beside the Seine that had been home to the tile factories that gave the Tuileries its name. The original gardens were Italian in style, but in 1664 King Louis XIV asked landscape architect André Le Nôtre (see pp.16, 17) to remodel the gardens in the formal French style. Le Nôtre created a large central path joining two ponds, with terraces along the river and what

later became the rue de Rivoli. The garden was opened to the public in 1667, after the king relocated his palace to Versailles, and, despite further refinements over the next two centuries – during the Paris Commune of 1871, revolutionaries burned down the palace and the garden was extended on to its former site – the garden of Pissarro's time remained largely faithful to Le Nôtre's plan.

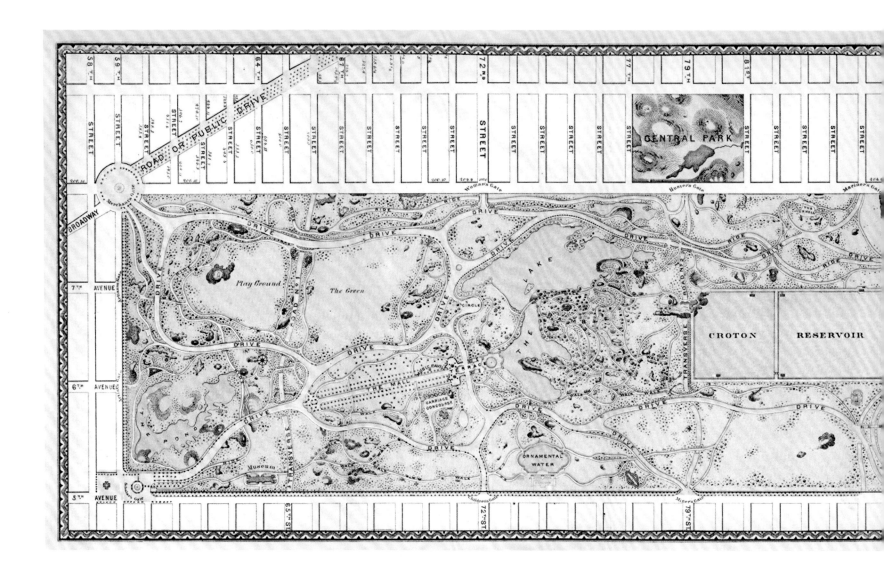

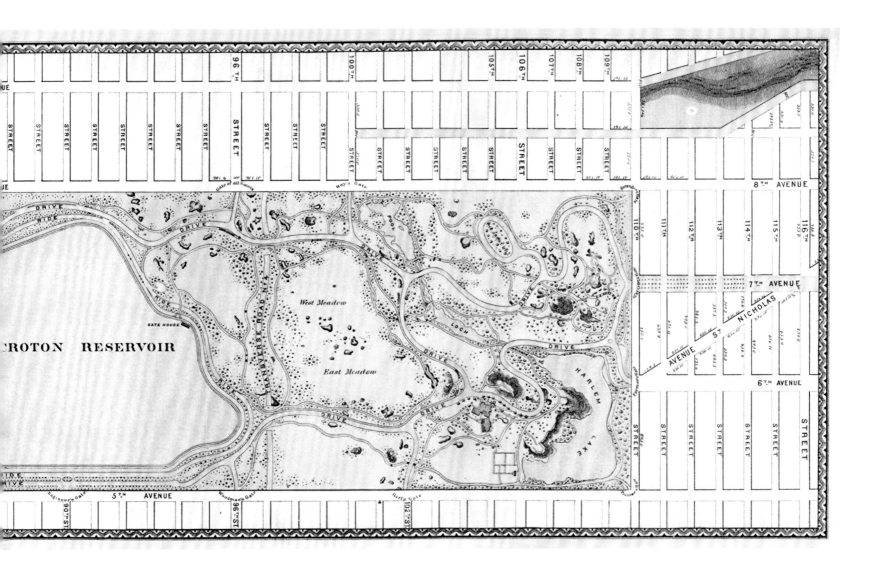

Frederick Law Olmsted and Calvert Vaux

Map of Central Park and the Upper West Side, New York City, 1868

Hand-coloured engraving, 21.6 × 77.5 cm / 8½ × 30½ in
Private collection

This remarkable hand-coloured map depicts what one of its creators called 'a democratic development of the highest significance': Central Park in the heart of Manhattan, New York City, the first public park created in the United States. The park had first been envisaged decades earlier by city authorities becoming alarmed at the detrimental effect on New Yorkers' health from the lack of outdoor public space as the population boomed – it nearly quadrupled in little over three decades – and living conditions became more crowded and

unsanitary. In 1851 the city mayor Ambrose Kingsland called for the creation of a park that would 'become the favourite resort of all classes'. The idea was enthusiastically received, and a site was eventually chosen in the middle of Manhattan, surrounding a new reservoir. The competition to design the park was won in 1858 by American designer Frederick Law Olmsted (1822–1903) and his partner the British architect Calvert Vaux (1824–1895), with a design that buried underground the roads that crossed the park as part of Manhattan's

street grid. The picturesque design was deliberately asymmetrical and informal, relying heavily on areas of grass and trees, with roads twisting through the contours of the landscape. Olmsted was inspired by a visit to the world's first public park, in Birkenhead, Liverpool, and by landscaped cemeteries in the United States. Construction took until 1876, thanks to the huge amount of work required to transform the swampy and rocky site into an accessible and attractive public space, involving an army of some 20,000 labourers.

Lucian Freud

Garden, Notting Hill Gate, 1997

Oil on canvas, 1.8 × 1.5 m / 5 ft 9 in × 4 ft 9 in
Private collection

Many gardeners might feel a sense of weary recognition at the size and profusion of the buddleia that completely fills this painting by Lucian Freud (1922–2011), one of the great British artists of the twentieth century. Imported to Europe from China during the nineteenth century because of its resilience to cold and the generous summer-long blooming of its spike-like flowers, buddleia quickly naturalized across the United Kingdom, becoming a fast-growing, ubiquitous weed – and a nightmare for most gardeners. Freud saw the plant differently when it took root unplanned, sprouting as a seedling in the very centre of his garden in Notting Hill, west London. The artist, despite being better known for his abrasively honest nudes, was also an extremely accomplished painter of plants – but an unorthodox one who believed that it is only when plants are left to grow without too much care and pruning that one can begin to see their real nature and character. True to his approach, Freud decided to leave the buddleia seedling where it had germinated. The result was this enormous behemoth, which inevitably grew to smother the rest of the garden. Despite the close-up viewpoint of this painting, Freud did not make it outside in the garden, but from the first-floor window of his studio. With the buddleia at its centre, unkempt but enduring, Freud's garden became a symbol of the artist's refusal to comply with any rules in art as well as life.

KEW GARDENS

All Climates, all Floras, at your choice,
Water and Woods for walks and shade,
Good Teas, Fancy Ducks, Scented Air.

UNDERGROUND STATION

Clive Gardiner

Kew Gardens, 1927

Colour lithograph, 101 × 63 cm / 39¾ in × 24⅞ in
London Transport Museum

In this colourful poster issued by London Underground, British illustrator Clive Gardiner (1891–1960) tempts visitors of the 1920s to use the Tube to visit Kew Gardens with a sunlit vista where verdant trees arch over the dappled waters of a lake, a woman reclines with a book beneath the trees and the scene is suffused with an atmosphere of peace and relaxation. Spread over 132 hectares (326 acres) beside the River Thames in southwest London, Kew was established as England's national botanic garden in 1840. The oasis on

the fringes of the city became a popular destination for a day out, reached easily by rail and later by the Underground public transport system. The poster's text summarizes the garden's attractions: 'All Climates' hints at the steamy rainforest warmth of the famous Palm House (the subject of another poster by Gardiner), the cooler Temperate House, and the hot and humid Waterlily House, as well as the seasonal changes in the gardens themselves. 'All Floras' reminds the visitor that Kew was founded as a scientific

enterprise, and cultivated plants from every continent. 'Water and Woods for walks and shade' are the subject of the poster itself, and 'Good Teas, Fancy Ducks and Scented Air' are listed as additional pleasures. There is a timeless classical quality to the design, but Gardiner's distinctive style blends elements of Cubism with the curves and arcs characteristic of contemporary Art Deco. The colours are vivid and lush, reflecting the work of such French painters as Paul Cézanne and André Derain.

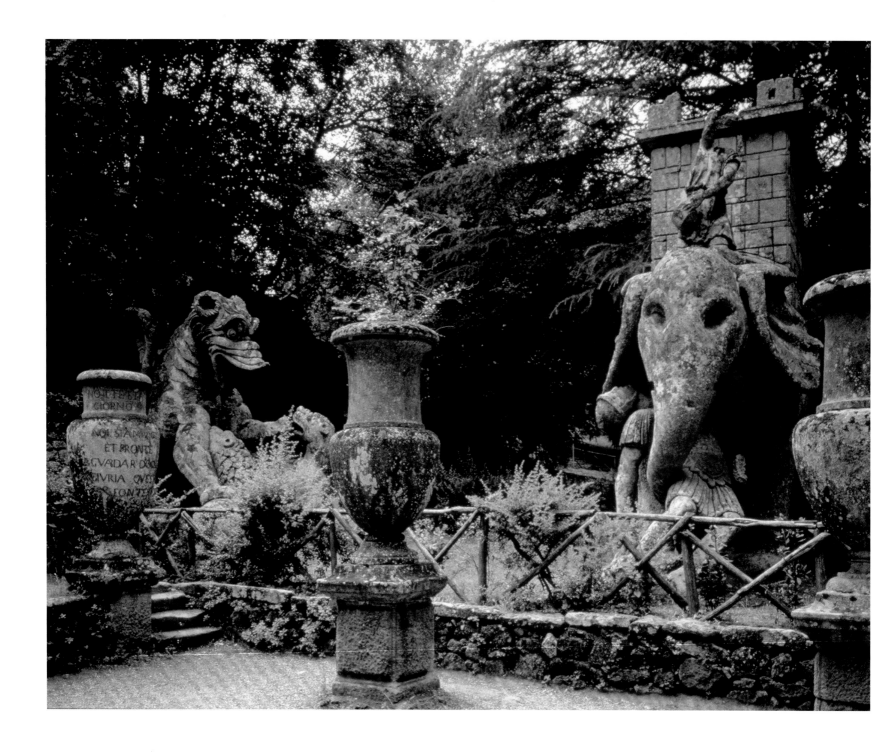

Raffaello Bencini

Sculptures in the Parco dei Mostri, *c.*1950s

Photograph, dimensions variable

A dragon attacked by lions and a war elephant overcoming a Roman soldier feature among the striking statues at Sacro Bosco, colloquially called Parco dei Mostri (Park of the Monsters), in Bomarzo, Italy. Construction began in 1552 on the garden, set in a wooded valley beneath Orsini Castle, for Pier Francesco Orsini, duke of Bomarzo. Its layout is attributed to papal architect and garden designer Pirro Ligorio, while the twelve bizarre statues – which also include a turtle with a winged woman on its back, a sleeping nymph and

a gaping hellmouth inscribed with the words 'all reason departs' – are the work of the Mannerist sculptor Simone Moschino. Forgoing the long vistas, symmetry and visual order common to Renaissance pleasure gardens, Sacro Bosco's haphazard design was intended to shock, perhaps reflecting the duke's mental state at the time. Its collection of monstrous statues is seemingly scattered arbitrarily around the unusual garden, with some carved directly into the volcanic bedrock. One of the most unsettling elements is

the Leaning House, a tilting structure designed to disorientate visitors and which fascinated Spanish surrealist painter Salvador Dalí (see p.79), who was filmed clambering on the various statues in 1949 for a newsreel that brought fame to the neglected garden. When Italian photographer Raffaello Bencini (b. 1929) took this photograph in the mid-twentieth century, Sacro Bosco was overgrown and unkempt, but restoration in the 1970s revitalized the site and it is now a major tourist attraction.

Simon Schijnvoet
and Jacobus Schijnvoet

Garden and Park Ornaments and Designs,
from *Examples of Pleasure Garden Ornament,*
early 18th century

Hand-coloured engraving, 29.8 × 20.3 cm / 11¾ × 8 in
Private collection

In the early eighteenth century, flush with revenues from the Dutch East India Company, Holland entered a period of great artistic growth, which was reflected in the attention lavished on gardens, both private and public. These engravings, made by Jacobus Schijnvoet (1685–1733), show highly decorative monumental urns and garden ornaments as part of a catalogue of designs by his father, landscape architect Simon Schijnvoet (1653–1727). The urns belong to what would become the Dutch Baroque style, which was heavily influenced by the French

Baroque style that originated in the gardens of the Palace of Versailles (see p.16) outside Paris and became the model for gardens around Europe – including pleasure gardens or *lusthof*, such as the one glimpsed in the background of this engraving. An architect and builder as well as a horticulturist, Simon Schijnvoet not only created the garden objects but also determined the landscape that framed them. Pleasure gardens – places where people could meet, eat and drink, and be entertained – had become popular in seventeenth-century

Holland. Typically, the gardens were divided into green segments, flanked by canals or groves of trees. Unusual topiary – as seen here – was a popular feature, while flower beds were filled with brightly coloured, scented blooms. Statues, shell grottoes, orangeries and menageries all provided variety, and there was a fashion for hothouses filled with pomegranates, oleanders, myrtles, laurels and aloes. The gardens were designed to appeal to the mind as well as the senses, to serve as a reminder of the earthly paradise in which the Dutch lived.

Junya Ishigami and Associates

*Botanical Garden Art Biotop –
Water Garden*, 2013–18

Artificial landscape, total area 16,670 sq m / 179,434 sq ft
Tochigi, Japan

Serried ranks of graceful trees grow from moss-covered islands of soil surrounded by artificial pools in a clever fusion of the natural and the artificial created by Japanese architect Junya Ishigami (b. 1974) in the magical wooded environment of *Water Garden*. The effect is a striking confluence of filtered sunlight, dappled shade and myriad reflections. Stepping stones link the network of islets, forming footpaths that weave through the sylvan dreamscape – a key element to encouraging meditation and contemplation, the primary role of

this unconventional garden that reflects the influence of more traditional 'stroll' gardens in Japanese culture. The award-winning water garden also demonstrates how human intervention can enhance the landscape and even provide new areas for nature to colonize. Formed of more than 300 trees planted around 160 small ponds, the garden creates miniature habitats for aquatic plants and animals. Part of the younger generation of Japanese architects, Ishigami is admired for creations that are often inspired by the natural

world. His view is that architecture can be formed naturally, 'like a stone built over time, through sedimentation and erosion', and he considers the surrounding environment to be an integral part of each of his architectural projects. *Water Garden* is part of Ishigami's retreat at Art Biotop near Japan's Nasu Mountains, to the north of Tokyo. The trees were transplanted from adjacent areas and used to create a garden that is just one element of a complex consisting of a restaurant, gallery, residences, and pottery- and glass-making studios.

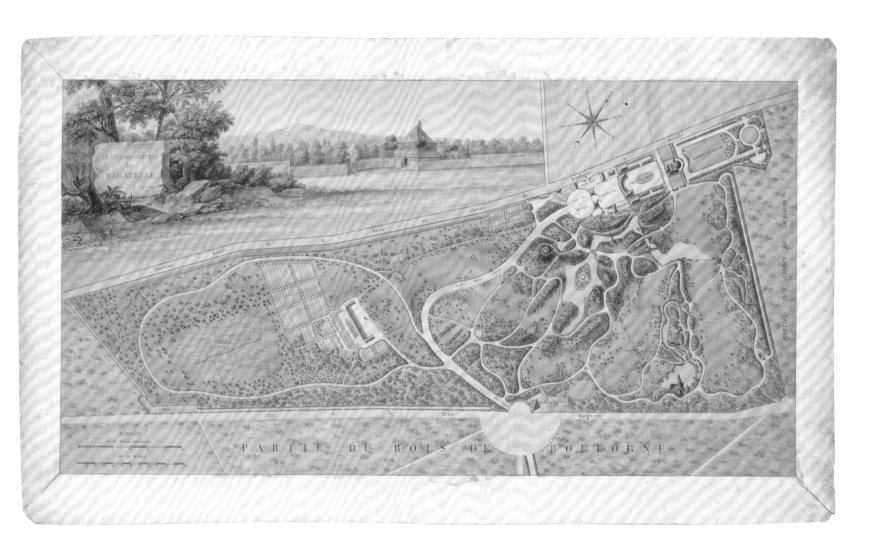

Pierre Lapie

*Plan for the Garden of the
Château de Bagatelle*, 1817

Pen, black ink and watercolour, 52 × 92.1 cm / 20½ × 36¼ in
Metropolitan Museum of Art, New York

In 1817, when French cartographer Pierre Lapie (1771–1850) created this watercolour plan of the gardens of the Château de Bagatelle in Paris's Bois de Boulogne – then still a forest – the house belonged to a six-year-old boy, Napoleon II. The small chateau and its 24-hectare (59-acre) garden had quite a history: originally the site of a hunting lodge, the neoclassical-style chateau and its landscaped gardens were realized in just sixty-four days following a wager in 1777 between King Louis XVI's brother the comte d'Artois, and sister-in-law, Queen Marie Antoinette, of 'let them eat cake' fame. The original gardens, the work of Scottish-born landscape architect Thomas Blaikie, replicated the newly fashionable English Landscape style, complete with fake ruins, huts and grottoes, as well as an obelisk and pagoda, replacing the rigid formality of typical French gardens of the period. Lapie's plan shows the garden as it appeared in 1817. Alongside the formal garden and vegetable gardens was a large area of winding paths, viewpoints and artificial lakes, as Blaikie had imagined. The Bagatelle Gardens as they are today owe their existence to Jean-Claude Nicolas Forestier, Commissioner of the Gardens of the City of Paris, who started re-landscaping the gardens in 1905. He added a rose garden, which now has more than 1,200 varieties, and an iris garden long before Claude Monet popularized irises in France in his gardens at Giverny (see pp.40, 212).

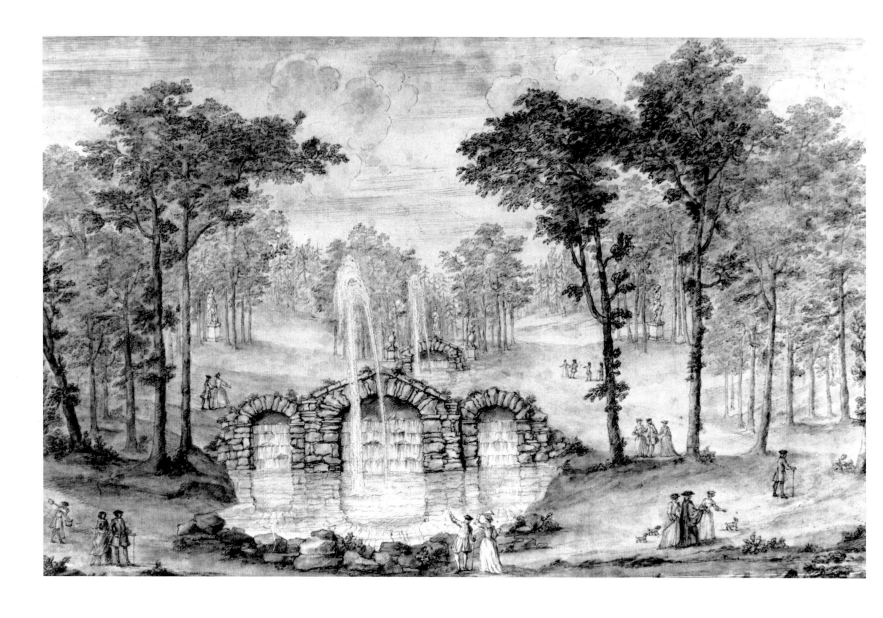

William Kent

Design for Venus Vale at Rousham,
18th century

Ink on paper
Private collection

English writer and politician Horace Walpole dubbed William Kent (1685–1748) the 'father of modern gardening', and Kent's work at Rousham House in Oxfordshire is the earliest example of what would be called the English Landscape movement. Born William Cant, the son of a joiner, he changed his name to the classier Kent before embarking on a Grand Tour to Italy, financed by wealthy friends. He stayed for ten years, absorbing Italian art and culture, and when he returned to England he quickly became in demand as an architect of historic

houses. When Kent agreed to renovate Rousham Park in the early eighteenth century, he made improvements to both the house and the 10 hectares (25 acres) of grounds. The house underwent further changes in the nineteenth century, but the gardens remain much as Kent designed them, developed from an original design by royal gardener Charles Bridgeman. Kent combined a sophisticated Italian classicism with an English pastoral Arcady, naturalizing and softening the geometry of the Bridgeman layout and bringing the surrounding fields and

woods into the design; as Walpole put it, 'Kent leapt the fence and saw that all nature was a garden.' In his rearrangement in the 1730s of the ponds and cascades in Venus's Vale, in a hollow of woodland at the heart of the garden, Kent retained Bridgeman's square basins but linked them to sloping lawns embellished by statuary, particularly sculptures on the theme of male beauty. Kent re-created the garden as a stage and gave it a drama, building 'ruins' on the boundaries to draw the eye out and suggest that the park extended further than it did.

Anonymous

The Garden of Chiswick Villa, 1757

Painted kid; pierced, carved, painted and gilded ivory; metal, glass, 26.4 × 47.9 × 2.5 cm / 10⅜ in × 18⅞ in × 1 in
Metropolitan Museum of Art, New York

The third Earl Burlington and his friend the polymath William Kent created the garden at Chiswick House that became the birthplace of the English Landscape style and influenced gardens from Blenheim Palace to New York's Central Park. Together Burlington and Kent wove informal serpentine paths among plantations of trees, punctuated the lawns with Italian cypress and cedar of Lebanon, and, as depicted on this intricately designed fan, laid out allées leading to temples, columns and rustic houses. The pair plotted a garden including a river with a cascade and rustic bridge across the landscape, and a gently sloping amphitheatre, adorned with orange trees in Versailles tubs, radiated from an obelisk within a circular pool. Alexander Pope in his *Epistle to the Right Honourable Richard Earl of Burlington* (1731) lauded Burlington as the first garden owner of importance to recognize 'the genius of place'. After the estate passed to the Dukes of Devonshire through marriage, a conservatory commissioned by the sixth Duke, completed in 1813, became one of the earliest large glass-houses to be constructed. In 1828 exotic fruit were replaced by camellias – an exciting new status symbol from China – among them four of the first cultivars to be introduced into Europe. In 1821 the Royal Horticultural Society leased land on the estate to create its first experimental garden. It was here that the sixth Duke of Devonshire befriended Joseph Paxton and enticed him to Chatsworth House to become his famed head gardener.

Claire Takacs

Trompe l'oeil, Schwetzingen Palace, Mittelbau Schloss, Germany, 2016

Photograph, dimensions variable

At the end of a *berceau* tunnel – a gazebo covered by foliage that culminates in a frame of tufa – a painted trompe-l'oeil picture of a bucolic lake surrounded by trees and bushes seems to lead the eye into a landscape of blueish, hazy mountains. Completed in 1775, this painting, entitled *Ende der Welt* (*End of the World*), is part of the garden at Schwetzingen Palace in Baden-Württemberg, Germany, a summer residence of the Palatinate Electors Charles III Philip and Carl IV Theodor, and gives the illusion of 'borrowing' the landscape beyond the garden. Trompe l'oeil is a popular technique in garden design to create the illusion of a larger space, to add depth to a garden or to create a focal point. It can be achieved in many ways, such as by using layering, terracing or specific planting. The eighteenth-century gardens at Schwetzingen feature a range of buildings and statuary – including an ornamental onion-domed 'mosque' in the Turkish garden – in a formal French baroque garden of parterres, allées and pleached lime trees. The garden's constant interplay of light and shade is a deliberate celebration of the Enlightenment, a golden age of light and wisdom, as symbolized by the temple dedicated to Apollo, the Greek god of art and culture. This image was taken by renowned garden photographer Claire Takacs (b. 1975), who is known for evocative and thought-provoking images that showcase the intricate beauty of gardens around the world and the relationship between humans and nature.

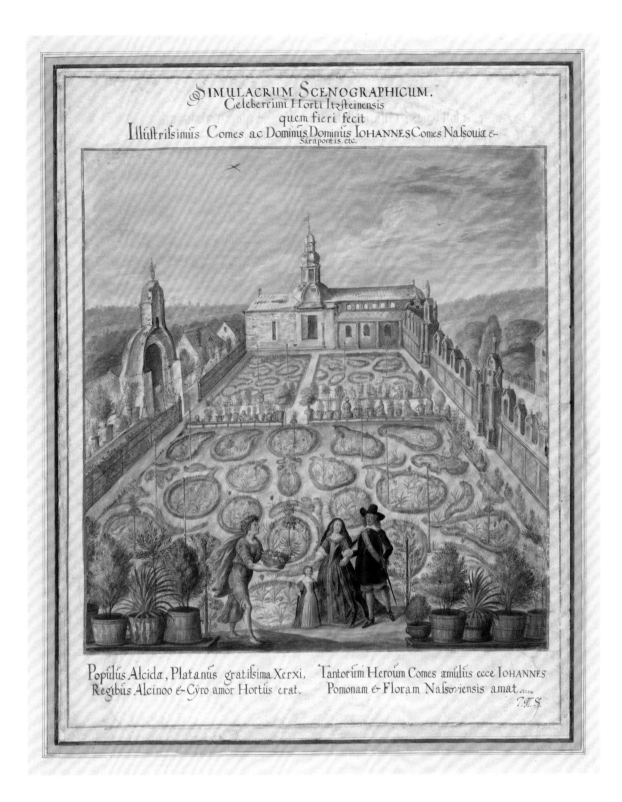

SIMULACRUM SCENOGRAPHICUM.
Celeberrimi Horti Itzsteinensis
quem fieri fecit
Illustrissimus Comes ac Dominus Dominus IOHANNES Comes Nassouiæ &-
Sarapontis. etc.

Populus Alcidæ, Platanus gratissima Xerxi, Tantorum Heroum Comes æmulus ecce IOHANNES
Regibus Alcinoo &-Cyro amor Hortus erat. Pomonam &-Floram Nassoviensis amat.

Johann Jakob Walther

Title page from *Simulacrum Scenographicum
Celeberrimi Horti Itzsteinensis*, c.1654–72

Watercolour and gouache on vellum, 60 × 46.2 cm / 23½ × 18 in
Victoria and Albert Museum, London

It is clearly springtime in this watercolour, for the beds are planted with bright tulips and magnificent crown imperials, widely spaced after the fashion of the mid-seventeenth century, and the garden is enclosed by trellised fencing and hedges, with walkways lined with potted plants and statuary. The man shown at the foot of the page with his wife and child is the garden's creator, Count Johann of Nassau-Idstein, whose horticultural achievements are acknowledged by the gift of a basket of flowers from the goddess Flora.

As the Latin text on the title page indicates, this is a view of the famous garden at Idstein, near Frankfurt in Germany, where Johann returned after exile in 1649 to find the family castle in disrepair after the Thirty Years War. Restoring the building, he also laid out a garden to reflect his passionate interest in plants, which he collected obsessively. He filled it with flowers ranging from the common – pinks and columbines – to the rare Marvel of Peru, which had only just arrived in Europe from the Americas. Johannes employed

the miniature artist and natural-history painter Johann Walther (c.1604–c.1677) of Strasbourg to paint views of the garden, and portraits of individual plants. Walther visited the garden at least eight times between 1651 and 1672, to see it at every season, and the resulting florilegium is a glorious record of a garden with several novel features including, as the count explained in a letter to a friend, beds shaped like fruit, such as lemons, peaches, pears and figs.

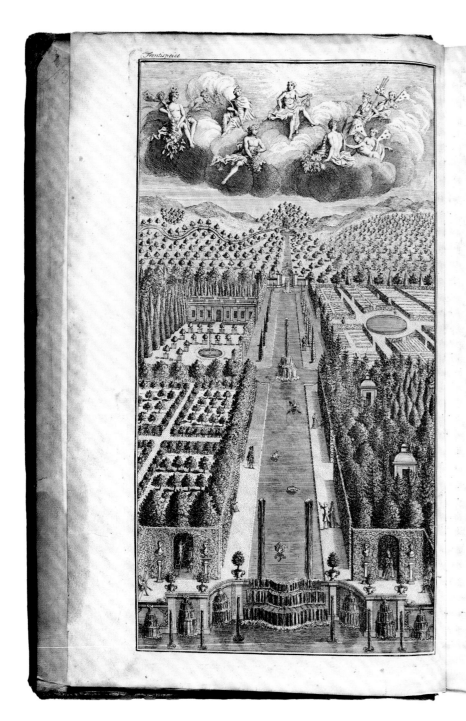

THE
Gardeners Dictionary:
Containing the METHODS of
CULTIVATING *and* IMPROVING
THE
Kitchen, Fruit *and* Flower Garden,
AS ALSO, THE
Phyſick Garden, Wilderneſs, Conſervatory,
AND
VINEYARD;
According to the PRACTICE of the
Moſt *Experienced Gardeners* of the *Preſent Age.*

Interſperſed with

The Hiſtory of the PLANTS, the Characters of each GENUS, and the Names of
all the particular SPECIES, in *Latin* and *Engliſh*; and an Explanation of all the
TERMS uſed in BOTANY and GARDENING.

Together with

Accounts of the Nature and Uſe of *Barometers, Thermometers,* and *Hygrometers,* proper for
GARDENERS; And of the Origin, Cauſes, and Nature of METEORS, and the particular
Influences of *Air, Earth, Fire* and *Water* upon *Vegetation,* according to the beſt NATURAL
PHILOSOPHERS.

Adorn'd with COPPER PLATES.

By *PHILIP MILLER,* Gardener to the Worſhipful Company of
APOTHECARIES, at their *Botanick Garden* at *Chelſea,* and F. R. S.

—— *Digna manet divini gloria ruris.* VIRG. GEO.

The THIRD EDITION, Corrected.

LONDON:
Printed for the AUTHOR;
And Sold by C. RIVINGTON, at the *Bible and Crown* in St. *Paul's Church-yard.*
M.DCC.XXXVII.

Philip Miller

*The Gardeners Dictionary: Containing
the Methods of Cultivating and Improving
the Kitchen, Fruit and Flower Garden,* 1737

Engraving, 34.3 × 22.9 cm / 13½ × 9 in
Private collection

The garden publishing sensation of the mid-eighteenth century, *The Gardeners Dictionary* by English writer Philip Miller (1691–1771) seamlessly combined botany, horticulture and gardening. With eight folio editions issued from 1731 to 1768, plus affordable octavo and quarto editions and abridgements and versions in Dutch, German and French, the book had perhaps the widest reach of any horticultural work of its time. Later editions extended this reach into the nineteenth century, when Miller's *Dictionary* was still regarded as a standard work for gardeners. The son of a market gardener and himself a florist, Miller rose to prominence during his lengthy curatorship, from 1722 until his death, of the physic garden established by the Company of Apothecaries at Chelsea, beside London's River Thames. This was the foremost British institution linking botany and horticulture, the centre of a worldwide network of collectors, and highly influential in an era before the establishment of Kew's Royal Garden. Miller's success derived from his ability to link horticultural experience in cultivating living plants at Chelsea with botanical knowledge from dried herbarium specimens and an extensive library. Gardening underwent a revolution in the eighteenth century, with gradual stylistic change, a burgeoning global interchange of seeds and plants, and a new appetite for horticulture as a fashionable scientific pursuit. Miller's *Dictionary* spanned this change, from its earliest edition drawing on French formal garden traditions to the transformation Miller witnessed through the introduction of new plants, particularly shrubs and trees from the Americas.

Gustave Caillebotte

The Gardeners, 1875

Oil on canvas, 85 × 112 cm / 33½ × 44⅛ in
Private collection

Two barefoot workers are busy watering neat rows of plants in a large, well-tended vegetable garden while the sun beats down – even with four watering cans, there is still much to be done. In a style that combines impressionism and realism, Gustave Caillebotte (1848–1894) conveys a sense of the labour required to maintain a sizeable garden. Born into wealth, the French artist developed his love of horticulture in the large, English-style garden on his family's estate at Yerres, southeast of Paris, where his childhood summers

were spent painting nature in the open air. A member and patron of the Impressionists, Caillebotte became known for his scenes of everyday life in Paris's modern neighbourhoods and rural outskirts. In 1881 he acquired a property with his brother at Petit-Gennevilliers, on the banks of the Seine near Argenteuil, where he moved permanently in 1887. Caillebotte laid out a large vegetable garden, built a studio and added a greenhouse where he grew orchids and other flowers. Gardens and flowers became the dominant theme

of his paintings and his correspondence with such artists as Claude Monet (see p.40, 212) revolved mainly around horticulture. Inside his home, he painted the dining room doors to resemble a greenhouse overflowing with orchids, and decorated interior panels with images of nasturtiums. A large canvas covered in daisies was to complete the scheme, but his premature death at the age of forty-five while working in his garden left the project unfinished.

AT. J. Andres

Agricultural & Gardening Tools, from the catalogue of Le Bazar de l'Hôtel de Ville, 1931

Lithograph
Bibliothèque des arts décoratifs, Paris

Set against a lush green background, presumably a well-manicured lawn, an extensive range of gardening tools for sale has been curated for this page from a catalogue produced in 1931 by the iconic Le Bazar de l'Hôtel de Ville department store in Paris, founded in 1855 and still in operation. Many of the tools illustrated remain popular in gardening today. At the top is a series of differently sized hoe-heads – hoes are used to cut weeds precisely at root height, or to dig shallow and narrow trenches for planting.

Below, from the left, is a flat-tip spade, which is useful when moving loose soil around, followed by a pointed spade designed for digging. To the right are three pitchforks – very efficient for lifting and stacking materials such as straw or manure – next to a range of rakes, which are excellent for levelling soil or gathering autumn leaves. In the row below is a selection of blade-tools including shears, essential for pruning bushes and small trees, and a sickle, which is useful when cutting tall grasses or harvesting grains. Below

is a ploughing tool as well as a lawn-roller, a heavy cylinder often pushed by hand or pulled by a horse or motorized vehicle that today has been supplanted by more modern, motorized equipment. The roller was originally used to smooth and level topsoil as well as press seeds into the ground when a new lawn was being planted. Next to it is a push reel-mower – with solid rubber wheels, this model was considered top quality at the time.

Chaumet

Land of Treasures Brooch and *Water Stones Brooch*, from *The Garden of Delights by Chaumet Collection*, 2019

Pink and white gold, set with diamonds and a pear-shaped chrysoberyl, H. 6.9 cm / 2¾ in; Pink and white gold, set with diamonds and tanzanite, H. 7.6 cm / 3 in

Diamonds stud the front of a watering can with a hosepipe of rose gold, while a white- and rose-gold shovel is festooned not with mud but with diamonds ending in a tanzanite stone. The brooches of the 2019 *Le Jardin des Délices* (Garden of Delights) collection by French jewellery house Chaumet also included bejewelled flowers tumbling out of a pair of rubber garden boots, a combative chicken confronting a scarecrow, a bee of diamonds and sapphires in white gold, and ears of wheat that echo a famous tiara worn by Joséphine, wife of

Napoleon Bonaparte. Chaumet's intention was to capture the beauty of the garden by using the best-quality stones to elevate the ordinariness of gardening and gardens to high art in homage to Joséphine, who was known for her impeccable taste and who made Chaumet her official jeweller in the early nineteenth century. The empress had a reputation as an eager botanist and a lover of nature, and her passions were behind Chaumet's decision to launch this collection as the latest addition to a theme that began in 2011 with *Bee My*

Love, a collection dedicated to her husband and featuring stones such as yellow sapphire, morganite and amethyst 'flowers' held in place by jewelled bees. Chaumet has been known for using flawless diamonds and precious stones in imaginative collections since the house was founded in Paris in 1780, and this collection continues that tradition in whimsical fashion, delighting gardeners and jewellery collectors alike.

Rex Whistler and Beverley Nichols

Down the Garden Path, 1932

Printed book, 20.9 × 14.6 cm / 8¼ × 5¾ in
Private collection

Published in 1932, *Down the Garden Path* by Beverley Nichols (1898–1983) was described wistfully by the author as 'a floral autobiography'. It is the story of how he purchased a Tudor cottage, 'Allways', in the village of Glatton, Huntingdonshire (now Cambridgeshire) and tended the extensive gardens. The thatched cottage, originally part of the Glatton Hall Estate, was built around 1540, and is a Grade II-listed Building that once ranked alongside Anne Hathaway's cottage as the most visited Tudor cottage in

England. The previous owner, American architect John Borie, had purchased the cottage with part of the estate grounds, and developed the garden. Although largely devoid of practical horticultural advice, the book, the first of a trilogy called *The Allways Chronicles* (also referred to as the *Glatton Trilogy*), was a popular success, running to many editions. It owes much of its appeal to the beautiful illustrations provided by British artist Rex Whistler (1905–1944), both for the book's cover and within. This particular

drawing depicts, in considerable detail, the formal layout of some of the garden's features that lie behind the cottage that fronts the lane. The elements include a secret walled garden and a small lawn, beyond which is a hedged garden with herbaceous borders dominated by a statue of the Greek god Antinous. Beyond this is a lake with a rockery, while to the right, orchards of cherries and apples are divided by a long pergola of roses.

Gustav Klimt

Garden Path with Chickens, 1916

Oil on canvas, 1.1 × 1.1 m / 3 ft 7 in × 3 ft 7 in

Petunias, zinnias, nasturtiums, asters and other colourful varieties cover the ground of a vibrant garden while glorious spikes of multicoloured hollyhocks tower towards the sky. In the middle of the path, chickens patrol in search of food, pecking at sand grains along the way. Austrian painter Gustav Klimt (1862–1918), one of the most original and celebrated of modern artists, completed *Garden Path with Chickens* in the summer of 1916, at Lake Attersee in the foothills of the Austrian Alps. This is where the artist spent every summer between 1900 and 1916, and where he created fifty-five landscapes that strongly influenced the course of modern art. The painting captures the lush vigour and rapid growth of the many flowering annuals in the beds along the garden path, encouraged by the mild and mostly wet summers beside Lake Attersee. The time spent there provided Klimt with a respite from the hustle and bustle of life in Vienna and the monotony of the portrait commissions that, although highly lucrative, the artist eventually began to find tedious. In 1916, escaping to the lake also meant leaving behind much of the dread caused by World War I, which unavoidably overshadowed everyday life in the capital of the Habsburg Empire. Given the turbulent background against which it was made – defeat in the war would lead to the end of the empire – Klimt's painting captures a glimpse of serenity that is also a plea for peace and normality to return as soon as possible.

Anonymous

My Garden, c.1945

Pencil on paper, 15.2 × 24.6 cm / 6 × 9¾ in
United States Holocaust Memorial Museum
Collection, Washington DC

This rudimentary line drawing of a neatly ordered garden displays the typical charm of a child's artwork but belies a darker story. Among the simply drawn varieties of flowers are aster and elegant clarkia, while V-shaped marks represent a rectangular bed of cress. Yet the image, made by an unidentified orphan at Weir Courtney, a large country house in Surrey, England, contains no hint of the traumatic experiences its creator endured. Following World War II, Weir Courtney's owner, Sir Benjamin Drage, leased the house rent-free, to provide a safe home for twenty-four young Holocaust survivors between the ages of three and sixteen who had been rescued from Nazi concentration camps and sent to England. The home was run by German-Jewish émigré and child therapist Alice Goldberger, who created a caring and nourishing environment for the children. The estate's expansive grounds and gardens provided great scope for outdoor play as much as healing, its orchard, herbaceous borders and greenhouses serving as the backdrop to numerous sports and games when the children were not studying. As this drawing and others in the United States Holocaust Memorial Museum indicate, gardening was an important activity for the children, who worked alongside the estate's gardeners to grow flowers, fruit and vegetables. Goldberger cared for the children at Weir Courtney from 1945 to 1957, helping them to know that, despite what they had witnessed to the contrary, the world was still full of friendly, charitable people to whom they could turn.

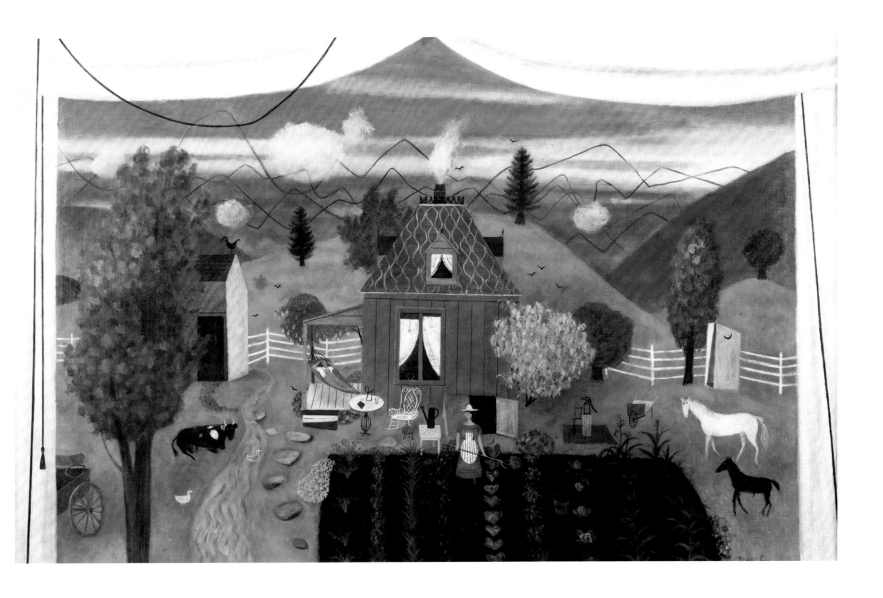

Doris Lee

The View, Woodstock, 1946

Oil on canvas, 69.9 × 111.8 cm / 27½ × 44 in
John and Susan Horseman Collection, St. Louis, Missouri

A woman in an orange dress and white apron tends the garden in front of her home with a pitchfork while a man in overalls relaxes in a hammock on the porch nearby, the whole scene framed by a window and its curtains. This painting by American artist Doris Lee (1904/5–1983) shows her home in Woodstock, New York, where she moved in 1931, becoming a leading member of the artists' colony developing in the area, which was close enough to New York City to guarantee a ready flow of artists back and forth from the country to the city. Lee was an exponent of Scene Painting, which focused on everyday life in order to record what made America *American*: the land, ideals and customs. Here Lee combines pure abstraction – seen in the sketched mountains in the background – with a love of American folk art, reflected in the picture's lack of depth and variable scale. The plants in the vegetable patch are placed in straight lines to maximize the harvest, but also to introduce an element of geometrical regularity in Lee's image. The reclining cow and the watching horses are nods to the domestication of nature, but the empty hills, abstract mountains and foreboding sky are a reminder that not all nature is tamed. Lee's work was frequently dismissed by contemporary critics, partly because of her gender, and also possibly because she went against the trend following the end of World War II, turning not to tragedy and doubt, like many of her contemporaries did, but to creating art that embraced play, wonder, empathy and joy.

Anonymous

Watering pots, 17th century

Earthenware, each 28 × 27 cm / 11 × 10⅝ in
Garden Museum, London

These two rare glazed earthenware pots from the Tudor period in England mark a step in the evolution of the watering can familiar to gardeners today. On the left is a watering or thumb pot, with a flat bottom pierced with small holes (like a modern watering-can rose). *The Florists Vade-Mecum* (1638) describes how such a pot was put into a vessel of water to fill from the bottom and the user's thumb placed over the top to create a vacuum. The water would 'stay in so long as you stop out the air with your thumb at the top;

this serves to water young and tender seedlings for by the motion of your thumb you may cause the water to fall gently upon them more or less as you shall desire'. Such thumb pots were in use throughout the medieval period until the 1700s, when they were superseded by watering pots like that on the right, which were filled from the top. This early seventeenth-century example, which was acquired from West Green House in Hampshire, has a short spout and broad rose. Watering plants has been a necessary part of

plant culture since gardening began. One notable example is a first-century AD silver Roman watering pot that was unearthed in Herculaneum, which was buried in AD 79 in the same volcanic eruption that destroyed Pompeii. For the record, the earliest use of the term 'watering can' appears in a Scottish inventory of 1685: 'Belonging to the yairds ... a wattering can'.

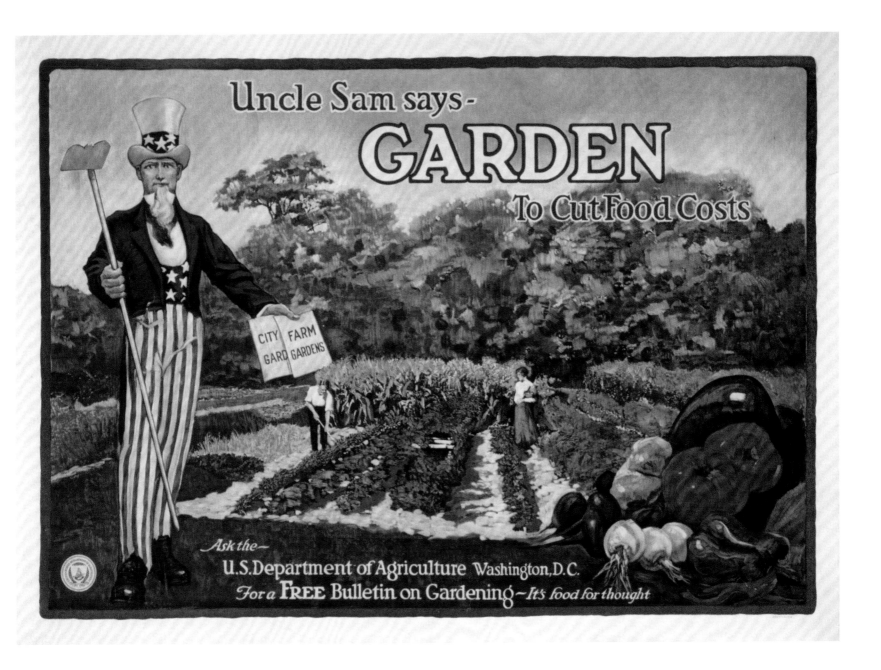

US Department of Agriculture

Uncle Sam Says – Garden to Cut Food Costs, 1917

Lithograph, 39 × 51 cm / 15¼ × 20 in
Library of Congress, Washington DC

'I want YOU for U.S. Army' read the iconic poster of 1917, designed by J. M. Flagg, in which a stern Uncle Sam points at the viewer to call for volunteers for World War I. Here, in his characteristic blue blazer, red tie and star-studded top hat, Uncle Sam – the incarnation of the American government – prompts civilians to garden rather than join the army in this poster from the same year produced by the Baltimore printer A. Hoen & Co. Gardening hoe in one hand and information leaflets in the other, Uncle Sam led a

nationwide campaign that changed Americans' relationship with urban gardening forever. At the time, World War I had negatively impacted food production across the globe.
By 1917 the cost of living in the United States had skyrocketed, leaving many on the brink of poverty and starvation. That same year, riots broke out in US cities just a couple of months before the nation joined in the war in April. In an unprecedented effort, the Department of Agriculture spurred civilians to transform their back gardens, front yards and

any unused lots into vegetable gardens. According to the National War Garden Commission, around 3.5 million gardens across the United States produced roughly $350 million worth of crops by the end of 1917 alone. In an unprecedented turn of events, gardening became a patriotic act. By 1918 so-called Victory Gardens had become established across the country, marking the beginning of what we call community gardening today.

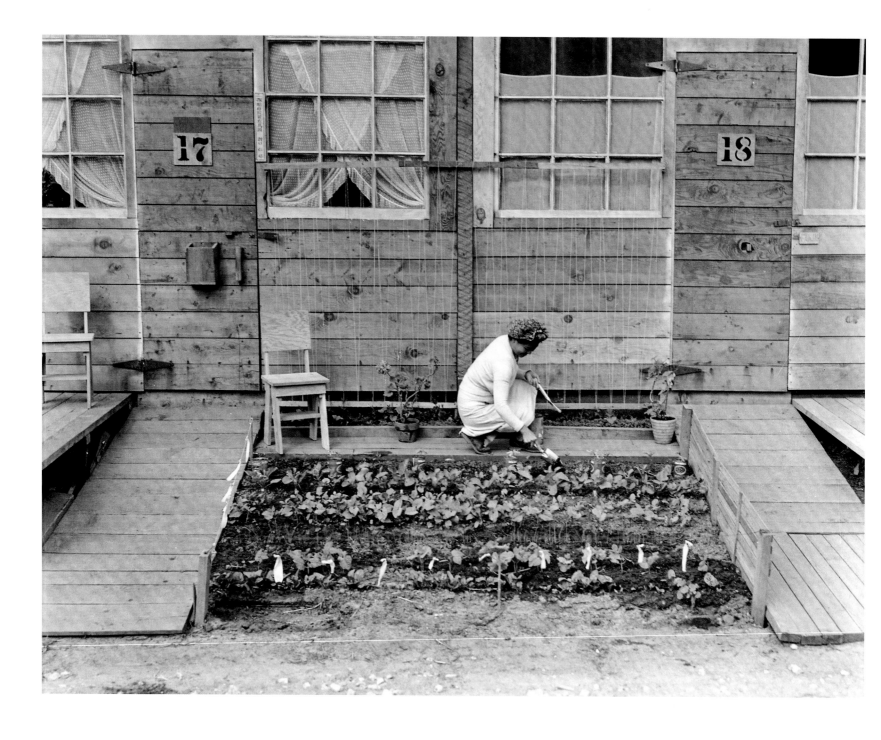

Dorothea Lange

San Bruno, California. Mrs Fujita Working in Her Tiny Vegetable Garden She Has Planted in Front of Her Barrack Home, 1942

Photograph, dimensions variable
US National Archives at College Park, Maryland

One of the most influential photographers of the twentieth century, Dorothea Lange (1895–1965) was also among the first to encourage social change with her critically aware images of disadvantaged people during the Great Depression and World War II. In 1942, already a well-known photojournalist, Lange was hired by the US government to document the forced relocation of Japanese-Americans to detention camps in the aftermath of the Japanese attack on Pearl Harbor that brought the United States into the war. Despite being opposed to the internment policy, Lange accepted the commission with the conviction that a truthful, rather than propagandistic representation of the historical moment might help future generations to avoid such tragedies. Her intentions became apparent in the final prints, and her choice of subjects and editing spoke volumes. The military commanders in charge of the documentary programme seized the images and deposited them in the National Archives. As Lange reveals, life in the relocation camps was dire. Detained Japanese-American families shared temporary barracks and unsanitary eating areas. Each prison camp was an isolated and self-sufficient unit where people grew their own food and reared livestock. This photograph shows Mrs Fujita tending a tiny vegetable garden, an indispensable source of sustenance in the camps. Detainees often grew traditional Japanese vegetables, such as *negi* (Japanese bunching onion), *kabocha* (kabocha pumpkin), *nagaimo* (Japanese mountain yam), *renkon* (lotus root), *takenoko* (bamboo shoots) and *satsuma-imo* (sweet potato).

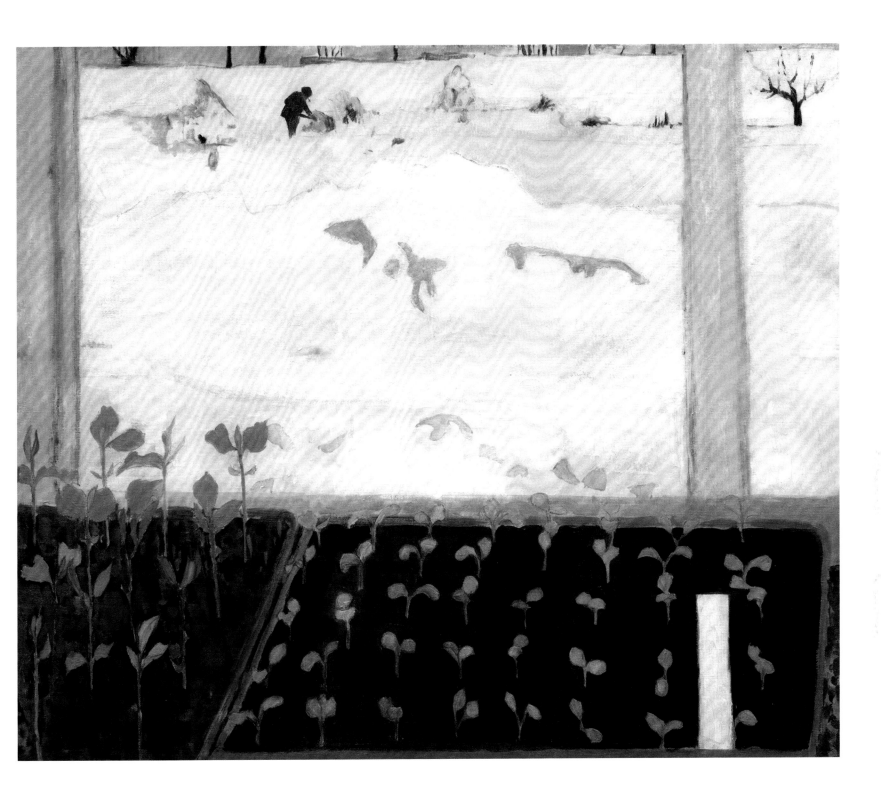

Christiane Kubrick

Plant Trays on a Window Sill, 1970

Oil on canvas, 50.5 × 60.5 cm / 19⅞ × 23⅞ in
Garden Museum, London

Two radically different worlds are divided by a thin sheet of glass – in late winter, seedlings germinate inside the house while outside snow blankets the garden and a gardener uses a shovel to clear buried shrubs. The seedlings in the left tray – most likely peas – have already sprouted young leaves. The sprouts on the right, much younger, are at their cotyledon stage, displaying only the two embryonic leaves upon which their lives depend. The identification label that would tell us what is growing here is turned away from the

viewer. Similar scenes are played out every winter in many regions across the world, as gardeners begin planting seeds indoors in an attempt to make the most of the growing season in areas where summer is relatively short. Seeds are sown indoors in mid-to-late February – a couple of months ahead of time – in shallow trays and placed by an east- or south-facing window to catch as much sunlight as possible. The seedlings will sprout and gain an important head start to the growing season as their roots begin to grow and

establish. Young plants are then transferred to the outside garden after the last danger of frost has passed. In this way, many sun-loving varieties, such as tomatoes, aubergines and peas, will deliver a high-yield harvest earlier in the summer. This scene was painted by German artist and actor Christiane Kubrick (b. 1932) in 1970 at Borehamwood, Hertfordshire, where she lived with her husband, film director Stanley Kubrick, and their three daughters; the man with the shovel is the family's gardener, Bill.

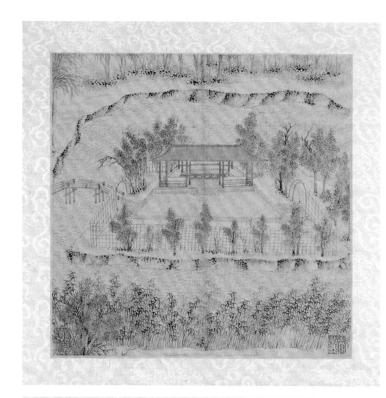

Wen Zhengming

Garden of the Inept Administrator, 1551

Ink on paper, each 26.4 × 27.3 cm / 10⅜ × 10¾ in
Metropolitan Museum of Art, New York

These delicate ink sketches are valuable records of one of China's most renowned historical gardens, the sixteenth-century Garden of the Humble Administrator (also known as the Garden of the Inept Administrator or Zhuo Zheng Yuan), a Classical Garden or so-called scholar garden that was both a spiritual escape from the world and a place to contemplate the mysteries of nature. The garden was created on the site of a run-down temple at Suzhou by Wang Xianchen, a censor during the reign of the Ming dynasty emperor Zhengde.

Begun in 1513, the garden took until 1526 to complete and drew the attention of Wang's friend the renowned artist Wen Zhengming (1470–1559), for whom it became a favourite subject. In 1535 Wen painted an album of thirty-one views of the garden, each accompanied by a poem and a descriptive note. Sixteen years later, at the age of eighty-one, he published this second album of eight leaves, with new views of the garden but the same poems as the earlier volume. In these works, Wen sought to achieve the ideal integration

of the 'three perfections' of art – calligraphy, painting and poetry – to evoke magical moments in the garden. At 5.2 hectares (13 acres) and laid out in three areas around a large lake, the Garden of the Inept Administrator is the largest garden in Suzhou and is still considered one of the finest scholar gardens, although centuries of restoration have made it difficult to identify Wen's views. Today, the garden is laid out mostly according to changes made during the Qing dynasty.

Anonymous

Oval tray, 1279–1368

Carved red lacquer on wood,
16.1 × 23.4 × 3.2 cm / 6⅜ × 9¼ × 1¼ in
Los Angeles County Museum of Art, California

An elaborate garden scene decorates this small, red-lacquered oval tray, intricately carved by an unnamed artist from the Chinese Yuan dynasty (1279–1368). In a large garden pavilion, a gathering of literati has just finished a banquet; the remains of food can be seen on dishes, as one guest nods off over the laden table while another guest leaves, followed by a servant holding a *qin*, a type of zither. The artist's dexterity is clear in the delicately fashioned elements: the contorted shapes of the rockery, the pine needles, flowers,

and a band of *lingzhi* mushrooms that fill the tray's border. The pavilion – an essential component of a Chinese court garden as a location for entertainment and contemplation – is realized in great detail, with its latticed windows, ornamental walls and furnishings. Framing the garden is *diaperwork*, a repeating ornamental pattern of rosettes intended to represent earth and sky. Lacquerwork dates back to Neolithic times, but Yuan dynasty artists mastered the technique. Using resin from the indigenous lacquer tree,

Toxicodendron vernicifluum, the artist brushed transparent layer upon layer on to the wood, a slow and laborious process that required hours of curing before the lacquer was ready to be carved. The spectacular red colour was the result of adding powdered cinnabar to the resin. The popularity of lacquerwork was, in part, down to its longevity: once the lacquer had dried, it was virtually impervious to liquids, meaning it could not easily be damaged and could withstand the test of time.

Anonymous

Villa Lante, Lodge of Palazzina Gambara,
16th century

Fresco
Villa Lante, Palazzina Gambara, Bagnaia, Italy

This fresco illustrates its own location: it is within the loggia of Palazzina Gambara, the right-hand of the two square *casini* that make up Villa Lante in Bagnaia, a relatively small Italian Renaissance garden but now one of the best preserved and least altered. The villa and garden were originally commissioned by Cardinal Gianfrancesco Gambara in the 1560s and completed after his death. The architect Giacomo Barozzi da Vignola designed a garden of four terraces, with the *casini* at the lowest level behind the square *quadrato*, which features the Islamic-inspired Fountain of the Moors, appearing to float within a quadripartite pool. The surrounding beds are shown enclosed by low clipped hedges and with the four *compartmenti* richly planted. Outside the garden wall to the right is the Pegasus Fountain. Behind the *casini* the dramatic garden is aligned on a central axis and the levels united by flowing water. Stone stairs lead around the Fountain of Candles to a wide terrace with a water table and the Fountain of the River Gods. Both are fed by a sloping water chain, the channel of which is carved with crayfish limbs (the crayfish being Gambara's symbol) to break the flow of the water. On the top terrace stands the Fountain of the Dolphins shaded by plane trees, and behind it the two Houses of the Muses flank the grotto-like Fountain of the Deluge. Beyond the garden wall and accessed through a gate set in it is the ornamental woodland of *bosco* or sacred grove, which no longer survives in its original form.

Jacques Fouquières

Hortus Palatinus, c.1618

Oil on canvas, 1.8 × 2.6 m / 5 ft 9 in × 8 ft 6 in
Kurpfälzisches Museum Heidelberg, Germany

This painting of Heidelberg Castle, Germany, shows the Hortus Palatinus, a garden in the Mannerist style popular in the early seventeenth century with regular knots and parterres covering its terraces, some in the latest 'embroidered' style. French Huguenot garden designer Salomon de Caus blasted away the hillside to build the series of terraces, and designed one of the most magnificent gardens of the age – including mazes, trellis galleries, pavilions, a river-god fountain, topiary, sunken beds, an aviary, a grotto,

an orangery, a water parterre, and even an automaton speaking statue of Hercules-Memnon. On a visit to England to marry Elizabeth Stuart, daughter of King James I, the garden's owner, the Elector Palatine Frederick V, met de Caus, who had been making gardens for the English royal family for a number of years, including at Somerset House, Greenwich and Richmond Palace. De Caus was a key figure in the introduction of ideas from the Italian Renaissance garden to England, and the heavy influence of the Villa

d'Este at Tivoli (see p.280) and the now lost Medici garden at Pratolino can be seen in the Hortus Palatinus. Frederick hired de Caus to work at Heidelberg, but the garden was not completed before the Thirty Years War broke out in 1618; in the conflict that followed, the garden was devastated beyond repair. Indeed, none of de Caus's gardens nor any of his remarkable hydraulic automata has survived, and this plan by Flemish landscape painter Jacques Fouquières (c.1580–1659) provides tantalizing evidence of what was lost.

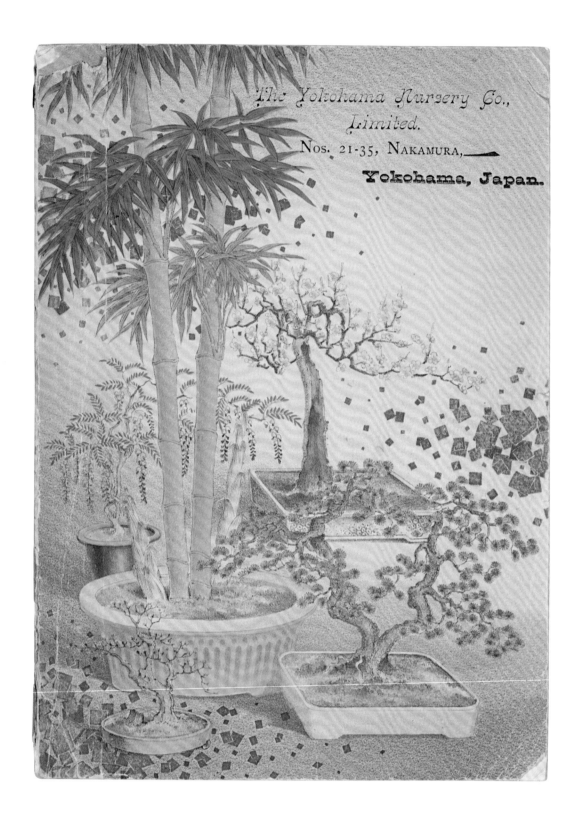

Yokohama Nursery Co.

Trade catalogue, 1900

Lithograph, 27 × 19.6 cm / 10½ × 7¾ in
Caroline Simpson Library, Museums of History NSW, Sydney

Five bonsai trees – or dwarf trees, as they were referred to at the time – appear on the front cover of a Japanese nursery catalogue advertising the company's products, carefully chosen to highlight their range, size, style and variety, as well as seasonal differences and containers, or jardinieres. Bonsai, the practice of miniaturizing trees by pruning their crowns and roots and constraining the root system in shallow pots, aims to produce a tree of aesthetic beauty that would have taken years and in some cases decades to shape

and grow at full size. Inside the catalogue, potential gardeners and growers would have found pages of woodblock prints of flowers and plants and additional information introducing many of the plants to a new market. As the lack of Japanese characters on the cover suggests, this catalogue produced by Yokohama Nursery Co. was aimed specifically at the international market. Japan had only recently emerged from self-imposed isolation, having been forced into a trade agreement with the United States in 1854, and

was now hurriedly promoting its commodities overseas. Capitalizing on the increasingly fashionable *japonisme* aesthetic that became popular in the West during the second half of the nineteenth century, the Yokohama Nursery Co. became globally known, specializing in Japanese plants and flowers, such as bamboo, Japanese laurel, cherry trees and magnolias. Founded in 1890 by Uhei Suzuki in the Japanese city of Yokohama, the nursery later opened branches in such cities as London, Tokyo and New York.

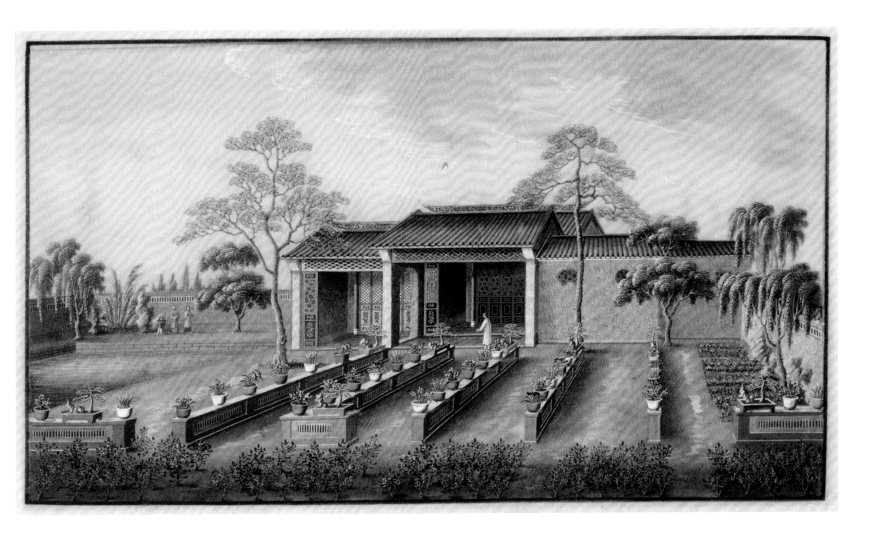

Anonymous

Garden Scene, 1850–70

Watercolour and ink on paper, 18 × 31 cm / 7 × 12¼ in
Victoria and Albert Museum, London

Painted by an unknown artist in the middle of the nineteenth century, this well-manicured garden, dominated by a series of low walls on which glazed pots, filled with flowers and plants including bonsai trees, sit at intervals, is a commemoration of the vast fortunes to be made in the trade between China and the rest of the world. At one end is a pool, while weeping willows and other trees frame an impressive garden pavilion that belonged to a merchant in Canton (present-day Guangzhou) in southern China. Under the Canton System between 1757 and 1842, all European traders in China were restricted to Canton, from where a group of some thirteen Chinese merchants – called the Hong – controlled all business with the rest of the world. As a result of their monopoly, the Hong became fabulously wealthy, building themselves grand mansions with spectacular gardens like this one. The Hong would invite visiting European and American traders to walk in their gardens before dinner and later to enjoy a play or a fireworks display in the garden courtyard. Word spread of the gardens' magnificence, and securing a visit to a Hong garden was an important part of any foreign merchant's itinerary. On display would be bamboo, lichen, ancient water pine trees, and plum and lychee trees, while the fruit and vegetable gardens grew everything the household needed, from Chinese cabbage to pomelo trees. For those who did not get to visit the fabled gardens in person, paintings such as this offered a glimpse into the world of luxury.

William Banks Fortescue

Lady Watering the Garden Room, c.1910

Oil on canvas, 61 × 51 cm / 24 × 20 in
Garden Museum, London

This domestic scene by British painter William Banks Fortescue (1850–1924) is a prime example of a recurring nineteenth-century genre motif that subtly reassessed the cultural conception that plants and gardening should be considered female activities because of the gentleness associated with them. At the time, leading domestic lives, far removed from the world of work and toil, was a matter of pride and virtue to upper-class women. The white dress the woman wears – Fortescue highlights that she is a 'lady' – is far from the kind

of pragmatic gardening outfit she ought to be wearing in the conservatory. But the elegance and whiteness of her attire, framed by the colourful blooms, evokes a purity and uncorrupted beauty that reflect positively on her character. Metaphorically, the painting unwittingly captures the entrapments that women still experienced at the beginning of the twentieth century – a time when, in many parts of Europe, they were still not allowed to walk outside unaccompanied by a man or an older woman. Conservatories such as

the one depicted here became popular in Britain during the nineteenth century as glass-production technology improved, leading to lower costs and more adaptable designs. At that point, they were no longer situated at the end of the garden to grow vegetables, as they had been for decades, but became joined to the house itself. A staple of upper-middle-class homes, the conservatory soon transformed into a desirable space in which to entertain guests and grow exotic plant varieties that were imported from Britain's many colonies.

Eric Ravilious

The Greenhouse: Cyclamen and Tomatoes, 1935

Watercolour and graphite on paper, 47 × 59.7 cm / 18½ × 23½ in
Tate, London

At first glance, this painting of cyclamen and tomatoes in a spacious greenhouse presents a vision of unchanging horticultural tradition, fruit and flowers ripening in a carefully controlled environment. But the unique viewpoint of the scene imparts a sense of delicacy. The vegetation also suggests a natural cycle of growth and decay, the timber and glass of the greenhouse suddenly vulnerable. Eric Ravilious (1903–1942) was a key figure of British interwar modernism, forging a singular vision underpinned by close observation, immaculate

draughting and lively composition. A close contemporary of Edward Bawden, he also revelled in local and domestic scenes. This work – according to the recollection of artist John Nash – was painted at Firle, near Glyndebourne on England's South Downs, while Ravilious was staying with artist Peggy Angus. The Furlongs, Angus's modest rented cottage, featured in several important works and the Downs produced an epiphany for Ravilious after some years at Great Bardfield, Essex, sharing a house with Bawden. The working method in

watercolour adopted by Ravilious, of careful underdrawing, accurate, sometimes exaggerated perspective, and often dry, sketchy colouring, gave his works vivacity and immediacy. Ostensibly undertaking an exercise in order and control, Ravilious – in tune with the times – also conjures a darker side of horticulture, perhaps a metaphor for wider social forces. Ravilious's career was brief but compelling, and this painting came as he approached critical acceptance; sadly, his life was cut short during World War II.

Maxfield Parrish and Tiffany Studios

The Dream Garden, 1914

Favrile glass mosaic, 4.6 × 14.9 m / 15 × 49 ft
Pennsylvania Academy of the Fine Arts, Philadelphia

In the foyer of the former Curtis Publishing Company building, just steps from Independence Hall in Philadelphia, lies a massive glass mosaic mural, a collaboration between celebrated illustrator Maxfield Parrish (1870–1966) and stained-glass experts Tiffany Studios. Commissioned by Curtis, the *Dream Garden* mural is one of the largest Tiffany works in the world, measuring more than 4 metres (15 ft) high and nearly 15 metres (49 ft) long. Based on a painting by Parrish, the mural was constructed in sixteen panels at Tiffany's New York studio from more than 100,000 hand-cut pieces of favrile glass. The glowing, surreal landscape exemplifies the distinctive styles of the two American artists. The tableau opens to a carved marble balustrade surrounded by flowers, trees and a waterfall. The idyllic scene, with classical elements, is typical of Parrish. Sunlit snow-capped mountain peaks appear in the distance and the scene is saturated in colour, including the rich hue known as 'Parrish blue'. Tiffany's unique technique of exposing glass tesserae to molten metals gives the jewel-like surface a shimmering iridescence. It is a lush garden bathed in radiant light, with blooming peonies, morning glories and cascading roses. A large oak, gnarled but mighty, anchors the left side. The scene is thought to have been inspired by Parrish's New Hampshire estate, known as The Oaks. Oddly ethereal, it is both cool and warm, alluring and unsettling. Once threatened by sale, the mural was designated a protected historic object by the city of Philadelphia in 1998.

Isaiah Zagar

*Philadelphia's Magic Gardens, c.*2008

Mixed media installation
Philadelphia, Pennsylvania

When is a garden not a garden? That is the question posed by Philadelphia's Magic Gardens, a remarkable, mosaic-covered art environment and museum in the American city's South Street district that shares the organic profusion and colour of a horticultural garden but created entirely from inanimate material. The gardens' visionary creator, American artist Isaiah Zagar (b. 1939), uses coloured glass bottles, mirror and ceramic fragments, handmade tiles, broken bicycle wheels and fine folk art collected from all over the world to craft

installations that now spread across more than 220 sites. Zagar began the project in the late 1960s, after he and his wife, Julia, moved to the derelict South Street area to open a gallery selling the art of Latin-American folk artists – the first property Zagar covered with mosaics. He then decorated the neighbouring buildings before expanding his vision of the unconventional 'garden' with tunnels, grottoes and entire streets covered in designs that are heavily influenced by the work of different folk artists Zagar met while travelling in

Latin America, India, Morocco, Iran, China and Indonesia. In 2004 the Magic Gardens faced destruction when Zagar's out-of-town landlord called for the installations to be dismantled. Following an outpouring of community support, a nonprofit organization was formed to purchase the land and preserve the project. In 2008 two indoor galleries and a two-storey sculpture garden opened to the public and the thriving cultural hub now hosts tours, art workshops, concerts, temporary exhibitions and events that attract visitors from all over the world.

Njideka Akunyili Crosby

Still You Bloom In This Land of No Gardens, 2021

Acrylic, photographic transfers, coloured pencil and collage on paper, 2.7 × 2.4 m / 9 × 8 ft
Private collection

In this large-scale mixed-media painting, verdant foliage envelops Njideka Akunyili Crosby (b. 1983) and her young child as they sit in a garden teeming with life on the back porch of their Los Angeles home. The plants – which include a fiddle-leaf fig, Madagascar jasmine, *Crocosmia* 'Lucifer' and a *Monstera deliciosa* – reflect a new lexicon for the Nigerian-born artist's work, their presence in Southern California implying the phenomenon of immigrants bringing along plants from their homelands. The artwork is also a celebration of generational motherhood,

countering the historical lack of positive representations of Black mothers in art: in the background, a photo of her illustrious mother hangs from the refrigerator. Akunyili Crosby's passion for horticulture was fostered by a family friend who offered to help transform her Los Angeles garden from a xeriscaped collection of mostly succulents into a space lush with flowers and vegetation. By working in the garden and learning about different types of plants, she began to incorporate into her paintings the garden flora she encountered in Los Angeles, as well as

in eastern Nigeria and Lagos, where she lived until moving to the United States in 1999. In this work Akunyili Crosby uses her distinctive photo-transfer technique, laying into her composition small-scale images from Nigerian pop culture and politics culled from magazine spreads, as well as childhood photographs of her family, to convey a sense of living between multiple cultures. The densely layered surfaces of the garden plants highlight the way in which cultural history, personal memory and identity intertwine to inform the artist's experience of the present.

Anonymous

Garden seat with birds and flowers,
16th century

Cloisonné enamel on copper alloy,
39.4 × 33.7 cm / 15½ × 13¼ in
Metropolitan Museum of Art, New York

As much an object of beauty as of practicality, this sixteenth-century portable garden seat was made by an anonymous craftsman during the Ming dynasty (1368–1644), a high point in Chinese art. The barrel-shaped copper seat, with copper-gilded lion-head handles on each side and a circle of small, plain bosses, or protrusions, surrounding the top and bottom sections of the barrel, was designed to be moved around the garden depending on the time of day or the mood of the viewer. Against a blue background, the sides of the

barrels are a colourful riot of exotic birds, flowers and plants in a profusion of reds, greens, yellow, white and dark blues, while the seat is decorated with mythical animals. The decorative technique of cloisonné arrived in China from Europe some time after the thirteenth century, probably introduced by well-travelled Mongol invaders, and by the sixteenth century it was being used to adorn luxury furniture such as this. Requiring a high degree of skill, the technique involved creating designs on metal objects using outlines of copper

or bronze wires moulded into the desired outlines – the word *cloisonné* comes from the French word for partition – and filling the small segments with coloured glass paste (enamel); once the pattern was complete, the object was fired and then polished until the edges of the cloisons were clearly visible, before gilding was finally added. During the firing process the enamel would shrink, meaning the process had to be repeated several times. The intensity of labour and the time it took to finish a piece made cloisonné very expensive.

Anonymous

Reciting Poetry in a Garden, 1600–25

Glazed stonepaste, 89.5 × 155.9 cm / 35¼ × 61½ in
Metropolitan Museum of Art, New York

In a scene from an eternal springtime, three men and a woman share a picnic, with a bowl of fruit and a flask of wine in a lush garden in Persia, now Iran. Two of the men hold *safinas*, landscape-orientated books typically used for poetry. The man in the centre is writing; the Arabic script on his *safina* is a couplet from a ghazal – a Persian poetic form invoking love, longing and melancholy – by the poet Ḥāfeẓ of Shiraz, reading: 'O king of the virtuous, cries from the sorrow of separation / The heart aches for your presence, it

is time for you to return.' A third man looks on from the left, and a woman approaches from the right, holding a Chinese blue-and-white covered vessel. The figures wear patterned robes and striped turbans, and the woman is represented with an air of propriety, wearing a long silk shawl and golden cap. During the long reign of the Persian emperor Shah ʿAbbās I (1588–1629), the Safavid capital of Isfahan and the city of Na'in were lavishly decorated with tilework in an innovative technique that involved painting square

tiles with garden scenes populated by elegant figures. In the *cuerda seca* technique, water-soluble glazes are separated by thin lines of grease mixed with a dark pigment, to keep them from escaping their demarcated areas. This panel, which probably decorated a wall beneath a window, indicated by the recess at the top, is said to have come from 'a palace pavilion built by Shah ʿAbbās on the garden avenue of his *chārbāgh* in Isfahan'.

Anonymous

Garden scene relief (detail), c.645–635 BC

Gypsum, 58.4 × 139.7 cm / 23 × 55 in
British Museum, London

This scene is less serene than it seems. On the surface, Ashurbanipal, king of Assyria, and his queen, Libbali-sherrat, are dining together beneath a grape arbour, accompanied by servants who wave fans and fly-whisks over the royal couple. The relief comes from the private apartments at the North Palace of Nineveh (present-day Mosul, in northern Iraq), where it forms the uppermost of three tiers of linear carvings. The lowest tier depicts wild marshes, while the middle tier is a scene of cultivated trees and shrubs being

tended by gardeners. The scene here formed the centre of the top tier; a flute, harp and percussion ensemble at the far left serenade the king and queen, more servants carry foodstuffs, and date palms and cedars of Lebanon contribute to the air of a delightful garden party. Yet the apparently domestic scene has been convincingly interpreted as a celebration of a military victory over the kingdom of Elam, in southwest Iraq. In 664 BC the Elamite throne was seized by an anti-Assyrian faction under Teumman. Ashurbanipal declared war against

Elam a decade later, and Teumman was killed, his severed head sent to Assyria; it hangs from the cedar tree to the left, forced to witness the victorious king's lavish banquet. In the relief, the head is shown with the left eyelid lowered over a damaged eye socket, possibly an indirect reference to the evil eye, signifying Teumman's disregard for omens. The relief shows Ashurbanipal at leisure, enjoying the celebration – but with his bow and quiver on the table behind him, immediately to hand should he need to fight.

Upper Rhenish Master

The Little Garden of Paradise, c.1410–20

Paint on oak panel, 26.3 × 33.4 cm / 10½ × 13 in
Städel Museum, Frankfurt

The Virgin Mary, crowned Queen of Heaven, peacefully reads a book in a walled castle garden alive with flowers, plants and birds. She is accompanied by several saints and the child Jesus, who plucks the strings of a psaltery at her feet. On the left, Saint Dorothy picks ripe cherries as Saint Barbara draws water from a well, while on the right, seated by a tree, Saint George (identified by a dead dragon) speaks with the Archangel Michael and Saint Oswald. Exquisitely painted in a late Gothic style by an unknown artist referred to as the

Upper Rhenish Master (active c.1410–1420), this secluded idyll is presented as a place of relaxation and enjoyment. It draws on the medieval philosopher Albertus Magnus's prescription for pleasure gardens and the medieval concept of *hortus conclusus* – Latin for 'enclosed garden' – which interprets lines from the Bible's Song of Songs as a reference to Mary's virginity. The paradisiacal nature of this garden is reflected by the presence of flowers that would not normally be seen blooming together. And although the setting flows from the

artist's imagination, it contains twenty-four identifiable plant species, many of which are traditionally symbolically associated with Mary. Violets symbolize her modesty and white Madonna lilies represent her purity. The rose was another medieval symbol of virginity, and in this garden they grow without thorns, indicating the absence of sin. The primrose, which is still known in Germany as *Himmelschlüsselchen*, meaning 'heaven's little keys', alludes to Mary as the mother of God, opening the door of heaven for humanity.

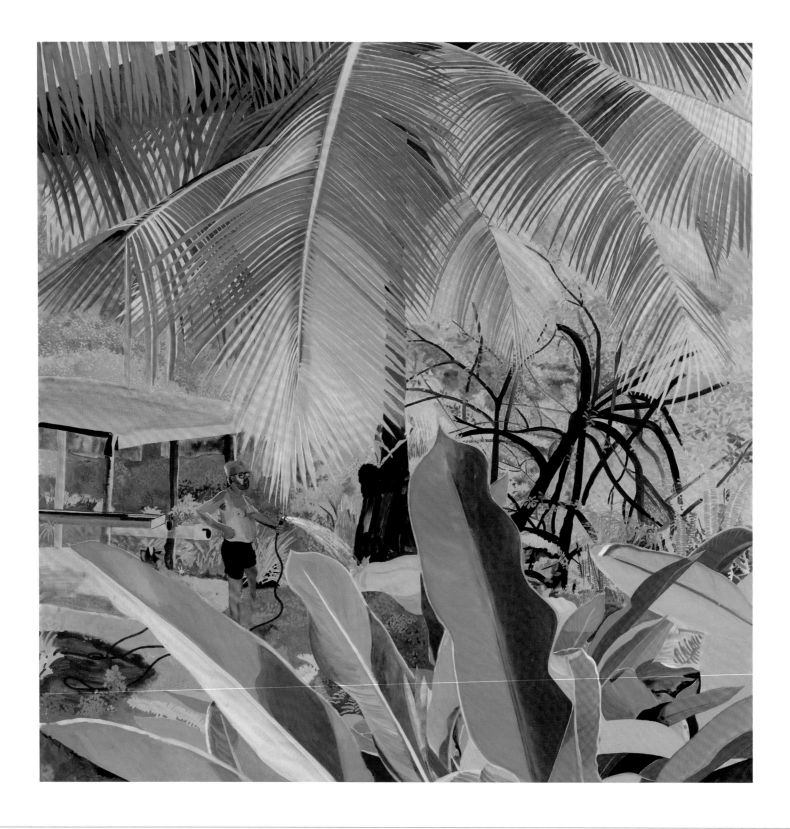

Hulda Guzmán

Gardening, 2022

Acrylic gouache on linen, 1.2 × 1.2 m / 4 × 4 ft
Private collection

Amid the serenity of a rainforest glade surrounded by verdant trees and plants, a man with a hosepipe quietly waters the foliage of a tropical garden. The enormous fronds and leaves dwarf the bespectacled man, making his attempt at gardening appear even more futile. There is something wonderfully absurd about the scene, which uses humour to reflect on a serious theme: the delicate balance between human activity and the planet's most fragile ecosystems. As the painting suggests, even the smallest action can have profound consequences for the natural environment. Nature is a constant source of inspiration to Dominican artist Hulda Guzmán (b. 1984), whose works frequently allude to humans' relationship with the natural world. Although human figures are central to her narratives, nature is also recognized as an important protagonist. Citing the imagined jungle scenes of French painter Henri Rousseau as a major influence, Guzmán paints from her remote beachfront studio on the Samaná Peninsula in the Dominican Republic, where she is surrounded by tropical landscapes and forests. Enamoured with the colours, shapes and textures encountered there, she sketches and paints vegetation from life. Despite this direct engagement with nature, the artist's vibrant and imaginative compositions are highly constructed, their many elements being pieced together digitally on a computer before being committed to canvas. In this way, Guzmán's paintings are reminders of humanity's impulse to manage, cultivate and exploit nature for its own ends – and the scale of that task in the face of the scale of the natural world.

Amelia Peláez

El Jardín, 1943

Gouache on paper, 130 × 96 cm / 51 × 37⅞ in
Private collection

A densely packed, riotous mosaic of tropical colour and exotic vegetation dominates this masterpiece of Cuban modernism, *El Jardín* or *The Garden*, by Amelia Peláez (1896–1968). Peláez was an important figure in the Cuban avant-garde art movement who not only created her own form of Cubism but also was the only woman to be exhibited in New York's Musem of Modern Art's groundbreaking *Modern Cuban Painters* exhibition in 1944. Painting at a time when women had few freedoms in Cuba's conservative society, Peláez drew her material from the domestic space of her home and inspiration from her Havana garden. The tropical garden was filled with a myriad of flora, as she detailed: 'red ixoras; queen's wreath with violet, purple, and blue flowers; crepe myrtles and aralia; or the hibiscus which offers itself in red, cream, yellow, salmon, solferino and hybrid … geraniums, begonias, frangipani, jasmine, orchids; lots of ferns, elephant ears and areca palms'. It is almost impossible to isolate any single flower or plant, however, since they deliberately overwhelm the painting to the point of almost obscuring the mask-like face of the hidden woman. Peláez transforms the plants into curved outlines, large petal shapes set against a series of zigzag patterns and black outlines, the palette of orange, red and yellow giving the garden a fantastical element. *El Jardín* represented something of a departure for Peláez: it is her only painting not to include any of the architectural elements for which she was known.

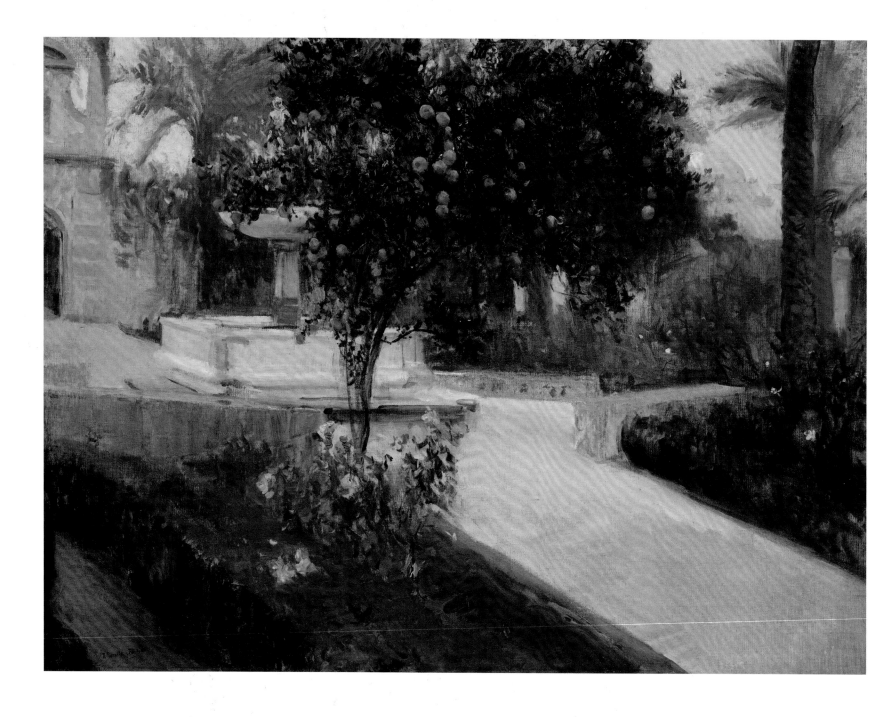

Joaquín Sorolla y Bastida

Jardín del Alcázar de Sevilla, c.1918

Oil on canvas, 76 × 100 cm / 30 × 39⅜ in
Museo Franz Mayer, Mexico City

The bright, warm colours of this painting betray its southern Spanish origin. This view of the renowned garden of the Alcázar Palace in Seville, with its ancient stonework, is dominated by the luscious orange-red tones of a pomegranate tree (*Punica granatum*) that overhangs the footpath, its leafy dark green branches laden with ripe fruit. Below, a profusion of pale pink roses merge with the gleaming pastel colours of the paths and the faintly sketched architecture that surrounds the scene. Tall green palm trees offer shade and seclusion. A small,

compact section of garden is formally separated into flower beds by pale pathways. At their intersection lies a square stone structure, probably a water feature, with a pedestal rising from its centre, supporting a shallow basin with a profusion of flowers and the suggestion of a classical statue. The extensive gardens of the Alcázar bring together different cultures and styles stretching back to the 1200s, including the Islamic-style sunken Garden of the Maidens, planted with citrus trees, and the Courtyard of the Cross, where palm trees rise over four

square compartments lined by clipped hedges. The gardens have provided recreation and food for centuries since the heart of the complex was constructed for the Moorish governor of Al-Andalus. Nearly two hundred species of plant flourish there, including fruit and palm trees, herbs and fragrant shrubs, some of Mediterranean origin, others from the Americas, Africa and Asia. Born in Valencia, Spanish artist Joaquín Sorolla y Bastida (1863–1923) returned frequently to the Alcázar, painting the gardens in different periods of his life.

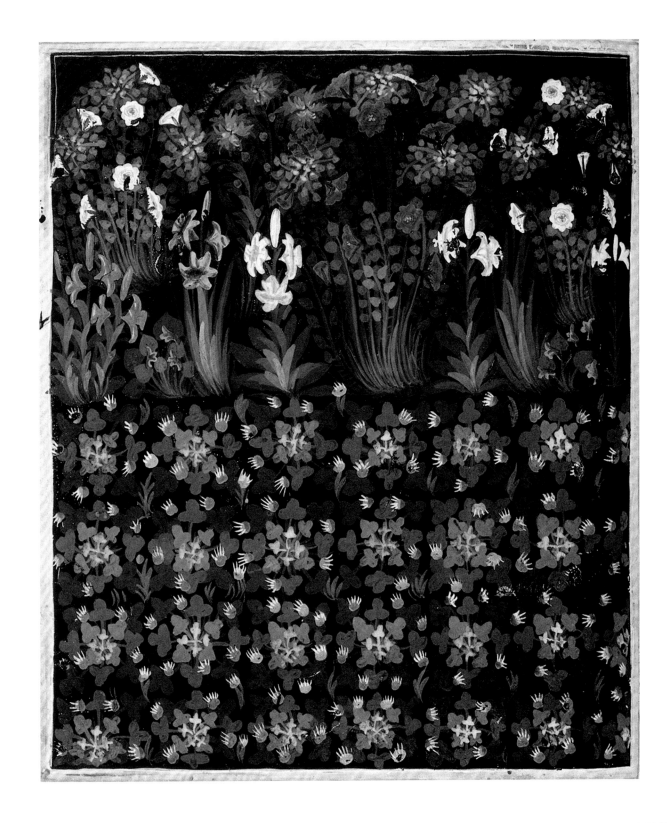

Pacino di Buonaguida

Detail of a miniature, from the
Regia Carmina, c.1335–1340

Colours and gold on parchment, 49 × 35 cm / 19¼ × 13¾ in
British Library, London

This lush image of a garden in bloom – the work of Pacino di Buonaguida (active *c*.1300–*c*.1350), a highly respected medieval artist working in Florence during the first half of the fourteenth century – is an allegory of the city as a garden, and specifically the Italian city of Prato, which in Italian means 'lawn'. Part of a book so rare that only three copies are still in existence, this exquisitely detailed image, along with many others, illustrates a poem by Convenevole da Prato inviting Robert of Anjou, who between 1335 and 1340 became the ruler of the kingdom of Florence, to protect Prato and bring stability to the Italian peninsula. Di Buonaguida's illumination places the focus firmly on the vegetation, the leaf patterns and blooms, while the landscape is occluded by a thick wall of white and red roses, climbing high above the ground. Above them, corners of a lapis lazuli-blue sky are just barely visible, enhancing a sense of enclosed protection – something of particular importance to medieval towns. The lilies in a row facing the viewer are mostly botanically correct, but the foliage varies dramatically from plant to plant, even though all of them carry lily blooms. In the lower portion of the garden scene, the illumination is filled with a patterned motif of ground cover – perhaps clover, given the shape of the leaves, and campanulas – that echoes Middle Eastern tapestries and Byzantine mosaics.

Christophe Guinet (Monsieur Plant) *Plant Your Mac!*, 2020

Mixed media, 60 × 32 cm / 23⅝ × 12⅝ in
Private collection

Inside the hollowed-out screen of a late 1990s Apple Macintosh computer, the artist Christophe Guinet (b. 1977) has created a terrarium garden featuring Venus fly traps and sarracenia that raise their trumpet pitchers to a clear blue sky formed of the computer's translucent plastic shell. Terrariums, transparent containers (usually of glass) in which plants are nurtured, allow controlled, precise growing conditions. Here, the computer's case provides a humidity suited to the tropical flora chosen by the artist, while in other works from the series, green papyrus stems shoot upwards from the sleek silver tower of a G5 desktop computer and spiked cacti burst from between the buttons of another computer's mouse. As Guinet's artistic moniker, 'Monsieur Plant', suggests, his creative practice holds nature as a central concern, and his series offers a commentary on the pervasive creep of computer technology into daily life. The choice of computer model for this piece is particularly apposite, since it was the success of the iMac G3, originally styled by British designer Jony Ive, that paved the way for Apple's iPhone, hence signalling the beginning of a transformative new era of internet-ready consumer electronics. Guinet's terrarium literally disrupts the spectacle of cyberspace, conceiving capitalism's objects of mass production as jungle-bound ruins and replacing the addictive entrapment of social media's image culture – the irony of whose fixation with houseplants and terrariums is not lost on the artist – fittingly, with carnivorous plants.

Lori Nix and Kathleen Gerber

Botanic Garden, 2008

Paper, styrene, foam, epoxy, beads, acrylic paint, living plants, 1.2 × 1.2 × 2.4 m / 4 ft × 4 ft × 7 ft 9 in Private collection

A botanic garden lies in ruin, its iron-framed roof collapsed and the tropical plants within – orchids, palms and ferns – withering, although they retain some of their bright colours. The dystopian world of American artist Lori Nix (b. 1969) and her collaborator Kathleen Gerber (b. 1967) is clear in the dark, foreboding photographs the pair creates of a desolate world devoid of people, the result of both human-made and natural disasters – yet such images are entirely created by humans. Before she can begin to photograph,

Nix painstakingly constructs complex disaster dioramas out of foam, board, paint, plaster and wood on her tabletop. This image from 2008 – part of a project, *The City*, that ran from 2005 to 2013 – shows what is no longer a place of exotic beauty but a collection of shrivelled plants and a dried-up pond, suggesting that, whatever their lush vegetation might convey, the plant life of the botanic garden is utterly dependent on humans, so removed from its natural state that it cannot survive alone. In other photographs in

the series, such as *Chinese Take-Out* and *Beauty Shop*, Nix and Gerber show a decaying New York – they live and work in Brooklyn – overtaken by an absence of care. For Nix, growing up in the Midwest with often cataclysmic weather and a diet of 1970s disaster movies, it has become her life's work to illustrate what happens in the aftermath of the catastrophe that might come at any time if humanity fails to nurture and protect the planet.

Anonymous

The Unicorn Rests in a Garden,
from the *Unicorn Tapestries,* 1495–1505

Fine wool and silk with silver and gilded threads,
3.7 × 2.5 m / 12 ft × 8 ft 3 in
Metropolitan Museum of Art, New York

One of seven tapestries by an unknown artist depicting a hunt for a magical unicorn, this scene of the captured creature in a garden is among the most exquisite and complex works of art to survive from the late Middle Ages. The tapestry is rich in secular and religious allegory. The unicorn, sitting contentedly in a flowery mead, appears loosely secured with a gold chain to a pomegranate tree and constrained by a low circular fence, but could easily jump over the enclosure to escape. The circular collar and fence

represent marriage vows; the gold chain, the chain of love, signifies the happy ending to a hunt as the prized animal is finally brought into captivity. The large purple orchid in the centre was reputed to have roots that would help beget a son, and the flowering plant bistort was used to help women conceive. In the lower right, the frog hidden among the violets was noted by medieval writers for its particularly noisy mating calls. The unicorn's body is splashed with red juice from the ripe, seed-laden pomegranates – another medieval

symbol of marriage and fertility. In Christian symbolism the seeds represented the incarnation of Christ – the red of his blood with the King's crown at the top of each individual fruit. The large iris in the foreground is associated with the Virgin Mary; its blue flowers mirror the colour of the garment in which she is often portrayed, and the sharp-edged, sword-shaped leaves represent her sorrow. White Madonna lilies symbolize Mary's purity, while the large carnations are said to have grown from her tears during Christ's Passion.

Anonymous

Prince Humay meets Princess Humayun in a Dream, 1430–40

Ink, colours, gold and pewter on paper,
29.2 × 17.9 cm / 11½ × 7 in
Musée des arts décoratifs, Paris

The only surviving folio from a lost illustrated manuscript, this vibrant Persian watercolour depicts the epic romance of *Humay and Humayun*. Written by Persian poet and Sufi mystic Khwaju Kirmani in 1331, the poem tells the tale of Prince Humay, who is shown a picture of the daughter of the emperor of China, Princess Humayun, by the Queen of the Fairies. He falls in love and sets off to find Humayun. He has adventures and setbacks, many drawn from traditional Persian folklore, but finally wins not only her hand but also the throne of China. Gardens feature prominently in *Humay and Humayun*, from the garden of the fairies to a tulip garden on the way to the emperor's hunting grounds, and the Samanzar Garden near the palace, to which only Humayun has access. After spending the night in the private quarters of the palace while the emperor is away, Humay must pass through this garden, where he kills a gardener who spies him. He is locked in a tower by the emperor, but escapes and returns to the palace, pleading with Humayun to allow him to enter again. She refuses, but later has second thoughts and searches for Humay in the garden. This image, showing a corner of an enclosed garden at night, may reflect the scene in which she finds him in the dark. Executed in the brilliant, decorative style of Persian art, this illustration belongs to the Timurid period of Persian painting, when the Mongol conquerors brought Chinese artistic styles west, but there is no Chinese influence to be found in the pure colours and formalized trees and flowers.

Anonymous

Jacques Majorelle in his garden
in Marrakech, c.1923–1956

Photograph, dimensions variable
Private collection

Wrapped in a silk robe, French Orientalist artist Jacques Majorelle (1886–1962) stands next to the lily pond in the renowned garden he created for himself in the 1920s on a 1.6-hectare (4-acre) plot he bought on the edge of a palm grove in Marrakech, Morocco, later commissioning architect Paul Sinoir to create a Cubist villa, workshop and studio. Majorelle had studied at the École des Beaux-Arts in Nancy and in Paris before travelling widely and developing a lifelong passion for flora and fauna. The garden became his obsession, and he implemented a colourful fusion of Islamic design, botanical collection and living painting. In 1937 he created the famous Majorelle Blue to paint the buildings and walls. Majorelle planted cacti, succulents and other plants from around the world among serene pools and rills, filling his canvas with rare and unusual species. Peacocks, monkeys, tortoises and flamingos roamed the garden, adding to the sense of the exotic. Majorelle sold his paintings to finance his plant-hunting expeditions, and even traded them for rare cacti. He wrote to a friend that he was 'waiting for an exhibition in Casablanca to replenish my finances which have been gravely depleted by my investment in the garden … You will eventually see that this voracious ogre of a garden which has been exhausting me for twenty-two years will need another twenty before it satisfies the angels in paradise.' After his death, the garden fell into decay, until it was bought and respectfully restored by fashion designer Yves Saint Laurent and his partner Pierre Bergé.

Henri Matisse

Periwinkles/Moroccan Garden, Tangier, 1912

Oil, pencil and charcoal on canvas,
116.8 × 82.5 cm / 46 × 32½ in
Museum of Modern Art, New York

In this almost hallucinatory scene, French artist Henri Matisse (1869–1954) uses lively brushwork, rich colours and bold shapes to describe the essence of a sun-soaked Moroccan garden. Like many European artists before him, he was intrigued by the perceived exoticism of Northern Africa, which had first been romanticized in art by Eugène Delacroix in the early nineteenth century. Matisse visited Tangier in 1912 and, after several days of heavy rain restricted him to his hotel room, he was eager to venture out and find subjects. He soon discovered the luxuriant gardens belonging to Jack Brooks, an Englishman living in a private villa overlooking the Bay of Tangier on one side and the Moroccan countryside on the other. Finding inspiration in the lush vegetation, Matisse set to work in a secluded corner of the garden, where towering trees spread their foliage high and wide. In this nearly abstract canvas – one of three identically sized paintings made in the same location – Matisse uses just a few thin washes of pigment, reducing flowers, plants and trees to elemental forms, and minimizing detail with a palette limited to green, purple, grey, yellow and pink. In addition to *Periwinkles*, which actually contains only a small scattering of the purple flowers, he painted *Palm Leaf, Tangier*, and *Acanthus*, which depict the titular plants in varying degrees of detail. The experience of painting in Morocco had a profound impact on Matisse, influencing his approach to colour, form and composition for the rest of his career.

Anonymous

Paradise Garden mural, 1570–85

Fresco
Monastery of the Divino Salvador, Malinalco, Mexico

This is a vision of the Garden of Eden – but one far removed from the Western artistic tradition. The landscape of cacti and indigenous animals roots this vision of Eden firmly in the Aztec world of sixteenth-century Mexico, where it was created. When the Spanish arrived in Mexico in 1519, they were intent not just on plundering Mexico's gold and silver but also on spreading their Catholic faith to the Indigenous people. To that end, they erected monasteries and churches across the newly conquered land, such as

the former Augustinian monastery of Malinalco (originally called San Cristobál and now known as Divino Salvador), close to Mexico City. It was at Malinalco in 1974 that archaeologists discovered these garden frescoes, which had been concealed under plain paint for centuries, entirely covering the ceiling and upper walls of the monastery's cloisters. The frescoes were the work of anonymous Indigenous *tlacuilos* – a Nahuatl word meaning literally 'the ones who work in stone or wood' – who were highly skilled local artists, both

male and female, schooled in the Aztec culture and the Nahuatl language, and acted to interpret the Aztec world to the conquerors. The Spanish achieved their aim of telling the biblical story of Adam and Eve and the Garden of Eden, but in a pictorial style that would have been familiar to Indigenous converts to Christianity, using plant-based dyes to depict the local flora and fauna in images that reflect the world of the Aztec rather than that of their oppressors.

Lucy Culliton

Hartley Cactus Garden, 2007

Oil on board, 60 × 60 cm / 23⅝ × 23⅝ in
Private collection

Emphasizing the austere beauty of a range of cacti, including prickly pears and many agaves or aloes, a scarlet ground covered in bloom accentuates their sculptural quality in this vibrant dry garden near the community of Hartley on the edge of the Blue Mountains of New South Wales in Australia. Devoid of human or animal life, with a harmonious colour palette, the painting induces a sense of calm and stillness. Australian artist Lucy Culliton (b. 1966) focuses on nature in her work – the domestic animals on her home farm

and the plants that thrive there – and uses her art to invite the viewer to empathize with the natural world. There are no native cacti in Australia, so the varieties in this garden have all been imported and naturalized since colonists arrived on the continent in 1606. Some species have adapted particularly well to local arid climates and now pose a serious threat to the balance of fragile native ecosystems. Prickly pears were introduced to Australia in 1787 to breed cochineal insects, which are used in the fashion industry to make red

dye. It is estimated that by the 1920s the plant had colonized 24.3 million hectares (60 million acres) in New South Wales and Queensland alone, making the land unusable and causing ecological havoc. The infestation was brought under control by the introduction of the cactus-feeding larvae of the American moth *Cactoblastis cactorum*. Growing prickly pears and several other varieties of cactus is still illegal in some parts of Australia today.

Anonymous

Model of a porch and garden, c.1981–1975 BC

Wood, paint and copper, 39.5 × 84.4 × 42.5 cm /
15½ × 33¼ × 16¾ in
Metropolitan Museum of Art, New York

This replica of an ancient Egyptian portico and walled garden from the Middle Kingdom (c.2030–1650 BC) was found in the tomb of Meketre, chancellor and chief steward to three successive pharaohs. The tomb, on the west bank of the Nile at Thebes (now Luxor), had been robbed in antiquity, but an undisturbed chamber discovered during cleaning operations in 1920 contained twenty-four almost perfectly preserved models. The porch roof is supported by eight painted columns in two rows; the rear columns

have capitals in the shape of bundled papyrus stems, while those in the front row have lotus-stem capitals. Three dowels in the roof represent rainwater spouts. Behind the columns are three doors: the large central double door, probably indicating the entrance to the main living room of the house, is surmounted by a latticework grille; two smaller doors stand on either side. The courtyard garden comprises seven sycamore trees with red fruit, surrounding a miniature pond lined with copper. Unlike the public face

of the tomb chapel with its statue, where family and friends might leave gifts for the care of the dead man's *ka*, or soul, the fact that this model was found in a secret chamber in association with the coffin suggests that it was meant to be accessible only to the dead Meketre, not to the living. As such, the garden functioned not as a token of the life that was, but on an independent plane of existence, as a symbolic stage for eternal life where the soul of Meketre might enjoy his garden in perpetuity.

Anonymous

Palace Garden of Hezar Jarib in Aliabad, c.1600–49

Gouache on paper, 33 × 22.1 cm / 13 × 8¾ in
Rijksmuseum, Amsterdam

Full of architectural and horticultural detail, this garden portrait shows an imposing palace building in the Hezar Jarib gardens in Isfahan, central Iran. Tree-lined irrigation channels punctuated by water fountains divide pale-green lawns on which roses and anemones are spread like the decoration of a Persian rug or illuminated manuscript. The building, with its blind arches, tall blue painted *iwan* portico and terraces holding sycamore trees, may be an idealized amalgam of several of the original garden structures, which

included a grand gatehouse, a tall central pavilion, a *caravanserai* enclosure and four dovecotes, one at each corner of the garden's walls. The Hezar Jarib was built as a pleasure garden in the southern suburbs of Isfahan by Shah ʿAbbās I, the greatest ruler of the Persian Safavid dynasty. During his reign from 1588 to 1629, Isfahan, lying at the confluence of two major trade routes, became the capital of the Safavid Empire, and the finest architects were brought there to create gardens, palaces and mosques that would reflect ʿAbbās's

power. The garden's name relates both to its size and to its foremost status: the Persian word *hezar* means 'one thousand' while *jerib* or *jarib* refers to a traditional square plot of land for farming. The original garden, which does not survive, was laid out as a large grid of square enclosures holding both fruit and decorative trees for shade, irrigated by a series of canals that brought water from the Zāyandeh River.

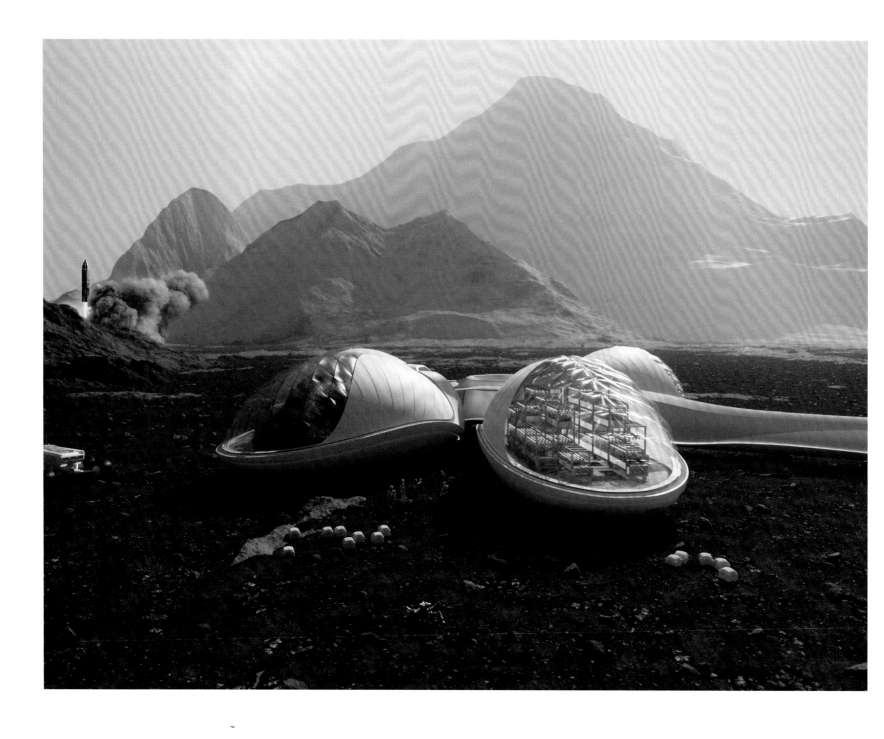

Interstellar Lab

Experimental Bioregenerative
Station (EBioS), 2023

The future is here. BioPod is an inflatable controlled-environment module designed to create the perfect climatic conditions to grow plants everywhere on Earth and soon in space. A number of BioPods will ultimately be connected together to form EBioS – Experimental Bioregenerative Station – a modular, scalable station designed to support a crew of astronauts on the moon or, as here, on Mars, with nutrition, air and water. EBioS is comprised of different functional pods that, when assembled together, form this closed-loop system: a living habitat unit, a precision agriculture unit for food production, a more traditional greenhouse unit with fruit trees, and a waste-management system unit. Backed by NASA and CNES, the French national space agency, Interstellar Lab is developing the modules to support future interplanetary space colonization, since experts predict that it could take a thousand years to make Mars suitable for supporting vegetation from Earth. BioPods also have a more immediate purpose, allowing the cultivation of high-value plants for the food, cosmetics and pharmaceutical industries where traditional agricultural methods cannot be used. BioPod works as a self-sustaining system using advanced aeroponics crop-cultivation technology combined with AI management, an autonomous monitoring software, as well as a nutrient-dosage system, to reduce energy and water consumption, and boost yield. Plants were successfully grown on early space flights and on space stations orbiting Earth, but with support from the world's leading space agencies, Interstellar Lab has the potential to change agriculture forever.

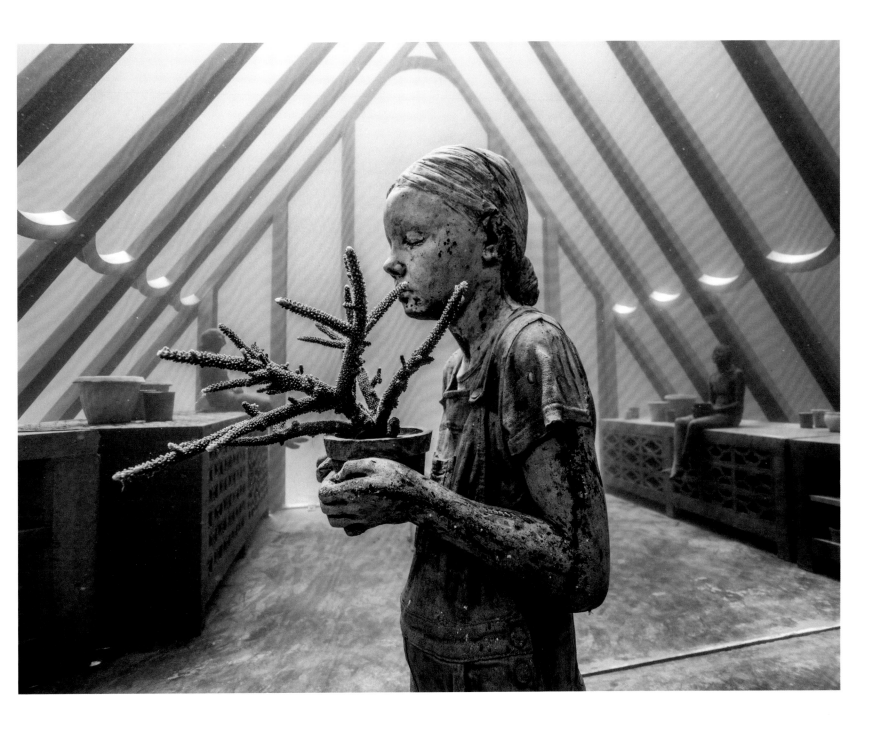

Jason deCaires Taylor

The Coral Greenhouse, 2019

Stainless steel, zinc, pH-neutral cement,
basalt and aggregates, installation view
John Brewer Reef, Australia, Pacific Ocean

The young gardener clutching a pot of coral in this serene underwater scene is one of many similar sculptures divers can discover at *The Coral Greenhouse*, an ambitious submerged artwork installed at John Brewer Reef, off the coast of Queensland, Australia. Created for the Museum of Underwater Art by British sculptor Jason deCaires Taylor (b. 1974), the exhibition mingles marine science, coral gardening and environmental art to increase understanding and appreciation of the Great Barrier Reef and its ecology, currently under

threat from the effects of climate change, marine pollution and overfishing. The 150-tonne (165-t) greenhouse and accompanying sculptures are made from pH-neutral cement compounds and corrosion-resistant steel, which encourage coral to grow in and around the otherworldly structure. Inside, sculptures of children tending coral cuttings are accompanied by workbenches and gardening tools designed to provide homes for marine creatures and refuges for small fish to hide from predators. Above, the greenhouse's beams provide

a place for fish to congregate in shoals, while around it, on the seabed, are large planters filled with coral and floating trees modelled on the eucalyptus and umbrella palms found on land. A two-hour boat journey from the coastal city of Townsville takes visitors to the site of *The Coral Greenhouse*, which stands on the sandy seabed 12 metres (40 ft) below the surface. The gradual colonization of the structure by marine life increases not only its appeal as an attraction for divers, but also its importance as a site of scientific study.

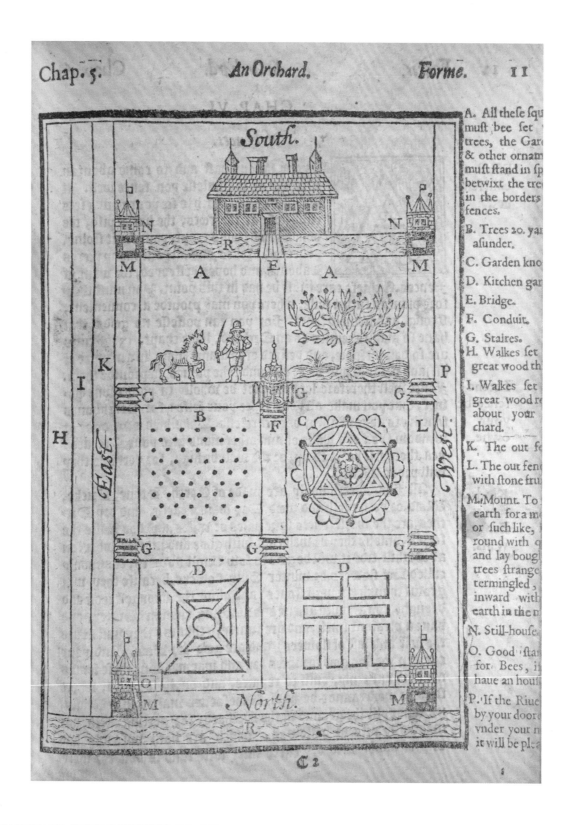

A. All these squ[...]
must bee set [...]
trees, the Gar[...]
& other ornam[...]
must stand in sp[...]
betwixt the tre[...]
in the borders [...]
fences.

B. Trees 20. yar[...]
asunder.

C. Garden kno[...]

D. Kitchen gar[...]

E. Bridge.

F. Conduit.

G. Staires.

H. Walkes set [...]
great wood th[...]

I. Walkes set [...]
great wood r[...]
about your [...]
chard.

K. The out f[...]

L. The out fen[...]
with stone fru[...]

M. Mount. To [...]
earth for a m[...]
or such like, [...]
round with [...]
and lay boug[...]
trees strange[...]
termingled, [...]
inward with [...]
earth in the n[...]

N. Still-house[...]

O. Good sta[...]
for Bees, i[...]
haue an hou[...]

P. If the Riue[...]
by your door[...]
vnder your [...]
it will be ple[...]

William Lawson

A New Orchard and Garden, 1623

Woodblock print, 18.3 × 13.5 cm / 7¼ × 5½ in
Wellcome Library, London

This plan of an ornamented orchard, first published in 1618, is among the best-known garden images of the early seventeenth century. It shows a late Elizabethan garden divided into six sections spread over three terraces, with staircases and walkways, a fountain and four mounts – raised areas at each of the garden's corners that provided a view over both the garden and the countryside beyond. The plan first appeared in *A New Orchard and Garden* by Yorkshire cleric and experienced practical gardener William Lawson (1553/4–1635), which ran

through several editions and other compilations. Lawson also wrote the separately paginated *The Country Housewife's Garden* (1617), the first English gardening book expressly addressed to women gardeners, which contained additional advice on herb and kitchen gardens, flower knot gardens, and 'the husbandry of bees'. *A New Orchard* was based on almost five decades of experience, stretching back to the Elizabethan era. Although undoubtedly formal, this plan expresses the utilitarian regularity of late Tudor gardens rather than any

grandiose formality associated with the Italian and French Renaissance, which, by the seventeenth century, was influencing aristocratic English garden design. In writing about 'the forme' of an orchard, Lawson included this idealized plan and proposed ornaments including walks, mounts, mazes, flower beds, berry borders, vine-clad seats, beehives, access to a river for fishing or a moat for rowing and even a bowling alley or 'a paire of Buts, to stretch your armes' – in all, 'Nature corrected by art'.

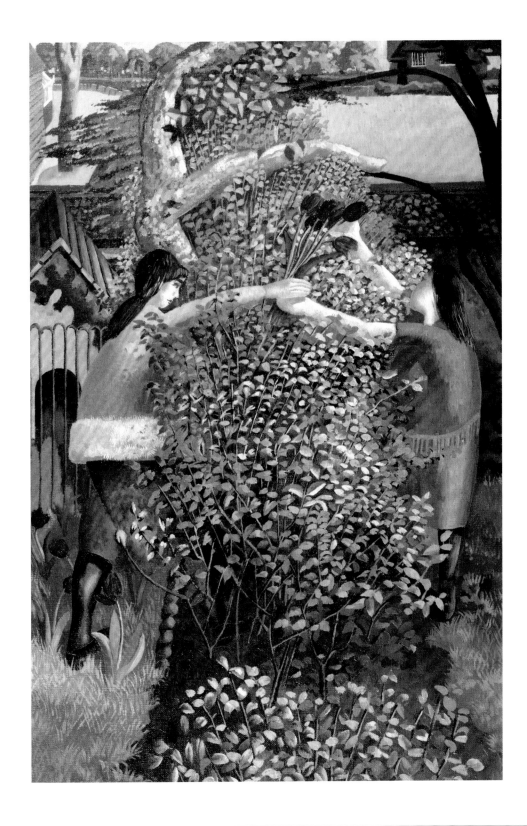

Stanley Spencer

The Neighbours, 1936

Oil on canvas, 95 × 70 cm / 37½ × 27½ in
Stanley Spencer Gallery, Cookham, Berkshire, UK

Giving flowers is an enduring act of horticultural generosity. Here, English painter Stanley Spencer (1891–1959) depicts two young women exchanging red tulips, the recipient on the right being his sister, Annie. *The Neighbours* records adjoining properties in the village of Cookham, just west of London: Fernlea, on the right – the Spencer family home – is divided by a privet hedge from Belmont on the left. Plants and gardens were a recurring theme in much of Spencer's work, and here domestic touches enliven the composition and religious allusions suffuse the work. Spencer's family and his beloved Cookham drove his creative expression. Before serving in World War I, Spencer had trained at London's Slade School of Fine Art, where his contemporaries included fellow modernist Paul Nash. Even at that early date, the precocious and prolific Spencer transposed stories from the Bible to his Cookham birthplace, often including biblical characters alongside identifiable villagers. This work was conceived as an ink drawing to represent April in *The Chatto & Windus Almanack 1927*, tulips perfectly illustrating the spring. Spencer reworked the scene in oils almost a decade later in a series depicting domestic scenes of his childhood and marriage to Hilda Carline. But there were dark undertones to *The Neighbours*. By 1936, Spencer's domestic life was in turmoil, driven by his erotic obsession with the artist Patricia Preece. The intensity of his compositions matched his visionary desires for life and art, but it was a vision often in advance of contemporary thought.

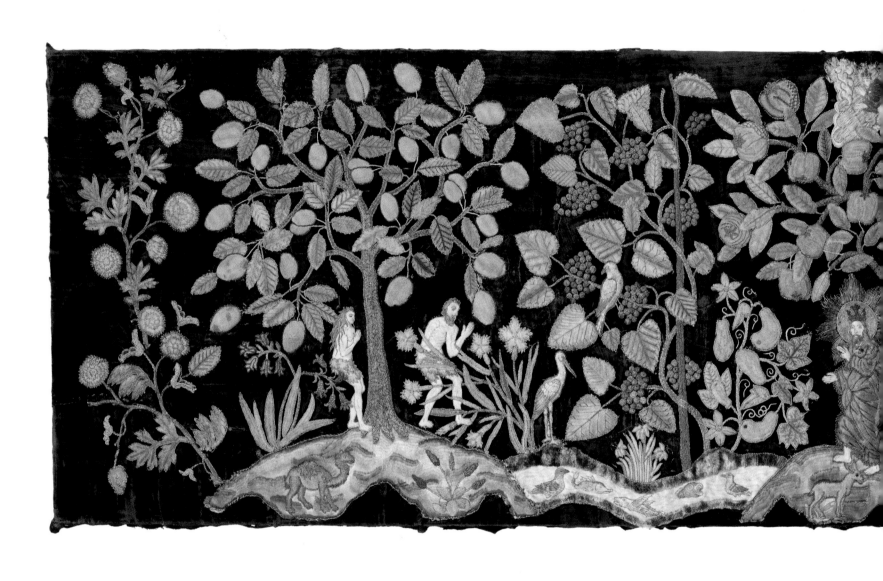

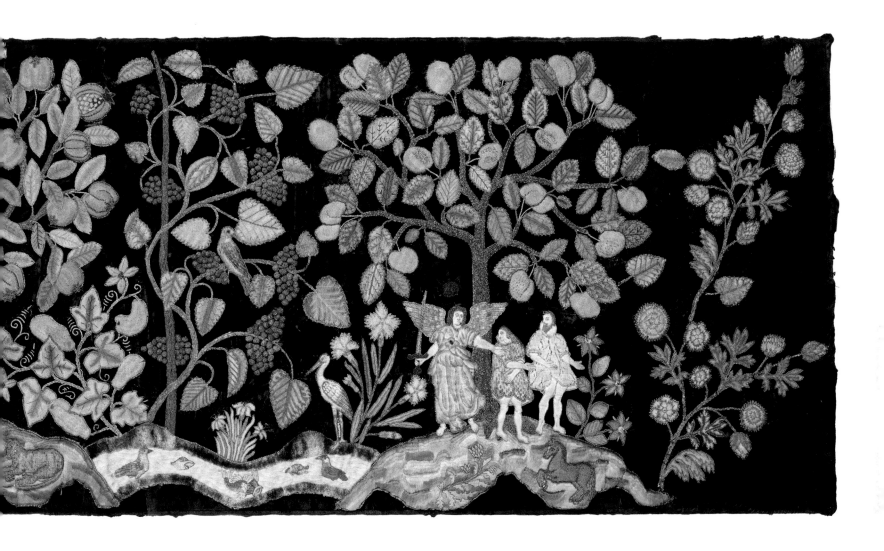

Anonymous

The Garden of Eden, c.1575–99

Velvet worked with silk and metal thread,
57.2 × 203.2 cm / 22½ × 80 in
Metropolitan Museum of Art, New York

Once part of a set of valances adorning a tester – the wooden canopy above a four-poster bed – this dazzling representation of the Garden of Eden is the result of painstaking stitchwork. Such pronounced realism makes ripe purple grapes, yellow squash plants, golden apple and red pomegranate trees, blush-coloured carnations, brilliant blue borage and pink thistles all readily identifiable. Across the bottom of the valance a river flows through the garden, its waters and banks populated by a variety of animals

including wading birds and ducks, fish, a camel, a horse and a leopard. Charged with symbolic religious meaning, the plants in the garden anchor the story of the Fall of Man, the expulsion of Adam and Eve from the Garden of Eden being depicted in three consecutive stages. On the left-hand side of the panel, Adam and Eve appear naked – they are one with the animals and plants in the idyllic Garden of Eden. At the centre of the image, God stands beneath a pomegranate tree symbolizing resurrection and

life everlasting, and warns the couple to stay away from the Tree of the Knowledge of Good and Evil. On the right-hand side, Adam and Eve are expelled from the Garden by Jophiel, the sword-wielding angel of beauty and guardian of Eden. Now eternally aware of their nudity, guilt-ridden and ashamed, Adam and Eve are destined to live in a fraught world, the harmony and peace that characterized Eden for-ever eluding them.

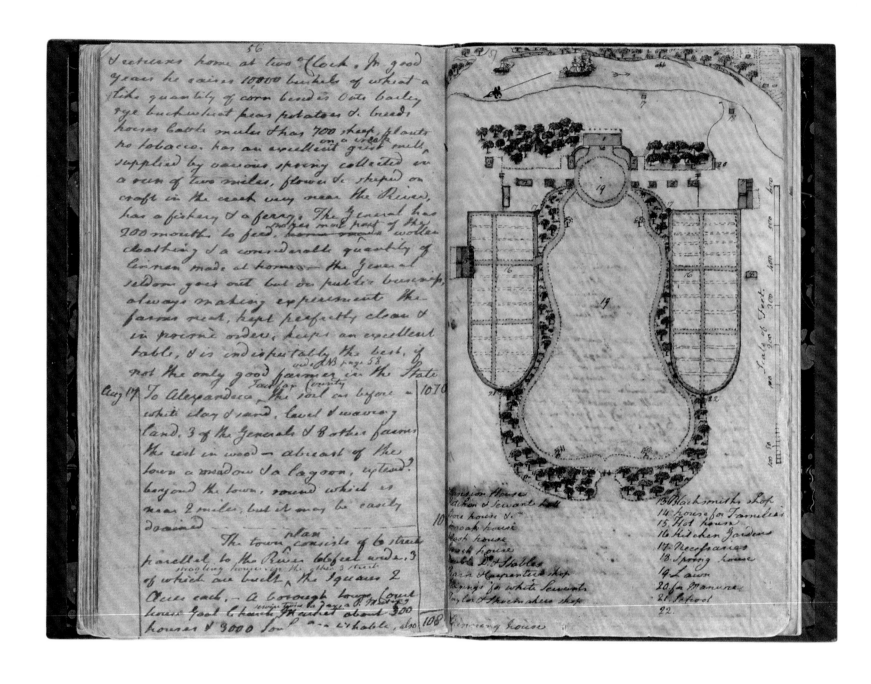

Samuel Vaughan

Plan of Mount Vernon, 1787

Ink and watercolour on paper, 41.2 × 81.2 cm / 16¼ × 32 in
Mount Vernon Ladies' Association, Virginia

Based on this sketch made in his journal during a visit in August 1787, Samuel Vaughan (1720–1802), an Anglo-Irish merchant, plantation owner, political radical and garden designer, gifted a plan of Mount Vernon to his avid gardening friend George Washington. In his letter of thanks that November, Washington politely noted that the plan 'describes with accuracy the house, walk and shrubs'. Mount Vernon in Fairfax County, Virginia, was the plantation home of the first President of the United States of America, which he began leasing in 1754 before inheriting the family estate seven years later. The ornamental garden, which could be described as being in the style of a *ferme ornée*, was laid out to the west of the house and complemented the loosely Palladian architecture. Key features include the informally shaped bowling green and enclosing ornamental shrubberies and tree plantings through which wound a path. From the grass circle at the front door, the visitor meandered along this circuitous, serpentine walk flanked by local tree species including crab apples, locusts, maples, pines and sassafras, and enjoyed views out over the borrowed landscape. Vaughan's plan, however, is not to scale and contained certain errors, notably omitting the mounds at the west end of the green. Also shown in the sketch are two enclosed shield-shaped gardens, as well as the upper garden to the left, which boasted two boxwood parterres and an orangery, as well as the right-hand lower kitchen garden. Despite many changes to Mount Vernon over the years, all the gardens have now been restored to their layout of the 1780s.

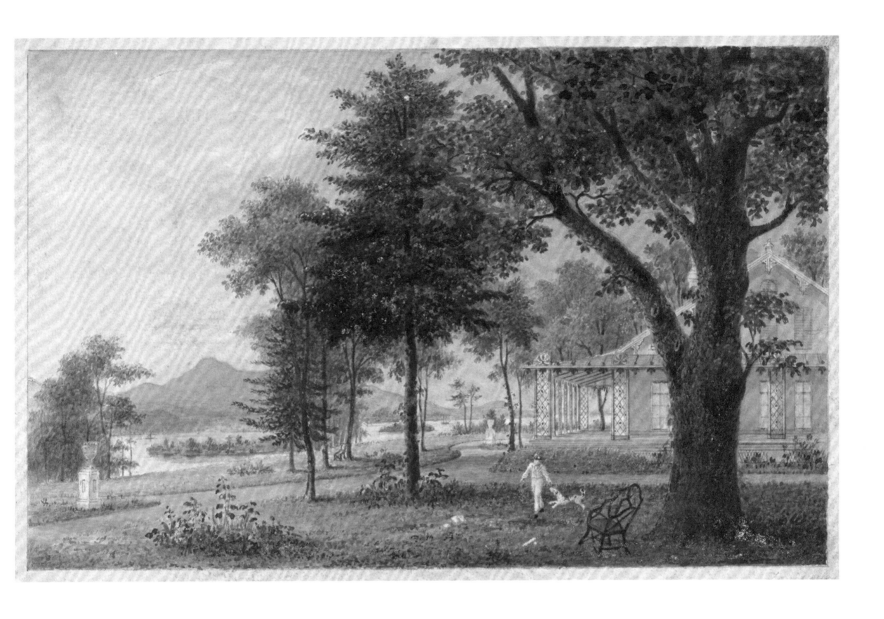

Alexander Jackson Davis
and Andrew Jackson Downing

*View in the Grounds at Blithewood, Dutchess
County,* from *A Treatise on the Theory
and Practice of Landscape Gardening*, 1841

Watercolour, 15.4 × 24.2 cm / 6 × 9½ in
Metropolitan Museum of Art, New York

This watercolour, of a boy and his dog in a garden next to
the Hudson River, depicts the celebrated villa and garden at
Blithewood, home of Robert and Susan Jane Donaldson, now
within the campus of Bard College in Annandale-on-Hudson,
New York. The Donaldsons asked talented architect Alexander
Jackson Davis (1803–1892) to transform the house into an orna-
mental cottage and reshape its grounds with new plantings and
decorative outbuildings, adding terraces for growing vegetables
and creating a geometric garden concealed by hedges and

shrubs. Blithewood became highly influential in American land-
scape architecture for its picturesque blending of the garden
with the landscape of the Hudson Valley – Donaldson installed
an oval 'picture window' in a new gallery in the house to allow
visitors to appreciate the view. Landscape gardener Andrew
Jackson Downing (1815–1852) used this image for the frontis-
piece of *A Treatise on the Theory and Practice of Landscape
Gardening* (1841). Downing's *Treatise* was a hugely influential
work that resembled the encyclopedias of British garden author

John Claudius Loudon (see p.42) yet was adapted to North
America. Not only was Blithewood praised by Downing and
other observers, it was also known for the innovations of the
gardeners, whom Donaldson encouraged to experiment. One
gardener, George Kidd, wrote articles about how he had grown
grapes indoors – Blithewood had an extensive conservatory
and grapehouse – and developed new techniques for growing
roses. Downing himself called the estate 'quite a model of
elegant arrangement ... for this species of refined enjoyment'.

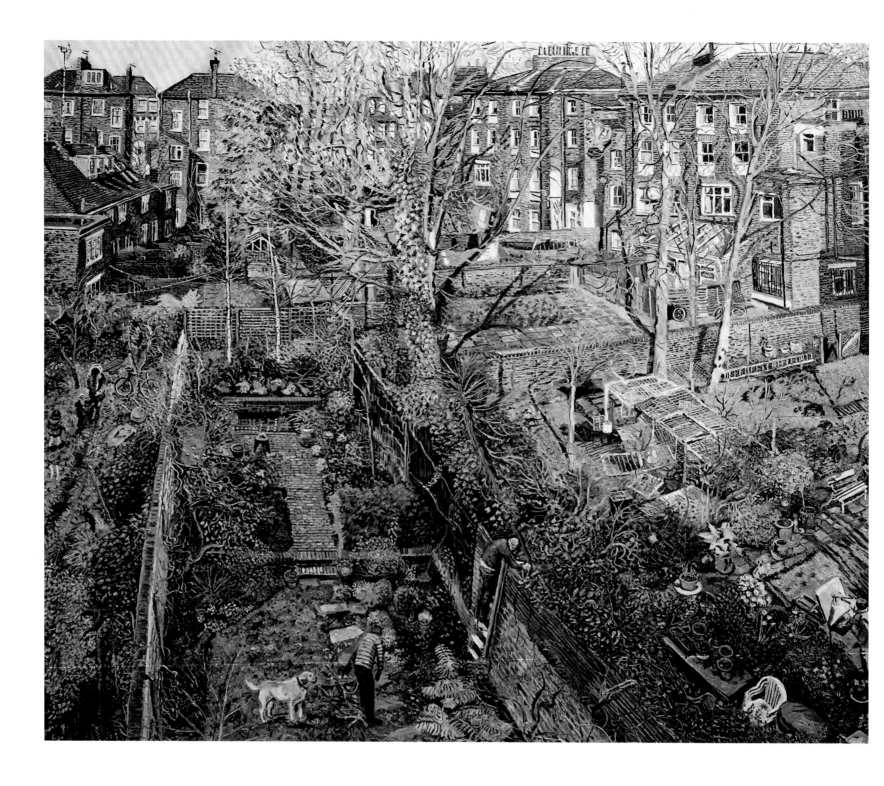

Melissa Scott-Miller

Winter Backgardens, Islington, 2018

Oil on canvas, 1 × 1.2 m / 3 ft 4 in × 4 ft
Private collection

Roughly 3.8 million homes in London are thought to have gardens, adding up to an estimated total of 37,900 hectares (93,653 acres) of green space across the city. Since the city spilled out from the centre to the suburbs, spurred by the coming of the railways in the mid-nineteenth cenutry, rows of terraced houses have hidden the patchwork of gardens behind them, as revealed in this hyperdetailed painting of the back gardens of Islington, in north London, by English artist Melissa Scott-Miller (b. 1959). Scott-Miller renders the distinctive vernacular signs of London's urban reality: the garden benches and plastic chairs, the scatter of clay pots, the quintessential garden sheds and trellises crowding fences that separate each pocket of green, the occasional tall ladder abandoned on the side of a building. In these details lie the warmth and signs of care that distinguish the much-loved London back gardens from those of other large cities. Part utilitarian space – for hanging laundry or child's play – and part relaxation and entertainment oasis, the London back garden is a true luxury in one of the biggest and most densely populated cities in the world. London gardens also played a key role during the world wars of the last century, when they served as Victory Gardens: civil morale enhancers and boosters to the food supply chain at a time of hardship, yielding vegetables and greens that fed local communities. A Slade School of Fine Art graduate, Scott-Miller has over time developed a distinguished career as a portraitist and landscapist.

Rena Gardiner

Summerhouse in the Valley Garden, Cotehele, 1999

Linocut print, 28.5 × 36.5 cm / 11¼ × 14¼ in
Cotehele, Cornwall, National Trust Collections, UK

Largely unacknowledged during her lifetime, British illustrator and printmaker Rena Gardiner (1929–1999) had a prodigious output. Working alone in the studio at her Devon home, she created around forty-five books, writing the text, providing illustrations and printing them herself. Her exuberant use of colour and texture is instantly recognizable in her many paintings, pastels and linocut prints, including this print – made in the last year of her life – of a summerhouse that sits in the grounds of a medieval house in Cornwall:

Cotehele. Cotehele, which now belongs to the British conservation charity the National Trust, sits on the banks of the River Tamar. Its extensive grounds – 5.6 hectares (14 acres) of gardens and 4.8 hectares (12 acres) of orchards – contain numerous formal gardens, a densely planted valley garden, a medieval dovecote, a stewpond (a pond traditionally stocked with fish for eating) and, as illustrated here, a Victorian summerhouse. Gardiner first visited Cotehele in 1972 and was so enamoured of the house and gardens that she soon

embarked on an illustrated guidebook to the estate and its grounds, returning to the gardens regularly. The National Trust, with which she had collaborated on a number of projects, offered her an exhibition at Cotehele, but it was not until 1999 that she was ready. She exhibited forty linocuts she had produced in the intervening years of the estate and grounds, including this one. But the Cotehele show would be Gardiner's last, as she died soon afterwards.

George Shaw

Home, 2004

Enamel on board, 24 × 31.5 cm / 9½ × 12½ in
St Bartholomew's Hospital, London

The paintings of English artist George Shaw (b. 1966) take as their subject the ordinary and the everyday, the unexceptional places where most of us live. There is an immediate autobiographical connection here – this drab terraced house is Shaw's childhood home in Coventry's Tile Hill estate, built in the 1950s, and it was still home to his parents when he painted this view in 2004. The small front garden has a rectangle of lawn and a path edged by narrow flower beds, with another below the windows. It is springtime, with bright daffodils and straggling rose bushes making a cheerful contrast with the weather-stained walls. The scene has a poignant nostalgia, but it is no historical curiosity; such gardens are still familiar to many people today. It is a garden where someone has clearly made an effort, albeit with modest means, and together with the white-painted window frames and clean net curtains, it affirms a care for appearances and asserts a pride of place. The scene underlines how important a garden can be in shaping a sense of home and bringing individuality to the bland uniformity of social housing schemes. The house and its garden are reminders of post-war utopianism, when a belief in social change and a fairer society was expressed in the building of new estates and garden suburbs. This picture is from Shaw's series on the theme of 'home' commissioned by St Bartholomew's Hospital in London, to bring a touch of familiarity and warmth to the previously sterile corridors.

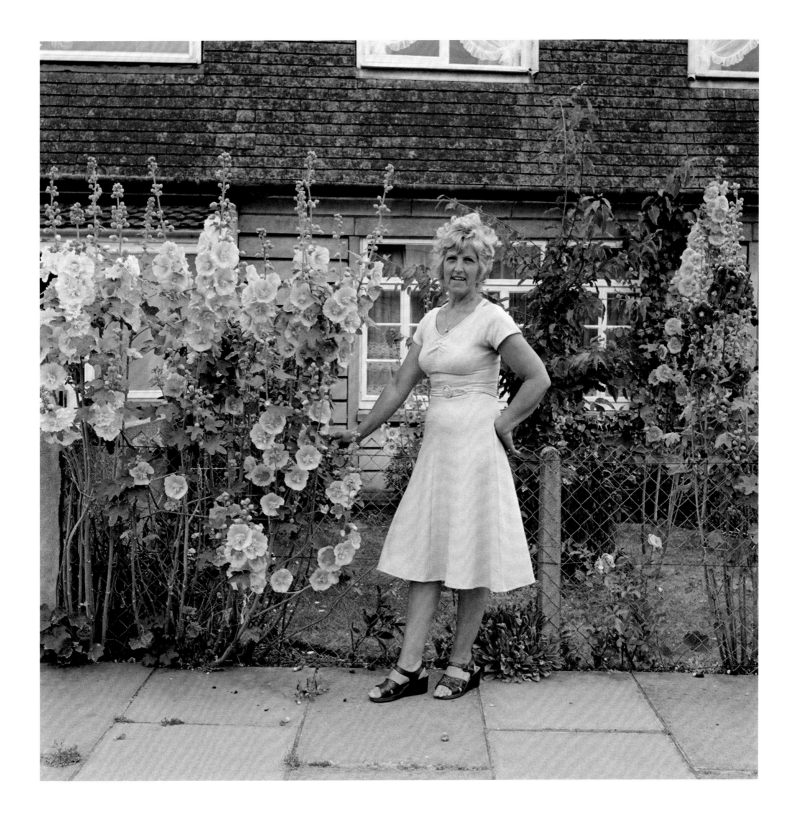

Keith Arnatt

From the series *Gardeners*, 1978–9

Gelatin silver print on paper, 27.5 × 27.5 cm / 10⅞ × 10⅞ in

A female figure stands in front of a cottage garden, her pale dress echoing the billowing white flowers of the leggy hollyhocks, in this photograph by British conceptual artist Keith Arnatt (1930–2008). The image is taken from Arnatt's *Gardeners* series, in which a number of subjects were similarly photographed as full-length portraits in front of their gardens. Although she is smiling, the woman's pose hints at a discomfort that mirrors the conceptual problem posed by Arnatt's works: whether the simple act of naming and picturing, over any more performative act of work, gives the sitter their identity as a gardener. Here, the woman's toes squeeze from her sandals just as the flowers poke through the chain-link fence, and her cocked elbow seems torn between an affected grace and sheepish concealment of an unkempt plot where vagrant sycamores have seeded between the shrubs. Some of Arnatt's earlier and most celebrated works – in which, for example, mirrored boxes are dug into the grassy earth, imperceptible but for his own shadow falling over the composition – camouflaged their subjects, questioning the authority of the artist and photography's ability to accurately capture and convey information. Here, his photograph purports straight reportage, yet still includes a light visual hide-and-seek (for which hollyhocks – dubbed the 'outhouse' flower for their ability to screen the unsightly – are fitting). Arnatt's shallow monochrome, flattening out the differences between the white of dress and of flowers, threatens to merge the subject and the source of her identity, gardener into garden.

Bradbury & Bradbury

Colonial Williamsburg, c.1930

Wallpaper, 53.5 × 58.4 cm / 21 × 23 in

An imagined bucolic scene of a leisured life in colonial America is the subject of this wallpaper design with scenes from Williamsburg, the largest and wealthiest of the British settlements in America from 1699 until 1780, when it fell into disrepair after Virginia governor Thomas Jefferson moved the capital to Richmond. It was not until 1926 that work began to restore both the buildings and the gardens of Williamsburg, and the horticultural element of the project spurred the rise in popularity of the twentieth-century American Colonial

Revival Garden. Produced by Bradbury & Bradbury, this printed image, dating from the 1930s, shows a somewhat less manicured Williamsburg: gone are the ubiquitous colonial white picket fences familiar from the restored site, and the Governor's mansion is surrounded not by tidy beds and box hedges but by undulating hills and over-scaled flowers, suggesting a degree of artistic licence. Wallpaper – the covering of walls with decorated paper – originated in China during the Qin dynasty (221–207 BC), but the earliest surviving European

example did not appear until the early sixteenth century in Great Britain, where it was used sparingly to decorate the insides of cupboards. Its popularity peaked in the early twentieth century, sparked by the work of English designer William Morris (see p.84), whose frequent use of motifs drawn from nature – flowers, trees and plants – single-handedly made wallpaper design a fashionable artistic pursuit. As Morris said: 'Whatever you have in your rooms think first of the walls for they are that which makes your house and home.'

Mary Davis

Embroidered sampler, 1826

Silk and silk chenille on linen, 76.2 × 97.8 cm / 30 × 38½ in
Metropolitan Museum of Art, New York

Presenting the perfect world of a largely self-sufficient home surrounded by its own patch of land and bounded by a white picket fence, this sampler shows a country house near the city of Baltimore, at the time a prosperous and developing port. The sturdy brick-built house with its large windows is flanked by two large trees, that on the left probably a weeping willow. On the right a man with a black cap and his dog at his feet admires a small flock of sheep and six ducks on the lawn. To the left beneath the willow tree stands a woman,

likely intended to be his wife, in a flowing dress and a bonnet, next to a table, perhaps preparing a picnic. Behind her is a bed of colourful flowers and at far left another animal, probably a second dog or a calf. The idyllic, homely scene is surrounded by a frieze of intertwining flowers and leaves, suggesting fertile growth and tranquillity. Samplers such as this one, created by a Mary Davis (c.1816–?) around the age of ten, were traditionally the work of young girls as a way of learning basic needlework skills, regarded as essential

in their future lives. The earliest samplers date from the late seventeenth century, and by the early 1800s schools or academies for girls and young women from rich households were flourishing. There, pupils created elaborate samplers with domestic or religious themes, often decorated with flowers, and their work was frequently displayed by their parents with great pride.

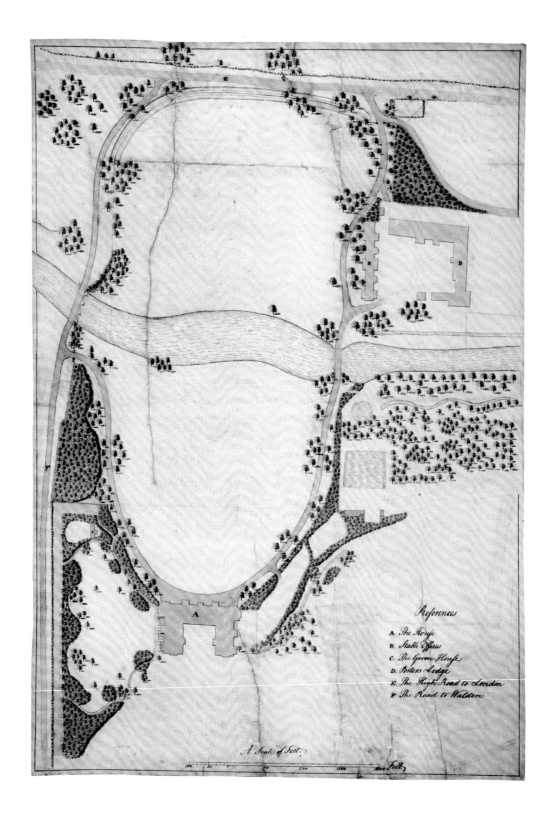

Lancelot 'Capability' Brown

Plan for Audley End, 1762

Ink and wash drawing mounted on board
Audley End House and Gardens, Saffron Walden, Essex, UK

Many consider Lancelot 'Capability' Brown (1716–1783) to be one of the first professional landscape architects. He is perhaps still the Western world's best-known gardener and garden designer, having permanently transformed the English landscape with his distinctive 'Brownian' style. His talent was sought out by nobility, and he became King George III's royal gardener as well as England's pre-eminent designer of gardens. Brown's contemporaries lauded his work for its emphasis on natural beauty. However, his carefully designed, artificial landscapes fell out of fashion as aesthetic taste shifted from public conceptions of nature embracing the gentle and pastoral to an emphasis on the wild and untamed. Designs that were once seen as improvements on nature came to be seen as contrived. Yet, despite the ebb and flow of Brown's popularity, today his oeuvre is widely admired and respected. The design for the gardens at Audley End is one of his smaller projects, but no less exemplary. The country estate of Sir John Griffin was the setting for a grand Jacobean prodigy house in Essex and features all the hallmarks of a majestic Brownian parkland: rolling carpets of green grass, a serpentine body of tranquil water, sweeping pathways, ornate bridges, intentionally framed views, open meadows, sunken fences (known as 'hahas') and groups of carefully placed trees. Brown orchestrated every element to create an idyllic parkland. Although the project was famously rife with conflict between Griffin and Brown, the result is a defining example of the latter's enduring legacy.

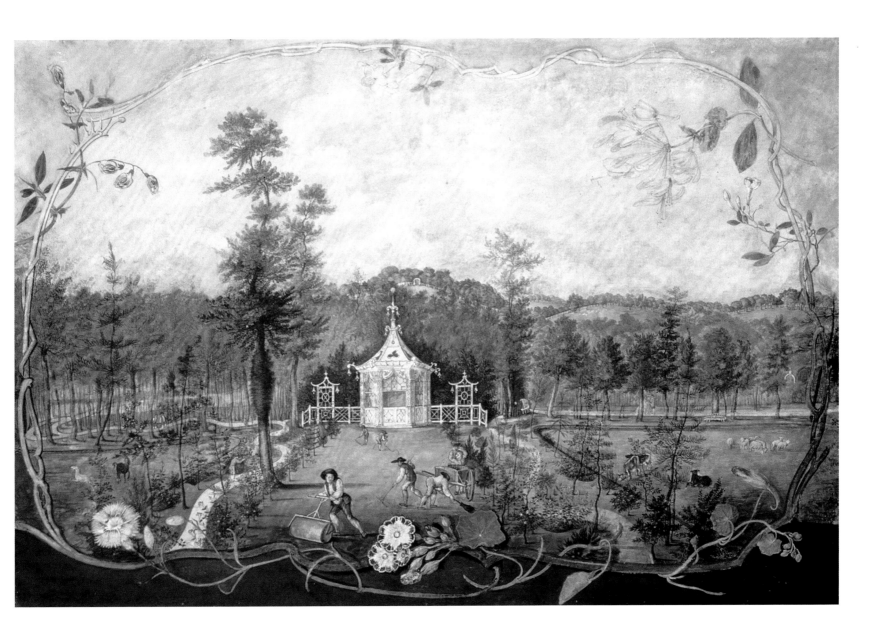

Thomas Robins the Elder

A View of the Chinese Kiosk at Woodside,
late 18th century

Watercolour and gouache on paper
Private collection

This Chinese bell-pavilion flanked by open fretwork trellis screens stood not in Asia but in Berkshire, in southern England. It was built for the owner of Woodside, Hugh Hamersley, who inherited the property in 1753 and created a relatively small but exquisite garden full of interesting features that displayed the influence of contemporary fashions for both chinoiserie and the rococo. The garden designer is unknown, but a likely candidate is Thomas Wright, a mathematician and astronomer turned garden

designer whose main patron was Elizabeth, Duchess of Beaufort, at Badminton House in Gloucestershire. Most of the scene is informal – the shrub border to the right and the serpentine paths leading off into the woodland – but there is a regular line of saplings flanking the main lawn to the left and an allée, or tree-lined path, on the right. In addition to the figures trimming the lawn (which in the days before lawn mowers meant scything), raking and sweeping the cuttings, the scene is surrounded by a border of flowers:

auricula, honeysuckle, jasmine, nasturtium, pink and sweet pea. Painter Thomas Robins the Elder (1716–1770) is chiefly remembered for garden views like this one, made for their owners and notable for themed rococo borders that include birds, butterflies, feathers, flowers, fruit, shells and tendrils. Since 1975 Woodside has been the home of the musician Sir Elton John, and the gardens were redesigned by Rosemary Verey and Roy Strong in the 1980s and 1990s.

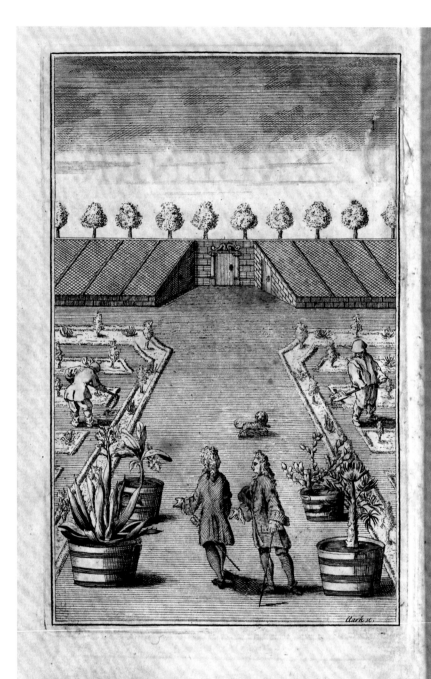

THE
CITY
GARDENER.

Jas. Barclay

Containing the moſt Experienced

METHOD
OF

Cultivating and Ordering ſuch
Ever-greens, Fruit-Trees, flowering
Shrubs, Flowers, Exotick Plants, &c.

as will be Ornamental, and thrive beſt
in the *LONDON GARDENS*.

By THOMAS FAIRCHILD,

Gardener of *Hoxton.*

LONDON:
Printed for T. WOODWARD, at the *Half-Moon*
againſt St. *Dunſtan's* Church in *Fleet-ſtreet*, and
J. PEELE, at *Locke's Head* in *Pater-noſter Row.*
M. DCC. XXII.

(Price One Shilling.)

Thomas Fairchild

The City Gardener, 1722

Engraving, each page 25 × 20 cm / 10 × 8 in
Guildhall Library, London

When Thomas Fairchild (1667–1729) wrote *The City Gardener* in 1722, he was a leading nurseryman in the London area and one of the outstanding horticulturists of the eighteenth century. A manual for growing ornamental and fruit trees, shrubs and flowers in the different climatic and growing conditions across London, *The City Gardener* was the first gardening book directed at an urban audience for whom gardening was already a challenge owing to increasing pollution and overcrowding. The frontispiece image shown here depicts gardeners tending a small space. Pithouses in the background were probably used for growing the exotic plants shown in pots in the foreground: agave, banana, cactus and palm. Fairchild's contributions to the plant world would have a lasting influence, stemming primarily from his experiments in botany. He produced the first recorded intentional hybrid by cross-pollinating sweet William (*Dianthus barbatus*) and carnation pink (*D. caryophyllus*). Being the first person to scientifically create an interspecific hybrid, and showing that plants were capable of sexual reproduction, was Fairchild's greatest achievement. His small Hoxton nursery specialized in rare and unusual plants and was the first to focus on floriculture, although he grew more than just flowers. Through his connections with other important plantsmen, such as Mark Catesby and Richard Bradley, who sent him specimens they collected on plant-hunting expeditions, he introduced a number of North American species to England, including the tulip tree (*Liriodendron tulipifera*) and flowering dogwood (*Cornus florida*).

Ilonka Karasz

Cover of *The New Yorker*, 19 July 1941

Lithograph, 29.2 × 21.6 cm / 11½ × 8½ in

Not all gardens are the same, yet the pleasure they bring to their creators is universal, whether it comes from vast lawns and flower beds or, as here, a collection of potted plants next to a water tank on the rooftop of an apartment building in New York City, a haven of peace above the crowded streets below. The garden tools suggest that work has recently finished for the day, allowing a woman to enjoy a rest in the sun while a man gazes up at the sky. This cover from *The New Yorker* magazine in July 1941 was the creation of Hungarian-born illustrator and industrial designer Ilonka Karasz (1896–1981), who had studied at the Royal School of Arts and Crafts in Budapest – she was one of the first women to be admitted – before she emigrated to New York in 1913, settled in Greenwich Village and became an active member of the New York art scene. Skilled at many disciplines, Karasz is arguably best known for the 186 covers she produced for *The New Yorker* between 1924 and 1973, often depicting everyday scenes pictured from above, using unusual colour combinations. Here, she manages to portray the magazine's ideal readers: imaginative, quirky, ready to embrace all the opportunities the city offered. With her background, however, it is little surprise that Karasz also imbues the scene with a sense of nostalgia, because this peaceful scene is under threat. Europe was already at war – and within six months, the United States would be dragged into the conflict.

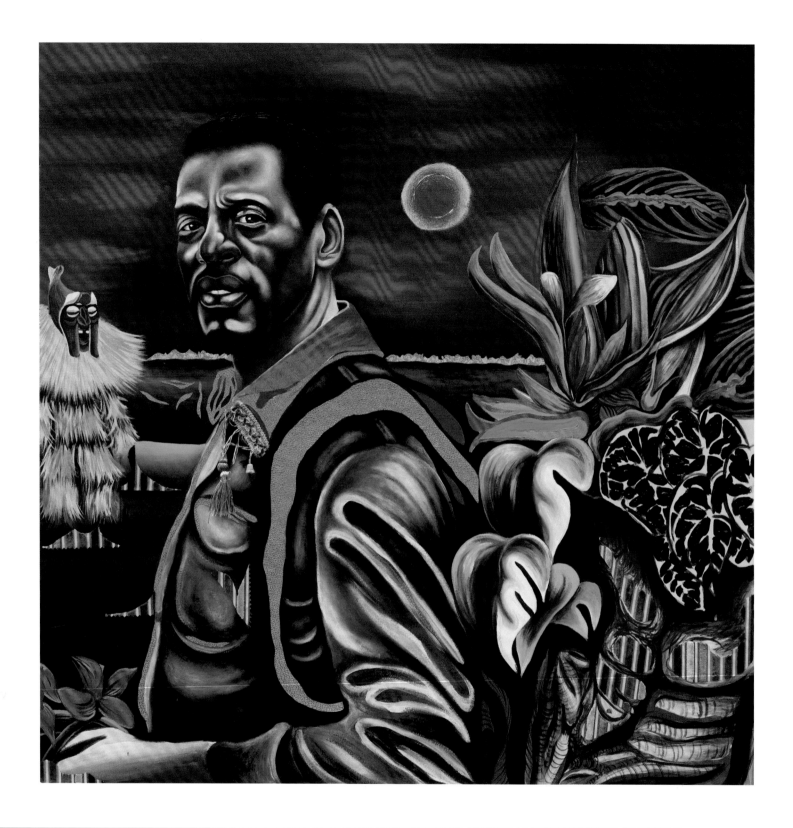

Phumelele Tshabalala

Gangster Gardener, 2021

Mixed media on canvas, 1 × 1 m / 3 ft 4 in × 3 ft 4 in
Private collection

The first time Ron Finley planted some vegetables in a patch of earth next to a sidewalk in his South Central Los Angeles neighbourhood, he was cited by the city authorities for gardening without a permit. Finley fought back, raising a petition with other activists and winning the right to garden and grow food in the streets. So the Gangster Gardener was born. South African artist Phumelele Tshabalala (b. 1987) – who focuses on people as an expression of resistance – portrays Finley with a rucksack full of plants, ready to go out and garden,

against a backdrop of dark colours watched over by a masked figure in traditional costume, inspired by the fibre ritual masks from the Lery Village in Burkina Faso. South Central Los Angeles, a predominantly Black and Latino neighbourhood, is full of fast-food outlets and offers little access to fresh food; Finley recalls having to drive forty-five minutes just to get a fresh tomato. In an area where eating healthily is almost impossible, obesity and associated problems are a major cause of death. Finley and his volunteer colleagues – known

as LA Green Grounds – dig up wasteland to plant gardens filled with fruit and vegetables, allowing people to harvest fresh food from the street and inspiring the creation of dozens of community gardens in the vast vacant spaces around Los Angeles. Finley is continuing to change the narrative. 'If you ain't a gardener, you ain't gangsta,' he tells young people in the neighbourhood, repeating his call to action: 'Plant some shit.' Growing your own food is cool, he argues, and gardening is a type of graffiti: spray-painting with plants.

Nike

Dunk Low Community Garden
Sneaker, 2020

Canvas, recycled foam and rubber, dimensions variable
Private collection

There might not be an obvious link between horticulture, the pastime of the countryside and the suburbs, and the sneaker – perhaps the dominant symbol of gritty inner-city streetwear – but Nike's Community Garden sneakers, released in September 2020, successfully bring the two together. The midnight turquoise and cardinal panels are decorated with collage-like leaves, floral patterns, and suns and stars as a celebration of the urban community garden. These gardens, grown on vacant lots or in spaces left between developments, often provide spaces where neighbourhood residents come together to share the work of planting and maintaining oases of plant life to be enjoyed by people eager to escape the 'urban jungle'. The first community garden in North America was said to have been created by Moravian settlers in North Carolina in the early 1700s, but urban schemes began in Detroit in the 1890s – partly to grow food during an economic recession – and were taken up by other cities. A revival of interest in the movement in the 1960s and 1970s led to the formation of the American Community Gardening Association to provide advice and resources. Nike's sneakers fit closely with the ecological impulse behind urban gardening. The patchwork design – unique in each case, so no two pairs are the same – features eco-friendly canvas uppers, and a midsole and outsole crafted from recycled foam and rubber, respectively. The shoe marks another step in Nike's drive towards sustainability – a goal the company shares with many thousands of community gardeners.

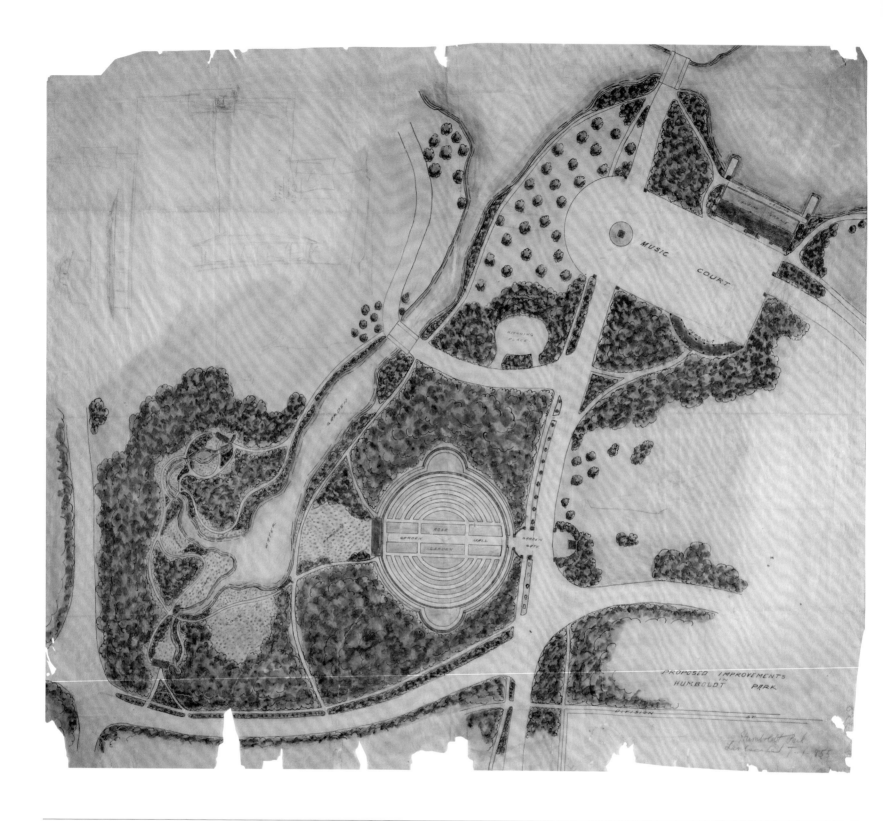

Jens Jensen

*Proposed Improvements
in Humboldt Park, c.1907*

Ink and coloured ink on paper, 94 × 106.7 cm / 37 × 42 in
Chicago Public Library, Special Collections

For Danish-born American landscape architect Jens Jensen (1860–1951), a public garden was vital to any neighbourhood and an essential asset for 'those who have no other gardens except their window sills'. That was the attitude that underlay his 1907 design for Humboldt Park, an 88.6-hectare (219-acre) parkland in an ethnically diverse neighbourhood of Chicago. Jensen had emigrated to the United States in 1884, settling in Chicago, where he worked for the municipal West Side Park System. His design for Humboldt

Park – as seen on this original plan – included the now iconic circular garden, with semicircular beds of roses and perennials that were typical of the era. Jensen bisected the garden with a reflecting pool and a fountain, encircling the whole with a terrace of wooden and concrete pergolas at a higher level. The garden served as an opportunity for him to put his ideas into practice: a passionate advocate of the prairie school of landscape architecture, he created a lagoon beyond the formal garden that was intended to

mimic one of the Midwest's natural, slow-moving 'prairie rivers'. Better known from the buildings of, among others, Chicago-based architect Frank Lloyd Wright, with whom Jensen collaborated, in gardens the prairie style set out to emulate the wide, flat, treeless expanse of the Midwest. Jensen used native plants in a naturalistic setting to represent what he described as the place where 'earth and sky meet on the far horizon'.

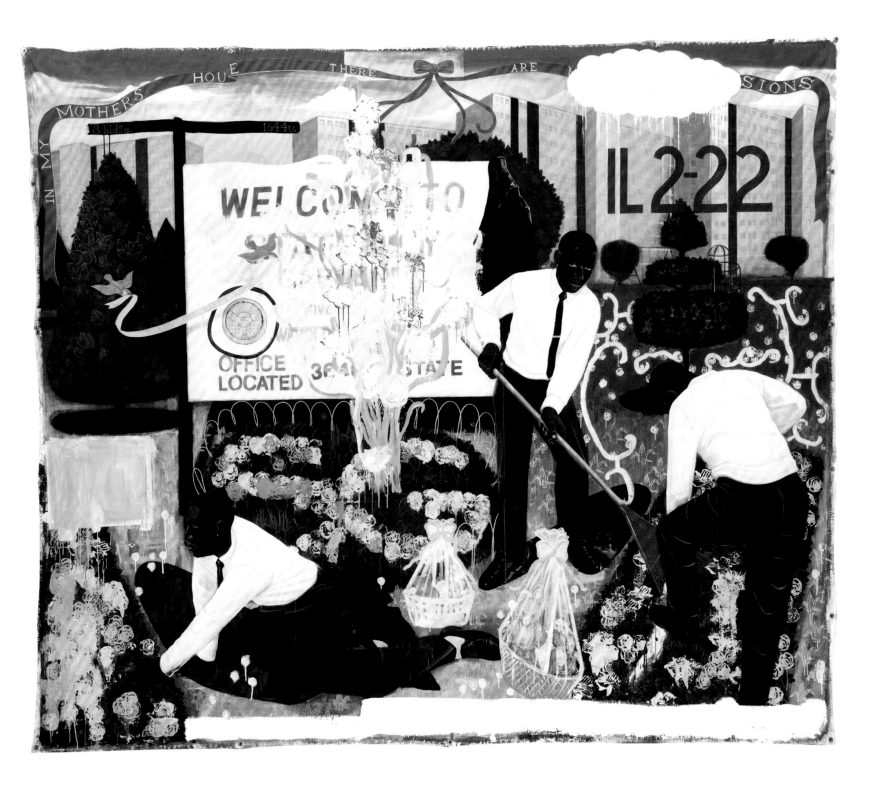

Kerry James Marshall

Many Mansions, 1994

Acrylic on paper mounted on canvas,
2.9 × 3.4 m / 9 ft 6 in × 11 ft 3 in
Art Institute Chicago

One of the most successful contemporary painters, American artist Kerry James Marshall (b. 1955) has developed a distinctive realistic style in which bold colours and intricate symbolism are used to foreground sharp and often uncomfortable socio-political critiques. *Many Mansions* is no exception. The first in a series of five large-scale canvases depicting housing projects in Chicago and Los Angeles, the painting derives its title from Christ's oft-quoted remark found in John 14:2: 'In my Father's house there are many mansions.' Marshall became

interested in the use of the word 'gardens' in the naming of far from bucolic low-income accommodation that eventually failed generations of Black Americans across the United States. Intentionally structured according to the compositional rules of classical art, the painting echoes the grand narrative style of early Romantic painting, in which great tragedies were immortalized with an impossible sense of composure and grandeur. The three men gardening at the entrance of the housing estate wear clothing that suggests both the authority of institutional

efficiency and the attire suited to a funeral. Their enigmatic presence is underscored by a subtle tension between life and death that emerges in such details as the dead pine trees on the left and the cellophane-wrapped teddies in gift baskets. It is no coincidence that a flower bed on the right-hand side of the painting ominously recalls the shape and size of a grave. In *Many Mansions*, gardening is cast as a practice of hope as well as a sinister attempt to cover up the systemic racism that has marred the lives of Black Americans in recent history.

Patrick Blanc

L'Oasis d'Aboukir, Paris, 2013

Live plant installation, H. 25 m / 82 ft
Rue d'Aboukir, Paris

The windows glimpsed in the profusion of greenery are clues that this is no ordinary garden scene but a 'green wall', a vertical garden created on the previously blank 25-metre (82-ft) tall, southwest-facing concrete wall of a building in Paris's second arrondissement. *L'Oasis d'Aboukir* (*The Oasis of Aboukir*), which features about 7,600 plants of 237 different species, is designed so that it seems to flow across the wall in a series of diagonal waves. It is the creation of innovative French gardener Patrick Blanc (b. 1953), a left-field genius

who is part artist, part botanist, part landscape architect – and whose ideas have revolutionized urban architecture over nearly four decades. This garden is held in position by a frame mounted on the wall that holds a series of pipes that provide water and nutrients to the plants via a layer of felt, which forms the substrate in which the plants take root. Each vertical garden is designed as a series of interlocking, leaf-shaped beds for a naturalistic look. Blanc is an evangelist for using vertical gardens to bring nature into cities,

where it is often absent, and believes that the benefit to the population is not just aesthetic, but also psychological and physical, as the plants help to purify the city air, in addition to insulating buildings to keep them cool in summer and warm in winter. Relentless in his pursuit of new species to increase his planting palette, Blanc has created gardens in locations from Spain to North America, Poland to Japan, and inspired many others by his talent and example.

Hurvin Anderson

Jungle Garden, 2020

Acrylic and oil on linen, 1.8 × 1.5 m / 6 × 5 ft
Private collection

There is a vibrant beauty to this garden, but the word 'jungle' in the title suggests that it is either already out of control or soon to become so. A vague atmosphere of menace pervades the painting as the lush profusion of foliage and bright flowers fills most of the frame, spilling past and over the stained and crumbling concrete and threatening to block the view of what lies behind. This is one of a series of paintings based on photographs taken in 2017 by British artist Hurvin Anderson (b. 1965) on a trip to Jamaica, and painted in the UK during the COVID-19 lockdown period. The series explores the way in which nature is encroaching on parts of Jamaica's tourism infrastructure, here an unfinished and abandoned holiday resort. Anderson has said of these paintings, 'It felt like the environment was inhospitable ... and you had a sense of nature taking over.' His imagery also reflects the ambivalence towards Jamaica experienced by the generation who migrated to the United Kingdom in the 1950s and 1960s, including Anderson's own family – he was the youngest child of eight and the only one born in the UK. Missing their homeland and feeling unsettled in their new situation, many migrants idealized Jamaica as a verdant utopia. Anderson suggests that these memories are hazy, even faulty, by painting with loose washes of paint that defy clarity and precision, and with blurs and drips that emphasize the sense of decay and erosion, while at the same time embodying the tropical humidity of the Jamaican climate.

Waruna Gomis and Geoffrey Bawa

Jayawardene House, 1996

Ink on vellum, 73.5 × 107 cm / 29 × 42⅛ in
Private collection

For his very last project, celebrated Sri Lankan modernist architect Geoffrey Bawa (1919–2003) created a house that didn't just pay homage to the landscape but seemed to blend into it. Commissioned in 1996 by Pradeep Jayawardene, grandson of former Sri Lankan president and prime minister J.R. Jayawardene, the house was built high on the red cliffs of Mirissa on the site of his grandfather's former colonial bungalow. The brief was simple: 'My perfect house would be a garden,' Jayawardene told a sympathetic Bawa, whose life's work had seamlessly blended the built and natural environments. Here, drawn by Waruna Gomis, the garden is absorbed into the house: green lawns merge into the steel and glass building, which is open to the elements on three sides. Since the plot sits in a copse of coconut palms and casuarinas overlooking the ocean, no additional planting was required. Bawa kept the garden pared back to concentrate the eye on the peerless sea views and sunrises. He also took the garden into the structure of the house: the narrow columns that hold up the horizontal roof resemble the trunks of the coconut palms that dot the property. Instead of the walls, doors and windows found in more traditional structures, there are just three rows of the slender columns to hold up the roof, which appears to float above the garden. Together, the house and garden represent a distillation of Bawa's forty years of thinking about and building minimal structures for a tropical climate.

Azuma Makoto

Mexx, 2022

Temporary installation
SFER IK, Tulum, Mexico

There is not a straight line in sight: the walls are curved, the floor undulates, and light seeps through a ceiling made from bejuco vines. The SFER IK art centre in Tulum, Mexico, is biophilic, meaning it coexists with its natural environment, reflecting the three pillars of its mission: nature, art and ancestrality. The installation *Mexx* was created by Azuma Makoto (b. 1976) as part of his ongoing exploration of the relationships between plants and their environments; the Tokyo-based artist has launched a bonsai into the stratosphere, plunged flowers thousands of feet beneath the sea, and frozen bouquets. He frequently places flowers and plants in an environment that is foreign to them. *Mexx* was an artificial living ecosystem designed to interact with the existing structures of the museum in Mexico, using such indigenous plants as bromeliads, philodendrons, pothos and cacti to give the interior the green and leafy feeling of an exterior. Makoto's use of local plants was intentional. Not only was he able to display their beauty and character, but he was also able to distribute them to the local community at the end of the installation, thus extending the life cycle of the plants and ensuring the work was sustainable. Over the course of the installation, Makoto intended the plants to grow into the museum space, blurring the line between natural and artificial as they interact with the existing vegetation and structures to create a living artwork.

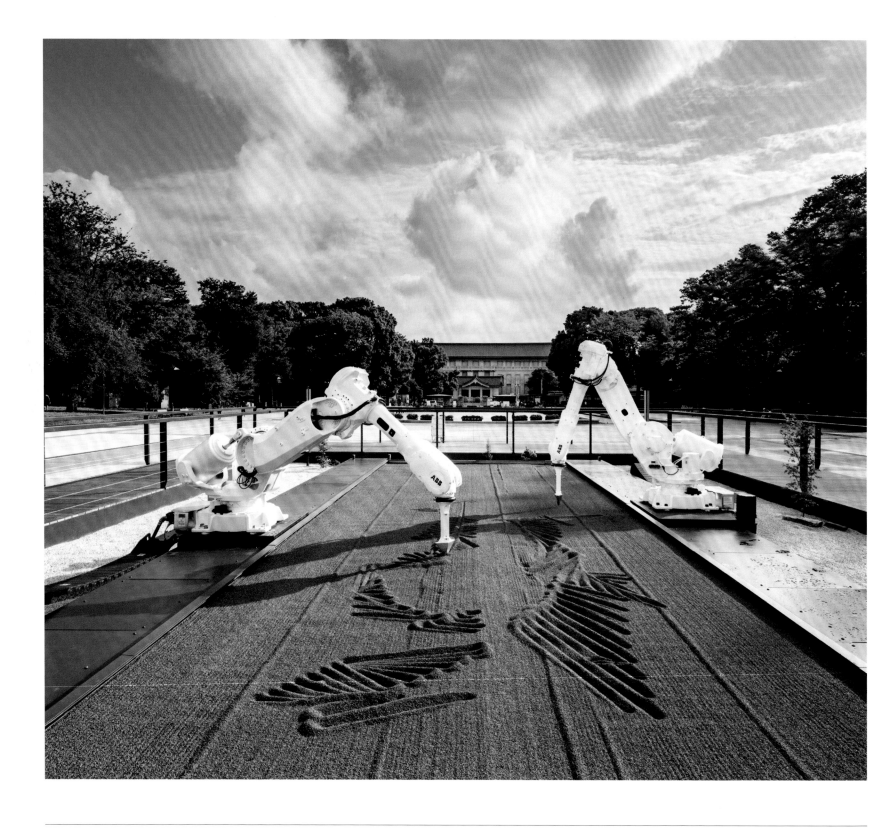

Jason Bruges

The Constant Gardeners, 2021

Mixed media, custom-control software and custom
electronics, 30 × 16 × 3 m / 98 × 52 × 10 ft
Temporary installation, Ueno Park, Tokyo

In this outdoor installation in Tokyo's Ueno Park, cutting-edge technology combines with the ancient tradition of Zen gardening to explore the relationship between technology, art and sport. Created by London-based multidisciplinary artist Jason Bruges (b. 1972) to accompany the 2020 Tokyo Olympic and Paralympic Games (held in 2021 owing to the COVID-19 pandemic), *The Constant Gardeners* involved giant robot 'gardeners' raking dynamic patterns inspired by the movement of athletes into a bed of gravel. Japanese Zen gardens, known

as *karesansui*, have provided tranquil spaces for meditation since the eighth century. The austere, waterless landscapes with very few plants usually contain rocks and a bed of gravel, which is meditatively raked by monks to produce distinct patterns. In Ueno Park, the mechanical rakers glided on linear rails, creating images in a bed 2.5 metres (8 ft) wide filled with 14 tonnes (15.4 t) of crushed black basalt and 4 tonnes (4.4 t) of silver-grey granite. The industrial robot arms were driven by artificial intelligence generative software, which analyzed

thousands of hours of video, translating the activities of sprinters, cyclists, gymnasts and skateboarders into visual designs that conveyed the athletes' movements. Sometimes the robots worked tentatively, at other times they made confident, sweeping gestures. In total, they created 150 illustrations during the games, but for Bruges the emphasis was on the process of creation rather than the finished images: he likened the robots' daily performances to the precise, repetitive movements of Olympic athletes who train for years to perfect their skills.

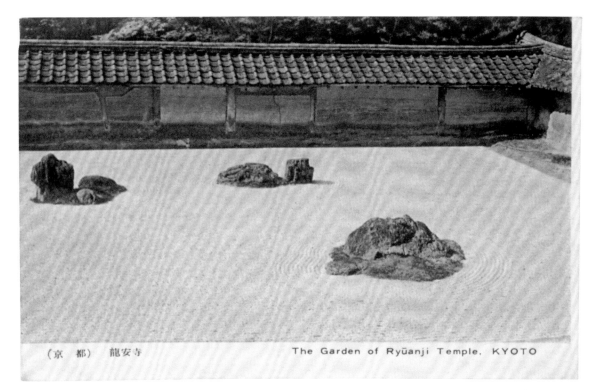

Walter Gropius

Postcard to Le Corbusier, 1954

Printed paper, approx. 90 × 140 cm / 3½ × 5½ in
Private collection

Modernists loved Japan. In the late nineteenth century French Impressionist painters gained inspiration from Japanese woodblock prints, revelling in their striking viewpoints, flattened picture planes, and immediacy in depicting everyday scenes. In the mid-twentieth century functional modernists sought out examples of Japanese architecture and design, seeing an echo and even a precursor of their own design philosophy. For those who lived through the Swinging Sixties, in particular, the phrase 'Made in Japan' conjured

novelty, inventiveness and a sense of fashion. With an image of the rock garden at Kyoto's Ryoanji Temple by an unknown photographer, this postcard from German-American architect and educator Walter Gropius (1883–1969) to his Swiss-French colleague Charles-Édouard Jeanneret – more commonly known after 1920 as Le Corbusier – in 1954 is an intimate glimpse of shared interests. Recording his first visit to Japan, Gropius likens the garden to abstract creations by modern sculptors Jean Arp and Constantin Brâncuşi. Disciples of the

Bauhaus school, which Gropius had founded in 1919, were particularly intrigued by parallels between modernism and Japanese design. 'You cannot imagine what it meant to me to come suddenly face to face with these houses', Gropius wrote after his visit, 'with a culture still alive, which in the past had already found the answer to many of our modern requirements of simplicity, of outdoor-indoor relations, of modular coordination, and at the same time, variety of expression, resulting in a common form language uniting all individual efforts.'

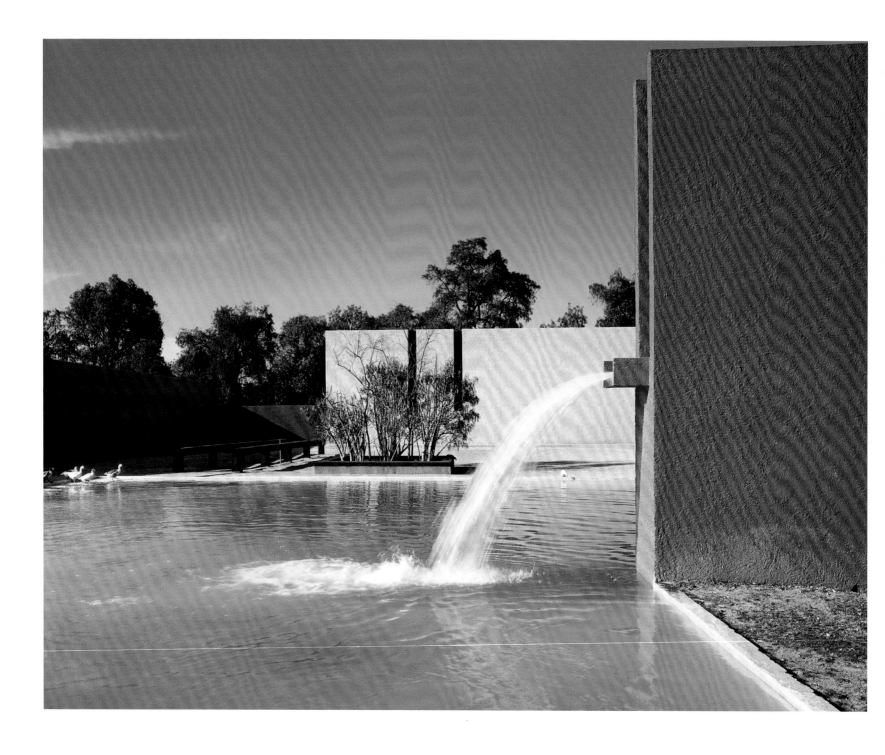

Armando Salas Portugal

Main Courtyard and Horse Pool, Cuadra San Cristóbal, Los Clubes, Mexico City, 1966–8

Photograph, dimensions variable

A vast pool fringed by a large pink wall and a few leafless trees is not everyone's idea of a garden, but this photograph by Mexican photographer Armando Salas Portugal (1916–1995) captures a garden of a different sort: a horse pool designed for a private estate, Cuadra San Cristóbal, that lies northeast of Mexico City. For more than forty years, Salas Portugal photographed the iconic buildings of his friend and fellow Mexican Modernist architect Luis Barragán, whose buildings are instantly recognizable by their vibrant colours and their minimal facades concealing glorious interior spaces. This estate, consisting of a house and a complex of stables, barns and grounds for breeding and training thoroughbred horses, was built in the late 1960s for an equestrian friend of Barragán's, Folke S. Egerström. Salas Portugal, commissioned to produce both black-and-white and colour studies of the estate, focuses here on the water gushing out of the orange-painted fountain that fills the horse pool. The two vertical slits in the pink wall hint at the space's function, allowing air to circulate in the hay bales behind the wall. A lower wall, painted purple, is offset by the blue sky. Unusually for a garden, most of the vegetation lies beyond; only a small clump of trees stands within the walls. Nevertheless, Salas Portugal's image captures the meditative beauty of a unique space built not just for the enjoyment of humans but also for the pleasure of animals – including ducks, which splash as the water's edge.

176

Roberto Burle Marx

Garden Design for Beach House for Mr and Mrs Burton Tremaine, Santa Barbara, California (Site plan), 1948

Gouache on board, 70.5 × 127.6 cm / 27¾ × 50¼ in
Museum of Modern Art, New York

A stunning garden for the ultimate California dream house, this design for a private residence in Santa Barbara by Roberto Burle Marx (1909–1994) was never realized, but the plan endures as a remarkable work of art. As Brazil's most influential landscape designer, Burle Marx frequently collaborated with fellow modernist Brazilian architect Oscar Niemeyer, as he did here. Although their residence for American industrialist and art collector Burton Tremaine never materialized, the documents they created stand as prime examples of their talent.

The house itself is a midcentury masterpiece in concept and on paper, and completely inseparable from the garden. Although it functions as a garden plan, this drawing has the appearance of a painting with bold, colourful shapes. Garden beds, grouped plantings and bodies of water are laid out as asymmetrical organic features. The free-form scheme, in contrast to the building's formalism, evokes Hans Arp, Henri Matisse (see p.143) and Joan Miró, evidence of Burle Marx's training as a painter. He was also a consummate plantsman and an

outspoken environmentalist, passionate about conservation and preserving biodiversity. Despite providing few details about specific plants in this plan, Burle Marx, who was known for selecting species indigenous to his native Brazil, punctuates the garden with prominent star-shaped suggestions of palms, bromeliads and other tropical plants. The garden would probably have included some of the many species named by or for him, and the plan, with its emphasis on native plants, was a major departure from traditional European landscape designs.

四天聖町通

聖天横町

北新町通御旗本
小出恕之助殿
御屋敷

萩之内通
松林之内竹萩

外浅草地寺中

Anonymous

Garden plan, *c*.1800

Ink and colour on paper, 34.7 × 57.8 cm / 13¾ × 22¾ in
Museum of Fine Arts, Boston

This detailed plan of a Japanese garden nestled among a variety of lush green trees and vegetation shows a typical layout in which canals and ponds are prominently featured. Topography has for millennia been a key feature of Japanese gardens, with elevations surrounded by water symbolizing the essence of Japan as an island surrounded by the sea. The topography of Japanese gardens is often defined by the excavation of ponds, as the soil extracted to make room for water is gathered and later landscaped into a series of mounds.

The numerous bridges in this plan are also vital to the all-important symbolic register of Japanese garden design: they stand for a connection to the natural world and thus to the spiritual realm. Created by an unknown artist, this plan was part of the collection of William Sturgis Bigelow, son of a prominent Boston surgeon. Bigelow began to collect Japanese *ukiyo-e* woodblock prints, or 'pictures of the floating world' that flourished during the Edo period (1603–1867), while he was a student in Paris. At the time, a craze for all things

Japanese was sweeping Europe after the ruling Tokugawa Shogunate – threatened militarily by the United States – opened its seaports to international trade with the West in 1854. Bigelow travelled to Japan in 1882 and explored the land for seven years. He returned to the United States with 75,000 Japanese objects, which he gifted to the Boston Museum of Fine Arts. That bequest was and still is the largest collection of Japanese art in the world outside Japan, and it proved extremely influential among artists and writers at the time.

Isamu Noguchi

California Scenario, 1980–2

Granite, sandstone, California redwood trees,
cacti, stainless steel, water, 0.6 hectares / 1.6 acres
Anton Boulevard, Costa Mesa, California

A bird's-eye view of an arid environment maps out a striking work of landscape design, as well as hinting at the view of the sculpture garden from the skyscrapers that tower around it at South Coast Plaza in Orange County, in southern Los Angeles. The small shapes of two visitors gives a sense of the monumental scale of this work by famed American sculptor Isamu Noguchi (1904–1988). The work was commissioned by his friend the property developer Henry T. Segerstrom in 1979 as a cultural site that would be open to the public. Noguchi's interest in dry Japanese gardens influenced his design, but the main inspiration was the climate, landscape and resources of southern California. Noguchi divided the garden into six distinct areas: Forest Walk, Land Use, Desert Land, Water Source, Water Use and Energy Fountain. The fulcrum of the work, visible at the top left of this image, is a mound-like sculpture called *The Spirit of the Lima Bean*, formed out of fifteen granite rocks fitted perfectly into one another in order to evoke the bean fields and agriculture that once dominated the region. Elsewhere are references to diverse Californian landscapes, such as the redwood trees planted around the C-shaped walk to the left, and a desert, at top right, containing a selection of native plants. The circuitous stream appears and disappears beneath the paving stones, joining Water Source to Water Use, drawing attention to both the scarcity of water in the region and the human impulse to terraform the entire desert to make it inhabitable.

Gisèle Freund

Frida Kahlo in Her Garden at Coyoacán, c.1951

Gelatin silver print, 60 × 60 cm / 23½ × 23½ in
Institut mémoires de l'édition contemporaine (IMEC),
Saint-Germain-la-Blanche-Herbe, France

German-born French photographer and photojournalist Gisèle Freund (1908–2000) fled Nazi Germany in 1933, fearing for her life as a Jew, a socialist and a lesbian. Landing in Paris, then South America, she later became known as one of the greatest portrait photographers in history. Freund spent two years in Mexico, where she met and befriended artist Frida Kahlo and her husband, Diego Rivera, also an artist. During this time Freund took hundreds of photographs of the famous couple in their home,

creating some of the most intimate and insightful portraits of them. They were also some of the last photos taken of Kahlo. Born in La Casa Azul (The Blue House) in Coyoacán, Mexico City, Kahlo lived most of her life there, creating many of her best-known paintings in it. Kahlo and Rivera filled their house and garden with pre-Hispanic artefacts, folk art, plants and pets. In this photograph, Kahlo stands in the middle of her garden, wearing a plain white dress and a shawl, with a small black dog at her side. She is surrounded

by numerous pre-Hispanic sculptures and a profusion of plants. The species are diverse, both tropical and desert, in pots and in lushly planted beds edged with volcanic rock. Several specimens of old man cactus can be seen, as well as other cacti, agave, yucca and palms. A large yam vine climbs the wall behind her and a vertical spray arises from a fountain. Like Kahlo's work and her home, the garden took inspiration from traditional Mexican culture and the surrounding landscape.

Ganna Walska

Lotusland scrapbooks, 1957

Printed paper, drawings, clippings and photographs, dimensions variable, Ganna Walska Lotusland Foundation, Santa Barbara, California

Lotusland in Santa Barbara, California, is as eccentric as its creator, Madame Ganna Walska (1887–1984), who bought the isolated wooded estate in 1941, having been married six times to wealthy men. Never having achieved her dream of becoming a famous opera singer, Walska spent forty-three years transforming the garden by adding unlikely touches, including a floral clockface surrounded by a topiary menagerie, a cascade made from giant clam shells, and a swimming pool planted with Asian lotus, reflecting her interest in Eastern mystical philosophy. Among the eighteen distinct gardens she created were an Aloe Garden with more than 160 different types and a Cycad Garden with 450 primitive plants from 120 species, arranged in beds by their continent of origin. Before starting each garden, she filled scrapbooks like these with articles and photos for inspiration and information – and proceeded to create something more operatic than the originals. Walska's innate sense of theatre produced the iconic Blue Garden, where chunks of blue-green glass slag from the furnaces of a nearby water-bottling plant form a path through blue fescue grass beneath blue Atlas cedars, Colorado spruce and Mexican blue palms. In time, Walska became less of a socialite and more of a gardener, selling her jewellery to finance new projects. One sale increased the number of palms in the garden to 375, and in 1971 she sold most of her remaining jewels to create her 'million-dollar' Cycad Garden, now a priceless conservation collection that contains some of the rarest specimens in the world.

Brassaï (Gyula Halász)

Exotic Garden, Monaco, 1946

Gelatin silver print, 39 × 29.3 cm / 15⅜ × 11½ in
Museum of Modern Art, New York

Set against the backdrop of the extraordinary Jardin Exotique in Monaco, the monochrome colouring of this fantastical photograph contrasts a flock of four nuns in long black robes and large, starched cornettes, with a dense forest of giant cacti. The nuns, with their wing-like wimples, seem to be in retreat down a garden path from the twisting, curving, looming prickly plants, but their passage may be thwarted by the overhanging cacti beyond. The stark contrast of the figures with the prominent, dangerous-looking cacti reveals

the artful mastery of light and dark wielded by Hungarian photographer Gyula Halász (1899–1984), better known as Brassaï. Having studied in Budapest, Brassaï joined the Austro-Hungarian cavalry and later moved to Paris, where he worked as a journalist before delving into photography, capturing portraits of artists in their studios, such as Salvador Dalí (see p.79) and Pablo Picasso. Brassaï's best-known images are those of the French capital between the two world wars, where he captured both high society and the seedy side

of life. As he quickly gained recognition, he was sought out by top publications of the day, notably *Harper's Bazaar*, and sent on assignments around the world. It was on a trip to Monaco that he photographed the Jardin Exotique, a botanic garden set into a cliffside that opened in 1933. Many of the succulents in the garden were brought back to Europe from Mexico in the late 1860s, with African species being added in the 1930s, such as the African candelabra seen here, which shares the form of a true cactus, belonging to the genus *Euphorbia*.

Dale Chihuly

Cattails, Niijima Floats,
Citron Icicle Tower, 2012

Glass and polyvitro installation
Chihuly Garden and Glass, Seattle

A vibrant array of shrubs, flowers and trees provides a rich setting for sinuous orange glass forms that are overshadowed by the 9-metre (30-ft) tall plant-like sculpture behind them. Located inside the Seattle Centre, close to the city's iconic Space Needle observation tower, Chihuly Garden and Glass is a popular attraction showcasing the spectacular glass sculptures of artist Dale Chihuly (b. 1941). Chihuly has frequently exhibited his creations in botanic gardens, but this was the first time a unique environment was created as a backdrop for his art. The garden's plant collection – including crimson camellias, scarlet daylilies, hardy fuchsias, black mondo grass, western red cedars and handkerchief trees – was chosen to complement Chihuly's installations, including his orb-like *Niijima Floats* and spindly *Neodymium Reeds*. Not all Chihuly's sculptures are made from glass: his *Viola Crystal* and *Citron Icicle* towers are fabricated from polyvitro, a type of plastic he developed for ambitious works on much larger scales. An exhibition hall containing eight galleries offers visitors a comprehensive overview of Chihuly's most significant works, including his iconic *Mille Fiori*, in which hundreds of glass flowers are set upon a plexiglass pond, and the multicoloured *Macchia Forest*, a collection of spotted mushroom-like sculptures. The centrepiece of the site is the 12-metre (40-ft) tall Glasshouse, where an enormous suspended sculpture containing more than 1,300 plant-like elements sparkles with brilliant reds, oranges and yellows – a celebration of the artist's love of nature and gardens.

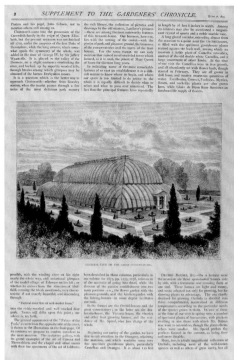
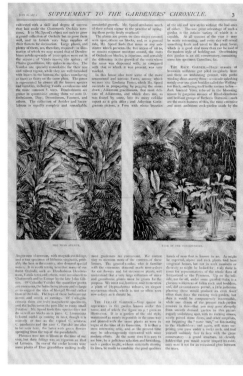
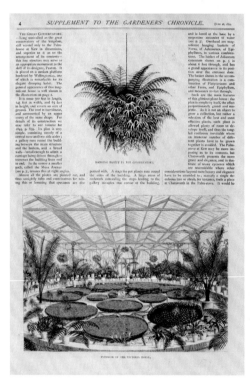
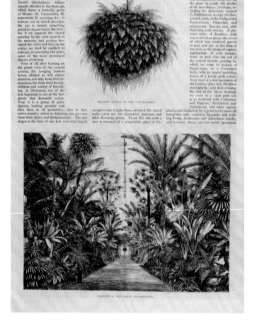

Worthington George Smith

Chatsworth, supplement to the
Gardeners' Chronicle, 1875

Ink on paper, each 26.1 × 19.8 cm / 10¼ × 7¾ in
University of Massachusetts, Amherst Libraries

Founded in 1841, one of the most famous and influential English horticultural magazines, the *Gardeners' Chronicle*, began as a general weekly newspaper. Entering a burgeoning horticultural magazine market that included two monthly magazines already established by one of its founders – and its editor – Sir Joseph Paxton, it soon concentrated purely on gardening. Each week, the *Gardeners' Chronicle* ran articles on every kind of gardening and included, from 1845, a substantial amount of advertising from glass greenhouses to exotic plants. Many of the illustrations in the advertisements were the work of Worthington George Smith (1835–1917), who, in addition to his drawings, was a skilled plant pathologist and mycologist. For this 1875 supplement, Smith drew the illustrations for the feature on Chatsworth, the Derbyshire estate of the Duke of Devonshire, for whom Paxton had started work as head gardener in 1826. Paxton went on to redesign the garden, extend the arboretum, build a rock garden and oversee the construction of a huge glasshouse between 1836 and 1839, where he successfully grew the Amazonian *Victoria regia* waterlily, with its huge pads, for the first time in Europe. Paxton's interest in glass buildings – he designed London's Crystal Palace in 1851 – led to a profitable sideline in small greenhouses, also advertised with illustrations by Smith in the *Gardeners' Chronicle*. These illustrations of Chatsworth for the supplement show that Smith was as good an architectural draughtsman as he was a horticultural illustrator.

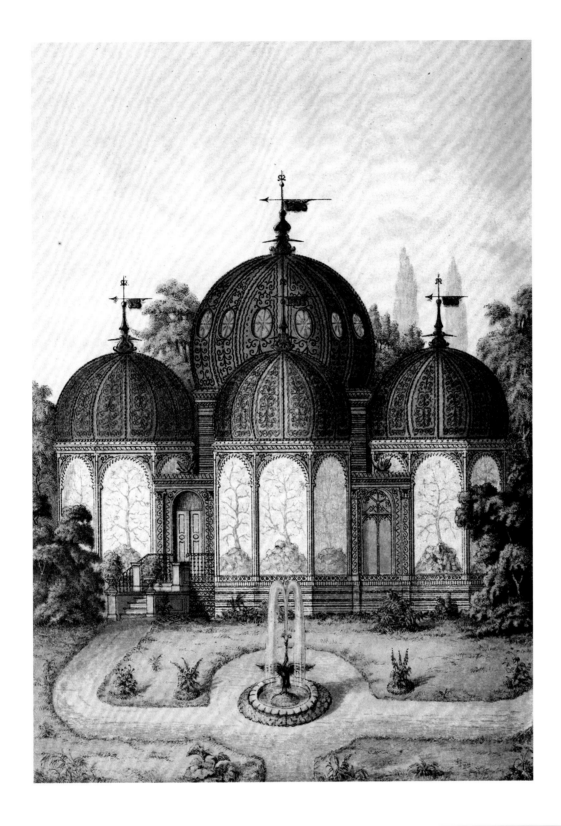

Alfred Brehm and Otto Finsch

Frontispiece of *Captive Birds* (*Gefangene Vögel*), 1872

Hand-coloured engraving, 25.5 × 17.5 cm / 10 × 6¾ in
Field Museum of Natural History Library, Chicago

Although never built, this design for a combined conservatory and aviary captures a fashionable moment in the second half of the nineteenth century, when wealthy Europeans began a trend for building ornate aviaries in the gardens of their large estates to display the exotic birds they had collected, a status symbol at the time. Collecting birds had been a popular hobby since the seventeenth century, following the European colonization of the Americas, but those birds were largely confined to cages inside the house.

With shortened sailing times, many more species of birds were being shipped back to Europe by a growing band of explorers, such as the German naturalists and ornithologists Alfred Brehm (1829–1884) and Otto Finsch (1839–1917), who were responsible for this cutting-edge conservatory design by an unknown illustrator. Brehm and Finsch recognized the growing appetite for large aviaries in which the birds could appear among their native vegetation, alongside improvements in glass technology and the development of

cast-iron frames, which made it easier to construct buildings with curved glass roofs. Aviaries were highly prized in grand gardens, and the structures were often used as a focal point, being placed at the end of a walk where guests would be treated to a display of lush vegetation, exotic plumage and birdsong. The expense involved in constructing, filling and maintaining such structures meant that only the wealthiest could afford them, which only increased their status as sophisticated people of the world.

Daniel Arsham

Blue Gradient Garden, 2017

Sand, cement, wood and paint, 7.6 × 24.8 × 15.4 m /
25 ft × 81 ft 3 in × 50 ft 7 in
Flamengo Park, Rio de Janeiro

What might appear at first glance to be a traditional Japanese Zen garden is jarring for two reasons: its unnatural blue colour, and the view it frames of Sugarloaf Mountain, which rises behind the Brazilian city of Rio de Janeiro. American artist Daniel Arsham (b. 1980), no stranger to reinterpretations of Japanese gardens, created this large mixed-media installation – including sand, stone, wood, concrete and a variety of plants – in Rio's Flamengo Park, replacing the stones usually found in the beds of raked gravel with petrified

contemporary artefacts, including a teddy bear. Arsham's reinterpretation brings the Zen environment that has been so important in Japanese culture as a refuge for meditation and contemplation to the notorious chaos and dynamism of Rio, while building on Arsham's own previous reinterpretations of Buddhist gardens. Arsham is colour-blind and is able to see and interpret different colours only thanks to high-tech eyewear, a fact that lies behind the creation of his single-coloured, multi-shaded installations. He created a

similar installation with *Hourglass*, a traditional Zen garden within a studio dominated by darker shades of blue, and *Lunar Garden*, another studio installation that uses pink as the dominant colour, with a soundtrack of ambient music to create a feeling of calm. In re-creating Zen gardens, Arsham explores a state somewhere between permanence and impermanence, signified by the artefacts and the gravel, which is raked differently every day.

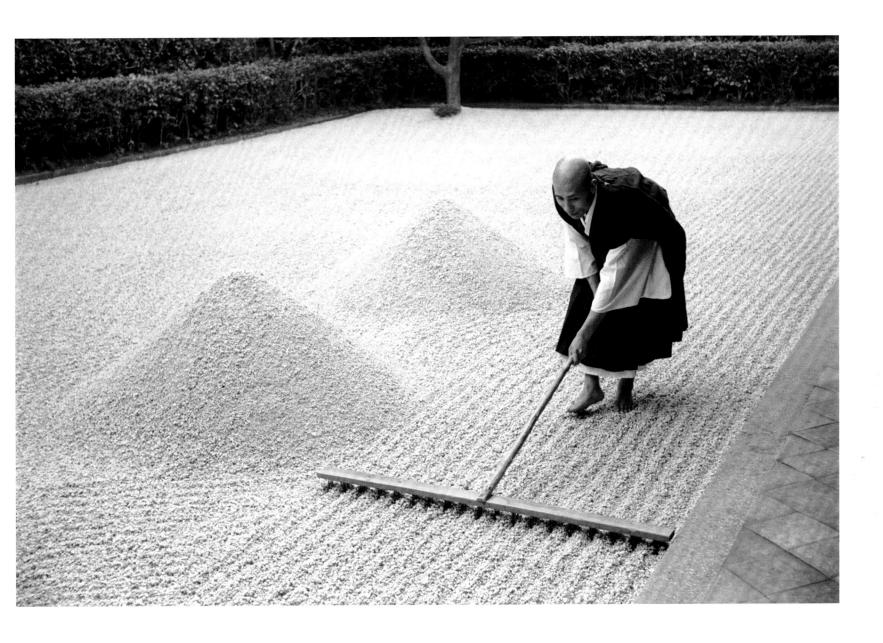

René Burri

Kyoto, Daitoku-ji Temple, The Buddhist Priest Soen Ozeki, 1961

Photograph, dimensions variable

Buddhist priest Soen Ozeki carefully rakes gravel at the Daisen-in garden, within the grounds of Daitoku-ji, one of Kyoto's most important Zen temples. This is one of several photographs of priests, temples and martial-arts displays that celebrated Magnum photographer René Burri (1933–2014) took during his travels through Japan, which were published in the Swiss periodical *Du* in December 1961. Daisen-in is one of the finest examples of a Japanese *karesansui* garden – also known as a Zen garden – a style

of dry landscaping founded on Buddhist Zen ideology that uses stone, gravel and sand to represent elements from nature. Some *karesansui* include greenery and even trees, while others adopt a more austere approach, using just a few simple elements. Traditionally attributed to monk-painter Sōami, the L-shaped garden at Daisen-in was laid out between 1509 and 1513. Its plots are long and narrow, with sections representing a forest, a river and a sea, which flow into the larger 'universal sea' seen here, with its two

distinctive mounds suggestive of mountains. In the corner, a single tree symbolizes the Bodhi Fig Tree at Bodh Gaya in Bihar, India, under which it is believed the Buddha sat when he attained Enlightenment around 500 BC. Designed as spaces for contemplation, *karesansui* gardens require careful maintenance; those who rake their gravel into precise patterns must stay focused, always remaining in the moment as they carry out the meditative duty.

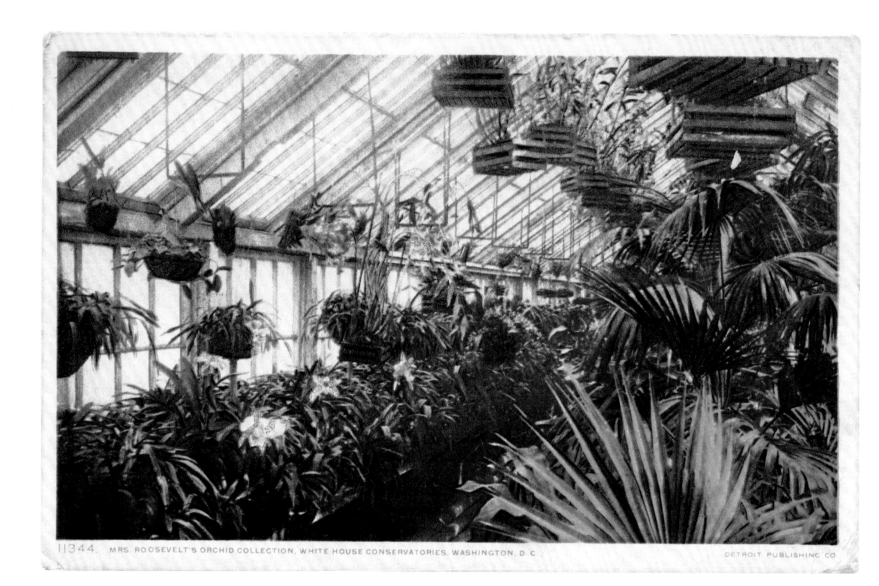

11344. MRS. ROOSEVELT'S ORCHID COLLECTION, WHITE HOUSE CONSERVATORIES, WASHINGTON, D. C DETROIT PUBLISHING CO.

Anonymous

*Mrs Theodore Roosevelt's Orchid Collection,
White House, Washington DC*, 1907–8

Printed postcard, 8.9 × 14 cm / 3½ × 5½ in
New York Public Library

This lush collection of orchids growing on shelves and hanging in baskets from the ceiling belonged to US First Lady Edith Roosevelt, wife of President Theodore Roosevelt, at the start of the twentieth century. Orchid houses had become fashionable in the late Victorian period and the Gilded Age, as greenhouse technology made it easier to control the exact heat and humidity required by some of the more fragile specimens collected from the far reaches of the world. This greenhouse was one of a cluster that rose from the west wall of the

White House in Washington DC, where the first greenhouse was built in 1835 by President Andrew Jackson to shelter a sago palm from Mount Vernon, home of George Washington (see p.154). In the 1850s President Franklin Pierce added the first glass-ceilinged greenhouse, followed a few years later by more. Presidential guests could take after-dinner strolls among exotic plants year-round. A fire in 1867 severely damaged the complex, but the greenhouses were rebuilt, and, over time, additions expanded to a footprint greater than that

of the White House building itself. Of note were a large palm house, a dedicated fern enclosure, and this orchid house. The complex of greenhouses was eventually demolished in 1902 to make space for the West Wing, a suite of administrative offices, as part of Roosevelt's ambitious renovation plan. White House gardener Henry Pfister initially suggested relocating the greenhouses instead of removing them altogether – a proposal that Edith supported, but which proved too expensive to be achievable.

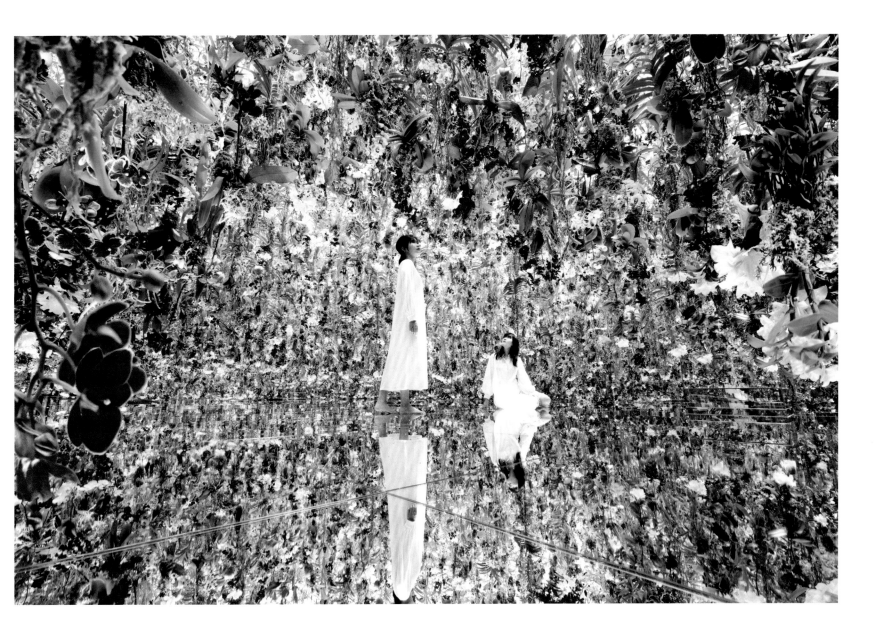

teamLab

Floating Flower Garden: Flowers and I are of the Same Root, the Garden and I are One, 2015

Interactive kinetic installation

teamLab, a Tokyo-based international art collective, was founded in 2001 with just five members. Now there are numerous specialists, including graphic animators, computer programmers, architects, artists and mathematicians, whose immersive works bring people to be a part of the artworks. *Floating Flower Garden* is a three-dimensional display of more than 13,000 orchids blooming in mid-air and surrounded by mirrored floors and ceilings. Orchids are a diverse, widespread group of flowering plants from the Orchidaceae family, which

is estimated to contain around 10 per cent of all species of seed plant. Elevating these remarkable flowers, the concept of the work reflects that of traditional Zen gardens, where devotees learn to become at one with nature, as well as an embodiment of the proverb, 'Heaven and I are of the same root. All things and I are of the same substance.' As visitors walk among the mass of flowers, the plants rise and fall, sensing the presence of people, transforming the artwork into an interactive kinetic sculpture. If someone looks at a flower it is as though the

flower looks back, and when visitors meet, the spaces merge, becoming one with each other and the garden; the boundary between individuals and the artwork becomes ambiguous. But *Floating Flower Garden* is not only visual. The intensity of the orchid fragrance changes throughout the day and a soundtrack suggestive of the natural world serves to intensify the immersive sensory experience. Through the confluence of science, art and technology, teamLab's installations transcend boundaries and explore humans' relationship with the natural world.

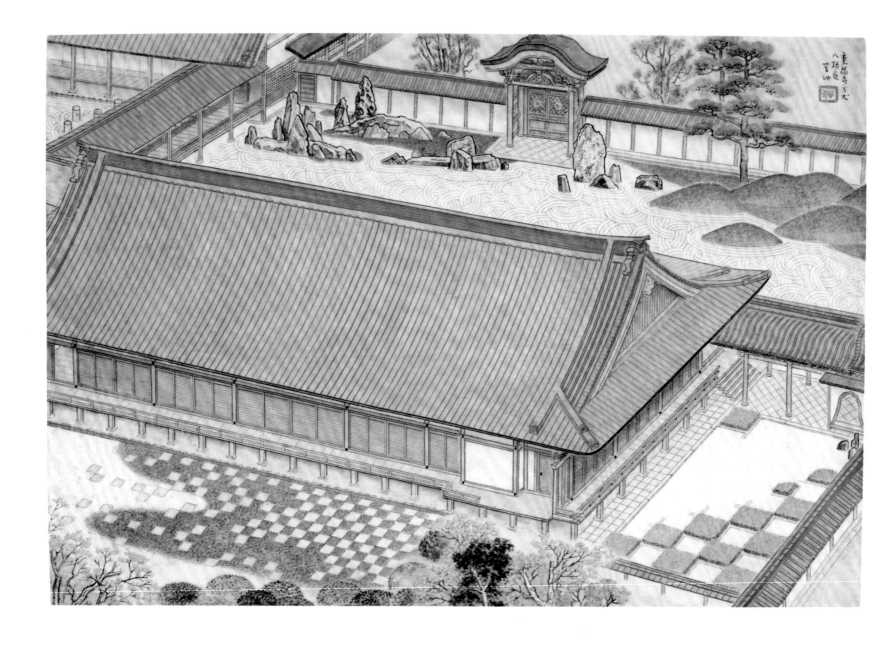

Mirei Shigemori

Tofuku-ji Hojo, 1930s

Ink and colour on paper
Private collection

One of the most popular of all Japanese gardens, Tofuku-ji Hojo in Kyoto, features in this drawing of a dry *karesansui* garden. Designed by Mirei Shigemori (1896–1975), one of the leading designers of such gardens, Tofuku-ji Hojo was an example of what Shigemori called 'concept gardens containing abstract expression'. The garden is made up of four parts, of which this drawing details the South, West and North gardens. The South Garden represents a world based on Chinese mythology: the white sand is the sea, the four rocks are islands and the five hillocks represent five key Zen temples. The West Garden represents rice fields shown in a chequerboard pattern, planted with azaleas. The North Garden tells the story of the spread of Buddhism from India to East Asia, conveyed by the moss-covered chequerboard pattern that gradually fades into green. In the East Garden – not visible here – Shigemori placed seven stone columns to represent the constellation of the Big Dipper. Shigemori completed the garden in 1939, a year after the publication of his comprehensive study of 242 Japanese gardens, *Illustrated Book on the History of the Japanese Garden*. He concluded that Japanese garden design stopped evolving after the Edo period (1603–1867) and needed modernizing. Tofuku-ji Hojo was the first work in which he blended traditional Japanese and European influences (he had spent time in Paris), and his use of stone cubes for the chequerboard patterns and the inclusion of stone pillars create a garden that is a physical manifestation of abstract concepts that combine foreign influences with Japanese tradition.

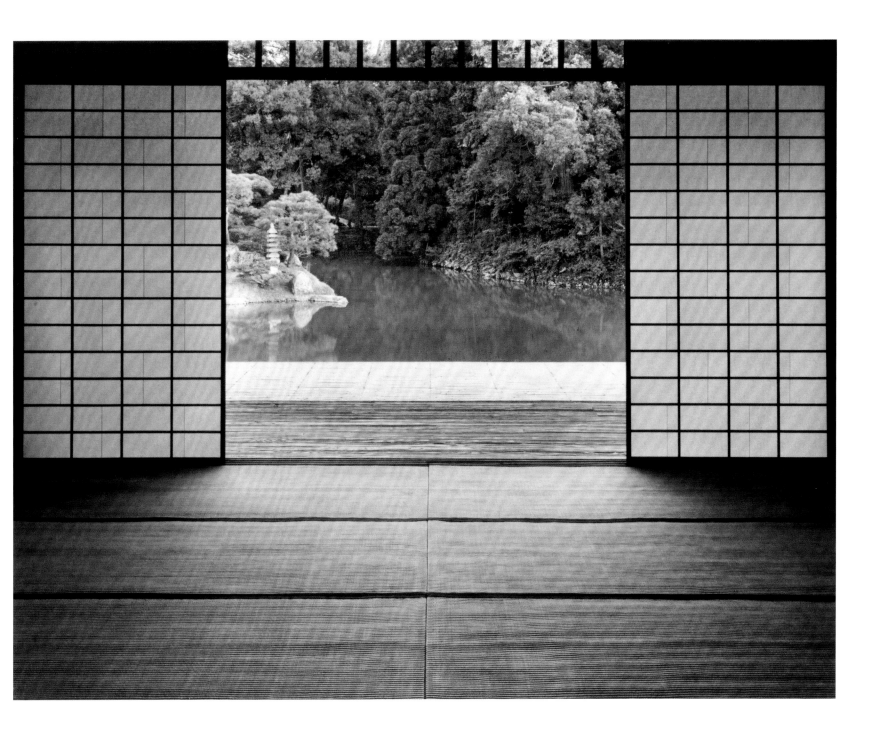

Yasuhiro Ishimoto

Moon-Viewing Platform Seen from the Second Room, Katsura, 1954

Gelatin silver print, 16.7 × 23.8 cm / 6½ × 9⅜ in
Museum of Art, Kochi, Japan

The presence of the moon has been integral to Japanese culture and garden design for centuries, and the seventeenth century brought the introduction of 'moon-viewing platforms', or *tsukimidai*, stages or surfaces from which to enjoy the reflection of the full moon on the surface of a pond or body of water built into the garden. The temporality of all elements of nature, from the seasons to the growing and flowering stage of a plant, is central to Japanese gardening and design, and so it is with the waxing and waning of the

moon: a means of marking time as well as a spectacle to relish and observe in itself. This photograph was taken from the Old Shoin, part of the Katsura Imperial Villa, the gardens and buildings of which were completed in 1645 for the Katsura, members of Japan's imperial family. Captured by Yasuhiro Ishimoto (1921–2012), the photograph is one of many taken by the Japanese-American photographer, who documented post-war life and culture on both sides of the Pacific Ocean. Born in San Francisco, Ishimoto was raised

in Japan before returning to America after high school to further his studies in agriculture. He was a student at the University of California when, in 1942, he was forcibly sent to one of the many internment camps for Japanese-Americans. By the late 1940s he had left the camp and was pursuing the photography that would come to define his life. Although he suffered for being of two cultures, it was ultimately this dual lens that enabled his greatest work.

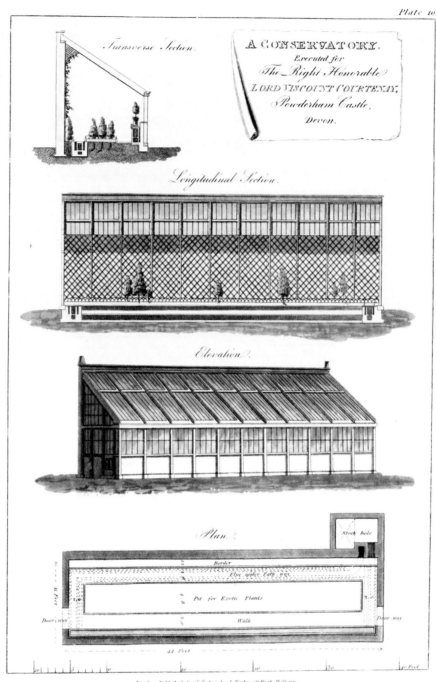

George Tod

A Conservatory Executed for ... Lord Viscount Courtenay, from *Plans, Elevations and Sections, of Hot-Houses, Green-Houses ... &c.,* 1807

Hand-coloured etching with aquatint,
38.8 × 27.5 cm / 15¼ × 10¾ in
Getty Research Institute, Los Angeles

A plan of a hothouse might not seem the most exciting element of garden creation, but this design for Powderham Castle in Devon, created by the self-styled 'surveyor and hothouse creator' George Tod (active early 19th century), is evidence of a profound change that took place in horticulture in the nineteenth century. As horticulturists in cool northern hemipshere climates increasingly grew plants shipped across the globe from warmer areas, advances in glazing technology allowed the development of more sophisticated hothouses to provide the heat and humidity required to grow them successfully. Tod published his book of 'plans, elevations and sections' of hothouses and other glazed structures he had built for patrons around England to advertise his practice, which was based on Sloane Square in Chelsea, London, but it also acted as a pattern book that would allow those of more modest means to build similar structures themselves. At the time, flues of hot air were the norm for heating plant houses (before the advent of piped hot water or steam heating), and Powderham Castle housed a 'Pit for Exotic Plants', with specimens grown in the soil or plunged in their pots. In coming decades specialization in various glasshouses became more common, and Scottish-trained landscape gardener Charles H.J. Smith adopted the term 'garden architect' in the 1830s, denoting a speciality in glazed horticultural buildings. By mid-century such specialization was monopolized by companies using a design-and-construct model based on prefabricated components and illustrated catalogues that echoed Tod's early example.

Tom Hammick

Koodge's Garden, 2022

Reduction woodcut with hand painting,
1.4 × 1.2 m / 4 ft 7 in × 4 ft 11 in
Private collection

In front of a makeshift potting shed, the glazed roof of which reflects a brilliant dusky evening light, a gardener surveys her colourful allotment, laid out like a striated runway of flowers and plant tops between dark pathways. For this inventive print, British artist Tom Hammick (b. 1963) carved several intricate plates from an original hand-inked drawing on oak board, printed in more than ten different stages over soft gradients of gouache colour. The twenty different impressions of the edition were inked with slight variations of colour to suggest the passage of late afternoon into evening, reminiscent of the 'all-day' series of haystacks by Claude Monet (see pp.40, 212). This quixotically technical approach was designed in part to do justice to the visual experience of a scene that to Hammick 'seemed almost quantum in its complexity' – but also as a fitting tribute to the gardener, his sister, who by her labour had marshalled such a pleasing horticultural display. Hints of the effort required can be found in the less-than-triumphal sag of the gardener's pose or intuited from the teetering tidal wave of flowers on the right, which threatens to crash over the manicured planting of the central bed. There is ambiguity in both the excesses of the display and its otherworldly, almost undersea coral-like appearance, entirely appropriate to the post-COVID-19 lockdown period in which Hammick rushed to create it – capturing both the optimism and delight of reconnecting with family, and anxiety about the fragility of a carefully cultivated security.

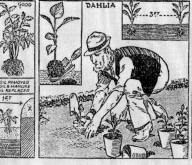

Celery plants grown in boxes can now be put out 9 in. apart in a 1-ft. wide trench, 10 in. deep. Place a layer of decayed manure in the trench about 4 in. deep. Tread the plants well in as each is planted. When all are planted, water them thoroughly. Later apply a dressing of nitrate of soda once a fortnight.

Dahlias in pots can be planted out in deeply dug soil in which decayed manure has been mixed. Water the dahlias the evening before planting. Allow 3 ft. between each—the more vigorous growers being 4 ft. apart. Use a trowel to make a hole large enough to take the full ball of unbroken soil. Stake soon after planting.

Use lawn sand on lawns infested with daisies and plantains; the method of making this is shown. The sand will turn the grass brown, but this will recover after about a week. When not too numerous, an old hand-fork will be useful in removing the weeds. A home-made weed extractor is shown in insets.

53

Lift the main carrot crop before cold weather sets in. Cut off the leaves and store in dry soil or sand in a shed, or arrange in layers of ashes or sand in covered boxes. Place them so that the crowns are away from each other. If lack of space prevents storing in a shed make small clamps in a dry spot in the way shown. Do not store any damaged roots, and see that all are quite dry. The soil covering should be 3 in. thick.

If you cannot use all your vegetable marrows within a reasonable time you can store them. Choose only sound, ripe, green-streaked varieties. Hang them up in a dry place in cradles made of pairs of broad tape or cloth, suspended by hooks and sticks as shown. In this way they should keep in good condition until January or February. Take care not to bruise the skins. The temperature should not be allowed to fall below 45 degrees F.

Store parsnips in layers against a wall or fence as shown. Lift and dry onions thoroughly before storing in a dry, cool place, by hanging them in nets. Lift celeriac when the bulbous stems are blanched. Remove leaves and store them in sand in a dry, cool shed. In the south it may not be necessary to lift them. By drawing up the soil around the bulbs and covering the plants with straw or bracken they should be sufficiently protected.

73

Cyril Cowell and Morley Adams

Adam the Gardener, 1946

Lithograph, each page 14 × 21 cm / 5½ × 8¼ in
Private collection

With his square jaw rimmed by the hint of an Old Testament beard, a gardener known only as Adam shows his readers how to plant leeks and dahlias and rid lawns of weeds in June, as well as how to harvest and store vegetables at the start of September. The use of a comic strip to convey gardening instructions was pioneered in the 1930s by the magazine *Garden Work for Amateurs*, but the *Daily Express* took it to a wider audience in the following decade when it started publishing 'Adam the Gardener', drawn by Cyril Cowell

(1888–1967) and written by Morley Adams (1876–1954); in 1946 the *Express* published a book of the cartoons arranged in a week-by-week guide. The title may have been inspired by Henrietta Batson's novel *Adam the Gardener* published in 1894, or by Rudyard Kipling's (see p.275) poem 'The Glory of the Garden': 'Oh, Adam was a gardener, and God who made him sees / That half a gardener's proper work is done upon his knees'. Adams described Adam as his ideal gardener, one who carried on gardening even on Christmas

Day, rising above the spirit of the garden as 'a place where savage battles with weeds and worms and men are fought and where bitter jealousies rage'. Later editions of *Adam the Gardener* appeared under various titles, illustrated anew each time by Cowell. In 1978 the work was rewritten by Max Davidson, and it was last reissued in the 1980s.

BE YOUR OWN GARDENING EXPERT

BY DR. D. G. HESSAYON

This invaluable book tells you in plain language all you need to know about improving your soil, understanding the needs of your plants, and recognising and dealing with the pests and diseases that attack them. It is full of answers to questions you have so often asked and never been able to find answered in ordinary gardening books.

1/6

FREE SOIL TESTER INSIDE!

David Gerald Hessayon

Be Your Own Gardening Expert, 1958

Lithograph, 23.8 × 18.3 cm / 9⅜ × 7¼ in
Private collection

Surrounded by small vignettes showing various gardening activities, a male figure surveys a day's work well done in this cover illustration for the best-selling gardening manual by British author and horticulturist David Gerald Hessayon (b. 1928). *Be Your Own Gardening Expert* was the first of a long-running series of 'Expert' guides by Hessayon that borrowed the school textbook formula of straightforward written instruction paired with colourful illustrations, charts and diagrams. The gardening manual explained,

among a wide array of topics, common weeds, improving different soil types – using the free soil tester provided with the booklet – ways to stave off unwanted insects and other garden nuisances, and the process of taking cuttings. Hessayon's guides arrived at the height of the post-war DIY boom of the late 1950s, when increasing rates of home ownership and shorter working weeks transformed gardening from the 'Dig for Victory' toil of the rationing era to an enjoyable and wholesome pastime that could bring the

family together. The cover reflects this new ideal, charting progress from the first spade dug into the unworked earth at the top left to the nuclear family unit of husband, wife and children bringing forth barrows full of vegetables and thick bunches of bright flowers whose colours resonate against the scumbled mossy green background. The 'Expert' series became the most popular gardening books of all time, amounting to more than twenty-two titles and selling more than fifty million copies worldwide.

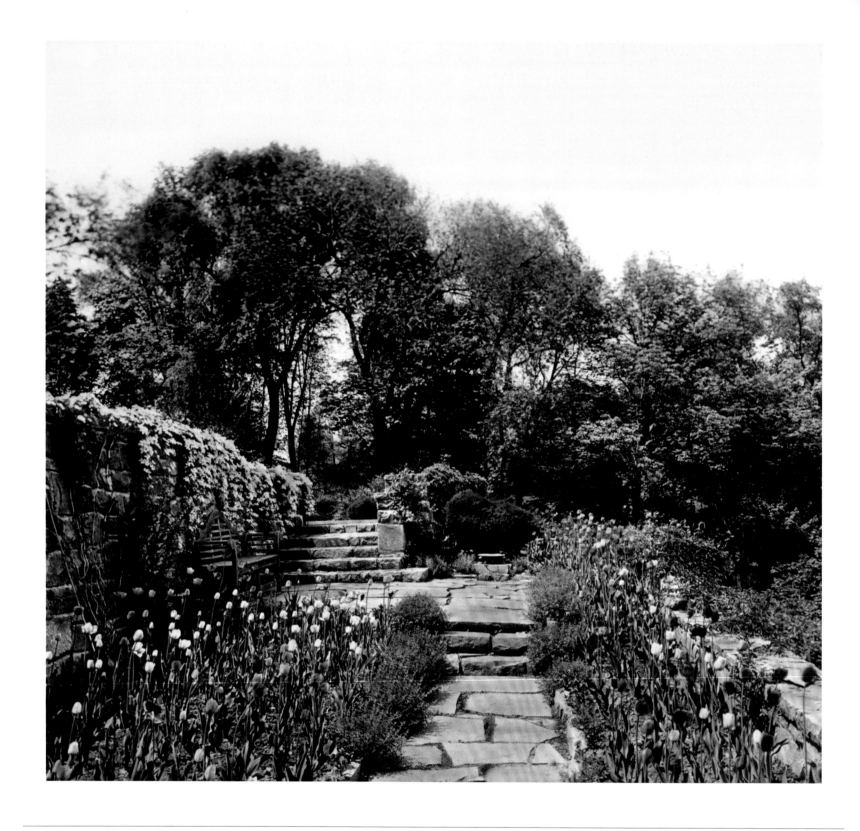

Mattie Edwards Hewitt

Niederhurst, the Lower Terrace, Designed by Marian Cruger Coffin, 1929

Lantern slide, glass, 12.7 × 7.6 cm / 5 × 3 in
Smithsonian Institution, Washington DC

The golden age of American garden design lasted roughly forty years, from the end of the nineteenth century to the start of the Great Depression in 1929. During that time, many of the country's richest families built imposing country houses with large gardens for entertaining. A number of those gardens were designed by the pioneering landscape gardener Marian Cruger Coffin, whose upper-class connections helped her establish a highly successful horticultural career. Many of her gardens, such as this one at Niederhurst on the bank of the Hudson River in New York, were photographed by another female pioneer, photographer Mattie Edwards Hewitt (1869–1956). Initially working with her then lover, Frances Benjamin Johnston, Hewitt set up her own practice in New York City after their split, specializing in architectural and garden photography. Hewitt's work appeared in publications that catered to the enthusiasm for gardening, including *Vanity Fair*, *House Beautiful* and the *Saturday Evening Post*, earning her a reputation as 'one of the best known and most lyrical garden photographers of her day'. Hewitt kept meticulous records: she made prints for the homeowners and kept her own archive, which later provided a detailed record of this golden age. This photograph of the lower terrace at Niederhurst, shot on a bright early summer's day in 1929, captures Coffin's skilful planting at its best, with the flower beds full of tulips and the stone stairs making the most of the slope down to the river.

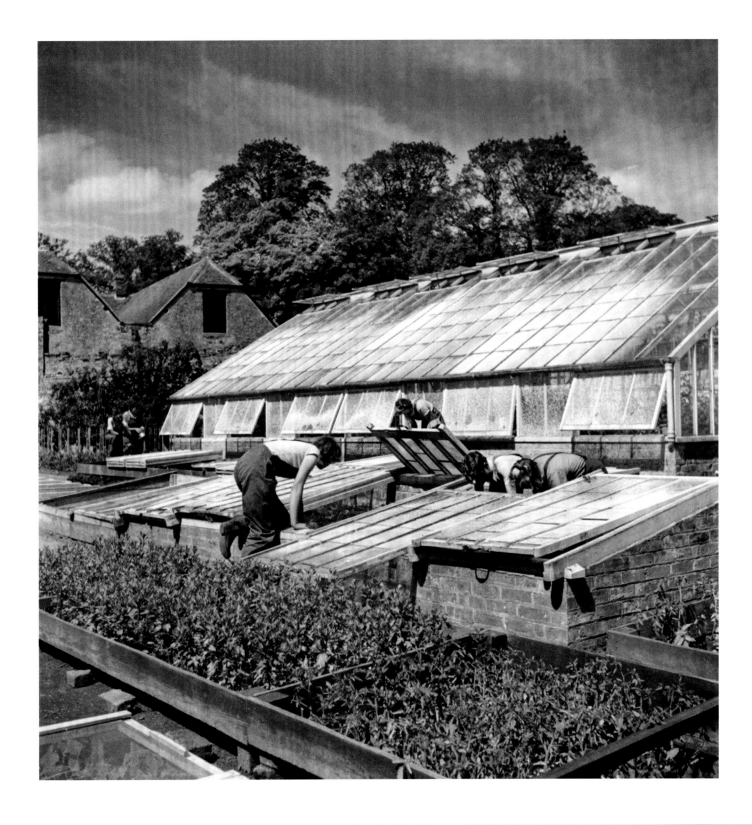

Cecil Beaton

Women's Horticultural College,
Waterperry House, Oxfordshire, 1943

Photograph, dimensions variable
Imperial War Museum, London

Remarkable for both its creator and its subject, this image was captured by Cecil Beaton (1904–1980), renowned as a photographer of high fashion and high society. It shows the Women's Horticultural College at Waterperry House in Oxfordshire in 1943, when it was involved in the World War II campaign to 'Dig for Victory' by growing as much fruit and vegetables as possible (see pp.30, 200). Waterperry, which became celebrated for its exhibits of 'Royal Sovereign' strawberries at the Chelsea Flower Show, was founded in 1932 by Beatrix Havergal and her partner Avice Saunders. It was the last of a series of horticultural schools for women that had started with Swanley College in Kent, which became an all-female college in 1902; in 1898 the Countess of Warwick founded a school for women gardeners that became Studley College; and Viscountess Wolseley founded the Glynde School for Lady Gardeners in 1902. Waterperry produced a succession of renowned gardeners, including Valerie Finnis (see p.81) and Mary Spiller, but in 1966, the government decided to concentrate agricultural education into fewer institutions and phase out single-sex schools. Studley College was closed, and Waterperry was the last, closing in 1971 after Sanders's death. The School of Philosophy and Economic Science acquired the estate, and opened the gardens to the public, in order to help finance its activities. In 1986 Mary Spiller and Bernard Saunders supervised a reorganization of Waterperry into an ornamental garden, with herbaceous borders, a knot garden, a canal with waterlilies, and extensive orchards.

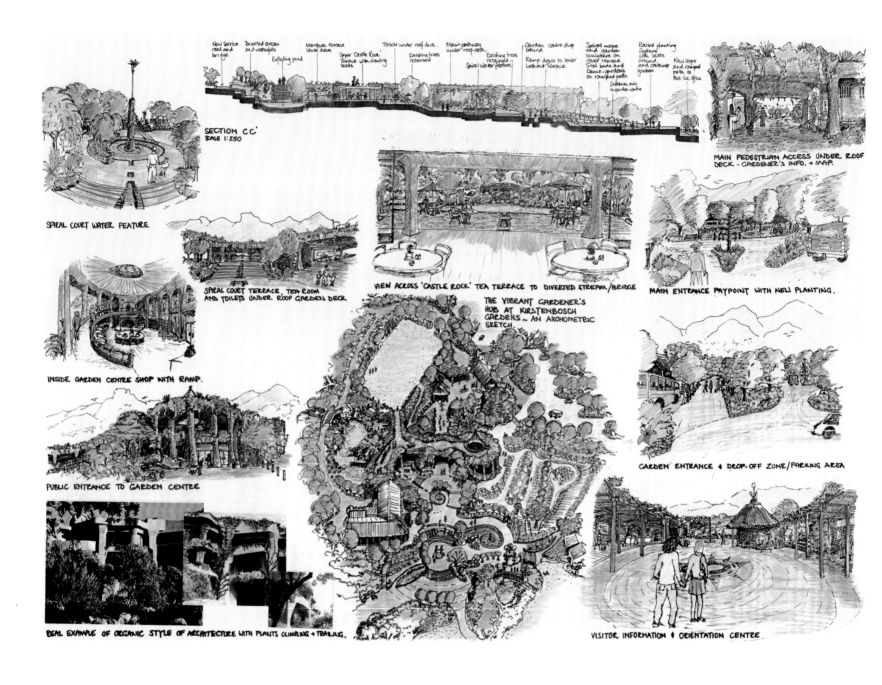

The various sketches are labelled:

SECTION CC'
SCALE 1:250

SPIRAL COURT WATER FEATURE

SPIRAL COURT TERRACE, TEA ROOM AND TOILETS UNDER ROOF GARDEN DECK

VIEW ACROSS 'CASTLE ROCK' TEA TERRACE TO DIVERTED STREAM/BRIDGE

THE VIBRANT GARDENER'S HUB AT KIRSTENBOSCH GARDENS ~ AN AXONOMETRIC SKETCH

MAIN PEDESTRIAN ACCESS UNDER ROOF DECK - GARDENER'S INFO. + MAP.

MAIN ENTRANCE PAYPOINT WITH NEW PLANTING.

INSIDE GARDEN CENTRE SHOP WITH RAMP.

PUBLIC ENTRANCE TO GARDEN CENTRE

REAL EXAMPLE OF ORGANIC STYLE OF ARCHITECTURE WITH PLANTS CLIMBING + TRAILING.

CARDEN ENTRANCE + DROP-OFF ZONE/PARKING AREA

VISITOR INFORMATION + ORIENTATION CENTRE

Ann Sutton, Michael Sutton and Clare Burgess

Kirstenbosch National Botanical Garden, Cape Town: Landscape Proposals for a Gardener's Hub, 1990s

Pencil, crayon and felt-tipped pen,
84.2 × 118.9 cm / 31½ × 47¼ in
Ann Sutton Archive, University of Cape Town Libraries

This hand-drawn plan with its extensive notes was produced for an architectural competition to create the Centre for Home Gardening at Kirstenbosch National Botanical Garden. One of South Africa's nine national botanic gardens – and the first anywhere in the world expressly intended to preserve a regional flora – it was founded by Harold Pearson in 1913 on land gifted to the nation by imperialist adventurer Cecil Rhodes. Set on the eastern slopes of Table Mountain, the gardens today contain more than 7,000 taxa, or types of

plant, of which 2,500 are endemic to the Cape Peninsula, the smallest of the world's six recognized floral kingdoms. The design, by Ann Sutton (1924–2011) – who overcame deafness and later a leg amputation to become one of South Africa's leading landscape architects – with her brother Michael Sutton (b. 1928) and Clare Burgess (b. 1957), is based on organic, natural shapes, particularly the spiral. As the accompanying notes spell out, the spiral had both a symbolic meaning – of evolution, and of the spirit – and a practical one, in making

paths more accessible for visitors with less mobility. In a forerunner of today's 'green buildings', the design called for greenery to cover the building completely – so that glass, concrete and stone coexisted with the plants that dominate the space – and was intended to enhance views of nearby Castle Rock. Ultimately, the design was considered too intimate and informal for the number of visitors expected at the site, and it came second in the competition, although it was acknowledged as being more site-responsive than the winning entry.

N9966 7/8- 4x5 Neg. Oct. 4, 1938.

N9968 7/8- 4x5 Neg· Oct. 4, 1938.

N11434 7/8- 4x5 Neg. Sept. 1942.

N9967 7/8- 4x5 Neg. Oct. 4, 1938.

N10487 7/8-4x5 Neg Sept. 27, 1939.

N11435 7/8-4x5 Neg Sept. 1942.

N10488 7/8-4x5 Neg. Sept. 27, 1939.

Anonymous

Hardy Aster with Conservatory in Background, 1939

Photographs mounted on card, each 10 × 12 cm / 4 × 5 in
LuEsther T. Mertz Library, New York Botanical Garden

Legendary horticulturist Thomas H. Everett left an indelible mark on the New York Botanical Garden (NYBG) landscape and made a lasting impact on the wider gardening world. Born in England and trained at Kew, he joined the NYBG staff in 1932 and remained involved there for the rest of his life. A skilled plantsman with ambitious and innovative ideas for the garden's living collections and exhibitions, Everett trialled and tested a wide array of species and growing conditions. In the springs of 1937 to 1939 he greatly expanded the flower border

pictured here, which was devoted entirely to hardy asters. With the stunning backdrop of a Lord & Burnham-designed glasshouse (now the Enid A. Haupt Conservatory), the asters culminated in a showy autumn floral display. To Everett and those in England, the asters were known as Michaelmas daisies, one of many plants that were underappreciated as common roadside weeds in North America but that were widely bred by European gardeners. Many of them were propagated at the NYBG and planted out as nearly 3,000 plants of 72 different varieties.

Although the genus *Aster* has been taxonomically split since, Everett's careful record-keeping and archived plant lists reveal impressive diversity, from wild-collected plants to new and 'improved' cultivars bred from other North American species, as well as European and Asian types. With a broad spectrum of vibrant colours and heights, from low-growing alpine asters to taller varieties, the hardy aster border attracted attention just as summer blooms began to fade, until at least the first frost of the season.

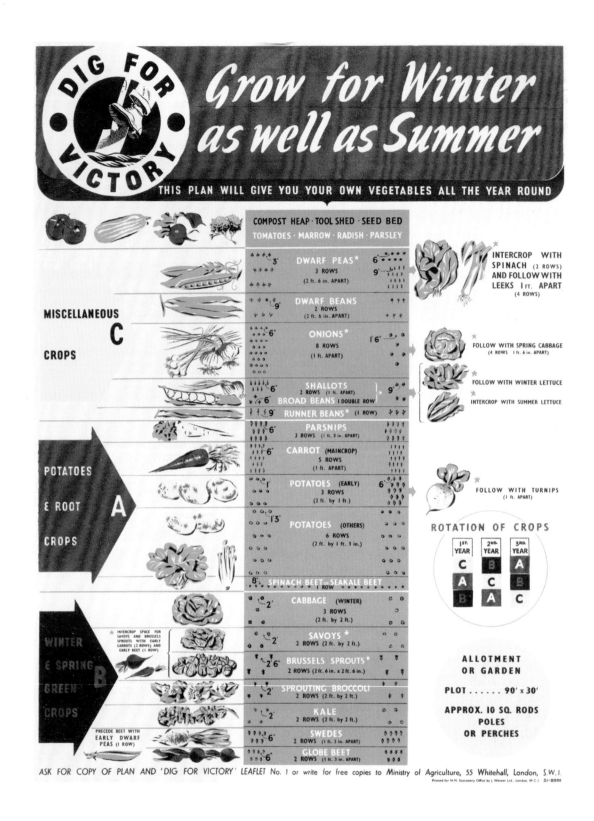

Ministry of Agriculture

Grow for Winter as Well as Summer, 1939–45

Lithograph, 50.7 × 38 cm / 20 × 14 in
Imperial War Museum, London

During World War I, an estimated 6 million tons of food destined for Britain was lost to U-boat attacks on transatlantic cargo ships. At the start of World War II, German Naval Command calculated that if they destroyed 750,000 tons of shipping every month, Britain would surrender within a year. The British were equally aware of their vulnerability. To reduce the dependence on imports, such as onions, citrus and tomatoes, Edward Bunyard, president of the Royal Horticultural Society's Fruit and Vegetable Committee, recommended such measures as stockpiling seed, maximizing fruit production through good pruning and hygiene, and using leaflets, booklets and posters such as this one to encourage people to 'grow their own'. In September 1939 young journalist Michael Foot encouraged readers of the *London Evening Standard* to 'Dig for Victory'. A few weeks later, when the 'Grow More Food' campaign was launched, Minister for Agriculture Sir Reginald Dorman-Smith took up the slogan, saying: 'Let "Dig for Victory" be the motto of everyone with a garden, and of every able-bodied man or woman capable of digging an allotment in their spare time.' The battle to feed Britain had begun. The cropping plan optimized the use of every inch of ground, advocating intercropping (sowing fast-maturing crops between slow-growing crops) and quick-maturing 'catch crops' to fill the ground before the main crop was planted. Although cabbage, potatoes and turnips lacked the exotic appeal of oranges and bananas, they became the foundation for feeding a nation and maintaining good health all year round.

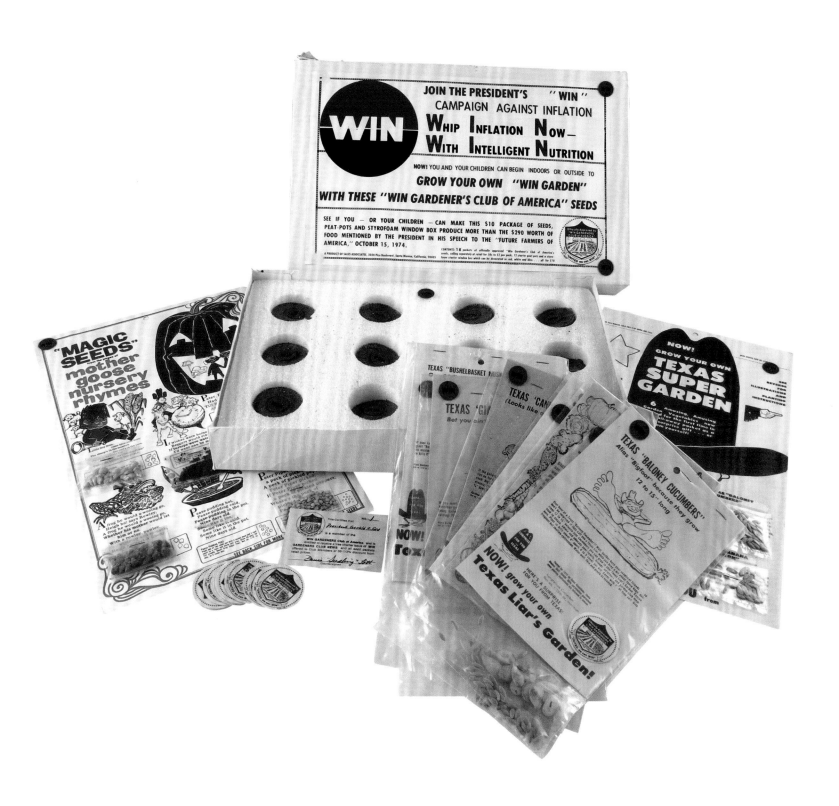

Whip Inflation Now (WIN)

Garden Kit, 1974

Box with seeds and planting accessories, 38.1 × 24.1 × 5 cm / 15 × 9.5 × 2 in, Gerald R. Ford Presidential Library & Museum, Ann Arbor, Michigan

In the autumn of 1974, US President Gerald R. Ford responded to a debilitating recession by launching a campaign called Whip Inflation Now (WIN). Intended as a massive mobilization of the American people to help fight the economic scourge, it called for compulsory and voluntary measures, both public and private, to soften the impact of rising prices. In an address to Congress, Ford suggested that Americans should take steps to reduce waste, save money and conserve energy through often simple acts, such as carpooling and turning off lights. In addition to providing support for farmers, the WIN programme encouraged people to overcome rising food prices by growing their own vegetables. The White House sold gardening sets like this for ten dollars, claiming that Americans could save nearly three hundred dollars in grocery bills by growing vegetables at home. The white box contained small seed packets, peat pots and a Styrofoam window box. Labelled 'magic seeds' and accompanied by Mother Goose nursery rhymes, the crops included cucumbers, pumpkins, peppers, turnips, beans and corn. This morale-boosting move recalled the wartime campaign to create victory gardens, which had also encouraged civilians to grow their own food (see pp.115, 200). Although the popularity of WIN gardens never equalled that of the earlier victory gardens, millions of Americans joined the cause by becoming new gardeners. This kit from the Gerald R. Ford Presidential Library and Museum includes President Ford's own membership card for the WIN Gardeners Club of America.

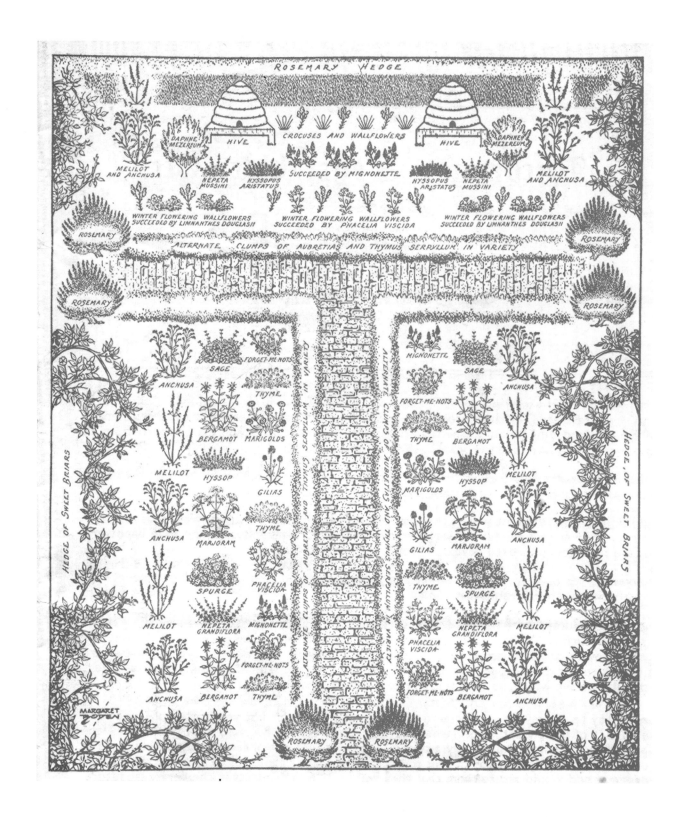

Eleanour Sinclair Rohde

Bee & Herb Garden, 1954

Printed paper, 27.5 × 21.5 cm / 10⅞ × 8½ in
Garden Museum, London

This monochrome illustration from the cover of a British nursery catalogue depicts a garden for bees, with two hives, a T-shaped path and a range of herbs to produce scented honey, including rosemary, thyme, bergamot and winter-flowering wallflowers. The artist, Eleanour Sinclair Rohde (1881–1950), who was an experienced journalist – and later became president of the Society of Women Journalists – had begun studying culinary herbs during World War I, when she joined the training school established by Maud Grieve at The Whins in Chalfont St Peter, Buckinghamshire, to encourage people to grow food crops in their gardens to support the war effort. At the end of the war in 1918, Rohde and Grieve helped to found the British Guild of Herb Growers, and a year later they staged the first herb garden to be shown at the Chelsea Flower Show. Rohde published *A Book of Herbs* in 1920 and produced four more books and numerous pamphlets on herbs and vegetables, as well as becoming a pioneering garden historian and bibliographer of Renaissance herbals and gardening books. She also continued her practical involvement with herb and vegetable growing, advising Hilda Leyel when she founded the herb store Culpeper House; after World War II, Rohde redesigned the kitchen garden at Lullingstone Castle in Kent. She also ran an herb nursery from her house, Cranham Lodge in Reigate. After her death the nursery was taken over by Kathleen Hunter, who eventually moved it to Wheal Frances in Cornwall, using this illustration for her catalogues.

Howard Hodgkin

Herb Garden, from *Alan Cristea Gallery Twentieth Anniversary Portfolio*, 2014

Carborundum relief print on paper, 28.5 × 38.3 cm / 11¼ × 15 in
Museum of Modern Art, New York

With a limited range of colours and relatively regular shapes, a deceptively simple composition of bright blotches of pigment in shades of green suggests closely grown plants in a flower bed – an impression reinforced by the painting's title, *Herb Garden*. As with much of the work of celebrated British artist Howard Hodgkin (1932–2017), however, the title suggests a specific place or view but the image is not a figurative rendering of its ostensible subject, and is rather an allusive composition that hovers between representation and abstraction. Hodgkin described his work as being imbued with feeling and sentiment, and each piece drew on his memories of a certain situation, time or place. Mostly small-scale, his work often focused on domestic scenes and the spaces of home, including gardens, which were a favourite and recurring subject throughout his career. Beyond the literal meaning of *Herb Garden*, the colour green is associated with health, peace and prosperity, and Hodgkin uses it here to suggest a sense of abundance but also order. The print was made for a portfolio marking the twentieth anniversary of the Alan Cristea Gallery, and these associations were intended as Hodgkin's tribute to Cristea's long cultivation of his career. This was one of the first prints Hodgkin made using the printing technique known as carborundum, whereby a carbon and silicon mixture is applied to an aluminium plate, giving a grainy, raised texture to areas of the finished print. Hodgkin was pleased with how this created a three-dimensional effect that enhanced the idea of sprouting foliage.

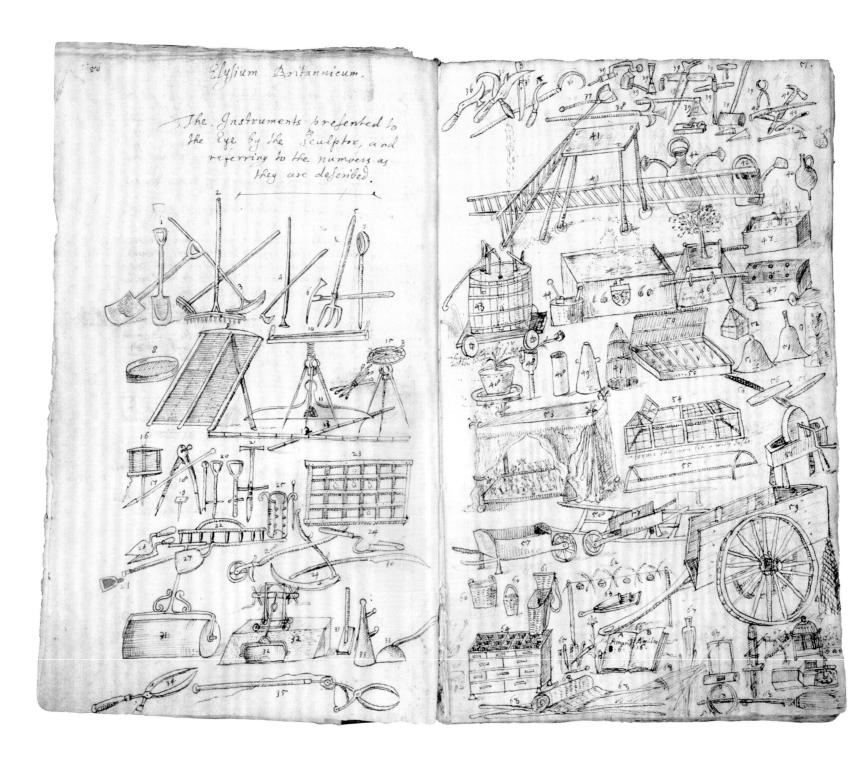

John Evelyn

Illustration of garden tools, from *Elysium Britannicum*, *c*.1660

Pen and ink on paper, 31 × 39 cm / 12¼ × 15⅛ in
British Library, London

Bursting with illustrations of every garden tool imaginable, from spades and rakes to wheelbarrows and shears, these pages are the work of English polymath John Evelyn (1620–1706). Principally known as a diarist, Evelyn was also a prolific author – notably of his 1664 practical treatise on trees, *Sylva* – courtier, pious Anglican, founder of the Royal Society, landed gentleman and passionate gardener. These two pages are from the start of his vast and, at the time, unpublished *Elysium Britannicum, or The Royal Gardens*,

which he began writing in the 1650s. With nearly a thousand pages, it was a personal assemblage of his horticultural knowledge gathered and generated throughout his life. On these two pages, in addition to the array of tools, there is also a variety of contraptions, such as cold frames and what appears to be an imaginative four-poster bed, curtains drawn back to reveal the plants inside. This cornucopia of implements speaks to Evelyn's interest not just in the simple acts of gardening, digging or hoeing, but also in the

wider questions of how to approach gardening as a system of interlacing ideas, such as growing, propagating and harvesting. Reading deeper into the manuscript, it becomes clear that Evelyn's true intention was to articulate an idea of horticulture as a discipline that was connected to all the arts and sciences, adding to a unifying theory of knowledge that would illustrate the infinite wisdom of God. Evelyn's tools were to be applied to the loftiest of ideas: to use the garden as the vehicle to re-create Eden on Earth.

Anonymous

Set of seven pruning tools, 1575–1660

Steel, partly gilded; mother-of-pearl, dimensions variable
Metropolitan Museum of Art, New York

Any gardener knows the satisfaction that comes from having just the right tools for the job – but few have ever possessed any as luxurious as these pruning tools, which were made from steel, partly gilded, inlaid with mother-of-pearl in their intricately cast handles, and further decoratively engraved with natural motifs including fruit and, somewhat anomalously, fish. The pruning set comprises four knives – the two largest could be classified as billhooks – a fine-toothed saw, a pair of what we know as anvil loppers, and a combination hammer, rasp file and auger. Each is punched with a palm frond or incised with the words '*faict a moulins a la palme*' (made at the palm mill), indicating that they were manufactured in France. The tools were made in the late 1500s or first half of the 1600s, during a golden age of French gardening as the French Renaissance style reached its high point at chateaus around Paris and especially in the Loire Valley, followed by the emergence of the French Baroque garden, which would reach its zenith at Versailles (see pp.16, 17).

The luxury of these tools, however, suggests that they were probably intended for a wealthy garden owner or his wife to use themselves, perhaps guided by the head gardener, in the *potager* or ornamental productive garden. A comparison between the design of these tools, those available to gardeners today and the oldest known garden tools identifiable on ancient Egyptian papyri and wall paintings reveals that the design of pruning tools has changed very little over four millennia of gardening.

Edward Steichen

Wheelbarrow with Flower Pots, France, 1920

Palladium and ferroprussiate print,
19.4 × 24.5 cm / 7⅝ × 9⅝ in
Museum of Modern Art, New York

One of the main protagonists of twentieth-century photography, American Edward Steichen (1879–1973) is credited with elevating the medium from a documentary tool to a true art form. This is particularly visible in his interpretation of mundane subjects, such as these flowerpots neatly nestled in an old wooden wheelbarrow. The composition, predominantly arranged around diagonal lines, emphasizes the flowerpot as a curious everyday object – often overlooked and yet essential to our day-to-day relationships with plants.

Pots allow plants to be moved wherever one might want to place them, whether that be arranged on a garden terrace, inside the home or on a balcony. In a sense, the use of pots radically altered the static essence of plants that are normally 'planted' in a single place. While the earliest occurrence of potted plants is still debated, it is known that clay and ceramic pots were widely used in India, Japan, China and Korea more than three thousand years ago, mostly to bring plants closer to houses, although in courtyards rather

than indoors, as is so common today. Terracotta pots have also been found in the Bronze Age Minoan palace at Knossos on Crete, while ancient Romans preferred to plant lemon trees in large marble pots. Throughout the Middle Ages, pots were used in convents to grow herbs, as well as to keep life-saving medicinal plants close at hand. The pots in Steichen's 1920 image look worn, evoking the lives of plants that we can no longer see, but perhaps also a sense of hope that they will soon host new growth.

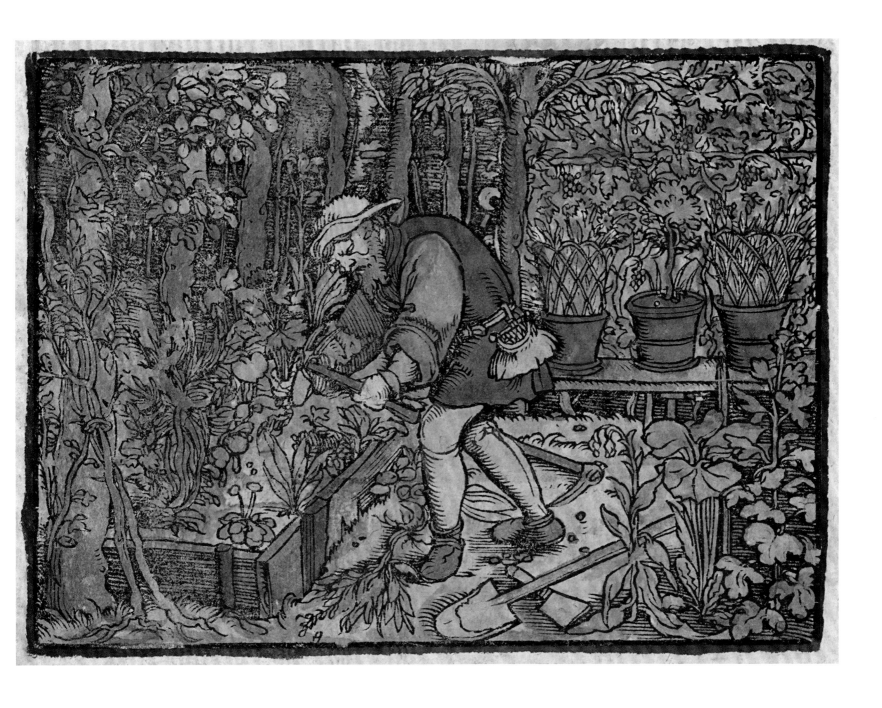

Adam Lonicer

Kreuterbuch (Herbal), c.1670

Hand-coloured woodblock print, 16 × 21.3 cm / 6¼ × 8⅜ in
Garden Museum, London

A gardener in traditional garb toils over a cultivated bed in this remarkably detailed woodcut print from the sixteenth century. The raised beds are bordered by sturdy wooden planks, a method of gardening still used today in many allotments. In his right hand the gardener holds a clump of herbs or edible greens that he has just harvested, while his left hand carries an adze, which would have been used to dig out weeds or prepare the soil for planting. From the belt around his waist hangs a small bag that would probably have held seeds for sowing. Behind the main bed are fruit trees with apples and pears, and in the background a shelf holds three earthenware pots, two with wicker trellises to support growth, in front of dangling bunches of grapes on a vine climbing a horizontal trellis. This hand-coloured woodcut is one of hundreds that appeared in the *Kreuterbuch*, or herbal, of Adam Lonicer (1528–1586), chronicling the growing and medicinal uses of plants. Lonicer studied in Marburg and Mainz, Germany, before becoming a professor of mathematics at the Lutheran University of Marburg. He also studied medicine and was later made City Physician of Frankfurt. Lonicer was fascinated by herbal medicine and botany, and published several editions of his *Kreuterbuch* between 1557 and 1577. The publication was a great success and editions were still being produced in Germany more than two hundred years later. In addition to herbs and other plants, the book included animals, such as mammals, birds and fish. The genus *Lonicera* (honeysuckle) is named in his honour.

Claude Mollet

Théâtre des plans et jardinages, 1652

Engraving, each page 27 × 21.6 cm / 10½ × 8½ in
Bibliothèque de l'Institut national d'histoire de l'art, Paris

Claude Mollet (c.1564–c.1649) was the son of Jacques Mollet, gardener to Diane de Poitiers, mistress of King Henri II, at Château d'Anet, where Italian Renaissance garden design ideas were first introduced into France. After apprenticing at Anet, Claude followed in his father's footsteps by becoming *premier jardinier du Roi* to three French monarchs – Henri IV, Louis XIII and Louis XIV – for whom he laid out gardens in the French Renaissance style, for example at Château de Fontainebleau, Château de Montceaux and the Tuileries.

Claude was also a pioneer in evolving the geometric *compartmenti* of Italian Renaissance gardens into that most recognizable feature of French Baroque gardens, the *parterre de broderie* – literally 'embroidery on the ground' – in the form of letters, devices, cyphers, coats of arms, frames, ships or – as shown in these plates from Mollet's posthumously published *Théâtre des plans et jardinages* – with elaborate arabesque or geometric patterns. He also cautioned against the use of dwarf box for picking out the clipped patterns,

advocating instead for the larger-leafed, more robust form. However, the original manuscript of *Théâtre* from around 1595 reveals that the twenty-two parterre patterns – which are the same as those in this later edition – were actually designed and signed by Mollet's own sons: André, Jacques, Noël and Claude. André is also remembered for designing royal gardens in England, the Dutch Republic and Sweden, while in 1649 Claude (junior) was passed over in favour of André Le Nôtre (of Versailles fame) as chief gardener at the Tuileries.

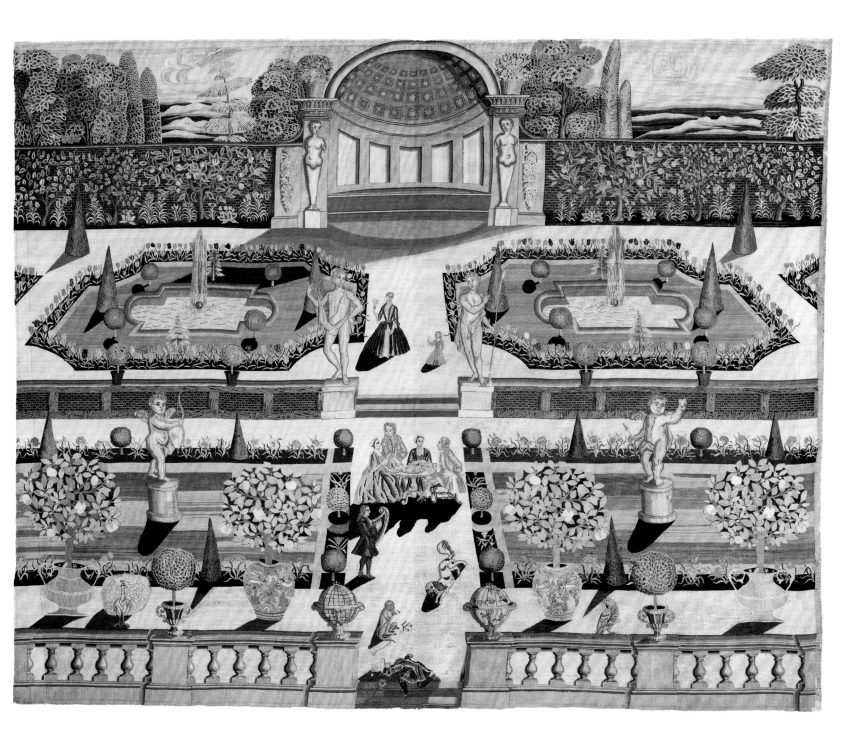

Anonymous

Wall Hanging, 1710–20

Embroidered linen canvas with silk and wool,
and appliqué, 3.2 × 4.3 m / 10 ft 6 × 14 ft
Victoria and Albert Museum, London

This intricate embroidery depicts an elegant walled garden, complete with fountains, statues, ornamental flower beds and orange trees, laid out in late seventeenth-century Anglo-Dutch style. On the upper terrace, lawns bordered by tulips and carnations contain manicured topiary shrubs and pools with gushing fountains. Below are rectangular lawns with cherubic statues, exotic plants in Chinese ceramic pots, and a stone balustrade. On the wide central path, a harpist plays while a group of people dine alfresco and a dog

scampers towards a servant who has tripped on the steps in the foreground, spilling his wine tray. The decorative embroidery, worked in silk and wool threads, is one of a pair of hangings depicting formal garden scenes that were produced for the walls of Stoke Edith House in Herefordshire, England. The scenes may reflect the property's park and gardens after they were remodelled in 1692 at the suggestion of leading English garden designer George London, or they could be composites, combining elements of formal

garden design popular during the period. Their highly cultivated, symmetrical appearance reflects the influence of Dutch gardens, which became fashionable in England after William of Orange, who took a keen interest in gardening, came to the throne in 1689. Inspired by French formal gardens, the Dutch style was highly geometrical, typically featuring broad gravel paths with lawned compartments, brightly coloured flower beds, dense clipped shrubs, low walls, water features and statuary.

British Broadcasting Corporation

Gardening in the Grounds of Alexandra Palace, 1937

Photograph, dimensions variable

This photograph marks a historic occasion: the first step in the long association between gardening and television. Today, millions of gardeners are inspired by shows on practical gardening or visits to renowned gardens, but when this photograph was taken in 1937 – soon after the BBC began broadcasting TV shows from Alexandra Palace in London – only around two thousand people in Britain had a TV set. However, the BBC decided that it was the medium of the future. To front its first gardening show, *In Your Garden*, it selected the

gardener and nurseryman Cecil Henry Middleton (1886–1945), always known as Mr Middleton, seen here in the light-coloured jacket filming in the specially constructed garden at Alexandra Palace. Middleton was already familiar from the radio, where talks on gardening had first been broadcast in 1923 by writer Marion Cran. In 1924 the BBC arranged with the Royal Horticultural Society for regular gardening bulletins, mainly written by Frederick Chittenden, director of Wisley Garden, but read by professional announcers. Middleton was recruited in 1931,

when the BBC decided to have the broadcasts made by gardening personalities instead, and his first volume of collected talks was published in 1935. The BBC discontinued TV broadcasting for the duration of World War II, but Middleton continued his radio programme, offering advice on growing food for the Dig for Victory campaign (see p.30, 200). After the war, the TV show *Country Calendar* began to feature a gardening slot, and in 1955 a dedicated weekly gardening programme began, '*Gardening Club*', presented by Percy Thrower.

Harry Shepherd

*Bomb Crater Vegetable Plot,
Westminster Cathedral*, 1942

Photograph, dimensions variable

A smartly dressed gardener waters neat rows of vegetables in a remarkable kitchen garden planted in a World War II bomb crater in the grounds of London's Westminster Cathedral. German bombs rained down on Westminster in the autumn of 1940, and although the Cathedral escaped a direct hit, a blast left a crater 9 metres (30 ft) deep in the choir school's playground; the soft clay absorbed the impact so that not even nearby windows were cracked. Over a period of nine months, the cathedral's caretaker, Jack Hayes, filled the hole

with bricks, garden refuse and soil to create an allotment in which to grow tomatoes, cabbages, cucumbers, beetroot, beans, lettuce, onions, parsley, peas and mint. This photograph, which shows Hayes tending a garden bordered by a bank of earth and rubble in the summer of 1942, was taken by news reporter Harry Shepherd, who documented everyday life in wartime Britain. Images such as this reflect the resilience and resourcefulness of British citizens, who at the time were being encouraged to 'Dig for Victory' by

the British Ministry of Agriculture (see p.30). The campaign saw people across the country digging up spare ground and growing their own food to alleviate shortages and supplement the strict rationing. Domestic gardens, school playing fields and public parks were all given over to allotments, and even the Royal Family's treasured rose gardens were replaced by rows of onions. Most plots, including this playground, were returned to their original uses after the war.

Anonymous

*Claude Monet in Front of His
House at Giverny*, 1921

Autochrome, 18 × 24 cm / 7 × 9½ in
Musée d'Orsay, Paris

This photograph is one of the few surviving to depict one of the world's most famous artists, Claude Monet, in one of the world's most famous gardens, his own at Giverny, just north of Paris (see p.40). The garden, Monet once said, was his greatest masterpiece, one that took twenty years to complete after he first moved to Giverny in 1883, buying the property seven years later. In this photograph, Monet proudly poses close to the house, surrounded by red and pink geraniums, rose bushes and towers of red nasturtiums – although the

colours were added by hand to the black-and-white photograph and we have no way of knowing how accurate they might be. Monet was a keen gardener and self-taught botanist, who, with the help of a small army of gardeners, landscaped and planted roughly 2 hectares (5 acres) comprising two distinct gardens. Near the house, shown here, was the Clos Normand, a formal pattern of flower beds influenced by Monet's visit to the Dutch tulip fields. On the other side of the road was the more renowned water garden, which

Monet began in 1893, personally helping his gardeners to dig out a pond to grow the waterlilies that dominated his paintings for the last thirty years of his life. Monet illegally diverted the course of the nearby river Ru in order to feed water into a pond fringed with weeping willow and crossed by a Japanese bridge, reflecting his admiration of Japanese Zen philosophy and woodblock prints.

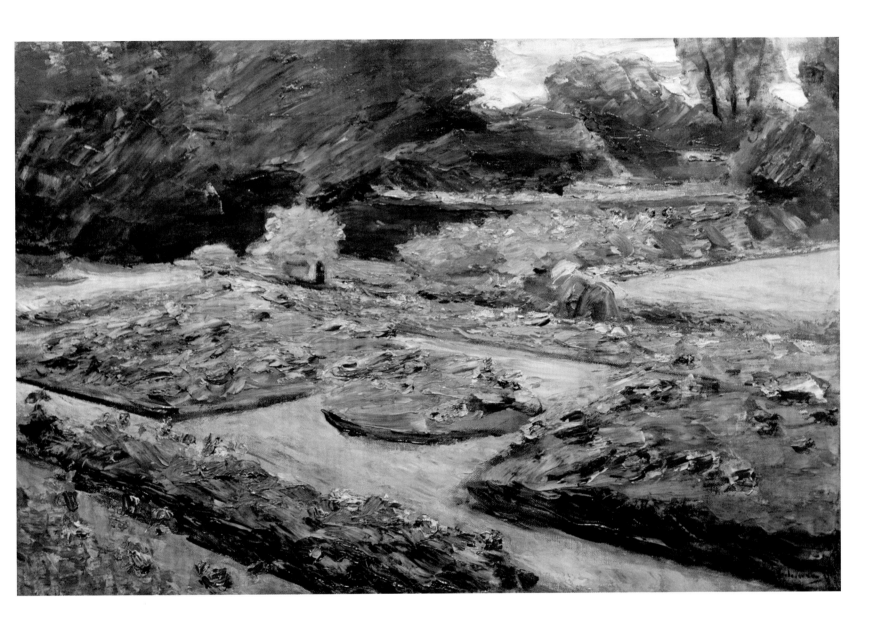

Max Liebermann

The Flower Terrace in Wannsee Garden Facing Northeast, 1915

Oil on canvas, 60.5 × 90 cm / 23¾ × 35½ in
Museum Behnhaus Drägerhaus, Lübeck, Germany

A flower garden created with bold strokes of vibrant greens punctuated by daubs of red and pink, this painting by the most highly regarded German Impressionist Max Liebermann (1847–1935), reflects not only a mastery of colour but also the artist's passion for gardening. Better known as a portraitist, Liebermann was greatly influenced by the French Impressionists in his open-air work, and became a key member of the avant-garde Berlin Secession movement. In 1909 he bought a villa on the Wannsee, a lake just west of Berlin, where he created a garden that preoccupied him for the rest of his life. Produced at the beginning of a period of intense creativity in German gardening, this painting displays the formality characteristic of domestic garden spaces at that time, which would be largely displaced by a more informal approach over the next few decades. Liebermann's garden had been designed in conjunction with Alfred Lichtwark, a prominent art historian known for his interest in horticulture and in particular in traditional country-garden styles. Rather like Claude Monet (see p.40, 212), Liebermann became increasingly absorbed in his garden in his later years, both cultivating and painting it. Although Liebermann was not part of the 'Bornim Circle' of artists and intellectuals that developed around the nurseryman and writer Karl Foerster (see p.324) at nearby Bornim, he would almost certainly have been in touch with members of the group, who reflected the closeness of garden-making to the heart of Germany's cultural elite in the early decades of the twentieth century.

Tony Ray-Jones

A Garden near Wolverhampton with 16 Dogs, 2 Cats and a Rat, from 'Happy Extremists', *Sunday Times Magazine*, October 1970

Kodachrome 35 mm slide, dimensions variable

The English enjoy a reputation as eccentrics, even in their gardens ... and few images confirm that reputation as powerfully as this picture of a small suburban garden in the city of Wolverhampton where the owner – Cyril Clifft, visible in the background – created an array of topiary figures crowded next to one another in a small plot, featuring sixteen Scottie dogs, along with two cats and a rat. Cutting and training shrubs into ornamental shapes – geometric, or in the form of animals – has a long history dating back to

ancient Rome. Clifft's garden took a form most frequently associated with large display gardens, and reproduced it on a far more intimate, domestic scale, possibly inspired by his own pets. British photographer Tony Ray-Jones (1941–1972) had a reputation as a social anthropologist, consciously setting out to capture something of the spirit of the English in his gently humorous records of their entertainments and pastimes. This picture was taken for an article Ray-Jones researched and illustrated for the *Sunday Times Magazine* in

October 1970 that featured a number of English characters under the title 'Happy Extremists'. Topiary is an ephemeral art, requiring regular, meticulous clipping to maintain the shapes, so Clifft's figures are long gone. Although most surviving topiary is still found in the gardens of historic houses, plenty of eager hobbyists have embellished their more modest gardens with examples of such horticultural folk art, although few can match the quirkiness of Clifft's suburban menagerie.

Tim Burton for 20th Century Fox　　　*Edward Scissorhands*, 1990　　　Publicity film still, dimensions variable

Appearing like a modern-day monster of Frankenstein, a black-clad figure admires spectacular topiary rising from beds of yellow marigolds, purple lisianthus and red foxtails in the garden of a ruined gothic mansion. Edward Scissorhands (played by actor Johnny Depp) is the protagonist of director Tim Burton's fantastical romance film of the same name, which tells the strange tale of an ageless humanoid with scissor blades for hands and an exceptional talent for the art of shaping shrubs and trees. After he is welcomed into a candy-coloured suburban neighbourhood, Edward uses his unusual skills to trim the neighbours' hedges into towering topiary. Dinosaurs, swans, penguins, teddy bears and numerous other figures transform the bland street into a living sculpture garden. After Edward takes the blame for a failed burglary, the residents begin to turn on him and, in frustration, he destroys several of his creations before finding love and acceptance. Whereas Depp's character worked at super speed, the film's production crew laboured for eight consecutive weeks to fabricate the giant topiaries, which were made by covering steel armatures with chicken wire and intricate layers of silk and plastic greenery. Initially designed to be 3 metres (10 ft) high, the sculptures eventually doubled or tripled in size in order to emphasize their surreal qualities. In the film, the topiary, like Edward's gothic garden, serves as a symbol of individual expression and creativity in contrast to the insipid conformity of suburbia's gardens.

The tomato plants were going to take some extra work. Hello Kitty and Mama made stakes for the tomato vines to wrap themselves around. But that was a long way off. First you had to wait for the seeds to sprout.

Hello Kitty wanted to plant lots of beautiful flowers around the garden, too!

Sanrio Company

Hello Kitty: In the Garden, 2012

Printed book, 19 × 30.4 cm / 7½ × 12 in
Private collection

Hello Kitty, one of Japan's most famous cartoon characters, was created by illustrator Yuko Shimizu for the Sanrio Company in 1974. Supposedly named after Alice's white kitten in *Through the Looking Glass* (see p.294) – her full name is Kitty White – she is an anthropomorphic cat-like creature, not quite animal and not quite human. Her species has been widely debated, but children around the world accept her as she is. Her iconic image epitomizes Japan's *kawaii* culture, which embraces cuteness. Kitty's moon-shaped face has

appeared on countless commercial products, from coin purses to aircraft, as well as a number of children's books. *In the Garden* comes from The Storybook Library collection, a boxed set of twelve books published in 2012. It tells the story of Hello Kitty starting a garden with her mother and grandmother and tending it throughout the season, from seed sowing to harvest. After intently monitoring the plants for signs of germination, Hello Kitty eventually learns patience and is rewarded with a fully blooming garden and ripe tomatoes – in just a few days.

Amused gardeners might envy the fast-paced growing cycle. The scenes are drawn and coloured in typical Sanrio style, with flat graphics that are bold and bright. Several pages depict Hello Kitty amid a field of flowers, arranged in a repetitive pattern reminiscent of paintings by Takashi Murakami, who in turn took inspiration from Japanese animation. Unlike Murakami's flowers, these are faceless but no less cheerful. The images evoke both Pop Art and traditional *nihonga*, in which the flower is held in high regard.

Vanessa Harden　　　　*Spade, Shovel & Rake Nail Dusters*, 2016　　　24ct plated gold and Swarovski Rivoli crystal, spade: 102 × 65 mm / 4 × 2½ in, shovel: 115 × 53 mm / 4½ × 2 in, rake: 73 × 68 mm / 2⅞ × 2¾ in

Counterculture, a horticultural revolution and luxury high fashion come together in this eye-popping trio of 24-carat gold 'nail dusters', pieces of jewellery designed to be worn on individual fingers, each finished with a Swarovski crystal. The inspiration of artist and designer Vanessa Harden (b. 1980) – also known as the Subversive Gardener – the spade, rake and shovel can be worn as urban fashion accessories and then used, in theory at least, for some inconspicuous 'guerrilla gardening'. Harden is a pioneer of the cause, having set up her nonprofit organization, the Subversive Gardener, to promote environmental education and creative design solutions for growing and planting in the face of climate change. In 2009 Harden released her first creation, the revolutionary seed pill: seeds packed into a pill case that could be dropped anywhere unnoticed and left to sprout. Guerrilla gardeners reclaim and bring life to abandoned city spaces – anything from a crack in a sidewalk to an abandoned patch of land or a roundabout at a road junction – and transform them into zones of beauty by planting flowers or vegetables to bring a sense of life to neglected neighbourhoods. The transformative, but not necessarily legal, act of rejuvenating an urban space in this fashion has become a way of life for guerrilla gardeners, who have formed a subculture in cities around the world – some working within organized communities and others preferring to accomplish their subversive plantings alone. These miniature tools would be useful to any aspiring guerrilla gardener, hiding in plain sight as one-of-a-kind jewellery pieces.

Pietro Porcinai

Winter Garden on the Roof of Lanificio Zegna, Trivero, 1960s

Watercolour, 48 × 66 cm / 19 × 26 in
Casa Zegna, Fondazione Ermenegildo Zegna, Valdilana, Italy

The planning stage of any garden makes clear what every gardener knows: that the most natural-seeming gardens are often those that are most carefully constructed. This beautiful concept by the renowned Italian landscape architect Pietro Porcinai (1910–1986) is for a winter garden on the roof of the Ermenegildo Zegna woollen mill, flooded by natural light varied by the inclusion of wooden panels in the ceiling. Here, as in the other gardens for which Porcinai was known, the plants are designed to integrate so well into

their surroundings as to appear untouched by human hand, transforming the space over time from a meticulously planned organization to an organic abundance. Porcinai's approach to plant selection depended heavily on phytosociology, the theory that plants have likes and dislikes in terms of their conditions, and that they therefore must be chosen to be in harmony with their surroundings. Only then will they become truly beautiful. Influenced by such horticulturalists as Karl Foerster (see p.324), Porcinai began a lifelong struggle in the

1930s to have garden and landscape design recognized in Italy as a modern discipline in its own right, becoming an evangelist for retaining natural planting in gardens and parks in the face of the imposition of impersonal architectural theory on the modern city. In the middle part of his career, Porcinai was commissioned to design gardens and landscapes for factories, offices and even swimming pools, and he later undertook more public parks and urban design projects in Milan, Sicily, Paris and Saudi Arabia.

Carl Theodor Sørensen

The Musical Garden, 1954

Watercolour

This design for a geometrical garden by Danish landscape architect, educator and author Carl Theodor Sørensen (1893–1979) stood at the abstract end of the spectrum of Modernist design in Denmark in the mid-twentieth century – and was considered so radical that it took nearly a decade after its original conception in 1945 for it to be built by industrialist Aage Damgaard. Sørensen conceived the scheme for a park in Horsens honouring eighteenth-century Danish cartographer and explorer Vitus Bering. What he called his Musical

Garden – designed both to enrich the soul and challenge the senses – was a closely linked sequence of hedged geometrical rooms, each polygon side based on an 11-metre (36-ft) segment that flanked the main oval. The rooms were separated by a consistent space, with limited openings suggesting a controlled exploratory sequence. When it was built at Damgaard's shirt factory Angli IV in Herning, the site was cramped, the dimensions reduced and the interior spaces filled with sculpture. However, a posthumous realization of the garden in its pure

form in 1984 at a new Sørensen master-planned factory park in nearby Birk yielded a sculptural landscape masterpiece. Sørensen – whose other garden designs included the Round Gardens, a group of thirty-nine allotments all enclosed in oval rooms made from tall hedges – was a key figure in Denmark's embracing and promotion of Modernism at a time when Danes saw functionalist design principles as being intimately linked with a deep sense of national identity, uniting to produce works of understated yet profound philosophical depth.

PLAZA

SCALE 1:100 METRIC

0 2 4 6 8 10M

F	FESTUCA AMESTHINA SUPERBA	AS	ASPERULA ODORATA
	PHLOX DIVARICATA	B	BRUNNERA MACROPHYLLA
Br	BRIZA MEDIA		CAREX BROMOIDES
	SESLERIA AUTUMNALIS	**	DESCHAMPSIA 'GOLDSTAUB'

BED 5B BED 5A

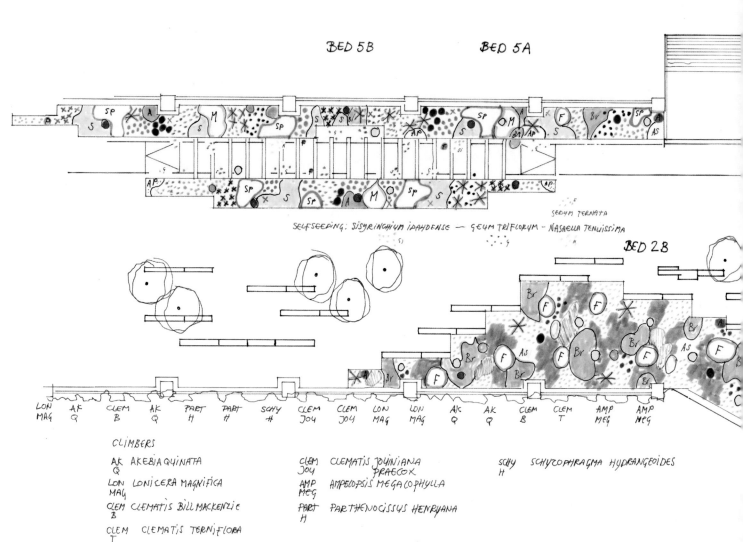

SEDUM TERNATA

SELFSEEDING: SISYRINCHIUM IDAHOENSE — GEUM TRIFLORUM — NASSELLA TENUISSIMA

BED 2B

LON AK CLEM AK PART PART SCHY CLEM CLEM LON LON AK AK CLEM CLEM AMP AMP
MAG Q B Q H H H JOY JOY MAG MAG Q Q B T MEG MEG

CLIMBERS

AK AKEBIA QUINATA
Q

LON LONICERA MAGNIFICA
MAG

CLEM CLEMATIS BILL MACKENZIE
B

CLEM CLEMATIS TERNIFLORA
T

CLEM CLEMATIS JOUINIANA
JOY PRAECOX

AMP AMPELOPSIS MEGALOPHYLLA
MEG

PART PARTHENOCISSUS HENRYANA
H

SCHY SCHYZOPHRAGMA HYDRANGEOIDES
H

BULBS: CROCUS TOMASSINIANUS — CROCUS SATIVUS — ORNITHOGALUM PYRAMIDALE — LEUCOJUM
CORYDALIS SOLIDA — ANEMONE NE x LIPSIENSIS — TULIPA SYLVESTRIS

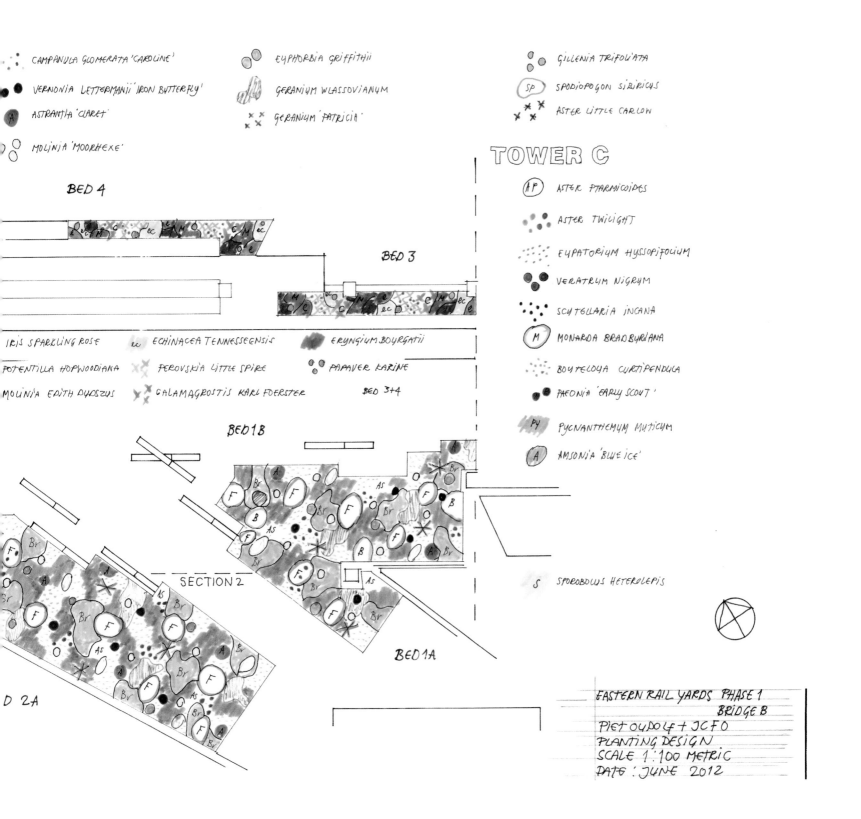

CAMPANULA GLOMERATA 'CAROLINE'

VERNONIA LETTERMANII 'IRON BUTTERFLY'

ASTRANTIA 'CLARET'

MOLINIA 'MOORHEXE'

EUPHORBIA GRIFFITHII

GERANIUM WLASSOVIANUM

GERANIUM 'PATRICIA'

GILLENIA TRIFOLIATA

SP SPODIOPOGON SIBIRICUS

ASTER LITTLE CARLOW

TOWER C

AP ASTER PTARMICOIDES

ASTER TWILIGHT

EUPATORIUM HYSSOPIFOLIUM

VERATRUM NIGRUM

SCUTELLARIA INCANA

M MONARDA BRADBURIANA

BOUTELOUA CURTIPENDULA

PAEONIA 'EARLY SCOUT'

PY PYCNANTHEMUM MUTICUM

A AMSONIA 'BLUE ICE'

S SPOROBOLUS HETEROLEPIS

BED 4

BED 3

IRIS SPARKLING ROSE

POTENTILLA HOPWOODIANA

MOLINIA EDITH DUDSZUS

ec ECHINACEA TENNESSEENSIS

PEROVSKIA LITTLE SPIRE

CALAMAGROSTIS KARL FOERSTER

ERYNGIUM BOURGATII

PAPAVER KARINE

BED 3+4

BED 1B

SECTION 2

BED 1A

D 2A

EASTERN RAIL YARDS PHASE 1
BRIDGE B
PIET OUDOLF + JCFO
PLANTING DESIGN
SCALE 1:100 METRIC
DATE: JUNE 2012

Piet Oudolf

*Eastern Rail Yards, The High Line,
New York*, 2012

Drawing on paper, 43 × 90 cm / 16⅞ × 35½ in
Private collection

The transformation of an abandoned elevated freight line into one of New York City's most popular parks helped turn Dutch landscape designer Piet Oudolf (b. 1944) into an internationally renowned figure in the horticulture world. In collaboration with James Corner Field Operations and Diller Scofidio + Renfro from 2006 to 2023, his planting plans for the High Line have had a profound influence on gardens everywhere. The High Line extends for nearly 2.4 kilometres (1.5 mi), framed by the industrial steelwork of the old railway, allowing a stroll above

the streets of Manhattan's West Side. Populated with Oudolf's signature repertoire of bold plant forms in muted colours, the eastern Rail Yard section juxtaposes naturalistic plantings against the urban setting. Before it was conceived as a park, the High Line was nearly reclaimed by nature, and while Oudolf preserved elements of the overgrown ruin, careful plant selections also evoke that wildness. Seen in this design, Oudolf chose a mix of early spring bulbs, vines and meadow plants, many of them native wildflowers and grasses. They are resilient

plants able to withstand challenging growing conditions while also softening their surroundings. Represented with bold colours and unique symbols in his artful composition, along with a key to identify individual species, the array of perennials is as beautiful on paper as in reality. As with other Oudolf designs, the High Line uses long-lasting plants that evolve with seasonal changes, emphasizing form over flower so that the plants retain interesting structure throughout the year while accentuating the original architecture of their environment.

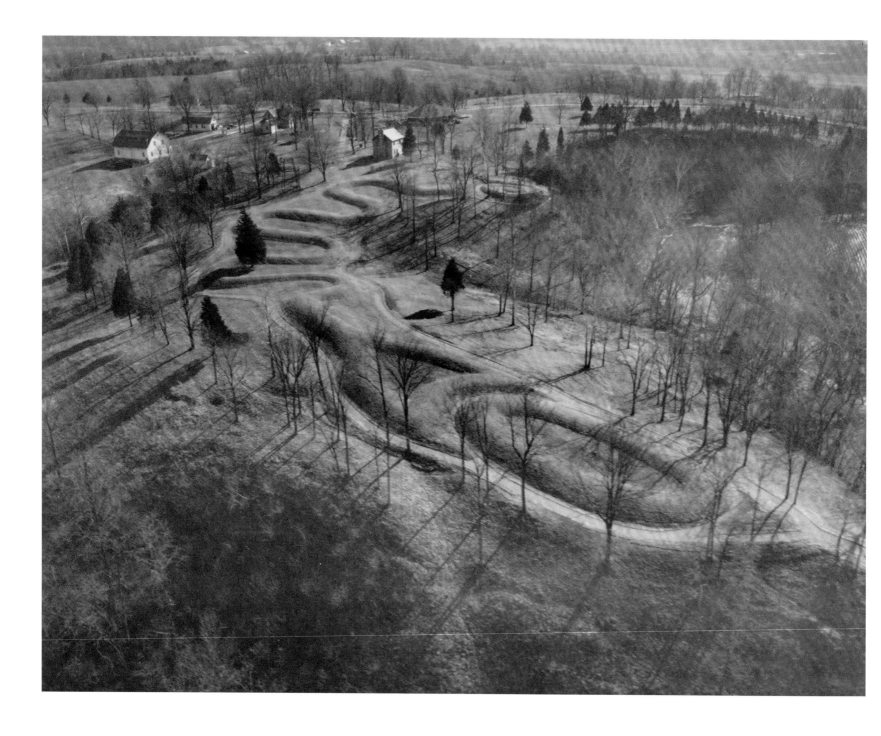

Dache McClain Reeves

Great Serpent Mound, c.1935

Photograph, dimensions variable
National Museum of the American Indian
Archives Center, Washington DC

Seen from the air, a long mound snakes through scattered trees in this image taken in the depths of the Ohio winter in the mid-1930s by one of the pioneers of the use of aerial photography in archaeology, Major Dache McClain Reeves (1894–1972). For centuries, the precise origins of this effigy mound – an earthwork in the shape of an animal – have been shrouded in mystery, as has the identity of its builders. More than two thousand years ago, the area was populated by Native Ohioans who built earthworks and mounds as part

of their burial rituals, underlining the close links between shaping the landscape and the sacred world. Archaeologists long suspected that the Serpent Mound – the largest such effigy in the world, at 411 metres (1,348 ft) long and 1 metre (3 ft) tall – was made by the pre-Columbian Adena culture, who lived in what is now Ohio between 500 and 100 BC, but the absence of artefacts made that difficult to verify. Recent developments in radiocarbon analysis have determined that the Adena did, indeed, build the mound around 300–100 BC;

it was repaired or rebuilt by the Fort Ancient culture around AD 1100. The Adena used hundreds of thousands of woven baskets filled with specially selected and graded earth to construct such mounds – but why they chose to remodel the land in this way remains unclear. Some speculation suggests the Serpent Mound was built to celebrate the summer solstice, when the 'head' of the serpent aligns with the setting sun.

Charles Jencks

Garden of Waves, Garden of Cosmic Speculation, 1993

Acrylic on board
Private collection

A swirling mass of undulating green waves and geometric patterns comes together to form a unique plan for a truly original garden. Using a technique of nesting lines, this early drawing of the Garden of Cosmic Speculation by postmodernist landscape designer and architectural historian Charles Jencks (1939–2019) clearly expresses the concept of the self-organizing geometries – waves and linearism – that he and his design partner and wife, Maggie Keswick Jencks, believed were apparent in nature. This idea of a landscape of waves was critical to the creation of the garden near Dumfries in Scotland, begun in 1989, which used landform architecture to create a fantastical garden imbued with complex symbolism and references to scientific processes. This is a garden of spirals, fractals, and lines expressed as grass covered landforms and ponds. For Maggie – an expert on Chinese gardens – the waves represented *chi*, or universal energy, while Charles was inspired to create a DNA Garden celebrating the six senses. He believed that the universe was always poised between order and chaos, and the route through the garden leads the visitor past the Universe Cascade to the Black Hole Terrace, then on to Taking Leave of Your Senses, before finally arriving at The Nonsense. The result is an uplifting garden that is both intellectually serious and delightfully whimsical. Following a second breast-cancer diagnosis in 1993, Maggie and Charles conceived the idea for Maggie's Centres, cancer treatment centres in which gardens are included as an essential recuperative element. The first opened in 1996, a year after Maggie's death.

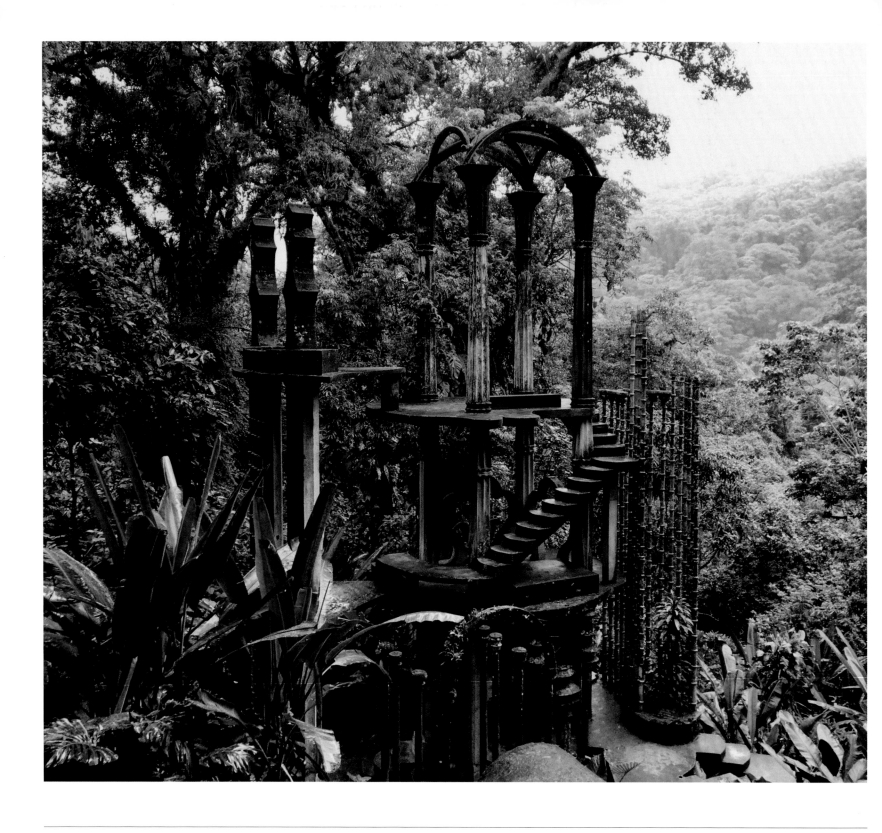

Edward James

Las Pozas, 1962

Xilitla, San Luis Potosí, Mexico

As if left by an ancient civilization, pillars and platforms support a staircase that leads nowhere in the midst of lush vegetation that threatens to overwhelm the ruins. In fact, nothing in the garden at Las Pozas (The Pools) in the Sierra Gorda mountains of Xilitla, Mexico, dates from earlier than the 1960s. The idiosyncratic garden is the creation of British poet and patron of Surrealist art Edward James (1907–1984), who peppered more than 32 hectares (80 acres) of natural subtropical rainforest, waterfalls and pools with a surrealistic assemblage of beds of plants, massive sculptures and structures with names including 'The House with a Roof like a Whale' and 'The Staircase to Heaven'. A collection of cages, pens and small buildings also housed a menagerie. A product of the British upper class, James attended Eton and Oxford before discovering Surrealist art. In the 1930s he sponsored both Salvador Dalí (see p.79) and René Magritte, and remodelled his Edwin Lutyens-designed Monkton House in West Sussex along Surrealist lines. In 1941 James was encouraged by his cousin Bridget Bate Tichenor to search Mexico for a location in which to express his esoteric interests. Immediately attracted to the Mexican jungle – he said it was 'naturally surrealistic' – James began building at Las Pozas in 1962, reportedly raising the five million dollars by selling his collection of Surrealist art. Las Pozas was unfinished at the time of his death and suffered some decline before it opened to the public in 1991. In 2007 the Fondo Xilitla was established to oversee its restoration, and in 2012 it was declared a National Artistic Monument.

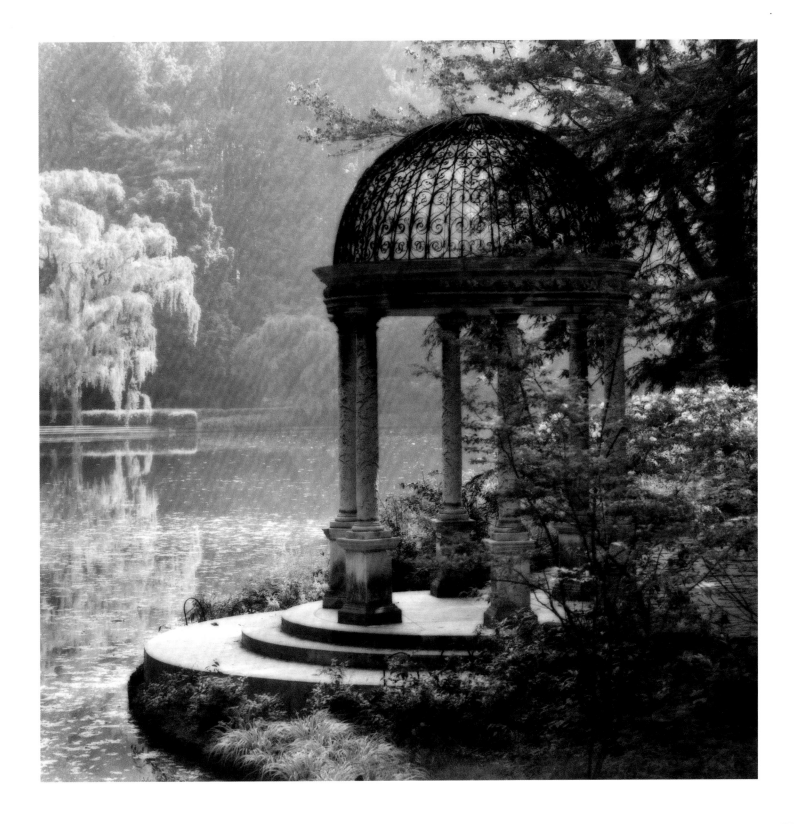

Lynn Geesaman

*Love Temple, Longwood Gardens,
Kennett Square, Pennsylvania*, 1984

Photograph, 48.3 × 48.3 cm / 19 × 19 in
Private collection

The classical Love Temple on the bank of the Large Lake at Longwood Gardens in Pennsylvania has an otherworldly air in this black-and-white photograph by Lynn Geesaman (1938–2020), whose photographic career was based on depicting public parks and formal gardens around the world. Longwood – for many gardeners, one of the greatest American gardens – was originally the expression of one man's horticultural vision: industrialist Pierre S. du Pont, who bought the property in 1906, by which time it was already home to an arboretum more than a century old. Du Pont had visited gardens around the world, and become fascinated by tropical plants, and he brought his interests together at Longwood in a series of gardens, meadows and woodlands. Today there are twenty distinct 'show gardens' outdoors, and another twenty indoors in a series of glasshouses, including the vast conservatory at the heart of the garden. The conservatory faces the Fountain Garden, based on a show garden du Pont had seen at the Chicago World's Fair in 1893, which is now used for *son et lumière* shows. Inspiration for the Italian Water Garden, meanwhile, came from Villa Gamberaia in Italy (see p.303). Longwood has continued to develop since du Pont's death in 1954, and a committee set up for the purpose commissioned gardens from renowned landscape architects, among them Thomas Church (see p.50) and Peter Shepheard. The tropical Cascade Garden was created inside the conservatory by Roberto Burle Marx (see p.177) and Conrad Hamerman in the 1990s, and Isabelle Greene designed the Silver Garden, based on Sissinghurst's White Garden.

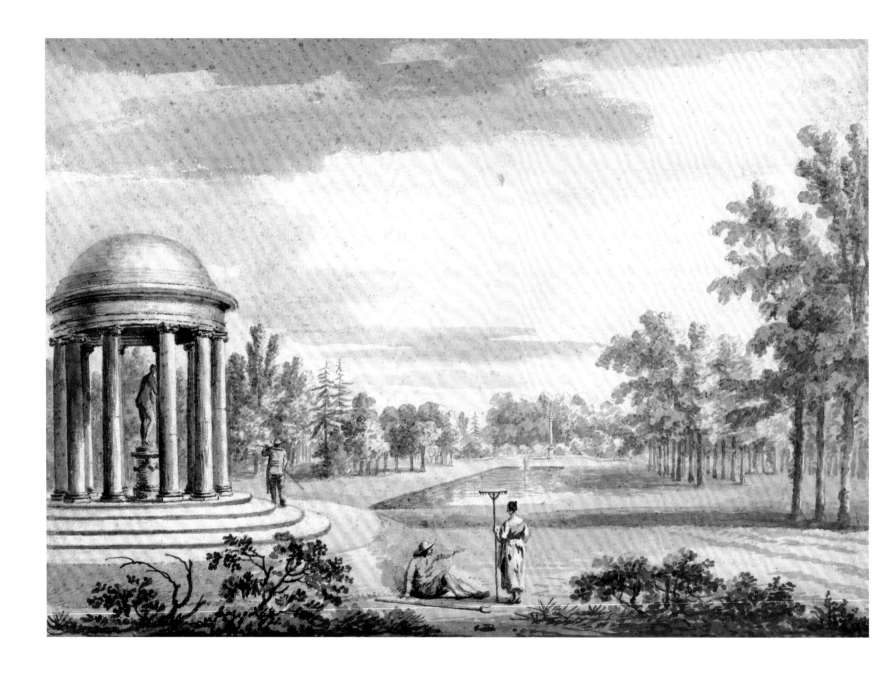

Jean-Baptiste-Claude Chatelain

The Rotunda and the Queen's Theatre, Stowe, 1753

Watercolour and graphite on paper,
23.2 × 32.4 cm / 9⅛ × 12¾ in
Yale Center for British Art, New Haven, Connecticut

Jean-Baptiste-Claude Chatelain (*c.*1710–1758) was one of the finest imaginative draughtsmen working in London in the mid-eighteenth century. One of a series of sixteen views of Stowe, Buckinghamshire, this watercolour – showing the rotunda, designed by Sir John Vanbrugh and erected in 1721 as a focal point of the landscape design by Charles Bridgeman – instantly popularized the grounds as one of Britain's most influential landscape gardens. From the rotunda, a statue of Venus looks out over the formal elongated rectangular pool set in a grassy clearing, but the setting appears highly informal and naturalesque. In contrast, earlier views of the rotunda depicted Bridgeman's transitional semi-natural landscape, heavy on straight-line geometry and light on the new pastoral. The change in style is largely thanks to William Kent, who in 1735 had worked with Bridgeman for four years, and became the sole designer transforming Stowe into an informal, picturesque landscape filled with classically inspired buildings and a symbolic allegorical programme set around the Choice of Hercules, who in Greek myth faced a decision between two paths, one of virtue, one of vice. By 1788, as a contemporary map shows, the rotunda remained (with Venus replaced by Bacchus) but the pool had been made less formal by English landscape architect Lancelot 'Capability' Brown (see p.162). Today, the 100 hectares (250 acres) of gardens and the surrounding 300 hectares (750 acres) of parkland are managed by the National Trust and see more than 200,000 visitors annually.

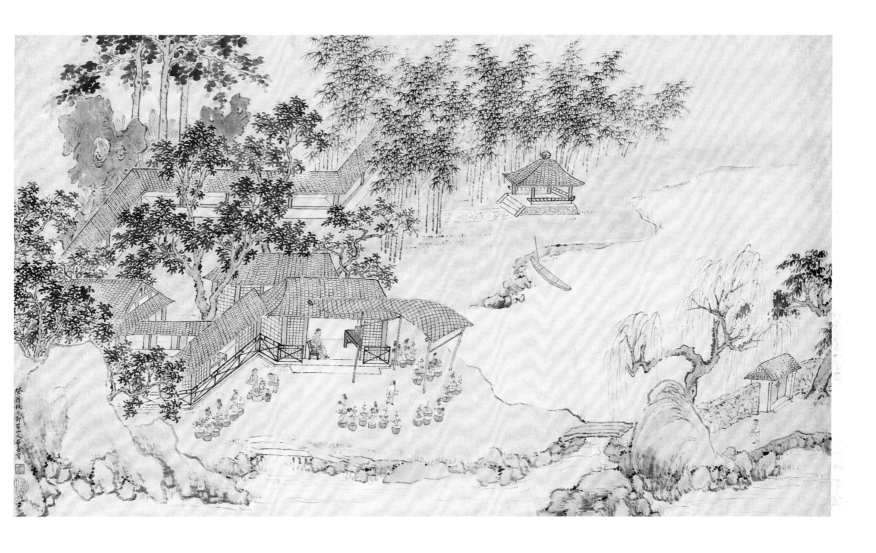

Hua Yan

Enjoyment of Chrysanthemums, 1753

Ink and colour on paper, 64.5 × 114.8 cm / 25½ × 45¼ in
Saint Louis Art Museum, Missouri

Sitting amiably in a garden pavilion, a man contemplates his collection of potted chrysanthemums while young acolytes prepare tea in this hanging scroll painting by the Qing-dynasty artist Hua Yan (1682–1756). There is much more to it than that, however. Educated Chinese viewers would have associated the chrysanthemums with the poet Tao Qian, who lived during a turbulent time in Chinese history in the late fourth and early fifth centuries AD. After a decade as a public official, Tao retired with his family to a remote village, where he wrote poetry, drank wine and cultivated chrysanthemums. The choice of withdrawal implies a devotion to spiritual values; recluses such as the man seen here turned their backs on status, power and wealth in favour of philosophy, art and attention to nature. A viewer of this painting would have understood it as depicting the garden of a scholar-recluse, with its implications of a Tao-like life of contemplation, as opposed to a Confucian life of duty. Flowering in the late autumn, chrysanthemums were associated in Chinese art with the pastimes and ideas of later life; they were typically given as retirement or mature birthday presents, with wishes for good health and a long life of ease and freedom. The flowers were traditionally picked on the ninth day of the ninth lunar month, and the Chinese word for 'nine', *jiu*, is a homonym for a word that means 'a long time'. The chrysanthemum inevitably conjured thoughts of decline and death, however, as it blooms while all around it are signs of decay and ending.

Walter Crane

Mistress Mary, 1903

Wallpaper frieze, 53.3 × 64.7 cm / 21 × 25½ in
Victoria and Albert Museum, London

One of the first gardeners many people encounter in their early childhood – 'Mary, Mary quite contrary', originally known as 'Mistress Mary' – appears in this part of a wallpaper frieze from the early twentieth century depicting the popular English nursery rhyme that ostensibly describes Mary's gardening exploits. The illustration, by English artist Walter Crane (1845–1915), features the rhyme in the border above Mary, who is shown as an assured young woman wearing a pale blue dress and wide-brimmed pink bonnet and carrying a watering can and rake, rather than the 'contrary' child more commonly associated with the rhyme today. Behind her is a border of lily-of-the-valley and nodding red flowers – perhaps a reference to the 'silver bells and cockleshells' mentioned in the rhyme – with neat hedges topped with fancy topiary in the shape of peacocks, and an equally sculpted tree in a pot. Like other rhymes, 'Mary, Mary' is said to have deeper meaning. In one interpretation, Mary is Mary Queen of Scots and the query 'How does your garden grow?' a reference to the fact that she never took charge of her realm. In another reading, Mary is the mother of Jesus, and the various flowers are symbols of the Catholic faith. A committed socialist, Crane was deeply involved in the Arts and Crafts movement led by William Morris (see p.84), producing paintings, books and ceramic tiles, as well as wallpaper, to help bring beauty into daily life. The design was machine-printed from engraved rollers, manufactured by Aspinall and Co.

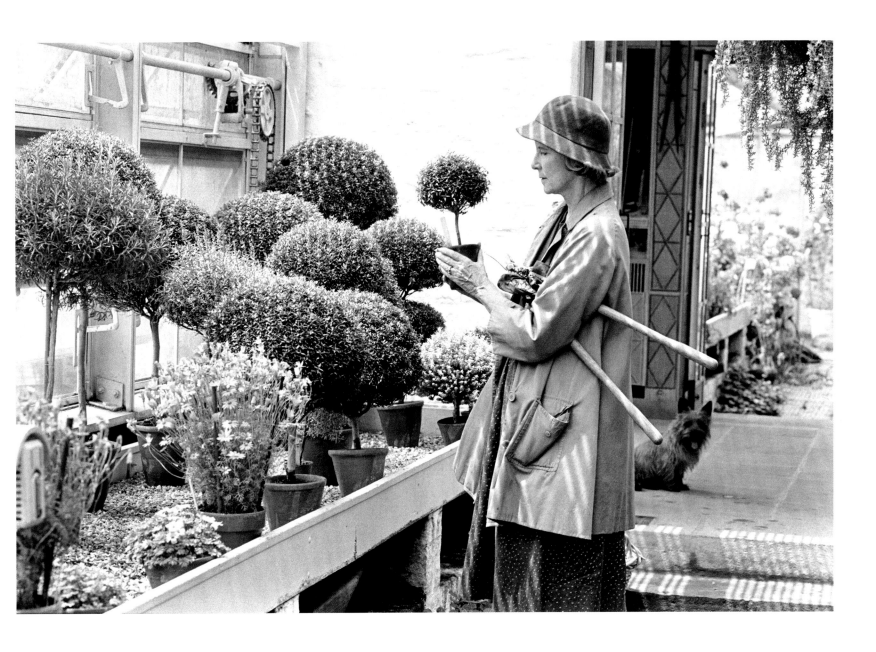

Fred R. Conrad

Rachel 'Bunny' Lambert Mellon Holding One of Her Miniature Herb Trees, 1982

Photograph, dimensions variable

Rachel 'Bunny' Lambert Mellon was a self-taught American horticulturist, gardener, philanthropist and art collector who believed that style can emerge only from a process of ordering, and that order brought pleasure to life. Mellon's international fame as a 'genius gardener' reflected her innovative aesthetic approach and attention to detail. Her stylistic inspiration came straight from the grand past of French royal gardens; seventeenth-century gardener Jean Baptiste de La Quintinie, who created Louis XIV's Potager du Roi at Versailles

(see p.17), was her main point of aesthetic reference. One of La Quintinie's specialities was topiary, the art of sculpting trees through precise and regular pruning, and he pioneered complex geometric topiary that often required up to fifteen years of growth to be fully appreciated. Mellon's interest in topiary grew when the gardener at George Washington's Mount Vernon (see p.154) gave her a cutting from a myrtle tree. Herb standards – so called because of their vertical habit – quickly became her passion. Each takes about two

years to shape, and the distinctive form is created by removing lower shoots and regularly pruning back the crown. Thanks to Mellon, herb standards have become a garden and kitchen staple the world over. In Oak Spring, Virginia, Mellon grew a gardening empire that at its peak employed more than a hundred people. Today the grounds, house and library are part of the Oak Spring Garden Foundation, which promotes scholarship and public dialogue on the history and future of plants, with a focus on environmental sustainability.

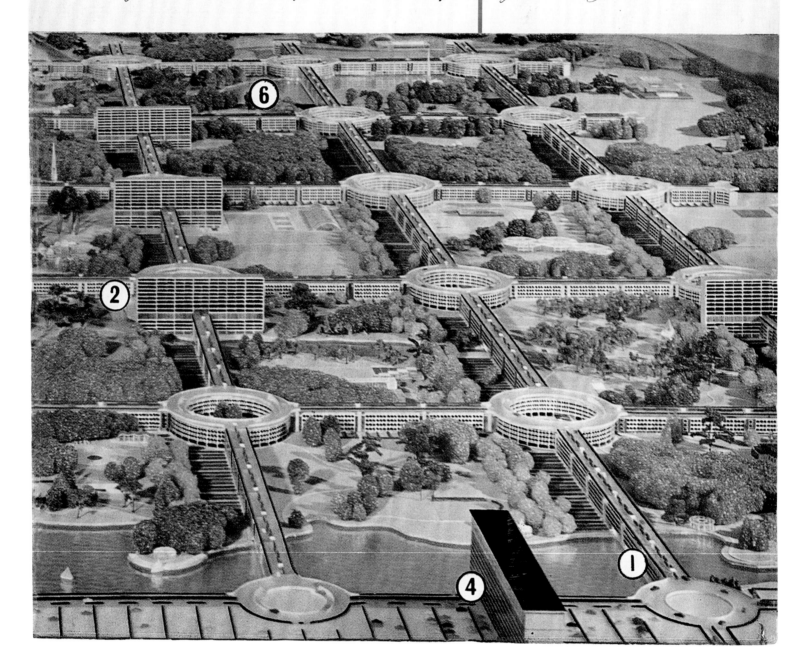

MOTOPIA

A Study in the Evolution of Urban Landscape | *by G. A. Jellicoe*

Geoffrey Jellicoe

Motopia: A Study in the Evolution of Urban Landscape, 1961

Printed book, 22 × 24 cm / 8½ × 9½ in
Private collection

Motopia was a Modernist dream, seamlessly linking the idea of Utopia with the motor car and individual mobility. Conceived in 1959, during an expansive and optimistic post-war era, and published in 1961 as 'a study in the evolution of urban landscape', the design by British town planner and landscape architect Geoffrey Jellicoe (1900–1996) was initiated by the Glass Age Development Committee of the Pilkington Brothers company. The ambitious scheme was illustrated on the cover of Jellicoe's book by a photograph of a detailed model constructed to showcase the ultimately unbuilt community. Motopia was based on people-focused nodes linked by elevated covered roadways, keeping cars and pedestrians separate and creating a series of landscaped courts. On the front, several elements can be seen: the roads (1), the residential terraces (2), the town centre (4) and the landscape (6), which is a combination of stretches of water and areas designated for sports fields, gardens and allotments. In these designs Jellicoe acknowledged his debt to Le Corbusier, whose idea of structures elevated on *pilotis* had paved the way for linking Modernist buildings with unimpeded landscape at ground level. While Jellicoe was responsible for the overall vision, he also credited his architectural practice Jellicoe, Ballantyne & Coleridge; his wife, Susan; and his employee June Colwill, who worked out the scheme in detail. Intended for a green-belt site outside London, Motopia was, Jellicoe cautioned, 'the diagram of an idea only', not to be taken literally 'either in regard to its site ... or in the severity of its geometry, which in reality would be complex'.

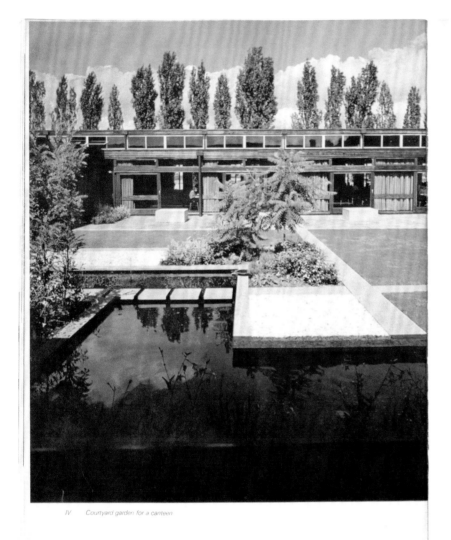

IV Courtyard garden for a canteen

plants have still not been decided, but you should by this time know that, say, a dense six-foot high screen is wanted at point A, or a standard tree to give some shade on the terrace at point B.

The final working plan can only be decided in the light of thorough knowledge of your type of soil and weather conditions. You will have to decide on your levels, which will be based on those of the house and those surrounding the site – if it is a new site, it might mean a considerable saving on cartage to use any spoil available from the foundations of the house for altering the levels. In the light of these decisions you will have to see if any drainage is necessary.

The different types of surfacing must be considered – what they will do aesthetically and what they will cost practically – and this covers not only pavings and pathways, but gravel, lawn or ground plantings as well. The same goes for the types of structure you want – a shed or greenhouse, a barbecue, fish pond or swimming pool.

Plant varieties come last of all and should be considered in two ways: those to be used structurally in the composition of the design and those which are to provide horticultural interest. The purely horticultural aspect tends to be very much over-emphasized as a result of the never-ending stream of plant catalogues and garden books available. Little wonder that the novice, after being seduced into buying a collection of ill-assorted varieties, cannot make the design of his garden visually coherent – he has been conned into putting the cart before the horse!

These elements making up the final plan will be examined in detail in subsequent chapters.

95–98 Above: Sketches showing alternative ways of arranging basic elements within a framework – in this case desks in an office

99 The courtyard of a Swiss school: boulders strategically placed in the corner of a bed to discourage children from cutting corners

John Brookes

Pages from *Room Outside: A New Approach to Garden Design*, 1969

Printed book, 23.2 × 36 cm / 9⅛ × 14⅛ in
Private collection

Rejecting the term 'gardener' in favour of 'landscape designer', John Brookes (1933–2018) revolutionized British garden design with his seminal 1969 book *Room Outside*, which conceived of the garden as 'a usable extension of the home into the outdoor world'. Recognizing that many homeowners were interested in using their gardens more as places to eat and relax than for the pursuit of horticulture, Brookes offered a style of gardening rooted in contemporary design that was better suited to modern lifestyles in the late 1960s. Containing

a plethora of advice on ways to design a domestic garden, however large or small, *Room Outside* was generously illustrated with photographs and drawings showcasing Brookes's approach. Heavily influenced by Californian Modernists such as Thomas Church (see p.50) and Garrett Eckbo, who believed that gardens should be primarily for people, Brookes adapted their principles for the British climate. Desiring to make garden design accessible to all, he emphasized unfussy, low-maintenance designs in which plants were subordinate to

the garden's purpose, included for colour and texture and no more important than paving stones or furniture. His designs were based on a simple grid, which he believed encouraged a formal unity. In some, he abandoned the lawn, replacing it with gravel – a revolutionary idea for the time. By encouraging readers to consider the character of their gardens, moving beyond the growing of plants and towards an understanding of line, shape, space, mass, colour and texture, *Room Outside* irrevocably changed gardening in Britain and beyond.

Harvey Wang

Adam Purple's Garden of Eden,
Forsyth Street, New York, 1984

Photograph, dimensions variable

Before its demolition, this flourishing community garden provided a beautiful oasis of tranquillity amid the decay of Manhattan's neglected Lower East Side, reflecting the resilient spirit of its creators, the artist and social activist Adam Purple and his partner, Eve. In 1975, after watching children play on the rubble of a razed building behind his New York apartment, Purple (born David Lloyd Wilkie) felt compelled to create a safe, green environment for the community, and he and Eve began working on what would become the Garden of Eden. The couple cleared the site by hand, physically hauling away debris and collecting manure from the horses that pulled carriages in Central Park to create a rich topsoil. The garden was designed around concentric walled circles and, as adjacent buildings were demolished, it continued to spread. After five years of work, it covered an area of nearly 14,000 square metres (15,000 sq ft) and yielded a range of produce, including corn, cucumbers, cherry tomatoes, asparagus, raspberries, strawberries and walnuts. By the early 1980s, the Garden of Eden was a celebrated landmark, and Adam and Eve, invariably dressed in purple tie-dyed clothes, were local heroes. But the city of New York never officially recognized Purple's creation, and after a protracted court battle it was demolished in January 1986 to make way for new development. Its legacy is seen in the hundreds of legal community gardens that exist today in New York and other cities, providing rest, relaxation and sustenance for body and soul.

Dan Kiley

Ford Foundation Building Garden, 1979

Photograph, dimensions variable

Since 1967, Midtown Manhattan in New York has had its own subtropical garden inside the Ford Foundation Building. The work of renowned American landscape architect Dan Kiley (1912–2004), collaborating with the architects Kevin Roche and John Dinkeloo, the brief was to fill the 49-metre (160-ft) tall atrium while taking into consideration a level change of 4 metres (13 ft) between the building's 42nd and 43rd Street entrances. Kiley – perhaps best known for the Gateway Arch National Park in St. Louis, Missouri – solved the elevation difficulty by creating a tiered garden on three levels with a staircase down to the garden's focal point, the square still-water pool on the atrium's lowest level. This black-and-white photograph, taken in 1979, shows a lone woman standing by the reflecting pond admiring the lush vegetation. Flanked by glass walls on two sides of the building, the atrium's temperate conditions are ideally suited to sub-tropical plants, of which the garden today contains around forty species of trees, climbers and shrubs. Kiley originally planted a dozen saucer magnolias, low shrubs and ground-cover, but these were later replaced – as the photograph shows – with subtropical plants better suited to the humid atmosphere. The planting continues to the upper tiers of the atrium, thanks to a series of planters on the third, fourth, fifth and eleventh floors of the building. Now a New York City Landmark, Kiley's gardens are open to the public.

Maria Louise Kirk and Frances Hodgson Burnett

The Secret Garden, 1911

Printed book, 20 × 15.5 cm / 7¾ × 6 in
Houghton Library, Harvard University,
Cambridge, Massachusetts

An inquisitive robin watches from a tree as a fair-haired girl dressed in red unlocks a secret door hidden behind drapes of ivy. American illustrator Maria Louise Kirk (1860–1938) designed this book cover for the first edition of *The Secret Garden*, the classic children's book published in 1911 by British writer Frances Hodgson Burnett (1849–1924). The book tells the story of Mary Lennox, a selfish ten-year-old orphan who moves to her aloof uncle's lonely house on the Yorkshire Moors, where she discovers a mysterious locked garden. After a robin leads her to the key, Mary enters the walled garden and encounters the transformative power of nature. The garden changes not only her own outlook on life, but also that of the other characters, including her sick cousin Colin, whose health is restored after spending time there, and Dickon, the twelve-year-old brother of her chambermaid, who shares Mary's newfound enthusiasm for horticulture. When Mary's uncle witnesses Colin's recovery and the restoration of his formerly abandoned garden, he embraces his family afresh and relationships are healed. Kirk contributed four colour illustrations to the book, depicting the story's protagonists inside and outside the garden. Originally trained as a painter, Kirk made her name in children's books, illustrating more than fifty titles. Her style was influenced by the German Jugendstil movement of the early twentieth century, which tended towards floral motifs, arabesques and organically inspired lines, and was perfectly suited to Burnett's celebration of nature's power to renew and regenerate.

Giovanni Boccaccio

Prisoners Listening to Emilia Singing
in the Garden, from *La Teseida*, 15th century

Ink and colour on parchment, 26.5 × 20 cm / 10½ × 7¾ in
Österreichische Nationalbibliothek, Vienna

Walled by castle parapets, a beautifully realized representation of an enclosed garden by an unknown artist fills the upper half of this chapter opener from a fifteenth-century illuminated copy of *La Teseida* by the Italian Renaissance humanist writer Giovanni Boccaccio (1313–1375). The princess Emilia sits on a bench of grass whose defined blades seem to echo the delicacy of the spun gold strands of her hair. Around her, the flora within the garden – including white and red roses for purity and irises for suffering – emphasizes the visual links to the Virgin Mary, most forcibly stated by the princess's blue, ermine-lined gown. The garden here is a whimsically layered visual play on the notion of the medieval *hortus conclusus*, or enclosed garden, itself strongly symbolic of the notion of virginal purity. Radiating from and returning to the central enclosure of Emilia's woven floral wreath is a visual push and pull of a 'room' encased by wooden gothic trellises and arches within the walls of the castle. Overlooking the trellis, the imprisoned Theban royals Palemone and Arcita peer out from their barred cell into a circumscribed space. The softness and languid beauty of the plants and flowers in the garden, and of those that make up a decorative frieze in the lower half of the page, bolster the sense of the men's desire for Emilia, a joint attraction that will lead them both to raise armies to battle for her affection. This section of Boccaccio's story was the principal inspiration behind 'The Knight's Tale' in Geoffrey Chaucer's *Canterbury Tales* (c.1400).

N. PETERS, PHOTO-LITHOGRAPHER, WASHINGTON, D. C.

François Carré

Chair Bottom, Patent No. 54,828, 1866

Ink on paper, approx. 29.3 × 20.3 cm / 11½ × 8 in
US National Archives at Kansas City, Missouri

With a seat that bears more than a passing resemblance to an upside-down sunburst, this metal chair revolutionized garden furniture by providing comfort without the need for padding. Ever since gardens were designed to be looked at and enjoyed, a garden seat has been indispensable: one of the earliest known garden chairs was found at Pompeii, Italy, where it was buried when Vesuvius erupted in AD 79. Designed by French-born François Carré (active 1860s), who filed the first patent for the chair's distinctive design in the United States in 1866, this chair was initially intended to meet the growing demand for outdoor seating in the parks of Paris. Its bent-steel rod-and-spring construction, whereby the curved sheet-metal strips were welded to a central brass button (giving them the appearance of sunrays), made it both light and flexible, unlike its cast-iron predecessors. For the back, the curved sheet-metal strips flexed at the ends, giving the support both flexibility and comfort – thus dispensing with the need for a cushion and making it possible to leave the chair outdoors in all weathers. Such was the success of the chair that Carré went on to produce different versions, including a chair with a sunbeam back that echoed its sunbeam bottom. The durability and lightness of the steel structure also made the chair very popular for use in cafés. Indeed, it had a starring role in Rick's Café Américain in the iconic 1942 movie *Casablanca* and featured in many stylish homes in the mid-twentieth century, including those by renowned French architect Le Corbusier, who used the chairs for a Parisian apartment's rooftop terrace he designed in 1930.

Suzanne Valadon

*Paysage à Montmartre
(Le Jardin de la rue Cortot)*, 1919

Oil on canvas, 92 × 73 cm / 36¼ × 28¾ in
Private collection

Remarkable French artist Suzanne Valadon (1865–1938), the first woman ever admitted to the prestigious Société Nationale des Beaux-Arts, painted her Montmartre neighbourhood many times. This oil painting of the peaceful gardens of rue Cortot, where Valadon lived with her son, the painter Maurice Utrillo, between 1912 and 1926, shows the same exuberant use of colour that characterizes her better-known male and female nudes. Painted in 1919, when Valadon was at the height of her fame, the restful scene captures an unknown woman sitting on the stone path amid the lush vegetation of the gardens in early autumn. The scene provides a notable contrast with the seedy underworld of Montmartre more often portrayed by contemporary artists. Unable to afford art school and therefore professionally untrained, Valadon started her career as an artist's model, posing for friends, such as Henri de Toulouse-Lautrec and Pierre-Auguste Renoir (see p.319), before they, and one of her closest friends, Edgar Degas, taught her to paint. Over a forty-year career, Valadon frequently painted domestic scenes, such as floral still lifes, her beloved pets and depictions of women bathers. The meditative stillness of this painting runs counter to the turbulence of her private life. An unmarried mother who had a series of passionate love affairs – including with the composer Erik Satie – Valadon only started painting full time in 1909, at the age of forty-four, and staged her first solo show just two years later to great critical acclaim.

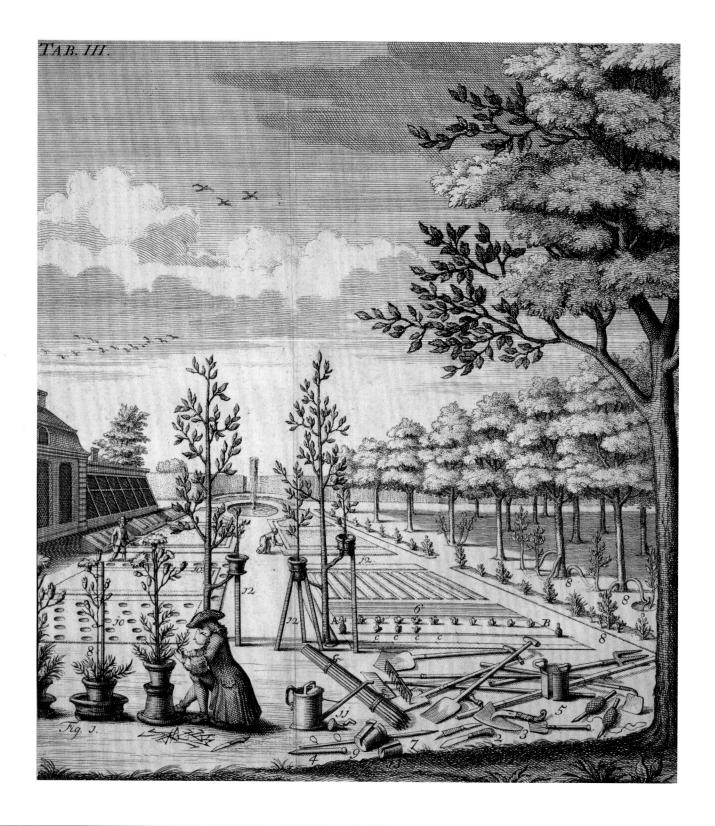

TAB. III.

Johann Hermann Knoop

Plate III, from *Contemplative and Active Gardener's Art, or, Introduction to the True Practice of Plants*, 1753

Engraving, approx. 24 × 21.5 cm / 9½ × 8½ in
Private collection

German-born polymath Johann Hermann Knoop (c.1700–1769) included mathematician, scientist, land surveyor, horticulturist and draughtsman in his résumé. He was also *hortulanus*, or head gardener, to the Dowager Princess of Orange, Princess Maria Louise van Hessen-Kassel, at her country estate at Mariënburg, near Leeuwarden in the Netherlands. This illustration, included in Knoop's publication *Contemplative and Active Gardener's Art* (1753), shows the detailed planning that went into the creation of part of a vegetable garden, most likely

at Mariënburg. The illustration includes letter and number keys relating to both the tools in the foreground – many of which remain familiar to modern gardeners – and the stages of plant development in the various beds, from being drilled ready for planting, to pruning and, at right, rooting new trees from living branches. Best known for his work *Pomologia* (1758), in which he systematically detailed 'the best varieties of endangered apples and pears in Holland, Germany, France, England and other countries, which was the reason why they

were grown', Knoop provided drawings of all the fruit for his engraver Jan Caspar Philips to engrave. Knoop had followed his father into horticulture – the fruit gardens at Mariënburg were Knoop's particular favourite – but he turned to writing books after leaving his position at the estate. After retiring from hands-on gardening and following the success of *Pomologia*, which remains a standard work on apple and pear varieties, he concentrated on documenting fruit species in the volumes *Fructologia* and *Dendrologia* (both 1763).

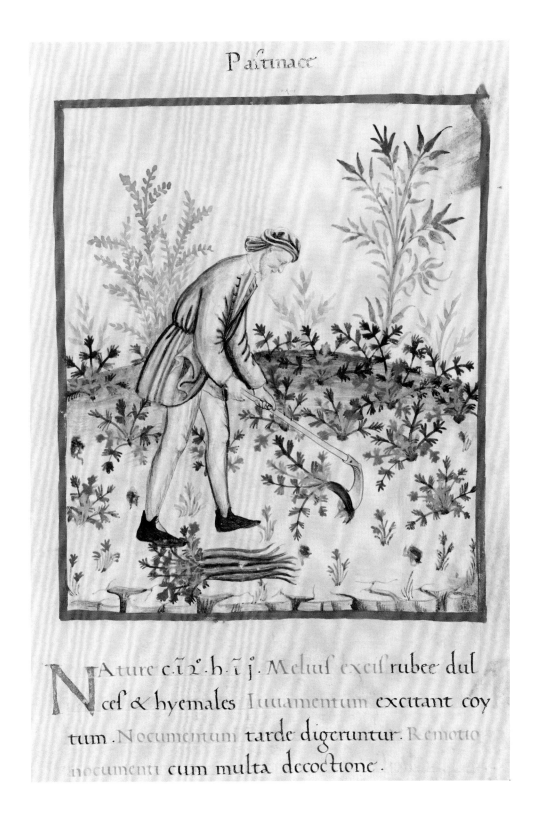

Pastinace

NAture c̄iz̄.h.ī.j. Meliuſ exciſ rubec dul
ceſ & hyemales Iuuamentum excitant coy
tum. Nocumentum tarde digeruntur. Remotio
nocumenti cum multa decoctione.

Anonymous

Harvesting Parsnips and Carrots,
from *Tacuinum Sanitatis*, 15th century

Illuminated manuscript on vellum, 24.3 × 16.2 cm / 9½ × 6¼ in
Bibliothèque municipale, Rouen, France

From a brown, cracked earth blanketed with vegetable tops spread out like decorative embroidery, a Renaissance peasant tugs a carrot to add to the pile at his feet. The lack of background detail along with the figure's rapt stare of concentration captures a feeling of serene focus, an absorption in the sanctity of the work, while the horizon's gentle curve suggests the cyclical nature of agriculture. The image is one of many from a Latin manuscript of *Tacuinum Sanitatis*, a popular early Renaissance handbook and guide to healthy living. Like many

Western European secular 'guidebook' texts from this period, it was translated from an Arabic original, the eleventh-century *Taqwim al-Sihha bi al-Ashab al-Sitta*, which expounded ancient Hippocratic notions of balancing the body's humours by focusing on diet and the beneficial properties of plant and vegetable cultivation. The foodstuffs shown are often signifiers of economic status; upper-class figures are shown with rarer fruit trees and peasants closely associated with root vegetables, which were their principal foodstuff – here even

through an echo of appearance between the figure's tunic and the piled crops. The book's illustrations and overall subject capture the cultural transformation of the private garden from the medieval enclosure, a site of mysterious chivalric love, into the smallholding or kitchen garden as a space of labour and experimentation in the Renaissance. Yet love and amorous passion have not entirely left the picture. The text below the image suggests the harvested carrots will slow digestion at the same time as increasing sexual excitement.

THESE LOVELY SHELLS ARE FROM AUSTRALIA AND THE ISLE OF ABALONE CALIFORNIA USA

Andrew Lawson

Mrs S. Howard, Southbourne Overcliffe Drive, Southbourne, Bournemouth, Dorset, from *Brilliant Gardens,* 1989

Photograph, dimensions variable

Adorned with more than a million seashells collected from around the world, this garden was a local landmark in the English coastal town of Bournemouth for more than fifty years. George Howard, who collected shells while travelling as a merchant seaman, began the garden in 1948 with his wife, Sarah, in memory of their teenage son Michael, who died after contracting meningitis. Alongside the enormous number of seashells, the seafront garden was also decorated with tiles, broken plates, coloured glass and even a fossilized tree.

Visitors could also spot fragments of Icelandic lava rock, Red Sea coral, South African quartz and giant clam shells from the Philippines, in which children were invited to have their photograph taken. Other elements that were added over the years included a statue of St George and the Dragon, a fountain, a wishing well, several shrines and two grottoes decorated with Victorian tiles and more seashells. At the height of its fame, the Shell Garden attracted thousands of tourists each summer, and although the Howards never profited from

their creation, donations from visitors enabled the couple to raise thousands of pounds for charitable causes. When garden photographer Andrew Lawson (b. 1945) documented the garden for the book *Brilliant Gardens* (1989), however, its heyday was already over. In the 1990s, following the couple's deaths, the site was regularly targeted by vandals and thieves, and in 2001 the family made the difficult decision to demolish the garden. The house survived briefly but was finally razed in 2003 to make way for an apartment block.

Bill Owens

Before the dissolution of our marriage my husband and I owned a bar. One day a toilet broke and we brought it home, 1971

Archival pigment print, 43.2 × 33 cm / 17 × 13 in
Private collection

For many, the garden is a site of experimentation where seemingly incongruous objects can be repurposed for new aesthetic or functional use. Just as Vita Sackville-West (see p.80) encouraged the placing of sinks or troughs of plants at waist level, 'permitting a close-up view of the small subjects it may have been found desirable to grow', the enterprising gardener in this image by American photographer Bill Owens (b. 1938) has sited a toilet on her lawn, filled with flowering plants. Leaning gently forwards, she teases a hosepipe curved in an S-shape around her leg from the house to the planter, gathering deadheads in her left hand as she waters. Owens's 1973 publication *Suburbia* documented the lives of commuter-belt residents in Livermore, California. He had studied visual anthropology at San Francisco State University, and pursued an image-making career concerned less with unrepeatable moments of visual piquancy in the mode of Henri Cartier-Bresson than with a drier, more journalistic sense of place, personhood and historical moment. Owens planned a 'shooting script' over fifty-two days, encompassing such events as Thanksgiving and the Fourth of July, to realize a holistic portrait of a community that stands among the quintessential documents of American suburbia. His lengthy titles, which incorporate deadpan quotations from their subjects, add further layers of political and interpersonal exposition and nuance. Here, the woman's all-black jumpsuit and careful tending of her display can be read as a backyard funerary rite in defiance of the conformity of suburban norms.

Dick Radclyffe & Co.

Advertisement from *Rustic Adornments for Homes of Taste*, 1870

Engraving, 19 × 13 cm / 7½ × 5 in
University of Toronto, Canada

This advertisement for Dick Radclyffe & Co., a thriving business trading in naturalia and accessories in central London, shows a range of domestic enclosures suitable for even modest middle-class homes, including tabletop greenhouses, window-sill mini-conservatories, and aquaria, that were popular in the second half of the nineteenth century as a means of bringing gardens indoors. Inevitably separated from the natural world by the Industrial Revolution and increasing urbanization, the Victorians and Edwardians turned to indoor souvenirs of the great outdoors, with terraria and hothouses like these allowing them to grow ferns and orchids in their homes. Indoor activities also appealed because of more practical considerations, from the lack of a garden or the cost of maintaining full-scale greenhouses to the simple satisfaction of growing one's own plants indoors. This advertisement appeared in the book *Rustic Adornments for Homes of Taste* (1870) by James Shirley Hibberd, a prolific garden writer and editor of three gardening magazines, who was one of the earliest supporters of amateur gardening at a time when the field was largely the preserve of professionals. Hibberd was also a supporter of people creating gardens in towns, beekeeping and recycling water, and generally taking more interest in what would today be termed conservation. Companies such as Radclyffe & Co. created a new consumer industry based on amateur gardening that is now highly lucrative; it is telling that one of Hibberd's magazines, *Amateur Gardener*, is the only magazine from the period that is still published today.

Indoor water gardening

If you can find a suitable dish or glass bowl for a tiny water garden, then you will be fascinated by the little water plants which you will be able to grow in it. Such plants are sold in most pet shops.

Aquatics are plants which float on the water with the roots hanging down. One of these is Azolla Caroliniana. Another aquatic is the 'Frogbit' which looks like a miniature Water Lily. It has three white flower petals in summer, and in late autumn the leaves die off, leaving a bulbil which sinks into the mud until the spring.

Non-aquatics need to be planted in half an inch of sand or soil, with a few pebbles in the bottom of the bowl. Glass bowls are best, especially goldfish bowls because you can see the water plants and their roots from outside. Whatever type of bowl you use, it will need topping up with water occasionally.

Another kind of water garden you could make is one which is set in a fairly shallow, small bowl and placed inside another larger, shallow bowl. The larger bowl can then be planted with moss, stones and tiny plants, to make it look like a miniature garden with a pond.

44

Bernard Herbert Robinson and June Griffin-King

Indoor Gardening: A Ladybird Book, 1969

Lithograph, each page 18 × 11.5 cm / 7 × 4½ in
Private collection

British readers of a certain age will instantly recognize the source of these pages: the Ladybird series of books that was a popular nonfiction format for children throughout much of the twentieth century. This spread comes from the 1969 title *Indoor Gardening*, one of the 'Learnabout' books that offered readers practical techniques and tips as a 'how-to' guide. In the text, author June Griffin-King invites the reader to create a water garden in a glass dish, such as a goldfish bowl, and explains how to stock it with water plants bought at a pet shop, describing *Azolla caroliniana*, the floating fern to the left at the surface of the glass bowl, and frogbit, *Hydrocharis morsus-ranae*, with its three-petalled white flowers. The paintings are the work of Bernard Herbert Robinson (1930–2004), a prolific Ladybird artist: 'non-aquatic' (non-floating) water plants are embedded in golden sand at the bottom of the bowl, with light and dark green fronds reaching up through the water. In the lower illustration, a small bowl is placed within a larger one, creating a rim in which pebbles and moss form a circle around a 'pond' featuring more floating species, including frogbit. Other horticultural titles among the hundreds of Ladybird books – now published by Penguin Random House – included *The Ladybird Book of Garden Flowers* and *The Ladybird Book of the Shed*. The series was first printed in 1967 and was revived in the 2010s by the release of Ladybird Books for Grown-Ups, which reproduced original artworks next to knowingly satirical text.

Jennie Pingrey Stotts

English Flower Garden Quilt, 1930–5

Cotton, 2.4 × 2 m / 8 ft × 6 ft 6 in
American Folk Art Museum, New York

Twenty virtually identical pots fill the grid of this patchwork quilt produced by an amateur American quilter in Kansas at the height of the Great Depression of the 1930s. The symmetrical shape of the flowers growing in each pot is equally standard – four leaves and three blooms – but the quilter, Jennie Pingrey Stotts (c.1861–after 1935), varies the colours and patterns of each bloom to suggest a rich variety of species in her 'English flower garden', although it is not possible to identify any specific plants. Flowers were

a popular subject for patchwork quilts, which had, since the early days of European settlement, become a particularly American form of folk art, putting together small pieces of fabric, or 'blocks', often embroidered, to create a much larger design. The urns in which Stotts places her flowers resemble those used in antiquity, and had become a consistent feature in quilts in the 1800s. Stotts' colours were unique, but her flower motif was based on a design by renowned local quilter Ruby S. McKim, published in 1929

by Capper's Weekly Print Quilt Block Service, which provided regular designs for home embroidery, and the next year in the *Kansas City Star*. Stotts combines McKim's design with a border created by McKim's predecessor at the *Star*, Eveline Foland, and adds her own innovation with the orange stripe across the top of each pot. The resulting proliferation of colour, variety and life is a stark contrast to contemporary Kansas, much of which was reduced to barren sand in the early 1930s by the Dust Bowl.

G. Rochette

Schoolchildren Gardening, 1931

Lithograph, 88.9 × 66 cm / 35 × 26 in
Private collection

A young woman holds a plant ready to be placed in the ground, while a student digs a hole and another carries a watering can from the well in the background, in a stylized landscape with a white fence and tree in bloom. This Art Deco French poster from 1931, the creation of an obscure graphic artist named G. Rochette, was probably designed to hang in a school classroom to encourage students' interest in gardening, and belongs to a tradition of schools having their own gardens that dated back to the introduction of universal education in France in the mid-nineteenth century. In rural areas where young adults were likely to enter agricultural work, school gardens were compulsory in order to provide horticultural instruction, as well as to produce food. The tradition continues today, albeit watered down, with a national 'School Gardens' week and the Best School Flower Garden competition held every March. Schools in towns and cities tend not to have gardens of their own, but sometimes adopt a nearby garden or even create their own gardens on unused urban space. In France – as in other countries – teachers with access to gardens find them helpful settings for a range of lessons, most obviously in the biology of plant propagation and growth, and the production of healthy food, but also in terms of practical gardening skills. Gardens are also a favoured subject for outdoor art classes, where students get to draw the growing plants.

Ellen Willmott

The Garden House, c.1902

Photograph, dimensions variable

Renowned for transforming the gardens at Warley Place, her family's home in Essex, and hailed as 'the greatest plantswoman ever', English horticulturist Ellen Willmott (1858–1934) is now all but forgotten – a stark contrast to Gertrude Jekyll (see p.61), who is still lauded and alongside whom Willmott was the first woman to receive the Royal Horticultural Society Medal of Honour, in Queen Victoria's Jubilee year of 1897. Nevertheless, the importance of Willmott and Warley Place in the English garden tradition cannot be overestimated. Coming

from a family of keen gardeners, Willmott turned Warley Place into one of the most celebrated and famous of all England's gardens, not only planting hundreds of new varieties of flower and shrub in a naturalistic style, but also, from 1882, building an alpine garden, complete with a special cave for her ferns. This photograph of the Garden House shows how she used climbing roses to soften solid structures. Jekyll included this image in her 1902 book *Roses for English Gardens*, but it was the publication in 1909 of Willmott's collection of forty-one

black-and-white photographs of different features of her garden, *Warley Garden in Spring and Summer*, that captured the public imagination. By then, her fame and Warley's reputation were well established, but the garden remained private, and few people had the opportunity to visit – although visitors included Queens Mary and Alexandra, and American industrialist Henry du Pont. The book received rapturous reviews despite the absence of explanatory text, and its images alone captured the garden's charming and unique planting.

HOUSE & GARDEN

Fall Planting Features in this Issue

© The Condé Nast Publications Inc.

October~1926

35 cts~3$\frac{50}{}$ a year

Pierre Brissaud

House & Garden, October 1926

Lithograph, 29 × 22 cm / 11 × 8½ in

Autumn is a conflicting season for gardeners. For some, it is associated with the plenty of harvest, while for others it is a time of remembrance and contemplation. Autumnal gardens quickly turn quiet; the chirping of birds and buzzing of insects give way to the gentle rustling of dry leaves blown around by cold morning breezes. Gone is the pyrotechnic spectacle of dazzling meadows and borders spilling over with annuals. Autumn in the garden is a different kind of spectacle – a sombre triumph of warm, rusty

hues pierced by sporadic glimmers of gold. The growing season might be coming to an end, but gardeners are still hard at work. Winter vegetables require care, and there is plenty to clean up, prune and ready for the winter months. But expert gardeners know that autumn is also a time to plan future planting that will brighten the warm spring days ahead. These notions are captured in this striking cover illustration for the iconic *House & Garden* magazine by French artist Pierre Brissaud (1885–1964). Brissaud

developed an illustrious career at the beginning of the twentieth century as an illustrator, particularly in his signature Art Deco style, for some of the most prestigious publications in the world, including *Vogue*, *Fortune* and, of course, *House & Garden*. Launched in 1901, *House & Garden* was originally focused on architecture, until it was acquired by Condé Nast in 1911. Nast transformed the magazine into its present form – still in print more than 120 years later – with an eye to interior design, entertaining and gardening.

Anonymous

*The Lamport Gnome, c.*1870

Plaster, polychrome and wood, 15 × 6 × 6 cm / 6 × 2¼ × 2¼ in;
plinth 9 × 9 × 8 cm / 3½ × 3½ × 3¼ in
Lamport Hall, Northamptonshire, UK

This figure standing proudly with his shovel is probably the oldest surviving example of a figure that has come to epitomize kitsch in the modern garden: the garden gnome. Gnomes were a purely German creation based on folkloric human-like creatures from ancient European fairy tales, where they were said to possess magical powers. Later, German miners carried tiny three-dimensional carvings of gnomes as good-luck charms. According to legend, Sir Charles Isham, an eccentric British aristocrat and serious horticulturist, travelled to Nuremberg

in the mid-nineteenth century and purchased a group of *Gartenzwerge* for a rockery he was building in his garden at Lamport Hall, Northampton. Isham's garden features soon caught on, and gnomes found a permanent home among garden plants. Shovel in hand, the Lamport Gnome, or 'Lampy' as he is affectionately known, is a hunched old man with a long white beard and trademark Phrygian cap. Lampy is the sole survivor of the original group, outliving Isham's unappreciative heirs, his purportedly 'gnomophobic' daughters, who

tried to destroy the whole collection. Crude and clay-like, and no taller than a snowdrop, the figure is often attributed to sculptor Philip Griebel. Lampy has since become an unlikely British national treasure, and helped to start a fashion for placing gnomes among garden plants. The travelling gnome is a popular modern meme, but the original Lamport Gnome is probably the most travelled. It has been loaned to countless museums around the world for display in numerous exhibitions, as it is now recognized as an important cultural artefact.

Peter Marlow

G.B. England. Kent. Romney Marsh, 2003

Photograph, dimensions variable

A line of garden gnomes in red Phrygian caps – including a gnome Father Christmas at far left – forms a guard of honour on the bare patch of earth in front of a mobile home in a holiday park in Romney Marsh, Kent, a seaside resort in southeastern England. The gnomes guard 'Margarets Caravan' along with two cultivated plants, a weed in a pot accompanied by a cherub, donkeys and a comical sign that welcomes the viewer ... then asks them to leave. This is a garden on a tiny scale – identified as such only by ornaments

more commonly associated with suburban flower beds and house fronts – but with far more spirited humour than many gardens with more striking blooms. British photographer Peter Marlow (1952–2016) began his photographic career in 1975 on an Italian cruise liner, later becoming a front-line photojournalist capturing major world events in locations such as Lebanon and Northern Ireland; he also served twice as president of the agency Magnum Photos. Later in his career he concentrated on a range of personal projects,

including a pilgrimage to document all forty-two English cathedrals at dawn. Marlow had a strong connection with Dungeness and Romney Marsh, and made this image as part of a ten-year project to create a book on the area that is a study in preformed plastic, a perfect example of his keen eye for the quirky. As for the unseen gardener, Margaret seems to be telling us to embrace nonconformity, cultivate your own garden, and if people don't like it, stuff 'em!

Russell Page

70th Street Garden, Frick Collection, New York, c.1976–7

Dyeline drawing, 36 × 57 cm / 14 × 22¼ in
Garden Museum, London

One of the most celebrated landscape architects of his era, British garden designer Russell Page (1906–1985) rarely worked on public projects but did accept a commission in 1977 for a garden at New York City's Frick Collection museum on Manhattan's East Side. His sketch for the garden on East 70th Street demonstrates his remarkable ability to develop a garden around the limitations of a small site intended to be seen from street level, surrounded on three sides by high-rise buildings. Page's use of spatial illusions and judicious planting, including his favourite Iceberg roses – used here despite his concern about light levels – resulted in a garden of calm and balance. Colourful seasonal planting, the siting of boxwood and of numerous trees, and the addition of a central fountain and pea-gravel paths created a garden that was intended to be seen through iron railings, rather than walked in. Perhaps better known for PepsiCo's world headquarters gardens in Purchase, New York, where he not only designed the landscape but also chose the sculptures placed through the gardens, Page was unique in his extensive knowledge of European and Islamic gardens, and approached gardening as an art form. As he wrote in his seminal book *The Education of a Gardener* (1962), 'Whether I am making a landscape or a garden or arranging a window box, I first address the problem as an artist composing a picture.' The enduring popularity of the Frick garden was made clear in 2015, when public protests succeeded in stopping its planned demolition.

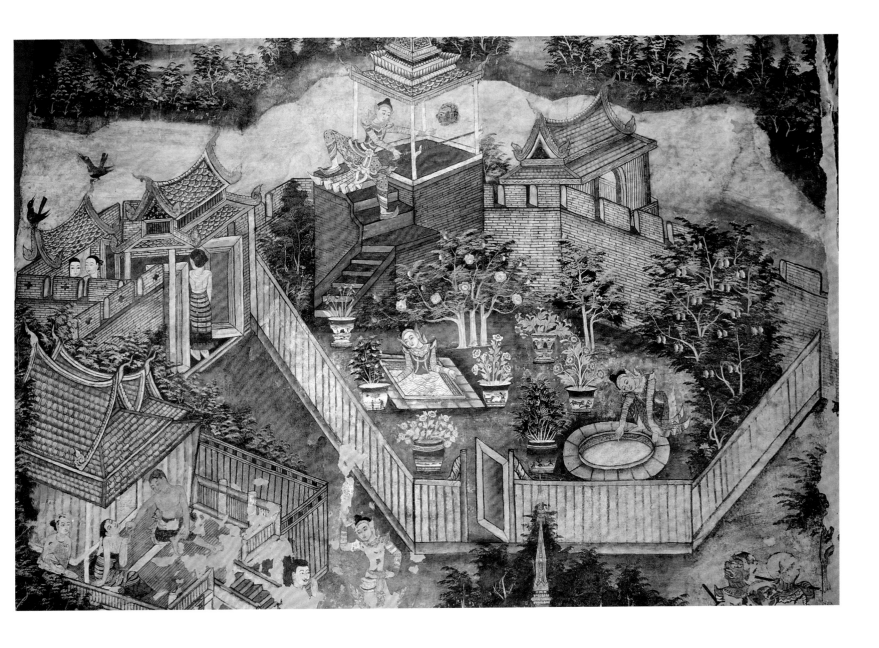

Anonymous

Royal Walled Garden, 1820s

Mural painting
Wihan Lai Kham, Wat Phra Singh, Chiang Mai, Thailand

A walled garden teems with potted plants and trees bearing fruit and flowers, representing a place of abundance, peace and harmony. Painted in the 1820s by an unknown Chinese artist on the orders of Prince Thammalangka, the ruler of Chiang Mai in northern Thailand, this colourful mural in the Chiang Mai temple Wihan Lai Kham depicts either a walled garden or a paradise scene. Around AD 400, Chinese artists began to adopt *qingl*, a restricted palette of greens and blues derived from plants used for medicinal purposes. Images

made using this technique both represented and materially embodied healing principles central to Daoist and Buddhist teachings. Ceramic blue-and-white planters dot the garden, adding beautiful floral accents to the areas surrounding the pools. Such flowerpots were traditionally reserved for special occasions and were considered symbolic: white symbolized purity and blue represented serenity. Bathing more than once daily was and still is an important part of Thai tradition and, as here, people often bathe clothed, outdoors.

The mural is just one part of a complex and extensive series depicting the story of Prince Sang Thong, in which he disguises himself – because of his recognizable golden skin – marries a princess of the Samon Kingdom, then undergoes a number of trials commanded by the king in order to prove his worthiness. Scene after scene, the paintings impart important cultural teachings, such as the triumph of good over evil, or celebrate the uplifting powers of beauty in life.

9/50 1958

Yamaguchi Gen

Tea Garden, 1957

Ink and colour on paper, 43.5 × 59.7 cm / 17⅛ × 23½ in
National Museum of Asian Art, Smithsonian Institution,
Washington DC

The Japanese artist Yamaguchi Gen (1896–1976) was a leading proponent of the Sosaku Hanga school of printmaking, a twentieth-century movement that championed the individual creativity of the artist as well as uncommon approaches and materials to create vibrant, modern works that welded currents of European modernism to traditional Japanese subject matter. *Tea Garden* encapsulates perfectly the movement's urge for experimentation, employing a wealth of techniques to create its forms: the Joan Miró-esque star – perhaps the garden's

tsukubai (purifying water font) or *toro* (ceremonial lantern) – is created with scratches of white through a pulsating blue miasma; the terracotta-red shards, floating like koi in a pond across the print's surface, are torn strips placed like those of a Henri Matisse collage (see p.143); and the darker enclosure at the bottom left appears to have been printed directly from the grain of a wooden panel. Despite this multiplicity, the overall impression is one of Zen-like calm and simplicity as elements are positioned harmoniously across a soothing pale pink

ground. The sense of space between objects and their careful interrelation are entirely appropriate to the traditional *roji* tea garden, which was conceived as a series of enclosures that led eventually to the *chashitsu*, or teahouse, where tea rituals occur. The suggestion of vegetation in Gen's representation is minimal, echoing the minimalist planting of *roji*, where mosses and ferns are favoured. However, in many of his works the same beautifully balanced abstraction is conjured from the direct imprint of the shapes and veins of leaves.

Anonymous

Lozenge-shaped dish, late 16th–17th century

Black lacquer with mother-of-pearl inlay and gold and silver foil, 21.6 × 28.6 × 2.9 cm / 8½ × 11¼ × 1⅛ in
Metropolitan Museum of Art, New York

Illustrated in luminous mother-of-pearl and gold and silver foil against black lacquer, Chinese literati are shown enjoying a beautiful garden in this lozenge-shaped dish from the late Ming dynasty (1368–1644). In the centre, two visitors to the garden approach a pavilion in the shade of a willow tree, where they will presumably join the musicians already gathered there. One musician plays a mouth organ (*sheng*) and another a zither (*zheng*), while a young attendant carries another type of zither (*qin*). A high point in China's

horticultural history, the Ming championed gardens – both real and imagined – as the ideal manifestation of human's harmonious relationship with nature, and as a setting for music, writing and reading poetry, or quiet contemplation. Gardens such as these were typically the preserve of Ming nobles and officials, who used them for pleasure or relaxation and to impress visitors. Garden masters designed the enclosures to be a microcosm of the natural world, in which every aspect was considered and expressed through

the key elements of any Chinese garden: flowers and trees, as elsewhere, but also rock formations, buildings that often had artistic significance, such as this pavilion, and a water element, such as a pond or stream. 'Stroll gardens' were deliberately designed to unfold as a series of vistas that were revealed to the visitor in turn as they wandered through the garden. Ming artists strove to capture the beauty and serenity of gardens in lacquerware, as here, and in more numerous woodblock prints.

Anonymous

Woman's mantle (*lliclla*), 18th century

Tapestry with cotton warps and wool wefts,
88.9 × 114.3 cm / 35 × 45 in
Museum of Fine Arts, Boston

The garden urns that appear in the bands on this mantle, or *lliclla* – a garment worn by Quechua women over their shoulders – are a reflection of the European culture introduced to Peru and Bolivia by the Spaniards who overthrew the Inca Empire in the early sixteenth century. Urns had become popular in European gardens later in the century, when it was realized that they became prominent in the gardens of Classical antiquity. This *lliclla*, from the Andean region of Peru, also features a double-headed eagle, with other birds and flowers, and is bounded by floral bands edged with lacy patterns. The Inca from whom the Quechua are descended were skilled horticulturists who introduced complex techniques to grow enough food to feed their population in mountainous terrain that was frequently unsuitable for cultivation. The Inca solution was to dig into hillsides to produce a series of flat, narrow terraces held in place by stone walls and watered by a system of aqueducts, pipes and trenches. These terraces allowed the cultivation of various crops, depending on their altitude. Potatoes, the main staple, were grown at nearly all elevations, while quinoa was cultivated at higher altitudes and cotton and coca further down the mountain. In the lowlands on either side of the Andes, market gardeners produced tomatoes, chilli peppers, sweet potatoes and cassava, among other crops.

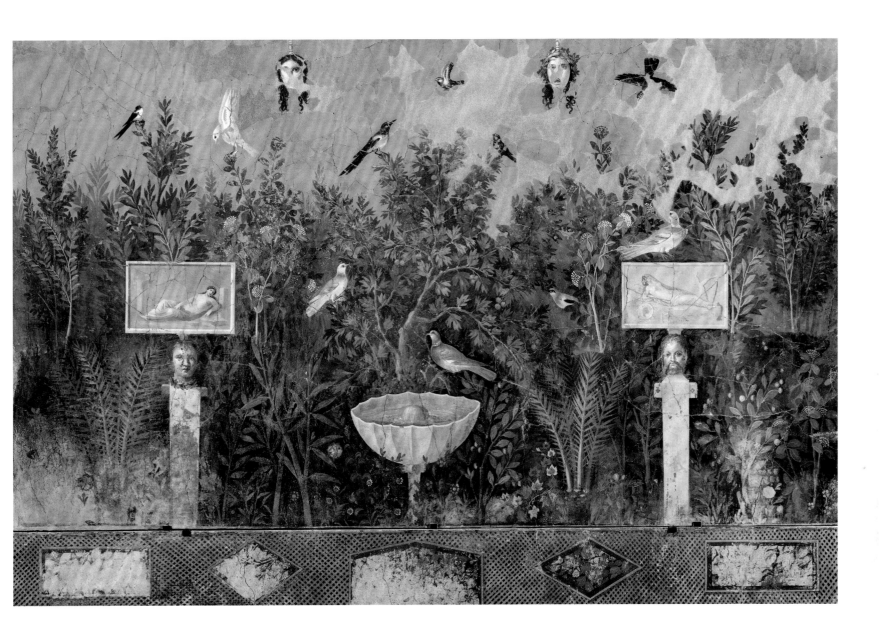

Anonymous

Fresco in the House of the Golden Bracelet
(detail), 1st century AD

Pigment on plaster
Pompeii, Campania, Italy

Nature appears to be reclaiming an architectural space in this fresco: one third of a painted room that opened on to and teasingly continued the garden of one of the largest houses to have been uncovered at the ancient Roman site of Pompeii. Around the oscilla masks, hung to ward off evil spirits, eerily naturalistic herma sculptures topped by framed pictures of reclining nudes and a central half-shell basin fountain crowd a dense backdrop of gently curving bay trees under a cloudless blue sky. The painting tells a dual story of the lives of

upper-class Romans at the time it was buried and preserved by the eruption of nearby Mount Vesuvius on 24 August AD 79. On one hand it encapsulates the advancement of Roman domestic decoration and the predilection for trompe l'oeil painting. Every leaf and berry seems to stand out in a painstakingly precise, hyper-real delineation that brings to mind Pliny the Elder's description of the renowned ancient painter Zeuxis, whose depictions of plants were so convincing that birds flew down to peck at them. On the other hand,

it documents the sophistication of private Roman gardens as spaces of quiet contemplation and rich symbolism for their owners and visitors. Here a gentle rhythm and symmetry in the placement of strawberry trees hung with yellow and red berries, white pointillist crescents of viburnum flowers and jagged saws of date palms reveal their very deliberate orchestration as shrubbery. At the fresco's centre, behind the fountain, the budding plane tree – a favourite of Plato – quietly signifies an appreciation of philosophical learning.

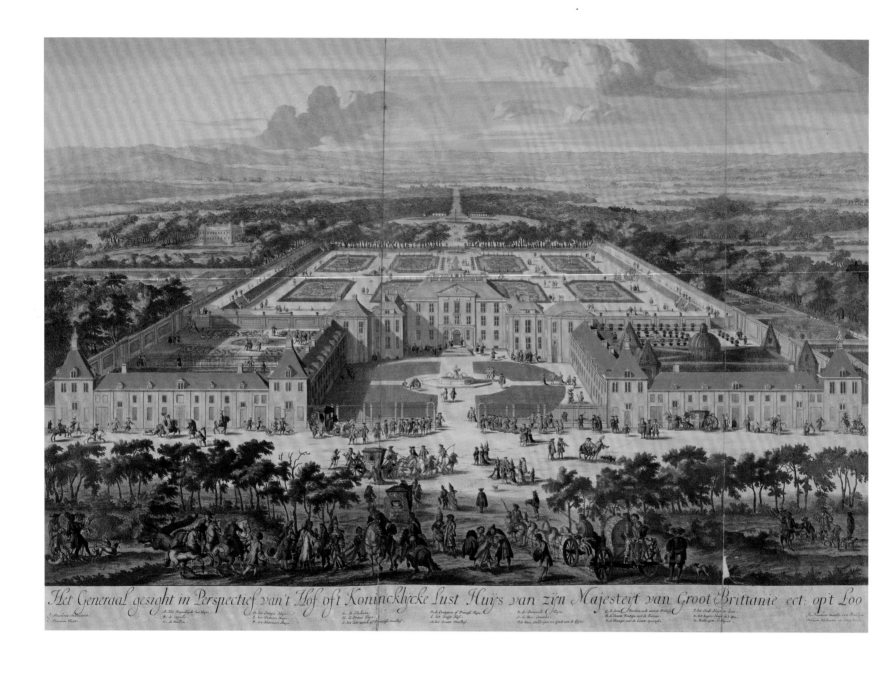

Het Generaal gesight in Perspectief van 't Hof oft Konincklycke Lust Huys van zyn Majesteyt van Groot Brittanie ect. op 't Loo

Isaac de Moucheron

Het Loo, from *Dutch Baroque Gardens*, 1718–48

Hand-coloured engraving, 34 × 54 cm / 13⅜ × 21¼ in
British Library, London

Situated near Apeldoorn in the Netherlands, Het Loo (The Wood's Palace) was one of the favourite residences of Prince William of Orange, later King William III of England, because it combined his two main pleasures: hunting and gardens. When Dutch artist Isaac de Moucheron (1667–1744) painted the palace and gardens, he included in the foreground groups of hunters and dogs with the carriage used by William's queen, Mary, to follow the hunt. William first commissioned the glorified hunting lodge with its formal

gardens in 1684, but, after he accepted the offer of the British throne five years later, he enlarged the house and doubled the size of the gardens. The gardens were designed by a Protestant refugee from France, Daniel Marot, who achieved a particularly Dutch version of the Baroque despite the clear influence of the grandiose gardens at Versailles (see p.16). The garden's different areas include the Queen's Garden – a typically Dutch 'green palace' of box and hornbeam – and the *berceau*, a network of arbours and pathways closer to the

house. The Lower Garden is a pattern of eight *parterres de broderie* divided by gravel paths and fountains, while beyond an avenue of trees the Upper Garden comprises *parterres anglaises* of swirling grass patterns around an octagonal pool, with a colonnade that forms a visual boundary for the garden. The original Baroque garden was destroyed in the eighteenth century to make an English-inspired landscape, but the garden was fully restored for its three-hundredth anniversary in 1984.

Crispijn de Passe

Spring Garden, from *Hortus Floridus*, 1614–15

Hand-coloured engraving, 19.3 × 29.7 cm / 7½ × 11¾ in
Private collection

The flower beds in the garden depicted in this plate, surrounded by arcades of carpenters' work, each contain a few specimen plants – tulips, peonies, crown imperials, small topiaries – setting a puzzle that provoked much debate among twentieth-century garden historians. Were the specimen plants merely indicative, identifying the type of flower planted in a given bed, rather than attempting a realistic representation of the quantity of planting? Or did the plate give an accurate visual impression of the low density of planting in the early seventeenth century? The illustration is one of the 172 plates depicting garden plants, arranged according to season of flowering, contained in the volume *Hortus floridus*, published in 1614 by Dutch artist and engraver Crispijn de Passe (*c*.1594–1670). Unlike previous florilegia, this work shows the plants growing in soil, rather than as detached specimens. In his book *Mediaeval Gardens* (1924), Sir Frank Crisp used de Passe's illustrations to argue that medieval and Renaissance flower gardens were sparsely planted, and his view was increasingly accepted in the last decades of the century. In the early 1990s the Privy Garden at Hampton Court Palace on the outskirts of London was restored, and the flowers widely spaced in accordance with this theory, making a grand public statement of the aesthetic of sparse planting. Those who had formerly condemned gappy planting suddenly swung around in favour of the new style, which became a major trend in gardening at the end of the century.

Norman Stevens

Levens Hall, 1985

Lithograph, 50.9 × 40.6 cm / 20 × 16 in
Private collection

The stillness and subtle flecked greens of this print of clipped trees in the gardens of Levens Hall in Cumbria, famous as one of the oldest surviving topiary gardens in the world, give the plants the appearance of characters on a stage behind borders of bedding plants. The 4-hectare (10-acre) walled garden contains ancient yews box-cut into abstract or geometric shapes; its other features include gigantic beech hedges, impressive herbaceous borders and the first recorded ha-ha built in England. The garden's main claim to fame, however, is somewhat suspect. It was created around 1700 by Guillaume Beaumont, but late eighteenth-century visitors made no mention of topiary. It is possible that original topiary had become overgrown and shapeless, and was pruned back into shape in the early nineteenth century; it is also possible that the clipping of the trees was a nineteenth-century innovation. In 1849, in his *Mansions of England in the Olden Times*, Joseph Nash published an illustration of the topiary at Levens Hall as he imagined it to have been, and it has been argued that the topiary garden as we know it was modelled on that illustration. Whatever its genuine antiquity, the topiary at Levens was widely imitated in the late nineteenth and twentieth centuries. Printmaker Norman Stevens (1937–1988) studied art at Bradford Regional College of Art and the Royal College of Art in London, and later became a teacher at the Manchester College of Art, becoming best known for prints such as this depicting views in English gardens.

Vaughn Sills

Pearl Fryar's Garden, Bishopville, South Carolina, 2002

Archival pigment print, 39 × 50 cm / 15½ × 19½ in
Smithsonian American Art Museum, Washington DC

Clay pots placed high in the air on top of carefully trimmed branches instantly suggest that this is no typical garden. Captured here by American photographer Vaughn Sills (b. 1946), Pearl Fryar's Topiary Garden in Bishopville, South Carolina, is an ode to positive thinking, hard work and perseverance. Despite having no horticultural experience, Pearl Fryar created a 1.2-hectare (3-acre) topiary garden from scratch. He saw his first topiary shrubs on a visit to the local nursery and, despite warnings from the nursery owner about

the hard work required to maintain such plants, he took home some pompom junipers he rescued from the nursery's compost heap, bought some electric clippers and started his garden in a cleared cornfield near his home. Today, the garden contains more than 150 topiaries, each with its own unique design, combining simple, formulaic designs typical of the more formal topiary tradition with abstract, organic shapes achieved by grafting and trimming such shrubs as camellia, juniper, holly and cypress. For much of his career, Fryar worked twelve-hour

shifts in a factory while gardening into the night. His designs were frequently ambitious and based on a long-term intuition of the shape within the plant: the so-called Fishbone Tree, for example, took seven years of careful shaping to achieve the shape he desired. Fryar does not use chemicals or water the garden, rather mulching with pine needles to retain the moisture in the soil. After his retirement, he spent more time in the garden, welcoming visitors with the large message picked out on his lawn in red begonias: 'Love Peace + Goodwill'.

Boulton & Paul

Advertisement for park and garden furniture and equipment, 1875

Printed paper, 50.7 × 38.6 cm / 20 × 15¼ in
Garden Museum, London

Benches, lounge seats and chairs sit at the heart of leisured enjoyment in the garden. In the sweep of garden history, the sedentary has been a close companion of the ambulatory, with seating and walks inextricably linked to landscape design. Frequently positioned at key viewpoints, under the shade of garden structures, in the vicinity of recreational features such as sports greens, or as portable accessories, seating has varied in design from formal to rustic. Especially during the nineteenth century, manufacturers sought to provide for all

contingencies with a bewildering array of shapes and sizes. Having antecedents dating back to 1797 and a notable later history manufacturing aircraft for both world wars, Boulton & Paul sat firmly in the garden scene of mid-Victorian Britain, as this advertisement from 1875 suggests. The previous year, William Staples Boulton (1820–1879) had acquired a lease on a factory and taken on a younger partner, his former iron-mongery apprentice Joseph John Dawson Paul (1841–1932), to create a specialized firm of horticultural builders. Based in

Norwich in the eastern English county of Norfolk, Boulton & Paul were among the most prolific contemporary manufacturers of horticultural buildings and associated accessories. Prefabricated buildings were another popular line in an era when there was a growing middle-class market for inexpensive hothouses and conservatories. Products were marketed by increasingly elaborate catalogues and point-of-sale posters, which in this case detailed myriad options, from faux bamboo slats to cast iron painted in imitation of birch.

Guy Lipscombe

A Garden in Summer, 1930

Oil on board, 23.7 × 22 cm / 9¼ × 8¾ in
Garden Museum, London

The shadows cast on the red-brick patio by the Lutyens bench, the deckchair and the small table holding a pitcher and glass are suggestive of the soporific light of late afternoon. This garden landscape by British artist Guy Lipscombe (1881–1952) – much better known as an illustrator for automotive periodicals, such as *The Motor* – has the feeling of a scene vacated by actors who might return at any moment to resume some entertainment on the lawn. The viewpoint, looking out from a domestic room on to a patio with a rose arch and beyond towards the outdoor tented 'room', offers a rather playful reverie on the nature of interior and exterior space. The idea of a garden of 'rooms' connected by paths, such as can be glimpsed beyond the archway, as well as the appearance of the iconic bench designed by the renowned Arts and Crafts architect Edwin Lutyens, might suggest links between this garden and Vita Sackville-West's Sissinghurst (see p.80). Lutyens was a good friend of the writer and gardener Sackville-West, and his traditionally minded Arts and Crafts architectural approaches cast their own long shadow over British gardening throughout the twentieth century. It is the gardens of another frequent Lutyens collaborator that are most forcibly suggested by Lipscombe's painting. Its densely planted herbaceous beds (anathema to Sackville-West), glowing with flowers and the painting's broken brush-strokes, instead channel the 'impressionistic' approaches of horticulturist Gertrude Jekyll (see p.61).

British Broadcasting Corporation *The Flower Pot Men, c.1952* Television still, dimensions variable

The antics of Bill and Ben, two cheeky puppets, and their flowery friend at the bottom of a suburban garden delighted generations of pre-schoolers in post-war Britain. *The Flower Pot Men* was first broadcast by BBC Television in 1952 as part of its 'Watch with Mother' strand, devised especially for younger children. With their flowerpot bodies, hobnail boots and gardening gloves, Bill and Ben appeared identical, distinguished only by their voices – Bill spoke with a high pitch and Ben in lower tones – and the names painted on

their backs. In each story, the string puppets wait until the human gardener has gone for his dinner before emerging from their flowerpots. They are encouraged by Little Weed, a smiley-faced plant whose shrill call of 'weeeed!' also warns when the gardener is about to return. Typically, after some minor mishap, Little Weed sings a song, asking viewers to identify whether Bill or Ben should take the blame. Each episode was narrated by Maria Bird, who, with her friend Freda Lingstrom, head of children's programmes at the

BBC, created the series and constructed the puppets in their garden workshop. British actor Peter Hawkins provided Bill and Ben's voices and invented their distinctive nonsense language, known as Oddle Poddle, which featured words such as 'flobbadob' and attracted criticism from adults concerned that it would promote immaturity and hinder children's speech development. Although the series amounted to just twenty-six short episodes, it is fondly remembered thanks to being repeated regularly for twenty years.

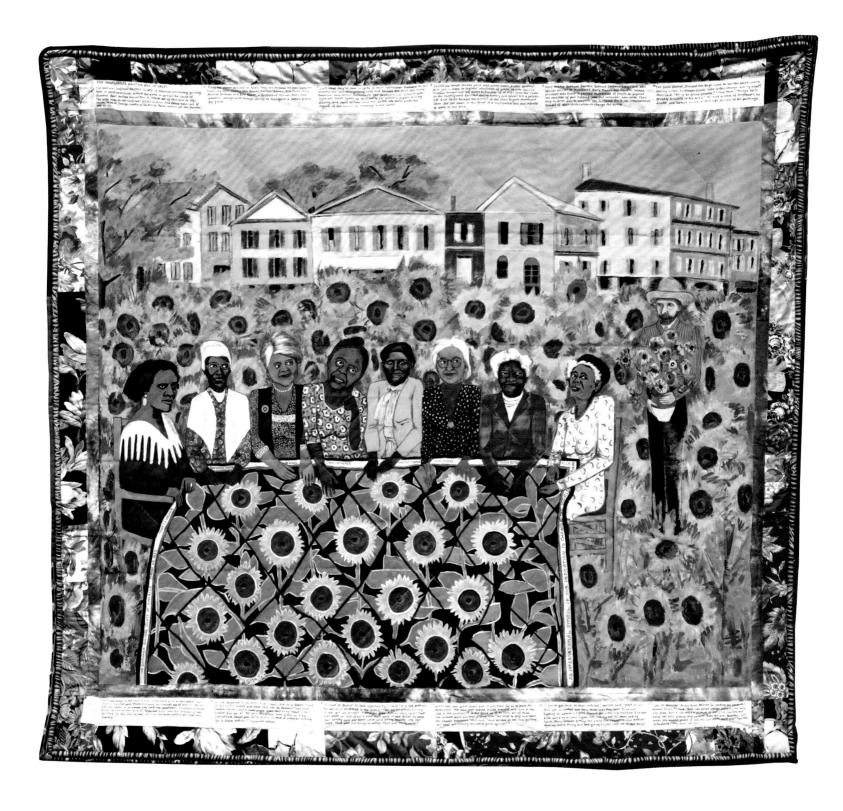

Faith Ringgold

The Sunflower Quilting Bee at Arles:
The French Collection Part I, #4, 1991

Acrylic on canvas, printed and tie-dyed pieced
fabric, ink, 1.9 × 2 m / 6 ft 2 in × 6 ft 8 in
Private collection

Eight women sit in a garden of spectacular sunflowers
in bloom, displaying a large quilt of the same pale yellow
flowers spread between them as they take part in a sewing
'bee'. Created by American painter, sculptor and mixed-media
artist Faith Ringgold (b. 1930), *The Sunflower Quilting Bee
at Arles* is the fourth in her *French Collection* of twelve story
quilts, which uses a mixture of painting, narrative text and
decorative border to feature Black American women who
historically have been omitted from the art world. Here she

depicts the Sunflower Quilters Society of America and a
particular patchwork quilt that was created on 22 March
1922. The influential women are, from left to right, Madam
C.J. Walker, Sojourner Truth, Ida B. Wells, Fannie Lou
Hamer, Harriet Tubman, Rosa Parks, Mary McLeod Bethune
and Ella Walker. In the distance, behind the profusion of
sunflowers, stand the tall, shuttered houses and tree-
lined avenues of Arles, their colours matching the gold,
red and green of the foreground. To the right of the seated

women stands the anxious, bearded figure of Vincent van
Gogh (see p.325), offering them his own vase of sunflow-
ers. Surrounding the scene is a quilted border made up of
fragments of floral fabric and a narrative text by Ringgold's
fictional character Willa Marie Simone, who tells the story
of these extraordinary women, celebrating both the artistry
of quilt-making and the contribution of Black American
women to education, freedom and justice.

**Underground Electric Railways
Company of London**

Golders Green, 1908

Colour lithograph, 100 × 61 cm / 39 × 24 in
London Transport Museum

Golders Green station in north London was opened by the Charing Cross, Euston & Hampstead Railway (now part of the Northern line) on 22 June 1907, and what had been a quiet country crossroads was transformed within a decade into a thriving suburban community. The first new houses were built in the then-fashionable Arts and Crafts style, with spacious gardens that were promoted as one of the chief attractions of the suburbs. This poster by an unknown artist, issued in 1908, was commissioned by Frank Pick,

publicity manager of the London Underground Railways; it was the first of many designed to encourage families to move out of central London to the city's rural fringes. With the station discreetly depicted in the background, this sunny view of Golders Green, marketed as 'a place of delightful prospects', has a picture-book charm celebrating the neatness and order of the ideal suburban garden. Here are closely mown lawns, bordered with stiff standard roses, clean, straight paths and flower beds crammed with

bright bedding plants. A woman enjoys the view from her deckchair while supervising a young child, and a man in his shirtsleeves waters a row of magnificent sunflowers. This is the rural idyll for the commuting middle classes. To emphasize the point, the artist has included lines by the eighteenth-century poet William Cowper suggesting that the suburb is a peaceful sanctuary from the noise and crowds of the city.

Charles Mahoney

The Garden, 1950

Oil on canvas, 1.8 × 1.2 m / 6 × 4 ft
Private collection

A gardener pushes his wheelbarrow down a long, straight path towards an open garden gate, drawing the eye from a foreground featuring precisely depicted giant sunflowers, yellow gloriosa daisies and candy-stripe carnations to the less distinct, more impressionistic grove of trees beyond. British artist Charles Mahoney (1903–1968) presents as quaint and idealized a vision of an English country garden as one might find, yet visual nods to the surrealist works of Giorgio de Chirico – the Palladian brick archway, the

faceless figure – lend it an uncanny air. There is a meta-physical stillness echoing the precision of the early work of Lucian Freud (see p.96) in the pale beach-glass barbs of the carnation leaves and the flecked seeds of the cut sunflower head in the tabletop *memento mori*, surrounded by a bushy corona of Japanese knotweed. The work was created for the famous '60 Paintings for '51' exhibition for the Festival of Britain, a post-World War II showcase of the future of British arts and industry. Mahoney's work, however, carries in its

quiet tension a sense of uncertainty about what the future might hold, at odds with the Festival's optimistic tone of renewal. The garden depicted may have been inspired by the views at Sissinghurst, which Mahoney visited regularly, as well as his own garden at Wrotham in northwest Kent. For the dedicated gardener Mahoney, who along with the artist Evelyn Dunbar (see p.14) had written an illustrated technical handbook, *Gardeners' Choice*, in 1937, his garden was a sanctuary and constant inspiration.

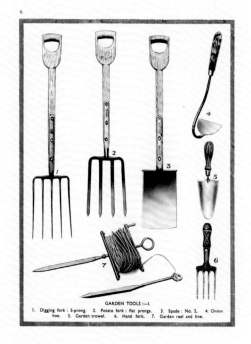

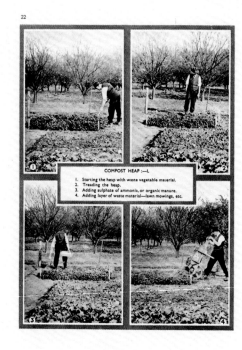

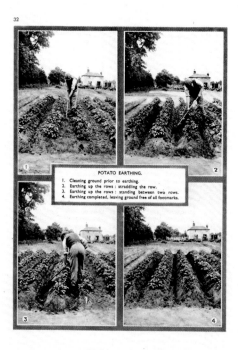

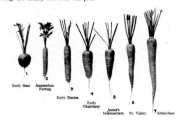

Royal Horticultural Society

The Vegetable Garden Displayed,
third printing, 1942

Printed book, approx. 24.2 × 18.2 cm / 9½ × 7⅛ in
Private collection

In 1938, as the looming threat of war with Germany caused rising alarm in Britain, the Royal Horticultural Society (RHS) in London drew up a plan to encourage domestic food production to avert shortages. A year later, the outbreak of war saw the plan put into action. Leaflets and pamphlets were produced to teach the public how to grow fruit and vegetables, using photographs of gardening activities taken at the Society's garden at Wisley; some of these images were also used in the Ministry of Agriculture's Dig for Victory leaflets (see p.30). The pamphlets sold well: *Simple Vegetable Cooking* sold 24,000 copies in its first few months. In 1941 the RHS issued a larger-scale work, *The Vegetable Garden Displayed*, which became its highest-selling work ever, with eight printings during the course of the conflict. After the war, it was translated into German, as *Frisches Gemüse im Ganzen Jahr*, to help food production in the cities whose market gardens had been destroyed by bombings. The photographs were also used for public display: in every settlement of more than 10,000 people a horticultural committee was created, a specimen allotment laid out, and an exhibition staged showing how to grow food. The exhibitions consisted of boards with text and the now familiar photographs on 'How to Dig' and other subjects. Only one set of these exhibition panels is known to have survived the war. It was rediscovered in 2011 at the Isle of Wight College and returned to the RHS Library for its archives.

Beatrix Potter

Illustration from *The Tale of Peter Rabbit*, 1902

Watercolour and pen and ink over pencil
on paper, 14.4 × 10.5 cm / 5⅝ × 4⅛ in
Private collection

In literature and the arts, gardens are often enchanted places – backdrops for romantic rendezvous and fairy sightings. The story is rather different in the case of Peter Rabbit and his siblings Flopsy, Mopsy and Cottontail, created by English writer and illustrator Beatrix Potter (1866–1943). Originally written in 1893 for Noel Moore – the five-year-old son of Potter's former governess Annie Carter Moore – the story went through many rounds of revision before it became one of the best-selling children's books of all time, with some

40 million copies sold. A classic cautionary narrative, *The Tale of Peter Rabbit* is about the temptation of forbidden things and the repercussions of disrespecting parental control. In the story, Peter's disobedience quickly leads him to disregard his mother's warning to stay away from Mr McGregor's vegetable plot. He ends up feasting to the point of sickness and getting a stomachache. What follows is a frantic hide-and-seek chase until Peter finds a way out of the garden, having lost his shoes and jacket. Back home, exhausted, he is confined to bed while

his virtuous siblings get to enjoy dinner. While *The Tale of Peter Rabbit* has enthralled children for more than a century, the damage rabbits cause in vegetable plots is far from enchanting to growers. Rabbits are voracious eaters of new shoots, and their sharp teeth can easily cut through wood. They can damage tender plants as well as young trees and mature shrubs, and entirely compromise lettuce and broccoli harvests. In the United Kingdom alone, rabbits cause damage worth an estimated £115 million to crops every year.

Jack Burnley and Jerry Robinson for DC Comics

Victory Garden, World's Finest Comics,
No. 11, 1943

Printed paper, 25.4 × 19.7 cm / 10 × 7¾ in
Private collection

Superman clutches a basket brimming with produce while Batman and Robin take a brief break from the tiring work of harvesting vegetables in their wartime garden. This inspirational scene, illustrated by Jack Burnley (1911–2006) and Jerry Robinson (1922–2011), graced the cover of the Fall 1943 issue of American comic-book series World's Finest Comics, published by DC Comics from 1941 to 1986. It was intended to inspire young readers to get involved in the United States government's national drive for citizen food production during World War II. People on the home front were encouraged to plant vegetable, fruit and herb gardens in order to ease the pressure on domestic food supplies and allow produce to be shipped to soldiers, Marines and airmen fighting overseas. Known as victory gardens, they helped to boost morale as well as lower the price of vegetables needed by the US War Department. By using all-American superheroes to promote the cause, DC Comics helped to portray the creation of victory gardens as a patriotic duty.

At the time, 54 per cent of Americans polled claimed they were also primarily motivated by the economic benefits of cultivating their own food at home. By the time Superman, Batman and Robin the Boy Wonder were showing fans how it was done with their bumper crop, there were 18 million victory gardens in the United States – 12 million in urban areas and 6 million on farms – responsible for producing around one third of the nation's fruit and vegetables.

Corry & Co.

Corry's Slug Death, 1970s

Metal, 9.5 × 9.1 cm / 3¾ × 3½ in
Garden Museum, London

'One taste and they are dead' reads the bold claim emblazoned across this bright yellow tin of Corry's Slug Death, a 'magic' slug and snail pesticide that promised to rid gardens of unwanted molluscs. The eye-catching label would have grabbed the attention of any exasperated gardener who discovered the slimy pests munching and shredding their prize plants and vegetables. Some swear by beer traps, while others insist on hand-picking slugs into containers, but many just want the destructive creatures gone for good. Corry's tapped into this desire, and the hyperbolic claims of its labels and advertising campaigns had some merit thanks to the product's original active ingredient of metaldehyde, a highly toxic chemical with no antidote, which not only terminates slugs and snails, but can also seriously harm birds, humans and other mammals if ingested. Certainly, nothing like it had ever before been discovered, but since April 2022 it has been illegal to sell and use metaldehyde products in the United Kingdom. The original Corry's Slug Death formula was developed in the nineteenth century by William Longman Corry, the head of Corry & Co., the largest manufacturer and supplier of agricultural and horticultural equipment in Britain. The company still produces pesticides, and its newest generation of slug and snail killer replaces the banned chemical with sodium ferric EDTA, which, although not as 'miraculous' as its predecessor, poses less risk to other wildlife.

FLOWER-SELLERS IN THE MARKET AT WASHINGTON, D. C.—[DRAWN BY A. L. JACKSON.]

A.L. Jackson

Flower-Sellers in the Market at Washington DC,
from *Harper's Weekly*, vol. 14, no. 701, 1870

Engraving, sheet 40.6 × 28 cm / 16 × 11 in
Lincoln Financial Foundation Collection, Allen County
Public Library, Fort Wayne, Indiana

During the late nineteenth century the intersection of Seventh Street and Pennsylvania Avenue in the heart of Washington DC was home to the biggest markets in the United States. The location was designated as a site for a marketplace by George Washington in 1797 and opened for business four years later. The market's success – it numbered roughly seven hundred sellers by 1870 – led to a rapid expansion, with many additional buildings and vendors joining Center Market in the decades that followed. Crowded and chaotic, the market sold a wide range of fruit, vegetables, flowers and meat. Enslaved Black people were also sold there until the slave trade was abolished in Washington DC in 1850. Thereafter, the market began to provide Black Americans, many of whom had previously been enslaved, some of the only available opportunities to own stalls and start their own businesses. This image, originally published in *Harper's Weekly* in 1870, shows a group of Black women selling cut and potted flowers they grew on their rural plots outside the city. The unassigned curbside areas of the market could be occupied by merchants free of charge so long as they showed up in time to claim their spot very early in the morning, or sometimes even in the middle of the night, depending on the season. With their baskets bursting with blooms, the famed Flower Farmers marked the arrival of spring.

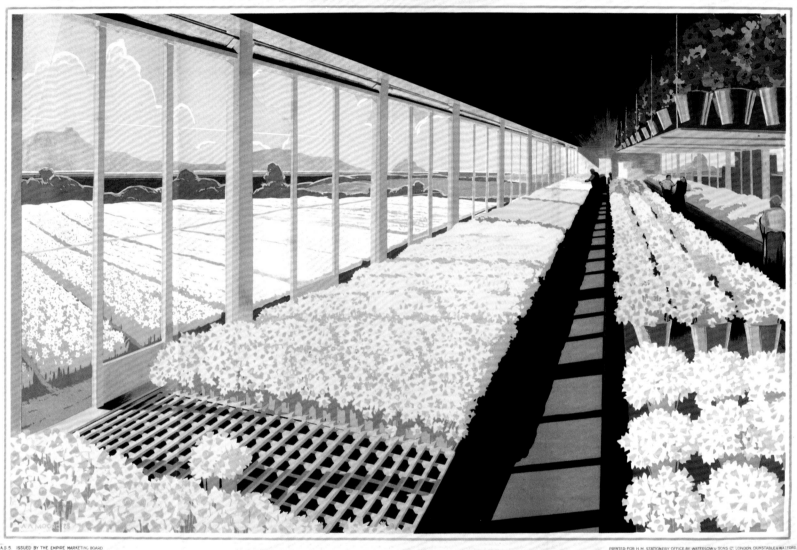

A. A. Moore

Home Bulbs for Home Gardens, 1928

Lithograph on paper, 1 × 1.5 m / 3 ft 3 in × 5 ft
Manchester Art Gallery, UK

Vibrant daffodils and tulips crowd a greenhouse and the fields outside in this colourful poster by artist A. A. Moore (active *c*.1926–1934) issued by the UK Empire Marketing Board in the 1930s. Formed in May 1926, the Board's mission was to promote intra-Empire trade, and its 'Home Bulbs for Home Gardens' poster series showcases flowers ready for shipping to international markets. This part of the campaign was aimed at one particular trade rival: the Netherlands, which had been the main source of British flower bulbs for more than two hundred years. As commercial flower growing expanded in Britain in the early 1930s, people argued that the £1.5 million then spent on foreign bulbs could be saved by developing a home industry. The Ministry for Agriculture issued a bulletin to encourage British bulb production, ranging from true bulbs, such as daffodils and tulips, to other 'bulbs', including gladioli – which actually come from corms – and giving practical advice for large-scale growing. Since the nineteenth century, potted plants and cut flowers have been produced on a mass scale, grown in extensive monocrop fields or large greenhouses. Britain's daffodil trade, for example, is said to have begun in 1875, when a potato farmer on one of the Isles of Scilly realized that semi-wild narcissi from his farm would arrive in London in just two days, still in bloom, thanks to the rail network. That realization prompted the growth of an industry that still thrives in southern England, although in market gardening everywhere the workforce is often underpaid, workers' rights are almost non-existent and the mass production of plants and flowers can harm local ecology.

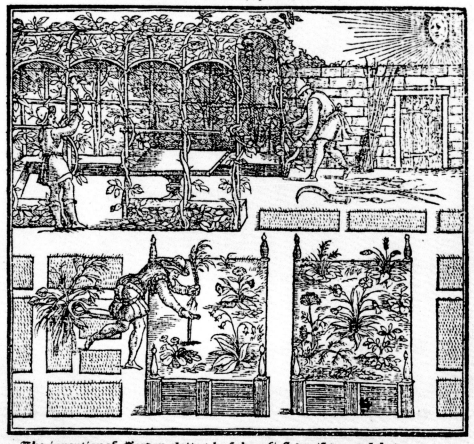

The Gardeners Labyrinth.

Contayning the manifolde trauayles, great cares, and diligence,
to be yearly bestowed in euery earth, for the vse of a Garden:
With the later inuentions, and rare secretes therevnto ad=
ded (as the like) not heretofore publisshed.

The inuention of Garden plottes, by whom first deuised, and what
commoditie founde by them, in time past. Chap. I.

He worthie Plinie (in his xix.booke) reporteth, that a
Garden plotte in the Auncient time at Rome, was
none other, than a smal & simple inclosure of ground,
whiche through the labour and diligence of the hus-
bandmã, yeelded a commoditie and yearely reuenew
vnto him . But after yeares(that man moze estee=
med

Thomas Hill

Page from *The Gardeners Labyrinth*, 1577

Woodblock print, approx. 18 × 13 cm / 7 × 5⅛ in
Private collection

There are few gardening books so charming as *The Gardeners Labyrinth*, written by English gardener Thomas Hill (c.1528–c.1574) and first published in 1577. Using the pseudonym 'Dydymus Mountaine' – Dydymus (sometimes rendered as Didymus) being Greek for a twin or double, and Mountaine a play on the surname Hill – the author melded practical experience with extensive reliance on a canon of Greek and Roman authors. The book was published posthumously, completed by Oxford-educated Henry Dethick, who apologized in his dedicatory epistle for the occasional 'vulgare stile' of Hill's unaffected text. Numerous excellent woodblock illustrations provide engaging garden views, and this opening illustration is a composite printing of two blocks, reproduced separately elsewhere in the book. The upper scene shows a 'herber', or arbour, framed with juniper poles and willow osiers forming arches for climbers, melons or cucumbers, offering shade and respite from hot days to 'walkers and sitters there under'; Hill also recommended musk and damask roses. The lower portion of the image shows 'bordures' – raised beds formed by boards, giving rise to the term 'garden border' – in which herbs might be grown. The second part of Hill's book treats 'Hearbs, delectable floures, pleasant fruites and fyne rootes', resembling a herbal more than the horticultural emphasis of the first part. Among the earliest British garden books, *The Gardeners Labyrinth* provides in both its text and illustrations compelling evidence for the design, planting and maintenance of Elizabethan gardens, and the many editions attest to its contemporary popularity.

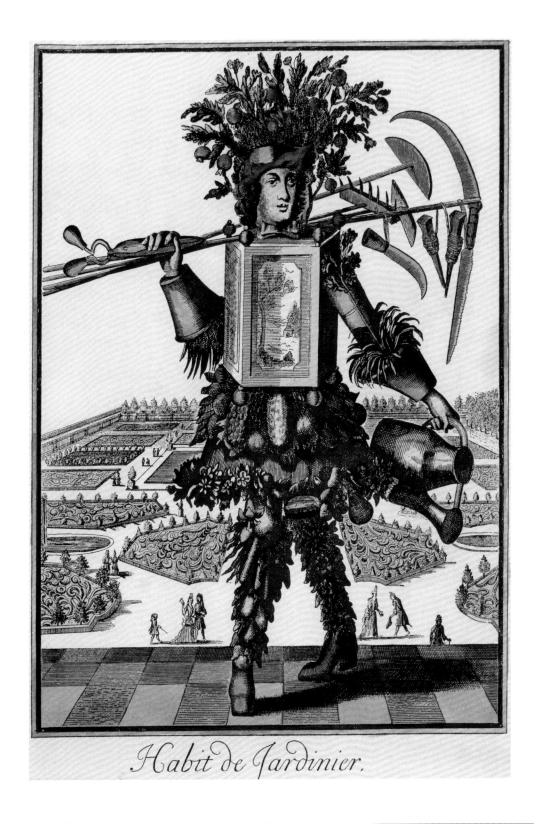

Habit de Jardinier

Anonymous

Habit de Jardinier, 17th century

Hand-coloured engraving, 27.9 × 18.5 cm / 11 × 7¼ in
Garden Museum, London

A gardener steps forward on a tiled patio against a background of a parterre garden where people stroll along paths around formal planted beds and ornamental ponds. He is carrying the tools of his trade: in his right hand he clutches a scythe, rake, shears, hoe and pruning knife, and in his left hand a sturdy watering can … but this is no ordinary gardener. In surreal fashion, his limbs and clothing sprout a glorious mix of flowers, vegetables, fruit and other plants, while his torso is contained within a hexagonal planter decorated with Chinese-inspired scenes. Thus, he carries not only the tools of his trade, but also the results of his labours. The gardener's head comically appears from the planter, topped by a crown of spreading flowers, leaves and pomegranate fruit. His hands emerge from flowerpots that sprout leaves and flowers, while various fruit and flowers dangle from his skirt. This charming and fanciful figure is based on a print by the French engraver and printmaker Nicolas de Larmessin II, from a series of ninety-seven similarly surreal engravings entitled *Les Costumes Grotesques et les Metiers* (*Fancy Trade Costumes*), first published around 1695. This style of incorporating plants and fruit into a portrait recalls the work of famous sixteenth-century Italian 'vegetable artist' Giuseppe Arcimboldo, who perhaps inspired Larmessin.

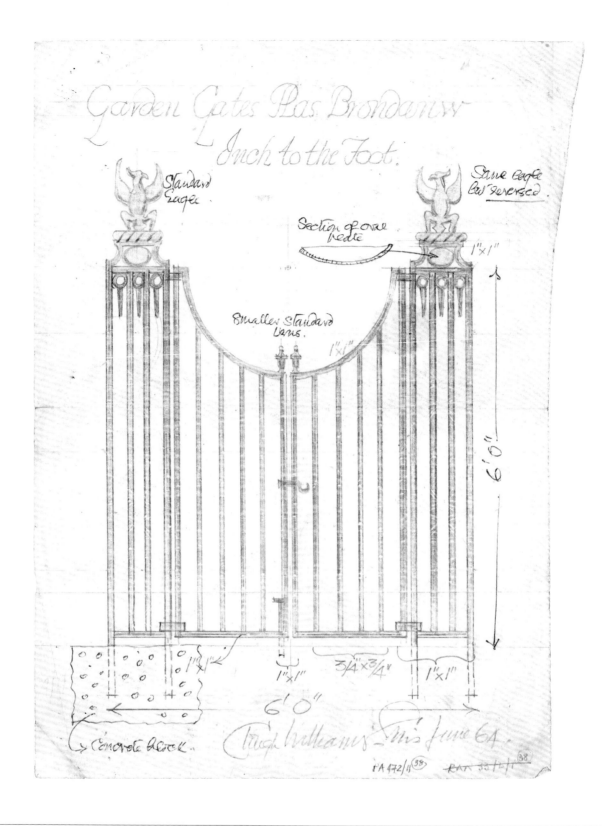

Clough Williams-Ellis

Designs for Plas Brondanw, Llanfrothen, Gwynedd: Elevation of Garden Gates with Heraldic Eagles, 1964

Pencil and ink on paper, 29.5 × 23 cm / 11⅝ × 9 in
British Architectural Library, London

Best known for the fantastical Italianate village of Portmeirion in north Wales, Welsh architect Sir Clough Williams-Ellis (1883–1978) inherited his father's house, Plas Brondanw, in 1908. That began his lifelong love affair with the house and the gardens, which Williams-Ellis extensively restored and redesigned. This plan shows his design for the gates, complete with heraldic eagles, that were incorporated into the new garden, made from fine columns of iron so as not to interrupt the view out into the countryside. Located inside

Snowdonia National Park in north Wales, Plas Brondanw is surrounded by mountains, and to maximize the views from different points in the garden, Williams-Ellis divided the garden into a series of rooms, in some of which he placed sculptures and architectural salvage objects. The gardens of Renaissance Italy inspired his use of water features, such as fountains and pools, low stone walls and avenues of trees that directed the viewer's attention to the borrowed landscape beyond the garden. Williams-Ellis's intention was

to maximize the dramatic views of the mountains and even the sea, which could be seen from the folly tower he built at the end of the woodland to celebrate his marriage in 1915. As a result, he did not fill the garden with colourful flower beds or borders. Instead, in a reflection of his architectural training, the garden's structure was provided by topiary, clipped hedges and trees, including a two-hundred-year-old evergreen oak (*Quercus ilex*), meaning that the garden changes little throughout the year.

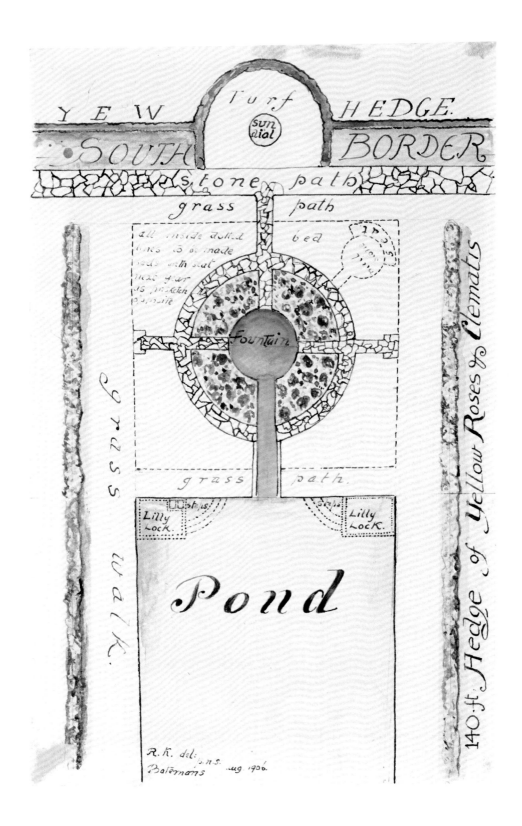

Rudyard Kipling

A Plan of the Rose Garden, 1906

Watercolour, 25.4 × 16.6 cm / 10 × 6½ in
Bateman's, East Sussex, National Trust Collections, UK

While he is widely known as a poet, novelist and journalist – as well as the first English writer to receive the Nobel Prize in Literature, in 1907 – Rudyard Kipling (1865–1936) was also an enthusiastic gardener. Beginning in 1902, Kipling, with his wife, Carrie, lived at Bateman's, a Jacobean manor and estate occupying 120 hectares (300 acres) of East Sussex countryside, near the village of Burwash. The couple enjoyed the seventeenth-century house, but the surrounding gardens needed improvements to become the idyllic retreat

Kipling envisioned. He created an orchard, divided spaces with yew hedges and established a kitchen garden. Here, his watercolour plan details the design for the rose garden and lily pond. A circular rose bed is surrounded by a square floral arena. The rose beds are cut neatly into quarters by three stone paths that radiate from a central fountain, and by a water channel leading to a rectangular lily pond. Floral bushes in yellow and green are roughly sketched. Two parallel borders enclose the garden, one of them labelled

'140 ft [42 m] hedge of yellow roses and clematis'. Between the elements of Kipling's design are stone pavements and wide grassy walks; a sundial with a semicircular enclosure intersects a yew hedge that marks the south border. The pond features 'Lilly locks' in the corners, with steps down to the water. Bateman's is now owned by the National Trust and the gardens and pond can be enjoyed by visitors, along with the beautiful manor house, full of Kipling memorabilia.

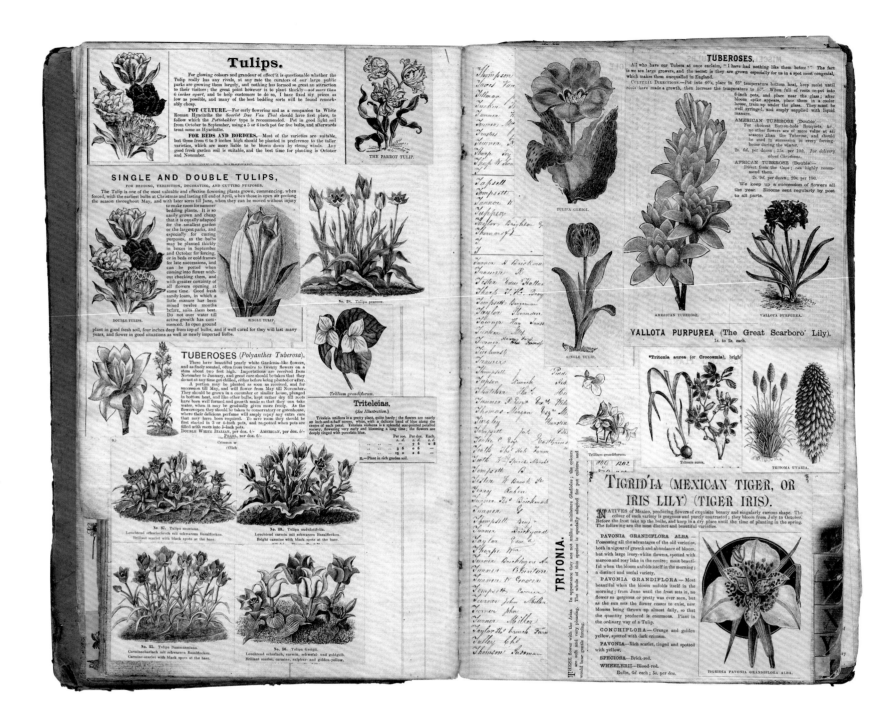

Elphick & Son Ltd

Pages from *Illustrations of Bulbs,
Flowers, Roots Etc.*, 1880–90

Scrapbook, 37 × 48 cm / 14½ × 19 in
Garden Museum, London

When gardeners can't garden, they turn to seed and nursery catalogues, ogling pages of plants they'll grow in the coming season. While such promotional literature serves a utilitarian purpose to advertise goods, catalogues are often visually stunning, incorporating eye-catching graphics, as well as being important historical documents. Elphick & Son Ltd of Lewes, England produced hundreds of such catalogues during its years of operation, from 1823 to 2003. Founded by merchant and entrepreneur George Elphick, the family-run business became one of the most prominent suppliers of agricultural and gardening equipment, plants and seeds, later known primarily as 'seedsmen'. Before the firm started to print its own distinctive, colourful catalogues, Elphick produced handmade scrapbooks filled with illustrations of the plants and other items it sold. *Illustrations of Bulbs, Flowers, Roots Etc.* was used from 1880 to 1890 and contained drawings and prints cut from other seed catalogues. Each page is a beautiful collage of images and growing information. Organized in alphabetical order by plants' common names, it was an encyclopedic reference for both customers and staff, who relied on it as a resource for their later printed catalogues. Here we see the book open at T, showing tulips, trilliums and tuberoses. Revealing much about botany and evolving horticultural trends, the scrapbook also records invaluable historical information about the business of gardening. Repurposed from a ledger listing customer orders, on top of which the cut-out images were pasted, it is a significant archival document.

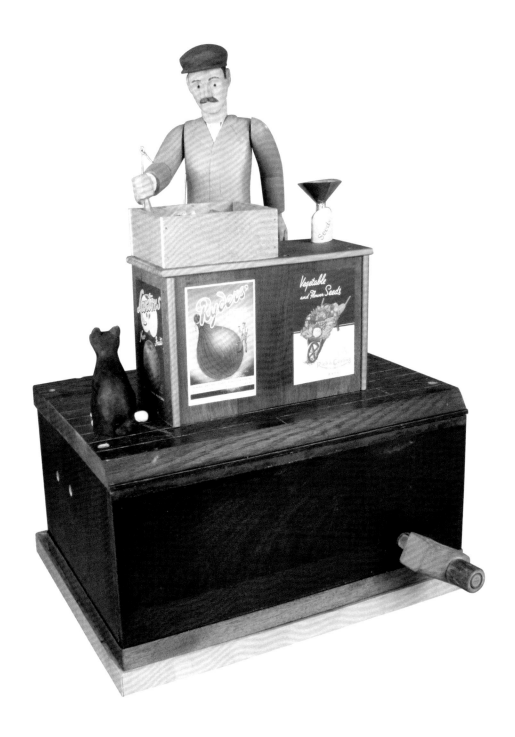

Robert Race

The Seed Man, 2017

Mixed media, 57 × 36 × 30 cm / 22¼ × 14 × 11¾ in
Garden Museum, London

The Seed Man in this automaton by British toymaker Robert Race (b. 1943) holds out his roughly carved hand to scoop seeds from a coarse wooden box across his counter to a metal funnel, filling a customer's paper bag. The mechanisms that move the shopkeeper's limbs – as well as wagging the tail of the cat next to his counter – when the customer turns the handle at the front of the box are largely concealed underneath the dark-grained wooden floor. Covered, yet not obscured entirely, as the work is designed to be inspected in the round. Race's works, which are often created from found objects and driftwood, do not feign the complexity of the watchmaker, but revel in their ability to produce an enchanting kinetic display from simple means – here a series of levers, wire and cogs as brightly painted as the shopkeeper's jolly yellow coat. This moving sculpture was commissioned by London's Garden Museum to commemorate the history of the commercial sale of seeds for gardening, which began with such private merchants weighing out seeds by hand into paper bags. The posters that adorn the Seed Man's stall are miniaturized versions of actual vintage catalogues held in the Museum's collections – and they unwittingly tell the story of the seed man's eventual demise. Ryders were pioneers of the mail-order penny seed-packet trade that would usurp the role of over-the-counter sellers from the 1890s onwards. The profits from the company's successful trade were eventually used by founder Samuel Ryder to support another of his great passions, golf, establishing the Ryder Cup.

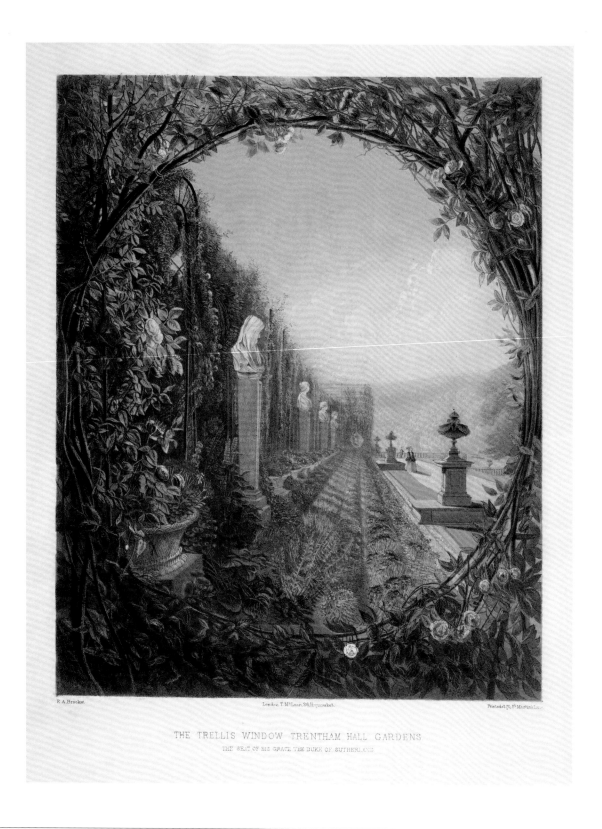

THE TRELLIS WINDOW TRENTHAM HALL GARDENS
THE SEAT OF HIS GRACE THE DUKE OF SUTHERLAND

Edward Adveno Brooke

The Trellis Window, Trentham Hall Gardens,
from *The Gardens of England*, 1858

Coloured lithograph, 54 × 38 cm / 21¼ × 15 in
Smithsonian Libraries and Archives, Washington DC

The frontispiece of *The Gardens of England*, first published in 1857, depicts the beautiful garden of Trentham Hall, laid out in the Italianate style, seen through an oval trellis 'window' formed from rose-covered branches. The lush foliage and flowers in the foreground contrast with the classical restraint of the formal gardens beyond. To the left, immediately behind the trellis, is a large urn containing more roses and geraniums. Flowers resembling foxgloves give way to a receding border of red, blue and yellow blooms.

The sloping bank of flowers is accompanied by a stately row of columns, each topped with a neoclassical figure. A lady with a blue dress and parasol walks along the parterre in the middle distance, while a distant male figure leans on the balustrade to admire the wooded park beyond. *The Gardens of England* is a series of twenty-four plates and accompanying text by English painter Edward Adveno Brooke (1821–1910), 'an attempt to realize a fair pictorial epitome of the horticultural beauties our country contains'. Despite the apparently

stylized nature of this image, Brooke's paintings were said to be faithful to the original gardens. Trentham Hall, on the banks of the River Trent in Staffordshire, was the seat of the Duke of Sutherland. The gardens were landscaped as a serpentine park by Lancelot 'Capability' Brown (see p.162) from 1758 onwards, and were laid out in the 1840s by Sir Charles Barry.

Clive Nichols

Pettifers, Oxfordshire: Dawn Light Hits the Parterre Framed by Rose Arbour, c.2015

Photograph, dimensions variable

From the bright, tumbling pink and red roses that form an arch in the foreground, over a broad stone step, a grassy path descends and winds into the distance. The walk is bordered by fine grasses and meanders between neat, softly rounded hedges and abrupt, pillar-shaped topiary, towards the hilly distance. The scene is suffused with the pinkish-gold light of dawn, captured in the fleeting moments just as the sun rises over Pettifers, an English garden in the north Oxfordshire village of Wardington.

Since 1984 the garden's owner, Gina Price, developed the small but beautiful landscape, and opened the garden to visitors by appointment. Captured by British garden photographer Clive Nichols (b. 1962), the view, framed by the rose arbour, looks down over the parterre, which is famed for its borders. The abundance of flowers and grasses here is designed for all seasons, offering a changing tapestry of plants. For more than thirty years, Nichols has travelled the globe to take photographs of the world's most beautiful

gardens, often privately owned, but Pettifers, one of his favourite subjects, is right on his doorstep. Attentive to the structure and atmosphere of the garden, Nichols has taken numerous shots throughout the year, but dawn is a special time for his photography: 'Sometimes it feels like heaven, literally. In the early morning at Pettifers … it's almost like God is shining a light on it.'

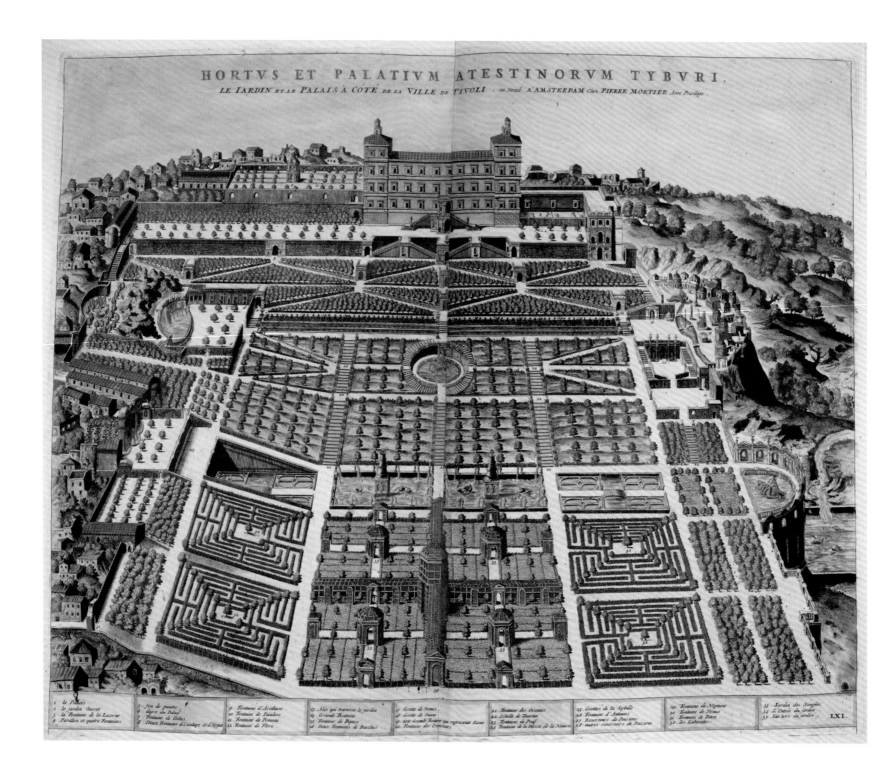

HORTVS ET PALATIVM ATESTINORVM TYBVRI.

LE IARDIN ET LE PALAIS À COTÉ DE LA VILLE DE TIVOLI . se vend À AMSTERDAM Chez PIERRE MORTIER Avec Privilege .

Étienne Dupérac

The Gardens at Villa d'Este, 1560–75

Hand-coloured engraving, approx. 45.5 × 57 cm / 18 × 22½ in
Private collection

The sheer scale and the virtually complete symmetry of the gardens at Villa d'Este, in Tivoli, Italy, are clear from this detailed coloured plan drawn by French architect and engineer Étienne Dupérac (c.1535–1604). Commissioned by Cardinal Ippolito II d'Este from Pirro Ligorio in 1550, the gardens are a prime example of the Italian Renaissance garden style, and influenced garden design across Europe for more than a century. The garden comprised a series of terraces that visitors originally entered from the bottom, so that the view back down over the garden became increasingly spectacular as they ascended. A key feature is the use of water as a design element. Ligorio diverted water from a nearby river to feed some five hundred separate jets in numerous fountains, including the impressive Fountain of Neptune, which stands at the centre of the lower garden, and the Fountain of the Dragons, featuring a series of sculpted dragons spewing water, while the Fountain of the Cascade is crowned by a water organ powered by water pressure to play music. There is also a series of terraced lawns, grottoes and a theatre, while statues remind the visitor of the d'Este family's claim to be descended from the mythical hero Hercules. The gardens were not only a testament to the wealth and power of Cardinal d'Este, but also a reflection of the cultural and intellectual climate of the time. Today, the Gardens at Villa d'Este are a UNESCO World Heritage Site and remain a popular tourist destination.

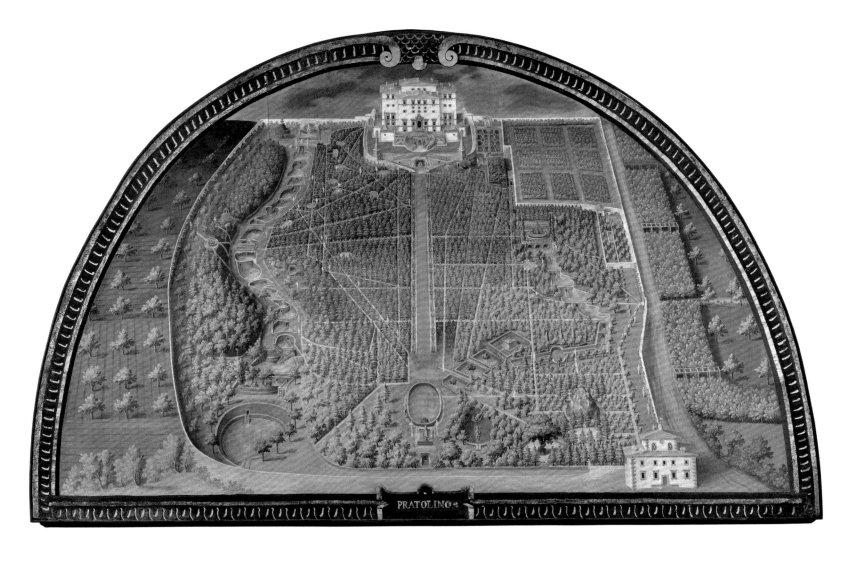

Giusto Utens

The Medici Garden at Pratolino, 1599

Tempera on canvas, 1.45 × 2.49 m / 4 ft 9 in × 8 ft
Museo di Firenze com'era, Italy

At Castello, northwest of Florence and commanding a view over the city, stands the Villa Medicea della Petraia, where the surviving fourteen lunettes by Flemish painter Giusto Utens (d. 1609) hang on the walls. Commissioned by Ferdinando de' Medici, third Duke of Tuscany, and executed between 1599 and 1602 each of the large, brightly coloured paintings offers a highly detailed and generally accurate bird's-eye view of one of the great estates owned by the wealthy ruling Florentine family. Villa Medicea di Pratolino stood at the foot of the

Apennine Mountains and was created by Bernardo Buontalenti for Grand Duke Francesco I de' Medici in 1569. Utens shows only the southern enclosure of the *barco*, which literally translates as 'hunting park' but by the mid-sixteenth century had come to mean a rural pleasure park juxtaposed to a villa. With its themes of nature and art, water and love, the pastoral park at Pratolino was organized around a dominant central axis, but without the formality of a grid pattern and compartments typical of other Medici gardens. Either side of the broad, grassy

avenue was an 'ordered nature' of densely planted woodland, pierced by straight walks and ornamented with glades, monumental rock work, statuary and even a treehouse. Beyond, water – brought to the garden by aqueduct at great expense – fell from columns and grottoes and in cascades between two series of meanderingly arranged and informally shaped ponds. Today, nothing survives of Pratolino: the villa was demolished in 1821 and the grounds, remodelled in the English Landscape style, today comprise part of the Villa Demidoff.

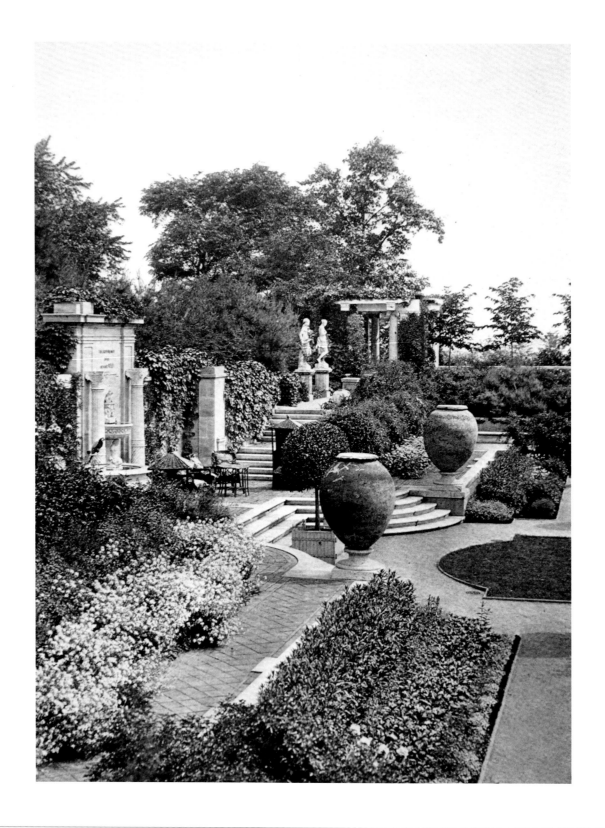

Charles Platt

Weld, Larz Anderson Residence, Brookline, Massachusetts, 1901

Photograph, dimensions variable

What might appear to be a formal European garden with various classical ruins, including pillars with Ionic columns, large urns and sculptures, is actually in Brookline, Massachusetts. Its resemblance to a European garden, however, is deliberate. American architect Charles Platt (1861–1933) was inspired to take up landscape architecture after visiting Italy in 1892 to study Renaissance gardens, which he later recorded in his book *Italian Gardens* (1894), helping to inspire the Beaux Arts style of garden in North

America. Originally a self-taught architect, Platt began to incorporate the features of Italian gardens when he constructed houses for his neighbours in the artists' community in Cornish, New Hampshire. When he received a larger commission to design a garden for Weld, the home of diplomat Larz Anderson and his wife, Isabel – unusually, Platt was not asked to design a house, too – he created one of the first large-scale formal gardens in North America, with a terrace containing a central area of grass flanked by parterres and

carefully clipped topiary balls, and using his characteristic architectonic elements throughout – mainly antique Italian urns and statuary. Beyond the central terrace, other terraces give vistas of the garden from different levels, and there are wild gardens, a flower garden and an allée, as well as a bowling green and a polo field. The garden was hidden from the road by a wall, but in a deliberately democratic gesture, Platt included a wrought-iron screen that allowed passersby to share the gardens he had created.

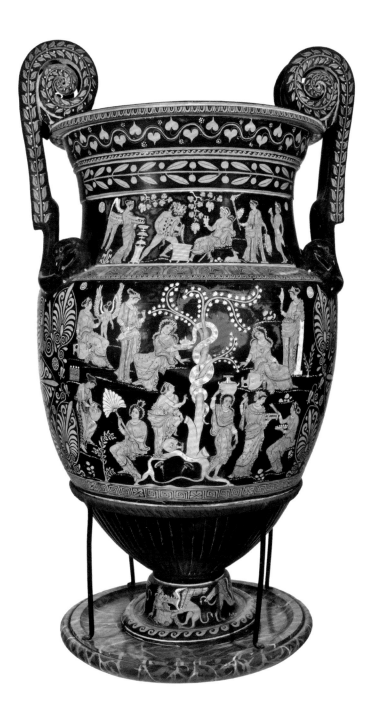

Lycurgus Painter (attrib.)

Krater showing the Garden
of the Hesperides, c.360 BC

Red-figure painted terracotta, H. 1.1 m / 3 ft 8 in
Museo Archeologico Nazionale Jatta, Ruvo di Puglia, Italy

The snake curled around the apple tree at the centre of the design on this red figure krater – used by ancient Greeks to mix water and wine at a social occasion such as a wedding or symposium – might suggest the biblical story of the Garden of Eden, but this is another renowned horticultural location from myth. This is the Garden of the Hesperides – daughters of the goddess Nyx (Night) and the nymphs of the evening – said to lie in the far west of the world, in the shadow of the Atlas Mountains. The Hesperides tended the sacred grove on behalf of its owner, the goddess Hera, who installed the hundred-headed dragon Ladon – the 'snake' on the krater – to guard the apple orchard at its heart. The tree at the centre of the garden bore the renowned golden apples of Greek myth, and grew from a cutting given to Hera at her wedding to Zeus, king of the gods, by Gaia (primordial Earth). It was a golden apple from the garden that was thrown among the guests at the wedding of Peleus and Thetis, inscribed with the words 'For the Fairest'. The dispute about who actually was the fairest led, ultimately, to the Trojan War. In addition, the eleventh labour of Hercules involved stealing apples from the garden of the Hesperides; he had to kill Ladon in order to succeed. Hera's garden is similar to the Greek concept of sacred groves, stands of trees dedicated to particular gods where the human and divine worlds came together.

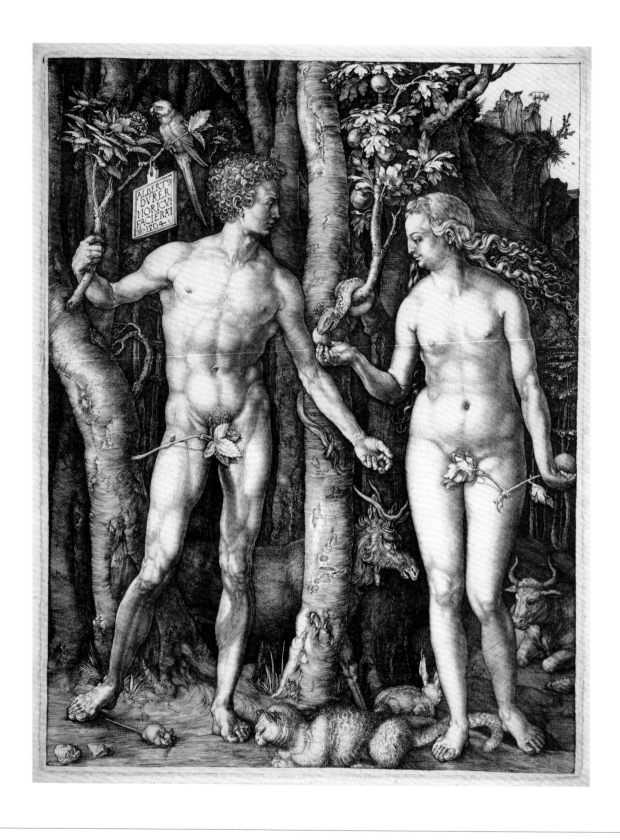

Albrecht Dürer

Adam and Eve, 1504

Engraving, 25.1 × 20 cm / 9⅞ × 7⅞ in
Metropolitan Museum of Art, New York

In one view, all gardeners are simply trying to make their own personal version of paradise, linking their horticultural efforts to the garden in which the Abrahamic religions agree the story of humanity began: the Garden of Eden, described in the Bible as a paradise on Earth. Eden – its name is said to have derived from a Hebrew word for 'pleasure' – embodied an otherworldly harmony in which all animals and plants coexisted peacefully. Accounts described how different types of tree grew from the ground that were pleasing to the eye and good for food, while all creatures spoke the same language and understood each other. In one of the most famous prints by the German Renaissance master Albrecht Dürer (1471–1528), the nudity of Adam and Eve symbolizes their innocence before they are tempted by the serpent to defy God's orders, eat the forbidden fruit from the tree of the knowledge of good and evil at the centre of Eden, and become ashamed of their nakedness. Adam and Eve's fall and expulsion from Eden shattered the garden's harmony, throwing it into a state of constant struggle and discord. Animal species were scattered across the globe and became unable to communicate; the world turned into a place of constant suffering. Throughout the history of gardens in the West, leading botanists took the re-creation of the unity and harmony of the Garden of Eden as the guiding principle behind their plant-hunting, the collecting of tropical specimens that would fill the greenhouses of European botanic gardens.

284

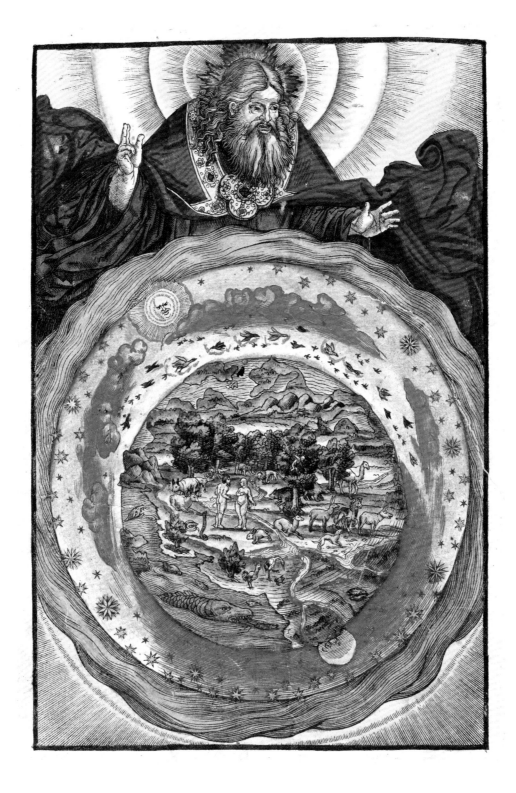

Lucas Cranach the Elder

Creation of the World,
from the Luther Bible, 1534

Woodcut, 29.5 × 19.5 cm / 11⅝ × 7⅝ in
British Library, London

Represented in all its verdant splendour – lush forests, rolling hillsides, implacable mountains, and rivers flowing to the sea – the Garden of Eden brims with life, encircled by a halo of blue skies bursting with birds and emblazoned with stars. As a primal conceptualization of life on Earth, various representations of the Garden of Eden almost always feature a multitude of animal and plant species living together in harmony – a state of universal serenity that Adam and Eve shattered when they ate the forbidden fruit from the Tree of Knowledge. This woodcut is one of the most important plates in the Luther Bible, the first full translation of the Bible into German by priest and theologian Martin Luther, published in 1534. In line with the teachings of the Protestant religion he founded, Luther wished to make the Bible accessible to laypeople who could not read Latin. To that end, he collaborated closely with artist Lucas Cranach the Elder (1472–1553) to create beautiful illustrations of sacred scriptures that enhanced the Christian message. By the late 1520s, Cranach had become one of the best-known artists in the Electorate of Saxony, in present-day Germany. A court painter in high demand, the artist achieved a heightened sense of naturalism and attention to detail that set his work apart from that of his contemporaries.

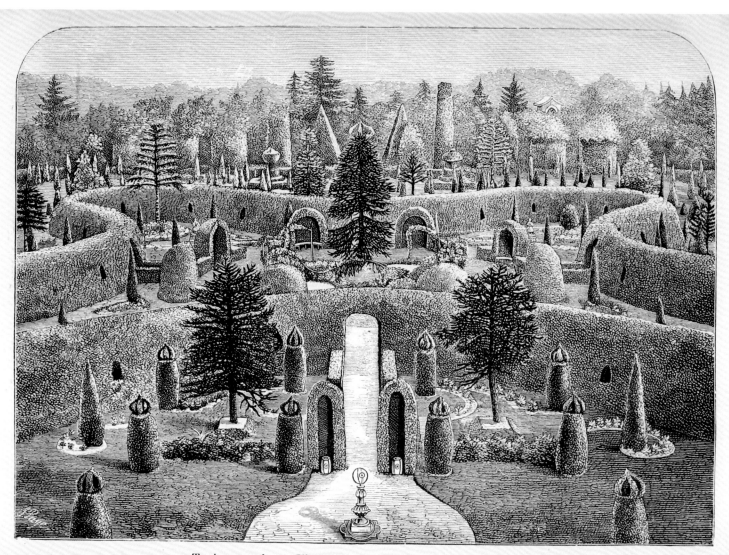

Topiary work at Elvaston Castle The Yew Garden.

Adolphus Henry Kent and James Herbert Veitch

Topiary Work at Elvaston Castle: The Yew Garden, from *Veitch's Manual of the Coniferae*, 1900

Engraving, 16 × 25 cm / 6½ × 10 in
University of Connecticut Libraries, Storrs

An immense hedge of arborvitae, an evergreen conifer of the genus *Thuja*, surrounds a topiary garden, with windows and tunnels cut out to provide glimpses of the monkey puzzle at its centre and out to the formal topiary gardens surrounding it. The Earl of Harrington, for whom the garden was created, was a virtual recluse, and few people visited his gardens at Elvaston Castle in Derbyshire for around twenty years. During that time, however, head gardener William Barron had created a unique formal garden, consisting of a series of garden rooms divided by hedges, each with a different theme or manner of planting. Upon reopening in 1851, the public was treated to the spectacle of hedges 'shorn as smooth as an Axminster carpet', their 'tops cut off as square as if they were pieces of masonry'. After generations in which topiary had been condemned or scorned, the spectacle of Elvaston suddenly restored it to favour, and by the end of the decade carefully trimmed hedges and even topiary garden buildings were appearing around the country. This wood-engraving comes from a treatise on conifers published by the nursery firm of James Veitch and Sons, of Chelsea, the first nursery to send its own plant-hunters to look for new species around the globe. James Herbert Veitch's (1868–1907) *Manual of the Coniferae* went through two editions (1881 and 1900), and was written primarily by the firm's botanist Adolphus Henry Kent (1828–1913). Most of the illustrations depict conifers and details of their anatomy, but Kent also inserted a few pages on the importance of yews in English garden history – culminating in Elvaston.

Martha Schwartz

Splice Garden, 1986

Mixed-media installation
Whitehead Institute, Cambridge, Massachusetts

High above the streets of Cambridge, Massachusetts, this rooftop garden combines elements of French Renaissance gardens and Japanese *karesansui* or Zen gardens in a curious collision of styles. The rocks common to Zen gardens are replaced by topiary pompoms, while box hedges from formal French gardens become geometric abstractions, fabricated in steel and covered in astroturf to form seating. Plastic palms and conifers sit incongruously in the space, some even appearing to defy gravity as they protrude horizontally from the

garden wall. American landscape architect Martha Schwartz (b. 1950) created this hybridized garden for the Whitehead Institute, a biomedical research centre dedicated to improving human health. Wanting her garden to relate to the Institute's work – particularly its research into genetics and genomics – Schwartz found inspiration in the controversial technology of gene splicing, a type of genetic engineering in which genes or sequences of genes are inserted into the chromosomes of another organism. As something of a Frankenstein's monster,

Splice Garden is a warning of the dangers of tampering with the building blocks of life. Before Schwartz got to work, the site was a drab rooftop courtyard, measuring 7.6 by 10.7 metres (25 by 35 ft), atop a nine-storey office building. With no maintenance staff or ready source of water, the introduction of living plants was unfeasible, so Schwartz used artificial materials. Her careful balance of colour and form conveys the sense of a real planted garden, transforming the dull space into a pleasant outdoor area with a serious message.

Ivon Hitchens

Composition, Wildflowers, c.1939

Oil on canvas, 50 × 83 cm / 19¼ × 32¾ in
Private collection

As in most works by the British modern artist Ivon Hitchens (1893–1979), there is a sense in *Composition, Wildflowers* that perception is wavering between the macro and the micro. Foxgloves, dog roses, cow parsley and anemones are at once closely observed and yet also suggestive of large trees looming over sweeping valleys and streams. This symphonic vision, full of trills and crescendos, interprets the natural world as a music of gestural movements from left to right on Hitchens's favoured 'double square' canvases. Hitchens's paintings merged Pierre Bonnard's (see p.10) adoration of nature and insistence on the decorative surface with his close compatriot Ben Nicholson's sinuous sense of underlying form, particularly in the phantom-like sketched outlines of flowers that weave between the more assured brushstrokes. Here there is a further seesawing of perception between object and representation, between orange sunset, glimpsed through the trees, and creamy, unpainted canvas that shows through the brush marks. Hitchens's garden was little more than a half-wild clearing hacked, by him and his wife, Mollie, out of 2.4 hectares (6 acres) of birch trees and rhododendron in the West Sussex countryside. But from the time that he moved his family there, following the destruction of his London studio in the Blitz in 1940, it was both a sanctuary and the principal inspiration for his art for the rest of his life. Like Bonnard, Hitchens successfully negotiated the paradox of living at a remove from modernity yet remaining at the heart of contemporary discourse and developments in painting.

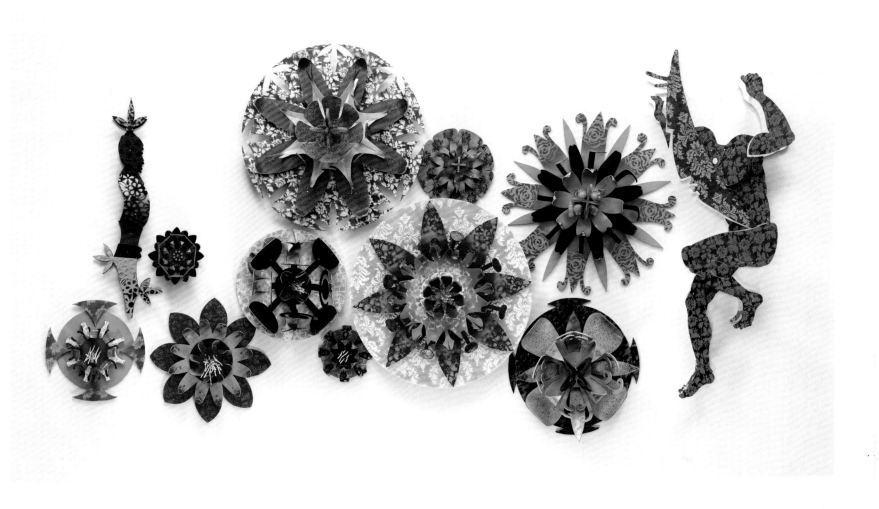

Brian Robinson

Custodian of the Blooms, 2014

Wall installation; synthetic polymer paint on plastic
polypropylene, steel and wood, 3 × 3 m / 9 ft 10 in × 9 ft 10 in
National Gallery of Australia, Canberra

The titular Custodian of the Blooms dances in a traditional Zenadh Kes mask next to sculptural flowers bursting in vibrant hues. The blooms recall the luxuriant growth of hibiscus, frangipani, bougainvillea, coconut, beach almond (*Terminalia catappa*), mango, banana and even the native Wongai (*Manilkara kauki*) fruit of the Torres Strait Islands, which sit in tropical waters in the strait between the north-eastern tip of Australia and the southern coast of Papua New Guinea. The horticultural skills highlighted by this large-scale wall installation are based on an understanding of the four seasons – Kuki (northwest winds), Sager (southeast trade winds), Zey (southerly winds) and Naigai (northerly winds) – as well as the movement of stars, constellations, tidal patterns and animal migration. One of a series of three, the work was created by Cairn-based artist Brian Robinson (b. 1973), who grew up with Maluyligal and Wuthathi heritage on Waiben (Thursday Island). Noted for his bold drawings and linocut prints as well as more recent installations and public artworks, Robinson uses his vivid blooms as part of his ongoing investigation into the cultural narratives and traditional customs of the Torres Strait Islands. The agricultural fertility celebrated in this and other works in the series, the artist notes, 'also entails a respect for inherited ancestral land and knowledge of how to influence rainfall and the growth of plants through actions, words, songs and the use of figures and stones'. The custodian alerts us to the need for vigilance not only to protect and nurture vegetation but also, at a wider level, to safeguard cultural traditions.

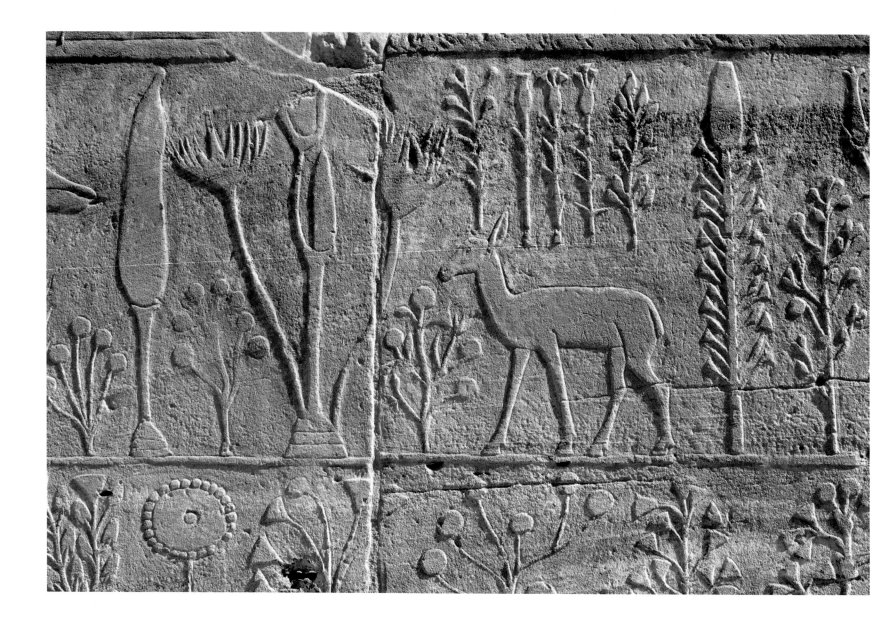

Anonymous

Botanic garden relief (detail),
c.mid-15th century BC

Stone
Temple of Karnak, Luxor, Egypt

The history of the botanic garden begins in ancient Egypt. Medieval and Renaissance gardens were grounded in the plant studies of Aristotle's pupil Theophrastus (fourth century BC), and his work was rooted in the gardens of Egypt and West Asia. Around a millennium earlier, the female pharaoh Hatshepsut had sent an expedition to Punt (present-day Ethiopia/Eritrea) to collect aromatic myrrh and frankincense to offer to the sun god Amun-Re. Her successor, Tuthmosis III (r. c.1479–1425 BC), was a renowned plant collector. In his Festival Temple, within the ancient temple at Karnak, Tuthmosis dedicated a sanctuary to his divine father, Amun-Re (an area now called the Sun Rooms), adorned with sphinxes, lotus-blossom columns and statues; the walls were carved with reliefs, including this one, representing some fifty different plant species and at least twenty-five species of bird and animal, including cattle, goats and gazelles. If the sanctuary was open to the sky, the reliefs may have been matched with living specimens planted in beds before them (although the rooms appear to have been roofed). Not all the plants in this panel can be identified, but the large plant left of centre may be teasel (*Dipsacus*) and those with trumpet-shaped flowers at lower right may be bindweed (*Convolvulus arvensis*). An inscription declares that the plants were brought to Egypt by Tuthmosis following military campaigns in the kingdoms along the eastern coast of the Mediterranean. Tuthmosis was thus able to claim to be a 'gardener king', one whose lush, well-watered gardens were evidence of divine favour and symbolic of his ability to nurture his people.

Anonymous

Mural of Tlalocan, AD 450

Fresco
Palace of Tepantitla, Teotihuacan, Mexico

Painted in an array of colours against a red background, this mural detail from the Mesoamerican complex at Teotihuacan, northeast of Mexico City, depicts what is thought to be Tlalocan, the land of the god of rain, Tlaloc. One of three possible afterlife realms the Aztec believed in, Tlalocan was a paradise of eternal spring and the place from which all rivers originated, rich in fertile soil and home to an array of flora. The mural was rediscovered in 1942 in a residential building on the outskirts of the enormous archaeological site. Within the detailed

paintings, a number of plants have since been identified, including maize – a staple crop, whose Nahuatl name, *theocintli*, means 'food of the gods' – cacao, tiger flower (*Tigridia pavonia*), jimsonweed (*Datura stramonium*), Mexican tarragon (*Tagetes lucida*) and opium poppy (*Papaver somniferum*). Many of these were used as hallucinogens to communicate with the gods and to treat various ailments, suggesting that part of the paradisiacal garden was dedicated to the cultivation of medicinal plants. The concept of a sacred garden was incorporated

in earthly Mesoamerican gardens as well. Paradise-like spaces were created for contemplation of the relationship between nature and humans – where nature always dominated – and for the curing of physical and spiritual ills. Mesoamerican creation stories often included mountains and caves (particularly those with water that were considered entrances to Tlalocan) as the source of life, and it is thought that this may be one reason many pre-Columbian cultures preferred to build their gardens on top of mountains or hills, near natural springs.

Anonymous

Ransomes' Lawn Mowers: The Best in the World, 1893

Printed advertisement
Private collection

Ostensibly an advertisement for Ransomes' lawn mowers, this brightly coloured image of a rural garden in the 1890s provides a far more reliable depiction of upper-middle-class life in the late Victorian age than it does of the rigours of maintaining a perfect lawn suitable for tennis, croquet or other garden pastimes of the period. The only concession to lawn-mowing is the figure of the young girl pushing a small blue handheld machine over the grass – clearly with minimal effort. Lawns first became popular as part of the eighteenth-century English landscape gardening fashion for re-creating pastoral scenery, including grass cropped to resemble the fields outside the garden. Those fields were kept short by cows or sheep, but within the garden, the grass was cut by gardeners with scythes until the 1830s, when the cylinder mower was invented by Edwin Beard Budding. The first mower had a heavy roller and required two gardeners to push or pull it. Through the rest of the nineteenth century the rising popularity of lawns in private gardens went hand in hand with the developing technology of the lawn mower, which grew increasingly light and brought maintaining the perfect sward within reach even of householders who could not afford a gardener – and which coincidentally encouraged the growth of grass-based sports including tennis, cricket and football. By the mid-1870s, lawn mowers were advertised as being light enough for women and girls to use. Around 1900 Ransomes' ironwork company invented the ride-on mowing machine.

Tina Barney

The Goff Family Gardening, 1982

Chromogenic colour print, 1.2 × 1.5 m / 4 × 5 ft
Private collection

Seemingly capturing an expression of the American dream, this image of a happy family working together in the backyard – the child smiling, the lawn neatly trimmed, the dog, the roses in bloom, the sun shining – is perhaps too perfect. The colour palette of the photograph, rich in pink, may indicate a 'rose-tinted glasses' attitude to an unproblematic world of privilege that often predominates in images of suburban living. Throughout her career, American photographer Tina Barney (b. 1945) has addressed and exposed the contradictions of her upper-middle-class upbringing mercilessly and yet tastefully, foregrounding the paradoxes that mark its sometimes uncomfortable essence. Widely acclaimed for her subtly critical portraits of her family and friends, Barney has developed an impressive body of work spanning four decades. She lives in Westerly, Rhode Island, where this photograph was taken. The photographer is well aware that it is in the mundane that the true essence of cultural attitudes can be revealed. Capturing apparently unremarkable domestic moments with a simplicity typical of snapshot photography, Barney's approach often involves a contemporary anthropological dimension. In this context, the garden becomes a virtue-signalling status symbol – a physical symbol of the insulation from society's problems that a certain income level can buy. An oasis inside the oasis, this garden is somewhat predictable, conventional and unadventurous: its layout, the varieties of plant and the topographical flatness all point to a homogenization of taste that ultimately reveals a lack of character and individualism.

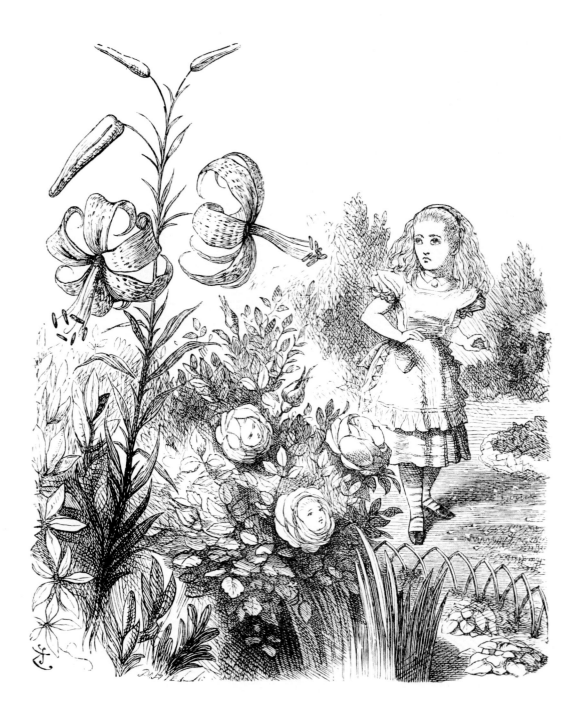

John Tenniel

The Garden of Live Flowers, from *Through the Looking Glass, and What Alice Found There* by Lewis Carroll, 1871

Wood-engraving after graphite drawing, 28.5 × 25 cm / 11¼ × 9¾ in
Private collection

Many gardeners talk to their plants, with some even insisting that conversation encourages growth more than fertilizer. But would we really want the plants to reciprocate? Perhaps not after reading about Alice's surreal garden encounter in Lewis Carroll's *Through the Looking Glass*. This iconic illustration by Sir John Tenniel (1820–1914) depicts Alice's startled surprise the moment a botanically realistic tiger lily (*Lilium lancifolium*) addresses her. By contrast, three rose flowers appear more cartoonish than lifelike, bearing

human faces as they offer impolite conversation full of humorous puns. Tenniel was a well-known satirical artist who brought his characteristic wit to the illustrations in *Alice in Wonderland* (1865) and its sequel, *Through the Looking Glass* (1871). The Dalziel brothers' woodblock-engravings, following Tenniel's graphite drawings, provide bold visuals for Alice's adventures and the odd, outspoken anthropomorphic creatures she meets. While Alice's retorts hint that the garden is wild and untended, the image suggests otherwise.

Neatly fenced, the garden is tidy, with no signs of leaf litter or spent flowers, and the plants look extremely healthy – it is a perfectly cultivated garden. It is also both a secret and a forbidden garden, located in the world beyond a framed mirror. The path leading to the garden tricks and teases Alice, who is determined to reach it no matter the obstacles. Absent in the illustration is the protective willow that anchors the garden, but a quiet clump of violets awaits near the fence, ready to spring to life.

Tim Walker

Inside Outside. Eglingham Hall Bathroom, Eglingham, Northumberland, 2000

Photograph, dimensions variable

Elegant, sword-like leaves of irises emerge from a bathtub surrounded by a meadow, while a passionflower crawls against the wall and ferns spill out of a sink. Depending on how much one loves plants, the scene might be a dream or a nightmare. As the title suggests, *Inside Outside* by internationally renowned photographer Tim Walker (b. 1970) explores the relationship between the wild and the domestic, nature and culture, and the positioning of individuals within the architectural and cultural structures that insist on separating the two. Humans' passion for bringing the outside inside began around 3000 BC, as gardeners in China and Korea started to use terracotta pots to bring plants into their courtyards. For centuries thereafter, potted plants were brought indoors during the cold winter months – and some would thrive better in the stable climatic conditions of the domestic space than outdoors in the cold regions of northern Europe. As the Industrial Revolution rapidly changed the lives of millions of people in Europe and the United States in the mid-nineteenth century, Victorians began to fill their living rooms and parlours with ferns, orchids and other exotic species. Suspended between the stark realism of photography and the oneiric uncanniness of surrealism, Walker's photograph poetically gestures towards the inherent absurdity of houseplants and the contradictory desire to bring plants indoors – where they do not inherently belong – and a longing to reconnect with our primordial lives spent in close contact with the natural world.

Lisa Nilsson

Grand Jardin, 2022

Japanese mulberry paper and gilt-edged paper,
106.7 × 139.7 × 7.6 cm / 42 × 55 × 3 in
Private collection

Seen from afar, this epic artwork by Lisa Nilsson (b. 1963) looks like an exquisite sixteenth-century Persian rug, with its central medallion and many borders. Look closer and you realize that *Grand Jardin* is made of paper, 6-millimetre (¼-in) strips rolled into coils that are shaped and fitted together, puzzle-like, to form the spectacular design. It's unclear when this art form, known as quilling, first originated. As early as the seventeenth century, nuns living in French convents adorned religious objects with quilling (*papier roulé*)

they fashioned out of gilt-edged paper as an inexpensive and modest alternative to metal filigree. Works of quilling are typically small in size, since the technique requires tenacity, patience and precision. In this piece, Nilsson expands the boundaries of the form in density, complexity and scale. Assembling thousands of tightly coiled strips of paper, she grew an expansive garden, with floral forms, butterflies and insects, as well as gold 'beads' made of gilt-edged paper that catch and reflect the light. Although the pattern appears to

have been meticulously planned, Nilsson built *Grand Jardin* from the centre out, problem-solving and designing as the piece developed, a process that took six years. Much as gardeners do, she applied geometric structure and symmetry, creating a calming order to contain the riot of organic shapes and delicate details. The relationship to a work that takes more than half a decade to create requires faith: planting today with the hope that those efforts will yield bounty over time.

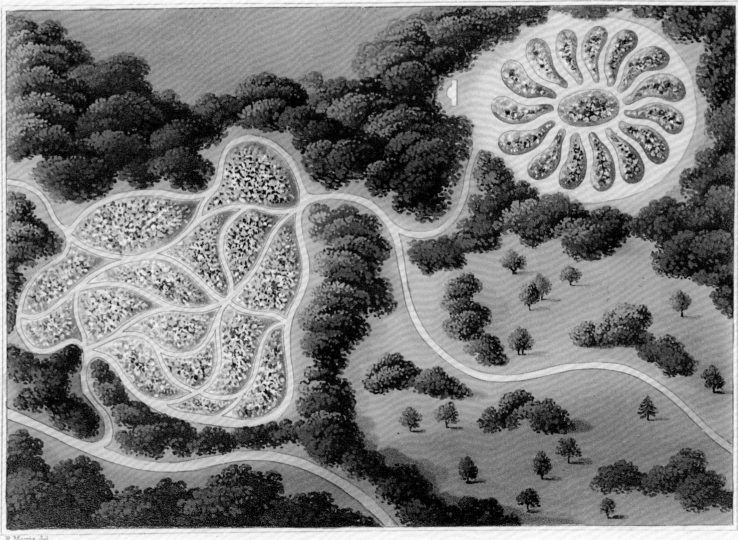

R.Morris del.

PLAN OF A FLOWER GARDEN & ROSARY.

London Published by J.Taylor, 59.High Holborn.

Plate III.

Richard Morris

Plan of a Flower Garden & Rosary, from *Essays on Landscape Gardening, and on Uniting Picturesque Effect with Rural Scenery*, 1825

Aquatint, 21.6 × 27.2 cm / 8½ × 10¾ in
Private collection

In 1825 Richard Morris (active 1820s), by profession a surveyor with offices on Vincent Square in London, published *Essays on Landscape Gardening, and on Uniting Picturesque Effect with Rural Scenery*. A quarto volume with large print and six leaves of plates, it received little attention and remains largely forgotten. However, Morris serves as an excellent example of a garden designer from a transitional period when the impulse to formal or geometric gardening was emerging, and gardeners were trying to reconcile it with the established tradition of the informal landscape garden. Morris was evidently intent on making a name for himself in the annals of horticulture, but so far he has fallen below historians' horizon. Little is known about him apart from his list of publications, including *The Botanist's Manual* (1824), a competent guide to exotic planting, and *Flora Conspicua* (1825–6), an anthology of garden plants, beautifully illustrated by William Clark. He advertised himself as a landscape gardener, but as yet not a single garden that he designed has been identified. In his *Essays*, Morris acknowledged the importance of Humphry Repton (see p.83), and a glance at his plates immediately situates him in Repton's ambience. Morris was not as daring as Repton, however. While Repton could boldly place a flower garden directly in front of the house, in full view of the windows, Morris instead shows extensive flower gardens, one of them in the shape of a flower head, kept carefully screened from the principal views by shrubberies or plantations. Twenty years later, such designs were considered timid and had fallen out of fashion.

Wang Yuanqi

Wangchuan Villa (detail), 1711

Ink and colour on paper, overall
36.5 × 1055.4 cm / 14⅜ × 415½ in
Metropolitan Museum of Art, New York

Nestled among dramatic, rolling hills, and ornamented with stately trees, a secluded pavilion stands amid a vast garden. One of the most famous gardens of ancient China, the outstanding Wangchuan Villa was the retreat of poet, musician and landscape painter Wang Wei, who acquired the property in Chang'an (near present-day Xi'an), around AD 740. Wang described the beauty of the gardens in more than one poem, and many artists captured its lush vegetation and sophisticated landscaping over the centuries. This detailed painting of the grounds was made by accomplished court painter Wang Yuanqi (1642–1715) almost a thousand years after the gardens were planted. Later in life, Yuanqi was appointed curator of the imperial collection during the reign of the Kangxi Emperor. His representation of the gardens is based on an illustration featured in *Wangchuan ji* – a poetry collection by Wang Wei and Tang dynasty poet Pei Di – as well as his own interpretation of the poets' verses. Over time, the beauty and fame of the Wangchuan Villa gave rise to an original genre of garden estate painting in which idealization played an important philosophical role. In Chinese culture the garden estate is considered a form of art in itself, akin to painting. This analogy was so firmly established that painters were often commissioned to landscape gardens. Their consideration turned not only to the topography and quality of the land but also to the character of the owner, which they strove to reflect across the landscape and in the paintings of it that they would later create.

Anonymous

Spring and Summer Palace Gardens,
from *The Tale of Genji*, 17th century

Six-panel folding screen; ink, coloured paint and gold
on paper, overall 1.7 × 3.6 m / 5 ft 6 in × 11 ft 9 in
Detroit Institute of Arts, Michigan

A six-panel folding screen dazzles the viewer with a golden
ground that represents both the clouds and the gardens
on either side of a meandering ornamental stream in this
scene showing two palaces from the eleventh-century
Japanese classic *The Tale of Genji* (1008), probably written
by Murasaki Shikibu, a lady-in-waiting at the Heian court.
Widely regarded as the world's first novel, the book tells the
story of the life and loves of Prince Genji and his descend-
ants, and is famous for its intricate descriptions of court

life, customs and the beautiful gardens that the characters
frequented. Genji builds himself a palace, Rokujō, where
each quarter of the large estate is home to a particular lady
from Genji's life, and each also contains a south-facing
garden designed to be at its most beautiful in one of the four
seasons, here spring and summer. In aristocratic society of
the Heian period (AD 794–1185), gardens were intended to
be places of contemplation and escape from the stresses of
daily life. The spring garden (right) is home to Genji's true

love, Murasaki, who is associated with the cherry blossoms
of that season because of her beauty; in addition to cherry,
the garden was planted with pines, plum trees, wisteria and
rock azaleas. The summer garden, in the northeast quarter,
is home to Hanachirusato, a consort to Genji's father who
later looked after Genji's son. It has groves of Chinese bamboo
to offer shade, together with pinks, roses and peonies; it
also included stables and a fenced-off area for horse riding,
visible at lower left.

Utagawa Kunisada I
and Utagawa Hiroshige I

Eastern Genji: The Garden in Snow, 1854

Woodblock print, triptych, overall 37.7 × 75.9 cm / 14¾ × 29⅞ in
Museum of Fine Arts, Boston

Snow covers the landscape in the background of this
Japanese woodblock print, a triptych that depicts a beautiful
Chinese court garden. Icicles hang from the frozen miniature
trees and snow covers the boughs of the cherry trees, which
appear to be in bloom. The hero Prince Genji is enjoying
the snowy garden, attended by a number of beautiful women,
including these three courtesans or ladies-in-waiting who are
busy making a snow hare. The triptych is the product of a col-
laboration between two of the masters of nineteenth-century

landscape painting, Utagawa Kunisada I (Toyokuni III, 1786–
1864) and Utagawa Hiroshige I (1797–1858). Both men had
trained at the Utagawa school – hence their adoption of the
name – to learn *ukiyo-e*, a type of art translating to 'pictures
of the floating world' that sought to capture the transitory
nature of life and its enjoyments. The setting is a tradi-
tional court garden of the Heian period (AD 794–1185), which
featured a series of buildings divided by courtyards and
enclosures that often featured a single species of flower in

a miniature garden of raked gravel. Here the two artists con-
centrate on a scene from the world's oldest known novel,
The Tales of Genji, written in AD 1008, probably by the Japanese
noblewoman and lady-in-waiting Lady Murasaki Shikibu.
The novel tells the story of the prince and a low-ranking con-
cubine during the Heian period, which is still regarded as
a high point in Japanese culture.

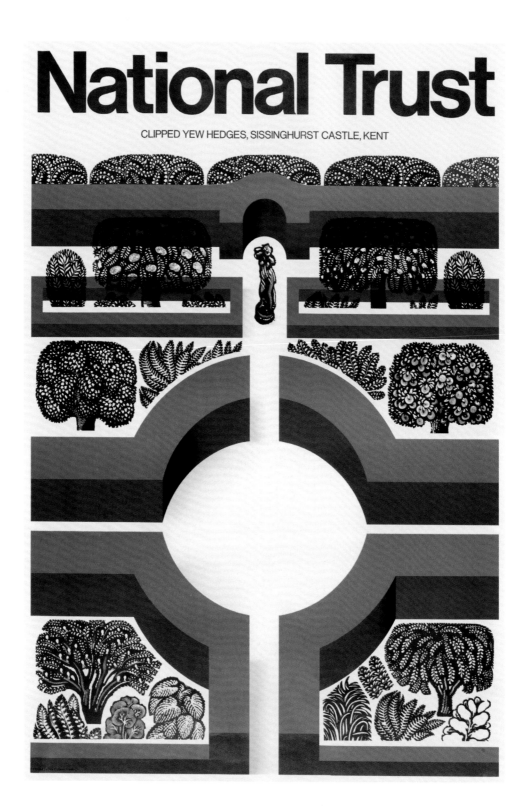

David Gentleman

Clipped Yew Hedges, Sissinghurst Castle, Kent, c.1972

Offset lithograph, 75.8 × 50.6 cm / 30 × 20 in
Victoria and Albert Museum, London

The garden at Sissinghurst Castle, Kent, was the creation of poet and writer Vita Sackville-West (see p.80) and her husband, Harold Nicolson, a diplomat and fellow author. Together they bought the property in 1930 and spent thirty years transforming a neglected farmstead into a garden famed for its beauty and originality. Nicolson was largely responsible for the planning – laying out the grounds as a series of 'garden rooms' – while Sackville-West oversaw the planting. Owned and managed by the National Trust since 1967, Sissinghurst remains one of its most popular sites. In the early 1970s it was chosen to feature in an adventurous advertising campaign that employed distinctively contemporary styling and a clean, modern typeface. Four posters were designed by English painter and illustrator David Gentleman (b. 1930) in a style intended to convey the idea that the Trust, guardian of the nation's heritage, was modern and relevant despite its focus on British history. Here Gentleman shows a bird's-eye view of the roundel at the centre of Sissinghurst's famed rose garden, with its symmetry and formal planting, defined by close-clipped yew hedges represented by bold blocks of dark green and black. Between and beyond the hedges, Gentleman has added simple black-and-white images of plants and trees, scaled up from his own wood-engravings, elegantly combining present and past in a highly graphic design.

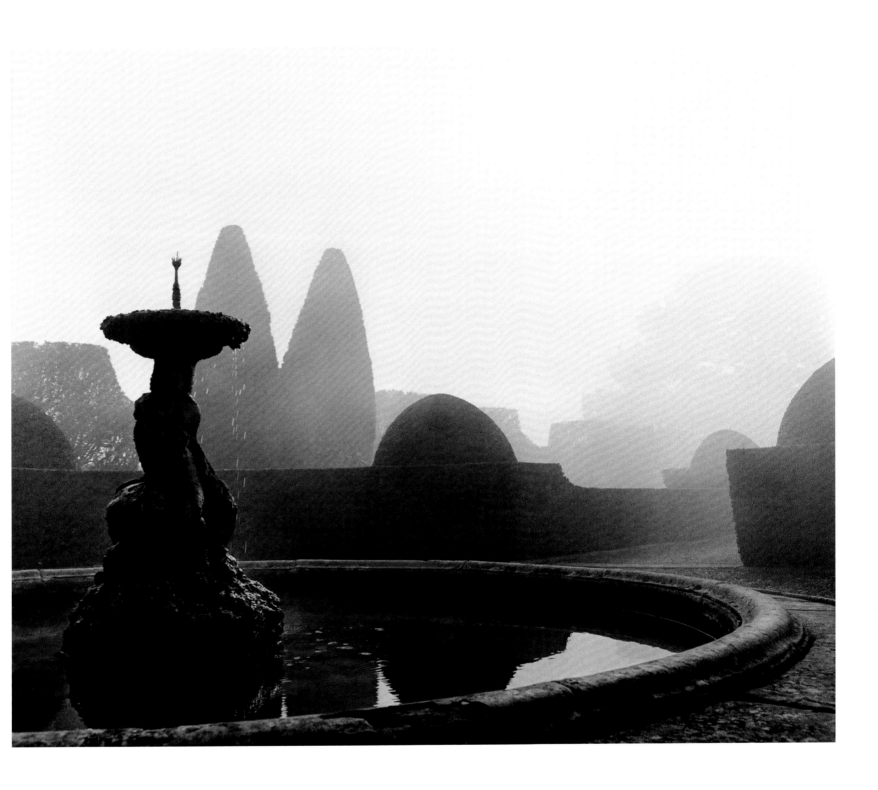

Balthazar Korab

Villa Gamberaia, c.1967

Photograph, dimensions variable

Thin sunlight turns the garden at Villa Gamberaia in Settignano, near Florence, into stark geometric shapes that melt into water and mist. The architectural training of Hungarian-born American photographer Balthazar Korab (1926–2013) is clear in this ethereal black-and-white image of a garden dating from the sixteenth century which, although of modest size – around 1 hectare (2.5 acres) in a cruciform shape, anchored to a hillside by a central villa – is one of Italy's most popular. The garden features a range of spaces, including an entrance allée, a long lawn, a formal Lemon Garden and a Nymphaeum, but since the early twentieth century visitors' imaginations have been captured mostly by its blend of the solid and liquid – as Korab shows – in its famous water terrace. Restored by the then-occupier of the villa, Serbian Princess Ghika and her American companion Miss Blood, the original eighteenth-century scrollwork parterres of the terrace were replaced not with planting or gravel but with water, including four pools around a central fountain creating a horizontal mirror, the glassy surface of which is broken only by its jet fountains. Partially destroyed during World War II, the house and gardens were acquired in 1954 and then restored by Italian industrialist Marcello Marchi and his wife, Nerina von Erdberg, who commissioned Korab to photograph the results. Better known for his images of modernist architectural masterpieces, Korab nevertheless captures the garden's poetic aesthetic and haunting, contemplative beauty, reinforcing his own assertion: 'I am an architect with a passion for nature's lessons and man's interventions.'

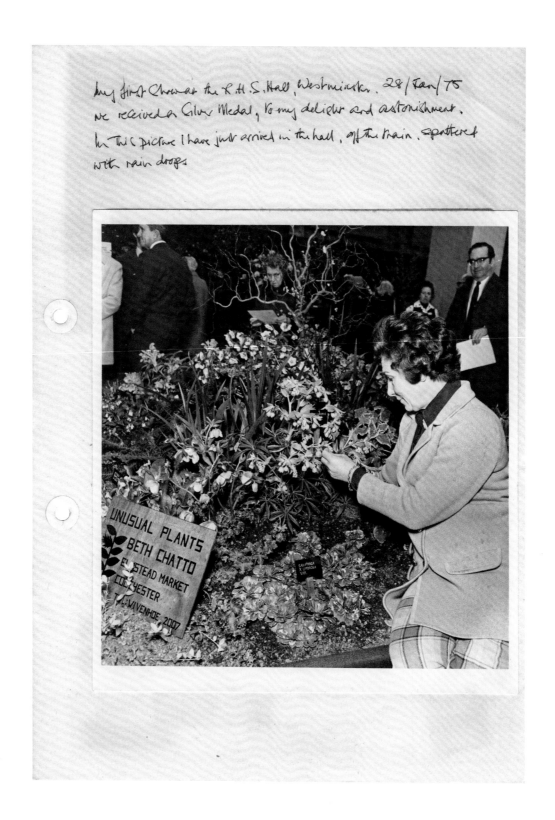

my first show at the R.H.S. Hall, Westminster. 28/Jan/75
we received a Silver Medal, to my delight and astonishment.
In this picture I have just arrived in the hall, off the train. Spattered
with rain drops

Beth Chatto

Scrapbook page, 1975

Photograph mounted on paper, 29.6 × 21 cm / 11⅝ × 8¼ in
Garden Museum, London

The visionary, award-winning English gardener, plantswoman and writer Beth Chatto (1923–2018) transformed the way people garden with a simple mantra: 'Right place, right plant.' Today, it seems remarkable that Chatto's belief in sustainable gardening, using plants that are adapted to their specific conditions in those same conditions, should have been considered transgressive when she burst on to the gardening scene in 1975. This black-and-white photograph shows Chatto arriving at London's Westminster Hall to check her first exhibit for the Royal Horticultural Society, a small winter garden that won a Silver-Gilt medal, despite including what one judge derisively called 'weeds'. The weeds were, in fact, uncultivated plants, although to gardeners drilled in the contrived planting that had prevailed since Victorian times, they amounted to the same thing. Chatto's modest success led to an invitation to exhibit at the prestigious Chelsea Flower Show the following year. For the show, which took place during a drought, her display of 'Unusual Plants' included those that were conditioned to thrive in hot, dry conditions, gaining her press coverage and enhancing her reputation to the extent that she was offered a job as gardener to George Harrison (which she refused). Chatto went on to win the first of ten consecutive gold medals at Chelsea. While working on her spectacular 3-hectare (7.5-acre) Essex garden, she published eight best-selling gardening books – including perennial favourite *The Dry Garden* (1978) – wrote numerous articles and lectured internationally on her pioneering way of gardening.

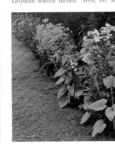

Christopher Lloyd

35 Years, In My Garden,
from *Country Life*, May 1998

Lithograph, 31.8 × 47 cm / 12½ × 18½ in
Private collection

Known among friends and the gardening community at large as 'Christo', English gardener and author Christopher Lloyd (1921–2006) delighted readers of *Country Life* magazine with his 'In My Garden' column from 1963 to 2005, never missing a deadline. Lloyd inherited the garden at Great Dixter in Sussex, England, from his mother, Daisy, and over his lifetime he developed it as one of the world's most creative and renowned horticultural spaces. Lloyd's weekly article was a way of conveying not just his immense knowledge but also his constantly

evolving ideas on planting design, all done with wit and panache. Lloyd was a bold innovator. His removal of a formal rose garden designed by Edwin Lutyens and its replacement with exotic foliage plants in 1993 shocked traditionalists but delighted his public, and it became one of the most important and influential parts of the garden. Lloyd's planting style was overwhelmingly about contrast – of foliage, of texture and of overall experience – to the point of leaving many visitors to Great Dixter feeling exhausted. Stories abound of him

sitting in a chair hidden from sight, eavesdropping on visitors' comments about his more provocative planting combinations. In some ways his style can be seen as bringing up to date the Victorian tradition of labour-intensive, high-impact horticulture. However, Lloyd's Dixter was also about conservation: the wildflower meadows surrounding the house were a biodiversity hotspot, and became one of his passions in later life. Lloyd's work has been continued in a similar vein by Dixter's head gardener, Fergus Garrett (see p.312).

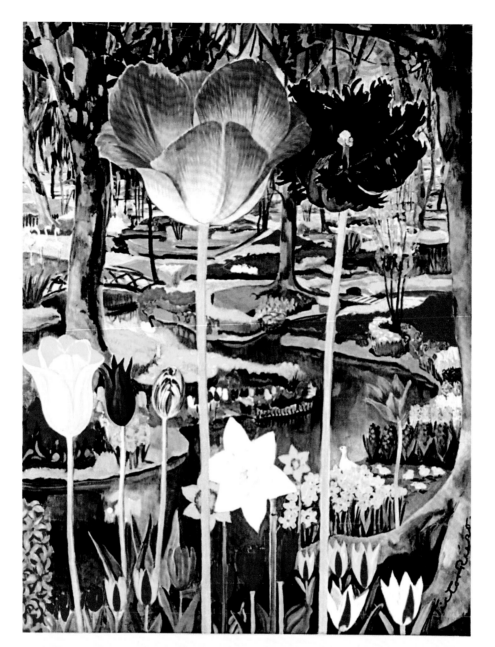

KEUKENHOF
LISSE·HOLLANDE
OUVERT DU 4 AVRIL À FIN MAI 1957

Victor Rutz

Keukenhof, 1957

Lithograph, 99 × 62 cm / 39 × 24½ in
Private collection

The colours seem otherworldly, and the flowers are depicted in a formal, conceptual way, but this poster faithfully captures the vivacity and variety of bed after bed of bulbs carpeting a wooded landscape pierced by sinuous water courses at Keukenhof, the self-styled 'Garden of Europe' and one of the world's largest and most celebrated flower gardens. In the fifteenth century, Keukenhof (meaning 'kitchen garden') was the vegetable garden of nearby Teylingen Castle but the gardens were later sold and a manor house built within them in 1641, now called

Keukenhof Castle. The modern gardens began in 1949, when twenty leading flower-bulb growers and exporters formulated a plan to use the castle's English landscape-style park (remodelled in the mid-nineteenth century) as the setting for an extravaganza of spring-flowering bulbs designed to showcase the Dutch floricultural industry. (Europe makes up 77 per cent of the global floriculture market, and the Netherlands is the continent's leading flower grower.) Keukenhof was an instant success, attracting 236,000 visitors in its first year. This poster

promoting the seventh annual spectacular of spring bulbs was created by Swiss artist Victor Rutz (1913–2008), later adopting the surname Ruzo, who was famous for the hundreds of advertising posters he created on either side of World War II. Today the garden works with each of a hundred participating companies to design a 'living catalogue' of their products: the 32 hectares (79 acres) of park are planted with approximately seven million flower bulbs each year, enjoyed by some million-and-a-half visitors during the gardens' eight-week season.

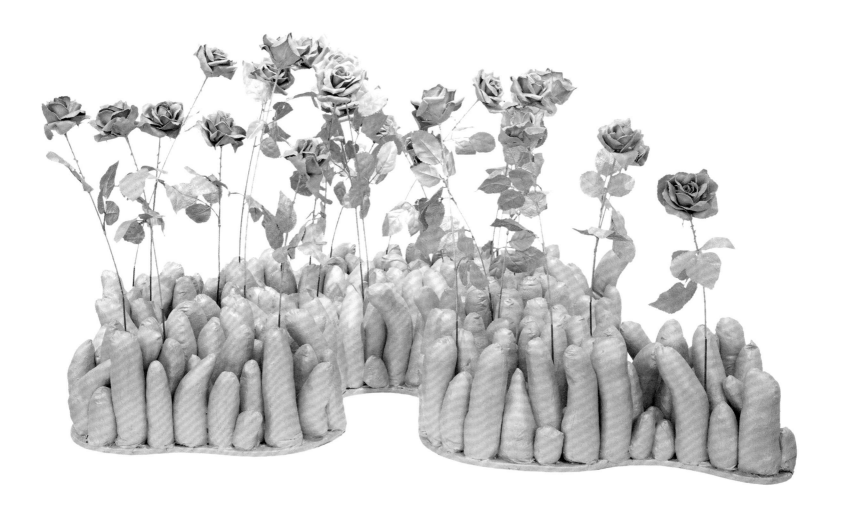

Yayoi Kusama

Rose Garden, 1998

Sewn and stuffed fabric, metallic paint and artificial roses,
68.5 × 124.4 × 129.5 cm / 2 ft 3 in × 4 ft × 4 ft 3 in
Private collection

Given that artist Yayoi Kusama (b. 1929) grew up deeply immersed in her family's plant nursery in Matsumoto, Japan, it is no surprise that floral imagery recurs throughout her work. Kusama's early work often featured literal depictions of botanical forms and her own experiences at the nursery, and while the later work – for which she is best known – became more conceptual, somewhat abstract, flowers, plants and gardens remain a central theme. *Rose Garden* is among numerous mixed-media soft sculptures that Kusama started to

create in the 1960s. Composed of stuffed, sewn fabric, it shows a compact garden as if floating on a small, self-contained island, isolated and alone. Single stems of artificial roses arise from a cloud of interplanted pillowy, yet phallic protrusions. Resembling stalagmites, these biomorphic shapes are soft but not quite flaccid. Kusama refers to such repetitions of organic forms, which are common in her work, as 'obliterations'. However, while these finger-like protuberances envelop the roses, their flowers, far from obliterated, bloom atop towering

stems. Armed with thorns, the roses further transcend the soft, unarmed forms. Although gilded, this small garden is more garish than opulent. The monochrome approach belies the colour mosaic typical of even a monocultural flower garden such as a rose garden. The overall shape recalls an *ikebana* arrangement, with the protrusions fixing the flowers in place like a *kenzan*, the device used in this traditional Japanese art. *Rose Garden* may not be horticulturally accurate, but it invites the viewer to admire a more fantastical variety of garden.

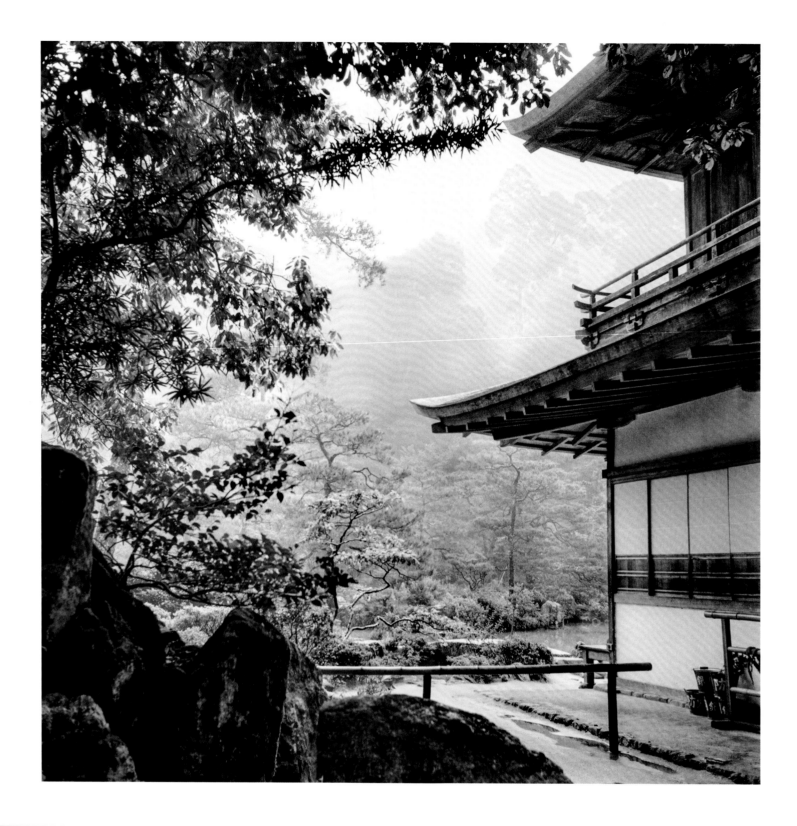

Werner Bischof

Japan, Kyoto, The Silver Pavilion, 1951

Photograph, dimensions variable

One of the most famous photojournalists of the twentieth century, Werner Bischof (1916–1954) produced an outstanding body of work ranging from war reportage to art photography. It was in 1951 that, upon accepting a commission to document the war in Korea, he travelled to Japan – an experience that radically changed his approach to photography. Mesmerized by the culture and aesthetics, Bischof ended up spending a year exploring 'the depths of the Japanese soul' through his lens. Much of his fascination revolved around

the balance between modern life and tradition, an aspect of Japanese culture on which he focused in his photographs of gardens and green spaces. This sombre and peaceful black-and-white image captured the picturesque beauty of Ginkaku-ji, the Zen temple known as the Silver Pavilion in Kyoto. The building and gardens were planned in 1460 by Ashikaga Yoshimasa, the eighth shogun of the Ashikaga shogunate, who reigned from 1449 to 1473. Designed by the great Japanese landscape artist Sōami, the garden features

a large number of *niwaki* conifers and other Japanese garden staples. The Silver Pavilion garden is well known for its *karesansui* garden, a dry landscape underlying the principle of *yohaku-no-bi* – the beauty of the blank space. A carefully shaped mound of sand standing in the middle of the garden is said to represent Mount Fuji.

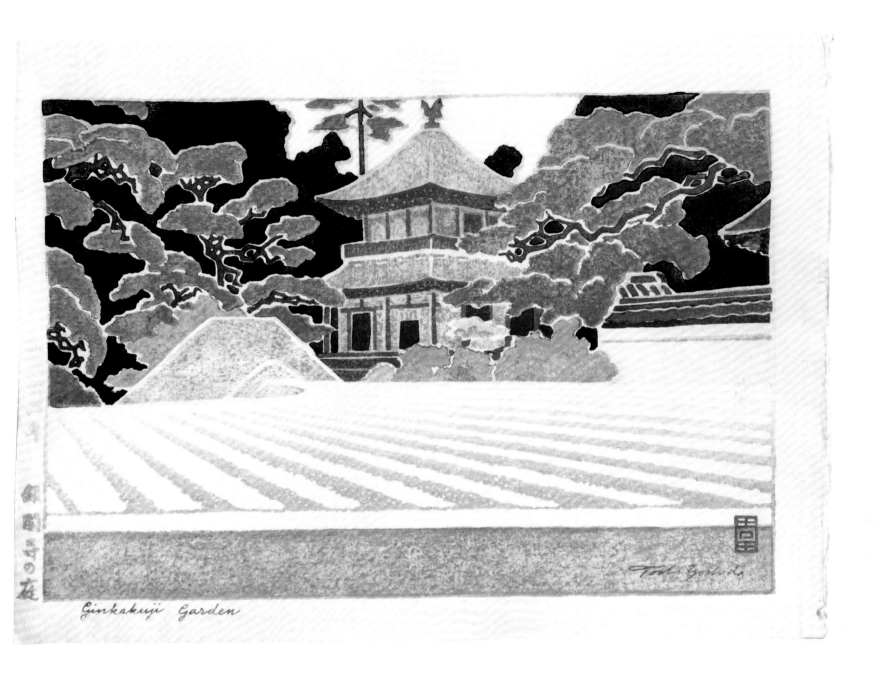

Ginkakuji Garden

Toshi Yoshida

Ginkakuji Garden, 1963

Woodblock print, 24.2 × 35.2 cm / 9½ × 13¾ in
Private collection

A two-storey temple building, topped by a mythical bird, is partially obscured by branching pine trees and low bushes, surrounded by a sea of fine raked sand and accompanied on the left by a stylized replica of Mount Fuji, formed of gravel. In somewhat austere style, this print portrays the Zen Buddhist temple of Ginkaku-ji, the Temple of the Silver Pavilion, near Kyoto in the eastern hills of Japan. It was built as a retirement villa for Shogun Ashikaga Yoshimasa and dates from 1482. Following the death of the original

owner, it was converted to a temple in 1490. Ginkaku-ji became central to a movement known as Higashiyama Culture, which embraced architecture, poetry and garden design, and the name of the temple possibly refers to the silvery reflections from the temple walls in moonlight. In contrast to the dry garden, the strolling garden in front of the temple is a naturalistic miniature landscape centred on a sinuous pool overhung with arching pines and surrounded by azaleas and maples. Said to have been designed by

landscape artist Sōami, it portrays scenes from Chinese and Japanese literature. The temple and garden are still revered as a holy site, and much visited today. Printmaker Toshi Yoshida (1911–1995) was born in Tokyo to another famous artist, Hiroshi Yoshida, who inspired his son to follow him in his profession. Toshi developed his own distinctive approach that often featured daring colour schemes, and from the 1950s he worked in a more abstract style.

Eugène Grasset

January, from *La Belle Jardinière*, 1896

Chromotypograph, 27.8 × 20.5 cm / 11 × 8 in
Cooper Hewitt, Smithsonian Design Museum, New York

It's a cold January day in this garden: the ground is still snowy and ice-bound, the water in the fountain is frozen, and most of the trees and shrubs are bare, except for the two conifers and the bright-berried holly bush. With her long dress, pinafore, shawl and headscarf, the young gardener is warmly wrapped for her heavy work, shovelling the melting snow away from the garden path and the trunks of the shrubs. It is a time when the garden is in many ways dormant – but the greenhouse in the background hints at the new plants that will be ready for spring. This image was created by French graphic designer Eugène Grasset (1845–1917), who was best known for his advertising posters, as part of a series of twelve prints illustrating the months. Each of the elegant Art Nouveau-style scenes shows a young woman at work in a garden fashionably dressed and wearing a garment patterned with a motif of the relevant sign of the zodiac; here the symbol is Aquarius, the sign for the latter part of January. In 1896 Grasset's prints were republished by the Parisian department store Maison de la Belle Jardinière (House of the Beautiful Gardener) in the form of a calendar, copies of which were given away to the store's customers. Grasset worked for La Belle Jardinière for nearly twenty years and designed two more calendars for them, including one on a similar theme, the seasons, in 1904.

h. Lanternes. K. Sallon dans les Roches, m. Soupiraux
par lesquels on entend la Musique dans le Sallon, K.

Coupe du nouveau

Berceau ou.
JARDIN D'HIVER
de S.A.S.M.
le Duc de Chartres
à Mousseau
par la ligne A.B.
du plan

Place des Musiciens

Cabinet

Cabinet

A B

Façade du Berceau d'hiver.

Serre des Ananas

6 12 18 24 30 pieds

le Tour

Salle à Manger
dans les Roches.

PLAN
du
Nouveau
Berceau
d'Hiver

Foyer

Serre des Ananas et Fleurs

conduits souterrains pour la chaleur

Anonymous

Facade of the Winter Bower,
from *Jardins Anglo-Chinois, c.1785*

Hand-coloured engraving, 37 × 23 cm / 14½ × 9 in
Bibliothèque des arts décoratifs, Paris

Showing the facade of the winter bower, or sheltered garden, in the Parc Monceau in Paris, this engraving by an unknown artist was made as part of the plans for a third transformation of the 8-hectare (20.3 acre) park in less than ten years. Owned by the fabulously wealthy Anglophile Louis-Philippe d'Orleans, duc de Chartres, cousin of King Louis XVI, the park was first completed close to the Arc de Triomphe in 1779. Its first iteration was modelled on the English garden at Stowe (see p.226), and it contained numerous follies, including an ancient Egyptian pyramid and a chemistry laboratory, to fulfil the duke's intention of creating a public park that was a 'garden of illusions'. Louis-Philippe wanted the park to amaze and surprise its visitors, 'to bring together all ages and all parts of the world in a single garden'. As all gardeners know, however, tastes change, and just two years later the garden was remodelled by the fashionable Scottish landscape gardener Thomas Blaikie. Blaikie's design lasted until 1787, when the garden underwent yet another transformation. This time, the construction of the Wall of the Farmers General – a new city wall along the park's northern edge, built as part of a series of toll walls around the city to collect taxes – meant the garden's size was reduced. Alongside the wall, French designer Claude-Nicolas Ledoux designed a rotunda in the form of a Doric temple – the Pavilion de Chartres – which both served as a customs house and gave the duke an apartment from which he could admire his garden.

woodlands

Cut back wall plants

Pot plants in nursery

Prick out seedlings

January

Hedges

Start one end of garden weed, compost, split & replant, prune, add new plants thin out self sowers

split & move snowdrops

woodlands

Sow Papaver, Ammi, Nigella, Sweet williams, Larkspurs, Cornflowers

February

Thin out bamboos

Split & pot perennials

weed, compost, split, replant prune, add new plants thin out self sowers

split & move snowdrops

woodlands

Sow Calendula Helipterum, Osteospermum Hyoscyamoides Papaver

Prune tender plants

March

Lawn repairs & feed lawns

Bring out Dahlias for cuttings

weed, compost, split, replant prune, add new plants, thin out self sowers

Feed hedges with Fish Blood & Bone

woodlands

Prastick plants

Plant out Ammi, cornflowers, poppies

POT DISPLAYS

Prune tender plants

GARDEN OPEN

Seed sow Tagetes, Ageratum, Cosmos

April

weed & thin out seed sowers

Basal root cuttings

Plant out gap fillers

Prastick Plants

Fergus Garrett

Garden mind map, 2017

Felt tip on paper, approx. 76.2 × 63.5 cm / 30 × 25 in
Great Dixter, East Sussex, UK

Looking after any garden can be a complex task, with jobs to organize not only for the present but for the long term as well – and gardening at Great Dixter, one Britain's most talked-about gardens, is a particular challenge for head gardener Fergus Garrett (b. 1966). Personally recruited by its original creator, the late Christopher Lloyd (see p.305), Garrett is now responsible for maintaining the gardens and Lloyd's legacy. Great Dixter attracts a constant flow of visitors, as well as volunteers and students who want to work at the famed institution to gain

experience and inspiration. The gardens are famously complex, both temporally and spatially. Within Dixter's permanent structure of shrubs and topiary, there are extensive plantings of perennials but also a final layer of bulbs, annuals and temporary plants that may require replacing several times during the growing season, resulting in the need for careful planning and a detailed allocation of tasks. Garrett produces 'mind maps' like this one to plan and visualize his work, and to communicate to staff, students and volunteers what needs doing when, on a

day-by-day basis or for a whole season, with jobs colour-coded for easy reference. The map links past, present and future – last week's transplants will need watering this week, while what happens this week will guide future work, such as sowing seeds to be timed with when spaces open up in the garden borders. Garrett is one of the world's great head gardeners, combining immense plant knowledge, technical skill and artistic flair. At Dixter, he has created both a laboratory and a college for bold experimentation and high-energy planting design.

Letts of London

Gardener's Notebook, 1890

Paper, card and fabric, 11 × 6.7 cm / 4⅜ × 2⅝
Garden Museum, London

What looks at first like a tweed collared shirt decorated with three brass buttons on its front is, somewhat surprisingly, the cover of a notebook made by Letts of London specifically for gardeners. Its pages are filled with notes made by an unnamed young professional gardener in 1890, listing various gardening tips learned during his employment with two different households – those of a Mr Taylor and a Mr Stringer – and providing details of a huge variety of plants and vegetables, and the chemicals used in the garden. Giving

an insight into English gardening at the end of the nineteenth century, the gardener notes different propagating techniques, including those used for vines, and records information about melons, peach trees, mushrooms, roses and amaryllis, among many others. The date of the notebook is significant: the author was working during the heyday of gardening as a profession. Between the middle of the nineteenth century and the start of World War I in 1914, many middle-class British families could afford to employ a gardener, previously the

exclusive preserve of those with large estates. The later period of the Industrial Revolution inspired a massive population shift from the countryside to the city, where the growing middle classes settled into villas and garden suburbs, such as that at Hampstead in London. Their gardens were tended by a growing band of male gardeners charged with keeping abreast of the latest gardening fashions and scientific advances in order to showcase their employers' status and taste.

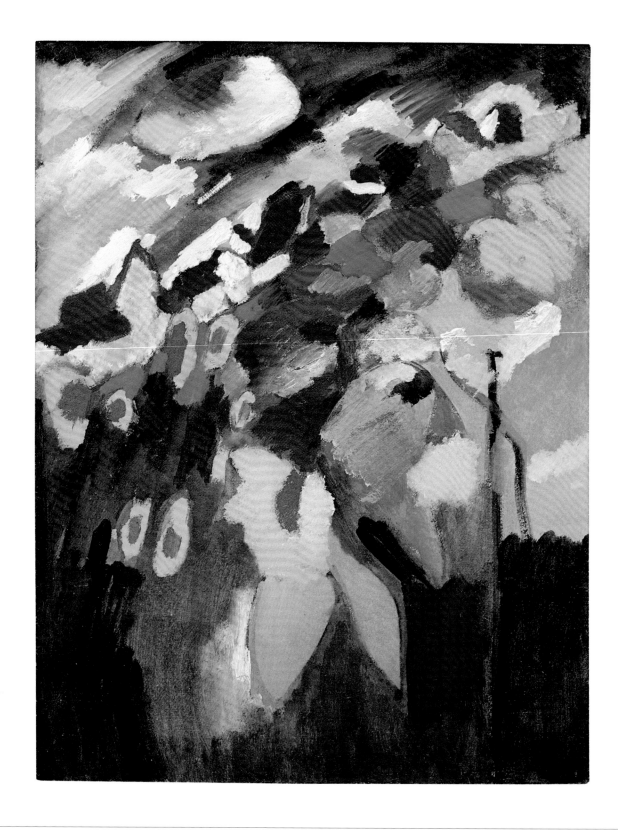

Wassily Kandinsky

Murnau The Garden II, 1910

Oil on cardboard, 67 × 51 cm / 26½ × 20⅛ in
Private collection

By 1910, Wassily Kandinsky (1866–1944) – one of the undisputed masters of early modern painting – had embarked on an uncharted creative journey: a radical departure from the rules and prescriptions of figurative Western art. The Russian avant-garde artist had come to believe that the essence of any artistic endeavour lay in the undisputed power of colour and its ability to reach deep into the human soul to express what words could not. *Murnau The Garden II* marks Kandinsky's transition from figuration to pure abstraction.

Of the actual garden in this village at the foot of the Bavarian Alps, Kandinsky only loosely evokes the cheerfulness of sunflowers. The topography remains vague. Slanted, the horizon line is broken in places by the intense crimson of remote rooftops. The surrounding vegetation and flowers are thoroughly subsumed into vibrant swathes of colour: teal, red, pink and blue. The painting presents a garden reinterpreted. This is not the landscaped perfection resulting from careful pruning but a transfigured whirl of uncontainable

intensity, brimming with vegetal life. Kandinsky's garden is at once simple and spiritually charged with a devotion to the natural world that indelibly marked the artist's development. Relinquishing any ambition to represent the garden in traditional ways, Kandinsky's art gestures to a sense of unity and an inextricable comingling with nature – an intimate pantheistic spirituality incarnated in the land that exists in a purely emotional dimension, reaching beyond the remit of religious doctrines.

Dan Pearson

Notebook page, 1980

Graphite and watercolour on cartridge paper, Daler Rowney spiral bound sketch pad, 21 × 14.8 cm / 8¼ × 5⅞ in
Private collection

This lively page from a notebook highlights the artistic approach to planting, supported by considerable botanical knowledge, of English garden and landscape designer Dan Pearson (b. 1964). Pearson's annotations for a 'Yellow Border – August: All Summer' indicate an awareness of which plant and flower combinations work well together, both aesthetically and ecologically, effectively painting with flowers to create a colourful planting scheme that will persist through the summer. The large dark green leaves at top left are those of *Ligularia*, described by Pearson as ornate yet unfussy and an excellent foil. The yellow flower heads of this species would dominate and are echoed by the small clump of bright yellow *Rudbeckia deamii* at lower left. The other flowers Pearson has chosen for this yellow border provide contrasting and complementary colours and shapes, notably the tall purple spikes of *Lythrum* 'Robert' on the right and the vivid red of *Potentilla* at lower right, while the large pink *Echinacea* flowers that dominate the centre provide a bold horizontal element. Pearson is well known for his publications and broadcasts, as well as for the many gardens he has designed in the United Kingdom and beyond. He trained in horticulture at the Royal Horticultural Society gardens at Wisley, the Royal Botanic Garden, Edinburgh, and the Royal Botanic Gardens, Kew. He is also a regular exhibitor at the RHS Chelsea Flower Show. Since 2014 he has been a garden adviser to the National Trust at Sissinghurst Castle near Cranbrook, Kent (see p.302).

Shen Yuan and Tang Dai

Spring Pavilion of Apricot Blossoms, from *Forty Scenes of the Yuanming Yuan*, 1744

Painting on silk, 64.5 × 65.3 cm / 25¼ × 25¾ in
Bibliothèque national de France, Paris

One of a series of forty works, this exquisite painting from the mid-eighteenth century depicts part of Yuanming Yuan, an extensive Chinese imperial summer palace. Similar in style, each of the works features a different part of a large complex of settlements set in a landscape of rolling hills and lakes. Located about 20 kilometres (12.5 mi) northwest of Beijing, Yuanming Yuan, the Garden of Perfect Brightness, was not far from the site of the Summer Palace that tourists still visit today. The buildings and landscaped areas formed

part of the Old Summer Palace and the paintings were commissioned by the Qianlong Emperor in 1744. The forty scenes are mainly the work of two court artists, Shen Yuan and Tangdai, and show how the palace and gardens would have looked before they were mostly destroyed by French and British troops in 1860, during the Second Opium War. This painting shows the Apricot Blossom Spring Villa, on the island with the highest elevation. A bridge crosses a body of water to a wooded island that rises to its highest

point at top right, where a tall pagoda is flanked by stately pine trees. Below the foothills lies a central plain under cultivation with vegetable plots, outhouses and a covered well, beyond which is an orchard of apricot trees bursting into pink blossom in the warmth of spring. It is said that Qianlong liked to visit at this time of year to write poetry and drink wine at the pavilion near the peak while listening to the rain.

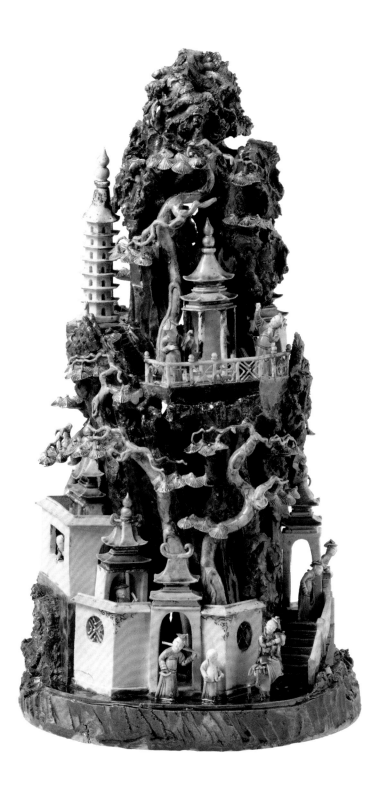

Anonymous

Miniature garden, *c.*1700–1724

Glazed porcelain, H. 47 cm / 18½ in
Rijksmuseum, Amsterdam

Symbolizing stability and virtue, the artificial mountain (*jiashan*) or hill is a fundamental element of classical Chinese gardens, along with a rock garden. The *jiashan* was intended to bring to mind the Island of the Immortals in Chinese mythology, a realm in which immortal sages lived in mountain grottoes among exotic beasts and plants. In his palace garden at Bianjing, the Northern Song emperor Huizong (r. 1100–1125) constructed an artificial mountain 100 metres (328 ft) high, which he called *Genyue*, or Mountain of Stability.

Five years after the garden was complete, Huizong was forced to flee before an invasion by the Jin. He returned to find his garden destroyed, the pavilions burned and the artworks looted – only the mountain remained. From then on, large, elaborate artificial mountains often adorned the gardens of wealthy merchants, scholars and emperors. During the Ming dynasty in the late 1600s and early 1700s, under the Kangxi emperor and his successor, the Yongzheng emperor, mountain follies were popular among the wealthy salt merchants of

Yangzhou, symbolizing both an intellectual refuge and a spiritual realm. This porcelain mountain, with its pagodas and other buildings, trees and figures, is glazed using the *susancai*, or 'soft three-colour glaze', technique, known in the West as *famille verte*, in which the glaze was applied directly on to the 'biscuit' of the porcelain model before firing. Great skill would have been required to mould, assemble, finish and enamel this intricate mountain garden, so the piece would have been extremely valuable and expensive to produce.

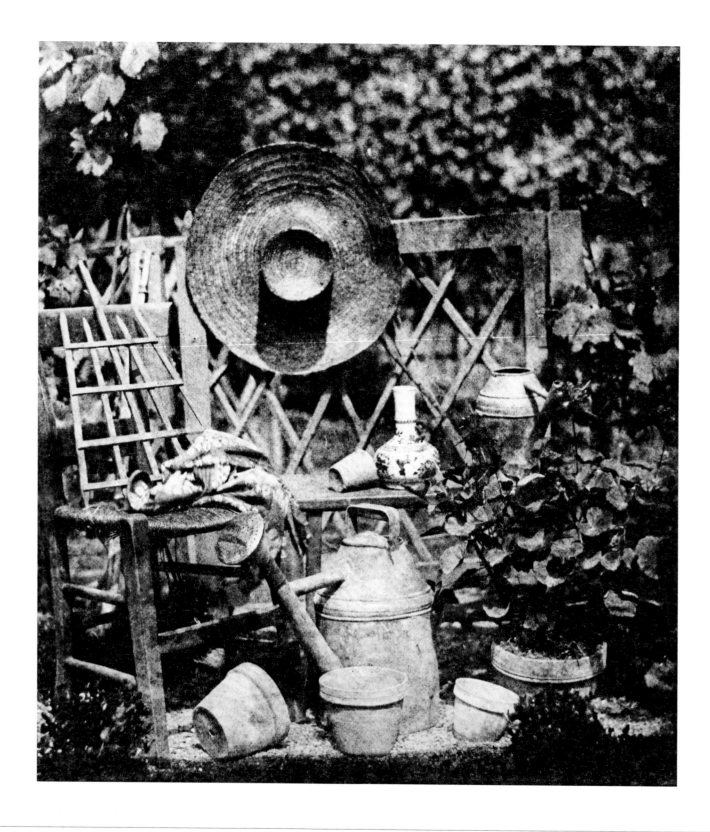

Hippolyte Bayard

Composition au Chapeau, c.1842

Gelatin silver print, 19.8 × 18.8 cm / 7¾ × 7½ in
J. Paul Getty Museum, Los Angeles

For a man considered the 'Grandfather of Photography', the name of Frenchman Hippolyte Bayard (1801–1887) barely registers compared with those of his contemporary photographic pioneers, such as Louis Daguerre and Henry Fox Talbot, even though Bayard mounted the first ever exhibition of photography, in July 1839. While working as a civil servant in the late 1830s and early 1840s, Bayard spent much of his free time experimenting with photographic processes in an attempt to capture and fix on paper images made from nature using a basic camera, light and chemicals. Many of these experimental photographs were taken in his beloved garden, including this 1842 image of a wide-brimmed gardener's hat, hanging on the garden gate, surrounded by tools and other paraphernalia. A watering can and several empty plant pots sit on the floor, while other garden tools are artfully arranged on a bench and chair, framed by ivy. Bayard showed an interest not just in photographing his garden but also in recording floral specimens for posterity. His images are carefully composed: spiky nigella flowers lie next to softer nasturtiums and sweet peas, and fragments of cloth and lace bring an extra dimension. Bayard saw how the new technology of photography could preserve and capture the intrinsically ephemeral nature of his garden – the garden that provided solace to a man who, having been largely overlooked for his contribution to photography, is now best known for his self-portrait in 1840 as a drowned man.

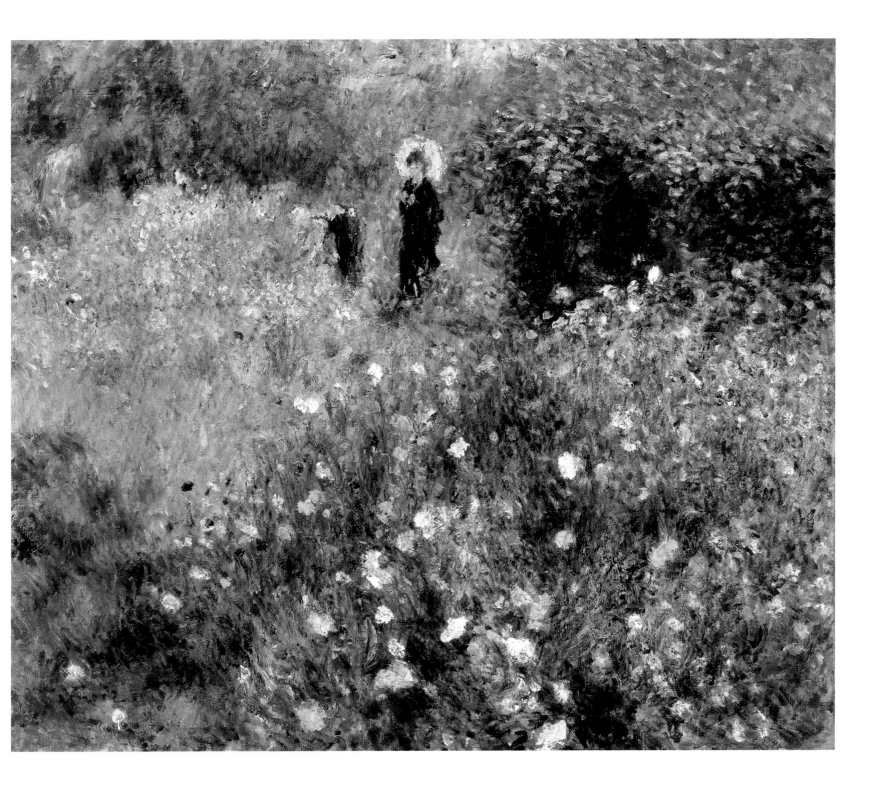

Pierre-Auguste Renoir

Woman with a Parasol in a Garden, 1875

Oil on canvas, 54.5 × 65 cm / 21½ × 25½ in
Museo Nacional Thyssen-Bornemisza, Madrid

At first glance this bucolic painting by Impressionist master Pierre-Auguste Renoir (1841–1919) might be mistaken for an authentic *en plein air* scene captured somewhere in the southern French countryside. However, this canvas was painted in the artist's back garden in the fashionable Parisian neighbourhood of Montmartre – a place Renoir cherished. Despite its wild appearance, this verdant refuge was an urban garden surrounded by tall brick walls. At times, the artist would include the walls in his paintings, while at others he omitted them to evoke the feel of a much wider, open space, as here. Renoir enjoyed the unmanicured look of the garden, where poppies and buttercups were allowed to grow freely across the lawn and the back of the plot was a fruit and vegetable patch surrounded by bushes and poplar trees. Gardens feature heavily in Renoir's paintings, as well as in those of other Impressionist artists. By the second half of the nineteenth century, as the Industrial Revolution led to a process of relentless urbanization that engulfed the countryside and polluted cities, gardens became sought-after oases for those who could afford them – fragments of harmony and serenity away from the hustle and bustle of modern life. To artists such as Renoir, plants and flowers also offered an opportunity to free themselves from the shackles of the artistic tradition of history painting. As Renoir once said, 'I am at liberty to paint flowers and call them flowers, without their needing to tell a story.'

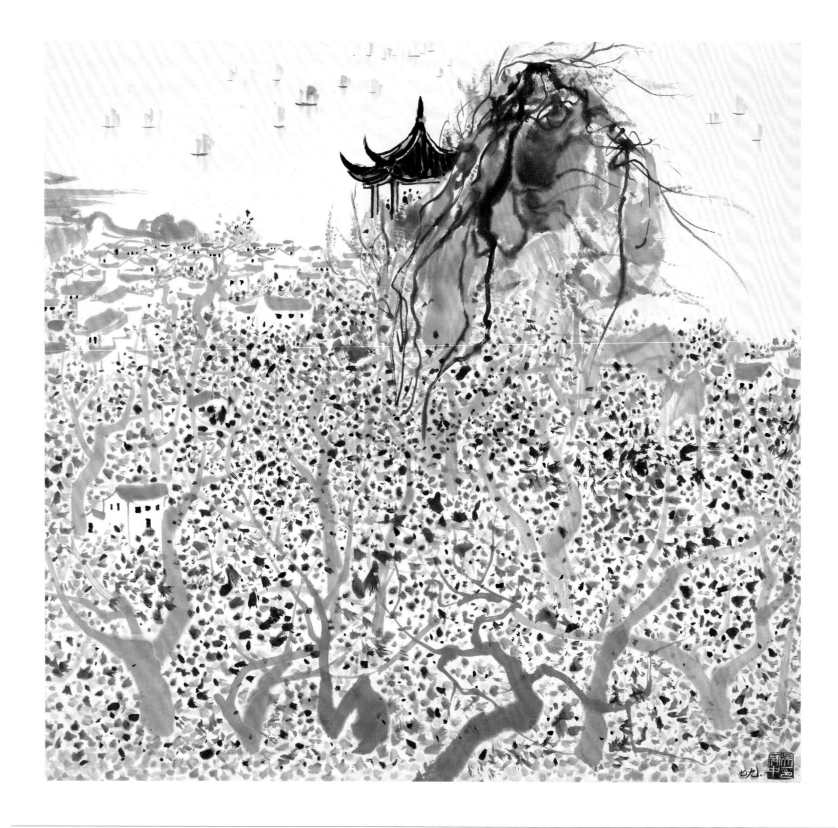

Wu Guanzhong

Plum Blossom Garden of Wuxi, 1979

Scroll, mounted and framed, ink and colour
on paper, 66.8 × 70.5 cm / 26¼ × 27¾ in
Private collection

Considered to be the founder of modern Chinese painting, Wu Guanzhong (1919–2010) often fused Chinese and Western traditions in his work. Wu attended technical school for electrical engineering before he transferred – against his family's wishes – to the National Hangzhou Academy of Art in 1936. Although he had studied Western painting, Wu's work was strongly influenced by his time studying in France from 1947 to 1950. Upon returning to China, he relished his new creative freedom, and this painting of a plum tree garden (*Meiyuan*) in

Wuxi clearly shows the influence of Western post-Impressionist artists, particularly Vincent van Gogh (see p.325), as Wu sought to capture a memory from his youth of the plum trees in full blossom. Adopting an aerial perspective to better encompass the entire garden, the artist looks down on the blossom-laden trees that fill the foreground, while in the background an oversized artificial rock formation and a traditional pagoda leap off the paper as distant boats bob up and down on Lake Tai. The exaggerated silhouettes of the trees' limbs

accentuate the gradations of pink and burgundy of the blossoms, almost eclipsing the white walls of neighbours' houses. Wu's painting, which echoes an earlier 1976 work depicting the same garden, breaks with the traditions of Chinese painting by setting the trees against a white background, enhancing the beauty of the transient blossom. Throughout his career, Wu painted his homeland, from landscapes and waterscapes to its flora and fauna, gradually moving from an early inclination to naturalism towards abstraction.

Philip Treacy for
Alexander McQueen

Chinese Garden, 2005

Cork, 43.2 × 46 × 21.6 cm / 17 × 18⅛ × 8½ in
Metropolitan Museum of Art, New York

Rising from a headband designed to perch vertiginously upon the head of its wearer, a landscaped Chinese garden has been intricately carved from cork bark to create this headdress by the renowned Irish milliner Philip Treacy (b. 1967). Platforms holding trellised pagodas with sawtooth hip-and-gable roofs appear to float between the trunks of beautifully sculpted conifers. On the platforms and among the trees, miniature white rice-paper cranes extend their necks to survey the scene. Treacy and English fashion designer Alexander McQueen (1969–2010), for whose Spring/Summer 2005 collection this piece was made, were closely associated with and mentored by the bohemian fashion editor and stylist Isabella Blow. She virtually launched McQueen's career by buying his entire graduate show, and was rarely pictured in public without the accompaniment of one of Treacy's outlandish creations, including a version of *Chinese Garden*. The influences and references at play in the headdress are as eccentric and manifold as those of Blow herself – the fantasy garden referencing the eighteenth-century chinoiserie craze as well as the elaborately coiffured architectural hairpieces worn by ladies of the time to masked balls. Representing around 150 painstaking hours of craftsmanship, the hand-carved cork figures were created using a Chinese technique called *Ruanmu Hua*, yet were acquired from Japan. The headdress was inspired by Treacy's trip to Kyoto, with trees in the Japanese *niwaki* style holding up their shaped boughs like powder puffs and spiked urchins.

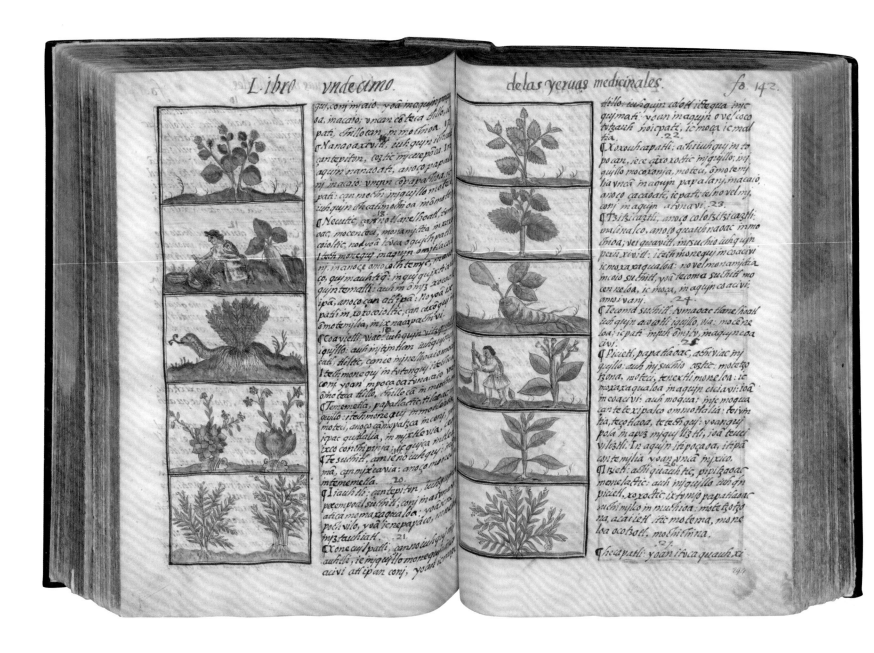

Bernardino de Sahagún

General History of the Things of New Spain: The Florentine Codex, 1577

Ink on paper, each page 31 × 21 cm / 12¼ × 8¼ in
Biblioteca Medicea Laurenziana, Florence

Plants have been used for medicine for thousands of years, and these illustrations and notes record *Tagetes* (marigold) and other sources of natural remedies used by the Aztec of central Mexico in the years after the Spanish conquest of the Aztec Empire in 1521. Presented in the style of a European herbal, a list of ailments and their plant cures, the Aztec believed marigold to be a 'hot' plant, perhaps because of its yellow and gold colours, and used it to treat symptoms associated with 'liquid', such as phlegm and diseases that made

parts of the body swell. At left a woman grinds up the root of a plant called *necutic* ('sweet thing') with the leaves of another to make a medicine for diseases of the eye. These illustrations are among 2,468 in *The General History of the Things of New Spain* (*Historia general de las cosas de Nueva España*) – the best-preserved manuscript is commonly referred to as the *Florentine Codex* – by the Franciscan missionary Bernardino de Sahagún (c.1499–1590), one of the most significant surviving records of Aztec knowledge. Sahagún spent three decades researching

the customs, culture, knowledge and natural history of the Aztec, consulting Indigenous Nahua elders, and using his Indigenous students at the College of Santa Cruz de Tlatelolco to translate the Nahuatl language and draw the illustrations that appeared alongside the translated Spanish texts. These pages come from Book 11, which describes Aztec food crops and the medicinal use of plants. Modern analysis of the content has established that about 60 per cent of the plants listed in the codex are medically effective.

Julieanne Ngwarraye Morton

My Country – Bush Medicine Plants, 2019

Acrylic on linen, 76 × 91 cm / 30 × 35¾ in
Private collection

Brightly coloured flowers are spread across the landscape in regular groups and rows that might suggest a conscious act of design and creation – yet this view shows a bush garden in Central Australia, where the distribution of flora comes down to the natural changes in microclimate in the rocky landscape. Like many of the artists of the Ampilatwatja community, Julieanne Ngwarraye Morton (b. 1975) paints plants used for bush medicine – ranging from the well-known desert acacias, or wattles, to the less familiar apple bush, native

fuchsia and emu bush – that are highly important to the local Alyawarr people. The artists of this small community northeast of Alice Springs have developed a distinctive style characterized by fine dots and the use of vivid colours and figurative depictions of native flora, some with fine detail, often in landscapes painted from an aerial perspective, seeing through horizon lines into the distance. These works convey the importance of looking after the natural landscape – hence the idea of a bush 'garden' – and can be

appreciated on many levels, the deepest of which is sacred. Some hidden layers are understood only by people initiated into the culture of the local First Nations community. The term 'garden' highlights a relationship with the land that is very different from the European notion; here it is indistinguishable from land or 'country', a resource to be nurtured and managed and in which each plant, animal and person has a meaning and a role to play. It is an approach that teaches respect for the living world.

BESTELLKATALOG

7. AUSGABE

1952

KARL FOERSTER

STAUDENGÄRTNEREI

ZÜCHTUNGS- UND FORSCHUNGSBETRIEB

WINTERHARTER BLÜTENSTAUDEN

POTSDAM-BORNIM

FERNRUF 6210

Karl Foerster　　　Cover of nursery catalogue, 1952

Lithograph, 21 × 15 cm / 8¼ × 5⅞ in
European Nursery Catalogue Collection

A delicate image of flowers growing in a stone-lined bed and left to bloom freely in the crevices of a garden staircase illustrates this cover of the 1952 catalogue for the renowned nursery at Potsdam-Bornim, just outside Berlin, run by the highly influential nurseryman, plant breeder and writer Karl Foerster (1874–1970). Foerster took the high-intensity horticulture that had developed in the late nineteenth century and brought it down to earth, developing and promoting a planting style that was based on permanent perennial planting, allowing his gardens to be naturalistic and sustainable owing to the hardy plants he selected, which were suited to the local conditions. The inter-war period in Germany was a time of immense cultural ferment and experimentation that expanded to include gardening and planting style, particularly in terms of colour theory. Foerster became the centre of a group of artists, writers and intellectuals – known as the Bornim circle – and his prolific writing and radio broadcasts became famous for their lyrical tone and philosophical reflections. Although influenced by Nazi-supporting garden designer Willy Lange, Foerster was a political liberal with a strongly multicultural approach to garden-making, rejecting Lange's focus on native German plants. Today he might be most associated with the ornamental grass that bears his name (*Calamagrostis × acutiflora* 'Karl Foerster'). Foerster supposedly discovered the cultivar among the plants at the Hamburg Botanic Garden in the 1930s and later brought it into the commercial trade; it is now the most popular hybrid feather reed grass on the market.

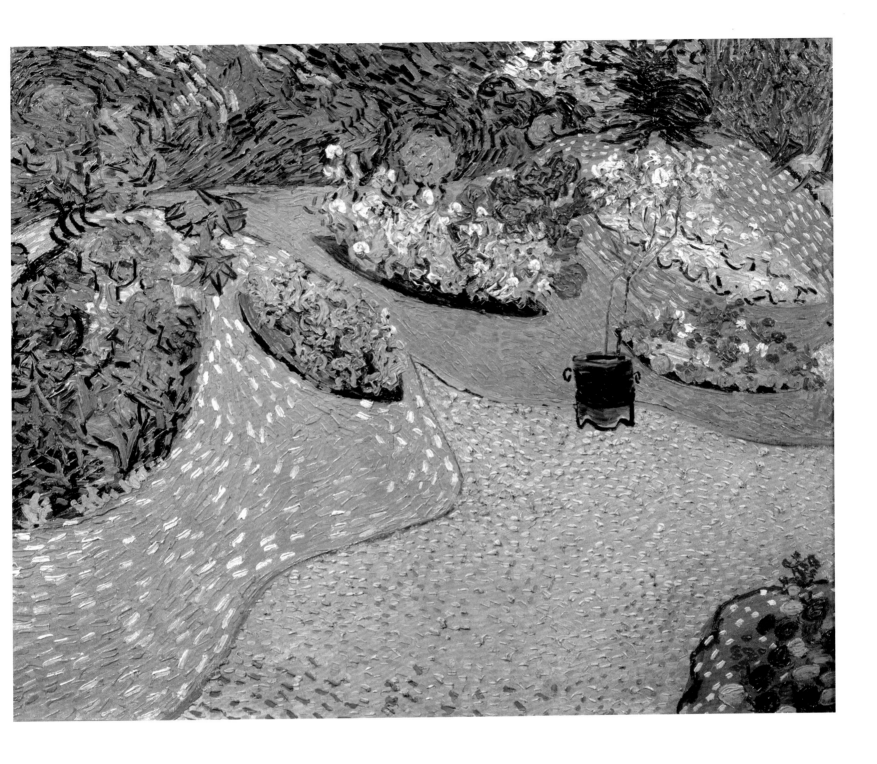

Vincent van Gogh

Garden in Auvers, 1890

Oil on canvas, 63.9 × 80 cm / 31½ × 25 in
Private collection

With broken brushwork, thick impasto and vibrant colour, the painterly style of Vincent van Gogh (1853–1890) is unmistakable. While the Dutch master is better known for his portraits, landscapes and paintings of cut sunflowers, he was also fond of gardens. Like his Impressionist predecessors, Van Gogh carried on the tradition of painting outdoors to capture the quality of natural light and colour. However, his paintings of gardens are more than evocative studies of serene outdoor spaces. Although he never owned a garden himself, gardens were important to Van Gogh as spiritual retreats to which he went regularly to read or find respite. He often charged his paintings of gardens and plants with a transcendental vibrancy that emphasized their mysterious character, and composed his images so as to exclude the urban reality that surrounded the greenery. In *Garden in Auvers*, he paid careful attention to the topography of the garden and how the blazing flower beds pierce the lime-green lawn that surrounds them. This aesthetic solution allowed him to convey a sense of remoteness more closely aligned with his personal interpretation of urban green spaces as little oases. Van Gogh moved to Auvers-sur-Oise, where this canvas was painted, on 20 May 1890, only a couple of months before his death. In that short period, he produced almost eighty canvases, many of which captured views of the garden of his physician, Dr Gachet, who became one of Van Gogh's most iconic portrait subjects.

VIRIDARIVM GYMNASII PATAVINI MEDICVM.

Io.Georg.sculps.

Filippo Tomasini

Plan of the Botanical Garden at the University of Padua, from *Gymnasium Patavinum*, 1654

Engraving
Wellcome Collection, London

Established in 1545, the Botanic Garden in Padua, Italy, is the oldest surviving university botanic garden in the world and still retains the original circular shape seen in this bird's-eye-view illustration by Italian scholar Filippo Tomasini (1595–1655). The shape is said to suggest the garden's role as a microcosm of the world, while the shallow moat that once surrounded it signifies the oceans and the importance of water. Originally created as a place to grow and study medicinal plants, the garden reflects the rise of the importance of herbal medicine during the sixteenth century, and the necessity of teaching medical students to identify curative plants accurately – a difficult task before an accepted standard for naming plants was introduced. The garden is divided into four quadrants of flower beds of various shapes, representing the four grades of botanical curative properties. In each, a single representative of a species still grows today. This type of structure is a living manifestation of the classification system that would in time become central to the study of modern botany: taxonomy. However, at the time, the study of plants wasn't solely a matter of expanding humans' knowledge of the natural world. Nearby, Venice held a lucrative monopoly of medicinal plants to which the Botanic Garden in Padua contributed. The tall walls surrounding the garden were built in 1552, as the collection of 1,500 species became targeted by thieves. Now home to 6,000 species, the institution is still active today.

John Haynes

The Physic Garden, Chelsea: A Plan View, 1751

Engraving with watercolour, 61.5 × 47.9 cm / 24¼ × 18¾ in
Wellcome Collection, London

This coloured engraving shows the Chelsea Physic Garden on the banks of the River Thames as it was configured in 1751. The second-oldest botanic garden in the British Isles, after the University of Oxford Botanic Garden, it was founded in 1673 by the Worshipful Society of Apothecaries to grow medicinal plants, on land leased from Charles Cheyne for an annual rent of £5. Four cedars of Lebanon were planted shortly after 1685, and in 1722 Sir Hans Sloane, who then owned the manor, leased the land in perpetuity to the

Apothecaries for the same rent and a promise to supply the Royal Society with fifty plants per year, up to a total of two thousand specimens. Sloane also initiated the building of the greenhouse and two hothouses. This plan was made by the surveyor John Haynes (c.1706–c.1770) during the golden age of the garden, when, under the direction of Philip Miller from 1722 to 1770, it became the world's most richly stocked botanic garden. The engraving includes the imaginary arrival of boats on the Thames bringing exotic plants, watched by

a fashionable audience on the riverbank. On either side of the garden are flowering *Aloe africana* plants, with the greenhouse in both elevation and plan at the top and the marble statue of Sloane in the centre. Outside the ornate frame at top left and right are numbered 'Explanations': guides to the various buildings and 'stoves' (heated frames or rooms), the four cedars, and the arrangement of bulbs, annuals, biennials and perennials.

Alma Thomas

Alma's Flower Garden, 1968

Oil on canvas, 91.4 × 129.5 cm / 36 × 51 in
Private collection

In this mosaic-like image, an array of multicoloured marks combine to evoke an ebullient flower garden in full bloom. American painter Alma Thomas (1891–1978) was in her late seventies when she made this painting, the only time she took her beloved garden in Washington DC as a subject. Painted using the bold, pointillist-style method for which Thomas is best known, the picture carefully balances vibrant complementary hues – orange and blue, red and green, and purple and yellow – that reflect her devotion to colour theory, not only in her art but also in her plantings. While individual species cannot be identified, the overall effect of the semi-abstract composition is one of a flower bed alive with the energy of nature, highlighting the artist's lifelong appreciation of horticulture. Thomas owed her love of gardening to the beautiful flower beds she remembered her parents planting at the family home in Columbus, Georgia, and the many different plants and trees she learned about while visiting her grandfather's plantation. Her observations of foliage, flowers and other plant forms, whether in her own garden or the US National Arboretum, fed the rhythmic patterns that characterize her late works. Despite painting for years, it was not until Thomas retired from a decades-long career in child and community education that her artistic talent was publicly recognized. She made history in 1972 as the first Black woman to have a solo exhibition at the Whitney Museum of American Art in New York, and again in 2015 as the first Black woman to have an artwork acquired by the White House Collection.

Clementine Hunter

Clementine in Her Flower Garden, 1984

Oil on canvas board, 45.7 × 61 cm / 18 × 24 in
William Louis-Dreyfus Foundation, Mount Kisco, New York

Protected from the Louisiana sun by a large blue headdress, artist Clementine Hunter (c.1886–1988) tends a garden of vibrantly coloured flowers of different sizes but highly similar shapes, against a flat background with twin trees and the sea beyond. The scene is drawn from Hunter's day-to-day experiences as a worker on a Louisiana plantation, who did not begin to paint until she was nearly sixty years old. It was in the 1940s that Hunter discovered by chance some paints and brushes left by a visitor to the plantation and began to paint scenes of everyday life. Working in the plantation house by day and painting by night, she used any materials she could find; her first work was made on a window shade, and she also painted on wood, wine bottles and empty milk cartons, as well as on canvas, as here. Hunter recorded the quotidian activities of life around the plantation, from working in the cotton fields and gardening to baptisms and funerals, using flat planes of colour and a shifting sense of scale to reimagine her daily environment in a similar fashion to another renowned pioneering Black artist of the South, Grandma Moses. Hunter's paintings were later exhibited in the Museum of American Folk Art in New York and the Los Angeles County Museum of Art, but the artist herself, after she retired in the 1970s, moved to a home just a few miles from the small plantation cabin where she had lived and worked her whole life.

PROJET DE ROSERAIE.

ECHELLE.

Une petite Roseraie

André Vera and Paul Vera

Une petite Roseraie,
from *Le nouveau jardin*, 1912

Engraving, 32 × 24 cm / 12½ × 9½ in
Smithsonian Libraries, Washington DC

Perhaps only in France could tradition and modernity combine with such verve as in the stylized gardens of *Le Nouveau Jardin*. Written by French garden designer André Vera (1881–1971), the book was published as a limited edition in 1912 with vignettes and ornaments drawn and engraved on wood by his brother, painter and designer Paul Vera (1882–1957). The opening chapters especially – on modernity, regularity and character – laid out André's manifesto for the New Garden, a style that acknowledged traditional French formal

gardens but looked forward to twentieth-century modernism. Vera moved away from the asymmetry of nineteenth-century naturalistic gardens and the prevailing Art Nouveau decorative style, being instead an early proponent of the rectilinear outlines and crisply geometric shapes of *arts décoratifs* (later known as Art Deco). Translating an essentially decorative style to the organic basis of garden design required horticultural skill of a high order, aided in Vera's designs by complementary architectonic elements, where clipped hedges

seamlessly combined with paved paths, metal edges, masonry walls and timber treillage, or latticework. Roses were a French horticultural speciality and this design for a small rose garden set tradition against modernity at an achievable, domestic scale. *Le Nouveau Jardin* was followed by *Les Jardins* in 1919. Vera's designs achieved great success in subsequent decades, particularly after the Paris *Exposition internationale des arts décoratifs et industriels modernes* in 1925, and in his first book we can see the formative ideas underlying this acclaim.

1. Coleus Verschaffeltii Improved.
2. Leucophyton Brownii.
3. Alternanthera paronychioides major.
4. Pyrethrum Golden Feather.
5. Echeveria secunda glauca.
6. Alternanthera amœna.
7. Mesembryanthemum cordifolium variegatum.

1. Echeveria glauco-metallica.
2. Pyrethrum Golden Feather.
3. Alternanthera amœna.
4. Antennaria tomentosa.
5. Sempervivum tabulæforme.
6. Echeveria secunda glauca.

Robert Thompson

Carpet Bedding, from *The Gardener's Assistant*, 1878

Lithograph, 25.5 × 19 cm / 10 × 7½ in
Garden Museum, London

This colour plate from the 1878 edition of *The Gardener's Assistant* by Robert Thompson (1798–1869), curator of fruit at the Royal Horticultural Society's garden at Chiswick (see p.103), would not have been possible in the first edition, nineteen years earlier. The mound of carpet bedding for which it provides a template – using alternantheras, antennarias, coleus, sedums and cinerarias for flat patches, with semper-vivums and echeverias for lines and dot plants – had not then been invented. Carpet bedding was created in 1868 when the head gardener at Cliveden in Buckinghamshire, John Fleming, tried a new way of planting summer bedding in the great parterre: instead of the usual arrangement of pelargoniums and other brightly coloured flowers, he created a pattern based on the monogram of the Duchess of Sutherland (who was responsible for the recent rebuilding of Cliveden after a fire) using dwarf succulents and arabis against a background of low-growing sedums. The new beds were so closely planted and uniform in texture – a far cry from any imaginable flower bed – that the *Gardeners' Chronicle* named the new style 'carpet-bedding'. During the 1870s carpet bedding became a major gardening fashion, and more gardens were described in the press for their patterns of multicoloured foliage than for their flowers. Among the advantages of the new style was the fact that it was unaffected by heavy rains that might knock the petals off flowers. The initial enthusiasm for carpet bedding subsided after a decade, but it continued to be a mainstay of public park planting until well into the twentieth century.

Careful Preparation of the Soil Before Planting a Rose-Bed

William Heath Robinson and K.R.G. Browne

Careful Preparation of the Soil Before Planting a Rose-Bed, from *How to Make a Garden Grow*, c.1938

Lithograph, sheet 19 × 13 cm / 7½ × 5 in
Private collection

The remarkable lengths that rose growers go to in preparing soil is lampooned in this cartoon, which shows gardeners carefully spooning loam on to numerous layers that descend deep into the ground. Beneath thick accumulations of fertilizer, hop manure and leaf manure is an extensive layer of rubble that includes an umbrella, a tin can and a cat. The satirical drawing is one of several that English cartoonist and illustrator William Heath Robinson (1872–1944) produced for the book *How to Make a Garden Grow*, written by his friend

and collaborator K.R.G. Browne (1895–1940). Published in 1938, by which time gardening had become a serious hobby for many British homeowners, the book gently pokes fun at 'keen amateurs of the trowel, the shears and the twopenny seed packet'. Despite addressing genuine concerns, it contains no serious horticultural advice. As Browne quips: 'The fact that neither Mr Heath Robinson nor myself has ever grown any of the flowers or vegetables mentioned in the work will not, we hope, detract from its education value or

its usefulness as a fly swatter.' Instead, readers learn about the importance of stilt-walking for weeding spring onions, how to curl curly kale using hair tongs, and that weeds are perfect for stuffing cushions. Browne's text is accompanied by several of Heath Robinson's characteristically impractical contraptions, including the 'Combined Telescopic Spaderake' for simultaneous digging and raking, and the 'Daff-Indicator', a dubious device that repurposes an old concertina and loudspeaker to signal the first blooms of spring.

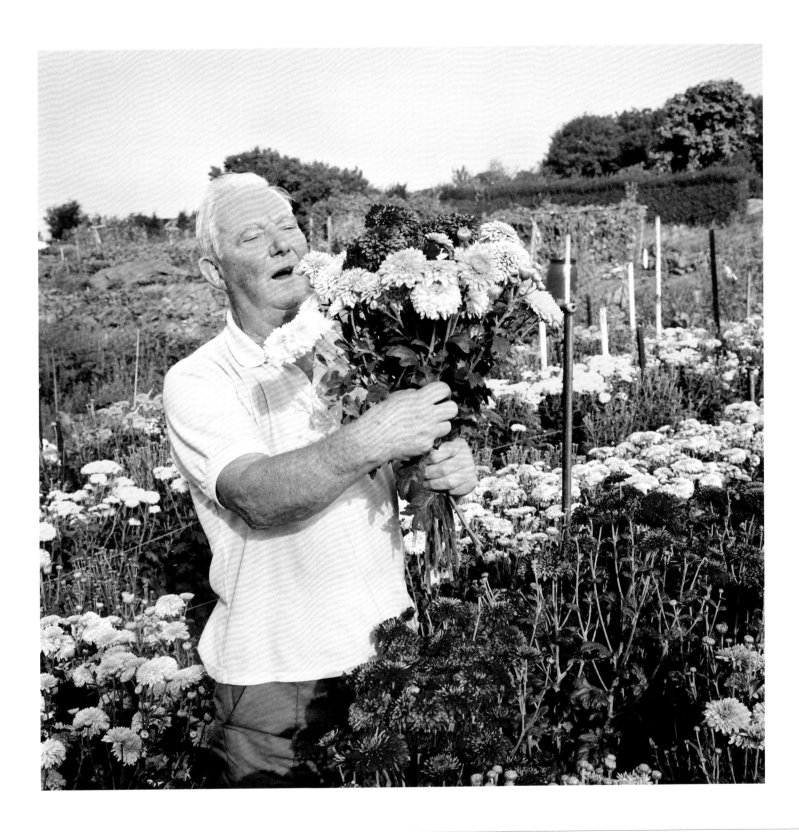

Andrew Buurman

Allotments, 2016

Photograph, dimensions variable
Private collection

Many gardeners will relish the triumph with which this gardener holds aloft a magnificent bunch of chrysanthemums in a photograph that captures the sheer pleasure allotment gardens have brought to British gardeners since the late nineteenth century. For the most part, though, allotments were strictly for growing vegetables, and flower growing was frowned upon, if not banned outright, on many sites. This grower, photographed by Andrew Buurman (b. 1966) as part of his *Allotments* series, has a plot on Uplands Allotments in Handsworth, Birmingham, the largest allotment site in Britain, with 422 plots. Unusually for a British allotment site, Uplands has always had a strongly social aspect, with weekly tea dances, bingo nights and an annual flower and vegetable show. Chrysanthemums may be best known as a commercial flower, but they have a particular place in British working-class garden culture: growing them to perfection and exhibiting them at late summer shows was a key part of a previous generation's gardening life. This 'grow for show' style of gardening has its roots in the 'florists' movement that started in the seventeenth century, when weavers grew flowers such as auriculas, polyanthus, pinks, ranunculus and tulips in pots in tiny yards, exhibiting them in competitive shows. The arrival in the nineteenth century of the chrysanthemum from China and the dahlia from Mexico added to the palette of plants grown by working-class gardeners. Today, chrysanthemum cultivation is on the decline in Britain, having been displaced by the growing of less labour-intensive flowering plants.

1939 BC

535 BC

60 BC

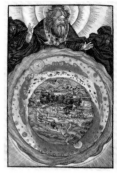

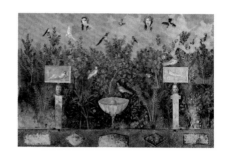

1

2

3

1939–1760 BC	A 12th Dynasty Egyptian tomb garden is created on the Dra Abu el-Naga hill at Luxor.
1800–1701 BC	*The Epic of Gilgamesh* refers to 'the Gardens of the Gods' and describes the city of Uruk (in present-day Iraq) as 'one-third' garden.
1600–1046 BC	Chinese kings and nobles of the Shang dynasty create enclosed hunting parks and celebrate the natural landscapes of the Yellow River Valley.
1495 BC	Egyptian pharaoh Hatshepsut imports trees from Punt – thought to be an area on the Red Sea – in the first recorded example of plant-hunting.
c.1450 BC	The Fresco of the Garlands in the Minoan palace at Knossos, Crete, depicts a number of plants that may have been cultivated.
c.1350 BC	A wall painting in the tomb of a high official of Egyptian pharaoh Amenhotep III at Thebes includes the earliest known depiction of an ornamental garden. ↑ 1, see p.53
800–701 BC	The mythical gardens of King Alcinous of the Phaiacians is described by Homer in his *Odyssey*.
c.722 BC	A cuneiform tablet lists plants grown in the garden of Marduk-apla-iddina II, a Chaldean prince who usurped the Babylonian crown.
c.716 BC	A designed landscape is created at Khorsabad (in present-day Iraq) for Assyrian king Sargon II.
c.690 BC	A designed landscape is made at Nineveh (present-day Mosul, Iraq) for Assyrian king Sennacherib.
c.600–401 BC	The original Book of Genesis tells the story of the Garden of Eden. ↗ 2, see p.285
546 BC	Gardens are created at Pasargadae (in present-day Iran) by its founder, the Achaemenid emperor Cyrus the Great.

535 BC	King Jing of the Chinese Zhou dynasty creates the lavish Terrace of Shanghua.
505 BC	Jing's son, King Dao, begins the even more elaborate Terrace of Gusu.
500–401 BC	Women in Athens make Adonis Gardens as part of the annual festival of Adonia, which mourned the death of Adonis.
400–301 BC	Persian *pairidaēza* (landscaped ornamental parks) belonging to Cyrus the Younger are described by Greek military leader and historian Xenophon in his *Oeconomicus*.
c.365–322 BC	Greek philosopher and scientist Aristotle writes twenty-six treatises on natural science including *De Plantis* (*On Plants*), although this is now generally attributed to Nicolaus of Damascus.
c.350–287 BC	Greek author Theophrastus, considered by some the 'Father of Botany', writes *Historia plantarum* (*Enquiry into Plants*); he inherited Aristotle's botanic garden in Athens.
307/6 BC	Greek philosopher Epicurus purchases a private house and garden just outside Athens, which becomes the location of his philosophical school.
300–201 BC	Ying Zheng, founder of the Qin dynasty, creates a palace garden near his capital of Xianyang.
c.206 BC–AD 220	*Divine Husbandman's Materia Medica*, a compilation of Chinese oral traditions concerning agriculture and medicinal plants, is created; it is traditionally attributed to the mythological emperor Shennong.
200–101 BC	The Shang Lin (Great Grove) is created by Emperor Wu of the Han dynasty outside his capital of Chang'an (now Xi'an, Shaanxi Province), China.
c.160 BC	The Roman soldier Cato the Elder writes *De Agricultura*.

c.60 BC	The Gardens of Lucullus on the Pincian Hill in Rome are laid out by Lucius Licinius Lucullus using Persian garden-making ideas. The Villa Borghese gardens still cover 6.9 hectares (17 acres) of the site today.
30s BC	The Villa of Livia, famous for its frescoed garden room, is built for Livia Drusilla, wife of Emperor Augustus, at Prima Porta, just north of Rome.
28 BC	A large circular mausoleum with a garden is built in Rome for Emperor Augustus.
c.AD 27–37	Emperor Tiberius grows cucumbers in a *specularia*, or proto-greenhouse, at Villa Jovis on the island of Capri.
AD 50–70	Greek physician Dioscorides writes *De Materia Medica* (*On Medical Material*), about using plants in medicine.
c.AD 75	A Roman garden is created at Fishbourne Palace in West Sussex, England, the largest Roman residence north of the Alps, for Tiberius Claudius Cogidubnus.
c.AD 77	*Historia Naturalis* (*Natural History*) is compiled by Roman writer Pliny the Elder, containing early references to topiary, which Pliny says was invented by G. Matius, who lived at the end of the 1st century BC.
AD 79	The eruption of Vesuvius buries the cities of Pompeii and Herculaneum in southern Italy in ash and lava, preserving many gardens. The rediscovered Villa dei Papiri at Herculaneum became the model for the Getty Villa at Pacific Palisades, California, built in 1974. ↑ 3, see p.255
AD 100–199	The Garden of General Liang Ji is one of the first gardens in China to attempt to create an idealized version of nature. A Roman *domus* garden is created at the Casa dos Repuxos in Conímbriga, Portugal.
AD 138	Roman emperor Hadrian builds his villa and garden at Tivoli, outside Rome.

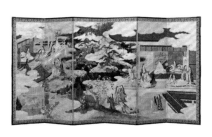

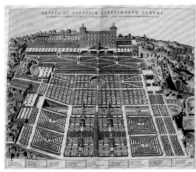

| 4 | 5 | 6 | 7 |

AD 400–99 The Palace Garden at Sigiriya, Sri Lanka, is created by King Kashyapa as part of his new fortress.

AD 494–812 *Capitulare de Villis* (*Decrees Concerning Towns*) is commissioned by Emperor Charlemagne and lays out the elements of land use in the Holy Roman Empire, including how much land should be planted.

AD 591–626 A formal garden and *pairidaēza* at Imarat-i Khosrow palace, Qasr-I Shitin, Iran, is created by the last great Sasanian (Persian) king, Khosrow Parviz.

AD 600–99 The Irish saint Fiacre creates the first garden specifically dedicated to the Virgin Mary at Breuil (now Saint-Fiacre), France.

AD 710 The East Palace Garden at Heijō Palace (now Nara) in Japan is laid out as an expression of Pure Land Buddhism (like the nearby Kyūseki Teien garden).

AD 727 Hisham ibn 'Abd al-Malik, the tenth Umayyad caliph, makes an early Islamic garden at Qasr al-Hayr al-Gharbi, near al-Rusafa, Syria, which is later destroyed by the Mongol army.

AD 756 The rural villa of Al-Munyat al-Rusafa is created for Abd al-Rahman, first emir of Córdoba in Spain, with extensive gardens. It is destroyed in 1010.

AD 820–30 A plan of St Gall monastery – the only surviving major architectural drawing from the period between the fall of the Roman Empire and the 13th century – clearly shows the monastic gardens.

AD 820–49 Benedictine monk Walafrid Strabo writes *Hortulus*, an account of his garden on Reichenau Island, southern Germany.

1000–99 The Bustān al-Nā'ūra or Huerta del Rey, one of the earliest botanical collections in Europe, is made for Al-Ma'mūn of Toledo by Ibn Wāfid.

c.1001–20 *The Tale of Genji* is written by Murasaki Shikibu. ↖ 4, see p.300

1053 The Byōdō-in temple is built at Uji, to the south of Kyoto, Japan.

c.1085 Leading Andalusian botanist and agronomist Ibn Baṣṣāl writes his horticultural treatise, *Kitāb al-Kasd wa 'l-bayān*.

1100–1199 *Umdat al-ṭabīb fī maˊrifat al-nabāt li-kull labīb*, probably the most important botanical encyclopedia of medieval Islam, is written in Al-Andalus by the scholar Abū l-Khayr al-Ishbīlī.

c.1180 Alexander Neckam, a teacher and later the Abbot of Cirencester, writes *De Naturis Rerum* and *Laudibus Divinae Sapientiae*, which describe botanical knowledge of the time.

c.1256 German philosopher and scientist Albertus Magnus writes *De Vegetabilibus*.

After 1273 The Generalife at Granada, Spain, famous for its Patio de la Acequia, is built by Nasrid sultan Muhammad II near the Alhambra.

1304–9 Bolognese jurist Pietro de Crescenzi writes *Ruralia commoda*, containing descriptions of medieval gardens.

1353 Giovanni Boccaccio publishes *The Decameron*, a collection of short stories set in an abandoned villa and its gardens.

After 1362 The Court of Lions within the Alhambra palace complex, Granada, Spain, is commissioned by Nasrid sultan Muhammad V.

1393 The retirement villa of Shōgun Ashikaga Yoshimitsu, Kinkaku-ji (the Golden Pavilion), is built in Kyoto, Japan; it later becomes a Buddhist temple.

1430 *The Little Garden of Paradise*, a painting by an unknown artist from the Upper Rhine, shows a *hortus conclusus* or Mary garden. ↖ 5, see p. 133

After 1431 The royal botanic and pleasure garden at Texcotzingo is designed and created by Nezahualcoyotl, *tlatoani*, or ruler, of the city-state of Texcoco, Mexico.

c.1440 Mayster Ion (John) Gardener publishes *The Feate of Gardening*, the first English book on gardening; the text was probably composed decades earlier.

1443–52 Leon Battista Alberti writes *De re Aedificatoria* (*On the Art of Building*), the first Renaissance text to include advice on garden design.

1451 Alberti designs the Villa de Medici, Fiesole, the prototype Italian Renaissance villa and garden, for Giovanni de' Medici, son of Cosimo; construction is completed in 1457.

1460s The royal pleasure garden at Huastepec (now Oaxtepec, Mexico) is created by Aztec ruler Moctezuma I.

From 1482 The retirement villa of Shōgun Ashikaga Yoshimasa, Ginkaku-ji (the Silver Pavilion), is built in Kyoto, Japan; it becomes a Buddhist temple upon his death.

1490s The Zen *karesansui* (dry garden) is made at the temple of Ryōan-ji, Kyoto, Japan.

1499 *Hypnerotomachia Poliphili*, an early printed pamphlet by Dominican priest Francesco Colonna, contains many woodcut illustrations of gardens.

After 1504 The first Mughal emperor, Babur, lays out nine gardens at Kabul (now in Afghanistan) after capturing the city.

1515–26 Zhuo Zheng Yuan (Garden of the Inept Administrator) is created in Suzhou, China, by Wang Xianchen.↑ 6, see p.118

c.1528 The Garden of Babur is built in Kabul, containing the tomb of the first Mughal emperor; it is restored in the early 2000s.

1528 The first Islamic garden in India is made at Aram (often Ram) Bagh, Agra, by Emperor Babur.

1537 Villa di Castello, the country residence of Cosimo I de' Medici, is created with gardens by Niccolò Tribolo.

1543 Europe's first botanic garden is established in Pisa by Luca Ghini.

1550 Villa d'Este is built at Tivoli by Ligorio for Cardinal Ippolito II d'Este; work continues until 1586. ↑ 7, see p.280

1552 The Sacro Bosco at Bomarzo is designed by Pirro Ligorio and its owner, Prince Vicino Orsini.

1553 *Crónicas del Perú* by Pedro Cieza de León becomes the first Western botanical record of South American flora.

c.1555 The topographical drawing of Henry VIII's Hampton Court Palace by Anthonis van Wyngaerde is the first known depiction of an English garden.

1561 *De Hortis Germaniae Liber Recens* contains the first published illustration of a tulip growing in a European garden.

1566 Villa Lante in Bagnaia, Italy, is created by Giacomo Barozzi da Vignola for Cardinal Gianfrancesco Gambara and completed by Cardinal Alessandro Peretti di Montalto.

1568 Thomas Hill writes *The Profitable Arte of Gardening*.

1573 Thomas Tusser writes *Five Hundred Points of Good Husbandry*.

1576–9 *Les plus excellents bastiments de France* by Jacques I Androuet du Cerceau describes many now lost French Renaissance gardens.

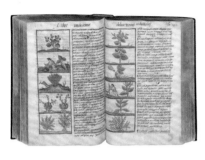

8

9

10

11

1577	Thomas Hill (under the pseudonym Didymus Mountain) writes *The Gardeners Labyrinth*.
	Historia general de las cosas de Nueva España (The Florentine Codex) is published by Bernardino de Sahagún, describing Aztec horticulture among other subjects. ↑ 8, see p.322
1590	Bagh-e-Fin gardens in Kashan, Iran, is made for Shah 'Abbās I. What is visible today is mostly a 19th-century renovation attributed to Fath 'Ali-Shah.
From 1592	Amber (or Amer) Fort Garden in India is created for Man Singh I, a trusted Rajput general of Emperor Akbar.
1593	Carolus Clusius is appointed the first *Horti Praefectus* (director) of the botanic garden at Leiden, the Netherlands.
	Xu Taishi begins the creation of Liú Yuán (The Lingering Garden) in Suzhou, China; it is expanded by Liu Su in the early 19th century, and has since been restored twice.
1595	Claude Mollet begins work on the gardens at Château Saint-Germain-en-Laye, Paris.
1597	John Gerard publishes *Herball, or Generall Historie of Plantes*.
	The first recorded instance of a South African plant, *Protea neriifolia*, is introduced in Europe; it is given the erroneous name 'Thistle from Madagascar'.
1598	Safavid ruler 'Abbās I of Persia makes Isfahan, Iran, his capital and develops it into a city of gardens.
1599	Giusto Utens begins painting seventeen lunettes of the villas and gardens of the Medici family.
1600s	European settlers in America learn the traditional Three Sisters planting technique from native Indigenous peoples.
1613–19	Hortus Palatinus, Heidelberg, is built by French engineer Salomon de Caus for the Elector Palatine.

1618	*A New Orchard and Garden* by William Lawson is printed together with *The Country House-Wife's Garden*, which contains designs for knot gardens.
1619	Shalimar Bagh at Srinagar, Kashmir, is made by the fourth Mughal Emperor, Jahangir, for his wife Nur Jahan.
c.1620	Inspired by *The Tale of Genji*, Prince Hachijō Toshihito begins the strolling garden at Katsura Imperial Villa, Kyoto, Japan.
1621	Oxford Physic Garden is founded as England's first botanic garden.
1625	Francis Bacon publishes *Of Gardens*.
1629	John Parkinson writes *Paradisi in sole paradisus terrestris*.
1631	*Yuan ye* (translated as *The Garden Treatise* or *The Craft of Gardens*) by Ji Cheng becomes the definitive work on garden design of the late Ming dynasty.
	Work begins on the Taj Mahal and gardens. Commissioned by the fifth Mughal emperor, Shah Jahān, it is completed in 1653.
1632	Isola Bella, Lake Maggiore, is designed by Angelo Crivelli for Carlo III Borromeo, and completed 1671.
1633	Nishat Bagh at Srinagar, Kashmir, is made by Asif Khan, elder brother of Nur Jahān.
1634	Boston Common in Massachusetts is purchased for the people as a town common; it becomes a public park in the 1830s.
	The complex of gardens and water features at Pura Taman Ayun temple is created at Badung Regency, Bali.
1635	The Jardin des Plantes is established in Paris as the Royal Garden of Medicinal Plants by an edict of King Louis XIII.

1637	John Tradescant the Younger makes a plant-hunting expedition to the environs of Jamestown, Virginia.
1641	André Le Nôtre begins work on the garden at Château de Vaux-le-Vicomte in France, completed in 1661.
1642	Shalimar Bagh, Lahore, is completed for the Mughal emperor Shah Jahān.
1652	The Company's Garden in Cape Town, is founded by Hendrik Boom of the Dutch East India Company.
1661	André Le Nôtre begins work on the garden at the Palace of Versailles; his work there lasts until 1678.
	The first record of the New Spring Garden at Vauxhall in London is made by diarist John Evelyn; the space is relaunched in 1732 as Vauxhall Gardens, the first and most significant pleasure garden of Georgian London.
1663	*The Compleat Gard'ner* by Jean-Baptiste de La Quintinie is translated into English by John Evelyn.
1667	Les Jardins des Tuileries in Paris, formerly a palace garden created by Catherine de' Medici in 1564, opens to the public. ↖ 9, see p.93
1671	A Renaissance, Indo-Portuguese and Moorish-influenced garden is made at the Palácio Fronteira, Lisbon, by Dom João de Mascarenhas, 1st Marquis of Fronteira.
1673	The Chelsea Physic Garden in London is established as the Apothecaries' Garden by the Worshipful Society of Apothecaries.
1684	Daniel Marot designs Het Loo in Gelderland, the Netherlands, for William of Orange and his English wife, Mary Stuart; the house and garden are completed in 1686.
1686–1707	*Historia Plantarum Generalis* by John Ray documents more than 17,000 plant species from all over the world.

1689	George London and Henry Wise become sole partners at Brompton Park Nursery, London, famous for creating Baroque gardens.
1690	*Upon the Gardens of Epicurus*, an essay by Sir William Temple, considered the origin of the English Landscape style, is published.
	George London and Daniel Marot begin work on the Baroque garden at Hampton Court Palace for the new monarchs William III and Mary II, completed 1702.
	Engelbert Kaempfer arrives at Dejima island in Nagasaki Bay, Japan, and makes the first Western study of Japanese flora.
1700s	Thumb pots – filled from small holes in the bottom and the user's thumb placed over the top to create a vacuum – are superseded by watering pots that are filled from the top. ↖ 10, see p. 114
1707	The creation of the complex of gardens at the Old Summer Palace (Yuanming Yuan) in Beijing, China, commences; it is destroyed in 1860 by Anglo-French troops. ↑ 11, see p.316
1707–9	*Britannia Illustrata*, is published by Dutch draughtsman Jan Kip and artist Leonard Knyff.
1709	Dezallier d'Argenville writes *La Theorie et la Pratique du Jardinage*.
1713	Richard Temple, 1st Viscount Cobham, begins work on the landscape at Stowe House, Buckinghamshire. The first design is by Charles Bridgeman and Sir John Vanbrugh.
1714	Jean-Baptiste Alexandre Le Blond begins work on the gardens at Peterhof Palace, Russia, for Tzar Peter the Great.
1715	Stephen Switzer publishes *The Nobleman, Gentleman, and Gardener's Recreation* (expanded to *Ichnographia Rustica* in 1718), which contains the first published history of gardening and introduces the term *ferme ornée*.

1717	1750	1771	1791

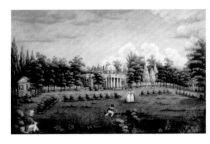

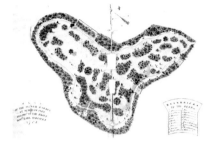

12	13	14	15

1717 British poet Alexander Pope begins his garden at Twickenham, London. In 1731 publishes his poem 'On Taste', advocating the new naturalistic landscape style.

1728 John Bartram of Philadelphia establishes his botanic garden, the oldest surviving of its kind in North America.

1729–49 *The Natural History of Carolina, Florida and the Bahama Islands* by Mark Catesby becomes the first published account of the flora and fauna of North America.

1731 William Kent joins Charles Bridgeman as landscape designer at Stowe and becomes sole designer in 1735, working there until his death. From 1741 the head gardener is Lancelot Brown.

The Gardener's Dictionary is published by Philip Miller.

1735–65 John Bartram, the 'Father of American Botany', hunts for plants on the eastern seaboard of North America, between Lake Ontario and Florida.

1737–41 William Kent begins work at Rousham, Oxfordshire, for Colonel James Dormer; Rousham is now the only extant unmodified Kentian landscape.

1741 Work begins on Middleton Place, Charleston, South Carolina, for Henry Middleton, the first landscape garden created in North America.

Work begins on the allegorical landscape garden at Stourhead, Wiltshire, designed by the owner Henry Hoare II and completed in 1780.

1743 John Bartram helps to found the American Philosophical Society in Philadelphia with, among others, Benjamin Franklin.

The poet William Shenstone begins his *ferme ornée* at The Leasowes in Halesowen, Shropshire, England.

c.1745 Lewis Kennedy partners with James Lee at the Vineyard Nursery in Hammersmith, west of London.

c.1750 The garden at Schönbrunn Palace in Vienna is extended by Jean-Nicolas Jadot de Ville Issey and Louis Gervais; it is completed in 1775 and opens to the public in 1779.

1751 Lancelot Brown sets up in practice and acquires the epithet 'Capability'.

1752 Work begins on the Palazzo Reale in Caserta, Italy, for Charles VII of Naples, who worked closely with his architect, Luigi Vanvitelli.

1753 *Species Plantarum* by Carl Linnaeus introduces a new way of classifying plants. ↖ 12, see p.11

Rhododendron maximum is the first of the genus to arrive in Britain from the Allegheny Mountains of North America.

The first American community garden is founded at the Moravian settlement of Bethabara near Winston-Salem, North Carolina.

1754 George Washington begins leasing Mount Vernon, Virginia, and develops the gardens there until his death.

1764 Capability Brown begins arguably his finest work, Blenheim Palace in Oxfordshire.

1767 *Every Man His Own Gardener* is published under the name of Thomas Mawe. The actual author, John Abercrombie, was jointly acknowledged only from the seventh edition onwards.

1768–71 Joseph Banks becomes the first to botanize New Zealand and Australia as naturalist aboard HMS *Endeavour* during James Cook's first circumnavigation.

1769 Thomas Jefferson begins developing the garden at Monticello in Charlottesville, Virginia, which he continues until his death. ↑ 13, see p.33

c.1771 King George III appoints Joseph Banks unofficial director of the Royal Botanic Garden at Kew.

1771 Island beds are made at Nuneham Courtenay in Oxfordshire by George Simon, 2nd Earl Harcourt, and his friend the poet and garden designer Reverend William Mason. ↑ 14, see p.41

Francis Masson, Kew's first plant-hunter, is sent to South Africa.

1772–81 *The English Garden: A Poem* by William Mason is published in four books.

1775 Humphry Marshall, a cousin of John Bartram, writes *Arboretum Americanum*.

1777 The first plant catalogue is published by Loddiges Nursery, Hackney, founded by Joachim Conrad Loddiges.

1778 Some of the earliest allotments are created on land outside the fortifications of the town of Fredericia, Denmark.

1780 Horace Walpole publishes *The History of the Modern Taste in Gardening*.

c.1785 Wǎngshī Yuán (The Garden of the Master of the Nets) in Suzhou, China, which dated to 1140, is remodelled by Song Zongyuan.

1786 The Santa Barbara Mission Garden is established by Spanish Franciscan monks alongside the first of twenty-one religious outposts in what is now California.

1787 Acharya Jagadish Chandra Bose Indian Botanic Garden is founded at the Calcutta Botanic Garden by Colonel Robert Kyd of the British East India Company.

Curtis's Botanical Magazine is first published, under the title *The Botanical Magazine*.

1788 Humphry Repton sets up in practice as a 'landscape gardener', a title he invented.

1791–5 Archibald Menzies, naturalist on the Vancouver Expedition that circumnavigated the globe, plant-hunts for Kew and introduces the monkey-puzzle tree (*Araucaria araucana*).

1794 Sir Uvedale Price publishes *Essay on the Picturesque*.

1801 Physician David Hosack establishes the Elgin Botanic Garden in New York, the first public botanical garden in the United States.

1803 Humphry Repton writes *Observations on the Theory and Practice of Landscape Gardening*. ↑ 15, see p.83

1804 The Royal Horticultural Society is founded as the Horticultural Society of London; it is renamed in 1861.

1806 Bernard McMahon publishes *The American Gardener's Calendar*.

Suttons Seeds is founded in Reading, Berkshire, England, by John Sutton.

1812 Humphry Repton begins work at Sheringham Hall in Norfolk, calling the design his 'darling child'.

1815 Muskau Park in the Upper Lusatia region of Germany and Poland is laid out for Hermann Ludwig Heinrich von Pückler-Muskau; it is sold in 1845 owing to massive debts.

1820 An act of Congress establishes the United States Botanic Garden in Washington DC.

1822 *An Encyclopædia of Gardening* by John Claudius Loudon contains the first detailed published history of garden-making.

1826 The first gardening periodical, *The Gardener's Magazine*, is run by J. C. Loudon until his death.

1829 *A History of English Gardening* by George Johnson is the first book published on the subject.

1829

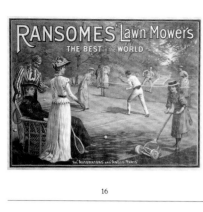

16

1841

17

1856

18

1888

19

1829 The first Philadelphia Flower Show is held by the Pennsylvania Horticultural Society, founded in 1827.

1830s John Caie works as head gardener at Bedford Lodge, Kensington, pioneering displays of summer bedding using tender annuals that are publicized through *The Gardener's Magazine*.

1830 The lawn mower is invented and patented in England by Edwin Beard Budding, who also invents the adjustable spanner in 1842. ↑ 16, see p.292

1831 The first Allotment Act comes into law in Britain. By 1873 there are 242,542 allotments covering 58,966 acres, and the Allotment Act of 1887 created another 200,000.

1832 *Practical Hints for Landscape Gardeners* is published by William Sawrey Gilpin.

1834–42 Sir Charles Barry, a pioneer of the Italian style, designs the gardens at Trentham Hall in Staffordshire.

1836 The Great Stove at Chatsworth, then the world's largest glasshouse, is designed by head gardener Joseph Paxton; it is completed in 1840.

Owner Martha Turnbull begins work at Rosedown Plantation, St Francisville, Louisiana.

1838 J. C. Loudon writes *The Suburban Gardener and Villa Companion*, in which he defines his concept of the Gardenesque style.

1840 *Gardening for Ladies* is published by Jane Loudon.

Derby Arboretum, designed by J. C. Loudon, becomes Britain's first public park.

1841 Influential weekly periodical the *Gardener's Chronicle* is founded by Joseph Paxton and John Lindley, among others. It runs for almost 150 years and still exists as part of the trade magazine *Horticulture Week*.

1841 Andrew Jackson Downing publishes *Landscape Gardening*.

1842 *On the Growth of Plants in Closely Glazed Cases* by Dr Nathaniel Bagshaw Ward describes his invention, the Wardian Case.

William Lobb becomes the first plant-hunter employed by the Veitch Nursery when he visits South America.

1843 Rothamsted Research is founded as Rothamsted Experimental Station, England, by Sir John Lawes and Sir Henry Gilbert; it is the world's first agricultural and horticultural research institution.

Robert Fortune becomes the first plant-hunter to explore the interior of eastern China on behalf of the Horticultural Society of London.

c.1846 An early example of a double herbaceous border appears at Arley Hall, Cheshire, England.

1849 James and Maria Bateman, together with their friend Edward William Cooke, begin the garden at Biddulph Grange, Staffordshire; it is sold in 1871 owing to overstretched finances.

1849–50 Joseph Hooker becomes the first European to visit the Himalayan kingdom of Sikkim when he plant-hunts on behalf of Kew.

1850s Sir Charles Isham introduces the garden gnome to Britain at Lamport Hall, Northamptonshire.

1850 Matthew Vassar hires Andrew Jackson Downing to design Springside in Poughkeepsie, New York; today it is one of the few surviving examples of Downing's work.

1851 The Crystal Palace of the Great Exhibition in London is designed by Joseph Paxton.

1856 *Rustic Adornments for Homes of Taste* is published by James Shirley Hibberd.

1856 John Dominy, working for the Veitch Nursery, flowers the first orchid hybrid, *Calanthe × dominii* (*C. masuca* × *C. fusca*).

1858 Frederick Law Olmsted and Calvert Vaux win the competition to design Central Park in New York City, which is completed in 1876.

1859 Red House in Kent, England, is co-designed by Philip Webb and owner William Morris; it is the first Arts and Crafts house and garden.

1860 John Gould Veitch and Robert Fortune plant-hunt in Japan.

1861 Dr George Rogers Hall sends the first consignment of Japanese ornamental plants to the United States.

1864 By now, subtropical bedding is being displayed at Battersea Park, London, the work of head gardener John Gibson.

1866 *The American Gardener's Assistant* is published by Thomas Bridgeman.

1868 Carpet bedding is invented by head gardener John Fleming at Cliveden, Buckinghamshire. ↖ 17, see p.331

1870 Horticulturist William Robinson publishes *The Wild Garden*.

1872 Thomas Algernon Smith-Dorrien-Smith begins the garden at Tresco Abbey, in the Isles of Scilly.

1882 The Marianne North Gallery opens at Royal Botanic Gardens Kew.

1883 William Robinson publishes *The English Flower Garden*.

Claude Monet moves to Giverny and starts to create a garden – the famous waterlily pond dates from 1893. He lives at Giverny until his death.

1884 William Robinson moves to Gravetye Manor and gardens there until his death.

1888 Jens Jensen, a pioneer of the Prairie Garden, plants a wildflower garden at Union Park, Chicago, creating what became the American Garden.

1889 Work begins on Biltmore House for George Washington Vanderbilt II; the garden and park are designed by Frederick Law Olmsted.

1890s The Battle of Styles for the future of British garden design is 'fought' by William Robinson and architect Reginald Blomfield. The winner is the Arts and Crafts garden of Gertrude Jekyll and architect Edwin Lutyens.

1891 John Dando Sedding publishes *Garden Craft Old and New*.

A group of women from Georgia organize the Ladies Garden Club of Athens, the first women's gardening society of its kind in the United States.

1892 Reginald Blomfield writes *The Formal Garden in England*.

1893 *Landscape Gardening in Japan* by Josiah Conder is the first English-language work published on the subject. ↖ 18, see p.66

1894 Charles A. Platt publishes *Italian Gardens*.

1897 Gertrude Jekyll moves into Munstead Wood in Godalming, Surrey. The house is designed by Edwin Lutyens, and the 6-hectare (14.8-acre) garden becomes her laboratory and the inspiration for her writings. ↑ 19, see p.63

Edward Hudson launches the weekly magazine *Country Life*.

1899 The American Society of Landscape Architects is founded.

Gertrude Jekyll publishes her first book, *Wood and Garden*.

Ernest Wilson, the penultimate of the Veitch Nursery's 22 plant-hunters, makes his first of four expeditions to western China. The last two are on behalf of Harvard's Arnold Arboretum.

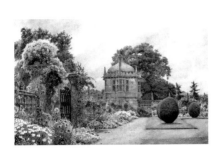

20

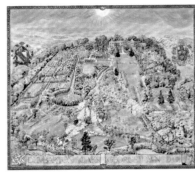

21

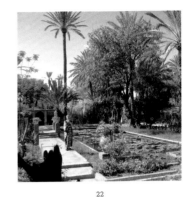

22

23

1900	The New York Botanical Garden opens to the public after nine years of planning and development.
	Thomas H. Mawson publishes *The Art & Craft of Garden Making*. ↑ 20, see p.68
1903	George Forrest makes the first of seven plant-hunting expeditions to Yunnan in western China.
1904	Gertrude Jekyll and Edwin Lutyens begin work at Hestercombe in Somerset; it is completed in 1906.
1906	Frank Kingdon-Ward makes the first of 22 plant expeditions to northwest China, Myanmar, Assam and Tibet. His last trip is to Sri Lanka in 1956.
1907	Lawrence Johnston moves to Hidcote Manor, Gloucestershire, England, and begins making his garden.
1908	Dr Joachim Carvallo begins re-creating a 17th-century-style *potager* at Château de Villandry in the Loire Valley; it is completed in 1918.
1913	The first Chelsea Flower Show (then known as the Great Spring Show) is staged by the Royal Horticultural Society at Ranelagh Gardens, part of the Royal Hospital Chelsea, London.
	Kirstenbosch National Botanical Garden in Cape Town, South Africa, is founded by Professor Harold Pearson.
	The Garden Club of America is founded.
1916	Work begins on Greystone (now the Untermyer Garden) for Samuel J. Untermyer, who works closely with designer William Welles Bosworth.
1917	Charles Lathrop Pack organizes the United States' National War Garden Commission; its 'Victory Gardens' were created in both world wars.
	Work begins on the Woodland Cemetery (Skogskyrkogarden) at Enskede, Stockholm, designed by Erik Gunnar Asplund and Sigurd Lewerentz, and completed in 1940.

1919	Ferdinand Bac begins his garden at Les Colombières in Menton, France, which is completed 1927; it is restored from 1995 by British couple Michael and Margaret Likierman.
1921	Pierre du Pont opens Longwood Gardens in Kennett Square, Pennsylvania, to the public.
	Beatrix Farrand begins her 29-year collaboration with owner Mildred Bliss at Dumbarton Oaks in Georgetown, Washington DC. ↑ 21, see p.64
	Gelasio Caetani begins the gardens at Ninfa in Cisterna di Latina, Italy.
1922	The American Horticultural Society is established.
	Diego Suarez begins work on Vizcaya in Miami, Florida, completed in 1945.
	Gabriel Guevrekian creates the Cubist Garden at Villa Noailles, Hyères, completed in 1927.
1924	Jacques Majorelle begins nearly four decades of developing Le Jardin Majorelle in Marrakech, Morocco. ↗ 22, see p.142
1925	*Italian Gardens of the Renaissance* is published, the first book by Geoffrey Jellicoe and John Shepherd.
	Wilhelmina Jacoba Moussault-Ruys begins what is now Mien Ruys Tuinen in Dedemsvaart, the Netherlands.
1926	Mabel Choate begins a long collaboration with designer Fletcher Steele at Naumkeag in Stockbridge, MA; the garden is completed in 1955.
	Elsie Reford begins work on the Jardins de Métis (the Reford Gardens) at Grand-Métis, Québec, Canada, completed in 1958.
1929	Britain's Landscape Institute is founded as the Institute of Landscape Architects, with Thomas H. Mawson as first president.
	The Islamic-inspired gardens of Sir Edwin Lutyens at Rashtrapati Bhavan in Delhi are completed.

1930	*New Pioneering in Garden Design* is published by Fletcher Steele.
	Vita Sackville-West and Harold Nicolson purchase Sissinghurst Castle and begin to make their garden.
1935	Ellen Biddle Shipman begins work at Longue Vue in New Orleans for Edgar and Edith Stern.
1936	Cecil Henry Middleton presents *In Your Garden*, the first television gardening programme on the BBC.
1937	Margery Fish begins three decades of gardening at East Lambrook Manor in Somerset, where she reinvents the cottage garden for the twentieth century.
1938	*Gardens in the Modern Landscape* is published by Christopher Tunnard.
1939	The Dig for Victory campaign is launched by the British Ministry of Agriculture at the start of World War II. ↗ 23, see p.200
1941	Ganna Walska begins work on the gardens at Lotusland in California.
1946	Alan Bloom begins Bressingham Gardens in Diss, Norfolk. His son Adrian begins the gardens at Foggy Bottom in 1963.
1948	Brenda Colvin publishes *Land and Landscape*.
	El Novillero in Sonoma, California, is created by Thomas Church.
	Luis Barragán builds his house, studios and garden in Miguel Hidalgo district, Mexico City.
1949	Markdale in New South Wales is created by the pioneering Australian garden designer Edna Walling.
	Roberto Burle Marx acquires Sítio de Santo Antonio da Bica, Barra de Guaratiba, Rio de Janeiro, where he makes his garden until his death.

1950	Garrett Eckbo publishes *Landscape for Living*.
1951	The Regatta Restaurant Garden at the Festival of Britain, designed by Maria and Peter Shepherd, is the first Modernist garden in Britain.
1952	Pura Taman Saraswati Hindu temple garden is created by I Gusti Nyoman Lempad in Ubud, Bali.
1955	Thomas Church publishes *Gardens Are for People*.
1956	Sylvia Crowe publishes her first book, *Tomorrow's Landscape*.
1957	*The Mixed Border in the Modern Garden* is the first book by Christopher Lloyd, who made his garden at Great Dixter, East Sussex, England, from 1954.
1958	Garden Organic is founded, now Henry Doubleday Research Association.
1960	Beth Chatto begins her garden on part of the Chatto fruit farm at Elmstead Market near Colchester, Essex.
	The US Department of Agriculture Plant Hardiness Zone map is created.
1964	Ayrlies Garden near Whitford, New Zealand, is created by Beverley and Malcolm McConnell.
1965	The JFK Memorial is created at Runnymede, Surrey by Geoffrey Jellicoe, who also designs the water garden at Shute House in Wiltshire, England, in 1978.
	Francis Cabot, founder of The Garden Conservancy, begins the gardens at Les Quatre-Vents in La Malbaie, Québec, Canada.
1966	The Garden History Society (now The Gardens Trust) is founded in Britain.
	Work on the Halprin Open Space Sequence in downtown Portland, Oregon, is begun by Lawrence Halprin. Completed in 1970, it includes the Ira Keller Fountain by Angela Danadjieva.

24

25

26

27

1966	Little Sparta (then named Stonypath) at Dunsyre in the Pentland Hills, Scotland, is begun by Ian Hamilton Finlay and his wife, Sue Finlay.
1967	Paley Park, a pocket park designed by Robert L. Zion in downtown Manhattan, New York, opens to the public.
1968	*Gardeners' World* is broadcast for the first time, presented by Ken Burras; later presenters include Percy Thrower, Alan Titchmarsh and Monty Don.
1969	*Room Outside* is published by John Brookes.
1970	Adachi Museum of Art in Yasungi City, Japan, is established by Adachi Zenko.
1971	Sylvia Crowe begins the landscape design at Rutland Water reservoir in England.
1975	Horticulturist and photographer Valerie Finnis is awarded the Victoria Medal of Honour by the Royal Horticultural Society. ↑ 24, see p.81
1976	The Garden Museum is founded as the Museum of Garden History in Lambeth, London.
1977	Wolfgang Oehme and James van Sweden pioneer the New American Garden at the Virginia Avenue gardens of the Federal Reserve in Washington DC.
	Isamu Noguchi begins the sculpture garden California Scenario at Costa Mesa, completed in 1982.
1980	Elizabeth Barlow Rogers founds the Central Park Conservancy in New York.
1982	Piet Oudolf begins his own garden at Hummelo in Gelderland, the Netherlands.
1983	The Promenade Plantée, a linear park, is made on disused rail tracks in Paris; it is the precursor of New York's High Line, which opens in 2009.

1984	Liverpool Garden Festival is established, the first of five national garden festivals aimed at regenerating large areas of derelict land in Britain's industrial districts; the last is held in 1992.
	Pearl Fryar begins work on his 3-acre topiary garden at his home in Bishopville, South Carolina.
1987	Prospect Cottage in Dungeness, Kent is purchased by filmmaker Derek Jarman, who creates the garden there until his death.
	British horticulturist and gardener Dan Pearson establishes up his landscape design practice. ↑ 25, see p.315
1989	The Garden Conservancy is founded in the United States.
	Charles Jencks and his wife, Maggie Keswick Jencks, begin planning the Garden of Cosmic Speculation at Portrack House, near Dumfries, Scotland.
1990	The restoration of the Elizabethan garden at Kenilworth Castle, near Solihull in England, opens to the public.
	Starring Johnny Depp and Winona Ryder and directed by Tim Burton, *Edward Scissorhands* and his topiary creations become an instant success.
1991	Martha Schwartz creates the garden at the Dickinson Residence in Santa Fe, New Mexico.
1992	Jeremy Francis begins the garden at Cloudehill in Olinda, Victoria, Australia.
1995	Mas de les Voltes in Ampurdan, Catalonia, Spain, is completed by Fernando Caruncho.
	Acclaimed American farm-to-table chef Alice Waters founds The Edible Schoolyard non-profit program in Berkeley, California.
1996	Jardin Los Vilos in Coquimbo, Chile, is designed by Juan Grimm.

1996	Conceived by Maggie and Charles Jencks as cancer treatment centres in which gardens are an essential recuperative element, the first Maggie's Centre opens in Edinburgh.
1997	Jane Percy, Duchess of Northumberland commissions Wirtz International to develop the new garden at Alnwick Castle, Northumberland.
2000	Dan Hinkley begins a new garden at Windcliff in Indianola, Washington.
	Tokachi Millennium Forest, near Obihiro, Hokkaido, Japan, is created by Dan Pearson and Fumiaki Takano.
	Designed by Tadao Ando, Awaji Yumebutai opens in the Hyogo prefecture of Japan; it includes the Hyakudanen Garden with one hundred stepped flower beds.
2001	Terraced gardens of the Shrine of the Báb of the Baháʼí faith are created at Mount Carmel in Haifa, Israel.
2004	Topher Delaney creates the Carolyn S. Stolman Healing Garden at the Avon Comprehensive Breast Care Center, San Francisco General Hospital.
	The 30-hectare (74-acre) Al-Azhar Park in Cairo opens to the public, designed by Sites International for the Aga Khan Trust for Culture.
	The garden complex at the Hindu Akshardham Temple in New Delhi is created.
2005	Designed by Taylor Cullity Lethlean and Paul Thompson, the first stage of The Australia Garden in the Royal Botanic Gardens in Cranbourne opens.
2006	Tom Stuart-Smith's reworked planting design of the parterre at Trentham Hall is completed.
2009	Zynga launches the social network game *FarmVille* on Facebook, reaching 83.76 million monthly active users in 2010. ↑ 26, see p.28

2009	US First Lady Michelle Obama plants the first garden at the White House since World War II on the South Lawn.
2010	Community activist Ron Finley plants his first vegetables in a patch of earth near his home in South Central Los Angeles, starting the guerrilla gardening movement. ↑ 27, see p.166
2012	Garden by the Bay, Singapore, opens; Grant Associates and Gustafson Porter design Bay South and Bay East, respectively.
	Chihuly Garden and Glass museum opens in Seattle.
2014	Phillip Johnson begins reworking his own garden at Olinda, Victoria, Australia.
2018	Following a decade-long restoration of the house and grounds, Chatsworth reopens to the public.
2020	*Show Me the Monet*, an appropriation of Claude Monet's *Le Bassin aux Nymphéas* by graffiti artist Banksy, sells for £7.5 million at auction.
2021	For the first time in its 108-year history, the Chelsea Flower Show is held in the autumn, rather than the spring, due to the COVID-19 pandemic.
	Designed by Heatherwick Studios and MNLA, Little Island opens alongside Hudson River Park; roughly 400 different species of tree, shrub, grass, and perennials are planted.
	Contemporary Japanese artist Yayoi Kusama presents her larger-than-life exhibition *Cosmic Nature* at the New York Botanical Garden.
2023	Plans are approved for the creation of the Camden Highline, an elevated public park and greenway on disused railways running from Camden Town to King's Cross in London.

Select Biographies

William Bartram
(United States, 1739–1823)

From a young age, William Bartram accompanied his father, John, founder of the first American botanic garden, on plant-collecting expeditions throughout eastern North America, during which he developed a skill for botanical drawing. In the 1770s he made his own four-year journey through the South and Florida, where he collected many new species; he published an illustrated account of his travels in 1791. From the late 1770s Bartram ran his father's garden, but he also illustrated *Elements of Botany* (1803–4) by his friend Benjamin Smith Barton.

Geoffrey Bawa
(Sri Lanka, 1919–2003)

The influence of architect Geoffrey Bawa's tropical Modernist style extends far beyond Sri Lanka. Educated as a lawyer, Bawa retrained as an architect in London, qualifying in 1957. Returning to Colombo, he began a practice focused on the dynamic role nature plays in the built environment. The prolific architect's portfolio included houses, schools, universities, factories, offices and hotels in Sri Lanka and overseas and numerous public buildings, including the new Sri Lankan parliament. As he grew older, Bawa's architecture became more radical, to the point where the garden became the central focus and his building a supporting act.

Vanessa Bell
(Britain, 1879–1961)

Vanessa Bell was a painter, designer and founding member of the Bloomsbury Group, a circle of artists, writers and philosophers who congregated to discuss culture and aesthetics in the Bloomsbury district of London at the turn of the twentieth century. Bell is remembered for her portraits and still lifes, first inspired by Post-Impressionism and later more abstracted, as well as her book jackets for all her sister Virginia Woolf's novels.

Lancelot 'Capability' Brown
(United Kingdom, 1716–1783)

The most famous garden designer of eighteenth-century England, Lancelot 'Capability' Brown received his nickname from his standard view that the properties he worked on had 'great capabilities' for improvement. Eschewing formal gardens, the pioneering Brown adopted natural planting in landscaped parks, on such estates as Blenheim Palace, Oxfordshire, and Highclere Castle, Hampshire. Having trained under William Kent, a pioneer of the English landscape garden, Brown became Head Gardener at Stowe in 1742. After Brown left Stowe in 1750, he freelanced, offering his well-heeled clients a comprehensive service that included design, landscaping, planting and management. He designed more than 170 parks in his lifetime.

Dale Chihuly
(United States, b. 1941)

Dale Chihuly is a contemporary artist whose glass sculptures – often massive, colourful, and employing organic patterns and forms – are installed in institutions and public spaces across the United States. A student of glassblowing at the famous workshop on the island of Murano, Italy, Chihuly lost sight in one eye in an automobile accident in 1976, leaving him to rely on assistants to execute his designs. The Chihuly Garden and Glass museum opened in Seattle, Washington, in 2012.

Thomas Church
(United States, 1902–1978)

A Bostonian by birth, Thomas Church spent his childhood in Southern California, which heavily influenced his pioneering 'California Style' of landscape gardening. He introduced the idea that a garden should be seen as an extension of the house, an outdoor room. Influenced by trips to Europe, where he saw the works of the Modernist architects Le Corbusier and Alvar Aalto, Church created a new garden vernacular of pared-back Modernism. From his office in San Francisco, Church designed more than 2,000 private gardens from 1929 until his death. He also worked on large-scale commercial commissions, including the 130-hectare (320-acre) campus of General Motors Michigan headquarters.

Crispijn de Passe
(Netherlands, c.1594–1670)

The son of Dutch engraver and print publisher, Crispijn de Passe the Elder, the younger de Passe was born in Cologne and lived there until 1611, when the family was forced to leave for Utrecht, the Netherlands. Along with his siblings, he learned to engrave in their father's workshop. Working in France, de Passe produced portraits of Louis XIII and Marie de' Medici as well as other European royals. He engraved a variety of historical and biblical subjects as well as plates for a book on dressage and 160 engravings of flowering plants for his *Hortus floridus*, published from 1614 to 1616.

Albrecht Dürer
(Germany, 1471–1528)

Albrecht Dürer was one of the most celebrated German artists of the Renaissance, best known for highly skilled woodcuts and engravings, although he was also a pioneer of landscape painting. He worked mainly in his native Nuremberg, although he travelled as far as Italy to study art and corresponded with such contemporary artists as Leonardo da Vinci. Dürer was renowned for his printmaking, through which his influence spread across Europe.

Lucian Freud
(Britain, 1922–2011)

A grandson of the founder of psychoanalysis, Sigmund Freud, Lucian Freud was born in Berlin and moved to Britain in 1933 to escape the Nazis. A champion of figurative painting at a time when the art world was dominated by abstraction, Freud often painted his subjects – both people and still lifes – as they were, emphasizing their imperfections to achieve an idiosyncratic beauty of their own. He remains one of the most significant painters of the twentieth and early twenty-first centuries.

Gertrude Jekyll
(Britain, 1843–1932)

Gertrude Jekyll, with her painterly approach to colourful plantings, was one of the most influential garden designers and horticulturists of the late nineteenth and early twentieth centuries. A lifelong enthusiasm for plants and plant-collecting led her to design a garden for her mother in 1885, after which she went on to design some 400 more, as well as writing prolifically. Her partnership with architect Edwin Lutyens played a prominent role in the Arts and Crafts movement in Europe and North America from about 1890 to 1910.

William Kent
(United Kingdom, 1685–1748)

After a successful career as an artist, first as a sign painter and then a landscape painter, William Kent turned to architecture under the patronage of Lord Burlington and Thomas Coke, the first Earl of Leicester. Kent's greatest architectural achievement, Holkham Hall, completed in 1761, still stands. From his architectural commissions, Kent moved to landscaping the immediate grounds around his buildings to reflect his belief that gardening was landscape painting in three dimensions. A pioneer of the picturesque and natural style of gardening, Kent enjoyed great success from the age of forty as a gardener and teacher of, among others, Lancelot 'Capability' Brown.

Athanasius Kircher
(Germany, 1601–1680)

Athanasius Kircher was a Jesuit priest and scholar. He used his knowledge of Greek and Hebrew as well as his education in science and the humanities to disseminate knowledge through his prolific writing. Although not a theorist himself, he wrote approximately forty books as well as thousands of manuscripts and letters, 2,000 of which still survive. Sometimes known as the 'last Renaissance man', he conducted research in such areas as geography, astronomy, mathematics, language, medicine and music.

Yayoi Kusama
(Japan, b. 1929)

The Japanese contemporary artist Yayoi Kusama now works predominantly with installations, which are at once representational and abstract. Prone to hallucinations from an early age, Kusama transforms these experiences – how she sees the world – into her art. Repetitive patterns, often polka dots, are obsessively mirrored and extended into infinite spaces that envelop the viewer. Her early work comprised paintings, referred to as 'infinity nets', of obsessively repeated tiny marks across large canvases, as well as performance.

André Le Nôtre
(France, 1613–1700)

Following in the footsteps of his father Jean Le Nôtre, master gardener of Louis XIII, André le Nôtre was steeped in the technical mastery of gardening. He studied the laws of perspective and optics, both of which he would employ in his garden design, most notably at the gardens of the Palace of Versailles outside Paris. Louis XIV commissioned Le Nôtre to design the vast Versailles gardens after seeing his work at Château Vaux-le-Vicomte. Such was his reputation for expressing power and taste in formal settings that Le Nôtre was in demand not just in France but across Europe.

Carl Linnaeus
(Sweden, 1707–1778)

Known in Swedish as Carl von Linné, Linnaeus was a naturalist and explorer who became the founding father of modern taxonomy. The foundations of his system of naming, ranking and classifying organisms are still in use today, albeit with many changes. Growing up in southern Sweden, Linnaeus began studying medicine at the Lunds Universitet but soon transferred to Uppsala Universitet. In 1735 he published his *Systema Naturae* (*The System of Nature*), which laid out his taxonomy of three kingdoms – stones, plants and animals – and their subdivision into classes, orders, genera, species and varieties.

Claude Monet
(France, 1840–1926)

Claude Monet was a leading member of the Impressionist movement, which took its name from his painting of 1874. For sixty years, Monet explored ways of translating the natural world into paint, with pictures that take viewers from the streets of Paris to the tranquil gardens of Giverny, where he painted his famous waterlily pictures. Monet's contribution to the painting tradition paved the path for twentieth-century Modernism and revolutionized the way we view nature.

Cedric Morris
(Britain, 1889–1982)

Cedric Morris was a painter, devoted plantsman and colourist best known for his flower paintings, which reveal a delicate simplicity and hint of abstraction. Morris was inspired by his bountiful garden of blooms both common and exotic, which he planted at Benton End in Suffolk. An instructor of Lucian Freud and largely self-taught, he founded, along with his partner, Arthur Lett-Haines, the East Anglian School of Painting and Drawing.

William Morris
(Britain, 1834–1896)

A poet, novelist, philosopher and political theorist, William Morris is perhaps best known as one of the leading designers of the Arts and Crafts movement. His iconic patterns, which appear on textiles, wallpaper and upholstery, pioneered a new approach to decorative arts and redefined Victorian taste. He was a man of many talents, and his work also includes furniture design, architectural drawings and typography.

Isamu Noguchi
(United States, 1904–1988)

Raised in both the United States and Japan, Isamu Noguchi's influences included not just the countries of his parents but also Beaux-Arts Paris and the work of sculptor Constantin Brancusi, in whose studio he worked in 1927. A sculptor by training, Noguchi also ventured into furniture and lighting designs (his iconic Akari lamps and his coffee table remain design classics), ceramics and set designs for, among others, American dancer and choreographer Martha Graham. He worked with the architect Louis Kahn between 1961 and 1966 on a playground design. His landscapes reflect his Japanese heritage, with their carefully placed sculptures made from a variety of materials.

Marianne North
(Britain, 1830–1890)

Although not formally trained, the talented painter Marianne North enjoyed two great advantages for a female artist in the nineteenth century: money and political connections (her father was the MP Frederick North). From 1871 she travelled widely, painting botanical species in North America, the Caribbean, Brazil, Japan, Australia, New Zealand, and Southeast and South Asia. Her 833 paintings, many of which depict plants in wider scenes, are today housed at Kew in the Marianne North Gallery, which was built in 1882.

Frederick Law Olmsted
(United States, 1822–1903)

The father of the American landscape gardening movement, Olmsted overcame near blindness in childhood to study scientific farming before turning to landscape architecture following a trip to Europe. Impressed by English landscaping, Olmsted wrote *Walks and Talks of an American Farmer in Europe* in 1852. Appointed superintendent of New York City's planned Central Park in 1857, Olmsted was responsible, along with his collaborator Calvert Vaux, for the design of the park. Determined to apply artistic principles to the improvement of public gardens, Olmstead designed many more public gardens, including the Capitol grounds in Washington DC.

John Parkinson
(Britain, 1567–1650)

The London apothecary and herbalist John Parkinson became royal botanist to King Charles I, but his reputation was largely overshadowed by the defeat of the Royalists in the English Civil War (1642–51). Parkinson was a leading gardener of his day, importing new plants from the Eastern Mediterranean and the new colonies in North America. His *Paradisi in sole paradisus terrestris* (1629) – written to introduce Charles's young French queen, Henrietta Maria, to English gardens – described the organization of flower, kitchen and orchard gardens. In 1640 Parkinson published *Theatrum Botanicum*, a catalogue of some 3,800 English plants – some never recorded before – intended as a guide for his fellow apothecaries.

Beatrix Potter
(Britain, 1866–1943)

Born Helen Beatrix Potter in London, Potter was a beloved British author and illustrator of children's books, who wrote the hugely popular *The Tale of Peter Rabbit* (1902) and other books with anthropomorphic animal characters including Jemima Puddle-Duck, Mrs Tiggy-Winkle and Jeremy Fisher. Potter grew up in London and spent holidays at her family's houses in Scotland and in the Lake District, where she was fascinated by the native wildlife. In later life she moved permanently to the Lake District, and settled at Hill Top in Ambleside.

Humphry Repton
(United Kingdom, 1752–1818)

The natural successor to Lancelot 'Capability' Brown, Suffolk-born Humphry Repton intended to pursue a business career in London. When that failed, he returned to the countryside to study land management and become an accomplished watercolour landscape painter. In 1788 he started as a landscape designer, calling upon friends, including the Duke of Norfolk, to employ him. Key to his success was his use of watercolour books with paper flaps to show clients how he would transform their gardens. Later, he worked with his architect son, John Adey Repton, to design houses and gardens together, such as Sheringham Park in Norfolk.

William Robinson
(United Kingdom, 1838–1935)

William Robinson's career started inauspiciously in his native Ireland, where he worked as a garden boy before becoming a foreman gardener. Relocating to London, he started work at the Royal Botanical Gardens in Regent's Park in 1862. After four years, he left to devote himself to writing gardening books, of which *The English Flower Garden* (1883) remains his most important work. His financial success allowed him to start *The Garden* magazine in 1871, which he owned until 1919, and to purchase Gravetye Manor in Sussex, where he lived from 1885, creating a renowned garden of his own.

Mirei Shigemori
(Japan, 1896–1975)

Before he designed gardens, Mirei Shigemori studied art at Tokyo's Fine Art School, adopting the name Mirei to reflect his love of French artist François Millet. Shigemori also trained in the traditional Japanese arts of the tea ceremony and *ikebana*, or flower arranging. In 1914 he designed a tea room and garden for his family's property; this marked the start of a career designing more than 200 gardens, mostly in the dry landscape or *karensansui* style, often using unusual materials such as tile or cement. In 1938, he published a twenty-six-volume guide including all the major Japanese gardens.

Anne Spencer
(United States, 1882–1975)

A civil rights activist and member of the Harlem Renaissance, Anne Spencer lived her entire married life in her Virginia home, where her garden became the subject of her poetry. The daughter of a former slave who later opened a saloon, Spencer studied at the Virginia Seminary in Lynchburg then taught for two years before marrying a fellow student Edward Spencer in 1901. In 1903 they moved to a Queen Anne-style house that Edward designed and built. There, they hosted Black travelers unable to stay in public inns due to Jim Crow laws, becoming a haven for creative luminaries of the time.

Edward Steichen
(United States, 1879–1973)

Born in Luxembourg, Edward Steichen emigrated to the United States with his family as a baby. After apprenticing as a lithographer, he began to take photographs, influenced by his friendship with the photographer Alfred Stieglitz. Steichen was an early adopter of colour photography, and in 1911 he took the first modern fashion photographs, for the magazine *Art et Décoration*, laying the foundations for a career as a leading fashion photographer. He served as a military photographer in both world wars, and was later an influential director of photography at the Museum of Modern Art in New York.

Glossary

Allée
A straight walk, path or ride bordered by trees or clipped hedges. A series of straight *allées* will often form an ordered geometric pattern.

Annual
A plant that grows, produces seed and dies within a year, or occasionally within a few months. Annuals can be sown in late winter under glass (tender annuals) or directly into the ground in spring (hardy annuals).

Anthropomorphism
The tendency for humans to interpret the physical appearance and behaviour of animals as similar to, comparable to, or the same as those of humans.

Arboretum
A botanical collection of trees and shrubs – both coniferous and broad-leaved.

Arts and Crafts movement
The late nineteenth-century British movement, promoted by William Morris, John Ruskin and others, that encouraged a return to the perceived values of medieval craftsmanship as a reaction to increasing industrialization. In a garden context, Arts and Crafts style often refers specifically to the work of Gertrude Jekyll and Edwin Lutyens and their followers working in the first two decades of the twentieth century.

Baroque
The seventeenth- and eighteenth-century European style making exuberant use of ornamentation. In a garden context, the Baroque style is highly formal and features include *parterres de broderie*, **topiary**, **allées**, richly carved fountains and statuary.

Bassin
A formal pool, often stone-edged and/or with a fountain at its centre, and usually part of a formal plan.

Berceau
Derived from the French word for 'cradle', a *berceau* is an arched trellis for climbing plants – similar to a **pergola** – but can also refer to trees that have been closely planted and trained to form an arched walkway covered by foliage.

Biennial
A plant that completes its life cycle in two years, germinating and growing in the first year, and flowering and producing seed in the second.

Binomial system
The universal system of naming living organisms, including plants, with two names: a capitalized genus name plus a species name, e.g. *Cyclamen* (genus) and *coum* (species).

Biodiversity
Biological diversity, or the variety of life on Earth, considered at all levels. This includes genetic variety within species, the variety of species themselves, and habitat variety within an ecosystem.

Bosco
A grove of trees or a wood, natural or artificial, often incorporated into the design of an Italian Renaissance garden. Wilder in aspect than a *bosquet*.

Bosquet
A small clump of trees, or a decorative glade with statuary, enclosed by a hedge or fence, usually a part of seventeenth- or eighteenth-century French Baroque gardens.

Botanic(al) garden
A garden used to research the relationships between plants. Such gardens are frequently associated with a university or other professional botanical organization, and are usually open to the public. The plants in botanic gardens are arranged taxonomically, by geographical area or by habitat.

Carpet bedding
The nineteenth-century practice of planting out foliage rather than flowering plants en masse to create patterns of grouped colours.

Chahar bagh
Term meaning 'four gardens' and referring to the Islamic quadripartite garden form whereby four beds ('gardens') are defined by four perpendicular rills fed from a central water source and enclosed by paths.

Chinoiserie
The Chinese-style decoration as imagined by European designers from the seventeenth century onwards. It was based mainly on travellers' descriptions – although the architect William Chambers championed the style in the eighteenth century – and was influential throughout Europe, particularly in Germany.

Codex (pl. codices)
An ancient manuscript in the form of a book.

Contextual
Designed to relate to or imitate its context or setting.

Cultivar
A plant produced in cultivation by selective breeding, and differing genetically from the wild species by possessing a desirable attribute, such as differently coloured flowers, extra petals or variegated leaves.

Cyanotype
A type of photographic printing that produces a blue image, or a white image on a blue background.

Ecosystem
The system or web of movement of energy and nutrients between living (biotic) organisms and the (abiotic) environment.

Endemic
An indigenous species that is found only in a specific region owing to factors that limit its distribution and migration.

English Landscape style
The garden design style that arose in Britain in the eighteenth century, first as an art form analogous to literature, with complex symbolic and political meanings expressed as buildings and landscape features. It evolved through various expressions by Charles Bridgeman and William Kent, and later became a purely visual or painterly medium, evocative of a pastoral idyll – as with the work of Capability Brown. It was reproduced throughout Europe in the eighteenth and nineteenth centuries.

Engraving
Cutting a design into a hard surface, such as stone or metal; also, a print reproduced from such a design.

Etching
A method of printing in which an artist incises a design on to a metal plate with a needle, then burns the metal with acid.

Evergreen
Describes plants that retain their leaves all year round. Evergreen leaves are often darker, thicker and tougher than deciduous ones. In hot and dry countries evergreen leaves can be densely covered in hair, making them appear grey or silver.

Family
A higher botanical classification group than **genus**. A family contains genera (pl. of genus) that are related to one another because they share certain fundamental characteristics. For example, the sage genus *Salvia* is related to the mint genus *Mentha* because both have square-section stems and hooded, tubular flowers; both genera belong to the family Lamiaceae.

Ferme ornée
A variation on the **English Landscape style**: a working farm ornamented by seats, temples, viewpoints and walks. *Fermes ornées* were generally of modest size and relatively cheap to create.

Flora
The collective name for flowering plants, or for plant life found in a specific region. Also denotes a publication describing the collective plants of a specific region.

Florilegium
A term that originally described a collection of plants gathered into a single bouquet, planter or urn, or a painting presenting such an arrangement of plants. Today it most commonly describes a treatise on flowers that concentrates on their ornamental rather than medicinal or botanical value.

Folly
A built structure whose principal purpose is decorative or whimsical rather than practical; occasionally a utility building made to look like a historic, ruined or fantastical structure.

Fruit
A seed-bearing structure that forms from the ripened ovary in flowering plants. Its purpose is to enclose the seeds in order to aid their dispersal, for example by being eaten or being carried by the wind.

Genus (pl. genera)
A subdivision of a botanical **family** that contains one or more species according to similar characteristics that show their close relationships. For example, the genus *Cyclamen* contains twenty-two species including the species *Cyclamen coum*, which has small, round leaves and short, squat flowers in spring; *Cyclamen hederifolium*, with ivy-like leaves and narrow flowers in autumn; and *Cyclamen repandum*, with ivy-like leaves and narrow flowers in spring. These all belong to the primula family, Primulaceae. The name of a genus is always written with a capital letter.

Germination
The first stage of a seed's growth, from embryo to the formation of its first root and then leaves.

Gouache
A type of opaque watercolour paint.

Grotto
A cave-like room, usually artificial, often decorated with shells, minerals and fossils. Italian Renaissance grottoes were semi-open structures set in the garden. Later, in eighteenth-century England, grottoes began to be made as discrete buildings – sometimes underground – lined with shells and minerals.

Ha-ha
A sunken wall resembling a dry ditch or moat with one vertical stone side. This meant that livestock could graze on pasture quite close to the house, furthering the illusion of pastoral ease in eighteenth-century landscape gardens.

Herbaceous
Plants whose stems are not woody; herbaceous plants grow from an underground root system, produce flowers and seed, then die back to the ground each year, surviving the winter in their dormant root system below ground. In practice, most 'herbaceous' borders are in fact mixed borders: i.e. they also contain **evergreens**, bulbs and **annuals**.

Herbal
A book or manuscript created to communicate the medicinal properties of plants.

Herbarium
A systematically arranged collection of dried and pressed plant specimens preserved for scientific study.

Horticulture
The science and art of growing plants.

Hortus conclusus
An enclosed medieval garden, made at certain monasteries and dedicated to the Virgin Mary, and often containing a fountain, statue of Mary and plants allegorically representing her virtues (for example, the white lily and red rose).

Hybrid
A genetic cross between two different species (usually but not always in the same **genus**). For example, *Primula × polyantha* is a cross between the cowslip, *Primula veris*, and the primrose, *Primula vulgaris*; the '×' denotes that it is a hybrid with its own **binomial** name.

Inflorescence
A collective term for the complete flower head arranged in a particular structure on one stem or shoot of a plant. There are different types of inflorescence: most members of the carrot family, Apiaceae, for example, produce their small flowers in an umbrella-shaped inflorescence called an umbel, whereas plants in the genus *Wisteria* produce flowers along one long axis in a **raceme**.

Invasive
Describes plants that encroach on and invade the territory of other plants, often pushing them out of their chosen habitat.

Knot garden
A Tudor innovation and form of bed, comprising low evergreen hedges, usually box, yew or thyme, planted to create an intricate knot-like or pleasing symmetrical pattern, sometimes with infills of brightly coloured flowers or gravel.

Lithograph
An image that is prepared on a flat stone surface using grease or oils and then used to create an ink print.

Modernism
The style formulated in the 1920s, characterized by architecture that could be mass-produced and the use of such modern materials as concrete. The 'white-cube' building is an archetypal Modernist style. A variety of garden styles have been used in an attempt to complement the building style.

Mughal gardens
A hybridized style of Indo-Persian garden design in sixteenth- to nineteenth-century India. The Persian garden tradition was first brought to India from Kabul with Emperor Babur's conquest of northern India in 1526. Enclosed symmetrical and axial **parterre** layouts, or the *chahar bagh*, combined with such features as stone terracing, geometric and leaf-shaped basins and fountains, water chutes and channels, and open-air pavilions, typify the Mughal style.

Native
A plant that occurs naturally in a particular country or region. Native plants may occur in a number of places within a country or region (indigenous) or be restricted to just one place (**endemic**).

Naturalist
Someone who takes a keen interest in, and has a deep knowledge of, the natural world, usually from a broad, ecological viewpoint. They may or may not be academically trained.

Naturalistic planting
An informal planting style in which hardy plants – **herbaceous perennials, shrubs**, trees and bulbs, both **native** and introduced – are arranged in beds and borders to best display their individual and collective attributes. Naturalistic planting was first popularized in the late nineteenth century by Irish plantsman and writer William Robinson.

Naturalize
To introduce a plant successfully to a new region. In some cases naturalization can be overwhelmingly **invasive**, as with the introduction of gorse into New Zealand.

Natural philosophy
The philosophical study of nature and the natural world as the precursor of modern science from the time of Aristotle until the separation of biology, physics and chemistry in the nineteenth century.

Nymphaeum
A semicircular structure, often semi-open, containing statuary on the theme of rustic nymphs and water.

Ornamental
A plant grown for its attractive appearance rather than for its medicinal or other uses.

Parterre
A favourite feature of seventeenth- and eighteenth-century **Baroque** gardens, this form of bed, laid out on a terrace, often below the dwelling, varied from simple patterns of cut turf and gravel to intricate designs made of low hedges, grass, gravel, turf and flowers (*parterres de broderie*). Meaning 'embroidery on the ground', the patterns of these last were often inspired by textiles and wallpapers.

Perennial
A plant that lives for many years; the term is frequently used in association with herbaceous plants that die back to a rootstock every winter.

Pergola
A wooden and/or stone structure that forms a covered walkway or roof over a patio, often covered with climbing plants such as roses, climbers or wisteria.

Picturesque
In the early eighteenth century the term referred to the landscapes of William Kent, which were inspired by the landscape paintings of, among others, Nicolas Poussin and Claude Lorrain. Later in the century it also came to mean a landscape style (almost exclusively English) that celebrates the power of dramatic, untamed nature, frequently in a setting of extreme terrain. Loosely used to describe the **English Landscape style** in Europe.

Plant-hunter
Someone who acquires or collects plant specimens for the purposes of research or cultivation, or as a hobby. Plant specimens may be kept alive, but are more commonly dried and pressed to preserve their quality.

Pleaching
The practice of training trees to grow into a hedge or screen, which is used to create arbours, arches, tunnels and walks. The method entails tying in or interlacing young shoots along a supporting frame.

Pollination
The means by which fertilization occurs in flowers. Pollen is carried by the wind or transported from flower to flower by insects (and, more rarely, birds and animals), which deposit it on the receptive stigmas.

Potager
A French-style decorative kitchen garden, edged with box and incorporating vegetables grown partly for their appearance.

Propagate
To reproduce a plant either from seed (sexual reproduction) or by taking cuttings, pegging down branches as layers, dividing plants or making grafts (asexual).

Raceme
A type of **inflorescence** in which flowers on stalks (pedicels) alternate up the stem of the plant.

Rill
With its origins in early Persian gardens, a rill is a narrow, shallow artificial stream or rivulet, usually lined with stone, and used on a gentle gradient to convey water from one area of the garden to another. Rills can be serpentine – a famous example is William Kent's at Rousham – or linear, as used in the Islamic *chahar bagh*, and by Edwin Lutyens and Gertrude Jekyll in their **Arts and Crafts** gardens.

Rococo
The exuberant eighteenth-century decorative style derived from *rocaille*, the Italian word for shell. In Rococo gardens, decoration is as vital as form.

Serpentine paths
Curving or twisting paths running through areas of shrub and tree planting. Serpentine paths frequently lend a note of informality to otherwise symmetrical schemes.

Shrub
A woody plant that is shorter than a tree, such as a bush.

Species
The basic unit of plant and animal classification within a **genus**. It is written in binomial classification with a lowercase letter, as in *Cyclamen libanoticum*. Species share close genetic relationships, but those that encompass a large geographic range may be further divided based on very minor characteristics, such as size, leaf shape or flower colour. Such changes can be called **subspecies** (abbreviated to subsp., usually occurring in geographically isolated populations), **varieties** (var., usually within one

Further Reading

population) or formae (f., very minor variation within a population).

Stroll garden
A Japanese style of garden, popular from the thirteenth century, which is designed to be viewed while walking following a particular path. The garden is then revealed gradually in a sequence of views, ambience and perspectives. It is reminiscent of the act of looking at a long scroll landscape painting. It usually involves a circuit around a lake with various tea arbours, bridges and islands.

Subspecies
A group of plants that genetically belong within a **species** but have characteristics that make them distinct from it in minor ways. Subspecies are usually found as geographically isolated variants. For example, all primroses, *Primula vulgaris*, in western Europe have yellow or white flowers, but in Turkey all *Primula vulgaris* subsp. *sibthorpii* have pink or lilac flowers.

Succulent
A plant with swollen water-bearing stems and/or leaves, that grows naturally in desert regions in order to conserve water, such as cacti, *Pachypodium* and many euphorbias.

Tapis vert
Literally, a green carpet: a close-cropped expanse of grass, usually part of a formal scheme, such as at Versailles where the *tapis vert* runs along the main axis down a gentle slope from the terraces to the head of the canal.

Taxonomy
The scientific study of classifying and naming plants.

Topiary
The art of clipping **evergreen** plants, such as box and yew, into geometric, abstract or figurative shapes.

Trompe-l'oeil
From the French for 'deceive the eye', an effect designed to alter normal perception; often used in gardens to increase apparent distances and change perspectives. It can take the form of out-of-scale plantings, trellises, mirrors or even painted surfaces.

Trug
A shallow, wide basket or container, usually wooden, with a handle, used to carry plants, cut flowers or gardening tools.

Tudor garden
Gardens made in Britain during the Tudor period (1485–1603). **Knot gardens** were a principal motif in designs of this type.

Variety
A wild minor variant within a species, for example *Primula denticulata*, which has lilac flowers, and *Primula denticulata* var. *alba*, which has white flowers. The term usually refers to plants within a population that differ in one or two small ways from the typical species.

Vellum
A smooth material for writing on, made from animal skin.

Winter garden
An indoor heated conservatory for the display of exotic plants.

Woodblock
A piece of wood engraved in relief and used for printing an image, typically called a woodcut print.

Aitken, Richard. *The Garden of Ideas: Four Centuries of Australian Style*. Melbourne: Melbourne University Press, 2011.

Allen, Jamie M., and Sarah Anne McNear. *The Photographer in the Garden*. New York: Aperture and George Eastman Museum, 2018.

Beeson, Anthony. *Roman Gardens*. Stroud, Glos.: Amberley Publishing, 2019.

Biggs, Matthew. *RHS Lessons from Great Gardeners: Forty Gardening Icons and What They Teach Us*. London: Octopus Publishing, 2015.

Biggs, Matthew. *RHS The Secrets of Great Botanists and What They Teach Us About Gardening*. London: Mitchell Beazley, 2018.

Bisgrove, Richard. *The National Trust Book of the English Garden*, new edn. New York: Penguin Books, 1992.

Bisgrove, Richard. *Gardening Across the Pond: Anglo-American Exchanges, from the Settlers in Virginia to Prairie Gardening*. London: Pimpernel Press, 2018.

Chatto, Beth. *The Dry Garden*, new edn. London: Weidenfeld & Nicolson, 2018.

Clarke, Ethene. *The Mid-Century Modern Garden: Capturing the Classic Style*. London: Frances Lincoln, 2017.

Compton, Tania. *The Private Gardens of England*. London: Constable, 2015.

The Cultural History of Gardens, 6 vols. London: Bloomsbury Academic, 2013.

Elliott, Brent. *Victorian Gardens*, revised edn. London: Batsford, 1990.

Elliott, Brent. *Flora: An Illustrated History of the Garden Flower*. Buffalo, New York: Firefly Books, 2003.

Fairchild Ruggles, D. *Islamic Gardens and Landscapes*. Philadelphia: University of Pennsylvania Press, 2008.

Fang, Xiaofeng. *The Great Chinese Gardens: History, Concepts, Techniques*. New York: Monacelli Press, 2010.

Fish, Margery. *Cottage Garden Flowers*. London: Faber & Faber, 1980.

Fusaro, Dario, and Lucia Impelluso. *Villas and Gardens of the Renaissance*. Milan: Mondadori Electa, 2019.

Goode, Patrick, and Michael Lancaster, eds. *The Oxford Companion to Gardens*, new edn. Oxford: Oxford University Press, 2001.

Hobhouse, Penelope. *The History of Gardening*, new edn. London: Pavilion Books, 2019.

Keswick, Maggie. *The Chinese Garden: History, Art & Architecture*, 2nd revised edn. London: Frances Lincoln, 2003.

Kingsbury, Noel, and Claire Takacs. *Wild: The Naturalistic Garden*. London and New York: Phaidon Press, 2022.

Laird, Mark. *A Natural History of English Gardening, 1650–1800*. New Haven, CT: Yale University Press, 2015.

Lazzaro, Claudia. *The Italian Renaissance Garden: From the Conventions of Planting, Design, and Ornament to the Grand Gardens of Sixteenth-Century Central Italy*. New Haven, CT: Yale University Press, 1990.

Lloyd, Christopher. *The Well-Tempered Garden*, new edn. London: Phoenix, 2014.

Lloyd, Christopher, and Beth Chatto. *Dear Friend and Gardener: Letters on Life and Gardening*. London: Aurum Press, 2021.

Mancoff, Debra N. *The Garden in Art*. London: Merrell Publishers, 2011.

Musgrave, Toby. *The Head Gardeners*. London: Aurum Press, 2009.

Musgrave, Toby. *The Garden: Elements and Styles*. New York and London: Phaidon Press, 2020.

O'Malley, Therese, and Marc Treib, eds. *Regional Garden Design in the United States*. Cambridge, MA: Harvard University Press, 1995.

Ottewill, David. *The Edwardian Garden*. New Haven, CT: Yale University Press, 1989.

Pavord, Anna. *The Curious Gardener: A Year in the Garden*. London: Bloomsbury, 2010.

Phaidon Editors and Toby Musgrave, ed. *The Gardener's Garden*, new edn. London and New York: Phaidon Press, 2022.

Phaidon Editors and Tim Richardson, ed. *The Garden Book*, new edn. London and New York: Phaidon Press: 2021.

Reid, Georgina, and Daniel Shipp. *The Planthunter: Truth, Beauty, Chaos, and Plants*. Portland, OR: Timber Press, 2019.

Richardson, Tim. *The New English Garden*. London: Frances Lincoln, 2013.

Tankard, Judith B. *Gardens of the Arts and Crafts Movement*, 2nd revised edn. Portland, OR: Timber Press, 2018.

Taylor, Patrick, ed. *The Oxford Companion to the Garden*. Oxford: Oxford University Press, 2006.

Walker, Sophie. *The Japanese Garden*. London and New York: Phaidon Press, 2017.

Way, Thaïsa. *Unbounded Practice: Women and Landscape Architecture in the Early Twentieth Century*. Charlottesville: University of Virginia Press, 2013.

Wilkinson, Alex. *The Garden in Ancient Egypt*. London: Rubicon Press, 1998.

Willsdon, Clare. *Impressionist Gardens*. London: Thames and Hudson, 2010.

Index

Page numbers in *italics* refer to illustrations

A

Aalto, Alvar 50
 Villa Mairea 51, *51*
Aarons, Slim, *Garden Party* 89, *89*
'Abbās I, Shah 131, 147
abstraction 21, 314
Adam 76, 144, *152–3*, 153, 284, *284*
Adams, Morley, *Adam the Gardener* 194, *194*
Adena culture 222
Alan Cristea Gallery 203
Albertus Magnus 133
Alcázar Palace, Seville 136, *136*
Aldridge, John 14
Alexandra Palace, London 210, *210*
Allingham, Helen, *South Border at Munstead Wood* 63, *63*
allotments 13, *13*, 207, 266, 333, *333*
Allways, Cambridgeshire 110, *110*
Alyawarr people 323
Amenhotep II 52
American Community Gardening Association 167
Amun 52, 53, 290
Amytis 54
Anderson, Hurvin, *Jungle Garden* 171, *171*
Anderson, Isabel 282
Anderson, Larz 282
Andres, AT. J., *Agricultural & Gardening Tools* 108, *108*
Angelelli, Giuseppe, *Plate LXIX* 52, *52*
Angus, Peggy 125
Antinous 110
Antoine 70
Apollo 104
Apple 138
Arcimboldo, Giuseppe 273
Aristotle 290
Arnatt, Keith, *Gardeners* 159, *159*
Arp, Hans 177
Arp, Jean 175
Arsham, Daniel, *Blue Gradient Garden* 186, *186*
Art Biotop, Japan 100
Art Deco 65, 97, 245, 247, 330
Art Nouveau 72, 310, 330
Arts and Crafts 8, 44, 61, 72, 73, 228, 261, 264
Asaf-ud-Daulah 39
Ashurbanipal 6, 132, *132*
Aspinall and Co 228
Aster 199, *199*
Athanasi, Giovanni d' 53
Atkins, Anna 9
Audley End, Essex 162, *162*
aviaries 185, *185*
Aztecs 144, 291, 322

B

Babur 57, *57*
Bacon, Francis, *Of Gardens: An Essay* 72, *72*
Baillie Scott, M.H., *Proposed Residence at Guildford* 44, *44*
Banister, Reverend John 7
Barbara, Saint 133, *133*
Barbie 85, *85*
Barney, Tina, *The Goff Family Gardening* 293, *293*
Baroque style 55, 82, 99, 104, 205, 208, 256

Barragán, Luis 176
Barron, William 286
Barry, Sir Charles 278
Barton, Benjamin Smith 33
Bartram, John 7, 32, *32*
Bartram, William, *A Draught of John Bartram's House and Garden as It Appears from the River* 32, *32*
Bateman's, East Sussex 275, *275*
Batson, Henrietta 194
Bauhaus 175
Bawa, Geoffrey, *Jayawardene House* 172, *172*
Bawden, Edward 14, *14*, 125
Bayard, Hippolyte, *Composition au Chapeau* 318, *318*
Bearden, Romare, *In the Garden* 58, *58*
Beaton, Cecil, *Women's Horticultural College, Waterperry House, Oxfordshire* 197, *197*
Beaumont, Guillaume 258
Beaux Arts 282
Beckford, William 19
Bell, Vanessa, *Garden at Charleston* 15, *15*
Bencini, Raffaello, sculpture in the Parco dei Mostri 98, *98*
Bensusan, Esther 72
Bergé, Pierre 142
Bering, Vitus 219
Berlin Secession 213
the Bible 23, 24, 25, *25*, 58, 133, 151, 169, 284, 285, *285*
Biccaccio, Giovanni, *La Tesieda* 235, *235*
Bigelow, William Sturgis 178
BioPods 148
Bird, Maria 262
Bird's-eye view of the Taj Mahal at Agra (Anonymous) 38, *38*
Birley, Lady Rhoda 81, *81*
Bischof, Werner, *Japan, Kyoto, The Silver Pavilion* 308, *308*
Bishndas, *Babur's Garden* 57, *57*
Black gardeners 26, *26*
Blaikie, Thomas 101, 311
Blake, William 24
Blanc, Patrick, *L'Oasis d'Aboukir, Paris* 170, *170*
Bliss, Robert Woods 64
Blithewood, New York 155, *155*
Blood, Miss 303
Bloomsbury Group 15
Blow, Isabella 321
Bomba Bloch 90, *90*
Bonaparte, Joséphine 109
Bonaparte, Napoleon 53, 109
Bonnard, Pierre 288
 Garden 10, *10*
bonsai trees 122, *122*
Borie, John 110
Bornim Circle 213, 324
Borromeo family 55
borrowed landscapes 104, 154, 274
Bosch, Hieronymus, *The Garden of Earthly Delights* 7, 76
botanic gardens 7, 65, *65*, 139, *139*, 183, 198, 284, 290, *290*, 326, *326*
 Royal Botanic Gardens, Kew 18, 26, 65, 97, *97*, 106, 315
Boulton, William Staples 260
Boulton & Paul 260, *260*
Boyceau, Jacques 92

Boyden, Casey, *Japanese Tea Garden* 49, *49*
Bradbury & Bradbury, *Colonial Williamsburg* 160, *160*
Bradley, Richard 164
Brâncuşi, Constantin 175
Brassaï (Gyula Halász), *Exotic Garden, Monaco* 182, *182*
Brehm, Alfred, *Captive Birds* 185, *185*
Bridgeman, Charles 102, 226
Brissaud, Pierre, *House & Garden* 247, *247*
Britain, William 29
Britains, miniature garden set 29, *29*
British Broadcasting Corporation: *The Flower Pot Men* 262, *262*
 Gardening in the Grounds of Alexandra Palace 210, *210*
British Guild of Herb Growers 202
Brooke, Edward Adveno, *The Trellis Window, Trentham Hall Gardens* 278, *278*
Brookes, John, *Room Outside: A New Approach to Garden Design* 231, *231*
Brooks, Jack 143
Brown, Lancelot 'Capability' 7, 22, 83, 226, 278
 Plan for Audley End 162, *162*
Browne, K.R.G. 332
Bruegel, Pieter the Elder 37
Brueghel, Jan the Elder 73
Brueghel, Pieter the Younger, *Spring* 37, *37*
Bruges, Jason, *The Constant Gardeners* 174, *174*
Bry, Theodor de, *Secotan, an American Indian Community in North Carolina* 74, *74*
Buchan, Ursula 81
Budding, Edwin Beard 292
buddleia 96, *96*
bulbs 271, 306
Bulgari, *Giardino dell'Eden Tourbillon Cuff Watch* 77, *77*
Bunyard, Edward 200
Buontalenti, Bernardo 281
Burden, Jane 84
Burges, William 66
Burgess, Clare, *Kirstenbosch National Botanical Garden, Cape Town: Landscape Proposals for a Gardener's Hub* 198, *198*
Burke, Edmund 9
Burle Marx, Roberto 7, 225
 Garden Design for Beach House for Mr and Mrs Burton Tremaine, Santa Barbara, California (Site plan) 177, *177*
Burlington, Earl 103
Burnett, Frances Hodgson, *The Secret Garden* 234, *234*
Burnley, Jack, *Victory Garden, World's Finest Comics* 268, *268*
Burri, René, *Kyoto, Daitoku-ji Temple, The Buddhist Priest Soen Ozeki* 187, *187*
Burt, James 19
Burton, Tim, *Edward Scissorhands* 215, *215*
bush gardens 323, *323*
Butchart Gardens, Vancouver Island 65, *65*
Buurman, Andrew, *Allotments* 333, *333*

C

cacti 145, *145*
Caillebotte, Gustave, *The Gardeners* 107, *107*
California Modernism 8, 50, 231
Camden Town Group 26

Carl IV Theodor 104
Carline, Hilda 151
carpet, garden (anonymous) 56, *56*
carpet bedding 331
Carré, François, *Chair Bottom, Patent No.54,828* 236, *236*
Carroll, Lewis 23, 216, 294, *294*
Cartier-Bresson, Henri 241
casket, embroidered 25, *25*
Catesby, Mark 164
Caus, Salomon de 121
Central Park, New York City 8, *94–5*, 95, 103
Centre for Home Gardening, Kirstenbosch National Botanical Garden, South Africa 198, *198*
Cézanne, Paul 97
chahar bagh 38, 57
Charles III Philip 104
Charles VII, King 88
Charleston, East Sussex 15, *15*, 81, *81*
Château de Bagatelle, Paris 101, *101*
Château de Marly 43, *43*
Chatelain, Jean-Baptiste-Claude, *The Rotunda and the Queen's Theatre, Stowe* 226, *226*
Chatsworth, Derbyshire 184, *184*
Chatto, Beth 8, 31, 304, *304*
Chaucer, Geoffrey 235
Chaumet, *The Garden of Delights by Chaumet Collection* 109, *109*
Chelsea Flower Show 8, 197, 202, 304, 315
Chelsea Physic Garden, London 7, 327
Cheyne, Charles 327
Chihuly, Dale, *Cattails, Niijima Floats, Citron Icicle Tower* 183, *183*
Chihuly Garden and Glass, Seattle 183, *183*
Chinese gardens 8, 223, 253, 317, 321
Chirico, Giorgio de 78, 265
Chiswick House, London 103, *103*
Chittenden, Frederick 210
Christ 140, 169
Christianity 7, 144
chrysanthemums 227, *227*, 333
Church, Thomas 8, 225, 231
Church, Thomas Dolliver, *Pool Area Design, Donnell (Dewey) Residence* 50, *50*, 51
Clark, William 297
Clegg, Ernest, *Dumbarton Oaks, Topographical Map* 64, *64*
Clifft, Cyril 214
cloisonné 130
CNES 148
Coffin, Marian Cruger 196, *196*
Colonial Revival Garden 160
community gardens 9, 115, 166, 167, 232
Company of Apothecaries 106
Compton, Henry 7
Conder, Josiah, *Flat Garden – Intermediary Style* 66, *66*
Conrad, Fred R., *Rachel 'Bunny' Lambert Mellon Holding One of Her Miniature Herb Trees* 229, *229*
conservatories 124, *124*, 192, *192*
Cook, Francis 19
Corry, William Longman 269
Corry & Co, *Corry's Slug Death* 269, *269*
Cotehele, Cornwall 157, *157*
Courtiers in a Rose Garden: A Lady and Two Gentlemen (anonymous) 88, *88*
Cowell, Cyril, *Adam the Gardener* 194, *194*

Cowper, William 264
Cran, Marion 210
Cranach, Lucas the Elder, *Creation of the World* 285, *285*
Crane, Walter, *Mistress Mary* 228, *228*
Cremorne Gardens, Chelsea, London 86, *86*
Crescenzi, Pietro de, *Ruralia commoda* 36, *36*
Crisp, Sir Frank 257
Crosby, Njideka Akunyili, *Still You Bloom In This Land of No Gardens* 129, *129*
Cruyl, Lievin, *Hanging Gardens of Babylon* 54, *54*
Cuadra San Cristóbal, Mexico 176, *176*
Cubism 97, 135
Culliton, Lucy, *Hartley Cactus Garden* 145, *145*

D
da Prato, Convenevole 137
da Vignola, Giacomo Barozzi 120
daffodils 271
Daily Express 194
Daisen-in, Daitoku-ji Temple, Kyoto 8, 187, *187*
Dalí, Salvador 78, 98, 182, 224
 Jardín de Port Lligat 79, *79*
Damgaard, Aage 219
Darly, Matthew, *The Flower Garden* 22, *22*
Davidson, Max 194
Davis, Alexander Jackson, *View in the Grounds of Blithewood, Dutchess County* 155, *155*
Davis, Mary 161, *161*
DC Comics 268, *268*
Degas, Edgar 237
Delacroix, Eugène 143
Derain, André 97
Dethick, Henry 272
Devonshire, Duke of 103
di Buonaguida, Pacino, *Regia Carmina* 137, *137*
Dig for Victory 9, 29, 30, 195, 197, 200, 210, 211, 266
Diller Scofidio + Renfro 221
Dinkeloo, John 233
dish, lozenge-shaped (anonymous) 253, *253*
Donaldson, Robert and Susan Jane 155
Donnell Pool Garden, California 50, *50*, 51
Dorman-Smith, Sir Reginald 200
Dorothy, Saint 133, *133*
Downing, Andrew Jackson, *View in the Grounds of Blithewood, Dutchess County* 155, *155*
Drach, Peter 36
Drage, Sir Benjamin 112
Dream Gardens (BBC) 78
du Pont, Henry 246
du Pont, Pierre S. 225
Dumbarton Oaks, Washington DC 8, 64, *64*
Dunbar, Evelyn 14, *14*, 265
Dunnett, Nigel 9
Dupérac, Étienne, *The Gardens at Villa d'Este* 280, *280*
Dürer, Albrecht, *Adam and Eve* 284, *284*
Dutch style 209

E
Eckbo, Garrett 50, 231
Edward Scissorhands 215, *215*
Egerström, Folke S. 176

Egyptians, ancient 6, 290, *290*
Elizabeth, Duchess of Beaufort 163
Elphick, George 276
Elphick & Son Ltd, *Illustrations of Bulbs, Flowers, Roots Etc.* 276, *276*
Elvaston Castle, Derbyshire 286, *287*
en plein air 18, 40, 319
enclosed gardens 7, 32, 39, 133, 141, 235
English Landscape movement 7, 22, 101, 102, 103, 281, 306
Eragny Press 72
Erdberg, Nerina von 303
Este, Cardinal Ippolito II d' 280
Evanion, Henry Evans, *Cremorne Gardens, Chelsea* 86, *86*
Eve 24, 76, 144, *152–3*, 153, 284, *284*
Evelyn, John 87
 Elysium Britannicum 204, *204*
Everett, Thomas H. 199
Expressionism 91

F
Façade of the Winter Bower (anonymous) 311, *311*
Facebook 28
Fairchild, Thomas, *The City Gardener* 164, *164*
Faivre, Annie, *Jardin à Sintra* 19, *19*
Farrand, Beatrix 8, 64
Ferney Hall, Shropshire 83, *83*
Finlay, Ian Hamilton, *The Present Order Is the Disorder of the Future – Saint-Just* 70, *70*
Finley, Ron 9, 166
Finnis, Valerie 8, 197
 Lady Rhoda Birley 81, *81*
Finsch, Otto, *Captive Birds* 185, *185*
Flagg, J. M. 115
Fleming, John 331
Flora 105
Florentine Codex 322
flower clocks 11, *11*
The Flower Pot Men (BBC) 262, *262*
Foerster, Karl 213, 218, 324, *324*
Foland, Eveline 244
Fondo Xilitla 224
Foot, Michael 200
Ford, Gerald R. 201
Ford Foundation Building Garden, New York 233, *233*
Forestier, Jean-Claude Nicolas 101
Fortescue, William Banks, *Lady Watering the Garden Room* 124, *124*
Fouquet, Nicolas 7
Fouquières, Jacques, *Hortus Palatinus* 121, *121*
Fratino, Louis, *Morning* 27, *27*
Frederick V, Elector Palatine 121
Freeman, Thomas 26
Freud, Lucian 31, 265
 Garden, Notting Hill Gate 96, *96*
Freund, Gisèle, *Frida Kahlo in Her Garden at Coyoacán* 180, *180*
Frick Collection, New York 250, *250*
Fry, Roger 15
Fryar, Pearl 259
Functional Modern 51
furniture, garden 130, *130*, 236, *236*, 260, *260*

G
Gambara, Cardinal Gianfrancesco 120
Garden of Cosmic Speculation, Dumfries 223, *223*
Garden of Eden 6, 12, 13, 75, 204, 283
 Adam and Eve (Dürer) 284, *284*
 Adam Purple's Garden of Eden, Forsyth Street, New York (Wang) 232, *232*
 Collapse in a Garden (LaChapelle) 23, *23*
 Creation of the World (Cranach) 285, *285*
 The Garden of Earthly Delights (Bosch) 7, 76, *76*
 The Garden of Eden (anonymous) *152–3*, 153
 The Garden of Eden (Voysey) 73, *73*
 Giardino dell'Eden Tourbillon Cuff Watch (Bulgari) 77, *77*
 In the Garden (Bearden) 58, *58*
 In a Shoreham Garden (Palmer) 24, *24*
 Paradise Garden mural (anonymous) 144, *144*
Garden of Fidelity, Kabul 57, *57*
Garden of Hesperides 283, *283*
Garden of the Inept Administrator, Suzhou 8, 118, *118*
Garden Museum, London 277
garden plan (anonymous) 178, *178*
Garden Scene (anonymous) 123, *123*
Garden Work for Amateurs 194
Gardeners' Chronicle 184, *184*
Gardiner, Clive, *Kew Gardens* 97, *97*
Gardiner, Rena, *Summerhouse in the Valley Garden, Cotehele* 157, *157*
Garrett, Fergus 305, 312, *312*
Gauci, Gerard, *Public Gardens Stamp Series* 65, *65*
Geesaman, Lynn, *Love Temple, Longwood Gardens, Kennett Square, Pennsylvania* 225, *225*
Gen, Yamaguchi, *Tea Garden* 252, *252*
Gentleman, David, *Clipped Yew Hedges, Sissinghurst Castle, Kent* 302, *302*
George III, King 41, 162
Gerber, Kathleen, *Botanic Garden* 139, *139*
Ghika, Princess 303
Gilman, Harold, *Portrait of a Black Gardener* 26, *26*
Gilpin, William 41
Ginkakuji Garden 8, 308, *308*, 309, *309*
Giverny, Paris 8, 40, *40*, 101, 212, *212*
Glover, John, *A View of the Artist's House and Garden, in Mills Plains, Van Diemen's Land* 69, *69*
gnomes 248, *248*, 249, *249*
God *152–3*, 153, 204, 284
Godfrey, Walter 81
Goldberger, Alice 112
Gomis, Waruna, *Jayawardene House* 172, *172*
Grandval, Sophie, *The King's Vegetable Garden at Versailles* 17, *17*
Granger, George Sr. 33
Grant, Duncan 15
Grasset, Eugène, *January* 310, *310*
Great Dixter, East Sussex 8, 305, 312, *312*
Greene, Isabelle 225
Griebel, Philip 248
Grieve, Maud 202
Griffin, Sir John 162
Griffin-King, June, *Indoor Gardening: A Ladybird Book* 243, *243*

Gropius, Walter 175, *175*
guerrilla gardening 217
Guinet, Christophe (Monsieur Plant), *Plant Your Mac!* 138, *138*
Gullichsen, Harry and Maire 51
Guzmán, Hulda, *Gardening* 134, *134*

H
Habit de Jardinier (anonymous) 273, *273*
Ḥāfeẓ of Shiraz 131
Halifax Public Gardens, Nova Scotia 65
Halprin, Lawrence 50
Hamerman, Conrad 225
Hamersley, Hugh 163, *163*
Hammick, Tom, *Koodge's Garden* 193, *193*
Hampton Court Palace, London 7, 82, *82*, 257
Handel, George Frideric 87
Hanging Gardens of Babylon 6, 54, *54*
Harcourt, 1st Earl of 41
Harcourt, George Simon 41
Harden, Vanessa, *Spade, Shovel & Rake Nail Dusters* 217, *217*
Hardouin-Mansart, Jules 17, 43
Hardy Aster with Conservatory in Background (anonymous) 199, *199*
Hariot, Thomas 74
Harrington, Earl of 286
Harrison, George 304
Harvesting Parsnips and Carrots (anonymous) 239, *239*
Hathor 53
Hatshepsut 290
Havergal, Beatrix 8, 197
Hawkins, Peter 262
Hayao, Miyazaki 46
Hayes, Jack 211, *211*
Haynes, John, *The Physic Garden, Chelsea, A Plan View* 327, *327*
Hello Kitty 216, *216*
Henri II, King 93, 208
Henri IV, King 208
Henry III of Nassau 76
Henry VIII, King 36, 82
Hera 283
Hermès (artisanal house) 19, *19*
Hermes (Greek god) 22
Hessayon, David Gerald, *Be Your Own Gardening Expert* 195, *195*
Hessen-Kassel, Princess Maria Louise van 238
Hestercombe House, Devon *60–1*, 61
Het Loo, Netherlands 7, 256, *256*
Hewitt, Mattie Edwards, *Niederhurst, the Lower Terrace, Designed by Marian Cruger Coffin* 196, *196*
Hezar Jarib gardens, Isfahan 147, *147*
Hibberd, James Shirley 242
Hicks, Ivan, The Garden in Mind 78, *78*
The High Line, New York 220–1, 221
High Victorian 8, 62
Hill, Thomas, *The Gardeners Labyrinth* 272, *272*
Hiroshige, Utagawa I, *Eastern Genji: The Garden in Snow* 301, *301*
Hitchens, Ivon, *Composition, Wildflowers* 288, *288*
Hodgkin, Howard, *Herb Garden* 203, *203*
Hodgson, Colonel John 38
Hoen, A. & Co. 115
Hogarth, William 87

Holmes, Paul, *In Your Garden* 80, *80*
the Hong 123
hortus conclusus 7, 88, 133, 235
Hortus Palatinus, Heidelberg Castle 121, *121*
hothouses 192
House & Garden 247, *247*
House of the Golden Bracelet fresco
 (anonymous) 255, *255*
houseplants 9, 295
Howard, George and Sarah 240
Hua Yan, *Enjoyment of Chrysanthemums*
 227, *227*
Hughes, Wormley 33
Huizong 317
Humay, Prince 141, *141*
Humayun, Princess 141, *141*
Humboldt Park, Chicago 168
Hunter, Clementine, *Clementine in
 Her Flower Garden* 329, *329*
Hunter, Kathleen 202

I

Impressionism 8, 40, 93, 213, 319, 325
Inca 254
International Peace Garden 65, *65*
Interstellar Lab, Experimental
 Bioregenerative Station (EBioS) 148, *148*
irises 31, 48, *48*, 91, *91*, 140, *140*
Isham, Sir Charles 248
Ishigawi, Junya and Associates, *Botanical
 Garden Art Biotop – Water Garden*
 100, *100*
Ishimoto, Yasuhiro, *Moon-Viewing Platform
 Seen from the Second Room, Katsura*
 191, *191*
Islamic gardens 7, 38, 120, 136, 142, 250
Isola Bella, Italy 55, *55*
Ive, Jony 138

J

Jackson, A.L., *Flower-Sellers in the Market
 at Washington DC* 270, *270*
Jackson, Andrew 188
Jahān, Shah 38
Jahangir, Emperor 39
James I, King 121
James, Edward 78
 Las Pozas 224, *224*
James Corner Field Operations 221
Japanese gardens 6, 8, 174, 175, *175*, 178–9,
 186, 190–1, 287, 308, *308*
Japanese Tea Garden, Golden Gate Park,
 California 49, *49*
Jardin Exotique, Monaco 182, *182*
Jarman, Derek 71, *71*
Jayawardene, Pradeep 172
Jayawardene House, Sri Lanka 172, *172*
Jefferson, Thomas 33, 160
Jeffrey & Co. 73
Jekyll, Gertrude 8, 9, 44, 63, 68, 246, 261
 Planting Scheme for West Rill, Hestercombe
 60–1, 61
Jellicoe, Ballantyne & Coleridge 230
Jellicoe, Geoffrey, *Motopia: A Study in the
 Evolution of Urban Landscape* 230, *230*
Jencks, Charles, *Garden of Waves, Garden
 of Cosmic Speculation* 223, *223*
Jencks, Maggie Keswick 223

Jensen, Jens, *Proposed Improvements
 in Humboldt Park* 168, *168*
jiashan 317, *317*
Johann, Count of Nassau-Idstein 105, *105*
John A. Salzer Seed Company 12, *12*
Johnston, Frances Benjamin 196
Jugendstil movement 234
Jullien, Jean, *Kent* 34, *34*

K

Kahlo, Frida 180, *180*
Kandinsky, Wassily 8, 91
 Murnau The Garden II 314, *314*
Karasz, Ilonka, *The New Yorker* 165, *165*
karesansui 8, 174, 187, 287, 308
Katz, Alex, *Roses on Blue 20–1*, 21
Kelmscott Press 72
Kent, Adaline 50
Kent, Adolphus Henry, *Topiary Work at
 Elvaston Castle: The Yew Garden* 286, *286*
Kent, William 7, 22, 103, 226
 design for Venus Vale at Rousham 102, *102*
Kertész, André, *Chairs, Luxembourg
 Gardens, Medici Fountain* 92, *92*
Keukenhof, Lisse, Netherlands 306, *306*
Kidd, George 155
Kiley, Dan 50
 Ford Foundation Building Garden 233, *233*
Kimbei, Kusakabe, *Horikiri Iris Flower
 Garden at Tokyo* 48, *48*
Kingsland, Ambrose 95
Kipling, Rudyard 194
 A Plan of the Rose Garden 275, *275*
Kircher, Athanasius, *Hanging Gardens
 of Babylon* 54, *54*
Kirk, Maria Louise, *The Secret Garden*
 234, *234*
Kirmani, Khwaju 141
kitchen gardens 6, 17, *17*, 42, *42*, 150, 154,
 202, 211, 239, 275, 306
Klimt, Gustav, *Garden Path with Chickens*
 111, *111*
Knoop, Johann Hermann, *Contemplative and
 Active Gardener's Art* 238, *238*
Knyff, Leonard, *A View of Hampton Court*
 82, *82*
Korab, Balthazar, *Villa Gamberaia* 303, *303*
Kreutzberger, Sibylle 8
Kristiansen, Ole Kirk 49
Kubrick, Christiane, *Plant Trays on a
 Window Sill* 117, *117*
Kunisada, Utagawa I, *Eastern Genji: The
 Garden in Snow* 301, *301*
Kusama, Yayoi, *Rose Garden* 307, *307*

L

La Casa Azul, Coyoacán, Mexico City 180, *180*
La Quintinie, Jean Baptiste de 17, 229
LaChapelle, David, *Collapse in a Garden*
 23, *23*
Ladon 283
Ladybird books 243, *243*
The Lamport Gnome (anonymous) 248, *248*
Lamport Hall, Northampton 248
Lange, Dorothea, *San Bruno, California.
 Mrs Fujita Working in Her Tiny Vegetable
 Garden She Has Planted in Front of Her
 Barrack Home* 116, *116*

Lange, Willy 324
Lapie, Pierre, *Plan for the Garden of the
 Château de Bagatelle* 101, *101*
Larmessin, Nicolas de II 273
Las Pozas, Mexico 224, *224*
lawn mowers 292, *292*
Lawson, Andrew, *Mrs S. Howard,
 Southbourne Overcliffe Drive, Southbourne,
 Bournemouth, Devon* 240, *240*
Lawson, William, *A New Orchard and
 Garden* 150, *150*
Le Bazar de l'Hôtel, Paris 108, *108*
Le Brun, Charles 16, 43
Le Corbusier 175, *175*, 230, 236
Le Nôtre, André 7, 16, 17, 93, 208
Le Vau, Louis 16
Ledoux, Claude-Nicolas 311
Lee, Doris, *The View, Woodstock* 113, *113*
LEGO 49
Lepautre, Pierre, *Plan general de la ville
 et du château de Versailles* 16, *16*
Lett-Haines, Arthur 31
Letts of London, *Gardener's Notebook*
 313, *313*
Levens Hall, Cumbria 258, *258*
Leyel, Hilda 202
Libbalisherrat 132, *132*
Lichtwark, Alfred 213
Liebermann, Max 8
 *The Flower Terrace in Wannsee Garden
 Facing Northeast* 213, *213*
Ligorio, Pirro 98, 280
Lingstrom, Freda 262
Linnaeus, Carl 11
Lipscombe, Guy, *A Garden in Summer* 261, *261*
Little Sparta, Edinburgh 70
Lloyd, Christopher 8, 312
 35 Years, In My Garden 305, *305*
London, George 82, 209
London Underground 97, *97*
Longwood Gardens, Pennsylvania 225, *225*
Lonicer, Adam, *Kreuterbuch (Herbal)* 207, *207*
Lory, Mathias Gabriel, *View of the Beautiful
 Island* 55, *55*
Lotusland, Santa Barbara, California 181, *181*
Loudon, John Claudius 155
 *Design for an Extensive Kitchen-garden with
 a Flower-garden and Orchard* 42, *42*
Louis XIII, King 208
Louis XIV, King 7, 16, 17, 23, 43, 93, 208, 229
Louis XVI, King 101, 311
Luffman, Charles Bogue 85
Luther, Martin 285
Lutyens, Edwin 8, 44, 61, 63, 68, 80, 224,
 261, 305
Luxembourg Gardens, Paris 92, *92*
Lycurgus Painter (attrib.), krater showing
 the garden of the Hesperides 283, *283*

M

McKim, Ruby S. 244
McQueen, Alexander, *Chinese Garden*
 321, *321*
Magritte, René 78, 224
Mahal, Mumtaz 38
Mahoney, Charles 14
 The Garden 265, *265*
Maison de la Belle Jardinière 310
Majorelle, Jacques 9, 142, *142*

Makoto, Azuma, *Mexx* 173, *173*
Malinalco, Mexico 144
Mannerism 98, 121
Manrique, César 9
mantle, woman's (anonymous) 254, *254*
Marchi, Marcello 303
Marie Antoinette 16, 101
Mariënburg, Germany 238, *238*
Marlow, Peter, *G.B. England. Kent. Romney
 Marsh* 249, *249*
Marot, Daniel 82, 256
Marshall, Kerry James, *Many Mansions*
 169, *169*
Martin, Pierre-Denis, *General View
 of Château de Marly* 43, *43*
Mary II, Queen 82, 256
Mary Queen of Scots 228
Mason, William, *Plan of the Flower Garden
 at Nuneham, Oxon, Belonging to the Right
 Honourable Earl Harcourt* 41, *41*
Matisse, Henri 8, 10, 27, 177, 252
 Periwinkles/Moroccan Garden, Tangier
 143, *143*
Mattel, Barbie Doll and Gardening Playset
 85, *85*
Mawson, Thomas Hayton, *Summerhouse
 at Montacute* 68, *68*
Medici, Queen Catherine de' 93
Medici, Ferdinando de' 281
Medici, Grand Duke Francesco I de' 281
Medici, Queen Marie de' 92
Meketre 146
Mellon, Rachel 'Bunny' Lambert 229, *229*
Meryt 52
Mesoamericans 291
Michael, Archangel 133, *133*
Michelangelo 37
Middleton, Cecil Henry 210, *210*
Mill Plains, Van Diemen's Land 69, *69*
Miller, Philip 7, 327
 The Gardeners Dictionary 106, *106*
Milton, John 24
miniature garden (anonymous) 317, *317*
Ministry of Agriculture, *Grow for Winter
 as Well as Summer* 200, *200*
Miró, Joan 177, 252
Mistress Mary 228, *228*
*Mrs Theodore Roosevelt's Orchid Collection,
 White House, Washington DC* (anonymous)
 188, *188*
model of a porch and garden (anonymous)
 146, *146*
Modernism 50, 219, 230
Mollet, André 208
Mollet, Claude, *Théâtre des plans de
 jardinages* 208, *208*
Mollet, Jacques 208
Monet, Claude 8, 101, 107, 193, 212, *212*, 213
 Le Jardin de l'artiste à Giverny 40, *40*
Monserrate, Sintra 19, *19*
Montacute House, Somerset 68, *68*
Monticello, Virginia 33, *33*
Montreal Botanical Gardens 65, *65*
Moore, A.A., *Home Bulbs for Home Gardens*
 271, *271*
Moore, Noel 267
Morris, Cedric, *Still Life in Summer Garden*
 31, *31*
Morris, Richard, *Plan of a Flower Garden &
 Rosary* 297, *297*

Morris, William 8, 72, 73, 160, 228
 Trellis 84, *84*
Morton, Julieanne Ngwarraye, *My Country –*
 Bush Medicine Plants 323, *323*
Moschino, Simone 98
Motopia 230, *230*
Moucheron, Isaac de, *Het Loo* 256, *256*
Mount Vernon, Virginia, 154, 188, 229
Mughal gardens 7, 39
Muller, J. S., *The Triumphal Arches, Vauxhall*
 Gardens 87, *87*
Munstead Wood, Surrey 63, *63*
Murakami, Takashi 216
Musical Garden, Herning, Denmark 219, *219*
My Garden (anonymous) 112, *112*

N
Nanha, Babur's Garden 57, *57*
Napoleon I 53, 109
Napoleon II 101
NASA 148
Nash, John 125
Nash, Joseph 258
Nash, Paul 151
Nast, Condé 247
National Trust 157, 226, 275, 302, 315
naturalistic garden style 8, 69, 168, 170, 221,
 246, 324, 330
Nazi Party 91
Nebamun 53, *53*
Nebuchadnezzar II 6, 54
Nevill, William 19
New York Botanical Garden, 199, *199*
The New Yorker 165, *165*
Nichols, Beverley, *Down the Garden Path*
 110, *110*
Nichols, Clive, *Pettifers, Oxfordshire: Dawn*
 Light Hits the Parterre Framed by Rose
 Arbour 279, *279*
Nicholson, Ben 288
Nicolson, Adela Florence 39
Nicolson, Harold 80, 302
Niederhurst, New York 196, *196*
Niemeyer, Oscar 177
nihonga 216
Nike 167, *167*
Nilsson, Lisa, *Grand Jardin* 296, *296*
niwaki conifers 67, *67*, 308
Nix, Lori, *Botanic Garden* 139, *139*
Noguchi, Isamu, *California Scenario* 179, *179*
Nolde, Emil, *Blumengarten (O)* 91, *91*
North, Marianne, *View in the Garden of*
 Acclimatisation, Tenerife 18, *18*
North Palace of Nineveh 132, *132*
Nurallah, Hafiz, *A View of Shalimar Bagh,*
 Srinagar 39, *39*
Nyx 283

O
Oak Spring Garden Foundation 229
Ogawa, Kazumasu 66
Olmsted, Frederick Law, *Map of Central Park*
 and the Upper West Side New York City
 8, *94–5*, 95
orchids 188, *188*, 189, *189*, 295
Orleans, Louis-Philippe d' 311
Orsini, Pier Francesco 98
Ortega 90

Oswald, Saint 133, *133*
Oudolf, Piet, *Easter Rail Yards, The High*
 Line, New York 8, *220–1*, 221
oval tray (anonymous) 119, *119*
Owens, Bill, *Before the dissolution of our*
 marriage my husband and I owned a bar.
 One day a toilet broke and we brought it
 home 241, *241*

P
Page, Russell, *70th Street Garden, Frick*
 Collection, New York 250, *250*
Palace Garden of Hezar Jarib in Aliabad
 (anonymous) 147, *147*
Palace of Versailles, Paris 7, 16, *16*, 17, *17*, 43,
 82, 92, 99, 205, 229, 256
Palmer, Samuel, *In a Shoreham Garden* 24, *24*
Paradise Garden mural (anonymous) 144, *144*
Parc Monceau, Paris 311, *311*
Parco dei Mostri, Italy 98, *98*
Parkinson, John, *Paradisi in sole paradisus*
 terrestris 75, *75*
Parr, Martin, *Ursula and Wolfgang Opitz*
 with Dog Lina 13, *13*
Parrish, Maxfield, *The Dream Garden*
 126–7, 127
Parsons, Alfred, *The Wild Garden* 62, *62*
parterres 7, 22, 208, 303, 331
Passe, Crispijn de, *Spring Garden* 257, *257*
Patterson, Ebony G., *...below the crows,*
 a purse sits between the blades, shoes
 among the petals, a cockerel comes to
 witness... 45, *45*
Paul, Joseph John Dawson 260
Paxton, Joseph 103, 184
Pearl Fryar's Garden, Bishopville, South
 Carolina 259, *259*
Pearson, Dan 315, *315*
Pearson, Harold 198
Peláez, Amelia, *El Jardín* 135, *135*
Peleus 283
Peticolas, Jane Braddick, *View of the West*
 Front of Monticello and Garden 33, *33*
Peto, Harold 68
Pettifers, Oxfordshire 279, *279*
Pfister, Henry 188
Philadelphia's Magic Gardens 128, *128*
Philips, Jan Caspar 238
Picasso, Pablo 27, 91, 182
Pick, Frank 264
Pierce, Franklin 188
Pilkington Brothers 230
Pissarro, Camille 8, 72
 The Garden of the Tuileries on a Winter
 Afternoon 93, *93*
Pissarro, Lucien, *Of Gardens: An Essay*
 72, *72*
Plas Brondanw, Wales 274, *274*
Plato 255
Platt, Charles, Weld, Larz Anderson
 Residence, Brookline, Massachusetts
 282, *282*
pleasure gardens 86, 87, 98, 99, 133, 147
Pliny the Elder 255
Poitiers, Diane de 208
Polier, Antoine Louis Henri 39
Pompeii 6, 114, 236, 255, *255*
Pop Art 216
Pope, Alexander 103

Popeye the Sailor Man 30
Porcinai, Pietro, *Winter Garden on the Roof*
 of Lanificio Zegna, Tivero 218, *218*
Port Lligat garden, Spain 79, *79*
potagers 6, 17, *17*, 205, 229
potted plants 206, 271, 295
Potter, Beatrix, *The Tale of Peter Rabbit*
 267, *267*
Powderham Castle, Devon 192, *192*
Preece, Patricia 151
Price, Gina 279
prickly pears 145, *145*
Prince Humay meets Princess Humayun
 in a Dream (anonymous) 141, *141*
Prospect Cottage, Kent 71, *71*
pruning tools (anonymous) 205, *205*
public gardens 8, 65, 168
Purple, Adam 232

Q
Quechua culture 254
quintas 90, *90*

R
rabbits 267, *267*
Race, Robert, *The Seed Man* 277, *277*
Radclyffe, Dick & Co., *Rustic Adornments*
 for Homes of Taste 242, *242*
Ransomes 292, *292*
Ransomes' Lawn Mowers: The Best in the
 World (anonymous) 292, *292*
Ravilious, Eric 14
 The Greenhouse: Cyclamen and Tomatoes
 125, *125*
Ray, Richard 'Jimmie', *Anne Spencer in Her*
 Garden 59, *59*
Ray-Jones, Tony, *A Garden near*
 Wolverhampton with 16 Dogs, 2 Cats
 and a Rat 214, *214*
Reciting Poetry in a Garden (anonymous)
 131, *131*
Red House, Kent 84
Reeves, Dache McClain, *Great Serpent*
 Mound 222, *222*
reliefs 6, 132, *132*, 290, *290*
Rembrandt 27
Renaissance 7, 68, 98, 202, 239, 257,
 284, 290
 French 150, 205, 208, 287
 Italian 7, 37, 54, 120, 121, 150, 208, 235,
 274, 280, 282
Renoir, Pierre-Auguste 237
 Woman with a Parasol in a Garden 319, *319*
Repton, Humphry 7, 41, 297
 The Red Book of Ferney Hall 83, *83*
Rhoades, Geoffrey Hamilton 14
Rhodes, Cecil 198
Ringgold, Faith, *The Sunflower Quilting Bee*
 at Arles: The French Collection Part I, #4
 263, *263*
Rivera, Diego 180
Robert of Anjou 137
Robins, Thomas the Elder, *A View of the*
 Chinese Kiosk at Woodside 163, *163*
Robinson, Bernard Herbert, *Indoor*
 Gardening: A Ladybird Book 243, *243*
Robinson, Brian, *Custodian of the Blooms*
 289, *289*

Robinson, Jerry, *Victory Garden, World's*
 Finest Comics 268, *268*
Robinson, William 10, 72
 The Wild Garden 8, 62, *62*
Robinson, William Heath, *Careful*
 Preparation of the Soil Before Planting
 a Rose-Bed 332, *332*
Roche, Kevin 233
Rochette, G., *Schoolchildren Gardening*
 245, *245*
Rohde, Eleanour Sinclair, *Bee & Herb*
 Garden 202, *202*
Romanticism 51, 169
Roosevelt, Edith 188, *188*
Rose, James 50
Rosellini, Ippolito, *Plate LXIX* 52, *52*
roses 7, *20–1*, 21, 88, 332
Rousham House, Oxfordshire 102, *102*
Rousseau, Henri 134
Royal Botanic Gardens, Kew 18, 26, 65, 97,
 97, 106, 315
Royal Botanical Gardens, Hamilton 65, *65*
Royal Horticultural Society 103, 200, 210,
 246, 304, 315, 331
 The Vegetable Garden Displayed 266, *266*
Royal Walled Garden (anonymous) 251, *251*
Rutz, Victor, *Keukenhof* 306, *306*
Ryder, Samuel 277
Ryders 277
Ryoanji Temple, Kyoto 175, *175*

S
Sackville-West, Vita 8, 81, 241, 261, 302
 In Your Garden 80, *80*
Sahagún, Bernardino de, *General History of*
 the Things of New Spain: The Florentine
 Codex 322, *322*
Saint Laurent, Yves 142
Salas Portugal, Armando, *Main Courtyard*
 and Horse Pool, Cuadra San Cristóbal,
 Los Clubes, Mexico City 176, *176*
Salt, Henry 53
Salzer, John 12
Sang Thong, Prince 251
Sanrio Company, *Hello Kitty: In the Garden*
 216, *216*
sansui gardens 67, *67*
Saunders, Bernard and Avice 197
Schijnvoet, Jacobus and Simon, *Garden and*
 Park Ornaments and Designs 99, *99*
Schleicher-Benz, Ursula, *Flower Clock* 11, *11*
school gardens 245
Schwartz, Martha, *Splice Garden* 287, *287*
Schwetzingen Palace, Baden-Württemberg
 104, *104*
Scott, Sir David 81
Scott-Miller, Melissa, *Winter Backgardens,*
 Islington 156, *156*
Secotans 74
Segerstrom, Henry T. 179
Sennacherib, King 6, 54
Sennefer 52
Serpent Mound, Ohio 222, *222*
SFER IK art centre, Tulum 173, *173*
Shalimar Bagh, Srinagar 39, *39*
Shaw, George, *Home* 158, *158*
Shen Yuan, *Spring Pavilion of Apricot*
 Blossoms 316, *316*
Shepheard, Peter 225

Shepherd, Harry, *Bomb Crater Vegetable Plot, Westminster Cathedral* 211, *211*
Shigemori, Mirei, *Tofuku-ji Hojo* 8, 190, *190*
Shikibu, Murasaki 300, 301
Shimizu, Yuko 216
Shin-Hanga 47
Sills, Vaughn, *Pearl Fryar's Garden, Bishopville, South Carolina* 259, *259*
Silver Pavilion, Kyoto 8, 308, *308*, 309, *309*
Sinoir, Paul 142
Sissinghurst Castle, Kent 8, 80, 225, 261, 265, 302, *302*, 315
6 Stars from the Winter Garden – Grow Them in Your Winter Garden (anonymous) 30, *30*
Sloane, Sir Hans 327
slugs 269, *269*
Smith, Charles H.J. 192
Smith, Worthington George, *Chatsworth* 184, *184*
Sōami 308, 309
Somerset, Mary, Duchess of Beaufort 8
Sooley, Howard, *Derek Jarman's Prospect Cottage* 71, *71*
Sørensen, Carl Theodor, *The Musical Garden* 219, *219*
Sorolloa y Bastida, Joaquín, *Jardín del Alcázar de Sevilla* 136, *136*
Sosaku Hanga school of printmaking 252
South Coast Plaza, Orange County, California 179, *179*
Spencer, Anne 8, 59, *59*
Spencer, Stanley, *The Neighbours* 151, *151*
Spiller, Mary 197
Spring and Summer Palace Gardens (anonymous) 300, *300*
Stansted Park, Hampshire 78
Steichen, Edward, *Wheelbarrow with Flower Pots, France* 206, *206*
Stevens, Norman, *Levens Hall* 258, *258*
Stigliani, Fabrizio Buonamassa 77
Stoke Edith House, Herefordshire 209
Stotts, Jennie Pingrey, *English Flower Garden Quilt* 244, *244*
Stowe, Buckinghamshire 226, *226*, 311
Stravinsky, Igor 64
stroll gardens 100, 253
Strong, Roy 163
Studio Ghibli, *Spirited Away* 46, *46*
Subversive Gardener 217
Sunflower Quilters Society of America 263, *263*
surrealism 78, 79, 224
Sutherland, Duchess of 331
Sutton, Ann and Michael, *Kirstenbosch National Botanical Garden, Cape Town: Landscape Proposals for a Gardener's Hub* 198, *198*
Suzuki, Uhei 122
Switzer, Christopher, *Paradisi in sole paradisus terrestris* 75, *75*

T
Tacuinum Sanitatis 239, *239*
Taj Mahal 38, *38*
Takacs, Claire, *Trompe l'oeil, Schwetzingen Palace, Mittelbau Schloss, Germany* 104, *104*
The Tale of Genji 300, *300*, 301

Tang Dai, *Spring Pavilion of Apricot Blossoms* 316, *316*
Tao Qian 227
taxonomy 11, 326
Taylor, Jason deCaires, *The Coral Greenhouse* 149, *149*
teamLab, *Floating Flower Garden: Flowers and I are of the Same Root, the Garden and I are One* 189, *189*
Tenniel, John, *Through the Looking Glass* 294, *294*
terrariums 138, *138*
Teumman 132
Thammalangka, Prince 251
Theophrastus 290
Thetis 283
Thomas, Alma, *Alma's Flower Garden* 328, *328*
Thompson, Robert, *Carpet Bedding* 331, *331*
Thrower, Percy 210
Tichenor, Bridget Bate 224
Tiffany Studios, *The Dream Garden* 126–7, 127
Tillmans, Wolfgang, *windowbox (37-36)* 35, *35*
Tipping, Henry Avray 68
Tlalocan, mural of (anonymous) 291, *291*
Tod, George, *A Conservatory Executed for... Lord Viscount Courtenay* 192, *192*
Tofuku-ji Hojo, Kyoto 8, 190, *190*
Tomasini, Filippo, *Plan of the Botanical Garden at the University of Padua* 326, *326*
The Tomb of the Vines, Egypt 52, *52*
topiary 214, *214*, 215, *215*, 229, 258, *258*, 259, 274, 282, 286, *286*
Toulouse-Lautrec, Henri de 237
Treacy, Philip, *Chinese Garden* 321, *321*
Tremaine, Burton 177
Trentham Hall, Staffordshire 278, *278*
trompe l'oeil 104
Tshabalala, Phumelele, *Gangster Gardener* 166, *166*
Tuileries, Paris 92, 93, *93*, 208
Tuthmosis III 290
20th Century Fox 215, *215*

U
Ueno Park, Japan 174, *174*
UK Empire Marketing Board 271
ukiyo-e 301
Underground Electric Railways Company of London, *Golders Green* 264, *264*
The Unicorn Rests in a Garden (anonymous) 140, *140*
Uplands Allotments, Birmingham 333
Upper Rhenish Master, *The Little Garden of Paradise* 133, *133*
US Department of Agriculture 115, *115*
Utagawa school 301
Utens, Giusto, The Medici Garden at Pratolino 281, *281*
Utrillo, Maurice 237

V
Valadon, Suzanne, *Pausage à Montmartre (Le Jardin de la rue Cortot)* 237, *237*
Van Gogh, Vincent 263, 320
Garden in Auvers 325, *325*
Vanbrugh, Sir John 226

Vaughan, Samuel, *Plan of Mount Vernon* 154, *154*
Vaux, Calvert, *Map of Central Park and the Upper West Side New York City* 8, 94–5, 95
Vauxhall Pleasure Gardens, London 86, 87, *87*
Veitch, James Herbert, *Topiary Work at Elvaston Castle: The Yew Garden* 286, *286*
Vera, André and Paul, *Une petite Roseraie* 330, *330*
Verey, Rosemary 163
Victoria, Queen 246
Victory Gardens 115, 156, 268, *268*
Villa d'Este, Tivoli, Italy 121, 280, *280*
Villa Gamberaia, Italy 225, 303, *303*
Villa Lante, Lodge of Palazzina Gambara (anonymous) 120, *120*
Villa Mairea, Finland 51, *51*
Villa Medicea di Pratolino 281, *281*
Virgin Mary 7, 88, 133, *133*, 140, 228, 235
Voysey, Charles F. A. 44
The Garden of Eden 73, *73*

W
Walker, Tim, *Inside Outside. Eglingham Hall Bathroom, Eglingham, Northumberland* 295, *295*
wall hanging (anonymous) 209, *209*
Walpole, Horace 102
Walska, Ganna, Lotusland scrapbooks 181, *181*
Walther, Johann Jakob, *Simulacrum Scenographicum Celeberrimi Horti Itzsteinensis* 105, *105*
Wang, Harvey, *Adam Purple's Garden of Eden, Forsyth Street, New York* 232, *232*
Wang Wei 299
Wangchuan Villa, Chang'an *298–9*, 299
Warley Place, Essex 246, *246*
Washington, George 154, 188, 229, 270
Washington, DC market, 270, *270*
watering pots (anonymous) 114, *114*
Webb, Philip 84
Weir Courtney, Surrey 112, *112*
Weld, Brookline, Massachusetts 282, *282*
Wen Zhengming, *Garden of the Inept Administrator* 118, *118*
Wesley, Charles 73
Westminster Cathedral, London 211, *211*
Whip Inflation Now (WIN), *Garden Kit* 201, *201*
Whistler, Rex, *Down the Garden Path* 110, *110*
White, John 74
Whitehead Institute 287
Wihan Lai Kham, Thailand 251, *251*
Wildpret, Hermann 18
William II, King 82
William III, King 82, 209, 256
Williams-Ellis, Cloud, *Designs for Plas Brondanw, Llanfrothen, Gwynedd: Elevation of Garden Gates with Heraldic Eagles* 274, *274*
Williamsburg, Virginia 160, *160*
Willmott, Ellen, *The Garden House* 246, *246*
window boxes 8, 35, *35*
wisteria 47
women gardeners 85, 124, 197

Women's Horticultural College, Waterperry House, Oxfordshire 8, 197, *197*
Wood, Jonas, *Japanese Garden 2* 67, *67*
Woodforde-Finden, Amy 39
Woodside, Berkshire 163, *163*
Woodstock, New York 113, *113*
Woolf, Virginia 81
Worshipful Society of Apothecaries 327
Wren, Sir Christopher 82
Wright, Frank Lloyd 168
Wright, Thomas 163
Wu Guanzhong, *Plum Blossom Garden of Wuxi* 320, *320*
Wynn-Jones, Bleddyn and Sue 7

Y
Yokohama Nursery Co. 122, *122*
Yoshida, Hiroshi, *Kameido Bridge, Tokyo* 47, *47*
Yoshida, Toshi, *Ginkakuji Garden* 308, *308*, 309, *309*
Yoshimasa, Ashikaga 308, 309
Ystumllyn, John 26
Yuanming Yuan 316, *316*
Yuanqi, Wang, *Wangchuan Villa 298–9*, 299

Z
Zagar, Isaiah, *Philadelphia's Magic Gardens* 128, *128*
Zeki, Semir 6
Zen gardens 8, 66, 174, 186, 187, *187*, 189, 212, 252, 287
Zeuxis 255
Zynga, *FarmVille* 28, *28*

Publisher's Acknowledgements

A project of this size requires the commitment, advice and expertise of many people. We are particularly indebted to our consultant editor Matthew Biggs for his vital contribution to the shaping of this book and his exhaustive knowledge.

Special thanks are due to our international advisory panel for their knowledge, passion and advice in the selection of the works for inclusion:

Richard Aitken
Historian, curator and author,
Melbourne, Australia

Matthew Biggs
Gardener, author and broadcaster,
Hertfordshire, UK

Tania Compton
Garden designer and author,
Salisbury, UK

Madison Cox
Garden designer, New York

Brent Elliott
Former Librarian, then Historian,
Royal Horticultural Society, London

Annie Guilfoyle
Garden designer, lecturer and cofounder,
Garden Masterclass, Easebourne, UK

Noel Kingsbury
Garden designer, author and cofounder,
Garden Masterclass, UK and Portugal

Abra Lee
Horticulturist and author, *Conquer the Soil*,
Atlanta, Georgia

Colleen Morris
Landscape heritage consultant, Sydney,
and former National Chair, Australian
Garden History Society

Toby Musgrave
Garden and plants historian, designer
and author, Copenhagen, Denmark

Polly Nicholson
Founder, Bayntun Flowers,
antiquarian book and historic
tulip specialist, Wiltshire, UK

Kristine Paulus
Collection Development Librarian,
LuEsther T. Mertz Library,
New York Botanical Garden

Anna Pavord
Gardener and author of *The Tulip*,
The Naming of Names and *The
Seasonal Gardener*, Dorset, UK

Carrie Rebora Barratt
Director, LongHouse Reserve,
East Hampton, New York

Georgina Reid
Founding editor of *Wonderground* print
journal and author of *The Planthunter: Truth,
Beauty, Chaos and Plants*, Sydney, Australia

Gill Saunders
Honorary Senior Research Fellow,
Victoria and Albert Museum, London

Ina Sperl
Journalist, author and head of Public
Relations at German Federal Horticultural
Show Ltd, Cologne and Bonn, Germany

Thaïsa Way
Director, Garden and Landscape Studies
(GLS), Dumbarton Oaks, Washington DC

Clare A.P. Willsdon
Professor of the History of Western Art
and Head of History of Art, University of
Glasgow, and specialist in art and gardens

Yue Zhang
Senior Lecturer in Chinese, Art History and
Visual Culture, University of Exeter, UK

We are particularly grateful to Sara Bader
and Rosie Pickles for researching and
compiling the longlist of entries for inclusion.
Additional thanks are due to Jenny Faithfull
and Jen Veall for their picture research,
Tim Cooke for his editorial support and
to Caitlin Arnell Argles, Vanessa Bird,
Olivia Clark, John Danzer, Rosie Fairhead,
Diane Fortenberry, Simon Hunegs, Rebecca
Morrill, João Mota, Celia Ongley, Elizabeth
O'Rourke, Lynn Parker, Michele Robecchi,
Matilda Southern-Wilkins and Christopher
Woodward for their invaluable assistance.

Finally, we would like to thank all the
artists, illustrators, photographers,
collectors, libraries, institutions and
museums who have given us permission
to include their images.

Text Credits

The publisher is grateful to Matthew Biggs for writing the introduction, Toby Musgrave for writing the timeline and additional thanks go to the following writers for their texts:

Richard Aitken: 18, 44, 64, 72, 75, 85–6, 90, 106, 125, 150–1, 155, 175, 192, 219, 230, 245, 260, 272, 289, 330; **Giovanni Aloi:** 12–13, 35, 37, 49, 55, 67, 74, 79, 91–2, 96, 108, 111, 115–17, 124, 137, 145, 153, 156, 169, 178, 188, 206, 212, 229, 247, 251, 267, 270–1, 284–5, 293, 295, 299, 308, 314, 319, 325–6; **Sara Bader:** 296; **Matthew Biggs:** 11, 17, 71, 73, 80, 103, 140, 142, 165–7, 170, 181, 189, 200, 249; **Louise Bell:** 46; **Tim Cooke:** 16, 27–9, 34, 48, 77, 87, 89, 99, 101, 109, 113, 119, 123, 130, 135, 139, 144, 148, 157, 160, 168, 172–3, 176, 184–6, 190, 196, 198, 217–18, 222, 225, 233, 236–8, 242, 244, 246, 250, 253–4, 256, 259, 274, 301, 303–4, 311, 313, 318, 320, 329; **Brent Elliott:** 54, 66, 81, 194, 197, 202, 210, 257–8, 266, 286, 297, 331; **Diane Fortenberry:** 52–3, 56–7, 102, 131–2, 141, 146, 227, 283, 290, 317, 327; **Tom Furness:** 10, 22, 26, 88, 138, 147, 159, 193, 195, 235, 239, 241, 252, 255, 261, 265, 277, 288, 321; **Noel Kingsbury:** 30, 213, 305, 312, 324, 333; **Colleen Morris:** 42, 62, 70, 223, 323; **Toby Musgrave:** 38, 43, 50–1, 68, 82, 114, 118, 120–1, 154, 163, 205, 208, 224, 226, 281, 306, 322; **Kristine Paulus:** 32, 36, 40, 45, 59, 61, 127, 162, 164, 177, 180, 199, 201, 216, 221, 248, 276, 294, 307; **Gill Saunders:** 21, 24, 31, 84, 97, 105, 158, 171, 203, 214, 264, 302, 310; **James Smith:** 23, 104, 122, 179, 204, 280, 282, 300; **David Trigg:** 14, 15, 33, 41, 58, 65, 69, 76, 78, 98, 107, 112, 128, 129, 133–4, 143, 149, 174, 183, 187, 209, 211, 215, 231–2, 234, 240, 262, 268–9, 287, 328, 332; **Alice Vincent:** 25, 191; **Martin Walters:** 19, 39, 47, 63, 83, 93, 95, 100, 110, 136, 161, 182, 207, 228, 243, 263, 273, 275, 278–9, 292, 309, 315–16.